ÄTHIOPISTISCHE FORSCHUNGEN
BAND 10

ÄTHIOPISTISCHE FORSCHUNGEN

HERAUSGEGEBEN VON

ERNST HAMMERSCHMIDT

BAND 10

FRANZ STEINER VERLAG GMBH · WIESBADEN

1983

STANISŁAW CHOJNACKI

MAJOR THEMES
IN ETHIOPIAN PAINTING

INDIGENOUS DEVELOPMENTS,
THE INFLUENCE OF FOREIGN MODELS
AND THEIR ADAPTATION

FROM THE 13TH TO THE 19TH CENTURY

FRANZ STEINER VERLAG GMBH · WIESBADEN

1983

Titelvignette: Adelheid Kordes, Hösbach

Gedruckt mit Unterstützung des Förderungs- und Beihilfefonds Wissenschaft der VG WORT GmbH, Goethestraße 49, 8000 München 2.

CIP-Kurztitelaufnahme der Deutschen Bibliothek

Chojnacki, Stanisław:
Major themes in Ethiopian painting: indigenous developments, the influence of foreign models and their adaptation from the 13. to the 19. century Stanislaw Chojnacki. – Wiesbaden: Steiner, 1983. (Äthiopistische Forschungen; Bd. 10) ISBN 3-515-03466-8 NE: GT

Printed in Germany

TABLE OF CONTENTS

GELEITWORT DES HERAUSGEBERS

Die Erforschung der äthiopischen Kunst, insbesondere der äthiopischen Malerei, ist trotz einer ganzen Reihe bedeutsamer Einzeluntersuchungen noch immer durch eine gewisse Unsicherheit gekennzeichnet, welches denn nun die Quellen waren, aus denen diese Kunst geschöpft hat, oder genauer gesagt, welche Faktoren auf sie in den verschiedenen Stadien ihrer Entwicklung eingewirkt haben. Im vorliegenden Band gibt ein hervorragender Kenner sowohl der alten, in ihren traditionellen Formen bis heute gepflegten, wie der zeitgenössischen äthiopischen Kunst auf diese Fragen – für bestimmte Themenkreise und Entwicklungsstadien – eine überzeugende Antwort.

Stanisław Chojnacki, am 21. Oktober 1915 zu Riga (Lettland) von polnischen Eltern geboren, schloß sein Studium der Rechtswissenschaften an der Universität Warschau 1937 mit dem Grad eines Ll.M. (= Legum Magister) ab. Nach dem Militärdienst in der polnischen Armee (1937–38) konnte er seine Rechtsstudien an der Sorbonne in Paris (1938–39) fortsetzen. Die Jahre 1939 bis 1945 mußte er als Kriegsgefangener in Deutschland verbringen. Von 1945 bis 1950 lebte er – mit dem Buchpublikationsprogramm der polnischen YMCA befaßt – in Rom. 1950 übersiedelte er nach Kanada, wo er an der Universität Montréal den Grad eines M.A. erwarb.

Auf Einladung der kanadischen Provinz der Societas Jesu ging er dann aber schon im November 1950 nach Äthiopien, um hier die Bibliothek des *University College* in Addis Ababā aufzubauen. Von 1950 bis 1963 war er *Chief Librarian* des *University College,* von 1963 bis 1976 *Librarian* des *Institute of Ethiopian Studies* der *Haile Sellassie I* (jetzt: *Addis Ababa) University.*

In den Jahren seines Wirkens in Äthiopien (1950–76) entfaltete *Stanisław Chojnacki* – sowohl als Organisator wissenschaftlicher Unternehmungen wie als Autor – eine bewundernswerte Aktivität, von der hier – in tabellarischer Form – nur einige wichtige Daten festgehalten seien:

Gründer und Kurator des *University College Museum* (1952–63);

Kurator des Museums des *Institute of Ethiopian Studies* (1963–75);

Adviser der *University College Ethnological Society* und Herausgeber ihres "Bulletin"[1], das mit dem "Journal of Ethiopian Studies" zu den besten wissenschaftlichen Zeitschriften Äthiopiens gehört;

Mitherausgeber des "Journal of Ethiopian Studies" (1963–75);

[1] Sein Nachfolger in dieser Funktion, *Georges Cl. Savard,* sagte: "I wish to thank especially Mr. Stanislas Chojnacki who has largely contributed to this current issue and who has been responsible for all the previous numbers of the Bulletin. Without his authentic love for Ethiopia and his unfailing devotion, there would have been no Ethnological Society and no Ethnological Bulletin." = Bulletin of the Ethnological Society–University College of Addis Ababa I 9 (Juli–Dezember 1959) 7.

Gründer des *Committee for the Preservation of Old Ethiopian Paintings* (1966);

Präsident der *Horticultural Society of Ethiopia* (1969–74).

1964 wurde *Stanisław Chojnacki* zum *Assistant Professor* ernannt, 1970 wurde ihm in Anerkennung seiner Verdienste um die "preservation of Ethiopia's cultural heritage" der Orden *Stern von Äthiopien* verliehen.

Im November 1976 kehrte *Chojnacki* nach Kanada zurück und ist seit Jänner 1978 *Director of the University of Sudbury Library* mit dem Rang eines *Associate Professor*.

Stanisław Chojnacki hat niemals den Anspruch erhoben, Äthiopist im philologischen Sinne zu sein. In diesem Bereich muß ihm daher vielleicht das eine oder andere nachgesehen werden, so wenn z. B. bei Bildbeschriftungen mitunter Details besprochen werden, die für den Philologen eine kaum erwähnenswerte Selbstverständlichkeit sind. Was die Ausführungen von *Stanisław Chojnacki* kennzeichnet, ist die Kombination von Intuition, Einfühlungsvermögen und einer Erfahrung aus zweieinhalb "äthiopischen Jahrzehnten". Nach meiner Überzeugung muß sein Werk als ein autoritativer Beitrag zur Aufhellung jener Dunkelzonen in der äthiopischen Kunst gelten, die uns bisher immer noch beunruhigen.

Schließlich habe ich die angenehme Pflicht, dem *Förderungs- und Beihilfefonds Wissenschaft der Verwertungsgesellschaft WORT* aufrichtig zu danken: Seine finanzielle Förderung machte es möglich, das vorliegende Werk in jener Form herauszubringen, in der es der Erforschung der äthiopischen Kunst am besten zu dienen vermag.

9. Juni (S. Ephraem, Diaconi et Ecclesiae Doctoris) 1980

Ernst Hammerschmidt

PREFACE

The studies published in this volume are intended to introduce to a wider public some of the major themes of the Christian art of Ethiopia. In each study the history is given of a particular theme and its relation is traced to Eastern as well as Western art. The quest is also initiated for the African background of Ethiopian painting. It is hoped that the many illustrations which are included will make the material more understandable.

The book is based mainly on unpublished material. The collection of the material started in the late 1960s during my lengthy residence in Ethiopia and is the result of my involvement in building up the art collection of the Museum at the Institute of Ethiopian Studies, Addis Ababā. Being its first curator from 1963 to 1975, I had the pleasant task of starting and developing the collection and on that occasion I had the opportunity of inspecting and recording a large number of paintings which then passed through the art market of Addis Ababā. Also I made many trips to Ethiopia's remote countryside to study wall paintings, icons and illuminated manuscripts in the churches and monasteries. The decade of the 1960s was particularly significant for our perception of Ethiopian painting because many works of art which had been previously unknown came to light. I was fortunate either to witness or take an active part in these discoveries.

The final text of the book was completed after my return to Canada in 1976. Unfortunately, during the move, an important part of my collection of slides was lost in transport. Also, being in Canada, I was naturally unable to study those paintings, which may have been discovered in Ethiopia since 1976. On the other hand, a generous grant from the Social Sciences and Humanities Council of Canada made it possible to use in full those Ethiopian collections, public and private, which are found in Europe. The grant is here gratefully acknowledged. In addition, I was able to study a few collections of Ethiopian paintings located in the United States.

I wish to thank the following institutions for help and permission to reproduce their paintings: The Department of Oriental Manuscripts & Printed Books, British Library; the Bibliothèque nationale, Paris; the John Rylands University Library, Manchester; the Bodleian Library, Oxford; the Stadt- und Universitätsbibliothek, Frankfort on Main; the Biblioteca Apostolica Vaticana; and the Peabody Museum, Salem (Massachusetts).

I am particularly indebted to my friends in Europe and the United States for allowing me to study the Ethiopian paintings in their possession and to reproduce some of them in this book. Many of these paintings are of the highest aesthetic quality and at times of great importance for the history of Ethiopian culture. I am not able to name all the collectors who showed much patience and understanding in my inquiries. I wish, however, to make a special mention of Professor and Mrs. Charles R. Langmuir who recently donated their outstanding collection to the

Peabody Museum Salem (Mass.). I hope that other collections, particularly in Europe, will follow this beneficial trend.

Special mention should be made of the collection of slides of Mrs. Eine Moore, Mr. and Mrs. Paul B. Henze, and Mrs. Diana Spencer which proved to be of invaluable assistance to my research.

I owe much to conversations and correspondence with my friends and colleagues who with great kindness answered my queries and searched for documentation. Special thanks are due to Dr. Richard Pankhurst and Professor Stefan Strelcyn and Rev. Roger Cowley in England; Dr. Rudolf Fechter, Hans W. Lockot, and Fritz von Randow in Germany; Jacques Mercier and Abbé Jules Leroy in France; Professor Lanfranco Ricci and Dr. Osvaldo Raineri in Italy; Dr. Thomas L. Kane, Dr. Julian Plante and Dr. William F. Macomber in the USA. They generously helped in matters of identification, but I accept final responsability for the results here printed.

During my years of residence in Ethiopia and numerous travels to the country-side in search for Ethiopian paintings I met a great deal of friendliness, assistance and encouragement from people in all walks of life. I owe them a great debt of gratitude. Above all my warmest tribute should go to two ladies who played a vital role in the promotion of knowledge of Ethiopian painting: to Princess Ruth Desta who initiated the idea of collecting Ethiopian paintings at the Institute of Ethiopian Studies, Addis Ababā, and generously helped in its establishment, and to Mrs. Diana Spencer who during her arduous travels to churches and monasteries made discoveries which gave a new dimension to our understanding of Ethiopian painting. Unfortunately it is not possible to mention by name all those who assisted in the difficult task of preserving Ethiopia's pictorial heritage. I wish, however, to make a special mention of thanks of my Ethiopian assistants and friends Girma Fisseha, Berhan Ayelew and Abebe Kifleyesus and of Mrs. Manna Zacharias for their devoted collaboration. Dr. Kinefe-Rigb Zelleke was my efficient companion during the field trips.

It took much time before the text of this book attained its final form. I must thank my friends George M. Bornet and Dr. Placide Gaboury, SJ, for their stylistic revision of the text and for many usefull suggestions.

I apologize to those whose names I may have inadvertently omitted; their aid is also gratefully acknowledged.

This book could not have been completed without the friendly encouragement of Dr. Lucien Michaud, SJ, and my colleagues at the University of Sudbury, Ontario. I also wish to thank Joan and Harry Rayfield in whose friendly house I wrote many pages of the manuscripts, and for promoting the knowledge of Ethiopian painting in Canada.

Finally I owe a special recognition to Professor Ernst Hammerschmidt, thanks to whose kindness and interest my work can now appear in print. I am grateful for his suggestions and criticisms which proved most beneficial in the crucial stage of preparation of the text.

Sudbury, May 1980 Stanisław Chojnacki

LIST OF ABBREVIATIONS

AÉ	Annales d'Éthiopie (Paris–Addis Ababā)
AlvPrJ	*Francisco Alvarez*, The Prester John of the Indies, being the Narrative of the Portuguese Embassy to Ethiopia in 1520 written by Father Francisco Alvarez. Edited by *C. F. Beckingham* and *G. W. B. Huntingford* (Cambridge 1961)
AnnDB	*Guy Annequin*, De quand datent l'église actuelle de Dabra Berhan Sellase de Gondar et son ensemble de peintures? = AÉ 10 (1976) 215–25
AnnLebna	*Guy Annequin*, Au temps de l'Empereur Lebna-Denguel = Tarik 2 (1963) 47–51
AnnTM	*Guy Annequin*, L'illustration des Taʾamra Maryam de 1630 à 1730; quelques remarques sur le premier style de Gondar = AÉ 9 (1972) 193–226
AOI	Guida d'Italia della Consociazione Turistica Italiana: Africa Orientale Italiana (Milano 1938)
ATHCrist	*Ayala Takla-Hāymānot* [= *Mario da Abiy Addi*], La chiesa etiopica e la sua dottrina cristologica (Roma 1974)
BassApÉ	*René Basset*, Les Apocryphes Éthiopiens I–XI (Paris 1893–1909)
BLM	*Ernest Alfred Wallis Budge*, Legends of Our Lady Mary the Perpetual Virgin and her Mother Hanna (Oxford 1933)
BourgCopts	*Pierre M. du Bourguet*, The Art of the Copts (New York 1967)
BruceTr	*James Bruce*, Travels to Discover the Source of the Nile in the years 1768, 1769, 1770, 1771, 1772, and 1773. 3rd edition corrected and enlarged (Edinburgh 1813)
BSyn	*Ernest Alfred Wallis Budge*, The Book of Saints of the Ethiopian Church (Cambridge 1928)
BuxAb	*David Roden Buxton*, The Abyssinians (London 1970)
CEP I–II	*Enrico Cerulli*, Etiopi in Palestina. Storia della communità etiopica di Gerusalemme I–II (Roma 1943–47)
CGesù	*Enrico Cerulli*, Il «Gesù percosso» nell'arte etiopica e le sue origini nell'Europa del XV secolo = RSE 6 (1947) 109–29
ChatzIc	*Manolis Chatzidakis*, Icônes de Saint-Georges des Grecs et la collection de l'Institut = Bibliothèque de l'Institut hellénique d'études byzantines et post-byzantines de Venise 1 (Venezia 1962)
ChojArtEth	*Stanisław Chojnacki*, Notes on Art in Ethiopia in the 15th and early 16th century = JEthSt VIII 2 (1970) 21–65
ChojArtEthE	*Stanisław Chojnacki*, Notes on Art in Ethiopia in the 16th century: an enquiry into the unknown = JEthSt IX 2 (1971) 21–97
ChojBap	*Stanisław Chojnacki*, A Note on the Baptism of Christ in Ethiopian Art = Annali dell'Istituto Orientale di Napoli 36 N.S. 26 (1976) 103–15
ChojIcGeorge I–III	*Stanisław Chojnacki*, The Iconography of St. George in Ethiopia = JEthSt XI 1 (1973) 57–73 [= I]; XI 2 (1973) 51–92 [= II]; XII 1 (1974) 71–132 [= III]
CLMM	*Enrico Cerulli*, Il libro etiopico dei Miracoli di Maria e le sue fonti nelle letterature del medio evo latino (Roma 1943)

CodAeth — *Ernst Hammerschmidt*, Illuminierte Handschriften der Staatsbibliothek Preußischer Kulturbesitz und Handschriften vom Ṭānāsee = *Ernst Hammerschmidt* (ed.), Codices Aethiopici 1 (Graz 1977)

CrawIt — *Osbert Guy Stanhope Crawford*, Ethiopian Itineraries circa 1400–1524; including those collected by Alessandro Zorzi at Venice in the years 1519–24 (Cambridge 1958)

CRCodErit — *Carlo Conti Rossini*, Un codice illustrato eritreo del secolo XV (Ms. Abb. N. 105 della Bibl. Nat. di Parigi) = Africa italiana 1 (1927) 83–97

CRCollAbb I–III — *Carlo Conti Rossini*, Notice sur les manuscrits éthiopiens de la collection d'Abbadie = Journal asiatique, Mai–Juin 1912 [= I]; Juillet–Août 1912 [= II]; 1914 [= III]

CRCosc — *Carlo Conti Rossini*, Il discorso su monte Coscam attribuito a Teofilo d'Alessandria nella versione etiopica = Rendiconti della R. Accademia dei Lincei XXI (1912) 395–471

CRMinArm — *Carlo Conti Rossini*, Miniature armene nel Ms. Et. N. 50 della Biblioteca Vaticana = RSE 2 (1942) 191–97

CSCO — Corpus Scriptorum Christianorum Orientalium (Louvain)

DEllmMar — *Pasquale M. D'Elia*, La prima diffusione nel mondo dell'immagine di Maria Salus Populi Romani = Fede e arte 10 (1954) 1–11

DidrIc — *Adolphe Napoléon* Didron, Christian Iconography; the history of Christian art in the Middle Ages (New York 1965)

DinNub — *Erich Dinkler* (ed), Kunst und Geschichte Nubiens in christlicher Zeit. Ergebnisse und Probleme auf Grund der jüngsten Ausgrabungen (Recklinghausen 1970)

DL — *August Dillmann*, Lexicon Linguae Aethiopicae (Lipsiae 1865)

DSCÉ — Documents pour servir à l'histoire de la civilisation éthiopienne (Paris)

Éth Mill — Éthiopie millénaire: préhistoire et art religieux (Paris 1974)

EthObs — Ethiopia Observer (Addis Ababā–London)

GerRock — *Georg Gerster* (ed.), Churches in Rock: Early Christian Art in Ethiopia (London 1970)

GraChrIc — *André Grabar*, Christian Iconography: a study of its origins (Princeton 1968)

GraMart I–II — *André Grabar*, Martyrium: recherches sur le culte des reliques et l'art chrétien antique I–II (Paris 1946)

GraRepr — *André Grabar*, La représentation de l'intelligible dans l'art byzantin du Moyen Age = Actes du VIe Congrès international d'études byzantines, Paris 27 juillet–2 août 1948 II (Paris 1951) 127–43

HelZirGan — *Marylin Eiseman Heldman*, Miniatures of the Gospels of Princess Zir Gānēlā, an Ethiopic Manuscript dated AD 1400/01 (Dissertation, Washington University, Department of Art and Archeology, August 1972)

HenAp I–II — *Edgar Hennecke* (ed.), New Testament Apocrypha. Edited by *W. Schneemelcher* Engl. translation ed. by *R. McL. Wilson*. I–II (London 1963–65)

HeyK — *Friedrich Heyer*, Die Kirche Äthiopiens (Berlin 1971)

IñSPintEsp — *Diego Angulo Iñiguez – Alfonso E. Perez Sanchez*, Historia de la pintura española; escuela toledana de la prima mitad del siglo XVII (Madrid 1972)

JäM — *Otto Arnold Jäger*, Äthiopische Miniaturen (Berlin 1957)

JäP	*Otto Arnold Jäger*, Ethiopian Manuscript Painting = EthObs 4 (1960–61) 353–91
JerphCapp I–III	*Guillaume de Jerphanion*, Les églises rupestres de Cappadoce I–III (Paris 1925–42)
JEthSt	Journal of Ethiopian Studies (Addis Ababā)
JuelJGr	*Bent Juel-Jensen*, The Ground Hornbill Artist of 17th-century Ethiopic Manuscript = The Book Collector (Spring 1977) 61–74
KRZHagTrad	*Kinefe-Rigb Zelleke* [= *Kenfē Regeb Zallaqa*], Bibliography of the Ethiopic Hagiographical Traditions = JEthSt XIII 2 (1975) 57–102
LashGate	*Christopher Lash*, 'Gate of Light': an Ethiopian Hymn to the Blessed Virgin = Eastern Churches Review 4 (1972) 36–46; 5 (1973) 143–56
LawMar	*Marion Lawrence*, Maria Regina = Art Bulletin 6 (1924–25) 150–61
LefRitF	*Renato Lefevre*, L'Imperatore David II in un ritratto a Firenze = Sestante III 1 (1967) 29–32
LepPÉth	*Claude Lepage*, Histoire de l'ancienne peinture éthiopienne (Xe–XVe siècle). Résultats des missions de 1971 à 1977 = Comptes rendus des séances de l'Academie des Inscriptions et Belles Lettres (Mai–Juillet 1977) 325–75
LerÉthG	*Jules Leroy*, Ethiopian Painting in the late Middle Ages and under the Gondar Dynasty (London 1967)
LerÉthP	*Jules Leroy*, Ethiopian Painting in the Middle Ages = GerRock 61–68
LerMadIt	*Jules Leroy*, Une «Madonne italienne» conservée dans un manuscrit éthiopien du British Museum = RSE 18 (1961) 77–82
LerMssCopt	*Jules Leroy*, Les manuscrits coptes et coptes-arabes illustrés (Paris 1974)
LinVoy	John Hvingen van Linschoten, John Hvingen van Linschoten; his Discourse of Voyages into the East and West Indies (London 1884)
MercRoul	*Jacques Mercier*, Les peintures des rouleaux protecteurs éthiopiens = JEthSt XII 2 (1974) 107–46
MonCorV	*Ugo Monneret de Villard*, La coronazione della Vergine in Abissinia = La Bibliofilia 44 (1962) 167–75
MonMad	*Ugo Monneret de Villard*, La Madonna di S. Maria Maggiore e l'illustrazione dei Miracoli di Maria in Abissinia = Annali Lateranensi 11 (1947) 9–90
MonMinVen	*Ugo Monneret de Villard*, Miniatura veneto-cretese in un codice etiopico = La Bibliofilia 47 (1945) 1–13
MooreCr	*Eine Moore*, Ethiopian Processional Crosses (Addis Ababā 1971)
MordGG	*Antonio Mordini*, Il convento di Gunde Gundiè = RSE 12 (1954) 29–48
PerrZar	*Jules François Celestin Perruchon*, Les chroniques de Zarʾ a Yâʾeqôb et de Beʾ ada Mâryâm, rois d'Ethiopie de 1434 à 1478 (texte éthiopien et traduction) (Paris 1893)
Play	*Beatrice Playne*, St. George for Ethiopia (London 1954)
RbK Iff.	Reallexikon zur byzantinischen Kunst. Herausgegeben von *Kl. Wessel* unter Mitwirkung von *M. Restle* Iff. (Stuttgart 1963ff.)
RéauIc	*Louis Réau*, Iconographie de l'art chrétien (Paris 1955–59)
ReisSant	*Luis Reis Santos*, On a Picture from Abyssinia = The Burlington Magazine for Connoisseurs 69 (1941) 26–29
RKÄth	Religiöse Kunst Äthiopiens. Religious Art of Ethiopia (Stuttgart 1973)
RiceByz	*David Talbot Rice*, Byzantine Art (Harmondsworth 1968)

RSE	Rassegna di studi etiopici (Roma)
SchillIc	*Gertrud Schiller*, Iconography of Christian Art (London 1971–)
SpencGojj	*Diana Spencer*, Travels in Gojjam: St. Luke Ikons and Brancaleon rediscovered = JEthSt XII 2 (1974) 201–20
SpencLuke	*Diana Spencer*, In Search of St. Luke Ikons in Ethiopia = JEthSt X 2 (1972) 67–95
StauAnt	*Wilhelm Staude*, Etude sur la décoration picturale des églises Abbā Antonios de Gondar et Dabra Sinā de Gorgora = AÉ 3 (1959) 185–235
StauReg	*Wilhelm Staude*, Die ikonographischen Regeln in der äthiopischen Kirchenmalerei = Archiv für Völkerkunde 13 (1959) 236–308
TedArtFig	*Salvatore Tedeschi*, Note storiche sull'arte figurativa etiopica medio-evale = Bolletino 3 (1964) 18–55
TTch	*Taddesse Tamrat* [= *Tāddasa Tāmrāt*], Church and State in Ethiopia 1270–1527 (Oxford 1972)
TTHayq	*Taddesse Tamrat* [= *Tāddasa Tāmrāt*], The Abbots of Dabra-Hayq, 1248–1535 = JEthSt VIII 1 (1979) 87–117
TTSteph	*Taddesse Tamrat* [= *Tāddasa Tāmrāt*], Some notes of the Fifteenth-Century Stephanite «Heresy» in the Ethiopian Church = RSE 22 (1966) 103–15
VirgIm	Congressus Mariologicus Marianus (2nd, Roma 1954). Virgo Immaculata: acta Congressus Mariologici Mariani Romae anno MCMLIV celebranti (Roma 1955–58)
VogFlucht	*Karl Vogler*, Die Ikonographie der "Flucht nach Aegypten". Inaugural-dissertation zur Erlangung der Doktorwürde der Philosophischen Fakultät der Universität Heidelberg (Arnstadt 1930)
VOHD XV	*Ernst Hammerschmidt–Otto Arnold Jäger*, Illuminierte äthiopische Handschriften = *Wolfgang Voigt* (ed.), Verzeichnis der orientalischen Handschriften in Deutschland XV (Wiesbaden 1968)
WaltMonEg	*C. C. Walters*, Monastic Archeology in Egypt (Warminster 1974)
WrBM	*William Wright*, Catalogue of the Ethiopic Manuscripts in the British Museum acquired since the year 1847 (London 1877)

INTRODUCTION

The traditional painting of Christian Ethiopia is virtually unknown except to a small group of interested people. Ethiopian works of art are virtually absent in art galleries and museums of Europe and America.[1] The achievements of Ethiopians have not been mentioned in publications dealing with the Byzantine world though their paintings preserved the Byzantine features as long as other branches of Eastern Christendom.

The main reason for this neglect is remoteness of the Ethiopian people who for centuries lived on their African high plateau far from the main currents of world history, though never entirely isolated. Indeed, the very existence of Ethiopian painting was hardly suspected. Yet, during over ten centuries[2] of artistic activity the Ethiopians produced a vast corpus of illustrated manuscripts, church murals and paintings on wood which are outstanding culturally and aesthetically. In spite of the heavy losses due to Ethiopia's turbulent past, much of her artistic heritage was preserved in immemorially old churches and monasteries and came to light mostly during the last few decades together with other treasures.

The miniatures in manuscripts were the first to draw the attention of scholars. Starting with the 16th century, the Ethiopian manuscripts found their way to Europe. During the last hundred years a great many of these, some richly illuminated and many centuries old, have been acquired by the libraries of Europe. Recent searches in monasteries and remote churches revealed other illuminated manuscripts. This contradicted the pessimistic opinion expressed in the past that virtually all manuscripts perished during the 16th-century Moslem invasion. Among the recently discovered manuscripts there are some which are believed to be the oldest.

Church murals have been occasionally commented on by 19th-century European travellers, who unfortunately came across those of a fairly recent period and of poor quality. For this reason they promoted an unfavourable opinion about Ethiopian painting. This opinion changed dramatically during the last two decades following the discovery of 13th to 15th-century church murals in rock-hewn

[1] The first nucleus collection of Ethiopian paintings in Europe known to the writer is owned by the Staatliches Museum für Völkerkunde (Munich) and by the Peabody Museum, Salem (Mass.) in USA. A few paintings of varied quality are found in the British Museum, the Museo Lateranense, Rome, the Völkerkundemuseum der Universität Zürich, the Musée de l'Homme, Paris, and the African Museum, Washington D. C. There are several outstanding collections of Ethiopian icons in private hands in Europe and USA. The only large and fully representative collection of Ethiopian paintings on wood is found at the Institute of Ethiopian Studies, Addis Ababā.

[2] The earliest known record of Ethiopian painting refers to the cathedral Māryām of Ṣeyon, Aksum, and its fine paintings which were praised by Ǧaʿfar ibn Abī Ṭālib, companion of Prophet Muḥammad in 616 A.D.; HeyK 47.

churches of Tegrē and Lāstā, as well as the 17th-century murals of the Gondarene school. All these proved to be of exceptional quality.

Of equally recent discovery are the paintings on wood. A few years ago, scholars hardly suspected the existence of the large number of icons preserved in Ethiopia. Yet, gradually those kept in churches and monasteries came to light. Their variety and, indeed at times quality, is astounding.

All these discoveries have given to the study of Ethiopian painting a completely new dimension. Indeed, an immemorially old expression of the Christian art in Africa emerged from oblivion and proved to be a unique and fascinating survival of the almost forgotten past.

Why is Ethiopian painting unique? One can summarize the answer as follows: Ethiopian statecraft, Christian belief and African soil are three wellheads of Ethiopian development. If any of these three had been missing, Ethiopian painting as we know it could not have existed. It was only the combination of Christian creed, grafted on African soil and the endurance of Ethiopian people which could have caused the artistic phenomenon known as Ethiopian religious painting.

How did it happen?

Let us start with the first element, the endurance of the Ethiopian state. We know, of course, that there were two other centres of Christian art in Africa close to Ethiopia, namely the art of the Copts in Egypt and the art of the Christian Nubians living in an area known nowadays as the Sudan. These two branches of Christian art in Africa lasted for relatively short periods and were related to the political situation in Egypt and Nubia. The great period of Coptic art lasted three centuries from the 5th to the 8th century, the Arab invasion of Egypt in 641 bringing its death warrant, while Nubian art had some four centuries of flourishing from the 9th to the end of the 12th century, the Arab conquest of Nubia also marking the end of Christian art in the Sudan. On the other hand, the art of Ethiopia has survived up to modern times. This has been possible because the Ethiopians have preserved their independence for more than the last two thousand years and have never been permanently conquered.

The second element at the source of Ethiopian painting is an important historical event–the introduction of Christianity into Ethiopia in the fourth century. It created the fervent faith of the Ethiopians which pervades their way of life and their culture until this day. Ethiopian Christianity, in fact, a particular branch of African Christianity, but basically belonging to its Oriental family, has been from the inception to the present a dominant factor in the political life of Ethiopia as well as the only agent dealing with her cultural and artistic life. In the 6th century the group of missionaries called by Ethiopians the Nine Saints came from Byzantium. They left a lasting impression on Ethiopian Christianity as well as on Ethiopian monasticism. In the 16th and 17th centuries the Catholic missionaries from the Jesuit Order tried unsuccessfully to bring Ethiopia into submission to the Holy See. This historical event influenced Ethiopian religious painting.

The impact of the third element, that is the African soil on which Ethiopian art was born and the African people who created it, is difficult to define. Nevertheless, there is no doubt that Ethiopian Christianity and culture were largely conditioned

by their African background. In spite of this, no scholar dealing with Ethiopian painting even considered the African factor except for J. Leroy's cursory remark about the negroid features of the Virgin's face in one of her 15th-century miniatures.[3] Therefore an attempt is made in this book to identify these stylistic elements in paintings which are manifestly common with those of African art. However, there is one fundamental difference between it and that of the Ethiopians: the overpowering Christian ingredient.

The particular geographical situation of the Ethiopian highlands is another differentiating factor. They are isolated from the rest of Africa by a great desert on the western side, and by the hot unhealthy jungle as well as a desert from the southern side. Ethiopians thus had little contact with their western and southern neighbours. On the other hand, the highlands are open to the vast area of the Indian Ocean which includes the Red Sea. India and Arabia traded for time immemorial with the people of the eastern coast of Africa who received from the former material goods as well as cultural incentives. Moreover, Ethiopia kept a fairly continuous intercourse with Egypt and the Near East from whence she received the essential component of her civilization, the Christian faith.

To sum up, Ethiopian painting is the product of a unique historical evolution of the Ethiopian people and their geographical situation. The painting is African by location. It developed from the Christian faith introduced sixteen centuries ago and entirely incorporated into Ethiopia's culture and life. Through the centuries it was influenced by significant contacts with Byzantine and Western European art. Ethiopian painting is entirely different from any other artistic expression in Africa.

The society which created the Ethiopian paintings was traditional in which the belief was pervading every walk of life, whereas in European society, especially in the post-Renaissance, science replaced tradition. The post-Renaissance artist strove to record the outward appearances of nature rather than the spirit operating behind the façade of actuality. On the technical plane, his aim was to create the illusion of three dimensional appearances of the visual world on a surface which had only two dimensions and this he achieved almost to perfection.[4] Ethiopian art is an equally valid expression of the traditional society in which every form of creation including painting is fashioned as an appropriate symbolical revelation of those supernatural powers that are believed to govern the terrestrial order.

The fascinating aspect of Ethiopian painting is that the artist expressed an objective truth independent of time and space. Things were shown in what are considered their real and immutable forms rather than changing their appearances according to the visual world. Such art, based on belief, is always conceptual. Ethiopians painted "the idea and not the shape", to paraphrase a well-known Chinese aesthetic canon. In other words, they never attempted to recreate an

[3] LerÉthG 25.

[4] *B. Rowland*, Art in East and West; an introduction through comparisons (Cambridge Mass. 1965) 2.

illusion of the three dimensional appearance of reality. That is why the Europeans, accustomed to the post-Renaissance vision of the world, who first faced Ethiopian painting could not understand it and consequently scornfully appraised it as inferior.[5] When our vision dramatically changed in the 20th century, the congeniality of Ethiopian art with that of modern Europe was fully recognized. Ethiopian painting "meets most of the demands made to pioneers of modern art in Europe at the beginning of this century", being at the same time fundamentally different.[6] This is because of the opposite concept of art held by Ethiopian and European painters. The former distrusted individual and subjective statements, the very thing the latter relied upon owing to the different aims of Western religious art.

Ethiopian painting being essentially Christian and traditional had to represent what is intangible and imperceptible and to narrate in colour and line the events which are miraculous. The painter has, of course, to utilize the forms borrowed from life surrounding him, but his artistic idiom consists mostly of the image-signs[7] based on iconographic forms widespread in the Christian world. The images take their force from the visual world – a man or woman, plant or inanimate object – but in the painter's intention they are not meant to represent objects as they appear. The Ethiopian painters have as a rule used stereotyped figures; that is why often the inscription is the only means of recognizing the personages represented; all particulars that do not contribute directly to the images are left out. The background is reduced to a flat surface in one or more colours and figures are disposed in rows – like hieroglyphs – or in apparent disorder, not according to the rules of the visual world, but to spiritual considerations.

[5] During the campaign of 1868, the British officers educated in the Victorian appreciation of art found the Ethiopian paintings "grotesque and rude" [Capt. C. A. More one of the volunteer painters for the Illustrated London News (March, 7 1868)]. Unfortunately this derogatory opinion lasted well into the 20th century. *C. Conti Rossini* writes in 1927 about Ethiopian painting "as a barbaric derivation of Copto-Byzantine" (CRCodErit 83), whereas *J. Leroy* in 1967 sees in Ethiopian paintings "childish efforts, interesting for their primitive and naive aspects but entirely lacking in qualities that make up a genuine work of art" (LerEthG 22).

[6] *R. Fechter* in: RKÄth 18f.

[7] When we talk about Ethiopian icons, murals or miniatures and the art they represent, we are accustomed to call them paintings. In a broad sense they are, of course, paintings, but in their author's intention they usually meant something more. In his book on early Christian symbolism, André Grabar pointed out: "We are wrong in confounding informative and expressive images. The first appeal solely to the intellect, while the others make an appeal to the imagination and aesthetic sense. It is an abuse to include among works of art all those images in paint or sculpture which to a large extent are really signs that stand for the human figure, an object or an idea, whether these signs are of a descriptive or symbolic character"; GraChrIc xliv. It is true that these signs as found in Ethiopian art often fail to confine themselves to their basically informative function. In interpreting a text they often turn to the methods of art. But essentially the icon, the mural as well as the miniature are a collection of image-signs, which like hieroglyphs, are meant to convey an idea or happening.

On the technical plane, the Ethiopian painter is concerned with the ornamental quality of the image-signs and at times with the evocation of a mood of aesthetics through the organization of shapes and colours on a flat surface. His method consists in drawing precise contours and then filling the delineated space with unmodulated colours. Over it he develops the linear pattern which is pervaded with an inner rhythm effected by the variations and imaginative repetitiveness of the component elements.

Ethiopian painting is bent on expressing what it had to say through the medium of man and the human figure. The figure is not a reflection of animate life but again a pattern of shapes integrated into the decorative system. In fact, the human figure consists of the design of textile to which heads and limbs are attached. If there is any illusion it is only that of a completely insubstantial form behind the flat drapery.

The Ethiopian artists have a tendency of reducing the narration to a few figures and any circumstantial description is left out. Architectural setting or landscape are considered unnecessary. Even if plants or animals are depicted to explain the meaning of the narration, these virtually never represent a specific type. The supreme achievement of the Ethiopian artist is that while being laconic and bent towards abstract design, he maintained the clarity in rendering the Christian theme. The Ethiopian never hesitated in distorting human anatomy and the shape of objects in order to emphasize the narration, symbol and moment of time.

To sum up, Ethiopian painting is always non-realistic in environment, figure and episode, and essentially meant to decorate and fill a flat surface. At the height of its artistic perfection, it renounces the illusion of volume, depth and perspective.[8] Even the 18th-century attempts at some concentration of light and expression of volume are not, in fact, a change into realism as no shadows were ever used by Ethiopian painters.

Painting in Ethiopia was never a gratuitous act—art for art's sake—but a functional one, since the religious images were made to enable the believer to apprehend the divine and follow visually the life story of Christ as well as those of the saints. The efficiency of the image did not depend upon realism of definition but upon the representation of what was recognized as the principle of the things portrayed and as thought by the Ethiopian Church. The spirit pervading the paintings was Christian, expressing simple and fervent feelings.

As in other branches of Eastern Christianity, the religious images were given a special significance though the theological definition of these was never formulated as in Byzantine art. Also, the cult of holy images was never as conspicuous as in other areas of Orthodoxy. This led F. Heyer to believe that "evidence of a relationship to the holy images either as an object of worship or for beseeching does not exist in Ethiopia. Ethiopians kiss the holy book, the threshold of the church, the priest's hand or the cross but not the holy picture. The anointing of the image performed by the priest which gives to it its sacred character like in Russian Orthodoxy is unknown in Ethiopia."[9]

[8] *R. Fechter* in: RKÄth 18.
[9] HeyK 48.

This opinion based on present day observation certainly corresponds to the facts. In Ethiopian churches there are no iconostases. Crosses instead of icons are exhibited during the liturgy of the holy service and there is no custom of keeping them in homes as in Greece or Russia. Yet, in the past, a kind of anointing of pictures and crosses was known and it was believed that by this action the object became holy and the spirit of God entered into it.[10] Later on when the anointing fell into disuse, in people's minds the image was a true reflection of the divine prototype even if this was never expressed in as articulate a manner as by the Byzantines. For example during the great religious controversy in the 15th century, the Stephanites, a group of monks accused of irreverence to Mary, were required to prostrate before her image in order to prove their orthodoxy.[11] There are records that certain images of Christ and Mary as well as of God the Father were believed to be particularly holy and performing miracles. Moreover, nowadays, there are icons which are thought to be a true image of the Virgin because they are reputed to be painted by St. Luke. Such icons are kept permanently hidden and shown to the people regularly once a year during impressive ceremonies and exceptionally whenever a special favour is required of them.[12]

Perhaps the clearest indication of the oneness between the divine person and his or her image made by man is given by the illustrations to the Book of Miracles of the Virgin Mary. In the stories described, people often pray to the holy pictures of Mary, yet in the illustrations the pictures are seldom depicted but simply the image of the Virgin. Obviously in the illustrator's belief that image stood for her picture.

In hagiographic literature there are references to people praying in front of holy pictures and to the belief that these used at times to address them.[13]

Another sign of veneration of the images is their screening. Whenever the images either of Mary or the Crucifixion as well as of other subjects of particular significance are included into the mural decoration of the church, a cloth is hung over them. In books, a small piece of cloth covers those folios in which the above subjects are depicted. This is done not for the material protection of the picture but as a sign of respect for the subject represented.

The purpose of painting in Ethiopia was didactic as well as intercessional and propitiatory. Paintings were made to visualize the sublime drama of the gospels, the mysteries of the faith and to portray the holy personages in a form intelligible to the believers who in great majority could not read. People used to order icons from

[10] In the 15th-century life story of Ezrā, the Builder, member of the Stephanite community there is a clear reference to the anointment of pictures. A. *Caquot*, Les actes d'Ezrā de Gunda Gundē = AÉ 4 (1961) 103.

[11] The same Ezrā who arrived at the court of Emperor Nāʾod (1496–1508) was questioned about his orthodoxy. At one moment he was shown the picture of the Virgin and Child "painted with golden ink" (probably an imported icon) and asked to worship it. Ezrā complied and embraced the picture. A. *Caquot*, Les actes d'Ezrā de Gunda Gundē = AÉ 4 (1961) 105.

[12] These icons are invariably of Greek origin.

[13] For example, the story of Marḥa Krestos: CSCO 331 (1972) 15. Marḥa Krestos went to the church, stopped in front of the image of the Virgin and talked with her.

the scribes and offer these to the churches, or fund church decorations to ensure the salvation of their souls, practices which are attested to by the inscriptions.

The painter's names appear exceptionally in icons, more often in colophons to the manuscripts, while in mural painting the practice of recording the maker's name apparently became common after the 17th century. However, the names of painters are rarely helpful for dating their work as we lack additional information on their lives. Only in the late 19th and early 20th century are scant records available about the important traditional painters.

On the whole, however, the Ethiopian paintings are mostly anonymous because of the deep religious significance attached to producing holy images. Making a painting was an act of piety. Before accepting the commission of decorating churches, the Ethiopian artist used to make a spiritual retreat and fast in order to find guidance as to his accepting the task.[14] Painters who were calligraphers as well usually belonged to the class of priests or church clerks and their occupation was respected. For example, the impoverished members of the Imperial family in Gondar during the first half of the 19th century supported themselves by decorating churches and painting miniatures.[15]

Little is known about the training of the painters. A Painter's Guide similar to that of the Byzantine one has not been recorded in Ethiopia and probably did not exist. The training was conducted on a personal basis, that is, the master taught his pupils the skill which he himself learned from the others and the pupils helped their master in executing his works. The whole process of passing the craft from one generation to another was effected by way of mouth. One may recall that the exquisite quality of Ethiopian traditional paintings was largely due to the use of local pigments. Their stability and purity coupled with the judicious application of binding material kept for centuries the colours always fresh and at times almost translucent. With the exception of the blue pigment which was imported, all other pigments were found locally.[16] For a student of painting an important step was to learn from his master how to make colours. These formulas were transmitted orally from one generation to another and were accompanied with some secrecy. This accounts for the fact that the local art of making pigments was lost as soon as the use of imported colours became general in the second half of the 19th century.

Students were striving to achieve excellence in copying the models, a method which fitted well into the conformist spirit of Ethiopian society. Thus, the art of painting was based on the most typical and apparently invariable forms, the strict following of which was considered as essential in keeping the workmanship stand-

[14] HeyK 54.

[15] A. d'Abbadie, Douze ans de séjour dans la Haute-Ethiopie (Abyssinie) (Paris 1868) 158.

[16] Virtually no study of the technical aspects of paintings was made except on the occasions of the restoration of the 18th-century cloth painting, Lālibalǎ, and the exhibition of Ethiopian paintings in Europe, 1974–75. The following papers were published: E. Denninger, Naturwissenschaftliche Untersuchungen an einer äthiopischen Malerei = Maltechnik 65 (1959) 17–19; K. Wehlte, Rettung einer äthiopischen Wandmalerei = Maltechnik 65 (1959) 1–18; F. Weihs, Einige technische Details zu äthiopischen Ikonen = RKÄth 298–305.

ards and insuring the spiritual efficiency of the images. Training in the art of copying and passing the "rules" by way of mouth have been essential factors in continuing the painter's craft, though a few books of patterns are known, the earliest dating to the 17th century.[17]

These "rules" have not been studied enough to give a clear idea about their nature and origin. The much advertised, so-called "left-hand rule" in the pictures of the Virgin Mary, proved to be an accidental outcome of the popularity which the image of S. Maria Maggiore enjoyed since the 17th century rather than the result of theological considerations. The disposition of subjects in church murals was studied by Marcel Griaule and Wilhelm Staude. In 1933, Griaule asked the painter-priest Kāsā who lived in Gondar to write down the rules of painting. The resulting document is a comprehensive description of how subjects should be arranged in decorating the church.[18] Subsequently Staude compared Kāsā's description with the paintings in two 17th-century churches known to him, one from Gondar and one from the nearby locality; he also made a quick visit to the area. His final conclusion is that the rules similar to those described by Kāsā guided the Ethiopian painters in the 17th century and during the following centuries. He also regretted that the absence of murals prior to that century prevented him from pursuing the sources of these rules.[19]

Staude's study is based on a limited number of examples which originate from the region of Lake Ṭānā; he did not investigate the church murals in other parts of Ethiopia. Moreover, since Staude published his findings in 1955, many church murals prior to the 17th century have been discovered. The disposition of subjects in these do not at all correspond to Kāsā's scheme which makes imperative the revision of the whole problem.

* * *

Scholarly investigation of Ethiopian painting started a few decades ago. At first linguists and historians discovered while studying illuminated manuscripts that the miniatures were obviously influenced either by Eastern or Western Christian art.[20] Since then, the approach to Ethiopian painting has mainly been historical; the question of inspiration received from other cultural centres was and continued to be discussed at length.

The 1950s brought the attempts to present a broad survey of Ethiopian painting.[21] In the 1960s and 1970s other surveys were published either as chapters in

[17] A 17th-century booklet (No. 5674) in IES Collection, Addis Ababā; a 17th-century booklet in private collection, Addis Ababā; 20th-century booklet described by *R. Plant* in: EthOb 16 (1973) 133–40.

[18] StauReg 236–308.

[19] StauAnt 185–235.

[20] Some eighty years ago *E. A. Wallis Budge* published an essay on illuminations of Ethiopic manuscripts = The Lives of Mabâ Sĕyôn and Gabra Krestos (London 1898) p. xi–lxxxii; during the next fifty years or so, scholars in Ethiopian literature, language and history published articles dealing with the problem of the Eastern and Western models.

[21] Beatrice Playne expressed a very personal view of Ethiopian art in her book of travels:

books dealing with Ethiopian history and culture[22] or as introductions to exhi-
bition catalogues.[23] These reviews written to satisfy the curiosity about an
unknown art proved to be useful in presenting the recent discoveries of and
discussions on the Ethiopian works of art and archeology. The book of superb
reproductions of mural paintings in churches of Tegrē by G. Gerster contains very
exciting material as well as its extensive description.[24]

Probably the earliest attempt at the classification of Ethiopian paintings was
made in 1961 by Otto A. Jäger and Liselotte Deininger-Engelhart. They distinguish
three periods of Ethiopian painting. The first seems to run from the 14th to early
16th century. The art of this period "seems chiefly to express the artist's worship of
God ... Painting seems to be one way of religious contemplation of talented
monks". The end of the first period coincides with the invasion of Aḥmad Grāñ in
the 16th century. The second period which then started culminated under Emperor
Fāsiladas (1632–67). This is the "Gondar style". The third period which started
about 1700 AD shows according to Jäger, "more deviation from the older
Ethiopian style. The art of painting split into several ways. One was the seculariza-
tion of religious themes by use of narrative illustrations. Another was the stereo-
type repetition of standard pictures. A third–the best one–may be called a flight
into mysterious chapters, such as the Revelation of St. John and the Miracles of
Mary ..."[25].

The more ambitious effort to present the history Ethiopian painting in chrono-
logical order and to define its historical background was initiated by Jules Leroy in
1964.[26] He further elaborated his theories in writings published in 1970[27] and
1975.[28] Two other scholars, Guy Annequin and Claude Lepage joined Leroy in the
arduous task. They presented us with a complete overall view on developments in
Ethiopian painting. According to them, its history is divided into two main
periods, the mediaeval and the Gondarene. The important point is, of course, when
the mediaeval period finished and the Gondarene started. Leroy proposed that the
Moslem invasion under Aḥmad Grāñ in the early 16th century should be con-

Play 177–95. Her presentation is as S. Tedeschi (TedArt 23) remarked "not a model of
order and clarity" though it includes first hand information. Playne persistently ignores
anything written by the Italians and consequently makes gross mistakes in dating those
manuscripts which have been described in Italian language.

[22] Chapters on Ethiopian painting in *D. R. Buxton*, The Abyssinians (London 1970); *E.
Ullendorff*, The Ethiopians. A introduction to country and people (London 1960); *J.
Doresse*, La vie quotidienne des éthiopiens chrétiens aux XVIIe et XVIIIe siècles (Paris
1972).

[23] RKÄth; EthMill.

[24] GerChRock.

[25] *O. A. Jäger–L. Deininger-Engelhart*, Some notes on illustrations of manuscripts in
Ethiopia = RSE 17 (1961) 45–47.

[26] LerÉthG.

[27] LerÉthP.

[28] Les étapes de la peinture éthiopienne = ÉthMill 41–45.

sidered as the dividing event. It brought the Empire to the verge of destruction but also resulted in "a break-through to a new school of painting. What interests us here are the cultural and artistic results of Grāñ's presence. They were not all bad. Even though that war was responsible for the destruction of innumerable works of art... it did bring some advantages through the influx of foreigners which, as usual, Ethiopia saw as a means of cultural enrichment. One favourable result was to be seen in the presence of the few remaining Portuguese who had survived the war against Grāñ. They settled in the vicinity of Gondar, not as colonial overlords but as farmers, and for nearly a century they maintained permanent contact with Europe. Peaceful cooperation had a marked effect even on painting, and gave rise to a stylistic revolution".[29] Leroy also stresses the point that "the influence of the Portuguese on the cultural destiny of the country was considerably strengthened by the arrival of a group of Jesuits". The Jesuits introduced the latest skills from Europe, and "brought Ethiopia's cultural centres–that is the court and the monasteries–into touch with ideas and techniques of their native land". "The Gondarene Dynasty achieved practically nothing", Leroy concluded in 1967. "Only in the realm of art did the Gondarene period achieve anything new."[30] In 1970 he emphasized this point even more strongly. "From the fusion of elements of Western art and the old Ethiopian tradition, the Gondarene painters created an independent school."[31] In short, this broad assessment can be summarized in this main idea: as the result of Aḥmad Grāñ's invasion, the Portuguese came to Ethiopia and introduced new skills and new ideas from Western Europe which brought about the "stylistic revolution" of the "Gondar Dynasty". The simplicity of the whole argumentation was already challenged by Lanfranco Ricci.[32] Another difficulty is the somewhat loose chronology. Leroy's theory covers some 200 years, if not more, in the history of Ethiopian art from the 1540s to the middle of the 18th century. Gondar was founded at some time in the 1630s under Emperor Fāsiladas. One may agree with Leroy that this Emperor and his immediate successors (called by him "the Gondarene Dynasty") proved to be great promoters of an art which does not present many problems in its identification. But the question still remains: what happened in art before the founding of Gondar and the advent of the "Gondarene Dynasty"? Between the defeat of Aḥmad Grāñ and the final settlement of the Emperors in Gondar almost a hundred years elapsed. In art, this means a large gap, a period between the fading of the 15th-century art and the arrival of the first examples of the Gondarene school. The writer tried to identify the art of that period which he believes has characteristics of its own, though on the whole it is transitional.[33]

[29] LerÉthP 66.

[30] LerÉthG 27f.

[31] LerÉthP 67.

[32] In an review of *Leroy*'s book, he pointed out a large number of factual mistakes and general weaknesses of argumentation: *L. Ricci* in: Rivista di studi orientali 29 (1964) 325–43.

[33] ChojArtEthE 21–97.

The main idea of Leroy's argumentation is this: during the "mediaeval period" Ethiopian painting was closely linked with and influenced by Eastern Christianity while during the "Gondarene" (modern) period, the impetus and pattern came from Western Europe. This statement should, of course, be qualified. In the Ethiopian context, the term "mediaeval" is misleading as Ethiopia's political and cultural history is not comparable to that of Europe. Moreover, Leroy himself was aware of some influence of Western Europe on Ethiopian painting prior to the 16th century; he does not think highly of it. "As we learn from the written sources," he writes, "European, that is to say Italian, visitors and craftsmen were already coming to Ethiopia at the beginning of the fifteenth century. Among them were artists appointed by the Negus. But these foreigners were few in number and cut off from their environment. Often they only stayed in the country for a short time – except those whom the emperor prevented from returning home. The names of some of them have entered history, as for example that Brancaleone, 'pictor venetus' about whom a whole legend was created. Most of them are anonymous, which is neither regrettable nor surprising since it is certain that not a single one of them could compare with the contemporary artists at work in Italy".[34] Annequin elaborated this point but while he echoed Leroy's disdain of the expatriate artists, he maintained his own ideas about their rôle. Brancaleon, he thinks, being a simple craftsman could hardly "shake the local aesthetics" whereas Lázaro de Andrade "a modern illusionist" who represents a very Flemish art is "too far from the local sense of vision"; on the other hand "Victor and Bicini, less known, could have had a more real influence".[35] Lepage is not really bothered with the Western influences, during the "mediaeval" period, or the "ancient" as he calls it, which is his main field of study.[36]

Lepage divides the "ancient" period into five main stages of evolution starting with the earliest paintings known to us, that is to say, from the 10th or 11th century to the beginning of the 16th century. He establishes the "typology" of each stage which coincides with the chronology set up on one or more representative works which, according to him, are datable. In fact, one has the feeling that the dating of most of these, except for a few, is not really established.[37] Another weak point of

[34] LerÉthP 66.

[35] G. *Annequin*, De Lebna Denguel à Théodoros, quatre siècles d'art et d'histoire (début XVIe – fin XIXe siècles) = ÉthMill.

[36] LepPÉth 325–75; also in: Abbay [DSCÉ 8] (1977) 59–91.

[37] The patent example of Lepage's dating is the murals in the church of Mary on Mount Qorqor, Garʿältä. The tradition has it that the church was founded by Dāneʾel of Garʿältä. Dāneʾēl was an uncle of Ēwosṭātēwos, c. 1273–1352, the monk who initiated the revival of the Ethiopian Church as well as the religious community in Sarāyē (Northern Ethiopia). Probably due to persecutions, he left Ethiopia and died in Armenia. The relation of Ēwosṭātēwos with the community at Mount Qorqor was certainly short and probably lasted only during his early manhood. Moreover, we know that his followers under the leadership of Absādi established the community of Dabra Māryām Qoḥāyen in Sarāyē. Subsequently, a chain of monastic groups was established in Sarāyē and Ḥamāsēn, northern Tegrē and Enfrāz, Bagēmder (TTCh 206–08). Qorqor Māryām

Lepage's argumentation is that his choice of representative works is arbitrary.[38] Also, Lepage, busy with the "ancient" period pays scant attention to the "modern" and of course in order to interpret the trends in a section he would have to be well familiar with the whole.

A different division and nomenclature was suggested in 1968 by E. Hammerschmidt and O. A. Jäger[39] who call the stages of development as follows: "symbolic" before the 14th century; "sacred", 14th and 15th century; "dramatic", 16th and 17th century; "narrative", end of 17th century and onwards. Understandingly, the works given as examples of each stage originate mainly from the churches of the Lake Ṭānā region in which Jäger made his explorations. Needless to say that there is a variance between the dating of particular works by these authors and that of the same works by Lepage and other Ethiopists.

is not mentioned among these. It appears from the above that there is no obvious link between Ēwosṭātēwos as well as his community and the church of Mary on Mount Qorqor and its murals. In spite of this, Lepage believes that part of the murals in the church have been painted during the second stage of evolution, that is at the end of the 13th century, and the rest during the third stage of evolution, that is in the 14th century. This interruption he asserts, is due to the persecution of Ēwosṭātēwos and his disciples. This implies that the decoration of the church was made by them and its pace related to their persecution. To prove his theory, Lepage quotes the story of Ēwosṭātēwos edited by B. Turaiev [CSCO 32 (1906)], but is careful not to give the exact page of the text referring to the church on Mount Qorqor. The dating of murals devised on such tenuous interpretations does not deserve confidence.

Another instance of this lack of precision in dating the paintings refers to the examples of the second stage of evolution. Lepage quotes three murals in the church and two manuscripts; in the footnote he explains that one manuscript is the book of the gospels from the Dabra Ḥāyq but presently kept in the National Library, Addis Ababā. The other manuscript, the Acts of the Apostles (Apocrypha) is undated and still kept in the above monastery. This information is given on the authority of TTHayq (87f.). The inquisitive scholar who would like to check the reference will find that Taddesse Tamrat writes about the book of the Gospels and not the Acts of the Apostles. Moreover, the book of the gospels is according to the Ethiopian scholar authenticated and bears the date in the colophon. The manuscript was copied in AD 1280–81, "which makes it the oldest Ethiopic MS known", he believes.

The book of the gospels in Dabra Ḥāyq Monastery is contemporary with the murals of the church of Gannata Māryām and thus another theory of Lepage, that is of the "certain lag between the mural paintings and the manuscript paintings during the second stage of evolution" crumbles to dust.

[38] *Lepage* does not take into consideration that the paintings studied by him are the remnants of a much larger production most of which got lost. He did not explain why the works which by good chance survived are representative of his stages of evolution and why those which did not survive are not. There is no evidence that all the lost paintings have been similar to those which still exist. Indeed, as a large number of early Ethiopian paintings came to light during the last two decades, the overwhelming impression is of their iconographic and stylistic variety.

[39] VOHD XV 19–22.

Let us conclude with a general remark. Is the periodization of Ethiopian painting possible? We are not yet in a position to suggest any kind of rigid pattern of its evolution. One may even ask whether in Ethiopian context such an endeavor is possible at all. In this connection the lack of method, manifest over and again, is astounding. Every piece of Ethiopian painting which happens to appear is immediately assigned to some period with no reason given for doing so and before it is compared with similar paintings. One cannot properly judge what is not identified and described.

In addition to general interpretations, a number of those referring to the particular aspects of Ethiopian painting has been suggested. Not all theories are corroborated by material evidence.

The main reason for it is that more Ethiopian works of art withstood the ravages of time than it was believed and that we are just starting to investigate the vast corpus of Ethiopian painting.

When in 1943 Ugo Monneret de Villard published his article on the *Majestas Domini* in Ethiopia he knew only one representation of it, the one in the Codex Palatinus or. 148,[40] whereas Lepage who dealt with the same subject two decades later could investigate a dozen miniatures[41] and, as it appears, missed a couple of others. Jules Leroy, in writing his history of Ethiopian painting, was not really aware of the existence of early mural paintings and he knew very little about the panel paintings which had just started to emerge from the monasteries and churches. The general inventory of Ethiopian painting which the late Antonio Mordini was advocating, has hardly started.

That is why a number of theories had a short life. Monneret de Villard ventured a theory in 1939 about "the lack in Abyssinia of the nursing Virgin and the equestrian saints ... which evidences that influence of Coptic miniatures [on Ethiopian painting] was not deep until the end of the 14th century.[42] We know nowadays that the equestrian saints abound in early Ethiopian painting and the theme of the nursing Virgin appeared in the 15th century. Nevertheless, we would not venture the conclusion opposite to that of the Italian scholar. The problem of the nursing Virgin is more complex than Monneret de Villard had expected.

Even shorter was the life of Guy Annequin's theory about the 17th-century illustrations in the Book of Miracles of the Virgin Mary. In 1972 he believed the illustrations to be "certainly the most happy issue and above all the most indigenous illumination of Ethiopian manuscripts; for the first time, it appears, we witness a purely local creation which is not due to the foreigners."[43] Three years later he had to admit that "a new discovery of Mrs. Diana Spencer evidences that

[40] *U. Monneret de Villard*, La Majestas Domini in Abyssinia = RSE 3 (1943) 36–45.

[41] *Cl. Lepage*, Dieu et les quatre Animaux Célestes dans l'ancienne peinture éthiopienne = DSCE 7 (1976) 67–112.

[42] *U. Monneret de Villard*, Note sulle più antiche miniature abissine = Orientalia 8 (1939) 19.

[43] AnnTM 193.

[this series of illustrations] is a borrowing".[44] However, he rushes in the same article into another theory, this time about the impact of foreign painters on the 15th and early 16th-century Ethiopian art. This theory, as explained in this book, is not corroborated by the present discoveries.

Such mistakes are bound to happen when the material on which scholars are working is a fraction of what, in fact, has been preserved. Indeed, we witness in the last two decades a series of astonishing discoveries; a large number of illuminated manuscripts from the 13th to 19th century, hundreds of icons from the 15th century to the present came to light whereas the existence of the extensive mural decorations has been recorded all over Ethiopia. A very superficial survey evidences that the discovery of an African nation's greatest heritage came through. In 1947, Monneret de Villard scornfully wrote about "this poor Ethiopian painting".[45] Thirty years later we marvel about an art bewildering by its variety and aesthetic quality.

"When one is faced suddenly with a great wealth of new material", writes Kurt Weitzmann, "it is only natural that the main task of scholarship is, initially, not so much to answer questions as to raise them".[46] It seems that this judicious advice was somewhat forgotten. Indeed, in the present stage of investigation our primary task is to record, inventorize, describe the paintings, to put these in some chronological order as well as to search for their iconographic origin.

Fortunately, a number of such preliminary studies have been already published during the last three decades or so. Considering the method used, these studies fall into two main categories. One category is concerned with the investigation of a single work of art, that is either the miniature or a set of these in the particular manuscript, or the mural decoration in the particular church, or a single painting on wood. Such investigation is primarily aimed at the complete description of the work; some attention is paid, of course, to its stylistic characteristics, but the main object is to analyze the themes, explain their significance and search for their iconographic sources. Also, the religious, liturgical and cultural background of the work is considered. The analysis of the miniatures in the gospels of Princess Zir-Gānēlā by Marylin Heldman, the description of the murals from the church Abbā Antonios in Gondar by Wilhelm Staude, and the analysis of "Italian Madonna" in Ethiopic manuscript British Library, Or. 641 by Jules Leroy are examples of such systematic investigation.

The second kind of investigation is mainly aimed at the chronological description of the single theme. Whenever possible, the period, the local inception or the introduction from abroad is established and the foreign model identified. The description includes all possible local transformations of the theme and special

[44] G. *Annequin*, De Lebna Denguel à Théodoros, quatre siècle [sic] d'art et d'histoire (début XVIe–fin XIXe siècle) = ÉthMill.

[45] MonMad 90.

[46] K. *Weitzmann*, Icon painting in the Crusader Kingdom = Dumbarton Oaks Papers 20 (1966) 83.

emphasis is put on its cultural and religious background. The study is iconographic as well as stylistic.

The investigation of this kind has been initiated by Monneret de Villard's description of the iconography of S. Maria Maggiore and a study of the *Kwer'ata re'esu,* a holy icon of Ethiopia, by Enrico Cerulli[47]. The writer has used the same method for describing several important variants of the iconography of the Virgin, the equestrian saints and selected themes from the life of Christ.

Naturally the two above methods of investigation are complementary; the findings of one allow us to check and complete those of the other.

One cannot stress enough the importance of the above studies. Although these seem to be tedious compared to the attractiveness of speculative essays, it serves nevertheless the purpose as a prerequisite step for all theorizing. Since iconography can be of greatest assistance in determining the date and provenance of works whose origin and age are disputed, the systematic investigation is particularly relevant in the study of Ethiopian paintings which notoriously lack the inscriptions indicating the maker and date as well as the written documentation.

As other artists in the Eastern Christian world, those in Ethiopia did not intend to create themselves new iconographic forms but used those taken from the treasury of Christian art. The artists were receptive and eclectic rather than critical. An icon, woodcut, illustration in a book or any other kind of image has been eagerly copied even though its content did not fully agree with the foundations of the Alexandrine creed. Borrowed themes abound in Ethiopian painting. Therefore, besides the question of whether the theme was borrowed, there is another question of whether or not it had been assimilated. The process of transformation shows in itself new characteristics of which in addition to changing iconography, the most important is the style as the very embodiment of inspiration. The model and its transformation are interrelated in a sense that the final result largely depends on the suitability of the model to the cultural background of the receiver.

It would be idle to assume that a humble scribe in the past had the same awareness of sources embodied in the forms he used as has the 20th-century scholar. The Ethiopian used image-signs which were in most cases stereotypes and he was not particularly concerned about their scriptural origins. These image-signs were transmuted according to the commentaries which at times had little or no pertinence to the texts. These commentaries reflect the cultural and spiritual environments in which the paintings were created. An investigation into Ethiopian paintings should consist in the discovery and the reconstruction of this environment rather than in indulging in interpretations which have little relevance to the Ethiopian situation.

The findings of both methods reveal what is unique in Ethiopian painting, that is, the process of creative adaptations of imported models coupled with the resulting local transformation. Expressing alien concepts by idioms based on local

[47] *E. Cerulli,* Il «Gesù percosso» nell'arte etiopica e le sue origini nell'Europa del XV secolo = RSE 6 (1947) 109–29.

colour is one of the fascinating aspects of Ethiopian culture. In painting, writes
Enrico Cerulli, "the adaptations and transformations of the models of different
origin resulted in their successive Ethiopianization by virtue of the assimilating
power which is characteristic of Ethiopian culture".[48] The same iconographic form
is expressed by continuously changing new idioms and the force of these is taken
from Ethiopian life. At no time in Ethiopian history did this process cease or lose its
impetus. In this respect all periods of Ethiopian painting are equally important,
though aesthetically the early period is more appreciated than the one starting with
the 17th century.[49]

As with the study of iconography, the systematic investigation of stylistic
characteristics is of great importance. The drawing of eyes and hands, the pose of
the figure, the use of colours or any other detail of style, all become significant for
the study of Ethiopian painting when related to similar cases and viewed in
chronological perspective.

Can we draw already some conclusions from such a systematic description of the
material? The answer is yes, but until all important themes are investigated, the
conclusions must remain preliminary. Nevertheless, the available evidence allows,
at least, to suggest a few guidelines for further investigation.

In order to make our point clear, let us consider the iconography, that is, the
subject matter of the work separately from stylistic qualities, that is, the manner in
which it is executed. "In dealing with problems of iconography and style", writes
Kurt Weitzmann, "one should be aware that they may or may not travel jointly. An
iconographical type, e.g., may be taken over and be recast so thoroughly in a local
style, that only the iconography may provide any evidence of an outside
influence."[50]

There are instances of such separate travelling of the iconography and style in
Ethiopian painting. For example, in the 15th-century painting, particularly the
images of the Virgin, the elements taken from Western iconography are combined
with stylistical traits influenced by Islamic art. Both contributed to creating the
form of the Virgin which is characteristic of that century. In the 17th century, the
paintings in the Octateuch, British Library Or. 481, follow the early Ethiopian
programme of Bible illuminations but are put in the idiom used by the school of
Gondar. If we are not aware of the phenomenon of separate travelling of
iconography and style, we risk arriving at the wrong dating.

Considering the inception of themes, most of these originate from foreign
models, though their exact identity cannot always be established. The over-
whelming impression is that of a great variety of sources and diversity of ways in
which the models have been introduced as well as a complexity of the adaptive

[48] Personal letter to the writer, October 6, 1964.
[49] *Beatrice Playne*, pioneer in study of Ethiopian paintings, wrote that she was not inter-
ested in the painting which obviously derived from European religious pictures in oil
(Play 89).
[50] *K. Weitzmann*, Some remarks on the sources of the fresco paintings of the Cathedral of
Faras = DinNub 325.

process. There may be one or more models used for a given theme. In the latter case the new model either replaces entirely the preceding one or the new form takes some elements from both, the old and new model. Moreover, there can be a lag of decades if not centuries between the introduction of the model and the Ethiopian response. The iconography of the Flight into Egypt described in this book evidences the process.

Comparing the developments of several themes we note the lack of synchronism. Each theme seems to evolve independently and its iconographic story is not comparable to that of the others in a sense that the origin and date of introduction of the model as well as the length of time and intensity of the adaptive process vary a great deal. Already in 1960, Hugo Buchthal writing about the 17th-century miniature in the manuscript, British Library Or. 510, remarks that "we cannot pin down the European influence in Ethiopic art to any single national school of Western painting; we are rather dealing with a succession of isolated instances of borrowing which may be taken to stand for a new aspect of the contact of Ethiopia with Western European civilization in general."[51]

This remark, certainly corroborated by recent studies, may refer as well to borrowings from other cultural centres. This makes it difficult to accept Leroy's division of history of Ethiopian painting into two main periods, "mediaeval" and that of the "Gondar Dynasty", as well as the Moslem invasion in the early 16th century as the dividing event between the two. Claude Lepage echoes this division by putting the term "ancient" instead of "mediaeval".

Leroy's and Lepage's division, though simple at first view, becomes much less clear as one starts to analyze examples of painting from each period. The confusing factor is a continuation of patterns and imitations, combined with the influx of models which were far from uniform. In a certain way the trouble is created by ourselves; we like to think of the periods as clearcut and distinct, but they did, in fact, overlap considerably.

Unless it can be proved that a given event in Ethiopian history can be directly related to a particular form or forms of art, all general conclusions must remain, at best, in the realm of guesswork. For example, we can assert at present that the image of the Virgin of S. Maria Maggiore was introduced into Ethiopia by the Jesuits. This statement is attested to by the analysis of the paintings as well as the detailed interpretation of the written documents. This however, does not allow us to conclude that other iconographic forms which appeared in the 17th century were also necessarily brought by the Jesuits.

Using the general terms like "missionaries", "Portuguese" or others and assuming that they are all necessarily the carriers of models for Ethiopian painting we risk a misinterpretation of the main trends of its history.

We have no evidence of the supposed direct impact of the 16th-century tragic events on the painting of the period. The developments of varied iconographic

[51] *H. Buchthal*, An Ethiopic miniature of Christ being nailed to the cross = Atti del Convegno Internazionale di Studi Etiopici, Roma 2–4 Aprile 1959, (Roma 1960) 334.

themes and idioms expressing themes do not show any synchronization with the
political history of the period. The paintings preserved contain many stylistc and
iconographic elements of the previous century and hardly announce those of the
Gondarene school. Ethiopian painting is equally "mediaeval" or "ancient" after as
well as before the 16th century. One has to wait until the 20th century for the
complete stylistic and other breakthrough in Ethiopian painting which then iden-
tifies itself with the art of the Western world as the result of the innovating trends of
the period.

Changes in paintings throughout the traditional period, that is, the last ten
centuries or so, are not comparable with changes of styles in Western art. The
religious and other attitudes of the Ethiopian painter remain always the same and
his technique alters very little. It is true, nevertheless, that the forms and their
stylistical expression have been evolving according to the models coming from
abroad.

In general, Ethiopian painting was affected by foreign influences in two ways.
One was through an expatriate craftsman or artist who happened to live in Ethiopia
and produced the paintings. The Ethiopians imitated his craft which thus brought
about the changes in subject matter and style as well as in some details of technique.
We can point to a few instances of such influence by the expatriates. The one best
documented by written records and paintings is the presence of the European
craftsmen in 15th-century Ethiopia and the Levantine craftsmen in the early 18th
century. The former are extensively treated in the present book, while the latter still
await an indepth investigation.

Another instance of foreign influence was when an object, a book with illus-
trations, an icon or textile or other found its way into Ethiopia and was reproduced
by the local craftsmen who were basically copyists. However, the process of
copying, as Weitzmann points out, "is by no means mechanical and permits ample
space for new stylistic, even iconographic interpretations."[52]

Neither can we advise at this stage of our knowledge a clear division into two
periods based on the principle of the Eastern and Western predominant influences
on Ethiopian painting. For the time being, each theme is to be presented according
to its own pattern of development, hoping that the overall view will emerge in the
future. The problem is well illustrated by the iconography of the Virgin, the history
of which does not fit into any clear-cut division. Thus, the earliest forms of her
iconography, in the 13th, 14th and early 15th centuries evidence the predominant
but not exclusive influence of Coptic art. However, we should bear in mind that the
scarcity of the examples preserved may create that impression. Starting with the
15th century the well documented developments show a strong Western European
influence coupled with distinct traces of Greek-Byzantine iconography. The
Western influence seems to fade with the coming of the 16th century; the type then
common obviously derives from the Cretan school. In turn that type has been

[52] *K. Weitzmann,* The narrative and liturgical gospels illustrations = New Testament manu-
script studies (Chicago 1950) 151.

replaced in the early 17th century by the image of S. Maria Maggiore which, as is well known, bears Byzantine characteristics. The fact that the Jesuits brought the copy of the famous painting to Ethiopia did not increase the Western influence on Ethiopian painting. Of course, forms other than the above have been sporadically used by the 17th and 18th-century painters, and some of these, as for example the *Pietà*, are manifestly of Western origin but also the Greek form of Eleousa was favoured by the artists of the Gondar school. Plainly the stiff labelling of periods according to Western or Eastern influence does not apply to the iconography of Mary. This may as well stand for other forms.

May we suggest that the attempted divisions into periods have little scope for understanding the pattern of borrowing models by Ethiopian painters and for their reactions. The already proposed schemes neither truly mirror what happened nor give justice to the richness and variety of the borrowings, to the receptive attitude of Ethiopian painters as well as the complexity of their reactions.

In order to make clear the fabric of Ethiopian painting, perhaps another approach would be necessary. When an unknown work of art is discovered, the art historian tends to fit it into the body of works which are executed in the same manner as well as to relate it to the time and place where that group was active. The subject matter is, of course, examined but special attention is paid to the style. The analysis of both leads to answering such questions as whether the works discussed have been executed by the same or by different persons; and if by different persons, how they were related to each other; finally whether this relationship was based either on common workshop or on common training.

The single painting, the set of manuscript illustrations or the decoration of the church thus related to other similar paintings are given their proper place in the cultural history of Ethiopia.

Let us demonstrate this with a few examples.

The style and iconography of two early books of the gospels, both originating from Dabra Ḥāyq, Wallo, are very similar. One book, Krestos Tasfāna Gospels, is at present kept at the National Library, Addis Ababā, the second, Iyasus Moʾa Gospels, is still in the possession of the Monastery. Lepage believed that both manuscripts are "really" not dated but painted "by the same hand". Moreover, they represent together with two sets of church murals the "second stage of evolution" of Ethiopian paintings.[53] These assertions are, of course, very personal and preliminary. Let us then briefly put together what is already known about the manuscripts. The manuscript at Ḥāyq is dated (see footnote 37) to the year 1280–81 by Ethiopian scholar Taddesse Tamrat, whereas the Addis Ababā manuscript, studied by Pāwlos Ṣādwā, another Ethiopian scholar, is ascribed by him to the period 1300–25.[54] However, the earliest historic note in the manuscript refers to the events of 1350 AD. Comparing the two manuscripts, the following points can so far be suggested:

[53] LepPÉth 336.

[54] *Pāwlos Ṣādwā*, Un manoscritto etiopico degli Evangeli = RSE 11 (1952) 28.

(a) there was most probably a scriptorium at the Monastery of Ḥāyq which was active at least during the second half of the 13th century and the first half of the 14th;
(b) both manuscripts evidence the style which was used for manuscript illuminations at that scriptorium;
(c) unless attested by the colophon, we cannot accept as granted that the illustrations in both manuscripts were painted by the same hand.

Already *Wilhelm Staude* suggested that painters in Ethiopia had to obey strict rules, iconographic and stylistic, and worked in teams.[55] Indeed, even today the traditional painters reproduce their works by way of a simple method of tracing. There is therefore the possibility that the works from the same scriptorium could be of a different hand, though painted in a very similar manner.

Further investigation of the documents and analysis of paintings will certainly help to identify better the scriptorium at Dabra Ḥāyq and define the stylistic and iconographic traits of works produced there. It would be idle however, at this point of our investigation to speak of the Ḥāyq school of painting, though we may come to that conclusion in the future. Neither can we suggest that the illustrations in two Ḥāyq gospels are representative of the production of a definite period in the history of Ethiopian painting, nor the "second stage of evolution". This is obvious when we consider the other group of manuscripts. These are the gospels, Éthiopien 32, Bibliothèque nationale, Paris; the gospels kept at the Dabra Ṣeyon, Garʿāltā and the folios of the gospels in the collection of the Institute of Ethiopian Studies (IES), Addis Ababā (No. 2475) which originate from the church Ṣeyon Māryām, Tulu Gudo Island on the Lake Zewāy. Eth. 32 is dated by Lepage to the 13th–14th century. In fact it contains the note attesting to the donation during the reign of King Sayfa Arʾād, (1344—71), which makes Marylin Heldman believe that the book was copied during that reign.[56] This cannot be fully proved but at least the date 1344—71 provides a *terminus ante quem*. The Dabra Ṣeyon Gospels and the folios in IES Collection manuscripts have not been published as yet and they are not clearly dated but their stylistic relationship with the Eth. 32 is obvious. We witness then another scriptorium, virtually contemporary with that of the Monastery of Ḥāyq; moreover, the style of manuscript illuminations developed in that scriptorium is significantly different from the style developed at Ḥāyq.

We lack precise information about the name of the scriptorium in which the three manuscripts were copied, but the guess is that it could be the royal scriptorium. The significant fact is that the manuscripts were obviously copied and sent to different places, for example to Egypt at the royal command, or the church in southern Ethiopia, whereas the third found its way to the monastery in the north of the country and is in the possession of that monastery to this day.

We can only guess when both scriptoria started and came to an end. It is therefore premature to class their activities with the presumed "stages of evo-

[55] StauAnt 226f.
[56] HelZirGan 397.

lution" which are based on a rigid chronological division. The pattern which seems to emerge is that each scriptorium, or group of these, followed their own course of evolution similar to that of iconographic themes as it has already been explained. We may witness the simultaneous existence of several scriptoria, workshops or even groups of itinerant painters the production of which differed significantly in style and iconography.

The existence of such groups and workshops is suggested by the murals in the church of Gannata Māryām, Lāstā, which are virtually contemporary with the Ḥāyq manuscripts. The well preserved murals contain three categories of subjects, the saints, the biblical narrations and the historical scenes. The subjects from the gospels include the Presentation in the Temple which is neither found in the Ḥāyq nor in the group of Éthiopien 32 gospels. Moreover, the iconography of the subjects which are common in the murals and gospels is not the same. Do we witness a third centre active in the same period but using the mode of painting which is at variance with those of the scriptoria? The answer will probably be found through a detailed description and analytic study of the murals.[57]

A large production of illuminated manuscripts and paintings on wood in the 15th century offer the possibility of a further grouping of works by their stylistic traits and relating these to varied scriptoria and workshops. Thus, there is a group of manuscripts similar to that of Abb. 105, Bibliothèque nationale, Paris, and related to the activities of scriptoria in the Eritrean plateau; the gospels and other manuscripts, incisions on crosses and others produced at the Gunda Gundē Monastery and other scriptoria in Agāmē; the group represented by the illustrated *Maṣḥafa Ṭefut*, attributed to the reign of King Zarʾa Yāʿqob (1434–68), and kept at Gešen Māryām Monastery, Wallo, and the *Lāḥa Māryām*, Bethlehem church near Dabra Tābor; paintings on wood, cloth and skin which originate from the Lake Ṭānā area (see p. 422). The list is by no means complete and each group needs a detailed description and study before their mutual relation is fully assessed.

The paintings of the middle and second half of the 16th century which are always difficult to date with precision show the similar fragmentation which perhaps stands for varied workshops and scriptoria.

Starting with the 17th century, the city of Gondar dominated for centuries the art of Ethiopia. The saying "who wishes to paint goes to Gondar" well illustrates this preponderance, which overshadows other equally valid expressions of the 17th-century painting.[58] These are the group of panels painted in a very distinct

[57] *Cl. Lepage*'s description of the murals (Peintures murales de Ganata Maryam = DSCÉ 6 (1975) 59–84) lacks precision. He does not even bother to list all the subjects in the murals disregarding those which probably he is not able to identify. Moreover, in spite of his intimation that he read the numerous inscriptions accompanying the murals, he obviously did not. That is why he missed the most important point in his long discussion about dating the church, that is the fact that the name of King Yekuno Amlāk (1270–85) is mentioned in the murals on two occasions.

[58] The compilers of the catalogue Ethiopie millénaire describe all 17th-century works at the Paris Exhibition, 1974–75, as painted in the "17th-century style" just as we would say

manner, conveniently called that of "parallel lines" (see p. 231). There is good reason to believe that the style can be related to the painting in Tegrē.[59] On the other hand, the art of the painter or painters conveniently called the "Hornbill painter" by B. Juel-Jensen can be most probably related to the activities of the Lāstā craftsmen (see pp. 491–94).[60]

The production of painters active in the kingdom of Šawā in the 18th and 19th centuries whose art developed characteristics of its own is extensively discussed in the present book.

In concluding, we think there is a need to take a new approach in the study of Ethiopian painting. Instead of the main preoccupation with dividing its corpus into clear-cut periods and "stages of evolution", the study would concentrate on the combined investigation of the paintings, the people who produced these and the spirit of the locality where the creation took place. Grouping of paintings by stylistic and iconographic traits would be linked with the records on activities of scriptoria and workshops evolving in varied places of the vast Empire. Their creations show significant stylistic and occasionally iconographic dissimilarity. The inception, duration and activity of these centres are not synchronic and vary a great deal. These varied centres might have some influence on each other, as they certainly did, and the itinerant painters might help to spread some particular modes of painting, but on the whole, the existence of independent workshops was the framework in which developed the fabric of Ethiopian painting. In order to give justice to those centres and their production, a close collaboration of the historian, linguist and art scholar is indispensable. Antonio Mordini who combined in one person these three qualities clearly saw the point and illustrated it by his study of the Gunda Gundē Monastery.[61]

This fragmented framework of Ethiopian painting finds perhaps its explanation in the geographical configuration of the country which in turn conditions its political and religious life. The country is composed of areas divided by steep valleys with rivers at their bottom. The flooded rivers thus isolate the areas for a few months of each year. On the other hand, the hilltops on which people live are natural bulwarks. This configuration instilled the feeling of independent life into the people.

Besides, in the life of the Church which was the only agent of artistic activities in Ethiopia this feeling of self-direction was prevailing. The churches and monasteries settled on hilltops or inaccessible ravines led the life characterized by seclusion, deep spirituality and remoteness. The scriptoria and workshops which produced illuminated books and images on wood were located mainly in the monasteries with the exception of a few town centres. Also, the artists who later decorated the churches had been trained in such places.

that the paintings of Louis David, Franz-Xavier Winterhalter and Claude Monet are painted in the "19th-century style".

[59] Described in ChojArtEthE 91 f.
[60] JuelJG.
[61] MordGG.

The new approach to investigating the Ethiopian painting does not preclude, of course, a further attempt at a larger grouping, whenever possible. Neither does the diversity of streams through which flowed the Ethiopian creativity diminish our feeling of what is "unchangeable and fundamental" in it.

Already Leroy in a broad sense initiated such a grouping. He identified the 17th-century first school of Gondar and the 18th-century second school of Gondar and described these in stylistic terms. However, he paid little attention to chronology, scriptoria and workshops as well as to the people. For example, he cites the murals in the church of Abuna Yem'āta of Guḥ as an example of the first Gondar style whereas Lepage ascribes the same murals either to the 15th or to the 16th century. Also, Lepage makes an effort at stylistic grouping but owing to his rigid division of all paintings prior to the 16th century into "five stages of evolution" arrives at an unconvincing proposition.

All said, the following studies do not aim at presenting an overall view of Ethiopian painting, but to clarify a number of important points using the two above discussed methods:

Three popular themes in Ethiopian painting, that is, the Flight into Egypt, the Holy Trinity and the Dormition and Assumption of the Virgin as well as the main forms of her portraiture are described chronologically.

In investigating European painters in 15th and early 16th-century Ethiopia, we are aiming at their identification, relating them with the paintings recently discovered and assessing their impact on Ethiopian art.

All above studies illustrate the way foreign models were introduced and the Ethiopian reaction to them.

The description of the little known group of paintings produced in the kingdom of Šawā opens the discussion on the fundamental characteristics of Ethiopian painting and leads to the quest for its African heritage.

I. THE FLIGHT INTO EGYPT:
A THEME FROM THE INFANCY OF CHRIST

The Ethiopian version of the Flight into Egypt is largely based on apocryphal texts, which have enriched the laconic passage of Matthew 2,13–21, with additional details. The passage in the Synaxary, the revelations of the Virgin Mary to two Patriarchs of Alexandria, Theophilus and Timothy, and perhaps the oral legends from Egypt brought by pilgrims, served as source material to Ethiopian painters for composing their images of the Flight into Egypt.

In the Ethiopic Synaxary the Flight into Egypt is commemorated on 24. *Genbot* (19. May) with an extensive reading; the details it contains are important for the iconography of the subject. On that day, goes the reading, Christ came to the land of Egypt and "he was a Child whose days were two years, even as the Holy Gospel saith".[1] Christ was accompanied by his mother, St. Joseph and Salome. The first city in Egypt at which the Holy Family arrived was called "Balatâ", but the people there did not receive them kindly. The stay in Egypt lasted three years and six months, after that the angel appeared again to Joseph and ordered him to depart "to the land of Israel".[2]

The Synaxary gives these reasons for the "coming of Our Jesus Christ" to Egypt. Firstly, if Herod found him and was able to kill him "others would think that his Incarnation was from below; and secondly: that the men of the Land of Egypt might not be deprived of his grace, and His going about in their midst, and that he might smash the idols which were in the land of Egypt..."[3]

The homilies of Theophilus and Timothy,[4] well-known Coptic devotional works of Oriental Christendom, answering popular curiosity about the unknown details of Jesus' life, are narrated in the first person by Mary herself in order to emphasize the authenticity of the story, according to the practice common at that time. According to Theophilus, Mary revealed to him the details of her journey to Egypt as follows: Herod waited for two years for the "magicians" before ordering the slaughter of the Innocents; therefore, Jesus was already walking when the Holy Family set out on the journey to Egypt, and "Salome was with us" added Mary.

[1] This means the gospel of pseudo-Matthew.

[2] BSyn 923–26. According to *I. Guidi*, Storia della letteratura etiopica (Roma 1932) 34f., the Synaxary was translated from the Arabic Alexandrine version into Ethiopic at the end of the 14th or even in the beginning of the 15th century. Recent discoveries of Mss earlier than those known to Guidi suggest that the translation took place long before.

[3] BSyn 923 and 444.

[4] BLM. Full text of Theophilus in CRCosc 395–471. The homily was, according to Conti Rossini, translated into Ethiopic around the middle of the 14th century or a little later. Probably the translation took place in the Monastery of al-Muḥarraqa close to Qwesqwām: CRCosc 399.

Then follows her vivid description of the method of travelling: "Joseph was in front of me. And I carried my Child sometimes on my shoulders and sometimes on my back and sometimes in my arms, and by reason of the length of the way and the weariness of the journey, Salome [carried him] in turn. Then, sometimes, I set Him down upon the ground that He might follow me, even as do women when they teach their children to walk, for I was a delicate woman, and it had not been my lot to toil hard ... Joseph carrying our provisions, when he saw Salome carrying the Child, used to take Him on his shoulders". The text does not clearly state whether Salome also relieved Joseph of his burden of carrying food or part of it but the above passage would suggest it. Another detail especially mentioned by the Virgin is that she suckled her Child.[5]

Theophilus as well as Timothy and the Synaxary narrate at length tales of the Holy Family's stay in Egypt and the miracles performed there by the Divine Child. They refer particularly to the place called Dabra Qwesqwām. The Holy Family went there because of the "pillar" which the people worshipped there; the "pillar" seems to be the pagan "idol". The Divine Child showed his power over it as it bowed "its head and worshipped Him". "And there came forth a command from my Son", Mary tells Timothy, "that His name should be associated with this place as it was with the rock, and it is so to this day".[6] These legends, popular in Medieval Egypt, must have impressed the Ethiopian pilgrims passing through it. They used to visit the places where the Holy Child was supposed to have lived and performed miracles; Dabra Qwesqwām (al-Qusia) was one among them.

The name of Qwesqwām (Qusqām) was given to several localities in Ethiopia, partly as a remembrance of the happening in Egypt and partly as a result of an old belief in the Family's visit to Ethiopia on their way to or from Egypt. Although not officially acknowledged by the Ethiopian Church, the legend still persists in the countryside and even now the people claim in some localities that the Holy Family had "rested" there.[7]

Also other localities, some well known places of Coptic pilgrimages in Mediaeval Egypt, are mentioned in the Synaxary as visited by the Holy Family. Among these there are Dabra Meṭmāq, "Ešmûnâyn", and the Church of St. Sergius, Cairo.[8]

Salome appears in a great number of Ethiopian images of the Flight into Egypt. She is well known in Christian mythology; her rôle and characteristics were elaborated in apocryphal writings of the early Church. Salome is called in the Synaxary either "the daughter of the sister of Our Lady" or "the sister of Our Holy Lady". She acts in Ethiopian context partly as an attendant for status' sake, partly as maid-servant and occasionally helper in the house. She eventually emerged in Ethiopian religious art as one of its main subjects. Salome is commemorated in the

[5] BLM 67f. and 79; CRCos 453f.
[6] BLM 95.
[7] Gannata Le'ul in Yaǧǧu and Mazgaba Qeddusān in Amārā Sāyent, Island of Qirqos, Lake Ṭānā.
[8] BSyn 923f.

Synaxary by a special day (25. *Genbot* = 20. May) because she "made the Child and Joseph and his mother, the Lady Mary, to take flight, and she became a participator in the trouble caused by Him ...".[9] Also according to Theophilus and Timothy, Salome faithfully followed the Holy Family in their journey to Egypt.

The above legends[10] contain the main elements for pictorial rendering of the Flight into Egypt which found their reflection in the Ethiopian imagery of the subject. The process of composing it seems to be a complex one. It was neither a simple transference of the legendary stories into paintings nor a direct copying of varied foreign models which reached Ethiopia at different periods, but the blending of multiple artistic inspirations into a unique Ethiopian image of the Flight into Egypt as illustrated by the subsequent examples.

DESCRIPTION OF PAINTINGS
THE MURAL IN ST. MARY'S CHURCH (BĒTA MĀRYĀM) LĀLIBALĀ

(1) The subject of the Flight into Egypt appears in the murals in St. Mary's church (Bēta Māryām), Lālibalā (fig. 1). The composition differs from the usual Ethiopian rendering of the subject and is most probably the earliest example of it known to us.[11] However, the dating of the murals, which is of

[9] BSyn 923 f., 928 and 978. According to gospels of pseudo-Matthew three youths and one "girl" accompanied the Holy Family. Arabian gospels on the childhood of Christ do not mention Salome. In the History of Joseph, chap. 8, she was the only companion named. On the other hand, the Mount Athos Painter's Guide is silent about her. VogFlucht 21.

[10] These stories adapted to the Coptic environment derive from the apocryphal Infancy gospels, the gospels of pseudo-Matthew and the Arabian gospels of the childhood of Christ: HenAp I 363–417; *S. Grebaut*, Miracles of Jesus = Patrologia Orientalis XII 4 (1919).

[11] *Beatrice Playne* recorded that she saw in the Yemreḥānna Krestos church a small "panel in fresco on the right of the north door by which we had entered. Even with lighted tapers, it was impossible to get sufficient light on this to examine it properly, but I could just distinguish a figure leading a donkey, on which sat the Madonna, followed by another figure, which I took to be St. Joseph carrying the Child on his shoulders". In the footnote to the passage Playne added: "A similar composition (in mosaic) can be seen in the Kareya Djami, Istambul (fourteenth century)" (Play 120). The well-known mosaics in the Kariye Djami (The Chora Monastery), Istambul, represent the Journey to Bethlehem, the Flight into Egypt as well as the Return from Egypt to Palestine. The mosaic of the Flight into Egypt is in a poor state of preservation, only the merest fragments of the youth, the animal on which Mary rode, and the landscape setting have survived. Nevertheless, Underwood seems to recognize "the well-known type in which the young James ... leads the donkey on which Mary is seated while Joseph, behind the animal, carries the infant Jesus astride his shoulders as he does in the mosaic of the Return from Egypt". In the latter, Mary walks behind Joseph instead of riding the donkey. P. A. Underwood, The Kariye Djami = Bollinger series 70 (New York 1966) I 86–88, 97 f, 104–06; II 182 f, 200–05, 152–58.

The rendition of the Flight into Egypt in the Iyasus Mo'a Gospels (fig. 2), the Krestos

vital importance for the study of early Ethiopian art, is not established as yet. Are the murals contemporary with the construction of the church, i.e. date from the end of the 12th or the beginning of the 13th century, or were they added during the reign of King Zarʾa Yāʿqob in the middle of the 15th century as oral legend has it? Considering that no detailed analysis of the murals has been made, the following estimates by the scholars in the field should be taken as tentative.

B. Playne, who noted the artistic value of the murals, has given, as usual, her opinion in cryptic terms: "In Europe I would have said twelfth-century, with those outstretched thumbs and the rest of the fingers in one piece, which always seems to me so characteristic. But from where did the Virgin get her brown, wavy Gothic hair, two hundred years before any European is known to have reached Ethiopia?"[12] Equally enigmatic is P. du Bourguet who as a result of his short visit to Lālibalā, wrote: "In Ethiopia, and then only in certain of the rock-cut churches of Lālibalā, the exterior form of which remains peculiar to the area, the painted decoration and certain reliefs appear to be influenced by the Coptic art of the Fatimid period."[13] Considering that the only murals of consequence remaining in Lālibalā are found in St. Mary's Church, we can assume that the remark of the expert in Coptic art refers to them. His opinion on the Fatimid influences was followed by others. Otto Jäger postulated that although some pictures in the murals are painted 'al fresco' on the fresh plaster, he is not sure whether they originate from the time of Lālibalā and "if so, then most probably the painter was a foreigner somewhat adapted to the Ethiopian style, but not truly representing this style". According to him the paintings of the period should be "spiritual" and "abstract", while those from Lālibalā are somewhat "more realistic".[14]

Less weight has the judgement of Cl. Lepage that "L'attribution des peintures de Bieta Maryam ... à une période allant du XI au XIII siècle me paraît pleinement justifiée".[15] He also emphasizes the analogies between the murals in St. Mary's

Tasfāna Gospels (fig. 3b) and the *Lāḥa Māryām* manuscript (fig. 5) recalls the Return from Egypt in Kariye Djami mosaics.

In the same book of travels Playne writes about the church Bilbalā Čerqos: "High over the west door I noticed another "Flight into Egypt", but its style was much more realistic than the rest of the paintings that I felt sure it was work of a much later date" (Play 123). This confused account does not allow to identify the "panel" in Yemrehānna Krestos with any degree of accuracy though undoubtedly the paintings in that church are as old as those in Bēta Māryām, Lālibalā. Respecting the Bilbalā Čerqos "Flight into Egypt" it is even more difficult to estimate its date and real meaning considering that the much damaged wall paintings in that church closely recall those in the Gannata Māryām church, Lāstā (late 13th century).

[12] Play 45.

[13] BourgCopts 191.

[14] JäP 355f.

[15] *Cl. Lepage*, L'ancienne peinture éthiopienne (Xe–XVe siècles): analogies et influences = DSCÉ 5 (1974) 34.

Church and the Coptic art "around the 8th century".[16] G. Gerster has com-
promised between the oral legend and the impressions of the above scholars. "One
is tempted", he writes, "to assign the tempera paintings–that is to say the rosettes
on the ceiling–to the period of [Zar'a Yā'qob]. On the other hand the painted frieze
and the Annunciation scene in the vaulting may be as old as the church itself".[17]
The present writer does not intend to add another personal estimate of the dating of
the murals on the whole, but to locate one of its details, the Flight into Egypt,
chronologically and stylistically through its detailed analysis.

The mural represents Mary riding on a donkey, with an angel standing in front of
her and St. Joseph walking behind her; this small party seems to be heading
towards a structure with a large palm beside it. Mary's body is drawn in profile,
unlike the Eastern iconography of the Flight into Egypt in which she is facing the
front. However, Mary does not seem to ride astride either, her two feet are shown
underneath her long robe, i. e. these are both drawn on the front side of the donkey.
Mary has a cloak on her back and shoulders in which she carries the Child, in the
way Ethiopian women transport their babies. With her left hand she probably
indicates the church, while with her right hand she supports the Child. Mary's face
is round as in other portraits of her in the murals and basically in frontal position
except the nose which is drawn in three-quarter pose. The irises of her expressive
eyes are attached to the upper line of the eyeballs which in Ethiopia is symptomatic
of 13th-14th-century painting.

The part of the painting behind Mary's back is faded and therefore the exact
figure of the Child is a matter of guesswork. He seems to be entirely wrapped in a
kind of cloak or apron. His head is protruding from it. The features of his face are
not clear except for the line of eyebrows and the blond hair. His face seems to be
turned towards the spectator. There is no cruciform nimbus around his head. The
donkey is clearly trotting at a fast pace, which is expressed by its two right legs
strongly inclined to the back and its two left legs to the front. However, this
movement of legs does not conform to reality. The head of the donkey is drawn in
three-quarter position so that both eyes are shown; the identical rendering of
horse's heads is found in Qorqor Māryām and Ḥaregwā Mikā'ēl churches,
Gar'āltā, both ascribed to the 13th or at the latest to the 14th century, but not
recorded in the works from the 15th century and after.[18] This method of drawing
the equine heads is also known in Coptic art as exemplified by the 13th-century
picture of St. Theodore Stratelates in the Monastery of St. Anthony-of-the-Desert.
Moreover, a large double collar of the donkey's neck in the Lālibalā mural and its
pointed ears recall the same in the Ḥaregwā Mikā'ēl picture of St. George.

[16] Cl. Lepage, L'ancienne peinture éthiopienne (Xe–XVe siècles): analogies et influences
 = DSCÉ 5 (1974) 31.
[17] GerChRock 97.
[18] The only exception known to the writer is found in the 17th-century Book of Miracles of
 the Virgin Mary from Dabra Warq Monastery. The horse of St. George represented in
 the twenty-first miracle has its head drawn in the three-quarter position. Probably other
 copies of the Miracles contain the same peculiarity.

The angel, identified as St. Gabriel (the inscription runs "Māryām" and "Gabre'ēl"), turns towards Mary and holds the reins of the donkey with his right hand and a cross in his left hand; the cross has an elongated lower arm similar to crosses in Coptic and Nubian art. On the whole, the figure of the angel, with characteristic pose of his left hand as well as the drapery of his garment, clearly stems from the Byzantine prototype which most probably had reached Ethiopia through the Coptic channel. This is suggested, among other characteristics, by a plain flat crown of hair instead of ornamental headgear, a tiara, usually adorning the heads of Nubian angels. In Ethiopian art, the angels carrying crosses with an elongated lower arm, belong to the 13th and 14th-century period, for example, they appear in the mural of the Gannata Māryām Church, Lāstā (13th century) or in the miniature, Krestos Tasfāna Gospels (early 14th century). Gabriel's face is clearly drawn in three-quarter pose.

The nimbi of Mary and Joseph are simple discs contoured by a single line, while the halo of St. Gabriel has a double line; the latter is typical of the 13th through the early 15th-century Ethiopian painting.

The rendering of the journey of the Holy Family in the Bēta Māryām Church, Lālibalā, contrasts with all renderings of the subject known to us from the 13th to the 17th century. Indeed, the personages in the mural seem to be set in a situation localized by the scenery depicted in front of them, namely the date palms and the building. The scaled trunk of the palm, its pointed leaves, as well as bunches of ripening fruit, are most probably drawn from life by someone who reproduced carefully the details of the plant but with some stylization. A point to note – no date palms are known to be cultivated in Ethiopia. The same accuracy of rendering the details, unusual in Ethiopian art, is demonstrated in the drawing of the building; the structure, built either of blocks of rock or more probably of dried blocks of mud, bears three domes surmounted by crosses.

The composition does not reflect the Ethiopian apocryphal stories on the journey to Egypt. The donkey on which Mary is riding, the absence of Salome, and the addition instead of the angel Gabriel, make it difficult to place this painting in developments of the subject in Ethiopian art.

The particulars seem to suggest that the painting was, indeed, made before the 15th century; the manner of drawing the donkey's head and the cross with elongated lower arm held by the angel accord with our knowledge of 13th and 14th-century Ethiopian art. Yet, the painting, as well as other works on the friezes in the church, does not seem to fit into an established opinion of "early" Ethiopian art: the preference for drawing the faces in three-quarter pose instead of the frontal one, the unusual softness of the drawing and the feeling of movement instead of rigid immobility, raise the problem of the painter's origin, the iconographic sources of this Flight into Egypt and, in general, of the place of mural in early Ethiopian art.

Where did this image originate? The earliest image of the Flight into Egypt known to us, which Karl Vogler calls "normal"[19] is found on a golden pendant

[19] VogFlucht 9. The "normal" form shows the Virgin Mary on the donkey's back which corresponds to the oldest version of the travelling in the Protoevangelium of James. "And

(enkolpion) from Adana, sixth-seventh century.[20] "Here we can see for the first time", wrote the other German scholar Gertrud Schiller, "the original type of the image of the Flight, although presumably this is not the earliest rendering ... Mary sits on an ass facing the spectator with the Child enthroned on her lap in the same frontal pose. The ass is led by Joseph and moves from left to right. Joseph ... stretches out his left hand towards the dome building. The building represents the goal of their journey and in particular the Egyptian town whose citizens had been thought by the miracle of the falling idols to recognize the Child as God"[21]. In Eastern iconography of the Flight into Egypt the core – Mary with the Child riding on an ass and Joseph – remains constant. Moreover, a young attendant, called either the son of Joseph or his servant was included in the composition. In Cappadocian murals ascribed to the post iconoclastic period he is usually walking in front and seems to lead the donkey[22] while in Syrian and court Byzantine painting he always follows the beast.[23] In the Painter's Guide of Mount Athos he is named as an essential figure of the composition. He holds the bridle of the donkey and carries the gourd. The building, or in more developed form, the town[24] towards which the Family is heading has usually an open gate. A woman wearing a tiara stands in front of it and welcomes the travellers. The figure is the personification of

he [Joseph]" runs the text "saddled his ass and made [Mary] sit on it; and his son Jacob led whereas Samuel [another son] followed". Cf. *E. de Strycker*, La forme la plus ancienne du Protoévangile de Jacques (Bruxelles 1961).

[20] *Kl. Wessel*, Jugend Jesu = RbK III 679, lists two fragments of the Flight into Egypt painted on the cupboard plate, 5th cent?, found in the Archeological Museum, Istanbul.

 K. Künstle, Ikonographie der christlichen Kunst I (Freiburg in Breisgau 1928) 369, mentions the fragment of the diptych from Thebais. This on the authority of Strzygowski (Bull. de la Société archeol. d'Alexandrie, No. 5, p. 84 f.).

[21] SchillIc I 118.

[22] JerphCapp II 443., attributes the introduction of the figure of the youth to Cappadocian or Anatolian painters; *L. Giovannini* (ed.), Arts of Cappadocia (London 1974) 150f., church of St. John, Güllü Dere; According to SchillIc I 120, he is supposed to be James the Elder, son of Joseph by his first marriage and half-brother of Jesus. "The flight into Egypt in Cappadocian paintings", writes *G. Millet*, "shows clearly the influence of the apocryphal writings. The painters did not fail to represent this episode the way in which the protoevangelium described the voyage to Bethlehem: He spread the covers on the ass, made Mary sit on it, while his son led the beast, he followed it "= Recherches sur l'iconographie de l'Évangile aux XIV, XV et XVI siècles d'après les monuments de Mistra, de la Macédonie et du Mont Athos = Bibliothèque des Ecoles françaises d'Athènes et de Rome 109 (Paris 1916) 155.

[23] *G. Millet:* in Recherches sur l'iconographie de l'Évangile aux XIV, XV et XVI siècles d'après les monuments de Mistra, de la Macédonie et du Mont Athos = Bibliothèque des Ecoles françaises d'Athènes et de Rome 109 (Paris 1916) 157f., writes "Byzantine iconography never puts James in front [of the ass]. This art follows faithfully the text of the Gospel "He took the Child and mother during the night...". Indeed, in Menologion of Basil II, 979–84, Joseph walks in front, the Child sits on Mary's lap and the boy follows behind.

[24] Miniature in Menologion of Basil II.

Egypt, often, as in Cappadocia, attested by an inscription.[25] This setting of the Flight into Egypt is considered by A. Grabar[26] and other scholars [27] as inspired by the *Adventus* (*perfectio Imperatoris*) of official Roman art. Moreover, they believed this biblical theme to be, in fact, the manifestation of theophany for the early Christians.[28]

Western European art also adopted the same schema.[29] However, it also developed around the 6th century a particular representation of the Family's arrival at the Egyptian town called Sotin.

Starting with 10th–11th century onwards, the "normal" representation of the Flight appears commonly in Italian and Byzantine cycles of the life of Christ. The Flight is at times combined with the so-called second dream of Joseph, i.e. a dream in which the angel orders him to take the Child and go to Egypt.[30]

Considering the areas close to Ethiopia, there are two early representations of the Flight into Egypt in the collection of icons at the Monastery of Saint Catherine, Mt. Sinai.[31] In icon No. 13 (9th–11th century) Mary sits on a donkey and probably nurses the Child. Joseph walks in front and a young man behind the beast. There is a town on the right with a woman welcoming the travellers. In icon No. 43 (11th century) the Flight is depicted twice. In the first picture, an angel either shows the road or leads the Family while two servants beside him carry jars with water. In the second picture the arrangement of figures and their setting is similar to those in the previous icon.

In Coptic art pictures of the Flight into Egypt are rare, which is understandable considering the ravages following the Moslem conquest.[32] The mural painting ascribed to the 6th century in the church of Dayr Abū-Ḥannis is thought to be the Flight into Egypt.[33] The much destroyed painting shows Mary riding on a donkey and supported by Joseph with a small structure in the background. The Painting is known from photographs only. Although Kl. Wessel considers the painting to be

[25] Schilllc 119f.; VogFlucht 16f.; JerphCapp II 89; RbK III 677.

[26] *A. Gorabar*, L'Empereur dans l'art byzantin; recherches sur l'art officiel de l'Empire d'Orient (Paris 1936) 236 and 288.

[27] Schilllc 118; *H. Hummel*, Perfectio Mariae. Zur Ikonographie der "Flucht nach Ägypten"1 Theologia Viatorum 9 (1964) 95–112.

[28] GraMart II 182f.

[29] Fragment in 8th-century fresco, S. Maria Antiqua, Rome. *P. J. Nordhagen*, The frescos of John VII, A. D. 705–707 in S. Maria Antiqua in Rome (Roma 1968); mural in St. Urban of Caffarella, 10th century; St. Mark's, Venice, 11th century.

[30] The earliest known representation of the theme is found in an ivory plate decorating the throne of Archbishop Maximian, Ravenna. Early sixth century.

[31] Listed by *G. Soteriou* and *M. G. Soteriou*, Icônes du Mont Sinai (Athens 1956–58).

[32] BourgCopts (166) wrote: "in painting, biblical and evangelical scenes appear sporadically. Their rarity is probably the result of acts of destruction which took place over the years".

[33] Dictionnaire d'archéologie chrétienne et de liturgie (Paris 1924) 2059–68; *A. Gayet*, L'art copte (Paris 1902) 273, writing about the Monastery of Dayr Abū-Ḥannis mentions the Flight into Egypt and gives its reproduction.

the Flight into Egypt[34] this identification however is open to doubt owing to its similarity to the first dream of Joseph (Matthew 1,20–21) and the subsequent journey to Bethlehem. Neither C. C. Walters nor du Bourguet[35] mentioned this painting. Whatever the meaning of the painting, it is of significance that Mary is indeed riding on an ass. On the other hand, a clear representation of the Flight into Egypt is found in the Copto-Arabic Ms. No. 1 at the Institut Catholique, Paris.[36] Mary with the Child is riding on a donkey while Joseph and a woman (probably Salome) follow her.

There is no representation known to us of the Flight into Egypt in Nubian Christian paintings.

It is clear from the above that the Flight into Egypt in Lālibalā murals is not a genuine Ethiopian composition, but was inspired by foreign models. However, the identification of these models and the area they came from is not easy. The inclusion of an angel, the palms and the building identified by an inscription suggest a complex origin of the composition.

The first indication is given by the caption over the building. If the reading is correct, the first sign is *so*, the second *ta* or *ti* and the third clearly *n*. This makes the word Sotan or Sotin, the name of the locality towards which the family is heading.

According to the gospels of pseudo-Matthew the Family arrived at the town called Sotin or Sotina in the region of Hermopolis. "Since there was no one they knew whom they could have asked for hospitality, they entered a temple" in which stood 365 idols. When Mary entered the temple with the Child, all the idols fell to the ground. The Egyptian governor of the town, Aphrodisius, witnessing the miracle recognized the Child as a God and "worshipped him".[37]

The arrival at Sotina is represented on the triumphal arch in S. Maria Maggiore Church, Rome. This 5th century impressive mosaic "differs from the text of the Gospels", writes Gertrud Schiller, "in that it shows the meeting with Aphrodisius not in the Temple after the idols have fallen but in an act of hommage at the arrival of the Holy Family at the city-gate".[38] The composition was presumably not repeated elsewhere. The triumphal entry of the Child in Sotina is parallelled as a revelation of Christ to the heathen. "Even when it appears as a mere architectural formula", continues Schiller, "it always alludes to the reception of the Holy Family in Sotina and the falling idols".[39] Hennecke thought that the gospels of pseudo-Matthew are a compilation of the earlier Infancy Gospels written probably in the West in the 8th or the 9th century to further veneration of Mary.[40] In Evangelium Infantiae Arabicum the miracle in Sotina is shortly mentioned, but instead of 365

[34] RbK III 679.

[35] WaltMonEg; BourgCopts.

[36] LerMssCopt pl. f. 4 scènes évangeliques. The Ms. is dated 10th–11th century; RbK III 680f.

[37] HenAp I 412.

[38] SchillIc I 118.

[39] SchillIc I 119.

[40] HenAp I 406.

idols there is only one in the temple.[41] On the other hand, in the Ethiopic Synaxary the miracle of "broken idols" happened in a locality called "Ešmûnâyn".[42]

In the Ethiopian liturgical calendar there is a feast of the Entry of Jesus into Egypt, commemorated on the 24. *Genbot* (19. May). Perhaps the painting is an illustration of the event as conceived by the Ethiopians before the Egyptian Synaxary was introduced into their country.

We can assume, therefore, that the painter of the Lālibalā murals had some knowledge of the miracle of Sotina; he did not necessarily get it from the literary sources then available in Ethiopia. Whether in fact he intended to illustrate the revelation of the Child as God is a matter of guesswork. However, the form of the "town" of Sotina gives one significant indication. It is by no means a copy, even simplified, of the Byzantine, Syrian or Cappadocian forms of the "town". Stylistically the structure in the Lālibalā painting belongs to Islamic-Coptic (or perhaps Islamic-Syrian) art. It may, in fact, represent a keep or tower of refuge in a monastery of the Egyptian desert.[43]

The other figure in the composition under consideration is an angel. The apocryphal narratives are silent about angels.[44] They are not mentioned in the Mount Athos Painter's Guide.

Not a single image is known of the Flight into Egypt with the figure of an angel in the early art of the Christian East. On the other hand, four of them walk beside the Child in the mosaic of S. Maria Maggiore, Rome. Vogler mentions the ivory antipodium in Salerno, 12th century, with an angel "accompanying on foot",[45] and Schiller the stone relief in Parma from the same century in which the angel precedes the Holy Family. "A motif", she added, "which must go back to the early renderings of the journey to Bethlehem".[46]

While the figure of an angel in the Flight into Egypt is found exclusively though infrequently in the art of the West, the journey to Bethlehem with an angel accompanying Mary and Joseph with few exceptions was confined to the great Byzantine cycles of the life of Christ.[47] The presence of an angel in this theme originates from the gospel of pseudo-Matthew.

[41] VogFlucht 49.

[42] BSyn 925. In some commentaries "Ešmûnâyn" is considered to be Sotina.

[43] A keep or tower of refuge was an important element in the construction of monasteries in the Egyptian desert. The monks, threatened by robbers or fanatical Moslems, used to withdraw to such towers erected within the walls of the monastery. WaltMonEg 91 f.

[44] VogFlucht 24.

[45] VogFlucht 24. Schiller discussing the iconography of the journey to Bethlehem lists the "ivory relief in Salerno", SchillIc I 58. One wonders whether this is the same ivory which Vogler thought to be the Flight into Egypt. *G. A. Wellen* [Theotokos (Utrecht 1960) 63] writes about two bas-reliefs in Berlin without giving details. He also mentions the mural in Dayr Abū-Ḥannis. It is clear that there is some confusion between the Flight into Egypt and the journey to Bethlehem.

[46] SchillIc I 120.

[47] SchillIc I 58.

The inclusion of the angel into the Lālibalā composition can be explained in three ways. Either the painter followed the Western European models, or he himself composed the painting borrowing the figure of an angel from the image of the journey to Bethlehem, or the angel was added as the result of local commentaries, which however did not last to our time.

The first proposition seems remote though not impossible. If the mural was contemporary with the construction of the church, it would date from the late 12th or early 13th century. This was the time of the Crusades and of the intensive interchange of ideas between the East and West. Nothing prevents the belief, and some monuments in Lālibalā support the suggestion, that some Western ideas then penetrated into the Ethiopian highlands.

The second possibility is equally plausible. The images of the journey to Bethlehem have been produced in the areas close to Ethiopia, for example in Coptic Egypt or the Monastery of Sinai. The Lālibalā painter could have had some contact with these.

Considering the inclusion of an angel as due to local commentaries on the evangelical narrative, one has to point out that in Ethiopian art an angel in the context of the Flight into Egypt is virtually unknown, except for the Lālibalā mural and one early miniature discussed subsequently. This leads to the conclusion that the angel in the Lālibalā mural was not added locally but rather transferred from a foreign model which represented either the journey to Egypt or to Bethlehem.

But why did the painter of the Lālibalā mural do it? Was he confused about the real meaning of the figures he painted? The answer is certainly not; one significant indication of it is the structure called Sotin just discussed, and the additional one is the date palms represented close to it.

The miracle of the date palm that lowered its branches to allow Mary and Joseph to pick up the fruit, is described in the gospels of pseudo-Matthew. According to Vogler the miracle is not mentioned in other apocryphal writing.[48] In fact, the Synaxary contains two other miracles performed by the Child during his stay in Egypt in which a tree plays an important rôle. In "Maṭârĕyâ" (near Heliopolis) the Child miraculously changed Joseph's staff into a balsam tree, whereas in "Ešmûnâyn" a *"kômôl"* tree bowed its head before him.[49] It is obvious, however, that a clearly recognizable date tree in the Lālibalā mural does not allude to these two miracles, but to that in pseudo-Matthew.

"The tree of the miracle", writes Schiller, "is unknown in Byzantine art, nor is it mentioned in the Mount Athos *Painter's Guide*."[50] On the other hand, Schiller as well as Vogler list a number of 11th–12th-century images of the Flight in Western art in which the tree or the palm are represented. These are alluding to the miracle which is now shown. "The motif of picking the fruit", added Schiller, "does not

[48] VogFlucht 28.

[49] BSyn 924f. VogFlucht (29) mentions the story of an old sycamore tree close to the village of Matariech, the friut of which the Family has eaten.

[50] SchillIc I 121.

come into use until the end of the Middle Ages and then – true to the legend – primarily in connection with the Rest on the Flight".[51]

However, the tree of the miracle must have been known in some parts of Eastern Christianity. Trees are found in the enkolpion from Adana. The motif was certainly known in Coptic Egypt; Vogler seems to recognize a tree in the much damaged fresco in Dayr Abū-Ḥannis.[52]

The reason why the story of the Flight was popular in Egypt is not difficult to see. "It seems", wrote de Jerphanion, "that the Flight into Egypt appeared in the repertory of Christian iconography rather late. The reason for it was obvious; the Flight not taking place in Palestine, no sanctuary was erected there to commemorate its memory. As the result there was no [iconographic] composition to popularize the event."[53] On the other hand, in Egypt there were a number of sanctuaries connected with the Holy Family's stay in the country and the miracles performed by the Child. Undoubtedly local traditions and stories developed around these sanctuaries; some of these took shape in literary works as for example Mary's sermon at Mt. Qwesqwām recorded by Theophilus of Alexandria. These stories must have found some reflection in local art which probably did not survive.

Does the painting in Lālibalā bear witness to the vanished Coptic models? Has the tree some relation to Western European images of the Flight into Egypt? Whatever the answer, it is clear that the trees in the Lālibalā mural are not an element of the landscape but the symbols or "synthetic images" of the miracle performed by the Divine Child. This composition, so rich in iconographic content points indeed at the complex influences in the art of the Zāgwē dynasty.[54]

In early Ethiopian art the Lālibalā mural proved to be an isolated and exceptional case. It fell into oblivion soon after it was painted and did not influence the mainstream of developments in Ethiopian imagery of the Flight into Egypt. These developments took an entirely different turn as attested by manuscript miniatures and panel paintings from the 13th through the 17th century.

13TH TO 18TH-CENTURY PAINTINGS:
THE VIRGIN MARY WALKING

Although in religious calendars of the Ethiopian Church the Flight into Egypt is listed among six less important feasts, the subject was obviously popular among the Ethiopians and caught the imagination of painters. Perhaps it owed its popularity to Coptic oral legends about the event which were full of dramatized details. The Ethiopians must have learned about them at an early stage. The hardships of the

[51] SchillIc I 121.

[52] VogFlucht 30.

[53] JerphCapp II 29.

[54] The dynasty which reigned in Ethiopia in the 12th and 13th century. *Taddesse Tamrat* writes (TTCh 57), that the Zāgwē period was "perhaps the richest and most artistic period of Ethiopian history since the conversion of Ézana".

Holy Family's journey throughout the desert, the dangers of a robbery and even of death, all reflected the real situation which Ethiopian pilgrims had to face passing through Egypt. It should be recalled that in the 14th and the beginning of the 15th centuries a large Ethiopian community lived in the Egyptian Monastery al-Muḥarraqa and served no doubt as a channel through which the legendary traditions of the Holy Family's life in that place have been diffused in Ethiopia.[55]

The reflections of these traditions of the Flight into Egypt already appear in 13th-century Ethiopian paintings. Moreover, the biblical happening has been transmuted by Ethiopians into local reality; thus the event has been imaginatively transferred from Egypt into Ethiopia and the Holy Family changed into a small Ethiopian peasant family in the process of travelling. This adaptation of a Christian theme to local folklore and feeling took place gradually, while the starting point of these developments is wrapped in mystery.

Virtually all 13th to 17th century Ethiopian compositions of the Flight into Egypt save the Lālibalā mural invariably include four persons: namely, the Child, Mary, Joseph and Salome. Mary is shown as walking, similarly to Joseph and Salome and never riding on a donkey. This is a very Ethiopian trait. In Ethiopia, a donkey is used extensively for carrying goods but virtually never for riding. It may happen that the countryside shepherds would ride on donkeys, one or two shepherds on one donkey, from the pasture to their village, but it would be unthinkable

[55] The Monastery was traditionally believed to be one of the stopping places of the Holy Family during the Flight into Egypt. The Monastery situated along the pilgrimage route from Ethiopia to Jerusalem, was well known to Ethiopians. It is even today one of the richest monastic establishments in Egypt. Nothing, however, is known of its earlier history, except the information in Abū Salih's descriptions of Egypt, who states that the keep of the Monastery was reconstructed during the caliphate of al-Hafiz i. e., between 1131 and 1144 AD. (WaltMonEg 91 f. and 246).

O. F. A. Meinardus [Ethiopian Monks in Egypt = Publications de l'Institut d'études orientales de la Bibliothèque Patriarchale d'Alexandrie 11 (1962) 67] gives the following information about the Monastery: "Apart from the Ethiopian monks in the Western Desert, the Wadi-'Natrun, Ethiopian communities were established along the pilgrimage route from Ethiopia to Jerusalem. Thus we know, for instance, that the Monastery of the Holy Virging (Dair al-Muharraq) at al-Qusia, or a church in the immediate vicinity of this monastery, was inhabited by Ethiopian monks from the 14th to the 17th century, for Protis and Charles-François d'Orléans, who wrote in 1668, mention the "Meherraq" which was inhabited by Ethiopian monks. Wansleben, on the other hand, who travelled up the Nile in 1673, observed that the Ethiopians had their own monastery near Dair-al-Muharraq. The connection of the Dair-al-Muharraq with the Ethiopian Church has always been rather an intimate one, for the Ethiopians refer to it as the Monastery of Qwesqwām in memory of which they built a church in Gondar which they called the Church of Kuska...".

The gospels, Eth. 32 Bibliothèque nationale, Paris, were sent by King Sayfa Ar'ād as a gift to the Ethiopian community in the Dayr al-Muḥarraqa. This indicates that there was a movement to and from this monastery to Ethiopia; the Ethiopian community was at that time some forty members strong. CRCosc 399.

for an adult especially of some importance to mount a donkey.[56] This made it hard to believe that Ethiopian painters would invent by themselves the picture showing Mary on a donkey. Moreover, the narrative of Theophilus does not mention explicitly this method of locomotion, instead it gives the impression that the Holy Family made its tedious journey on foot. This corresponds also to the Ethiopian habit of walking long distances; in fact, except for a few important personages, everybody travels on foot to the weekly market.

This "walking" setting of the theme is not exclusive to Ethiopia. "There is a small group of images", writes Gertrud Schiller, "in which the ass does not appear and Mary travels on foot carrying the Child in her arms". Schiller gives as example the ivory relief on the 10th-century casket, school of Metz. These variations, she added, are exceptions and "unimportant as far as the sense of the image is concerned".[57] This conclusion is correct for European images of the Flight into Egypt. In Ethiopian imagery of the Flight into Egypt from the 13th until 17th century the "walking" form was virtually the only one used. Moreover, no structures have ever been included in the composition (except for the Lālibalā mural), and the palms rarely. Therefore it is doubtful whether the Ethiopians interpreted the Flight in their art as a triumphal *Adventus* of the Holy Child into Egypt. Instead there is a feeling that they put an emphasis on the flight, its hardships and dangers. Indeed, Theophilus, who greatly influenced Ethiopian iconography, narrates at length Mary's anguish and tears.

While in early Ethiopian representations of the Flight into Egypt, the donkey is always missing, other features vary a great deal. The Holy Child is shown in different situations: he is carried either by Mary or Joseph or Salome or walking along with them. In virtually each picture the disposition of personages in relation to each other is also different, Mary being placed usually, but not always, in the middle. Lastly, the captions which reveal the painter's intent are far from being uniform.

The following is a description of these particulars as illustrated by some 13th through 18th-century pictures of the Flight into Egypt.

[56] Until recently in Tegrē as well as in other parts of Northern Ethiopia, riding a donkey is considered as undignified especially in relation to women. In this province a girl's virginity was highly rated and traditionally a young girl was warned by her parents to behave well; if she was found not a "good girl" by her husband on her wedding day, she would be put on a donkey to ride through the village to her shame and her family's as well. In fact, as it was pointed out by *Haile Michael Misginna*, [*Ḥāyla Mikāʾēl Mesgennā*], Betrothal and Marriage Customs in Endarta = Bulletin of University College of Addis Ababā Ethnological Society 8 (1958) 57, "there are no unpleasant consequences for the bride if she is found not a virgin. Usually she is not sent back to her parents and no return of gifts is asked by the husband".

It is of interest to note that the Council of Trent censored the donkey in the representation of the Flight into Egypt, because the donkey was considered as not a sufficiently noble beast to serve as a mount to the Virgin. In case the donkey was retained in respect to tradition, an angel was shown to be leading it by the reins. Réaulc II 282.

[57] SchillIc I 121, fig. 317.

(2) The oldest known miniature representing the subject is found in the gospels of
Iyasus Moʾa, Dabra Ḥāyq Estifānos, written in 1280-81 (fig. 2).[58] The caption
defines the content of the miniature as follows: "As Joseph took the Child and
his mother and went to the land of Egypt". Indeed, a small party composed of
Joseph carrying the Child on his shoulders on the right, Mary in the middle
and Salome on the left, seems to be travelling. The legs of all personages
directed to the right and the hands of Mary and Salome pointing in the same
direction, effectively express the feeling of marching.

The round figure of the Child with attached small head but no hands is par-
ticularly crude in comparison to other figures in the miniature. These render fairly
well the garments and actions of the personages. Joseph seems to hold the Child
with his large hands; he wears a long tunic with a cloth wound around his waist
similar to clothes of other saints in the manuscript. These originate from art
influenced by the Byzantine. An interesting detail is the legs of Joseph that do not
fit exactly with the vertical line of his dress and exceed it by half of its width; this
illustrates well the method of drawing human figures in Ethiopian art, without
consideration of the anatomy. Mary, wrapped in a dark blue cloth covering her
head, holds an elongated form in her hand; is it a scroll which usually appears in the
hands of Christ or an object of everyday life rendered in a clumsy manner? Salome
wears a blue robe and yellow cloak which does not cover her head; she has only one
hand and does not carry provisions.

The nimbi of Mary and Joseph are traced with double line according to the
method common in the 13th to 15th-century paintings; the nimbus of Christ is
plain yellow instead of cruciform; Salome also has a nimbus around her head.

(3) The Krestos Tasfāna Gospels from the Dabra Ḥāyq (at present in the
National Library, Addis Ababā) date most probably from the first three
decades of the 14th century.[59] They contain two pictures of the Flight into
Egypt. The first picture is an assemblage of elements from different icono-
graphic sources (fig. 3a). The central figure of the Virgin Mary embracing her
Child seems to be modelled after her Byzantine Eleousa type.[60] The sympto-
matic inclination of Mary's and the Child's heads and their cheeks pressed
against each other as well as their expressive eyes, transmit the message of
tenderness and sorrow.

Much less effective are two additional figures which usually do not appear in
Eleousa portrayals of the Virgin but suggest that, indeed, the painting is intended
to represent the Flight into Egypt. On the left there is Salome, hardly recognizable
as a female, and on the right Joseph holding a long staff. Their faces, as well as
clothes, are identical to those of other figures in the manuscript; the elongated faces

[58] TTHayq 90f.

[59] TTHayq 98; *Pāwlos Ṣādwā*, Un manoscritto etiopico degli Evangeli = RSE 11 (1952)
27f.

[60] *S. Chojnacki*, Notes on a Lesser-known Type of St. Mary in Ethiopian Painting = Abba
Salama 1 (1970) 164f.

with sunken cheeks obviously belong to the Coptic iconographic tradition and are meant to represent emaciated anchorites dwelling in the desert. Joseph's staff with a ball on top perhaps represents the pastoral staff known in Egyptian monasticism and used by monks and church dignitaries in Ethiopia to the present day.

This poorly executed image of the Flight into Egypt became meaningful only by the addition of the caption which runs "How Mary wept on the way about her beloved Son while going to Dabra Qwesqwām and Salome consoles with her and Joseph weeps with her". The caption clearly reflects the apocryphal stories on the Flight into Egypt, the actions of Salome and Joseph and the anguish of Mary so dramatically rendered in the narrative of Theophilus. Moreover, we have the proof that the connection between the Flight of the Holy Family and the miraculous sanctuary of Qwesqwām in Egypt was already known to Ehiopians at the beginning of the 14th century.

The second miniature (fig. 3 b) shows great similarity to that in the Iyasus Moʾa Gospels. Indeed, the first part of the caption accompanying the miniature and running "How Joseph took the Child and his mother and went to the land of Egypt" is identical, while the second part of the caption explaining that "the angel of God was with them" marks the difference and introduces a new iconographic element.

The full-page miniature is divided into two registers. In the lower register Salome and Mary walk while Joseph carries the Child as in Iyasus Moʾa Gospels. Clearly both miniatures stem from the same scriptorium. Particularly interesting is a double sinuous line at the bottom of the garments which is obviously meant to express volume of the figures. This detail rarely occurs in Ethiopian art and is certainly influenced by foreign models.

In the upper register the "angel of God" on blue background seems to hover above the Holy Family; this is expressed by his outstretched wings. He touches with his left hand the nimbus of the Child. His gesture may be interpreted either as protection or directing. To Diana Spencer (letter of November 28, 1980) the gesture suggests the idea of "This is the One of whom it was said..."

There are two details in the angel's figure which point to its Coptic origin. These are the cross with elongated lower arm and a stylized "crown". Such a crown adorns King Yekuno Amlāk in his dedication portrait, Gannata Māryām church, and also the important personages in Arabic-Coptic manuscripts.[61]

As demonstrated in the analysis of the Lālibalā mural, the Ethiopians have been exposed to the compositions in which the Holy Family was accompanied by an angel. However, in the Lālibalā mural, the angel walks along with Joseph and has his wings folded, while in Krestos Tasfāna Gospels he seems to fly above and has his wings outstretched.

These two forms and poses of the angel correspond to similar ones in Western European art: the "walking" form is exemplified by the S. Maria Maggiore mosaic, the "flying" form by a number of examples dated to the 11th century and later.

[61] The origin of these head-gears is to be traced to Islamic and Persian art.

Indeed, according to Vogler who lists some of these, the "flying" angels form is more frequent than the "walking" one.[62]

Has the angel in the Krestos Tasfāna Gospels been added because of local commentary on the text of St. Matthew and apocryphal traditions, or was it borrowed from abroad? There is no clear-cut answer to this question. Assuming the angel was depicted because of the painter who followed the commentary which imagined the Holy Family assisted by an angel, it must have been his very personal interpretation. Even in the Flight into Egypt in Iyasus Moʼa Gospels the angel is missing. Moreover, to the writer's knowledge, no angel in this context has been recorded in any picture found in Ethiopia, except of course the Lālibalā mural.

Considered as the whole the second miniature in the Krestos Tasfāna Gospels (fig. 3 b) does not seem to mirror a particular foreign model. Nevertheless the form of a flying angel might indeed be imported and the composition might be an amalgam of figures borrowed from Coptic art.[63] Still the question of the iconographic sources remains open and is related to the problem of Zāgwē art. The cultural history of the Zāgwē period and that of the first Solomonic kings is still shrouded in mystery. Recently Taddesse Tamrat threw some light on the complexity of the problem and the vast possibilities of interpretation, through for example, the contacts with the Holy Land. "The number of Ethiopian pilgrims", he writes, ". . . seems to have increased".[64] In spite of the occupation of Jerusalem by Salāh-al-Dīn, intercourse with the West was continuing. There is also another factor which the Ethiopian scholar tentatively puts forth. This is the presence in 13th-century Ethiopia of the "Syrian metropolitan".[65] This temporary break with the Alexandrine patriarchate possibly resulted in a shift of cultural influences and an opening of the channels for the diffusion of Western ideas. All this is a matter of speculation as is often the case in the study of Ethiopian art, but it is to be hoped that some enlightenment will come from in-depth investigation of other themes.

One has the impression that in the late 14th and 15th century gospels the Flight into Egypt was rarely depicted. Nevertheless, the following significant examples have been found.

(4) One of these is the miniature in the gospels, Dabra Tansāʼē, Tambēn, Tegrē (fig. 4).[66] The book does not contain a colophon but on iconographic grounds should be ascribed to either the last decades of the 14th century or to the beginning of the following century.

[62] VogFlucht 24 f., lists the 11th-century ivory, Victoria and Albert Museum, London, bas-relief in Città di Castello and the 13th-century mosaic in St. Mark's, Venice.

[63] For example, Salome's face is surrounded by a thick black beard. Though the face is obviously that of a man, the caption identifies the figure as a female. The painter used as a model the figure of a "saint" known to him, without paying attention to secondary attributes.

[64] TTCh 58.

[65] TTCh 69 f.

[66] The ms was discovered by *Dr. Kinefe-Rigb Zelleke* [= *Kenfē Regb Zallaqa*] and the writer in 1974. Unpublished.

The upper register of the miniature represents the Holy Family and Salome "how they are going to Qwesqwām" according to the caption. Mary on the left carries the Child in her arms while Joseph in the middle and Salome on the right walk along. The picture then is an illustration to the narrative of Theophilus. Only one hand of the Child is shown. He wears a yellow, red-striped tunic. Joseph's and Salome's right hand and arm are hidden under the drapery while the left hand and arm are raised but also wrapped in the cloth. These figures are obviously borrowed from models unrelated to the subject. The garments of the adults are basically the same, namely a long striped robe and a large cloth covering the upper part of the body; the folds of the cloth are rendered by multiple lines running diametrically. Mary and Salome wear a veil which follows the right side of their head leaving the left side uncovered. This mode of drawing the head is known in Islamic and is common in Armenian art. It appears in a number of 15th-century Ethiopian pictures of Mary as well as in the incisions on processional crosses. Christ's nimbus has a cruciform decoration. The nimbus of Mary, Joseph and Salome is drawn with double line, which seems to be an archaic feature in the miniature. Another archaic trait is that all faces, except that of the Child, face the front, though they are intended to be in three-quarter poses, as indicated by there being one ear only to Joseph's face, and also by the rendering of Mary's nose. We witness then a formative stage of introducing the three-quarter pose into Ethiopian painting.

This graphic picture in dark brown and yellow hues renders effectively the feeling of walking which is expressed by the widely outstretched legs and the feet directed to the right.

(5) The miniature in the gospels from Dabra Madḥanē ['Ālam], Tambēn in Tegrē,[67] combines two different themes. In the upper register there is "a picture of Saint Zacharias as they killed him" and "as Elizabeth runs away with her child to the Monastery of Sinā", as explained in the captions.

The picture is an illustration to the apocryphal story of what happened to John the Baptist, his mother Elizabeth and his father Zacharias, when the Holy Family

The Monastery of Tansā'ē (Tansē) was founded in the 14th century by the monk Be'esē Egzi'abeḥēr also called Be'esē Salām of Mazbā. The Monastery is situated circa 10 km east of Agara Salām, Tambēn, at the bottom of a large canyon with a small river. The church of the Monastery, hidden by wild olive trees, is dedicated to the Covenant of Mercy (Kidāna Meḥrat). Be'esē Salām founded also another monastery in the area between Ṭālṭāl and Azabo. Cf. KRZHagTrad 67.

[67] The ms discovered by Dr. Kinefe-Rigb Zelleke and the writer in 1974. Unpublished. Dr. Kinefe-Rigb dates the ms to the second half of the 15th century, which agrees with the estimation on iconographic grounds. The ms contains the ornamented Canons of Eusebius, the pictures of four Evangelists and two miniatures illustrating the cycle of the Infancy of Christ.

The Monastery of Dabra Madḥanē ['Ālam] is situated circa 25 km east of Agara Salām, Tambēn. It was founded by the monk Madḥanina Egzi'e who was the disciple of Takla Hāymānot. Cf. S. Strelcyn Catalogue des manuscrits éthiopiens de l'Accademia Nazionale dei Lincei (Roma 1976) 10; KRZHagTrad 81 f.

escaped to Egypt.[68] The story narrated in the Protoevangelium of James was obviously known to the 15th-century Ethiopians.[69] Actually neither the killing of Zacharias nor the running away of Elizabeth are shown.

In the lower register the picture represents "as Mary ran away to Dabra Qwesqwām with her Child because Herod was killing children". In fact, the picture features a particular episode of the Holy Family's stay in Egypt which is manifested by the inclusion of the fourth adult personage in the composition. This is Yosā, a relative of Joseph, whose dramatic story is recorded by Theophilus. While Mary and Joseph lived in Qwesqwām, Herod was informed about it and decided to dispatch ten warriors ordering them to kill the Child. Yosā, a young and brave man, learned about the plan and travelled from Jerusalem to Qwesqwām to warn the Holy Family about the danger. After his arrival he delivered the news to Mary who was terrified and cried out bitterly. The Holy Child comforted her as well as Salome and Joseph and then said to Yosā: "You have come and brought us the news, your effort and your arrival deserve a reward. But for the fright you caused to my mother take this stone on which I was washed, put it under your body and sleep. I will take your spirit . . . to my realm". Indeed, Yosā took the stone, put it under his head, turned towards the Orient, and then his soul departed from him. Joseph wrapped his body in a cloth and buried him at the threshold of the Holy Family's house.[70] Yosā is also mentioned in the description of the Dayr al-Muḥarraqa by Abū Salih from the beginning of the 13th century, who calls him Musa son of a carpenter.

The disposition of figures in the miniature differs from the previous one and is as follows: Yosā, Joseph, Mary, the Child and Salome counting from the left. Mary, wrapped in a blue cloak covering her head, and a red robe, seems to put her hand on her Son's shoulder, while the Child points with his hand at Salome. The Child is walking instead of being carried; this manner of rendering the Child seems to be favoured by the 16th-century painters. Salome is dressed in a yellow cloak draped differently to Mary's. Joseph has a thin black beard and an equally black narrow crown of hair. His garment is composed of a long yellow tunic and a red cloak wound around his waist. Joseph and Salome perform an identical movement with their hands, perhaps expressing their anguish, that is the right hand uplifted and the left one pressed against the breast. Yosā is shown with only one hand which he

[68] HenApI 387.

[69] BLM 140f.

[70] CRCosc 465. There is another version of Yosā's story which most probably found its way to 18th-century paintings and was still depicted in the early 20th century. The mural in the church of St. Mary built by Menilek II (1889–1913) at the foot of Mannāgašā Mountain close to Addis Ababā, represents the Holy Family excaping Herod's soldiers, and taking refuge under a tree, Yosā, who according to the caption is the son of Joseph, warns Mary about the danger. The Divine Child punishes Yosā telling him: "You will lay on this stone until my Second Coming". Indeed in the mural, the dying Yosā lies on the ground while a tree envelops the Holy Family and thus hides them from the soldiers. The mural is described in HeyK 51.

points at Joseph. All personages clearly have their faces in the three-quarter position. The peculiar feature of this miniature is that Joseph's and Yosā's heads are adorned with nimbi while Mary and Salome have none. This does not seem to be accidental but a deliberate omission by the painter and perhaps has something to do with his stand in the 15th-century controversy on the cult of Mary.

The miniatures and ornamentation of the Dabra Madḥanē Gospel clearly belong to the Gunda Gundē style. The Monastery of Gunda Gundē was the stronghold of the Stephanite community renowned for its manuscript production. J. Leroy described summarily three beautiful gospels he found in the Monastery but did not attempt to date them.[71] The Gunda Gundē Monastery was founded at the end of the 15th century; its scriptorium was apparently active throughout the 16th century; therefore the Dabra Madḥanē manuscript should be ascribed either to the last decade of the 15th century, or to the first half of the 16th century.

(6) Two miniatures in the manuscript, Bethlehem church near Dabra Tābor, refer to the Flight into Egypt. The priests serving the church told Diana Spencer who photographed the miniatures, that the manuscript was the *Lāḥa Māryām*, Laments of Mary.[72] Jäger in his list of manuscripts which he had inspected in churches of the Lake Ṭānā area recorded the same manuscript as the book of the gospels "ordered by King David II (1508–1540) for his deceased daughter Lahe Maryam". Jäger described the miniatures (fig. 5a and b) as follows: "4. The Holy Family fleeing to Egypt. Joseph carries the Infant on his shoulders and stands mutely turned to the reader. Mary and Salome, her faithful servant, recite their plight to the onlooker. 5. In Egypt, the refugees rest on Mount Kusqam. Mary, sitting in a tabernacle-like alcove, shields the Infant in her lap with her hands. A deceased Saint lies at the family feet. Death is pictured by black blotches in the place of eyes".[73] The deceased "Saint" is, of course, the unfortunate Yosā; already his spirit has left him, while his head rests on the stone as told him by the Divine Child. Clearly, the miniature illustrates the narrative by Theophilus, which is attested by an inscription.

[71] *J. Leroy*, Recherches sur la tradition iconographique des Canons d'Eusèbe en Ethiopie = Cahiers archéologiques (1961) 187–91.

[72] Mentioned by *I. Guidi*, (Breve) storia della letteratura etiopica (Roma 1932) 30; *H. Zotenberg*, Catalogue des manuscrits éthiopiens de la Bibliothèque nationale (Paris 1877) 97f.; the Geez text of the Laments of Mary is included in the lectionary for the Holy Week and printed in *Gebra ḥemāmāt* (Addis Ababā 1942 E.C.).

[73] JäP 362. *Jäger's* identification of the manuscript does not seem correct, though the style of the miniatures corresponds to the period. Neither the subject-matter of the miniatures nor their arrangement agree with known to us gospel illuminations. Moreover, *Abbā Heryāqos*, bishop of the city of Behensā and author of the Laments, is depicted in 9th miniature. *Jäger* also misunderstood another miniature in the same manuscript. He wrote about No. 8 as follows: "Christ and his 12 apostles surround a corpse. It may be presumed that the corpse is of Lahe Maryam, the deceased daughter of David II, the king entrusting her body to the mercy of Christ". In fact, this is the Dormition of the Virgin Mary.

The fact that Yosā appeared in the miniatures of two important manuscripts proves that his story was popular in the art of the late 15th and early 16th century.

Both miniatures belong to the style which apparently flourished in the first three decades of the 16th century. The style developed from the impact of two different influences in the art of 15th-century Ethiopia, the influence of Islamic art[74] and that of the art of the Renaissance in Western Europe.

The influence of Islamic art is still noticed, though already much transformed, for example in the way of drawing elongated eyes and the line of eyeballs left open at the outer end, and the ornamented slippers of Mary. She wears a *maphorion* decorated with the intricate pattern over it. This ornamentation which has an Oriental touch appears in paintings dated to the reign of King Zarʾa Yāʿqob. On the other hand, the setting of the scene with Yosā, with three niches as a back-ground to the figures of Salome, Mary and Joseph, point to Western European impact. Three arches supported by two slender columns and the ornate chair of the Virgin, have clearly Renaissance characteristics.

In 15th-century Ethiopian art, in the same picture one figure is represented full-faced and flanked by two other figures in three-quarter position. The scribe of the Bethlehem manuscript followed this trend, except that he put Joseph on the right instead of in the middle. However, in the miniature with Yosā, he followed the established arrangement. The picture gives the impression that for composing it the scribe used a well-known form of the enthroned Virgin, merely replacing the figures of angels by those of Salome and Joseph. The effect is overwhelming, though probably not entirely intentional. This miniature no longer represents a family escaping for their life as in all the previous ones, but the majestic Child and his mother dominating over the "land of Egypt". However, this is an exception because the "escaping version" is typical of the Ethiopian iconography of the Flight into Egypt. In the first miniature of the *Lāḥa Māryām* manuscript the drawing of the Child seated on Joseph's shoulders is most effective. He grasps Joseph's head with two hands, while his foster-father holds firmly his legs. The drawing was certainly made from life. It announces significant transformations which took place in the imagery of the Flight into Egypt during the 16th century.

(7) The diptych IES Coll. No. 4434 (fig. 6a and b) is characterized by an exceptionally fine drawing of figures with thin black lines and care for such details as hair and hands. Stylistically it belongs to groupe B of the classifi-cation of paintings from the 16th century.[75] The icon is ascribed to the first half of that century.

Standing, Mary is the predominant figure of the composition, twice the size of Salome or Joseph. She faces the front holding the Child on her left arm. She wears a long robe and a cloak or veil flowing down to the foot of the panel, but leaving her head uncovered; a curious collar on the left side of her neck seems to be an imitation of a Renaissance woman's dress. The Child holds his left hand behind

[74] LepPÉth 370–73.
[75] ChojArtEthE 90.

Mary's neck, his head close to his mother, and his cheek pressed against her cheek. The rendering of the Virgin who caresses her Child is influenced by either the Renaissance Madonnas or the Greek Eleousa Virgin and is evidently a copy from a foreign model. The caption running "Mary with her beloved Son" hardly helps in discovering the painter's plan. The subject became evident only by association of Mary's figure with that of Salome carrying a pot or basket on her shoulder and of Joseph holding a pilgrim's staff in his hand and a leather bag on his head. A rare theme in Ethiopian art, two trees crudely drawn and probably representing palms, suggest the desert through which the Holy Family is passing. Mary, Salome and Joseph have plain yellow nimbi over their heads while Christ has a cruciform one.

The composition is, in fact, an assemblage of iconographically disparate elements and probably represents another stage of the transformation of the foreign subject into the Ethiopian formula. The most important change is the addition of local wares, a pot and a leather bag, a *saleča*, to the composition; this indicates the direction taken by the 16th-century painters in transmuting the biblical story into local reality.

(8) The above Flight into Egypt (No. 7) seems to have some relation to the "Italian Madonna" found by Jules Leroy in the Ethiopic manuscript Or. 641, British Library in London (fig. 188).[76] The parchment painting is obviously much earlier than the manuscript into which it was inserted. The painting represents a standing Virgin who holds in her arms the Child. He tenderly presses his head against her and embraces her with both his arms. Mary's head is uncovered, instead her long hair flows down to the bottom of the picture. Two stylized trees or shrubs are depicted on both her sides. Joseph and Salome are missing, yet, the inscription runs that this is a "Picture of Our Lady Mary in pilgrimage to Qwesqwām". Leroy believed that this unique rendering of the theme was painted either by an Italian living in the 15th-century Ethiopia or an Ethiopian who worked in Western manner.

(9) Two side panels IES Coll. No. 6589 (fig. 8) are the component parts of the 16th-century triptych the main panel of which got lost. Three great themes of Christian iconography, the Annunciation, the Nativity and the Baptism of Christ, are depicted in the left panel, while the Flight into Egypt is depicted alone in the right panel. Plainly, the painter must have had a preference for that subject. He elaborated it in two registers. In the upper register, Mary holds the hand of the Child who walks together with her. In the lower register, Salome and Joseph seem to follow Mary and the Infant Jesus. Salome carries a pot in her hand. Joseph holds a staff leaning on his shoulder. A red thing, probably a bundle of cloth, is attached to the staff.

The above panels and the just described panel No. 4434 possibly originate from the same scriptorium. Some stylistical traits and a curious collar on the left side on Mary's neck as well as the Child's figure and her own much larger than those of Salome and Joseph point to the common origin. However, the arrangement of figures is not the same and that might be dictated by the varied shapes of the

[76] LerMadIt 77–82.

panels; also the rendering of details is different and that might be the result of local commentaries to the biblical narrative.

(10) The Flight into Egypt was depicted by Nicolò Brancaleon in the panel of the box framing the Greek icon, Gētēsēmānē Māryām church in Goǧǧām (fig. 182f.). The Italian followed the local manner of representing the theme though he must have known the paintings in which Mary rides a donkey. In the panel, she walks with the Child carried on her arms. On the left, Joseph leads the group; he holds a long staff to which the gourd is attached. On the right, Salome holds in her hands an Ethiopian food-basket. This is the earliest instance of depicting such a domestic implement in the Ethiopian image of the Flight into Egypt.

(11) Brancaleon also depicted the theme in Walatta Dengel Book of Miniatures, kept in the Wāfā Iyasus church (fig. 7). The composition includes Yosā who attempts with a graphic movement of the hands to stop Herod's soldiers. Mary seems to walk trying to rescue her naked Child whom she clasps in her arms. Joseph rendered as an old man marches in front and holds in his right hand a bamboo staff with the gourd flung on it. Salome is left out altogether.

The miniature makes complete the pictural record on the story of Yosā. In the Dabra Madhanē Gospels, his motionless form, depicted along those of the Holy Family, stands for the story. In the *Lāha Māryām* mauscript, the equally immobile figure of Yosā symbolizes the spiritual meaning of this death. Brancaleon following the Western tendency for narration described in colour and design the dramatic aspect of Yosā's role in rescuing the Divine Child.

The transmutation of the biblical theme into Ethiopian became complete in three icons, Nos. 388 and 4261, Institute of the Ethiopian Studies Collection, Addis Ababā and the icon No. 91, Langmuir collection, Peabody Museum, Salem. The first icon is ascribed to the second half of the 16th century while the second and third either to the same period or to the first decades of the 17th century.

(12) The caption in the diptych, IES Coll. No. 3888 (fig. 9) runs as follows: "Picture of Mary on the way to Qwesqwām with the Child". According to the inscription on the upper ridge running across both panels, the diptych belonged to Ehwa Krestos. This is followed by the common formula stating that "whoever steals [the icon] or erases [it], may he be excommunicated in the name of the Father, the Son and the Holy Spirit".

Mary is travelling on foot and holds Christ's hand. The Child is shown as a boy a few years old. Joseph, at Mary's back has a staff in one hand and supports a sheep or goat-skin bag, slung over his shoulder with the other. A gourd is slung at his waist. Salome carries a pot in one hand and a food basket, a *masoba warq*, on her head. The dresses of the Holy Family show another dramatic change. Mary wears a blue blouse with multiple folds on her arms and a kind of tunic over it covering also her head and fastened on her waist with a colourful belt. Salome is dressed in a similar manner. The Child's garments, as well as Joseph's, are characterized by a peculiar shape of the collar and a kind of large tie joining it with the belt. One has the feeling that these dresses have been drawn from life.

The use of nimbi in the picture demonstrates that their symbolic significance has been lost and they became a mere element of ornamentation. Christ's nimbus obviously developed from the cruciform type but was changed into a set of red and yellow multiple stripes. Mary has a dark brown circle round her head, Joseph a plain yellow one and Salome none.

(13) The triptych IES Coll. No. 4261 (fig. 10) shows "Our Lady Mary and her beloved Son as she goes down to Egypt". The disposition of figures was manifestly dictated by the narrowness of the panel; on the whole the rendering of the subject follows the previous one, but with a few significant changes.

Mary is wrapped in a large mantle covering her head and flowing down her shoulders and body. This is then the Syrian *maphorion*, probably borrowed from her image of S. Maria Maggiore. Additionally a set of long, thin plaits of hair appear on both sides of her face. She seems to lean on a staff, *maqwamiyā*, an Ethiopian praying staff. The Child walks in front of her, apparently playing with his two hands. He is dressed in a tunic fastened at the waist with a belt and reaching the calf. A curiously shaped collar similar to the one in the previous icon adorns his garment.

Joseph's garment is similar to the Child's, the only differences are the trousers and a kind of slipper or shoe he wears while Jesus is barefoot. Joseph, "the old", holds a staff in his right hand and supports a leather bag, "provisions for a journey", with his left hand. A gourd is slung at his waist. Salome carries a basket, *masob*, on her head, holding it with her left hand, and a clay pot for milk or butter, *masaro*, in her right hand. All these implements as well as the staffs have been obviously drawn from life and with care for details. They are easy to identify and are implements which are widely used in Ethiopian households even nowadays.

(14) The picture of the Flight into Egypt in the multiple-subject triptych, the Langmuir Collection, Salem Mass., No. 91 (fig. 11), is placed at the bottom of the side panel.[77] The painting is characterized by the extensive use of parallel lines, which was the manner of drawing of the particular school at the end of the 16th and the beginning of the 17th century.

Mary is placed in the centre of the composition; her head and body are wrapped in a blue *maphorion*; she wears a red robe underneath. She carries a chicken in her left hand whilst her right hand tenderly rests on the shoulder of Jesus, who is rendered as a boy and walks in front of his mother; he also carries a chicken. He is clad in a blouse garnished with a round collar similar to those in the previous pictures, a checkered skirt and long trousers with multiple foldings. Joseph and Salome follow Mary; they are much smaller than she is. Salome wears a red scarf around her neck, a red blouse, a white striped skirt and long trousers with foldings. She transports the local ware, namely the food basket on her head and the butter or milk pot in her hand. Joseph has a beard fashioned into three pointed tips; he also wears a striped skirt and trousers with foldings. Although we know little about

[77] Reproduced in the catalogue of the exhibition: Ethiopia: the Christian art of an African nation (Salem, Mass. 1978) 4f.

Ethiopian costumes of the past, one has the feeling that the garments of the Child, Salome and Joseph have been drawn from life, while the dress of Mary is obviously copied from her S. Maria Maggiore image. Joseph bears the gourd for water or milk in one hand and supports the leather bag slung on his shoulder with the other hand. This Flight into Egypt might, in fact, illustrate the Ethiopian scene, the artist having equated it to the Ethiopian family's travelling to the weekly market.

(15) The cloth painting which originated from the Dabra Dāmmo Monastery but subsequently was in possession of the late Prof. A. Mordini, has been described and commented upon on several occasions.[78] The writer's contention is that it should be ascribed to the period around 1600. The painting is intended to be an image of the Virgin but it contains several additional subjects; one of these is the Flight into Egypt.

Four figures are included in the composition; Salome in the middle carries the Child on her back; a large cloth wound around her waist form in its upper part a fold in which the Child is placed. Two ends of the cloth are tied up on her left shoulder and she seems to grasp these with both her hands. The figure of Salome drawn in three-quarter pose gives the impression that she is walking. Perhaps her figure was drawn from life. This feeling is strengthened by the black plaits of hair adorning her forehead and by the spontaneous movement of the Child. He is clearly turned towards Joseph and stretches his hand to him.[79] Joseph, placed on the left, with his praying staff leaning on his shoulder, seems to respond and reaches out to the hand of the Child. This spontaneous rendering of Salome and Joseph contrasts with a stiffness of Mary's figure clearly borrowed from her S. Maria Maggiore portrait, the only difference being the praying staff added to her hands.

Basically, the artist followed the plan of previous paintings, but showed originality in disposing the figures and expressing their behaviour; he put Salome as a central figure in interpreting the passage from Theophilus about her help in carrying the Baby; the vivid expression of sympathy between the Child and his foster-father is perhaps the result of the Western concept of representing the Holy Family which most probably penetrated into Ethiopia with the Jesuit missions. Moreover, in rendering Mary, the painter followed the form established in Ethiopia at the beginning of the 17th century.

(16) A crude copy of the Dabra Dāmmo Flight into Egypt is found in the triptych, IES Coll. No. 4461 (fig. 12), dating either from the late 17th or the 18th century. The disposition of figures and their movements are identical save the garments which are already adapted to the new style; the checkered skirt of Salome

[78] *A. Mordini*, Un'antica pittura etiopica = RSE 11 (1952) 29–32; Deutsche Aksum-Expedition III (Berlin 1913) 50, pl. 3; LerÉthG pl. XXII, considers the painting "one of the finest pieces known to us of the Gondarene painting of the first period."

[79] Ethiopian painters introduced the same tender pose of the Child into their representation of Mary being taken by her parents to the temple. The composition shows how Anne carried the little Mary on her back and how Mary turned to Joachim and gave her hand to him. Cf. Ms Or. Rüpp. IV, 2, f. 5v, in Stadt- und Universitätsbibliothek, Frankfort on the Main.

recalls the 18th-century paintings, while Joseph's hat the 17th-century minia-
tures; however the hat is deformed because the painter did not understand the
meaning of it. Joseph and Salome have no nimbi.

(17) The miniature in the Book of Miracles of the Virgin Mary, British Library Or.
 655 (fig. 13), is another rare 18th-century representation of the Flight into
 Egypt in which all members of the Holy Family, including Mary and the
 Child, are travelling on foot. The book "written in a good hand of the first half
 of the 18th century"[80] was probably ordered by a certain *Abuna* Yoḥannes
 who is depicted with his attendants Abrehām and Dingo on the second folio.
 The rendering of the Flight into Egypt contains another donor who is repre-
 sented at the bottom of the picture.

Except for the mode of garments and the soft drawing and colouring of the
figures, according to the second Gondarene style, the picture follows the tradi-
tional plan. Mary, her figure much larger than those of Joseph and Salome, walks
in the centre and holds Jesus with one hand. He is depicted as a big boy, turns his
face towards the mother and indicates the direction of travelling with his hand.
Joseph and Salome behind transport the goods and provisions, namely, Joseph a
bundle attached to his staff, and Salome an ornamental gourd filled with milk or
butter.

(18) Also in the 18th-century book of Prayers of the Virgin Mary, Stadt- und
 Universitätsbibliothek, Frankfort on the Main,[81] there is a miniature in which
 the whole Family walks (fig. 14). Mary in the middle bears the Child who
 stretches one hand to Joseph walking in front of Mary, Joseph carries a bundle
 attached to his staff. Salome, behind Mary, carries a pot in her downstretched
 hand. The garments which all personages wear are typical of the Second
 Gondarene school. Mary and the Child have elaborate halos around their
 heads while Joseph and Salome have none.

In the same manuscript there is another representation of the Flight into Egypt
which follows a new 17th-century form.

The above icon and miniature prove that the traditional representation of the
Flight into Egypt was still known and practised in the 18th century, even after the
dramatic change in its iconography had taken place in the 17th century.

(19) The miniature in the 18th-century Hymn Book, British Library Or. 590,[82]
 contains three joint images of the Flight into Egypt, namely the second dream
 of Joseph (Matthew 2,13–23), Mary raising up the Child and the actual travel
 to Egypt (fig. 15).

"The only Early Christian representation of Joseph's second dream", writes
Gertrud Schiller, "in which the angel tells him to flee with Mary and the Child to

[80] WrBM 58.
[81] Ms Or. Rüpp. IV, 1, Prayers of the Holy Virgin Mary recorded by Abrocoros, student of
 Yoḥannes. Undated. Cf. *L. Goldschmidt*, Die Abbessinischen Handschriften der Stadt-
 bibliothek zu Frankfurt am Main (Berlin 1897) 55 f.; *E. Hammerschmidt* and *O. A. Jäger*
 (VOHD XV 87) ascribe the manuscript to c. 1750.
[82] "Written in a fine character of the 18th century": WrBM 132.

Egypt ... appears on the triumphal arch of Santa Maria Maggiore ... During the Middle Ages Joseph's dream was an exceptional scene and was only occasionally used in detailed cycles of the Childhood of Jesus." On the other hand, continues Schiller, "The dream ... is often found in post-Mediaeval art. The angel appears to the Holy Family as they sleep and wakens Joseph."[83] In Mediaeval art Joseph is represented alone and the dream usually takes place in a stable.

Our miniature is the only example of the second dream of Joseph known to us in Ethiopian art. The incident probably takes place in a stable. Joseph rests on raised ground; he is asleep. Above an angel dives towards him and with his fingers touches the rim of Joseph's nimbus. The movement of the angel symbolizes delivering the message of the Lord who is depicted in the upper part of the miniature. Mary, also fast asleep, sits close to Joseph. In the middle of the miniature Mary seems to wake up the Child who leans against her and has his eyes closed. Mary gently supports the back of his head. Further to the right, Mary and Joseph travel on foot followed by Salome. Mary carries on her back the Child wrapped in cotton cloth according to Ethiopian custom.

This compounded representation of the Flight into Egypt bears no relation to the early Western and Eastern representations of the dream of Joseph. On the other hand, our miniature shows similarity with the post-Mediaeval representations of the dream which are characterized by the presence of Mary. Was then our miniature inspired by a foreign model? Considering the period during which the miniature was painted this is likely. William Wright suggests that the eighteen century paintings "are all copied from European models, namely coarse woodcuts, imported no doubt, in the first instance, by Roman Catholic missionaries".[84] Although the Ethiopians themselves could have made changes in the composition of the Flight into Egypt, the analysis of details in our miniature supports Wright's assumption.

Mary and Joseph are depicted with the nimbus in one scene and without it in another. Moreover, the Child and the angel do not have the nimbus at all, which is very unusual in Ethiopian painting. How can this be explained? In Western realistic representations of the dream of Joseph either the nimbus is left out or replaced by hazy rays around the heads. Perhaps this was the case with the foreign image which our painter took as a model. He compromised between it and the local iconographic traditions. As a result he made a confusion in using the nimbus.

* * *

The just concluded survey of works from the 13th to the beginning of the 18th century allows us to sum up as follows:

(a) The foreign model showing Mary riding on a donkey that appeared already in the 13th century did not influence the developments of the early Ethiopian imagery of the Flight into Egypt. We do not know the reason for it, the guess is that either the model was not accepted by Ethiopian painters or ignored by them. As a result they created their own composition.

[83] Schillc I 117.
[84] WrBM x.

(b) The composition, especially of earlier works, seems to be an assemblage of forms borrowed from other subjects; this practice is noted time and again, whenever Ethiopian painters have to rely on themselves.

(c) The compositions were either inspired by or directly translated from the apocryphal stories of Theophilus and Timothy which have been incorporated into Ethiopian literature and oral lore. In fact, the differences between the particular works are to be explained as painters' own commentaries on these texts.

(d) The typical feature of early compositions is that the whole party, including Jesus and Mary, is represented in the process of walking. This seems to be a genuine Ethiopian trait and not a foreign addition. Such is the conclusion from the study of paintings from the 13th to the 17th century. The likelihood of foreign inspiration at the initial stage of development, always probable in Ethiopian art, seems to be remote in this case. Moreover, the influence of the Italian representation of Mary proceeding on foot which appeared in this art as late as the end of the 16th century should be excluded.[85]

(e) Simultaneously, an Ethiopian acculturation of the subject took place; the biblical narrative has been transmuted into Ethiopian actuality and the accessories to the event taken from everyday life. Eventually, the Flight into Egypt became the most Ethiopianized representation of all the events of Christ's and Mary's life. At the end of the 16th century or in the beginning of the 17th century the process of local adaptation reached its most accomplished form, and then, around the middle of the 17th century, the dramatic change in the imagery of the Flight into Egypt took place; the donkey reappeared and Mary again was put on it. This change was accompanied by another innovation, namely, Mary is nursing her Child while riding on the beast.

These two innovations appeared in pictures clearly belonging to the First Gondarene school. While the first innovation is to be related to the influence of the Evangelium arabicum,[86] an illustrated book of the gospels in Arabic, on Ethiopian art, the second most probably to further Ethiopian commentaries on the biblical event.

The influence of the Evangelium printed in Rome at the end of the 16th century, on the miniatures in the 17th-century Ethiopian gospels has been clarified by the scholars in the field.[87] The writer pointed out the relation between the Nativity in

[85] MonMad 55.

[86] Evangelium Sanctum Domini Nostri Jesu Christi conscriptum a quatuor evangelistis sanctis idest Matthaeo, Marco, Luca et Johanne (Romae Tip. Medicea 1590–91). The text in Arabic is illustrated by Antonio Tempesta, well-known artist whose name appears in a number of engravings. Two complete copies of the Evangelium are found in the John Rylands University Library, Manchester. The writer is indebted to Miss Glenis Al Matheson, Keeper of Manuscripts, for permission to study and reproduce the miniature.

[87] *H. Buchthal*, An Ethiopic miniature of Christ being nailed to the cross = Atti del Convegno Internazionale de Studi Etiopici, Roma 2–4 Aprile 1959 (Roma 1960) 333f.; *J. Leroy*, L'evangeliaire éthiopien illustré du British Museum (Or. 510) et ses sources iconographiques = AÉ 4 (1961) 155–68.

the Evangelium and the rendering of the same in the late 17th-century Ethiopian paintings.[88] The Flight into Egypt is another case of the impact of the Evangelium on Ethiopian iconography.

There are several 17th-century illustrated Ethiopian gospels which have been influenced by the Evangelium. No comprehensive study of these has been made as yet and, therefore, the relation between them and the Evangelium is not clear. The crucial problem, whether they are a series of successive copies from each other or each is a direct copy from the Roman model, or both, is not clarified. It should be recalled that the work on the Ms. Or. 510 started in the last years of the reign of Emperor Fāsiladas (1632–67), and was completed during the first year of the reign of his successor, Yoḥannes (1667–82).[89] This new adaptation proved to be a success and several other copies of the gospels with pictures deriving from the Evangelium have been produced in the second half of the 17th century.

(20) The image of the Flight into Egypt in the Evangelium (fig. 16), the work of Antonio Tempesta, represents Mary riding a donkey; her right arm leans on the back of the animal in a pose of someone who tries to keep balance. Indeed, she seems to be riding side saddle though only one of her feet is shown; it has its toes pointed to the ground. Mary supports her Child with the left hand. He is naked and seems to touch Mary's bosom with his head but he does not suckle.

A point to note in the donkey's figure are the multiple thin lines over it; this is an obvious attempt of the engraver to express the volume of the beast and its grey hue. These lines found their way into Ethiopian images of the Flight into Egypt.

Joseph walks behind the donkey. He is rendered as an old, grey-bearded man and wears a flat hat on his head; a large cape over his shoulders reaches his knees and is fastened on his chest with a square clamp. He also wears a long coat fastened with a belt at his waist, and high boots with their upper part turned down. He holds a large water bag in his right hand and with his left hand a traveller's staff which leans on his shoulder; a small round bundle or container is attached to it.

The group moves in a landscape composed of large trees in front and behind the Holy Family, and the hills, town and the groups of houses in the background.

Due to this picture in the Evangelium, Ethiopian iconography of the Flight into Egypt has been enriched with the following new details: the donkey on which Mary is riding, the head cover of Joseph, the footwear of Mary and Joseph and the sketchy landscape as well. Ethiopian painters faced with these unusual, to them, innovations reverted to adaptations, which make a fascinating chapter in the study of Ethiopian art; let us then follow these efforts in the examples described below.

[88] *S. Chojnacki*, The Nativity in Ethiopian Art–JEthSt XII 2 (1974) 28 f.
[89] WrBM 24 f.

17TH AND 19TH-CENTURY PAINTINGS:
THE VIRGIN MARY RIDING

(21) The closest Ethiopian copy of the engraving in the Evangelium, save for the figure of Salome, is found in the gospels, Dimā Giyorgis church, Goğğām. The text of the manuscript has not been analysed as yet, but it should be tentatively ascribed to the last three decades of the 17th century,[90] as it does not seem to be earlier than the similar manuscript in the Br. Lib. Or. 510.

The picture (fig. 17) shows "as Māryām escaped to Egypt with her Son" according to the inscription; Mary sits astride a donkey, smilar to all subsequent pictures. She holds the naked Child on her lap supporting him with her left arm; her right arm leans on the back of the animal similar to her pose in the Evangelium. Mary's large mantle, her white cap on her head, a brown robe and slippers all originate from Tempesta's engraving. Also Joseph's figure derives from the European book; he walks behind the donkey; his face is adorned with a grey beard not in the Gondarene fashion; the soft hat, dark brown tunic, cape buckled with a brooch as well as the boots recall the miniature in the Evangelium. Even such details as a small bag or bundle hanging on his right hand are copied exactly from the Roman book. The donkey's body, ornamented with the horizontal stripes composed of multiple short thin lines is an attempt to render the texture of the engraving in the Evangelium.

Mary, Joseph, as well as the Child, have plain yellow nimbi over their heads. The sophisticated modelling of Mary's and Joseph's figures contrasts with a very schematic rendering of Salome whose dress and face are drawn in First Gondarene manner. Salome carries a large, colourful basket on her head and a clay pot in her hands. Her static figure is manifestly a local addition to an alien rendering of the subject in order to conform with the well-rooted tradition of the role Salome played in the Flight into Egypt; however, no attempt was made at blending her figure with the style of the composition.

The personages are surrounded with three trees; this is a synthetic reproduction of the landscape in the Roman picture. Two trees are a direct copy from it while the third, depicted in the left of Joseph, is a result of the painter's own efforts; the poorly drawn crown of the tree painted red and the stiff trunk painted black are indicative of Ethiopian indifference to nature.

(22) The Flight into Egypt found in the gospels, Brit. Lib. Or. 510 is depicted in First Gondarene style (fig. 18). Mary rides a donkey. Her figure, as well as that of the Child, is obviously borrowed from the S. Maria Maggiore portrait of the Virgin, save the pose of Mary's arms embracing her Child. Joseph walks behind the donkey. He wears a flat hat on his head. As to local adaption, Joseph's staff became an Ethiopian *maqwāmiyā* whilst the water bag and a

[90] AnnTM (200) dates the Ms to 1661 without giving a reason for it. Considering that in the same article he dates the Br. Lib. Or. 510 to 1665 which is obviously wrong, his information about the Dimā Giyorgis Ms. should be taken with caution.

small gourd hanging on his belt became Ethiopian wares. Two elaborate trees fill the space in front of Mary.

The peculiar feature of this rendering of the Flight into Egypt is that Salome is missing; one feels that on the one hand, the painter made a concession to the foreign model and eliminated Salome, but, on the other hand, he made an effort in local adaptation by transforming substantially the figures of Mary and the Child and adding the folklore details to the figure of Joseph.

(23) A similar rendering of the theme is found in another book of the gospels which is kept in Marṭula Māryām church, Goǧǧām (fig. 19).[91] The miniature, painted in First Gondarene style, clearly derives from Tempesta's engraving though in the process of copying the painter left out some details and changed others. Thus Mary's right arm is outstretched to the back, but her hand does not touch the donkey's rump and thus the feeling that she is leaning on it is lost. Joseph does not carry a water bag as in the Roman engraving; on the other hand his travelling staff has been transmuted into an Ethiopian maqwāmiyā. Also Tempesta's landscape has been replaced by an elaborate pattern of stylized trees filling the space around the figures of Mary, Joseph and the donkey.

An unusual feature of this rendering of the Flight into Egypt is that the faces of Mary, Joseph and the Child are depicted in profile. This corresponds to the Roman prototype but is contrary to the Ethiopian prohibition of drawing in such pose the faces of holy personages.

The following miniatures evidence the process of local adaptations made in Italian model. The subject is rendered entirely in the First Gondarene manner with four significant innovations. Mary is depicted according to her S. Maria Maggiore type dominant at that time; her blue mantle is a replica of the maphorion. Joseph walks in front of the donkey and points to Mary with his outstretched hand. The trees which have been part of Tempesta's landscape changed their character and became a mere ornamental pattern of the background. Their large leaves drawn along the stems and twisted branches as well as large flowers recall the design of Oriental textiles. The fourth innovation is the Ethiopian house implements put on Joseph's and Mary's heads in the same manner as the food basket on Salome's head. These new details in the following miniatures are the result of the extensive local commentaries to the narrative of the Synaxary and revelations of Mary to Timothy and Theophilus.

(24) The picture of the Flight into Egypt, found among the illustrations in the Book of Miracles of the Virgin Mary donated by Emperor Iyāsu in 1678 Eth. Cal. to the church of Daqā Kidāna Meḥrat, near Gondar, reveals the process of adaptations. The caption in Amharic accompanying the image has been probably added at a later date and runs as follows, "As our Lady was exiled to Egypt". Mary rides a donkey and nurses the Child supporting her exposed breast with her right hand while embracing the Child with her left arm.

[91] Photographed by Diana Spencer. Unpublished. The manuscript dates from the second half of the 17th century.

A bulky donkey painted in pale grey colour has one ear pointing to the back and one to the front, instead of both directed to the front as in previous pictures. This curious detail should be most probably explained by different ways of rendering donkey's ears in images of Christ's entry into Jerusalem. The trappings of the donkey are of local type but used in Ethiopia for horses and mules, which is clear from the breast girth composed of three leather straps buckled by a ring.

The Child dressed in a yellow shirt and wrapped in Mary's mantle holds his mother's nipple in his mouth; Mary's as well as the Child's nimbi are typical of the first Gondarene school; Joseph and Salome are without them. Salome, standing behind the Virgin, is facing forward; her two hands are pressed against her breast in a pose often used for the 17th-century figures of angels; in addition, Salome carries a small pot on her head. Salome's dress is identical to Mary's save the yellow colour of the mantle.

The simplicity of Mary's and Salome's dresses contrasts with the richness of the garment of Joseph. He walks in front of them and points to Mary with his right hand. He wears on his head a curious conical hat with a small ball on top of it. The object seems to be either an Ethiopian household implement, namely a flat basket, a cover for a baking pan used in preparing the *enǧerā*, a native pancake, or a hat the origin of which is more complex. Perhaps the form of this head-covering goes back to the first quarter of the 16th century when Nicolò Brancaleon produced for Emperor Lebna Dengel a series of illustrations for the Book of Miracles of the Virgin Mary. In several of these illustrations the bishops, including St. Ildefons of Toledo, wear flat hats which have been used by Catholic Church dignitaries during the Renaissance period.[92] Some of these hats are ornamented with a small ball on top. Apparently Ethiopian painters liked such hats and introduced them in various subjects; the hats appeared on the heads of soldiers in the 16th-century diptych (IES Coll. No. 4132) representing scenes from the Passion. Although the painter followed the foreign model for the figure of Joseph, he made his own adaptations; the face of the foster-father is, in fact, that of St. Gabriel in 17th-century pictures of the Annunciation to Mary. Moreover, a *maqwāmiyā* and a gourd attached to it offer local colour to this beautiful piece of work.

(25) The main portion of the Book of Miracles of the Virgin Mary, British Library Or. 641, was written during the reign of Emperor Fāsiladas and the last folios during the first year of his successor Yoḥannes.[93] Among the miniatures of the first portion there ist the Flight into Egypt (fig. 20).

The donkey is treading to the left which is opposite to the usual travelling direction of the Holy Family. Consequently Joseph is depicted on the left side of the miniature and walks in front of the beast. He points his outstretched hand to the direction of travelling and turns his face towards Mary, holding with his left hand the loop of the donkey's reins. The same is found in the majority of subsequent paintings. The movement of Joseph is obviously inspired by Ethiopian life; when-

[92] One of the miniatures was reproduced in SpenLuke 90.
[93] WrBM 48.

ever a nobleman rides a mule one of his servants runs along and holds either the reins or the pommel or both.

Mary rides a donkey and nurses a half naked Child supporting her exposed breast with her right hand while embracing him with her left arm. Her thoughtful face is in a frontal pose which is unique in 17th and 18th-century images of the Flight into Egypt.

The miniature is worthy of note for the quantity and variety of house implements transported by the Holy Family. Mary carries on her head a large jar, Joseph on his shoulders carries a large jar for water and in addition a gourd on his arm. Salome holds a clay pot used for butter and milk. Moreover, another gourd is affixed to the trappings of the donkey.

This display of kitchenware makes this biblical scene look like an image of Ethiopian family travelling and corroborates the suggestion by Ignazio Guidı that "the natural spirit of hagiographical stories in Abyssinia gives the impression that the Holy Family visited Ethiopia journeying in clouds".[94] The means of transportation used in our miniature is different, but perhaps we witness in it a direct visual response to the local stories on the travel of the Holy Family that have been truly integrated into Ethiopian life and lore.

(26) The other Book of Miracles of the Virgin Mary in the British Library, Or. 639 also dates from the 17th century, according to W. Wright.[95] It contains the miniature of the Flight into Egypt (fig.21) which is characterized by similar peculiarities, namely the leftward direction of marching, the schematic trees as ornamental background and the prodigality in depicting house implements.

The four stems of the trees and their branches arched above Joseph, Mary and Salome form three niches in which they are depicted. This method of framing the figures is characteristic of the First Gondarene style.

The housewares are varied as in the previous miniatures but their distribution is different. Joseph transports a gourd and a bag for water both slung on his staff, Mary transports a cover for the enǧerǎ pan on her head and Salome a big basket on her head as well as a clay pot in her hand. Indeed, the miniature evidences the painter's true preoccupation in representing the travel of the Holy Family as passing through the Ethiopian countryside.

(27) The image of our Lady, "as she made the pilgrimage to Qwesqwām with her Son" (IES Coll. No. 4127) is painted in the First Gondarene manner and with a further elaboration of the subject (fig. 22). The landscape is missing altogether, instead the background is divided into three areas in green, red and green colours according to the practice common in 17th-century art.

Mary nurses her Child supporting his head with her left hand. She wears a blue cape and a red robe underneath; her feet are not shown. The figure of the Child is obviously borrowed from the S. Maria Maggiore portraits of Mary in a number of which he has a characteristic curl on his forehead. The donkey, especially its head,

[94] *I. Guidi*, Storia della letteratura etiopica (Roma 1932) 54.
[95] WrBM 52.

is rendered fairly realistically; its long ears decorated with stripes are pointed in different directions as in the previous pictures. Also, the trappings showing the crupper and the reins ending with an ornamental knot are drawn from life, but in fact, not used in Ethiopia for donkeys but for mules or horses.

Salome placed behind Mary, wears a mantle identical to hers but in white colour instead of blue and carries a basket on her head as well as a very realistically drawn clay pot in her hands.

Joseph in front of Mary, points at her with one hand and holds a staff in another, a small bag or a bundle of cloth and a gourd are attached to it. His face slightly inclined towards the Virgin, is typical of First Gondarene paintings and his long tunic (a Turkish kaftan), striped shirt underneath, blown up trousers with many folds and pulled in at the ankle as well as pointed slippers, recall closely the garment of Christ in 17th-century images of the Resurrection.

The Virgin and Child have nimbi ornamented with red radiating lines which are characteristic of the First Gondarene school, while Salome and Joseph have plain yellow ones.

(28) A delightful image of the Flight into Egypt is painted on the left panel of the late 17th or early 18th-century triptych (IES Coll. No. 4755). It belongs to the particular mode of painting which is characterized by the use of white for the background which is probably an imitation of vellum as well as a curious mixture of progressive stylization of the composition and the realistic rendering of some details (fig. 23).

All faces have large eyes marked by a double line around the eyeballs and equally prominent and well-shaped sensual mouths typical of the First Gondarene paintings. Mary nurses Jesus who holds her nipple in his mouth; she is wrapped in a blue mantle entirely covering her body so that neither her red robe nor her feet are shown.

A bluish donkey is an assemblage of two disparate beasts. While the hind part, judging by the tail, is that of a donkey, the front is clearly of a horse; indeed, the pointed ears directed to the back are typical of First Gondarene horses. Moreover, the painter felt it necessary to add a particular touch of realism by representing this unusual beast with full anatomy, an occurence virtually unique in rendering donkeys in Ethiopian art.

Salome does not carry the usual basket on her head, instead she holds a clay pot in one hand and a short staff, a crudely drawn *maqwāmiyā* in another. She is dressed differently to Mary and wears a blue blouse and a yellow skirt with red stripes.

St. Joseph placed below the donkey, wears a large blue skirt, trousers cuffed just above the knee and orange pointed slippers; this dress marks still another fashion of Joseph's garments. Moreover, he carries a long shepherd's staff with a ball at its top instead of the usual *maqwāmiyā* with two very realistically drawn gourds attached to it. All figures have halos over their heads.

Apparently, the painter did not intend to follow the Western idea of producing the illusion of a landscape as in the Evangelium arabicum. Instead, he enhanced the ornamental value of his composition by filling the background with a pattern of stylized branches of trees and multicoloured flowers attached to them.

A prostrate figure of a young man is depicted at the bottom of the painting and having a nimbus over his head. His eyes seem to be that of a dead man. We do not know for certain whether this figure belongs to the subject of the Flight into Egypt, but it seems to be so; probably this is Yosā reappearing in this image after two centuries of oblivion, though the caption accompanying the figure runs "St. George".

(29) The Flight into Egypt found in the 17th-century Book of Miniatures, in the Stadt- und Universitätsbibliothek, Frankfort on the Main,[96] is painted in First Gondarene style. The composition shows "how our Lady Mary rode to Qwesqwām" according to the caption (fig. 24). Indeed, Mary sitting on a donkey, nurses the Child supporting her breast with her right hand; no left hand is shown. The donkey has unusually long ears probably to emphasize that the beast is, indeed, a donkey and not a mule. Salome stands on the left with her arms crossed on her chest; she carries a small pot in her hand and a basket on her head. Joseph walks in front of Mary; his right arm is outstretched over Mary's halo, in a movement which can be interpreted either as protection or showing the direction. He does not carry either a staff or a leather bag. Christ, Mary and Joseph have halos over their heads; Salome has none.

The subject of the Flight into Egypt in the Second Gondarene style follows basically the First Gondarene composition, but with further elaboration of details. Two examples of the works described below belong to the flamboyant period of the Second Gondarene school and most probably date from the third through the fifth decades of the 18th century.

The triptychs represent a number of incidents of the life of Christ and Mary and among these is the Flight into Egypt. The following is the description of it in the triptych IES Coll. No. 4114.

(30) In the middle of the composition (fig. 25), Mary, mounted on a white donkey,[97] nurses her Child; she supports her conspicuous breast with her right hand and the head of her Son with her left hand. The upper part of her body is wrapped in a blue cloak decorated with a rosette pattern according to the Second Gondarene mode. The lower half of her figure, including the pointed slippers inserted into the Moorish stirrups, gives the feeling of a masculine rider and is obviously modelled on the figures of equestrian saints. The horse trappings are elaborate; the crupper with additional leather strap running from the rump down, the breast girth composed of three leather straps buckled with a brass ring and the part of the reins close to the bit made of copper chain reflect the horse or mule trappings of the period.

Joseph stands in front of Mary and turns towards her; he gazes at the Child and holds the reins of the donkey. Following the Second Gondarene manner, he is

[96] Ms Or. Rüpp. IV, 2. Reproduced in VOHD XV 59, pl. 47.

[97] Byzantine painters used to depict the ass which had the priviledge of carrying Christ and Mary as white. Emperors of Byzantium and kings of Persia also mounted on white horses; this was to enhance their elevated rank.

rendered as an old man with a bald head and woolly white hair on the temples. Also his garment is typical of the style except for his sandals. This detail is obviously borrowed from the figure of the Child in the S. Maria Maggiore image of Mary (see p. 227). A *maqwāmiyā* leans on Joseph's shoulder; a water bag used by people in the hot lowlands of Ethiopia and a small gourd decorated with leather straps are hanging on it.

Salome, behind Mary, carries a basket on her head and a clay pot in her right hand. Her left, free arm is pressed against her breast, while her hand grasps her right arm. This unusual pose seems to be characteristic of the Second Gondarene images of the Flight into Egypt and is found also in the next picture. Salome's green blouse with overall pattern of dots and her red skirt reaching the knees and ornamented with rosettes, are typical of the flamboyant Gondarene period. Salome wears sandals similar to those of Joseph. Mary and the Child have nimbi over their head, while Joseph and Salome have none.

A tree placed between Salome and Mary and a branch over Joseph's head mirrors a sketchy landscape in the Dimā Giyorgis miniature (fig. 17). Additionally, a row of stylized flowers appears at the foot of the picture; an identical flower pattern is found on covers of many 18th-century icons.

(31) The miniature in the Book of Devotional Pictures (IES Coll. Ms. 315) is intended to represent Mary "as she nursed [him] at Dabra Qwesqwām", but, in fact, this is a copy of the previous picture (fig. 26). Mary's head and the upper half of her body are wrapped in a dark blue mantle while her legs and feet recall the 18th-century equestrian saints. This impression is strengthened by the narrow stirrup-iron into which two of the Virgin's naked toes are inserted. Also the trappings featured by a high pommel to which the reins are fastened and the double collar decorated with a row of bells are, in fact, those of horses or mules but not of donkeys.

Joseph holds the reins of the donkey; his rendering is similar to that in the previous picture save for the sandals which are missing. Also Salome's figure recalls the previous picture except for the basket which is larger in size, the clay pot which has a different shape and the sandals which are missing.

The body of the donkey is striped white and recalls a zebra rather than the carrier of Mary in the Evangelium arabicum. Thus the process of transformation which started in the Dimā Giyorgis miniature became complete in this miniature. A stylized tree or the trunk of one and small plants with flowers are intended to localize the composition.

In the lower register of the miniature, appears a prostrate figure of a priest who obviously was the donor of the book. His servant stripped to the waist carries a whisk and staff ornamented on its top with a ball. This illustrates the kind of staves used by clergymen in 18th-century Ethiopia. Identical staves were probably known before that century as suggested by the figure of St. Joseph in the gospels of Iyasus Moʾa.

(32) The composition of the Flight into Egypt found in another Rüppellian manuscript (see footnote 81) is the same as in the previous miniature save a few particulars (fig. 27). Joseph does not have his hand outstretched above Mary;

Salome supports a colourful basket with her left hand; Mary's large *maphorion* is ornamented with one star on the front and one on her right shoulder. Also the ears of the donkey are short and pointing upwards and not curved and long as in the First Gondarene painting. Obviously, in the process of copying, the painters were permitted to introduce small changes into the figures. Moreover, they consistently depicted Mary seated astride, i. e. riding a donkey in a manner the men and women in Ethiopia sit on horses and mules.

(33) The Flight into Egypt in the Book of Miracles of the Virgin Mary, Māḫdara Māryām church, Dabra Tābor district,[98] evidences a progressive acculturation of Tempesta's engraving to the Ethiopian environment (fig. 28). The composition follows the pattern established in Second Gondarene style, namely Mary rides on a donkey, Joseph walks in front and Salome behind. Nevertheless, the painter introduced new details taken from Ethiopian life. Mary does not wear the usual *maphorion*, instead a white cloth covers her head. The beast on which she rides is depicted fairly realistically but also demonstrates the hesitation of the painter as to what kind of animal he should represent. Although the movement of legs is similar to those in the Evangelium, the head is quite different, especially the ears which in the Evangelium are pointing to the front whilst in the miniature they are directed to the back. It seems that Ethiopian painters of the late 17th and the 18th century did not make up their minds whether, as Mary's mount, they should depict a donkey or a mule which Ethiopians consider to be a more dignified animal than a donkey. As a compromise the pictures usually show a hybrid animal having some characteristics of the donkey and some of the mule, but always caparisoned with horse or mule trappings. Mary, Joseph and Salome have bare feet according to Ethiopian custom; moreover, Salome's basket and pot and Joseph's staff are clearly drawn from life.

The Family travels through a countryside of trees and small plants; this is an obvious influence of the Evangelium; however, the form of the trees has changed dramatically; these recall the trees in Indian miniatures.

(34) The Ethiopian effort at expressing the Flight into Egypt in local idiom became accomplished in the art of the kingdom of Šawā. The miniature in the Psalter of King Šāhla Śellāsē (1813–47) kept in Sala Dengāy is intended to represent how Lady Mary and the Child "went to the land of Egypt", but, in fact, the scene mirrors how a noble Ethiopian lady used to travel in the past (fig. 29). Mary is wrapped in a dark blue mantle, a *kāppā*, trimmed with golden lace. She carries her Child on her back and holds in her hand an ornamental parasol. The Child peers at Salome walking behind the donkey. She is a pretty maid with a large hairdress in which three rosettes are pinned according to the fashion of the court of Gondar. She also protects her delicate face with a parasol. She transports a large earthenware vessel on her back as the Ethiopian woman do, and carries in her hand another small one for butter or

[98] Reproduced in *O. A. Jäger*, Äthiopische Miniaturen, pl. 10. The manuscript was offered to the church by a certain "Walata Gelandios" (Walatta Galāwdēwos?).

milk. Joseph walks in front; he holds in his right hand a leather strap the end of which is attached to the donkey's bridle. He thus leads the animal as do the attendants of noble ladies.

This bucolic group is protected by three winged heads of angels hovering above. The Šawān painter expressed the idea similar to that of the scribes six centuries before, but using an entirely different form.

On the whole, the 18th century marks the final stage in developments for the iconography of the Flight into Egypt, the works of the 19th and 20th century being mostly copies of the 18th-century form. Nevertheless, a few additional developments took place. The painters started to illustrate the so-called Story of Mary (*Nagara Māryām*), an Ethiopian version of the gospels of pseudo-Matthew. The illustration of miraculous happenings during the Holy Family's travels in Egypt is different from those discussed above; the donkey has virtually disappeared, instead Mary travels on foot and either carries her Child in her arms or holds him by his hand; occasionally she gives him her breast. These miniatures are obviously a blend of old traditions, of 17th-century additions and of 18th-century commentary to the text of *Nagara Māryām*.

SUMMARY

The above survey offers ample documentation on the 13th to 19th-century developments in Ethiopian iconography of the Flight into Egypt. It appears that the middle of the 17th century marks the major change in the rendering of the subject. Before that date Ethiopians composed their own image of the Flight into Egypt, while after that date they copied the engraving in the Evangelium arabicum.

Did foreign models penetrate into Ethiopia before the 17th century? Indeed, we have proof that this was the case. The mural in St. Mary's church, Lālibalā, was certainly inspired by the iconography developed outside the country. Although there is an obvious influence of Coptic art on some of the details, the origin of the mural is not fully clarified. The miniature in the Krestos Tasfāna Gospels possibly bears traces of foreign influence. Moreover, it appears from Coptic sources that the mission sent by the Alexandrine Patriarch Matthew II to the court of King Zarʾa Yāʿqob around 1453 brought to him among other gifts a "golden" image of Mary "when she went to Mount Qwesqwām with her Son, then the Child". Golden, according to Enrico Cerulli who studied the document, means most probably the golden background.[99] We do not know the fate of this picture and as yet neither the material proof of its existence has been found nor its impact felt on Ethiopian iconography of the Flight into Egypt.

Apparently the early contacts had very limited influence on Ethiopian imagery of the Flight into Egypt. From the 13th until the 17th century, Ethiopian painters

[99] CLMM 101.

created their own image of the Flight into Egypt independent of foreign models. The painters took inspiration from apocryphal writings, particularly the revelations of Theophilus, otherwise called the discourse of Mary on Mount Qwesqwām, as well as oral legends centred around the Monastery al-Muḥarraqa (the Ethiopian Qwesqwām): the writings and legends originated from the Valley of the Nile which for obvious reasons was the main source of apocryphal stories about the flight of the Holy Family. The Ethiopian rendering of the subject is thus, until the 17th century, related to the Coptic version of the flight. This becomes obvious when one considers the figures in the paintings.

Virtually all pictures of the Flight into Egypt, starting with Iyasus Mo'a Gospels, include Salome. This corresponds to her prominent rôle in the Coptic version of the flight. Moreover, Yosā and his sad story also originate from Coptic legends related to the founding of the Monastery al-Muḥarraqa. According to material investigated, Yosā appeared in Ethiopian painting in the 15th century and was still depicted in the 17th century, even in those paintings which derived from the Evangelium arabicum.

The Child is rendered in two ways. In early works, until the middle of the 17th century, he appears as a small boy usually walking but now and then occasionally carried by Mary, Joseph or Salome. This rendering follows the text of Theophilus who indicated that Jesus was two years old when his parents travelled to Egypt. From the middle of the 17th century, Jesus is depicted as a baby carried by his mother according to Western European interpretation of Matthew's text.

Early works, from the 13th until the 16th century show understandable iconographic instability; each picture brings new variations of the composition and details; this is an obvious result of local commentaries on the apocryphal texts and legends. In the 17th century the foreign model was adopted and the composition stabilized. Nevertheless the painters changed the details partly taking these from Ethiopian life, partly following the earlier traditions, and adding a new element of theological significance. Moreover, during the transitional period lasting from the second half of the 17th century to the middle of the 18th century, they continued to use the "walking" form in addition to the newly adopted one. Thus we find in the same set of illustrations the Flight depicted twice, namely according to the new and old patterns.

The figure of Mary demonstrates these developments; in early paintings, except the Lālibalā mural, Mary is invariably depicted in the process of travelling on foot. In the 17th century, she either walks or rides a donkey; after that century she is mostly depicted riding a donkey.

Curiously enough, the form which Ethiopians adopted in the 17th century was already fading away in Western European art. In this art, the donkey, carrier of the Virgin, had its great days in Mediaeval and early Renaissance periods. The Counter-Reformation attempted to remove from art the details originating from apocryphal writings and consequently the donkey has been ostracized; the beast, however, was not cleared away entirely; it appeared occasionally during the 16th century and later. Moreover, in the same period the theme of travelling has been replaced by that of the rest of the Holy Family and with secularization of art, both

themes often play a subsidiary part in the landscape in which they are set up.[100] To sum up, while in Europe the donkey's popularity declined, the opposite happened in Ethiopia. The donkey, introduced from Europe in the 17th century, became until the present the vital element of Ethiopian iconography of the Flight into Egypt.

The Ethiopians themselves would not create the image of Mary on a donkey because riding on such an animal was alien to their way of life and their concept of Mary's exalted position; yet, they accepted from abroad the "riding" form. How to explain this contradiction? There is no clear answer but it seems that traditional Ethiopian painters combine two opposite attitudes, that of tenacious attachment to old forms and blind fascination with any foreign model which happened to penetrate into their country.

In the 17th century two other innovations were introduced into the figure of Mary. Are they genuinely Ethiopian?

One innovation was Mary dressed in a Syrian *maphorion* similar to that in her S. Maria Maggiore painting. The other innovation was Mary suckling her Child while riding a donkey. Not a single instance of this is known in Ethiopian paintings prior to the middle of the 17th century. Around that date, the new form of a nursing Mary appeared and since then has been constantly used.[101] The prominent breast of Mary and the realistically drawn Child in process of suckling, suggest that Ethiopian painters have given special significance to this theme. What is the reason for it? It seems that the painters have been motivated by theoretical considerations. Perhaps one has to search for the explanation in two apocryphal Eastern Christian texts, the so called Prayer of the Virgin at Bartos and the Prayer of the Virgin at Golgotha. The texts of mixed, magic and religious character have been known to Ethiopians since the 14th century but enjoyed particular popularity in the 17th and 18th centuries.[102] These texts describe Mary's prayers during which her Son descended from heaven and concluded with her the so-called Covenant of Mercy or Pact of Intercession; this means that whatever is asked of the mother will be given by her Son. The texts are to be found at the origin of the iconographic form called the Covenant or Pact of Mercy developed in 17th-century paintings. The form represents the very moment of bestowing the intercessionary power on Mary. The introduction of the nursing theme into the Flight into Egypt seems to be also related to the above texts. In course of justifying her request, Mary twice makes mention of the hunger and thirst she suffered because of her Son during the exile to Egypt. In addition she repeats several times that she fed him from her own

[100] RéauIc II 281 f.

[101] According to VogFlucht 13, the motif of feeding the Child on the way is rare in European art and limited to Dutch 16th-century painting. Schiller gives two examples of Mary feeding the Child while taking rest (SchillIc fig. 328 and 332) without elaborating the theme.

[102] In the Vatican Library there is a large number of Mss containing the Prayers of Mary at Golgotha and at Bartos (apud Parthos): Bor. Aeth. 26, 1390–1408; Aeth. Vat. 37 and 42, both of 15th century; Aeth. Vat. 35, 1536. The British Library possesses several 17th and 18th-century Mss which contain the same prayers.

breast.[103] The spiritual significance given to this physiological function is suggested by the following passage in Mary's speech. "Greetings to you my King and my God who has sucked milk from my breast so as to make the Incarnation complete".[104] This is in agreement with the teaching of Church Fathers that Mary's nursing of the Child is the manifestation of the reality of Incarnation. Moreover, in the Prayer at Golgotha there is a comment on the above, "It is he who feeds with his clemency all being which has a body".[105] Sucking of the breast is a popular theme in Ethiopian hymns: "He who feeds all creation was suckled as a babe at thy breast" is mentioned in some form in all hymns of the Virgin.

Ethiopian painters impressed a distinctly local character on the image of the Flight into Egypt by introducing details taken directly from Ethiopian life, namely the bag for grain, basket for food, pot or gourd for milk, butter or water which Salome and Joseph carry on the way. These implements bear no relation to the implements which Joseph and the accompanying youth carry in Cappadocian, Byzantine and Western European images of the Flight into Egypt.[106] Joseph's travelling staff undergoes a transformation, probably due to the religious character

[103] BassApÉ I 14, 25, 31f. and 37.

[104] BassApÉ I 25.

[105] BassApÉ I 25.

[106] In early Eastern iconography, a young attendant carries a water bottle and other belongings in a bundle slung on a stick; in Western iconography this is usually the function of Joseph. SchillIc 120.

In early Ethiopian representations of the Flight into Egypt no such details are known except a rarely depicted staff in Joseph's hand. The gourd slung over Joseph's staff and the basket of food as well as other details taken from daily life appeared first in the 16th century.

The implements carried by the Holy Family are, in fact, the common utensils of the Ethiopian household. Thus the paintings of the Flight into Egypt offer a unique insight into the material life of Ethiopia in the past; forms, materials, way of manufacturing are rendered correctly and with care for details. The bag. for grain, saleča, is, in fact, a complete skin of a goat or a sheep, save the head and hoofs, which were cut off; when filled with grain the bag takes again the form of the animal. The food-basket, masoba warq, is of a particular shape; it is usually flat and wide and has a cover affixed firmly to the main body of the basket. At times a round wide leg supports it; the basket combines the qualities of a container and miniscule table; moreover, it is easy to carry on one's head. Baskets are made of grass and occasionally decorated with colour patterns. Special baskets serve for travelling; they are filled with food which is a mixture of pancakes with a pungent chili sauce on a base of meat or pulses. Small clay pots, masaro, have a leather strap which serves as a handle attached to two ears. These pots are often polished with a mixture of ashes and castor oil. Such pots serve for keeping milk or butter; in the Flight into Egypt they are carried by Salome. The gourds, čočo, some elongated and some round, have also a leather strap serving as a handle and are made of pumpkin fruit or a hollow piece of wood. They are used as containers to carry milk, honey or butter to market. Another object of local usage is the water bag carried by Joseph. The bag is made of leather, has a handle and a wooden tap. In the past it was extensively used by ambulant traders.

of the subject. The staff is often rendered as a praying staff, *maqwāmiyā*, which has the characteristic handle at its top; the handle is made either of metal (iron, copper, brass) or of wood and has the form of horns of the ram bent inwards. Praying staffs are used by priests, deacons and older members of the community during long hours of the holy service and prayers and as the choreographic implement for ritual dances at the Epiphany and other religious ceremonies. In the picture of the Flight into Egypt, the *maqwāmiyā* is usually carried by Joseph, occasionally by Mary and virtually never by Salome.

Turning to the captions, the first impression is that their contents and wording vary a great deal. In captions to the early images of the Flight into Egypt the angel is mentioned, in one instance his name, Gabriel, is given and in another his presence is mentioned. The captions indicate the destination of the journey by two different words; in some captions the name of the country, Egypt, is given, in other captions the particular place, Qwesqwām; this presents additional evidence that the Coptic version of the story was familiar to Ethiopians in the 14th century and probably before. In the captions to the 16th-century paintings and those of the subsequent centuries, the names, Egypt and Qwesqwām, are interchangeable. In the 17th-century captions, the scope of the journey is defined more precisely than before and with such words as "escape", "exile" or "pilgrimage". In 18th-century captions, the function of nursing the Child is emphasized.

These various wordings of the captions mirror the continuous and creative commentaries to the narrative of the Flight which has been ever popular among Ethiopians. They owe the incentive and the initial story to the Copts and the detail of the donkey to Western European art; they developed the theme and made it an important subject matter of their manuscript illustration, church decoration and painting on wood. Moreover, by extentive use of idiom taken from everyday life, they created a unique, distinctly Ethiopian portrayal of the Flight into Egypt.

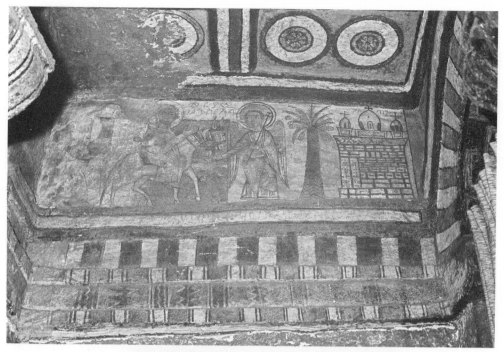

1. Wall painting, 12th–13th century. Bēta Māryām, Lālibala

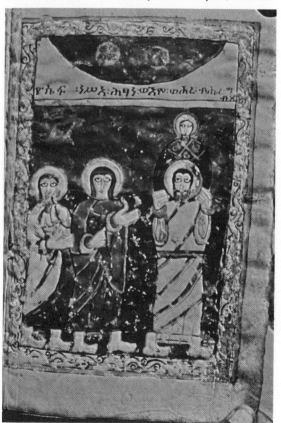

2. Iyasus Mo'a Gospels, 1280–81. 31,0 : 20,5 cm. Dabra Ḥāyq, Wallo

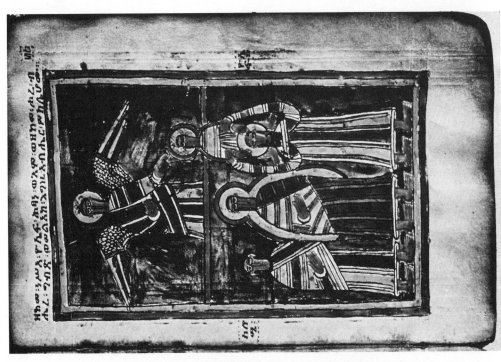

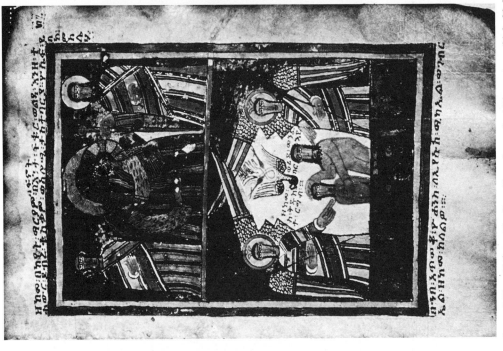

3a and 3b. Krēstos Tasfāna Gospels, early 14th century. 30,0 : 20,5 cm. National Library, Addis Ababā (fol. 19r, 20r)

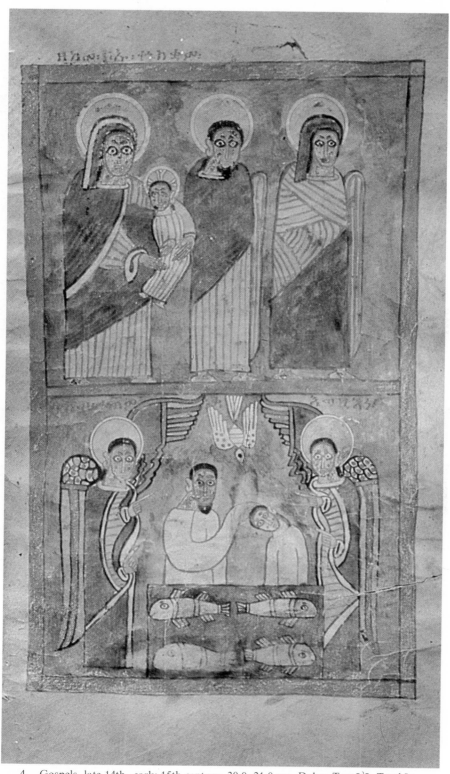

4. Gospels, late 14th – early 15th century. 30,0 : 21,0 cm. Dabra Tansā'ē, Tambēn

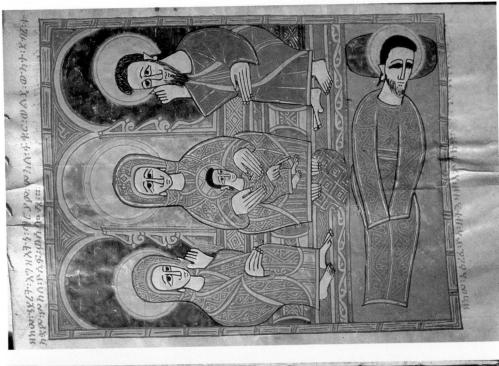

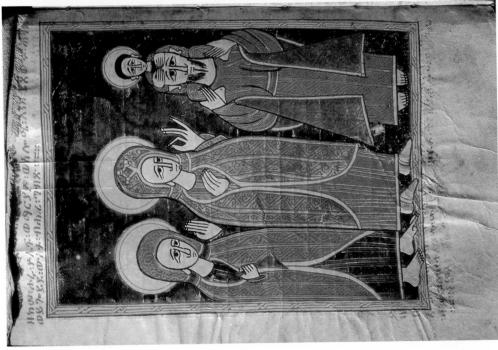

5a and 5b. *Lāḥa Māryām*, c. 1508–40 c. 30,0:22,5 cm. Bethlehem church, Dabra Tābor, Bagēmder

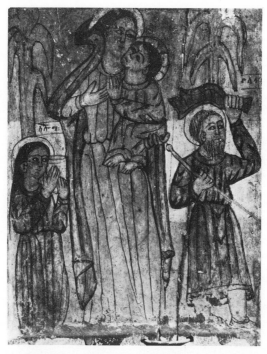

6a and 6b. Lime panel, 16th century. 24,0 : 20,2 cm. IES Coll. No. 4434

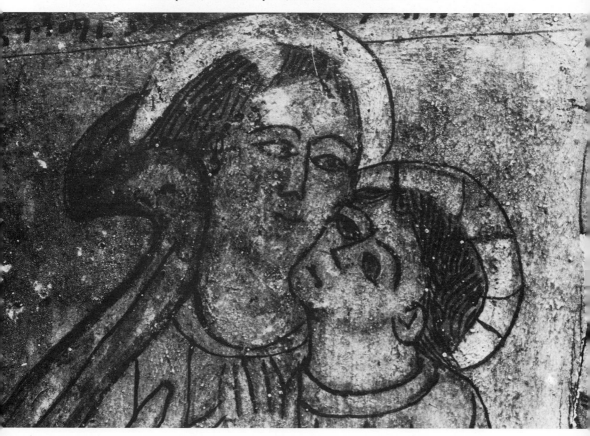

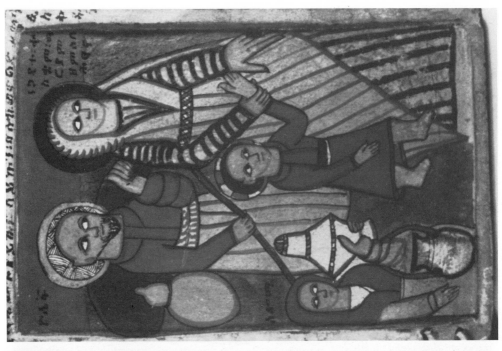

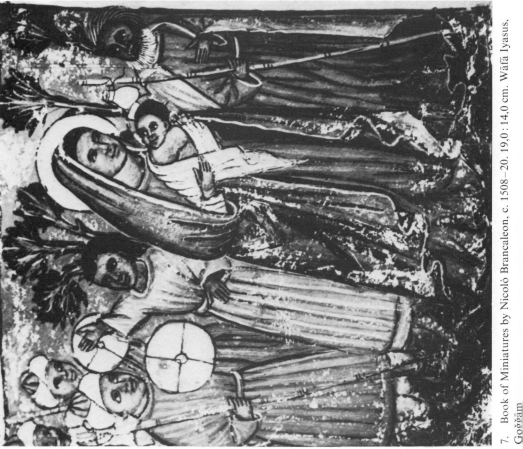

7. Book of Miniatures by Nicolò Brancaleon, c. 1508–20. 19,0 : 14,0 cm. Wāfā Iyasus, Goǧǧām

9. Diptych, late 16th century. 16,4 : 15,5 cm. IES Coll. No. 3888 (right panel)

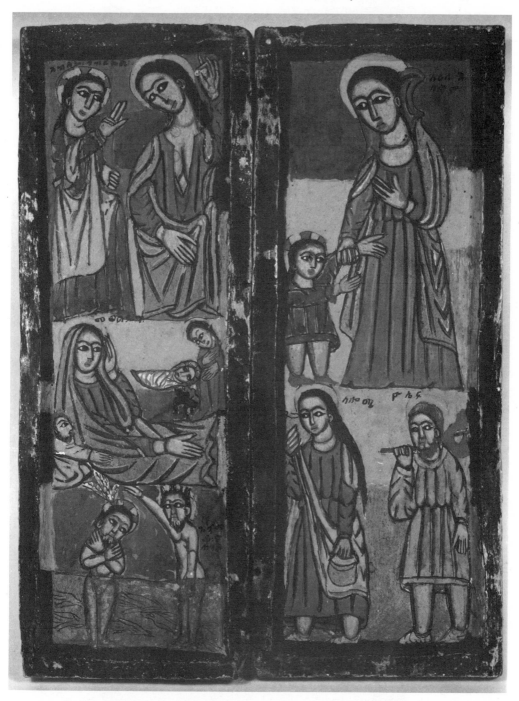

8. Lateral panels of a triptych, 16th century. 26,0 : 8,0 cm. IES Coll. No. 6589

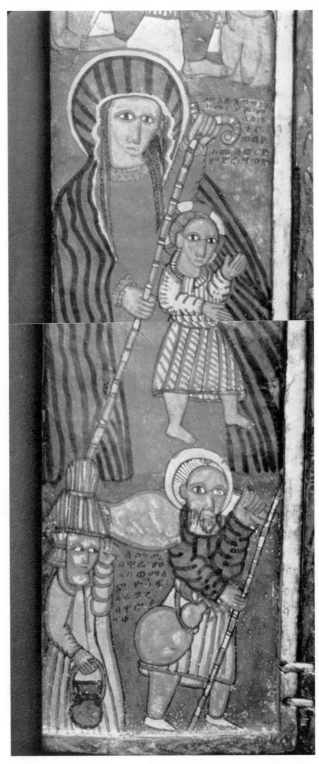

10. Triptych, late 16th century, IES Coll. No. 4261 (detail)

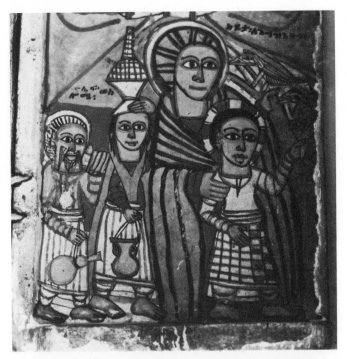

11. Triptych, early 17th century, The Langmuir Coll. No. 91, Peabody Museum, Salem, Mass. (detail)

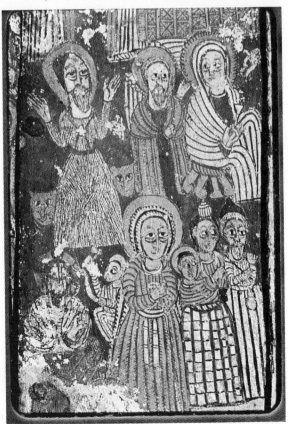

12. Triptych, late 17th century. 36,0 : 24,0 cm. IES Coll. No. 4461 (detail)

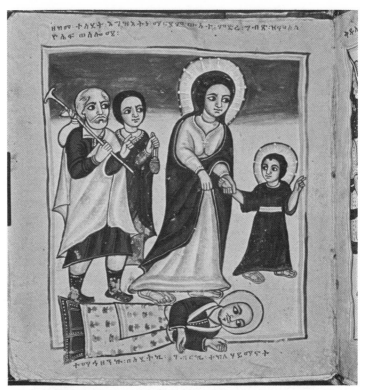

የሔፈ፡ወለሰሎሙዕ፤

13. Miracles of the Virgin Mary, early 18th century. 32,8 : 30,3 cm. British Library, Or. 655 (fol. 1v)

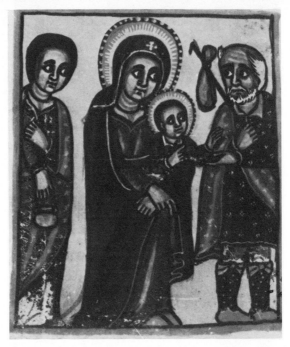

14. Prayers of the Virgin Mary, 18th century. 12,5 : 8,5 cm. Ms. or. Rüpp. IV,1, Stadt- und Universitäts-
bibliothek, Frankfort on the Main (fol. 68v)

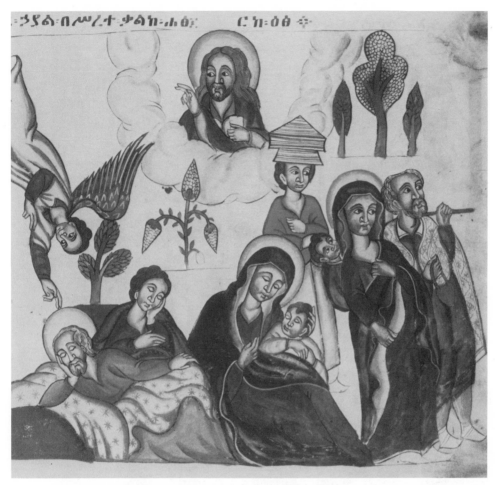

15. Hymn Book, 18th century. 40,8 : 35,7 cm. British Library, Or. 590 (fol. 43r)

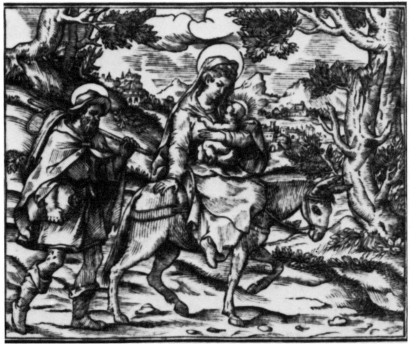

16. Engraving by Antonio Tempesta in Evangelium Sanctum Domini Nostri Jesu Christi, 1591. 22,0 : 33,0 cm.

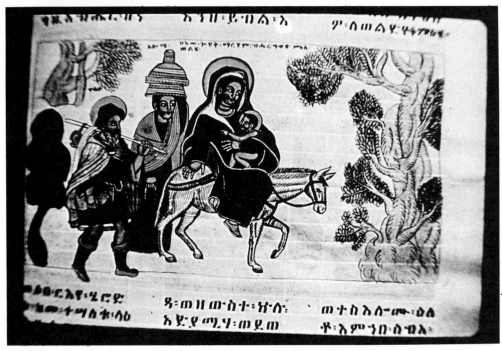

17. Gospels, 17th century. 39,6 : 27,5 cm. Dimā Giyorgis, Goǧǧām

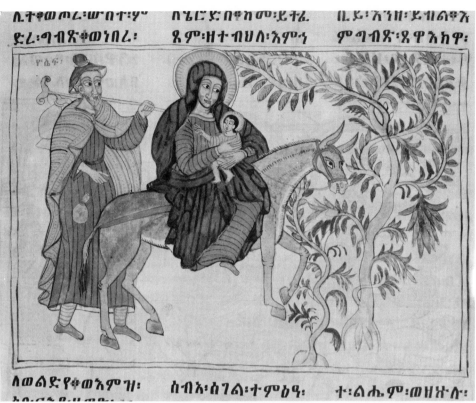

ሊተቀወጠረ፡ወበተሃም ለጌሮ፡በቀጸመ፡ይተሊ ዚዶ፡እንዘ፡ደብልቀእ
ድረ፡ግብጽቀወነበሪ፡ ጸም፡ዘተብህሉ፡እምነ ምግብጽ፡ጸዋእክዋ፡

ለወልድየቀወእምዝ፡ ስብእ፡ስገል፡ተምዕዓ፡ ተልሔም፡ወዘጵሉ፡

18. Gospels. 1666–67. 41,1 : 40,0 cm. British Library Or. 510 (fol. 10r)

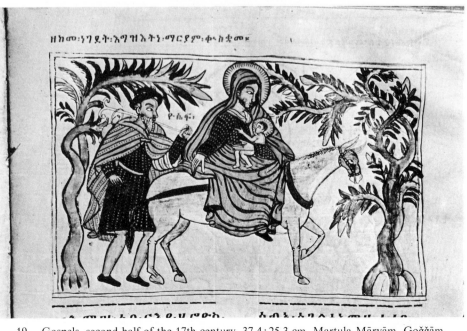

19. Gospels, second half of the 17th century. 37,4 : 25,3 cm. Marṭula Māryām, Goǧǧām

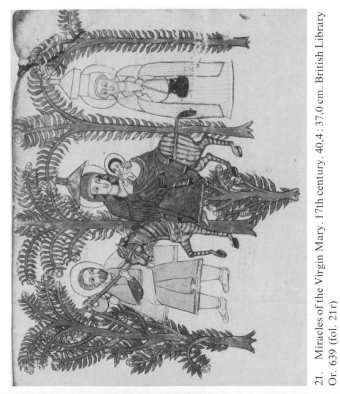

21. Miracles of the Virgin Mary. 17th century. 40,4 : 37,0 cm. British Library
Or. 639 (fol. 21r)

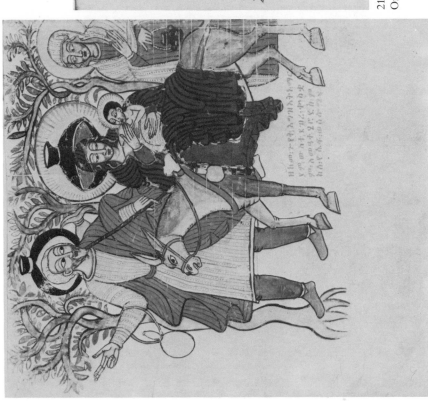

20. Miracles of the Virgin Mary, 17th century. 37,8 : 33,8 cm. British Library
Or. 641 (fol. 29r)

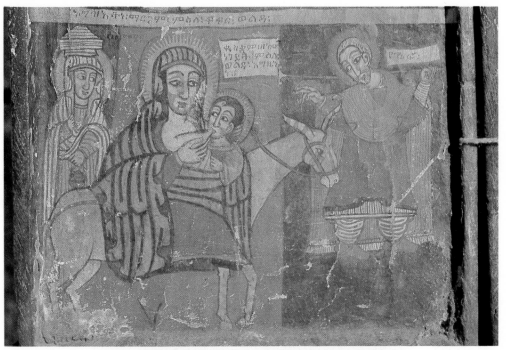

22. Diptych, 17th century, IES Coll. No. 4127 (detail)

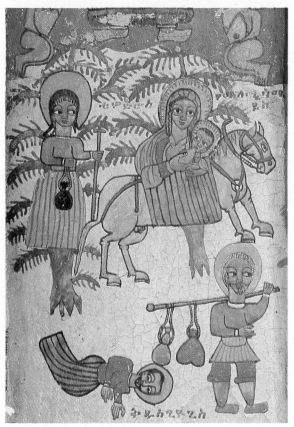

23. Triptych, late 17th–early 18th century. 39,0 : 24,0 cm. IES Coll. No. 4755 (detail)

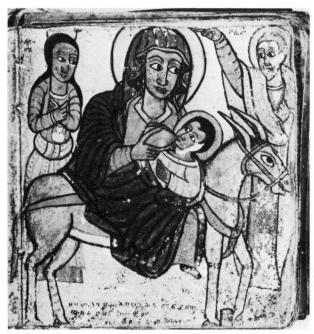

24. Book of Miniatures, 17th century. 9,0 : 8,5 cm. Ms. or. Rüpp. IV,2, Stadt- und Universitätsbibliothek, Frankfort on the Main (fol. 12r)

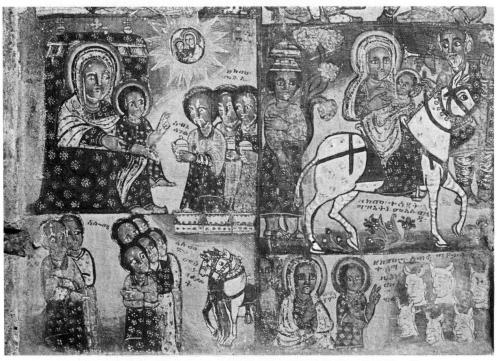

25. Triptych, 18th century. 46,0 : 28,0 cm. IES Coll. No. 4114 (detail)

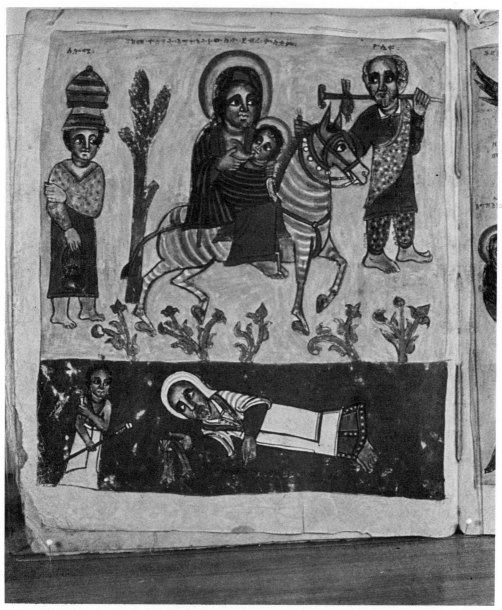

26. Book of Devotional Pictures, 18th century. 37,0 : 31,5 cm. IES Ms. No. 315.

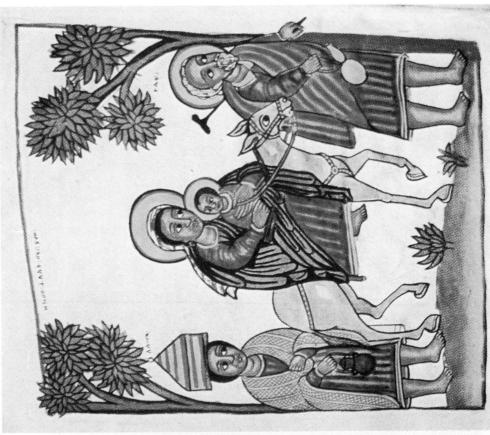

28. Miracles of the Virgin Mary, 18th century. c. 31,0 : 26,0 cm. Mäḥdara Māryām, Dabra Tābor District

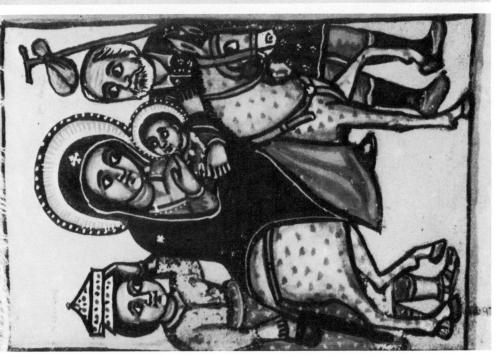

27. Prayers of the Virgin Mary, 18th century. 12,5 : 8,5 cm. Ms. or. Rüpp. IV,1 (fol. 10v). Stadt- und Universitätsbibliothek, Frankfort

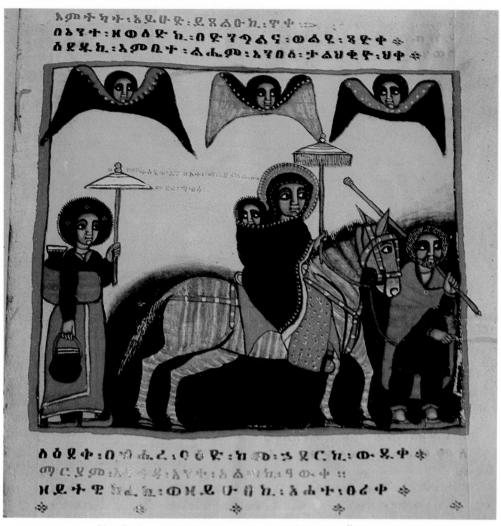

አመትካተ፡እዴሁዊ፡ይጸልዑ፡ኪ፡ዋቀ ⁕
በእንተ፡ዘወለዱ፡ኪ፡በዩጣዓልና፡ወለዩ፡ጻደቀ ⁕
ሰደዲ፡ኪ፡እምቤተ፡ልሐም፡እንበሰ፡ተልሀዊዩ፡ሀቀ ⁕

ለዕደቀ፡በገሐረ፡በዓዩ፡ከወ፡ጻርኪ፡ወዴቀ
 መርህም፡እየ፡ቀዩ፡እንተ፡እሐ፡ከ፡ገወቀ ⁝
ዘዴተዋ፡ዘበሆበኪ፡ወዘዩሆበኪ፡እሐተ፡በረቀ ⁕

29. Psalter, 1813–47. 24,5 : 20,0 cm. Salā Dengāy, Šawā

II. THE HOLY TRINITY AND REPRESENTATION OF THE ANCIENT OF DAYS

One of the most popular themes in Ethiopian painting is that of the Holy Trinity. The subject is virtually always represented by three identical old men, either seated or standing, and holding orbs in their hands. The figures of the Trinity are usually placed in an octagonal frame in the corners of which four Living Creatures of the Apocalypse are depicted. To the left and right of the Trinity stand the twenty-four Elders of the Apocalypse arranged in two groups of twelve and usually in two rows.

This representation of the Trinity has already been discussed by Helmuth Staude.[1] He pointed out the relation between the iconography of the Trinity and two biblical texts, namely Daniel 7,9, and the Revelation of Saint John 4,4. He tried to explain some obvious inconsistencies between these texts and the Ethiopian representation of the Holy Trinity and to interpret some details of it such as the orb in the hands of the Persons. His analysis concludes with speculations about the relation between the Ethiopian image of the Trinity and similar European triple-figure forms. Staude's answer seems to be rather negative. "These [tricephalous] and other [triple figure] representations of the Trinity", he writes, "finally lost the favour of the Roman Church and were in fact prohibited by Pope Benedict XIV in his Constitution of October 1, 1745. In the preceding centuries, these images had been more or less spreading around and some of them could eventually have been brought into Ethiopia. We do not see, however, the Roman Catholic missionaries who during the centuries performed missionary work in Ethiopia, accept such representations of the Trinity as valid, even if these then existed in Ethiopia. The images known to us originate from the time when the Roman Catholic influence in Ethiopia was eliminated by force. This also corresponds to the period during which the Church of the West strictly prohibited the use of triple-person images of the Trinity ..."[2]

Unfortunately Staude's speculations were based on a very limited material which dated from the late 17th and the 18th centuries. These paintings are different from the early representation of the Trinity in Ethiopia. Also, similar to other Ethiopists, he was under the erroneous impression that it was mainly the Roman Catholic missionaries who were introducing into and spreading in Ethiopia, Western holy images and therefore he tried to relate the image of the Trinity with the activities of the missionaries of the 16th and early 17th centuries.

Since 1958, the year Staude published his findings, a wealth of new material has come to light. We are now able to complete his work on the iconography of the Trinity. Indeed, the following is an attempt to trace the origin of this intriguing

[1] StauReg 265–72.
[2] StauReg 272.

composition and to find its relation to another peculiar subject of Ethiopian art, namely God the Father surrounded by the four Living Creatures.

16TH-CENTURY IMAGES OF THE TRINITY

In the 16th century appeared the earliest known to us images of the Trinity in Ethiopian painting. They can be classified into three groups: group A, the earliest of all and believed to originate from the scriptoria situated in Tegrē, Northern Ethiopia; group B, the paintings probably made in the middle and the second half of the 16th century, which evidence substantial alterations of details although they follow the iconography of group A; group C, images of the Trinity found in Ethiopia but made by foreigners. These images date from the early 16th century.

The following is the description of each group.

Group A
 (1) Triptych (called subsequently T1), property of the Monastery of Abuna Abrehām (Dabra Mā'ār), Gar'āltā, Tegrē (fig. 30);[3]
 (2) Triptych (T2), property of the Monastery of Abuna Yoḥanni (Dabra Āsā) Tambēn, Tegrē (fig. 31);[4]
 It is almost certain that T1 and T2 were kept in the above monasteries from the 16th century when they were donated up to the present;
 (3) Triptych (T3), in private collection, Germany, origin in Ethiopia not recorded (fig. 32);
 (4) Triptych (T4), property of IES Museum (No. 4328), Addis Ababā (fig. 33), origin in Ethiopia not recorded. The main panel was acquired by the Institute of Ethiopian Studies, Addis Ababā; the wings have either been previously destroyed or sold separately. The panel was sawn into two halves, probably during the transportation of the triptych from the countryside to Addis Ababā market.
 (5) Triptych (T5), in private collection, Switzerland, origin in Ethiopia not recorded (fig. 34);
 (6) Triptych (T6), property of Dāgā Esṭifānos, Lake Ṭānā.[5] The triptych is in a poor state of preservation and large portions of the paint have vanished.
 (7) Triptych (T7), property of the Monastery of Ahiya Afaǧǧ Qwesqwām, Wallo (fig. 35).[6]

[3] Church situated above Māryām Pāpāseyti and Ḥaregwā Mikā'ēl, about 2,000 ft above the wide valley and plateau of Degum. Described by R. Plant in: EthObs 13 (1973) 193f.
[4] Called Dabra Āsā, Monastery of Fish, because of the form of the cross kept in the church. Situated ca 10 km northeast of Abiy Addi, Tambēn in Tegrē. The church is hewn in the middle of a steep cliff; portion of the walls collapsed and are rebuilt.
[5] Described by G. Annequin, as: "... du XVe–XVIe siècle centré sur la Trinité, mais très peuplé d'autres scènes intéressantes." Le Lac Tana et ses îles = Les dossiers d'archéologie 8 (1975) 105.
[6] The Monastery is situated close to the locality Warra Ilu c. 60 km west of Dasē, capital of Wallo. The triptych was discovered and photographed by Diana Spencer.

Presumably there are in and outside Ethiopia similar paintings not known to the writer. Nevertheless, the materials studied already led to determine the origin of the iconography of the Trinity in Ethiopia.

The first seven triptychs show a striking uniformity of their style, composition and multiple subject matter; T5 has a few characteristics of its own. It is believed that all originate from the same scriptoria which were situated in Tegrē. Perhaps T2 and T3 were made by the same hand.

In all triptychs the rendering of the subject is particularly sober, yet the meaning of the themes depicted except in one case is clearly expressed. The Trinity and the Elders of the Apocalypse whom Ethiopians call Priests of Heaven (see p. 132f.), both depicted in the main panels are an entirely new theme in 16th-century painting. Equally new is a presentation of the life of Christ in a series of pictures in the wings.

The series contains the following subjects: Annunciation, Nativity, Circumcision, Baptism of Christ, Crucifixion, Entombment, Ascension, Descent into Limbo or Harrowing of Hell.

The choice and rendering of the subjects differ from those in miniatures in early gospels. The important subjects namely the Flight into Egypt, the Marriage in Cana and the Entry into Jerusalem are missing. These subjects are virtually always found in the miniatures illustrating the gospels. On the other hand a new subject, the Circumcision of Our Lord, is added.

The choice of the subjects does not accord with the liturgical division of the corresponding feasts in the Ethiopian Church: the series includes the main as well as secondary subjects.[7] Moreover, the combination of these with the subject of the Trinity is unique. Such series of Christ's life are not found in other 16th-century triptychs nor in any known painting on wood starting from the 17th century.

In all our triptychs the choice, order and rendering of the subjects, save very minor changes, are identical. This leads to the conclusion that the triptychs either follow a pattern elaborated in the scriptoria of Tegrē, or more probably originate from a particular painting, also a triptych, which has served as model to all the above paintings. The following is an analysis of the themes depicted in order to identify the characteristics of the prototype and possibly to establish the dating of the triptychs.

The Annunciation does not follow a version found in early miniatures and in a well-known mural at Lālibalā. Instead of Mary seated and spinning, she is standing and seems to have her hands pressed against her breast. St. Gabriel neither makes the usual gesture of greeting her nor carries a staff. Perhaps this poor rendering of the Annunciation was due to the lack of space.

In the Nativity, the representation of the tender mother embracing her new-born Child seems to be inspired by Western art and marks a clear departure from the miniatures following the Oriental tradition. There is written evidence that a

[7] *B. Velat*, Etudes sur le me'erāf, commun de l'office divin éthiopien; introduction, traduction française, commentaire liturgique et musical = Patrologia orientalis XXXIII (1966) 22–5.

European painting of the Nativity was brought to Ethiopia in 1542.[8] This indicates that Western models possibly played a rôle in shaping the 16th-century iconography of the Nativity. The writer does not pretend that the above painting was used as a model for depicting the Nativity in the triptychs, though the possibility cannot be excluded. Joseph and Salome are missing and the heads of the beasts are depicted instead of their figures. This was obviously due to the small space allotted to a subject.

In the Baptism of Christ, St. John is placed on the left of the Saviour according to an archaic form. Starting with the 15th century, John is virtually always placed on the right of Christ.[9] The dove and the angels carrying Christ's garments are missing. Both Christ and John are immersed up to their chests in the Jordan river which is figured by a blue square. This is also an archaic feature in the rendering of the subject.

The next picture represents an old man holding the naked Child while another performs his circumcision. The fact is commemorated by the feast on 6th of *Terr* (January 13) which is secondary in the Ethiopian liturgical calendar. Circumcision is briefly mentioned in Luke 2,21. Since the father of the house usually was the minister of the circumcision, it would seem that St. Joseph performed this ceremony for Christ. However in art it is usually the high priest who does it.[10] The Christian Ethiopians practice circumcision along with other customs of the Old Testament. They have given to it a religious significance and insisted on its importance. According to Francisco Alvarez the Ethiopians believed the circumcision to be "commanded by God".[11] The Circumcision of Christ appeared late in Christian art. The Menologion of Basil II, 979–84, contains a picture representing the arrival of Mary and Joseph at the temple and their meeting with the priest, *mohel,* who will perform the ceremony. The actual moment of it is not shown. The subject became popular during the 14th, and particularly, the 15th century. Italian painters, including the Venetians, depicted the Circumcision in a realistic manner, with the naked Child and the *mohel* holding a knife in front of him. Has the popularity of the theme in Europe some relation to its introduction into Ethiopia? The Circumcision is found neither in gospel miniatures nor in early murals. On the other hand we find it in a Book of Miniatures by Nicolò Brancaleon (p. 383). The Circumcision he painted is different from those in the triptychs. Nevertheless, there is an intriguing coincidence. The Circumcision of Christ appeared in Ethiopian art as late as the 16th century either during the lifetime of Brancaleon or shortly after his death. Moreover, the popularity of the theme was apparently limited to those scriptoria which produced the triptychs discussed.

[8] *M. de Castanhoso,* The Portuguese Expedition to Abyssinia ed. by *R. S. Whiteway* (London 1967) 125.

[9] *S. Chojnacki,* A Note on the Baptism of Christ in Ethiopian Art = Annali dell'Istituto Orientale di Napoli 36 n.s. 26 (1976) 103–15.

[10] Dictionnaire de la Bible 2 (1912) 772–80.

[11] *F. Alvarez,* Narrative of the Portuguese Embassy to Abyssinia during the years 1520–1527 Tr. by *Lord Stanley of Alderley* (London 1881) 48.

Indeed, the Circumcision of Christ is neither found in other groups of 16th-century paintings nor recorded in those of the Gondarene era.

The Crucifixion shows the early as well as late iconographic characteristics. For example, in T2 the feet of Christ are clearly outstretched while in T1 and T3 they are over-lapped and pierced with one nail. The former is found in Crucifixions prior to the 15th century, the latter after that date. The anthropomorphous sun and moon are usual additions to the 16th-century Crucifixions. On the other hand, mounds of stones and earth on which the cross is set up, and the skull of Adam, also common features of 16th-century Crucifixions, are missing. Moreover, there are square or slanted rectangles at the bottom of the stem of the cross which represent foot-boards *(suppedaneum)* on which the feet of Christ are resting; these are symptomatic of 15th-century Crucifixions.

To sum up, we witness the transitional stage of the iconography of the Crucifixion which probably lasted from the last decades of the 15th until the middle of the 16th century. The Crucifixions contain two unusual details. The legs of Christ are tied to the cross either with thin ropes or cords, besides being nailed. Nails are not mentioned in the gospels, except the passage of St. John's describing how Christ appeared to Thomas after his resurrection (20, 27). Nevertheless, it was generally accepted that nails were used for affixing Christ to the cross. Consequently he was represented in that way, though, exceptionally he and the thieves are not nailed to the crosses but bound to them with bands crossing over their chests.[12] The thieves usually have their hands and legs transfixed with nails, for example in the sixth-century Rabula gospels. In Ethiopian Crucifixions Christ is nailed but the thieves bound to their crosses. This practice is consistently followed by the 14th and 15th-century painters. No Christ tied to the cross with ropes around his legs is known to the writer. Perhaps this unusual detail in our triptychs mirrors the local commentaries on the way Christ was crucified but also another explanation of it is possible. The works of Brancaleon evidence his tendency of portraying ropes as means of enhancing the drama of the events depicted. For example, the Christ in the Flagellation is tied to the pillar. On his way to Calvary he is pulled by a rope held by a soldier. In scenes of St. George's martyrdom, the Saint often has his legs tied. Perhaps this frequent use of the rope motif by Brancaleon induced Ethiopians to do the same and use it for their representation of the Crucifixion, though in Crucifixions by Brancaleon known to us, the Christ does not have his legs tied to the cross.

Another unusual detail is a reversed position of Mary in relation to St. John: she stands on the right and John on the left. This is unique in Ethiopian art.

The rendering of the Entombment marks a dramatic change of its early iconography. The tomb has disappeared altogether and the body of Christ is directed to the left, instead of to the right. Joseph and Nicodemus seem to lower it into an open ground represented as a band of dark blue. This new form, based on the Ethiopian practice of disposing of the dead, developed in the 16th century and was used extensively in the art of successive centuries.

[12] 6th–7th-century Syriac silver plate found in Perm (Leningrad). SchillIc II 92.

In the Descent into Limbo Christ stands in the middle and grasps the hands of Adam and Eve, both placed on each side of him, according to the pattern used in the 16th century. In the same period, the broken gates of Hell were replaced by the devil and the banner was put in Christ's hands. Banners as well as devils are missing in all triptychs, while the broken gates are shown in one instance. Therefore it is suggested that this not fully developed composition should be ascribed to the first half of the 16th century.

In all triptychs except T2, a series ends with the picture of the Ascension of Christ which is unique in 16th-century icon painting. The picture is composed of two separate images, above the Christ in Glory is depicted and below the twelve Apostles.

The rendering of Christ in Glory differs in three ways from that used from the 13th to the 16th century. The bust of Christ is shown instead of his full figure. He does not hold a book or a scroll in his left hand as he always does in the miniatures of the gospels. His round mandorla is supported by two angels instead of by four Living Creatures, (comp. painting on cloth, Dāgā Eṣṭifānos, pp. 420 f.). Moreover, the lower half of the body of the angels is hidden behind the mandorla. In T6 one angel only supports the mandorla with his hand and both angels lack wings. In T5 even the mandorla is left out and thus the angels seem to uphold Christ who exceptionally carries a book in his left hand.

The form of Christ in Glory in our triptychs evidently springs from the iconographic source which is different from that of the form with the Living Creatures. The prototype of the former included two flying angels who supported the glory and the Christ who did not hold a book in his left hand. Two or four angles supporting the mandorla are well-known in Eastern Christian art, particularly in the art of the Armenians.[13] Here however, the angels are drawn with their legs fully outstretched and thus their flight is rendered effectively.

Whatever the source of the form under analysis, two facts should be noted; it did appear in Ethiopian painting as late as the 15th–16th centuries and it passed through significant transmutations before the Tegrē painters used it for their triptychs.

The form of Christ in Glory is obviously meant to be viewed jointly with the Apostles arranged in two rows of six and to express one iconographic proposition. In T3 and T7, the image of Christ in Glory is placed below the picture of Mary and above the Descent into Limbo; it is thus separated from the Apostles who are depicted at the bottom of the wing. In T1, the Christ in Glory is placed immediately above the Apostles. The painter made an iconographic juxtaposition of these two themes as in early miniatures, obviously intending to represent the Ascension of Christ. He did not include the Virgin though she is usually shown in the middle of the Apostles, but he rearranged the upper row to express their witnessing the Ascent of Christ. In T5 the Apostles are placed directly under the double composition of the Descent into Limbo and the rather ineffective rendering of Christ in Glory. However, the Apostles do not turn towards Christ but look in the opposite

[13] *L. A. Dournovo*, Armenian Miniatures (London 1961).

direction. We can conclude therefore that in T3 and T7 two separate forms, that is of Christ in Glory and that of the twelve Apostles should be considered as parts of the picture of the Ascension. This, in fact is attested by the inscription in T7.

In addition to the cycle of the life of Christ, the panels include the saints on horseback and the picture of "Mary with her beloved Son".

All equestrian saints, including St. George, hold spears slanting upwards in one hand and reins in another. The dragon and snake are missing altogether. This representation of equestrian saints is found in 15th and early 16th-century paintings on wood.

The form of the Virgin is typical of the 16th-century art. According to the typological chronology, the form followed those of the nursing Virgin and the Virgin under the canopy of wings, but preceded the image of S. Maria Maggiore introduced at the turn of the 17th century. The Child is always seated on Mary's right arm. Her mantle is so wide at the bottom as to give to the figure the form of a triangle. The wings of the guardian angels are folded. In T1 and T3 the veil of the Virgin runs down on the left side of her head and neck leaving the other side uncovered. This draping is well-known in 15th-century portraits of Mary. In T2 a veil already covers both sides of her head.

Another indication for dating is found in the triptych T5 in which there is a flower, in fact, a stem with three buds in Mary's hand. Such a flower is symptomatic of her 15th-century portrayals, but obviously its use continued for a few decades of the following century. These details indicate the transitional character of Mary's picture in our triptychs.

The T5[14] provides an additional evidence for dating. The painting is outstanding by its soft drawing and gamut of deep-brown and blue colours. Moreover, each theme is framed in a kind of arch supported by a column. This setting does not seem to bear similarity to the tympana of the Canons of Eusebius in early gospels, but to the structures in a Book of Miracles of the Virgin Mary, most probably illustrated by Nicolò Brancaleon (see p. 393). In the Book some scenes of Mary's miracles are placed in an arched niche supported by a slender column. This setting seems to have inspired the painter of T5. It reappeared a century later in the First Gondarene manner of displaying the Apostles.

The above analysis leads to the conclusion that the seven triptychs were painted in the first half of the 16th century. This is corroborated by their style. Although the group is characterised by a progressive stiffening of drawing it still bears the main stylistic elements of the 15th-century icon painting which show some relation to Islamic art. The faces have rounded chins, elongated eyes, strongly pointed at their outer ends, short and upward slanting eyebrows and small mouths usually traced by two short lines.

The main subjects of the triptychs, the Trinity and the Elders of the Apocalypse, are depicted in the main panel, the former in the upper register and the latter below

[14] At the top of the main panel there was a long inscription certainly indicating the donor of the painting. Unfortunately the large portion of the inscription vanished. The partial reading is: "my mother Amata Māryām".

it. The Elders are usually displayed in two rows of twelve in each row. In T4 there is a third row of fifteen, and in T6 of thirteen prophets.[15] In T5 a third row of bearded figures most probably represent prophets. The Trinity is rendered as three identical old men who are shown frontally. The faces are surrounded by white hair and beards. The noses have their tips and nostrils flat and enlarged giving the impression of three concentric circles. The eyebrows are drawn with a strong line and additionally with multiple short lines above and below it. This manner of delineating noses and eyebrows is symptomatic of the group. The Persons of the Trinity wear long, red tunics with bands of embroidery at the neck and large white, or white striped with blue, cloaks over these. The cloaks cover both shoulders and the lower part of the body, the draping of the cloaks on the knees giving the feeling that the Persons are sitting. Each one raises his right hand in blessing and holds a book in his left hand. The pose of the blessing hand shows only the index finger outstretched while the three other fingers are folded but usually without touching the thumb. The Persons are neither surrounded by a mandorla nor a *clipeus* but are flanked by the four Living Creatures. Their placing follows the usual order, namely, the man, the eagle, the ox, and the lion. However, their form differs from that in the gospels. The Creatures do not have human bodies and wings. The lion has a paw and the ox an animal foot instead of human arms and hands as in the gospels. Usually but not always the man and the eagle have nimbi over their heads while the other Creatures do not have them.

In T1, T3 and T7 a narrow rectangular space at the top of the panels is filled with drooping elongated figures. In T3 their form is carefully delineated and they are painted white. These figures are most probably meant to be eyes and thus belong to the complex image of the Living Creatures. The whole is a pictorial definition either of the vision of Ezechiel 10,12 or the Revelation of St. John 4,8 who saw that "round about and within they [Living Creatures] are filled with eyes".

The Elders of the Apocalypse in the upper row face to the left while those in the lower row to the right. They are invariably rendered as beardless youths. They wear long tunics and a kind of cape open in front and thrown over their shoulders. Only one hand is shown. In some triptychs the Elders carry censers.

The following two paintings belong to the group A but differ from the above by choice and arrangement of the secondary subjects.

(8) The diptych, IES Coll. No. 7071 (fig. 36) has the Trinity depicted in the right panel and an equally large picture of Mary and Child in the left panel. The Elders of the Apocalypse are distributed evenly in both panels and a small figure of St. George is added to the left one. The portrayal of the Virgin is obviously of Western origin. She wears no veil instead her long flowing hair is bound up with a narrow diadem, an arrangement clearly inspired by a style favoured by the Renaissance women in Europe. St. George has a spear slanting upwards. All this indicates that the diptych was painted at the latest in the first decades of the 16th century. The Persons of theTrinity are similar

[15] The other count is 16 prophets, four great corresponding to four gospels, and twelve minor corresponding to an equal number of Apostles.

to the ones in the T group triptychs except for the white colour of the tunics and cloaks and the rather schematic drawing of their legs. The tunics are embroidered in front. All three Persons hold one book only which is placed on the lap of the middle Person. Also the arrangement of the Living Creatures is unusual. The man is depicted on the left and the eagle on the right, but the ox and the lion are under the Trinity. The man is shown in profile and has rather a beastly silhouette recalling that of the eagle. Each Creature has two wings as well as a nimbus. The Elders wear white tunics as well as pointed caps and carry censers.

(9) The Trinity depicted in a small panel, IES Coll. No. 3898 (fig. 37) is particularly significant for the discussion because each Person is identified by an inscription: the Holy Spirit on the left, the Son in the middle and the Father on the right. The general composition and the details follow the type just described but the execution is more schematic and the Persons are placed in a square corresponding to the shape of the panel.[16] Two of the four Living Creatures bear some resemblance to animals well-known in Ethiopia's everyday life; the ox has a hump and the lion a mane; on the other hand, the eagle is rendered according to the usual schema with a round head and long beak, unlike the real eagle. The Living Creatures do not have wings, instead their heads are adorned with nimbi.

Group B

The following two paintings are given as examples: triptych No. 4463 and triptych No. 3992, both property of the Institute of Ethiopian Studies, Addis Abābā. Their origin in Ethiopia was not recorded, but the presumption is that they originate from the Tegrē province.

(10) The triptych No. 4463 (fig. 38) belongs to the group D of the 16th-century paintings according to the classification proposed by the writer.[17] It contains two themes from the life of Christ, the Harrowing of Hell and the Crucifixion on the left and right wings respectively, below the twelve Apostles divided into two groups of six with St. George the dragon-slayer and St. Victor at the bottom.

The Trinity is represented in the upper register of the main panel, the Elders of the Apocalypse in the middle and the Virgin with Child at the bottom. Such placing of Mary is quite unusual and probably due to the change of subject-matter in the course of painting. In fact, there are fourteen Elders only instead of twenty-four. Obviously Mary has replaced the ten missing. Her portrait contains two details

[16] Geometrical figures had a symbolic meaning; the square was considered by Mediaeval theologians as a perfect form and a symbol of God. Spherical shapes imply rotation and movement, while squares, according to Denis de Chartreux symbolize the divine stability and immutability. Whether Ethiopian theologians or painters had such ideas is hard to say. It should be recalled that rectangles, squares, circles and ovals were used by them for framing the figures of Christ as well as God the Father.

[17] ChojArtEthE 91.

probably evidencing the Western impact on Ethiopian art. These are the orb which the Child holds in his left hand and the pose of his right hand. The orb appeared in Ethiopian painting around 1500 (see p. 119). Moreover, his hand shows two fingers, the index and middle finger outstretched, and the two last fingers folded. The same pose is found in the next triptych. The rendering of the Trinity follows the pattern already described but with significant modifications. The Persons are framed in an irregular mandorla while the Living Creatures are reduced to inconspicuous heads. Moreover, the strongly schematic drawing of the garments does not show the folds on the knees. As a result, the Persons seem to be standing instead of sitting. A blessing pose of their hands is identical to that of the Child in the same triptych. Another innovation, perhaps secondary but of interest, is the way of drawing the hands in relation to the book. In earlier paintings the Persons keep their hands over the book which is resting on their knees while in this painting they hold it firmly by its upper edge.

The Persons have brown hair and beards instead of white. This change of colour which is not an oversight of the painter was noted in a number of paintings ascribed to the second half of the 16th century.

Some Elders hold crosses in their hands. The crosses are drawn from life and are easily identified as iron made with an elongated lower arm which is probably the oldest type of hand cross in Ethiopia.

(11) The multiple-subject triptych No. 3992 (fig. 39) seems to be an attempt at reproducing on a small scale the composition which the beholder would expect to find in church murals. Indeed, some fourteen subjects are displayed harmoniously and interpret dramatically the Trinitarian concept. In the upper register of the main panel, the Father, the Son, and the Holy Spirit, one God, are depicted. In the right panel, the Theotokos holds the Logos Incarnate in her arms for thus the God was revealed to the generations of the age of Grace. The redeeming mission, the Passion of the Logos Incarnate, evolves in the lower register of the main panel and culminates in the image of the Crucified. Lastly, the Harrowing of Hell which in Eastern Churches symbolizes the fulfilment of the Redeeming is depicted in the left panel and graphically expressed by the figure of Christ spearing the keeper of the door of Hell.

The rendering of Mary and the Child and of the Harrowing of Hell mirrors the Eastern Christian art, whereas the pictures of the Passion contain the scenes which evidence the Western impact. These are the Christ carrying the cross and the Flagellation. Both scenes do not appear in narrative miniatures of the early gospels but are found in the panels of the box at the Gētēsēmānē Māryām church (see p. 390). The contention is that the box was painted by Brancaleon. Moreover, the figure of Salome consoling the Virgin at the Crucifixion is symptomatic of his art. Also the arched upper tier of the triptych, rare in Ethiopian icon-making, evidences the Western influence, probably Italian.

There is much similarity between the Trinity in our icon and that in icon No. 4463 except the standing pose which is more evident in the former than in the latter and the hair which is white instead of brown. Their nimbi are plain yellow, not cruciform. On the other hand, the figures of the Elders have been iconographically

developed. Each one wears a pointed cap which stands for a crown referring to Saint John's Revelation and holds a censer in one hand and a cross in another.

The above paintings signify the end of developments in the 16th-century iconography of the Trinity.

Group C

To this group belong the painting and pen drawing which have certainly been made by a foreigner. Both are ascribed to the first two decades of the 16th century and thus chronologically precede all paintings discussed above. They differ in technical plan from all previous works.

(12) The Book of Miracles of the Virgin Mary, Tadbāba Māryām church in Amārā Sāyent, Wallo,[18] is described on pp. 393–95.

Among many drawings illustrating the miracles, there is one which combines the image of the Trinity in the upper register with that of Mary and Child in the lower register (fig. 40). The Trinity enclosed in a mandorla is flanked by four standing angels and ten elderly prostrate men, all divided into two groups of two and five respectively. The angels carry no swords as is usual in Ethiopian painting but hold their hands crossed on their chests. Their wings are folded. The old men kneel and bow deeply to the Trinity. Perhaps they are the Apostles, though in Ethiopian art these are usually shown in their full number of twelve.

The lower half of the mandorla surrounding the Persons of the Trinity is filled with three curved stripes which most probably signify the "spheres" of the heavens. The Persons are sitting and the folds of their white garments clearly show the shape of their knees. The cloak over these covers both shoulders leaving a triangular collar open at the neck. The faces are round, the noses flat and the dark hair covers the shoulders. The heads are ornamented with a cruciform nimbus. Each Person has the right hand raised, its fingers arranged according to a probably Latin pose of blessing. In their left hand they hold a book posing the hand on its upper edge. This rendering of the Trinity bears striking similarity to that of God the Father in the Walatta Dengel's Book of Miniatures (see p. 126). Moreover, our Trinity drawn by a foreigner is analogous to the 16th-century paintings of the Trinity by Ethiopian painters.

In the lower register, the female figure holding the chubby naked Child on her lap is obviously the Virgin Mary though she is not graced by a nimbus. She rests on a large cushion which is pointed at the edges and recalls the Byzantine Imperial seat. Whenever Mary is represented in the Tadbāba Māryām Book of Miracles she is always seated on this kind of cushion. Mary reposes relaxed with her legs comfortably stretched. She does not wear a veil on her head, instead her long hair flows down over her right shoulder. This interpretation of Mary is well-known in Italianized Ethiopian paintings from the second half of the 15th century. In the same period there appeared the figuration of the naked Child.

[18] The church which lost much of its great importance of the past centuries was visited by Diana Spencer and described in SpenLuke 67–71; 74–81.

The European art of the period created similar compositions exalting the Trinity. For example, the well-known work of Jean Fouquet,[19] c. 1450, is also expressing the theological foundation of the growing cult of Mary. The three divine Persons preside on the bench with separate canopies and their magnificence is enhanced by the chanting hosts of the entire Paradise. Mary sits on an equally elaborate throne on the right of the Triune God. She is alone without the divine Child. Obviously she seems to be equal to the Trinity in the celestial hierarchy because of her attribute of the Immaculate Conception. "To support this idea", writes Mirella Levi D'Ancona, "contemporary writers had often quoted the verse from Eccl. 24 : 14 'From the beginning and before the world, I was created, and unto the world to come I shall not cease to be'".[20]

Brancaleon's composition evidences a different theological proposition. The Virgin's glory derives from her divine maternity. Therefore the presence of the Incarnate is essential and gives the full meaning of the composition. Brancaleon's drawing truly interprets the position of Mary in Ethiopian religious thinking.

(13) The triptych in possession of St. George's church, Dimā in Goǧǧam,[21] is tentatively dated to the third decade of the 16th century (pp. 404f.).

The Trinity (fig. 41) is represented in the upper register of the main panel and the Virgin and Child flanked by St. Michael and St. Gabriel in the lower register. In the wings the Apostles Peter and Paul, St. John the Baptist as well as St. George killing the dragon are depicted.

The Virgin sits under the canopy; she is dressed in the European manner. A naked Child on her lap stretches his hand towards St. Gabriel. St. Michael is trampling over the devil and St. George, clad in European armour attacks the monster with a sword instead of a spear. The other saints read from an open book. A European landscape with trees, houses and a castle on the mountain is depicted in the background. Plainly this part of the painting is European in concept and execution.

The Trinity identified by the caption is personified by three identical old men who wear crowns, hold orbs in one hand and raise the other for blessing which is according to the Latin rite, i.e. two fingers, index and middle, are outstretched and the rest are folded. The neatly combed hair of the Persons is dark brown while the long beard is greyish. They are clad in royal or papal attire which consists of a kind of white surplice with large sleeves, a dark brown band running across the chest and carmine robes trimmed with ermine, covering the shoulders and legs. The Persons are seated on a wide *synthronos*, a bench with high back which is obviously meant to symbolize the oneness of the Trinity. The clouds surround the Persons; over

[19] In the Book of Hours of Étienne Chevalier, Musée Condé, Chantilly.

[20] LeviImmCon 28.

[21] Important church situated on the high plateau above the Blue Nile Gorge, c. 30 km northeast of Baččanā, Goǧǧām. The treasury of the church is famous for the richness of books, works of art, old church vestments and other paraphernalia. Described by *P. B. Henze*, Ethiopian Journey: travels in Ethiopia (London 1977) 239–43.

these, the four Living Creatures are depicted in circles; they are rendered in full figure and with much realism. Except for the man they are wingless.

This representation of the Trinity is European in concept and execution of details. The Living Creatures rather recall the symbols of the Evangelists, well-known in European art, than the anthropoid creatures found in Ethiopian miniature painting. The conclusion is that the painting has been made by a foreigner and most probably in Ethiopia; the latter is suggested by a Geez inscription above the Holy Trinity.

ORIGIN OF THE ETHIOPIAN ICONOGRAPHY OF THE TRINITY

What is the significance of the two above works? They make it possible to substantiate the theory that the Ethiopian iconography of the Trinity is of European origin. This is evidenced by the following facts.

(a) At the beginning of the 16th century there existed in Ethiopia pictures of the Trinity which were made by European artists. The pictures represented the figure thrice repeated of the divine Person.

(b) In one of these paintings the Persons are seated, wear a cruciform nimbus, have the right hand raised in blessing and hold a book in their left hand. All these characteristics are found in 16th-century Ethiopian paintings of the Trinity.

The conclusion is that the Ethiopians either copied or were inspired by the paintings made by Europeans. However, two additional questions should be clarified. The first is whether pictures of the Trinity existed in Ethiopia before the 16th century. The second is the type of representation of the Trinity that was then used in Europe.

Let us start with the second question.

In Christian art, the representation of the Holy Trinity was one of the most difficult iconographic problems. In Paleo-christian art "no satisfactory iconography of the dogmas of the Trinity has ever been achieved" according to A. Grabar, "and the best proof of it is that all the iconographies that have ever been proposed have been rapidly abandoned." Among three early attempts at representing the Trinity one is known only by a single example on the sarcophagus in the Lateran Museum; it consisted of three identical figures, one seated and two standing. "The failure of such a figuration" continued Grabar, "is understandable, since it retains only the idea of the identity of the three divine Persons, entirely rejecting their unity".[22] Yet, the concept of representing the Trinity by three

[22] GraChrIc 112. The same author in his: La réprésentation de l'Intelligible dans l'art byzantin du moyen âge = Actes du VIe congrès d'études byzantines Paris 27 juillet–2 août 1948, III (Paris 1951) 131 f., gives examples of the Byzantine figuration of the Trinity in which either two persons are identical (Paris graec. 64) or have different hair (Paris graec. 923) or even dissimilar, the elder in the middle, Christ with beard and Christ adolescent on his sides (Paris graec. 74). These figurations bear no direct relation to our discussion but are worth mentioning.

identical figures reappeared in the art of Western Europe as well as in the art of the Ethiopians. Other figurations of the Trinity, less direct and more allegorical, are based on events described in the Old and New Testaments. One of them, the Baptism of Christ "is the iconographical interpretation of the Trinity that survived the Paleo-christian period and that remained valid throughout the Middle Ages and into modern times. It had the advantage of being supported by a phrase of the Gospels which affirms that at the moment of baptism of Jesus there was a simultaneous theophany of three Persons: the voice of God the Father was heard descending from heaven; God the Son stood in the waters of the Jordan and God the Holy Ghost appeared as a dove hovering above the Son."[23]

The other attempt at representing the Trinity is called Philoxenie, the Hospitality of Abraham or the Trinity of the Old Testament. It was used in Oriental Christianity and in areas strongly influenced by Byzantine culture. According to the passage from Genesis 18, three men appeared to Abraham while he was staying in the vale of Mamre. They were interpreted by Church Fathers, among others by St. Ambrose[24] and St. Augustine,[25] as a manifestation of Godhead, three in one. Abraham's three visitors grouped around the table and shown as angels are well-known in Eastern Christian art. The earliest examples of the Philoxenie date from the 5th century; the theme is found in several Byzantine and related mosaics and paintings on wood dated to the successive centuries up to the 15th century.[26]

These hesitations and weakness in representing the Trinity are understandable when one considers polemics of the early Church Fathers devoted to the definition of the Holy Trinity. Particularly the question of whether it is possible at all to make an image of God the Father was of primary importance for the iconography of the Trinity. "Since the Gospels", writes Grabar, "thought that God in heaven, God the Father, is invisible, he has never been represented as he is, in his essence. But there are several well-known exceptions to the general rule of the invisibility of God. The prophets, notably Isaiah and Ezekiel were able to contemplate God with their own eyes. The conclusion therefore follows that since the theophany was accorded to these prophetic visionaries, their description of it authorizes its pictorial representation ... In contradiction also to the numerous affirmations of the theologians who continued to deny the possibility of representing God in heaven pictorially, these images made their appearance soon after 400 and were never abandoned afterwards."[27]

In Western European art the representation of the Trinity or the figure three times repeated developed in the 10th through to the 12th century.

The theme in concept is close to the Philoxenie but has been entirely reshaped in

[23] GraChrIc 115.

[24] Sancti Ambrosii Mediolanensis Episcopi Opera Omnia = *J. P. Migne* (ed.) Patrologiae cursus completus ser. pr. XIV (1845) I 1 435.

[25] Sancti Aurelii Augustini Hipponensis Opera Omnia = *J. P. Migne* (ed.), Patrologiae cursus completus ser. pr. XLII (1845) VIII 809.

[26] RéauIc II 1 20.

[27] GraChrIc 116.

the Occident. According to A. Didron, the drawing in the manuscript of St. Dunstan, Archbishop of Canterbury who died in 908, was the earliest known example of this kind of representation of the Trinity. "The Father and the Son, clad in kingly apparel, with crowns on their heads and sceptres in their hands, both appear to be about thirty-five years of age. The Holy Ghost is younger, and scarcely more than eighteen or twenty-five. A similarity of person is apparent, but a difference in point of age. That latter difference finally disappears, and in the manuscript of Herrade, dating from the year 1180, it is replaced by absolute identity. The three Divine Persons are of the same age, in the same attitude, of the same temperament; all wearing also the same costume."[28] Réau and other authors added a number of examples, as the 12th-century miniature in Hortus Deliciarum, the 14th-century Augustinian missal presently in Toulouse and the 15th-century Book of Prayers of the Duke of Berry.[29]

The figures are disposed horizontally, seated or standing, and usually facing the front; they are similar in age and facial expression. They carry identical attributes of their dignity, an orb surmounted by a cross and either a crown or a papal tiara on their heads. This mode of representing three rigourously identical Persons: the symbol *Quicumque, talis Pater, talis Filius, talis Spiritus Sanctus*, was particularly favoured in the 15th century.

At times, elements of identification are introduced; God the Father is wearing a papal tiara, the Son has wounds on his side and leg, the Holy Spirit has wings. In other cases, they hold their attributes, the Father an orb, the Son a cross and the Holy Spirit a dove or book. In order to express the unity of the three, the Persons wear one mantle, or sit on one large bench.

Another form of the theophany called Throne of Grace, which was first seen in England[30] and then spread in French, Northern Italian and German works,

[28] DidrIc II 40.

[29] RéauIc II 23; *K. Künstle*, Ikonographie der christlichen Kunst (Freiburg i. Br. 1928) 220–22; *A. Hackel*, Die Trinität in der Kunst; eine ikonographische Untersuchung (Berlin 1931); *A. Heinemann*, L'iconographie de la Trinité et son développement en Occident = L'art chrétien (1934); *F. De'Maffei*, Christian World and the Representation of God = Encyclopedia of World Art IV (New York 1961) 407–20.

[30] Alabaster carvings, 13th–14th century in Victoria and Albert Museum. These trinitarian compositions include God the Father wearing pointed tiara who holds with his hands a piece of cloth from which three heads of the youth are protruding. This is an obvious allegory of the three visitors of Abraham at Mamre. Below there is Christ on the cross. His hands are raised. Two angels kneel on both sides of the cross, they hold the cups into which blood is flowing. In the carving no. 28–1946 the general composition is the same, except that in the cloth there is one winged youth (this probably represents the Holy Spirit), instead of three; three cups are placed at the endings of the *patibulum* and one at the stem of the cross; blood flows from Saviour's wounds into the cups. Around the cross there are four symbols of the Evangelists.
Trinity with Christ crucified: Austrian school, National Gallery, London, 15th century; Barnaba da Modena, 1362–83, No. 2927, National Gallery, London; The Throne of Grace was also painted by Filippo Lippi.

represents God the Father placed behind or rather abover Christ who is on the cross. God the Father may hold each end of the *patibulum* or cross-piece in his hands or he holds a book bearing the Greek letters alpha and omega. These two Persons are interconnected by the dove placed just above Christ's head.

Western painters obviously felt that the three similar figures, while adequate in expressing the identity of three Persons, did not sufficiently emphasize their unity. They tried to improve the composition. After the 13th century "not only do the divine figures *touch* but they actually cohere. The three bodies form now one only with three heads which later in their turn are completely welded together".[31] These tricephalous images of the Trinity vaguely recalling the Hindu *Trimurti* degenerated into such works of monstrosity and bad taste that they were denounced as sacrilegious by some theologians in the Middle Ages and censured by the Council of Trent. Eventually Pope Urban VIII, by a bulla of August 11, 1628, prohibited representing the dogma by the figure with three heads on one neck, under threat of excommunication. He ordered to burn such existing images of the Trinity which accounts for their rarity nowadays. Pope Benedict XIV in 1745 prohibited altogether the representation of the Trinity as the human figure three times repeated.

Long before the papal condemnation was issued, the "normal" representation of the Trinity as three human figures already fell into disuse. Not particularly common during the Middle Ages and the Renaissance, the form was not favoured by the Counter-Reformation and virtually disappeared at the end of the 16th century.

The conclusion of the above is as follows.

At the time Brancaleon made his drawing and other European artist in Ethiopia the painting of Dimā Giyorgis, the Western European painters still used to represent the Trinity by three identical figures. Therefore, Brancaleon and the Dimā Giyorgis artist reproduced a European model as known to them.

Could they follow an Ethiopian model? Obviously not since there was none. We find no representation of the Trinity as the figure three times repeated among a large corpus of Ethiopian miniatures, paintings on wood and murals from the 13th century until the end of the 15th century.[32] Moreover, in the following centuries, only one form of the Trinity was painted, namely that as described above. Ethiopians evidently did not know other forms. The Oriental theophany, the Philoxenie, was not yet found in Ethiopia.[33] Also, in representations of the

[31] DidrIc II 44f.

[32] Francisco Alvarez in his report to Archbishop of Braga writes "In the churches there are many figures painted on the walls. Figures of Our Lord and Our Lady, and of the Apostles and Patriarchs, and prophets and angels and in all the churches St. George" AlvPrJ 514. Alvarez does not mention the Trinity.

[33] The only possible example of the Philoxenie is found in Psalter from Dabra Warq, p. 395. Among its numerous miniatures, there is one in which three standing youths are depicted. Their rendering does not accord with the Byzantine form, they neither have wings nor sit at the table. However the three youths are included in the sequence of the twenty-four Elders of the Apocalypse who in the Ethiopian context usually accompany the theo-

Baptism of Christ, except for two miniatures, the trinitarian concept is not particularly evident.[34]

To sum up, in Ethiopian painting, until the beginning of the 16th century, there was no figurative representation of the Trinity. At that time, two foreign painters introduced the model from Europe in which the Trinity was depicted by three identical persons. Apparently, the model suited local beliefs and attitudes and therefore was accepted and reproduced in great many copies.

It is a well-known fact that Christian iconographers rarely created an entirely new form. Usually they borrowed the already existing models and transformed these according to local requirements. The subject of the Trinity is such a case.

The exact circumstances in which the foreign model influenced the Ethiopians and was copied by them are not known. However, the comparison of the Dimā Giyorgis painting and Brancaleon's drawing with the early Ethiopian images of the Trinity shed some light on the process of adaptation.

The first question is how the two works kept at present in Goğğām and Wallo became known to the scribes of Tegrē. It was suggested that the production of the early paintings of the Trinity was limited to one or a few scriptoria in that province. Dimā Giyorgis and Tadbāba Māryām church are situated in Goğğām and Wallo respectively far from Tegrē.

There is no indication that both works were originally made for the churches in which they are kept nowadays, but it is also evident that the triptych and the book have been in possession of both churches for many centuries. The possible explanation is that in the 1530s during the invasion of Aḥmad Grāñ, the Christians from Šawā and Wallo as well as the royal court, while retreating before the invader, used the monasteries and churches of Goğğām as hiding places for church paraphernalia

phany. *Jules Leroy* who reproduced the miniature in LerEthG pl. 16 thought that "from their youthful aspect and their similarity to each other, these figures recall the three young men in the furnace or even more probably the three angels who appeared to Abraham (Gen. XVIII) in whom the Patriarch recognized a symbol of the Trinity. But these explanations remain very hypothetical ..." (LerEthG 52). Yet, this type of composition had a special significance in 15th-century Ethiopia, as it appears from the following passage in the Acts of Marḥa Krestos, the Ethiopian saint of the period. He saw a church in fire. When he entered it he found it full of smoke from the incense. He stopped in front of the image of three young men [it was the feast of the Transfiguration] [S. Kur in: CSCO 331 (1972) 29].

[34] One example is a miniature in Berber Māryām Book of Homilies. The main theme is the Baptism of Christ, but the concept of the Trinity is also clearly expressed. The miniature shows the bust of God the Father at the top, a dove placed in a ray of light and below the Son immersed in the pool. Perhaps, the trinitarian symbolism is the result of a successful composition and was not fully intended by the painter. Moreover, as far as the part of the miniature badly damaged allows us to guess, God the Father is rendered as a young, beardless man, has brown hair and wears no cruciform nimbus. Perhaps he has wings. Plainly, there is no connection between this representation of God the Father and his other 15th-century representations. ChojBap 106f. The other example is described on p. 124f. of this book.

and holy pictures. This might be the case with the painting of the Trinity and the Book of Miracles. Dimā Giyorgis is known for keeping its treasures in a cave at the bottom of a ravine, well protected against any intrusion. The works made by the foreigners at the royal court eventually found their way to the hiding places in Goǧǧām and Wallo. At the court the Tegreans might have seen the painting and drawing and either copied these or gotten the idea which they later reproduced in their scriptoria. Considering that our painting and drawing were made shortly before the Moslem invasion, there were few years left for spreading a new icono-graphic idea. The Moslem invasion of the 1530s was followed by that of the Oromo people. Šawā and southern Wallo, the provinces where the royal court resided in the 15th and early 16th century fell under centuries of pagan domination. Any production of holy images virtually ceased except in a few enclaves of Christian Amhārā in Eastern Šawā. The European inspired representation of the Trinity has survived in the north of the country while the models themselves, hidden for centuries in the south, waited for their discovery until the 20th century.

However, most of this story is hypothetical since there are no records referring to the paintings. But the fact remains that the European form of rendering the Trinity reached Ethiopia around the turn of the 16th century and was since then used by Ethiopians.

The second question refers to the process of adaptation. Let us start with the Dimā Giyorgis painting. The artist faithfully reproduced the European type of the Trinity. He made, nevertheless, an important change by introducing into the composition the four Living Creatures. In the European art of the 10th to 13th centuries, the representations of the Last Judgement as well of St. John's theoph-any included the four Living Creatures, but these are only exceptionally used in representations of the Trinity. On the other hand, the Ethiopian theophanies are virtually always accompanied by the Living Creatures, and therefore the maker of the Dimā Giyorgis triptych followed the Ethiopian iconography in this respect. However, he gave these Creatures a wingless animal form, while the typical Ethiopian form is anthropomorphous and with wings.[35] The incorporation of the Living Creatures into the subject-matter proves beyond doubt that the Dimā Giyorgis triptych was made in Ethiopia. The painter placed the Living Creatures in circles which is an arrangement well-known in Eastern as well as in Western Christian art.

Although in general style and in several details the Dimā Giyorgis paintings do not concord with 16th-century Ethiopian painting, this work influenced the early as well as late iconography of the Trinity. Apparently, the Godhead depicted as celestial pope or emperor did not agree with Ethiopian conditions and was there-

[35] In the miniature representing Christ in Glory, gospels of Princess Zir Gānēlā, the Creatures have an animal body but they also have wings. They hold books in their paws and hands. The Creatures represent the symbols of the Evangelists. HeldZG 200f.; 258; This form of the Living Creatures, exceptional in Ethiopian painting, is different from that in our image of the Trinity.

fore changed. On the other hand, the rendering of the Living Creatures in the early image of the Trinity was clearly influenced by the Dimā Giyorgis painting, without being realistic.

The other detail which possibly found its way into Ethiopian painting about that time is the orb. Brancaleon in his Book of Miniatures depicted the Choir of Archangels as holding raised swords in one hand and an orb in another. No crosses are affixed to the orb (fig. 175 e). Similar orbs have been painted by the Ethiopians, as evidenced by late 15th or early 16th-century miniature in IES Collections (fig. 42).

In the 16th century the Persons of the Trinity are mostly depicted with books in their hands, rarely with orbs. In the 17th century the orbs topped with a cross appear in theophanies of God the Father and the ascended Christ, while in the 18th century they became a common attribute of the Trinity.

Brancaleon as well as the painter of Dimā Giyorgis triptych might have contributed to introducing orbs into Ethiopian painting.

The process of Brancaleon's drawing of the Trinity may be reconstructed as follows. The painter followed the European idea of representing the Trinity by three identical figures. He also adopted from Western art the angels and the Elders of the Apocalypse, as well as the prophets and Apostles, who in all probability worship the Trinity. The rendering of the Persons, however, derives from Ethiopian painting. In Brancaleon's drawing the Persons probably mirror the local rendering of God the Father. Indeed, at the beginning of the 16th century, the Ethiopian form of the theophany inspired by the Old Testament, was already fully developed after a long period of trials which is difficult to determine specifically.

THEOPHANY IN EARLY ETHIOPIAN ART

(14) The earliest theophany in Ethiopian paintings which is known to the writer is found in the Book of Prayers from the Monastery of Dabra Saḥel, Šerē, Northern Ethiopia. According to tradition, the book belonged to the founder of the Monastery, Sāmuʾēl of Qoyaṣā, who is believed to have lived in the first half of the 15th century.[36] In addition, the manuscript contains the pictures of two Egyptian saints, Shenute and Pachomius, two 6th-century Ethiopian saints Pạntalēwon and Liqānos as well as a youthful St. Cyriacus. The choice of these saints and their rendering as well as the patterns ornamenting the folios corroborate the dating based on tradition. The inscription which runs, *Beluya Mawāʿēl*, Ancient of Days, identifies the theme of the miniature (fig. 43). The Ancient of Days is depicted in a rectangle and surrounded by four Living Creatures which are framed into another rectangle. He is facing the front and holds in his left hand a small book or a scroll which is placed under his chin and covers most of his beard. He raises the right hand in blessing. His long and slightly curved fingers recalling spider's legs are drawn differently

[36] KRZHagTrad 89.

than fingers in 15th-century paintings. His face is pink, his nose is flat and has large nostrils. His hands and face are similar to those of Christ found in the image of the Ascension in the gospels of Princess Zir Gānēlā dated to 1400/1401.[37] The mouth is rectangular. The tousled white hair and beard are drawn with multiple twisting black lines over the white background. The nimbus surrounding his head is decorated with six oval figures. No neck or arms are shown his body being entirely wrapped in a red-brown robe.

The four Living Creatures have human bodies and multi-coloured wings which are typical of the 15th-century paintings. Their widely outstretched hands support the frame of God's image. The man's face is in profile which is unusual in Ethiopian painting. The eagle is also drawn in profile, while the lion and the ox are in full face. The lion is placed on the right and the ox on the left which is opposite to the usual order. The head of the man as well as the heads of the beasts are adorned with nimbi traced with a double line, which is symptomatic of the 14th and 15th-century paintings. The faces of all the creatures are painted with dark brown colour.

The miniature contains two significant characteristics. The Ancient of Days is rendered as a head-and-shoulders figure, and the fingers of his hand are arranged in the pose described above. In fact, the hand recalls those of the Pantocrator in mosaics of Daphni and Arta, in which he is shown as a bust. This rapprochement does not suggest, of course, a direct influence of Byzantine mosaics on the Ethiopian miniature. Nevertheless, the Ethiopian painter did not reduce the Ancient's body because of limited space, but most probably he borrowed the bust of the Ancient of Days from the foreign model. Close to Ethiopia, in Christian Nubian art, there is the representation of the bust of Christ Pantocrator, placed in a *clipeus*, surrounded by four Living Creatures. At times the arms of the cross serve as a background to the *clipeus*. The theophany was extensively used by Christian Nubian painters.[38] Did it influence the Ethiopian miniature?

Although in Nubian art the facial features, the pose of hands, the way of holding a book as well as the forms of the creatures differ from the Ethiopian, the two important elements of composition are similar. One is the rendering of the theophany as a head-and-shoulders figure and the other the particular treatment of the drapery. *K. Weitzmann* in analyzing the paintings from Faras draws attention to the way of draping clothes. It developed in Nubian painting starting with the second half of the 9th century and lasted until the early 11th century. It consisted of double folds "rendered with soft, dark red brush strokes at fairly regular intervals".[39] Among many Nubian representations of the theophany, the one painted in ʿAbdallāh Nirqi has a red-brown drapery which is surprisingly similar to that of the Ancient of Days in the Dabra Saḥel miniature.

[37] HelZirGan 258.

[38] *P. P. V. van Moorsel*, Die Wandmalereien der Centralen Kirche von Abdallah Nirqi = DinNub 103. The theophany is reproduced in several instances, p. 109 (ʿAbdallāh Nirqi), p. 154 (Kulubnarti), p. 218 (Sonqi Tino).

[39] *K. Weitzmann*, Some Remarks on the Sources of the Fresco Paintings of the Cathedral of Faras = DinNub 328 f.

The image of the Ancient of Days was inspired by the passage of Daniel 7,9 in which "the hair of his head [was] like clean wool". "The white hair in the image of God", writes A. Grabar, "is directly connected with the idea of Eternity. The idea was supported in the beginning by the text of Daniel 7,13 which also inspired the Apocalypse 1,14. The name which the Byzantine have given to the image derives from Daniel and already the Historia ekklesiastikê defines the term as follows: Ancient of the eternal days. Then in the 6th century, Andreas of Caesarea and the scholiast Michael Acominate, in the 12th century repeated in all writings: He is Eternal, which is symbolized by white hair, or white hair means eternity".

However, the scholiast, remembering certain allusions in the Book of Enoch and of Andreas of Caesarea, added the following: "they say that (white hair) belong to the one who is since the beginning . . . ; and yet he was sacrificed for us recently and made himself Child through the Incarnation". Other authors readily emphasize these oppositions. "Son who recently appeared . . . who came to the world since time immemorial and yet newly-born; who existed for ever and before all creatures, the first and the last, Christ of the same age as His eternal Father, and entirely similar to Him . . . Also the hymn sung at Candlemas proclaimed 'the Ancient of Days made infant and incarnated by way of the virgin mother'. In short, the elderly man is simultaneously a child and a Son the age of His Father, all these texts try to define God in relation to the idea of Eternity . . ."[40]

Perhaps our miniature should be viewed in the context of the above exegesis which hopefully will be corroborated by the study of Ethiopic texts. The miniature might be a literal translation of the consubstantiality of the Trinity, the physical traits of the Father being identical with those of the Son. Indeed, around the first millenium Byzantine art created under the name of Pantocrator the image of Christ in which the characteristics of the Father and Son intermingle.[41]

However, this interpretation should not be pushed too far. Ethiopian life and religious thinking in the past were intensely pervaded by Old Testament traditions. A more direct relationship between the text of Daniel and the iconography of the Ancient of Days is demonstrated in the following painting.

(15) The Ancient is depicted in the wing of the triptych No. 4186, IES Museum, Addis Ababā (fig. 44), dated either at the middle[42] or second half of the 15th century.[43] Below, there are two rows of prophets and among these, Daniel and Ezekiel. The Ancient is resting on a cushion and encircled with a double line. "Conforming with doctrines of philosophy and religion", writes A. Grabar, "in the art of Antiquity, the image of Eternity represents an infinite return of time. The Eternal God is a Lord who forever insures the endless movement, that is in a circle".[44] The circle surrounding the Ancient of Days probably mirrors the idea of this "infinite return of time". The cushion,

[40] GraRepr 132f.
[41] Christ Pantocrator, Daphni, c. 1100. Réaulc II 9f.
[42] ÉthMill No. 101.
[43] RKÄth 96f.
[44] GraRepr 129.

probably originating from Byzantine art, is occasionally found in Ethiopian images of Christ in Glory (murals, Dabra Salām Mikā'ēl, Aṣbi; Codex Palatinus Or. 148, Florence) as well as in the images of Mary (Psalter from Dabra Warq; the Book of Miracles of the Virgin Mary, Tadbāba Māryām). The Ancient holds a book on his lap with his left hand and raises his right hand in blessing. The pose of his fingers is in accordance with the 15th-century arrangement. His face is shown frontally, his ears are big, his nose is flat with round conspicuous nostrils and the similar tip of the nose. The eyes are pointed and their contour ends with a single line. The tousled white hair and beard are shaped into waves and spirals. The hair, which gives to the face a fearful appearance, blends the characteristics of the Byzantine Pantocrator with the reference to Ezekiel's "whirlwind coming out of the north", 1,4. His nimbus is cruciform with the flared cross-pieces. He is clad in a yellow shirt covered with a red tunic. The tunic is trimmed with ornamental bands at the neck and wrists. A blue cloth, the *pallium*, covers the shoulders and the lower part of the body. The draping of the robe shows the knees, but not the feet. The four Living Creatures are placed around the circle. Their hind parts are hidden behind the glory while their front is a combination of human and animal elements. All have wings and nimbi over their heads. The eagle's head and neck are covered with feathers. The lion has a mane while the ox's head is clearly that of an animal, complete with horns. Yet, like a man, the lion and the ox have hands with which they hold a book. This detail identifies the form as the symbol of the Evangelists. The form is rare in early Ethiopian painting, the only examples known being the miniature in the gospels of Princess Zir Gānēlā,[45] a triptych already discussed, and a mural in Yediba Māryām church, to be discussed subsequently.

 The general composition derives from the representation of Christ in Majesty, a well-kown Ethiopian form. However, the origin of the form of Ancient of Days can be defined more specifically. The triptych belongs to the school of painting which flourished around the middle of the 15th century. The Institute of Ethiopian Studies, Addis Ababā, possesses two diptychs produced by the school (Nos. 3980 and 4324) besides our triptych (see p. 421). The figure of Mary in diptych No. 3980 (fig. 208) and that of the Ancient in our triptych are similar, except of course, the heads and the pose and function of the left hands. Both Mary and Ancient wear the same tunics with a yellow lining and a border at the neck and their large cloak is identically draped. The right hand of the Ancient with its curious pose of the fingers in the triptych is explained by the pose of Mary's hand in No. 3980. Her middle finger and thumb hold the stem of a flower; the painter of the triptych removed the Flower but did not change the position of these fingers and that is why they do not touch each other. Moreover, he made the little and ring fingers slanting. As a result, the position of the fingers neither corresponds to the Greek nor to the Latin rite. Nevertheless, this pose of the hand found its way to the early paintings of the Trinity. The schematically drawn cushion on which the Ancient rests corresponds

[45] HelZirGan 200 f.

to the ornamented cushion in icon No. 3980, while the cross-piece of his nimbus corresponds to the nimbus of the Child in the above diptych.

The origin of the head of the Ancient of Days which is in the frontal pose can be also explained by the manner of rendering a group of three saints, which was popular at that time. The saint in the middle is always shown frontally while the two on either side are in a three-quarter position. In the Dāgā Esṭifānos panel (fig. 206) St. Stephen flanked by the Apostles Peter and Paul is represented in this manner. In diptych No. 4324 (fig. 200) Abraham is shown flanked by two other personages from the Old Testament, Isaac and Jacob. The face of Abraham is drawn frontally and recalls the face of the Ancient of Days in our triptych. Both faces have the widely outstretched ears, the flat nose as well as the marked nostrils and the tip of nose. The painter of our triptych made the details more schematic, emphasizing their flatness.

The way the Ancient holds a book does not correspond to the usual 15th century pattern; according to the latter, the book is in the form of a flat square or rectangle and the grasping hand hides a part of it. Usually all fingers are shown but at times the thumb is hidden under the book. The Ancient holds in his left hand an open book supporting it with his fingers which rest on its upper edge. Where does the pose originate from? The answer is found in the painting of Brancaleon discussed subsequently; indeed, the two lines in the middle of the book are explained by the realistic rendering of the Italian text in the book.

Our image of the Ancient of Days is, in fact, an assemblage of elements borrowed from different sources. Moreover, the painter introduced a significant detail. He made the eyes of the Ancient red as fire, while those of all other figures in the same triptych are black. The detail evidently derives from the Scriptures. The question is which of the passages was used. If the painter was illustrating entirely the text of Daniel, the garment of the Ancient of Days would be white "as snow". In fact it is not. On the other hand, both Daniel and St. John write about the white hair.

It is obvious that the painter of the triptych has taken at least one element from St. John's vision, namely his reference to the Ancient's eyes. The prophets often saw fire on the occasion of a theophany, Ezekiel refers to ". . . a great cloud and a fire enfolding it", 1,4, Daniel saw the throne of the Ancient which was "like a flame of fire", 7,9, but John localized fire in the One's eyes: they were "as a flame of fire" (1.14), and this is probably what was interpreted by our painter. Perhaps he was also impressed by the graphic description by King Zarʾa Yāʿqob of the theophany at Mount Sinai in his Book of Light: "on the third day", wrote the King, "descended the Lord with the sound of a thunder, in clouds and mist, and with fire; all Mount Sinai smoked like an oven".[46] His fellow countrymen apparently considered this detail important, that is why it is still found in Yediba Māryām mural paintings a century or so later.

[46] CSCO 251 (1965) 34; LashGate 156 quotes the Ethiopic Anaphora of Mary as follows: "O Virgin, since a devouring fire dwelt in your womb – for his face is fire, his clothing fire and his brightness fire – how was it that he did not burn you up?" The association of Godhead and fire has been obviously very vivid in Ethiopian imagery of the theophany.

The 15th-century Ethiopians extensively used the form of the Ancient of Days for decorating crosses and manuscripts, as demonstrated by the following examples.

(16) The Ancient of Days is incised on one face of the processional cross (fig. 45a), Dr. R. Fechter Collection, FB/3–2, and the Virgin and Child on the other face of the same cross (45b).

The cross of the short-armed type is datable to the second half of the 15th century considering its manufacture as well as the style and iconography of the incisions.

In the picture of the Virgin, the Child is seated on her right arm. He holds a bird in his hand. The draping of her veil is also characteristic of the period, in that it covers one side of the head while leaving the other exposed. The incision clearly belongs to the school which was influenced by Islamic as well as Western art, and, in addition the upturned right foot of the Child showing its sole suggests some influence of Greek art.[47]

The Ancient of Days differs from the one in icon No. 4186 by the way he holds a book; his crown of hair is smooth instead of tousled. The Symbols of the Evangelists seem to be similar in both the cross and the painting, though in the cross there are no books which the Creatures are supposed to hold.

(17) The miniature in Dr. R. Fechter Collection, PA3, is painted on a folio which is all that remains of vanished manuscripts, probably the gospels. The painting dates from the 15th or the early 16th century.

The picture of the Ancient of Days occupies a large part of the folio (fig. 46). It differs significantly from all representations of the subject known to the writer but is analogous to a particular type of the majestic image of Christ in Glory in which the Living Creatures are characterized by two or more pairs of wings. The type appears in the late 15th century; there are a few extant examples, one of them being found in the *Maṣḥafa Ṭēfut* kept in Gešen Māryām Monastery, Wallo.[48]

The "picture of Our Lord, the Ancient of Days and His four Living Creatures" according to the inscription is partly inspired by the Book of Ezekiel and partly by the Book of Revelation, but neither text is strictly followed, since the painter so obviously did not translate his work from the texts but form a ready-made model.

The Ancient of Days is seated on an elaborate throne, holds a book in one hand and points at it with his other instead of blessing. The throne, the way of holding the book and the pose of the Ancient's right hand are obviously borrowed from the image of Christ in Majesty. In this miniature we witness the transition from the form of the *Majestas Domini* into that of the Ancient of Days.

The robe of the Ancient of Days is red and his hair grey instead of white; the irises are black not red as in icon No. 4186. If there was an attempt to express fire which the prophets saw in their visions this was effected by painting in red the wings of the Creatures and the double circle of the mandorla.

[47] Chatzle pl. 5.
[48] The other example is found in the gospels Ğāḥğāh Giyorgis, Wagarā, reproduced in LerÉthG 49, pl. 3.

The Living Creatures look like seraphim because of the red colour and the tips of the two upper wings giving the impression of crossing each other. The double pair of wings is probably justified by the passage from Ezekiel who saw" . . . four wings of the living creatures", 1,6. The eyes, an important detail in the iconography of the *Majestas Domini* are indeed depicted in our miniature on the wings of the Creatures. This recalls the text of Saint John, 4,8.[49]

In the lower register of the miniature a modest composition contains all the elements of the Ethiopian iconography of the Baptism of Christ. It also has a few characteristics of its own. Christ and Saint John are immersed almost neck deep in the baptismal tank. A white dove seems to rest on the Saviour's head instead of diving downwards. John is placed on the left of Christ, and both, he and John lack a nimbus. These two details are similar to those in early 14th-century gospels of Krestos Tasfāna.[50] Manifestly, our painter followed a model which was different from those used by 15th-century painters.

The miniature is expressing the trinitarian doctrine by juxtaposition of the historical image of Baptism which is the Epiphany in the Ethiopian Church, to the image of the theophany of the Old Testament. Both miniatures illustrate the Ethiopian commentary to the passage of Saint Luke 3,22. In our miniature the theophany seen by prophets serves as an interpretation of the "voice from heaven", in accordance to the spirit of Judaic traditions pervading the Ethiopian culture.

(18) The Ancient of Days depicted in the right panel of the Triptych (fig. 47) IES Collection, Addis Ababā, evolved from the form of Christ in Glory. The Ancient sits in a round mandorla; his smooth hair and the irises of his eyes are black; the nimbus is ornamented with flared crosspieces instead of being angular as in theophanies of the Ancient of Days. The robe is red and the cloak is white but with a pattern of short red lines on it. The right hand is raised for blessing and the left posed on the upper edge of the book. The figure could be mistaken for Christ in Majesty, save for the inscription specifying that indeed this is the Ancient of Days.

Other figures in the triptych with round faces and tiny mouths recall the 15th-century painting on wood. Saint George holds his spear slanting upwards and the Apostles carry books in the 15th-century manner. The Child seated on the right arm of his mother reaches the border of her cloak with his outstretched hand. The movement is characteristic of those 15th-century paintings in which the impact of Western art is evident. However, the stiff drawing and the manner of delineating eyebrows with multiple vertical lines, justify assigning the painting to the first decades of the 16th century.

(19)–(20) Two paintings of theophany are known to be made by a foreigner living in Ethiopia. One painting is found in the Book of Miniatures which was signed

[49] One has to search outside Ethiopia for analogy in representing the Cherub, wings of which are ornamented with eyes: the Cherub guarding the gate of Paradise, murals in the church of Kariye Djami, Istanbul, early 14th century; Cherub guarding the gate to Paradise in the Last Judgement, Torcello, 12th century.

[50] ChojBap 108.

by Nicolò Brancaleon (see p. 383) and the other in the triptych, Gētēsēmānē Māryām church, Goǧǧām.[51] There is good reason to believe that the triptych was also made by the Italian painter.

The rendering of the Ancient of Days (fig. 48), or God the Father according to Brancaleon's inscription, is very similar in both paintings. He sits within a rimmed mandorla and supports with his left hand a book resting on his lap. The open pages of the book face the beholder. In the miniature an Italian inscription "Dio Padre" is written on the open pages. The right hand is raised for blessing; two fingers, index and middle, are outstretched and the ring and little fingers folded and touching the thumb. His white hair flows on his shoulders, while the white beard covers his neck and part of his chest. His ears are outstanding and facing the onlooker. The round nostrils and the tip of the nose are conspicuous. The nimbus is cruciform with flared cross-pieces. The Ancient wears a red tunic and ample white cloak wrapping his body and trimmed with stars. The folds of the cloak show the knees underneath.

The Living Creatures have human bodies. They support the mandorla, grasping its frame with their outstretched arms. In the miniature the Creatures wear no nimbus, while in the triptych only the man wears one.

In the triptych, the Ancient of Days (fig. 49) is accompanied by twenty-four beardless Elders of the Apocalypse clothed in "white raiment" and wearing "crowns of gold" according to the description of Saint John (Revelation 4,4). The "crowns" are in the form of pointed caps with rings at the bottom, while the "raiment" is composed of white tunics and capes open in front. The faces of the Elders are directed towards the image of God. They carry censers which some of them seem to swing, and thus give "glory and benediction to him that sitteth on the throne" (Revelation 4,9).

In the miniature, the Elders are depicted in the folio which is facing the image of God the Father. They are similar to those in the triptych but they lack nimbi Obviously the two pictures put together are meant to represent the Revelation of St. John.

This coupling of Old and New Testament elements in Brancaleon's theophany proves his sensitivity to local traditions and at the same time his innovating influence. On the one hand, he followed the Ethiopian figuration of the Ancient of Days, and hence the four Living Creatures, on the other hand, he added the Elders of the Apocalypse who became a characteristic feature of Ethiopian theophanies.

The Elders of the Apocalypse are well-known in Italian painting. In Venice (St. Mark's) and nearby Ravenna (S. Apollinare in Classe) images of the Elders can still be seen. These images existed during Brancaleon's life in Venice.

The Italian painter had memorized one of these varied forms of the Elders and reproduced it in the paintings he made in Ethiopia. He represented them standing, young and beardless. He put "crowns" on their heads. Also, he has given them an attribute taken from the local lore. This is the censers which are extensively used in Ethiopian church liturgy instead of vases with perfume and incense.

[51] Discovered by Diana Spencer and summarily described in: SpenGojj 205–10.

The conclusion from the above is as follows: Until the late 15th century the Ancient of Days was represented without the Elders of the Apocalypse. Moreover, the latter did not appear in Ethiopian paintings until the same date. Around the 1500s we find the Elders either depicted as a subject independent of the Ancient, for example in Psalter of Dabra Warq (see p. 395) or as a compound composition of the Ancient and the Elders. These compositions are works of Brancaleon, while the Psalter was evidently produced by an artistic centre which was under the influence of the Italian. Therefore, there is good reason to believe, barring new discoveries, that Brancaleon is the first to have introduced the subject of the Elders of the Apocalypse into Ethiopian theophanies. The Ethiopians took the subject over and developed it further. This is demonstrated in the following painting.

(21) The miniatures in the Life and Miracles of Gabra Manfas Qeddus, Ms. or. Oct. 555 Staatsbibliothek Preußischer Kulturbesitz, were published by E. Hammerschmidt, who ascribed the folios with the text to the years 1530–1550, whereas, according to him, the folios with the miniatures "evidently originate from earlier manuscripts" and were bound together with the text.[52]

The iconography of the miniatures recall the 15th-century painting. However, they seem to be executed at a later date on account of the stiffness of the drawing, which also characterized the figure of "God the Father" (fig. 50). For example, his striped robe does not show the knees. The Eternal seems to stand, as in the 16th-century representations of him, instead of being seated, which is symptomatic of 15th-century iconography of the Ancient of Days. Nevertheless, the origin of forms in our miniature is obvious. The central figure is similar to that in triptych No. 4186 (fig. 44), and surrounded by four symbols of the Evangelists holding the book. The eyeballs of the Eternal are glowing red, whereas those in other figures of the same manuscript are white. The iconography of the Eternal in our miniature corresponds to that of the Ancient of Days as conceived by Ethiopian painters. Yet, the inscription accompanying the miniature runs "God the Father, creator of Heaven and Earth, who made the cosmos".

This representation of the theophany combines the form of the vision inspired by the Old Testament and a new name of that vision, perhaps taken from the New Testament. Incidentally, this new name corresponds to that which Brancaleon used in his image of the Eternal.

(22) The wall paintings in the rock-hewn church Yediba Māryām,[53] dedicated also

[52] CodAeth 1 (1977) 22 and 30, pl. 11.

[53] The church was visited and its murals photographed by Walter Krafft in 1972 and the writer in 1974. The murals covering the walls of one large and two small chambers are in a good state of preservation. They are with those in Abuna Yemᶜāta, Garᶜāltā, the only well preserved and complete examples of 16th-century mural paintings.

According to the 16th-century hagiography preserved in the church it was built by Abuna Musē, called also Salāmā II, who came to Ethiopia shortly after Frumentius (4th century). Musē is said to have built many churches including the one of Yediba Māryām (KRZHagTrad 85). The historical identification of Salāmā II is not certain. According to TTCh (36), he must have lived in the 9th century. In the list of Ethiopian bishops Frumentius is followed by Minas.

to Abuna Musē,[54] Dāwent in Wallo, are tentatively ascribed to the first half of the 16th century. They recall the paintings found in the church of Abuna Yemʿāta, Mount Guḥ, Garʿāltā in Tegrē, which are ascribable to the 16th century.[55] The style and iconographic forms of the murals in Yediba Māryām derive from the 15th-century paintings on wood, but the treatment of details, coupled with some rigidity of drawing are different.

The Ancient of Days (fig. 51 a, b, c) is represented on a wide pillar in the left of the entrance to the church. Below, the Elders of the Apocalypse are depicted in two rows, five of them in each row. The remaining fourteen Elders are found on the other face of the pillar; they are arranged in three rows of five, six and three.

The Ancient is similar to the one in triptych No. 4186, including the red eyes. However, his hair is smooth and the beard dressed in a number of pointed plaits. The eyebrows and eyelashes are drawn with multiple short vertical lines similar to those in triptychs T1 and T5. The book and the way the Ancient holds it recall 15th-century paintings.

The Ancient's yellow shirt, blue tunic with colourful bands at the neck and wrists and a cloak with a scattered rosette pattern initiate the trend of lavish ornamentation of the garments which reached a climax in 18th-century pictures of the Trinity. There is no attempt at rendering the folds of the cloak and the knees are roughly sketched with a dark line. Two elongated figures at the bottom of the robe probably stand for the feet of the Ancient.

The four Living Creatures are depicted around a mandorla. Similar to those in triptych No. 4186, they symbolize the Evangelists. The Elders are drawn either in full face or in three quarters and their large cloaks are draped in two different ways. Also there are two kinds of nimbus, one is plain yellow and the other decorated with a set of parallel lines. The latter is also found in Abuna Yemʿāta murals.

The ten Elders which are placed below the Ancient of Days, are depicted with wings, while the remaining fourteen are without. The former clearly derive from the 15th-century angels, the swords being merely replaced by censers and crosses. The winged figures thus have double characteristics, namely those of the angels and also of the deacons, signified by the crosses and censers they carry. All this is in accordance with the teaching of the Ethiopian Church that the Elders of the Apocalypse belong to the celestial "choirs" which surround the Supreme Being. In the Yediba Māryām we witness the initial stage of the transformations which the Gondarene painters creatively completed.

(23) The choice of subjects in a large triptych, IES Collection, follow those in triptych No. 3992 (p. 110) except for the three figures of the Trinity which have been replaced by the figure of God the Father (fig. 52).

The period of the triptych is ascertained by its style and iconography. The painting follows the manner which developed in the first decades of the 17th century, before the advent of the First Gondar school, and is classed with the group

[54] GerChRock 135f., 187–95.
[55] AlvPrJ 304.

F and G of the classifications of 16th-century painting proposed by the writer. It also announces the approach of the Gondar mode of painting. Most probably the triptych was executed either in the last decade of the 16th century or the first three decades of the 17th century.

An old man with grey hair and beard, depicted in the upper tier of the main panel sits within the mandorla which is supported by the four Living Creatures. These have their arms widely outstretched; their bodies are hidden behind the mandorla. The pose and form of the Creatures derive from the miniature of God the Father by Brancaleon (fig. 48), the rays which in that painting radiate from the figure of God are changed into straight lines ornamenting the robes of the Creatures. The Italian failed to adorn these with nimbi and this was followed by the Ethiopian, except for the figure of man. God the Father in our triptych recalls the "Dio Padre" of Brancaleon; both have the white hair falling over their neck and shoulders and the folds of their garments are similar. We assume therefore that along with the form also a new name of theophany was adopted. The triptych no longer represents the Ancient of Days conceived by Eastern Christianity but rather God the Father imagined by Western Christianity.

Our painting is the result of a long process of copying during which substantial transformations of the prototype occured. One of these are the pointed caps of the Elders of the Apocalypse. In Brancaleon's painting the Elders wear a kind of coronet over their curly blond hair, trimmed around the neck, according to Renaissance fashion. Ethiopian scribes apparently misunderstood these details and amalgamated the coronets and hair into one head cover which is similar to the hood but has curved borders at the bottom. On the other hand, the censers which Ethiopians used extensively in ceremonies have been properly copied and enriched with details taken from life. Our triptych evidences the transition from 16th-century theophany into that of the 17th century. The important innovation was the orb, symbol of might which replaced the book, symbol of the gospels. The cross was added to the orb.

Let us sum up: Ethiopians used to represent the Eternal long before they started to paint the images of the Trinity. It seems that they followed the posticonoclast Byzantine form of the Ancient of Days, which had its roots in the Book of Daniel and the Book of Revelation. Possibly the early Ethiopian form was also influenced by the art of Nubia.

The earliest example known to us of the Ancient of Days dates from the early 15th century, but probably Ethiopians must have produced other similar images before that date. Indeed the miniature in the Book of Prayers of Sāmu'ēl of Qoyaṣā evidences the transmutations of the prototype which most probably lasted decades if not centuries.

Recently, Cl. Lepage in an article on Dabra Salām Mikā'ēl church, Tegrē, tried to explain the significance of its intriguing wall paintings. The much damaged figure painted in the apse of the church was the key factor of his hypothesis. Lepage concluded that the figure "certainly" represents Christ though in fact, only the lower part of the legs, the hand holding a book, the large cushion on which the figure was sitting and the parts of the Living Creatures are all that remains of the

painting. The main argument for the identification was his assertion that only "the late Ethiopian painting starting with the 18th century represented without hesitation God the Father surrounded with the Four Creatures".[56] The plan seemed to work well. Four centuries, according to Lepage's belief, have passed between producing the much damaged representation of "Christ" in dabra Salām Mikā'ēl and the earliest Ethiopian representations of God the Father. The facts are different. The Dabra Saḥel and other 15th-century representations of the Ancient of Days have been painted a century later than the murals of Dabra Salām Mikā'ēl. In iconographic chronology this is very close, too dangerously close, to support Lepage's theories. The writer does not intend to propose another identification of the figure which has vanished but to explain that Lepage's assertions are much less sound than he wishes us to believe.

CHRONOLOGY OF DEVELOPMENTS

Let us now conclude this survey of 15th and 16th-century works correlating the form of the Ancient of Days with the representation of the Trinity and suggesting the following chronology of developments. The writer cited all the examples he could find and if any other instances turn up, as they probably will, they should not fundamentally alter the course of developments outlined.

First period: it is impossible to determine the inception of this period but it is known that it lasted until the end of the 15th century. During this lapse no representations of the Trinity are known to have been produced. Instead, the Ethiopian painters used to depict images of the Ancient of Days surrounded by four Living Creatures. Two forms of the Ancient are distinguished, the head-and-shoulders form and the seated full-figure form. The latter was fully evolved in the second half of the 15th century and in the next century was eventually used for composing the image of the Trinity.

Second period: it covers the two last decades of the 15th century and the first two decades of the 16th century. The major facts bearing on our subject occurred during this period. The Italian painter Nicolò Brancaleon introduced two innovations into the Ethiopian image of the Ancient of Days. He depicted him clad in white garments, and even more significantly, surrounded by the twenty-four Elders of the Apocalypse. He kept the four Living Creatures which evidently were already well rooted in Ethiopian rendering of the Ancient of Days.

Also during the same period, the European type of the Trinity expressed by three identical figures appeared in Ethiopia. It is almost certain that Brancaleon was instrumental in introducing the model of that type into Ethiopia. At the time when another foreigner painted his triptych of Dimā Giyorgis in the 1520s, the European mode of depicting the Trinity was already known in the country.

[56] *Cl. Lepage,* Dieu et les quatre animaux célestes dans l'ancienne peinture éthiopienne = DSCE 7 (1976) 96–101, 108.

Third period: some time during the first half of the 16th century, the painters in scriptoria of Tegrē started to depict three identical figures of the Ancient of Days seated beside each other. In doing this they had been inspired by a newly introduced European manner of representing the Trinity. They included in their pictures the four Living Creatures, according to an old Ethiopian iconography of the Ancient of Days. They also included twenty-four Elders of the Apocalypse following the example set up by Brancaleon. They added the figures of the prophets. Thus the Ethiopian form of the Trinity came into being.

Fourth period: it lasted from the middle until the end of the 16th century, or possibly a few decades longer. The form which developed during the previous period passed through several stylistic changes, but the iconographic definition remained the same. The most important change refers to the draping of the cloak on the knees and legs of the Persons of the Trinity; the draping became progressively stiffer and eventually disappeared altogether. As a result the Persons give the impression of standing instead of sitting.

The form which eventually evolved in the second half of the 16th century is different from the earliest form of the Trinity known to us. One detail, however was constant throughout the whole period, namely the book which the Persons hold in their hand. Indeed, the book is typical of 16th-century representations of the Trinity. Other details undergo changes and therefore two types of the Trinity are differentiated, the early and the late; these types respectively correspond to the third and fourth periods of developments.

The characteristics of the early type are as follows:
(a) no mandorla or any kind of framing of the Persons;
(b) the Persons are always seated; this is expressed by way of drawing folds on their legs and knees;
(c) the tunic worn by the Persons is either white or coloured but always trimmed at the neck with a large decorated band; the cloak over the tunic is white;
(d) the hair and beard are white;
(e) the blessing hand: only the index finger and thumb are outstretched, all other fingers folded;
(f) the flared cross-pieces of the nimbus, ornamented dots are occasionally drawn in between;
(g) the Elders of the Apocalypse are youthful, exceptionally they wear caps, and a few carry censers.

The characteristics of the late type are:
(a) framing in the form of a flattened oval around the Persons of the Trinity;
(b) the Persons give the impression of standing;
(c) both tunic and cloth over it are always coloured. The tunic is plain with no ornamentation; the draping of the garments is drawn with straight, parallel lines;
(d) usually the hair and beard are brown;
(e) the blessing hand: the index and middle finger outstretched, the ring and little fingers folded;
(f) no clearly cruciform nimbus, instead four, six or eight radiating double lines;

(g) the figures of the Elders of the Apocalypse are developed in full; in most of the paintings they carry crosses and in some they wear caps on their heads and hold the cross in one hand and censer in another.

The Ethiopian Trinity is always accompanied by four Living Creatures. Their form which has been initially borrowed from the image of the Ancient of Days marks a break from 13th to 15th-century iconography of the Living Creatures. In early representations of the *Majestas Domini*, they support the glory within which Christ is seated, whereas in connection with the Trinity they seem to act as symbols of the Evangelists. However, their function is rarely well defined. In late 16th-century paintings, they became a mere ornamental pattern displayed in the four corners of the painting. Their form is reduced to heads to which, occasionally, inconspicuous wings are attached.

The subject of the Elders of the Apocalypse appeared first in Ethiopian painting in the late 15th century and a few decades later it merged with the subject of the Trinity.

Similarly to the Living Creatures, the twenty-four Elders derive from Oriental symbols and knowledge. Almost totally excluded from the imagery of the Greek/Byzantine with the exception of the paintings of Cappadocia,[57] they are known in the art of the Copts.[58] The subject thrived in Western art, the oldest examples dating from the 5th century. For centuries Apocalyptic compositions occupied the place of honour in churches and decorated their apses. Around the 12th century the theme culminated in awe-inspiring compositions on the tympana of great portals. But in the same century the theophany of St. Matthew prevailed over the theophany of St. John which gradually was losing popularity, although still occasionally attracting the artists' imagination.

The iconography of the twenty-four Elders is very unsteady. They are represented alternatively as old or young, with beards or beardless,[59] with or without nimbus and crown. The attributes of the Elders show a similar variety; they carry vases with incense or even chalices and at times they hold harps and seem to play on them.

[57] *N. Thiery*, The Rock Churches = L. Giovannini (ed.), Arts of Cappadocia (London 1971) 170.

[58] The twenty-four Elders are represented in the sanctuary of St. Macarius at Abū Makār. "They held", writes *Walters*, "an honoured place in Egyptian hagiology (cf. Anba Hadra and Moallaqah) and no doubt their status as priests accounts for their presence in the sanctuary, along with Abraham and Melchisedech" (WaltMonEg 135).

[59] *Nicole* and *Michel Thierry* write about the Elders in Cappadocian murals: "These priests often have no beard and their hair is brown, perhaps to express that they have been in part chosen from among the personages of the New Testament not only from those of the Old Testament. On the other hand, the word used by John has been translated as 'elders' or exactly 'ancient' and later became 'priest'. Originally the 'ancient of the people' signified a person of distinction, the one who occupied a high position in Jewish and Christian primitive community. Thus the word 'ancient' is not necessarily a synonym of 'old'". Nouvelles églises rupestres de Cappadoce, region du Hasan Daği (Paris 1963) 94–6.

The form in which the Elders have been interpreted as young men was popularized in Europe through the numerous illuminated copies of Beatus of Liebana commentaries to the Apocalypse. Some twenty manuscripts of the commentaries from the 9th to the 13th century still extant exemplify the great popularity which this work enjoyed in Western Christianity. There is no doubt that from Western art the Ethiopians borrowed the form of the Elders; on the other hand, the idea of merging them with the image of the Trinity is most probably their own.

The term *kāhnāta samāy, kāhnāt* of heaven, is particular to Ethiopia. Dillmann. in his dictionary translated *kāhnāt* as *sacerdotium*, priesthood, or *munus sacerdotale*, function of the priest. Thus *kāhnāta samāy* would mean priests of heaven. Also, according to Dillmann, *kāhnāt* corresponds to the Greek *presbyteroi*.[60] However, Ethiopic text of the Apocalypse uses the term *liqānāt*, not *kāhnāt*. Whatever the solution proposed by the linguists, it is obvious already that Ethiopian painters associated mentally the term *kāhnāt* with the functions and attributes of Ethiopian priests and monks. Hence the censers and particularly the crosses which the Elders carry in their hands, mirror the Ethiopian life.

The other peculiarity of the Ethiopian iconography of the Elders of the Apocalypse is their wings, which indicate another mental association, namely between the Elders and the angels. According to what the writer gathered from the traditional church scholar, the Elders belong to the category of angels. The twenty-four Elders follow the archangel Surāfᵓēl in celestial hierarchy. They live close to God himself in the seventh division of heaven, which may be defined as the dwelling of God. When an order comes from him, dealing with either mercy or punishment, the first receivers of the message are the angels called Kurubᵓēl (Cherubim), the second Surāfᵓēl (Seraphim), the third the twenty-four Elders *(Kāhnāta samāy)* and finally an ordinary angel passes on the message to the world.[61] This interpretation which has all the rustic flavour of primitive Christianity, mirrors the life and protocol of the Ethiopian royal court of the past. It may be also a very old interpretation of the fact that wings appeared already in the earliest representations of the Elders of the Apocalypse. In the Dabra Warq Psalter all Elders are winged, in the Yediba Māryām murals some Elders are winged and some are not. The 17th-century examples of winged Elders are found in wall paintings, Dabra Sinā church, Abbā Antonios church, Gondar, and in a painting on cloth at Dangalāt Māryām church, Aṣbi in Tegrē.

[60] DL 813.

[61] The writer is indebted to *Abebe Kifleyesus* [= Abbaba Kefla Iyasus] for checking information. His personal communication of June 21, 1977. Informant *Alaqā* Embākom, Institute of Ethiopian Studies, Addis Ababā. LashGate 149, commented that Ethiopians "are hopelessly divided over the precise order in which choirs of angels occur". On the other hand in the translation by *V. Arras*, De Transitu Mariae II = CSCO 325 (1974) 47f. (De Thoma Apostolo Lectio) the following order is given: "cherubim primus ordo, seraphim secundus ordo, dominationes tertius ordo, principatus quartus ordo, virtutes quintus ordo, potestates sextus ordo, rabawāt septimus ordo, seniores octavus ordo, throni nonus ordo, arbāb decimus ordo".

17TH AND 18TH-CENTURY DEVELOPMENTS

By the end of the 16th century the process of incorporating the iconography of the Trinity in Ethiopian painting was concluded. Our exposé could very well end here. It seems, however, advisable to follow briefly the developments of the two followings centuries. These developments present a problem.

It should be recalled that in the second half of the 16th century, the Ethiopian court settled in an area north of Lake Ṭānā and remained there for the next three centuries. In the fourth decade of the 17th century, the capital city of Gondar was founded and became a flourishing centre of arts and crafts. In painting, a style called the First Gondarene developed in the middle of the 17th century and lasted until the first decades of the 18th century; it was followed by another style, called the Second Gondarene which in decadent form lasted up to the present. Now the puzzling feature of the First Gondarene painting is that we did not find in its subject-matter the theme of the Trinity. In a large corpus of First Gondarene paintings still preserved the writer did not record even one which represented the Trinity. On the other hand, in Second Gondarene paintings the Trinity is found in a number of murals, miniatures and paintings on wood. It appears that for some hundred years from the end of the 16th century or early 17th century until the last decades to the 17th century virtually no paintings of the Trinity were produced.

The question which immediately arises is whether perhaps the Trinity was painted during the First Gondarene period but the works did not survive.

The royal chronicle of the reign of Iyāsu I (1682–1706) refers to Sebḫāt-la-Ab, a monk of the monastery on Lake Ṭānā, who died in 1702. He "conscripsit" according to the chronicle "effigiem sanctae Trinitatis" *(za-darasa malk'e śellus qeddus)*.[62] Annequin interpreted the sentence suggesting that the monk had painted the image of the Trinity in Dabra Berhān church, Gondar.[63] In fact, according to O. Raineri, the sentence refers to the lauds, *malk'e* of the Trinity, a literary devotional work which in florid style is called "image of the Trinity".

The second record, more complete, is found in the hagiographic story of King Iyāsu I who ordered a church built. Senodā, the author of the story and a clergymember has described its construction and mural paintings. Over the door on the west wall, he writes, the King ordered to paint "his Masters, the Holy Trinity".[64] The existing paintings in the church are not those which Senodā described in his narrative.[65] Nevertheless, it would seem from both records that

[62] *R. Basset*, Etudes sur l'histoire d'Éthiopie (Paris 1881) 316 and footnote p. 381.

[63] AnnDB 233.

[64] *C. Conti Rossini*, Iyāsu I re d'Etiopia e martire = Rivista di studi orientali 20 (1942) 111. AnnDB 225 gives the bibliography referring to the paintings of the church. The story of Iyāsu edited by Conti Rossini is not included, though it contains the only known description of the paintings.

[65] Recently AnnDB 215–25, convincingly argued that the present church was built in the early 19th century, the original church then being destroyed by fire.
 The paintings in the church are in the Second Gondarene style i.e. they do not fit into the period in which they were thought to have been painted.

perhaps around the 1690s the subject of the Trinity emerged after a century-long oblivion. However, as the problem stands there is no material proof that the First Gondarene artists painted the Trinity. Indeed, there is an indication that they did not. The subject is missing in two fairly complete examples of the First Gondarene church murals.[66] Instead, these include a composition representing God the Father accompanied by the Elders of the Apocalypse. The composition has been painted in the place which is usually reserved for the Trinity.

The explanation for these facts is not at hand but the following points should be considered.

During the 17th and 18th centuries the devotion to the Trinity had been as fervent as during the preceding centuries and invocations to it abound in writings of the period.

The possible current within the Ethiopian Church which objected to the pictorial representation of the Trinity should be excluded.[67] Indeed, the theophany was frequently depicted in 17th-century painting. This theophany however was different than the form of three old men.

Since the interruption was not the result of the currents within the Ethiopian Church, perhaps the explanation should be searched for in some external factors.

One possibility is the Jesuit mission in Ethiopia which could have had some relation to the change of mind among Ethiopians. The Jesuits had certainly no enthusiasm for representing the Trinity in the form of three identical figures which already had fallen into disfavour in Europe. The interruption in the Ethiopian production of the paintings of the Trinity lasted long after 1634, the date when Jesuits were expelled from the country. However, they could possibly have influenced the painters. Jesuit missions were active in Tegrē, the centre of production of Trinitarian images, and in art their impact lasted longer than their actual stay in the country.

A second possibility of foreign influence was the activity of a Protestant missionary, Peter Heyling. He arrived in Ethiopia when the Jesuits left and during the reign of Emperor Fāsiladas exerted his activity for over a decade from ca. 1634 until 1651. As a Protestant, he certainly had strong objections to any anthropomorphic representations of God. The question is whether his attitude could prevail in a strongly xenophobic and conservative society.[68] All this is hypothetical and unless new evidence is found there is no need for pursuing the argument. Nevertheless, the

[66] Dabra Sinā church, Gorgorā and Abbā Antonios, Gondar.

[67] *E. Cerulli* commenting on the 17th-century theological texts writes about the so-called Mikaelite current in Ethiopian Church, which among others postulated the impossibility of visually comprehending God. Scritti teologici etiopici dei secoli XVI—XVII (Città del Vaticano 1958) vii—xi.

[68] Peter Heyling's life in Ethiopia is known only from second hand sources. On his way to Ethiopia he spent some time in Egypt and from there sent letters to his family. He lived in a monastery with Egyptian monks. His behavior there showed that he was capable of fighting the religious beliefs and customs which he considered as erroneous even if this meant trouble for him. Cf. *H. Michaelis*, Sonderbarer Lebenslauf Herrn Peter Heyling aus Lübeck und dessen Reise nach Ethiopien (Halle 1724); *D. Gothe*, Peter Heyling, der

contention is that there was a long interruption in depicting of the Trinity and that it lasted roughly for the whole of the 17th century.

Let us now turn to the 17th-century theophanies which replaced the representations of the Trinity in church murals.

(24) An example of such a theophany is the mural painting from the church of Abbā Antonios, Gondar, at present in the Musée de l'Homme, Paris.[69]

The composition painted on the west side of the tambour, above the door to the sanctuary (fig. 53), is identified by an inscription *Egzi' abeḥēr*, God the Father, which implies that the Old Testament name, the Ancient of Days was not used anymore.

God the Father is depicted in a round glory and surrounded by stylized clouds. He sits in the Moorish manner, wears a shirt with pointed collar and a large cloth ornamented with a colourful pattern.

He faces to the front, his hair is white, ears protruding and beard short and pointed. The latter is symptomatic of the First Gondarene rendering of the faces.

The ornamentation of the nimbus with oval crosspieces evidently originates from the 16th-century prototype, but it was transmuted and stars have been added in between the crosspieces.

The pose of the blessing hand of God the Father is similar to that in late 16th-century pictures of the Trinity. In his other hand, he holds a large orb with a cross affixed to the top of it.

The glory is drawn within a square. In the four corners of the square the Living Creatures are depicted. Their faces are turned towards God and their outstretched wings fill a narrow space between the glory and the square. They seem to support the glory. This arrangement is followed in most of the 18th and 19th-century theophanies, except in some the round glory is replaced by an octagonal frame.

The twenty-four Elders are depicted on both sides of God the Father in two rows. They are clad in Ethiopian church vestments, wear church crowns and hold censers in their hands; all this mirrors the Ethiopian priests or deacons during the church ceremonies. Our Elders obviously belong to the category of angels, a fact which is expressed by depicting them with wings.

The above is a classical representation of the theophany of the First Gondarene school.

erste Deutsche in Äthiopien = Zeitschrift für Kulturaustausch, Sonderausgabe: Äthiopien (1973) 147f.

Roger Cowley wrote to the writer as follows: "Peter Heyling certainly had some influence on the andam (commentaries) tradition, but how much is very difficult to say ... I think you are probably correct in thinking that there was opposition to the representation [of the Trinity] as three old men. Certainly in some of the commentary material I have been studying (in particular the andam on Hāymānota Abaw) there are discussions which might well form the background to this." Personal communication, September 25, 1977.

[69] StauAnt 212f.

 M. Griaule, Peintures abyssines = Minotaure I 2 (1933) 88; *Griaule* in his: L'enlèvement des peintures d'Antonios = La revue de Paris (1 Octobre 1934) 546–70, described how the murals kept in a half destroyed church were transferred from Gondar to Paris.

(25) A similar composition is found in the Dabra Sinā church,[70] except the Elders are depicted in one row all around the tambour instead of in two rows.

(26) Still another First Gondarene theophany was discovered in the Māryām Dangalāt church in Aṣbi, Tegrē.[71] The painting shows God the Father in a round mandorla flanked by two winged Priests of Heaven, and the four Living Creatures around. The rest of the composition vanished. The discovery evidences that Tigreans knew and painted the theophany which was probably conceived and certainly popular around 17th-century Gondar. This popularity continued well into the 19th century.

(27) A partly vanished mural in the rock-hewn church of Abbā Garimā, Sallā in Tegrē, was published by Ruth Plant.[72] In the upper register God the Father sitting in the mandorla was represented but only the bottom of his garment and his hands are extant. The right hand is blessing while the left holds a small orb between the thumb and index. In the lower register there are fourteen Elders of the Apocalypse; two others stand on both sides of God the Father, and the rest must have been painted nearby. The Elders wear church crowns and liturgical vestments, all painted in the Second Gondarene manner. Plainly, the mural dates either from the 18th or early 19th century. It proves that in Tegrē a change took place from large to small orbs whereas in and around Gondar the painters usually continued to paint the orbs of a large size.

(28) The theophany (fig. 54) is given a prominent place in the mural decoration of the church Abrehā Aṣbehā, Tegrē, executed during the reign of Emperor Yoḥannes IV (1872–89). God the Father painted in flamboyant Second Gondarene style has his cloak ornamented with a rosette pattern. He holds a minute orb in his left hand. He is encircled by four Living Creatures, the form of which is reduced to heads and wings. The whole is flanked by Mary on the left and St. Michael on the right; the Elders of the Apocalypse are missing altogether. However, in the same mural decoration there is also an image of the Trinity in which they are included.

It would be idle to describe in detail all pictures known to us of God the Father in 18th and 19th-century manuscripts. The pictures are numerous which proves that the theme was popular.[73] The representation of figures follows the Second Gondarene style and iconography. In the manuscripts, the twenty-four Elders are

[70] The murals were briefly described in StauAnt 216; *O. Jäger* in his description of the murals, Antiquities of Northern Ethiopia, a guide (Stuttgart 1965) 63–4, omitted the theophany altogether; he seems to recognize only the Covenant of Mercy and twenty-four Elders. The dating of the murals is still under discussion, but the most probable date is c. 1680–1708. *G. Annequin*, Le Lac Tana et ses îles = Les dossiers d'archéologie 8 (1975) 93.

[71] Reproduced in *Oxford University Exploration Club*, Rock-hewn Churches of Eastern Tigray; an account of the Oxford University Expedition to Ethiopia, 1974 (Oxford 1975) fig. 87. The painting is wrongly identified as Christ in Majesty.

[72] *R. Plant*, Rock-hewn Churches of the Tigre Province = EthObs 13 (1970) 209.

[73] To name a few examples in: Lives of Saints, 1730–55, Dabra Maḍhanē Monastery, Tambēn; Lives of Saints, 1730–55, Monastery of Sāmu'ēl za-Qoyaṣā; Hymn Book, 18th

usually left out. Instead St. Michael or the prostrate figures of donors or exceptionally a biblical scene (fig. 55) are depicted at the bottom of the miniatures. Frequently, in the same manuscript there are the images of God the Father, and that of the Trinity.

As to the wall paintings, the only known text referring to the order of themes in Ethiopian church murals is that by Priest Kāsā in Gondar. He indicated that the Trinity should be depicted on the west side of the tambour above the door to the sanctuary.[74] His information is correct as far as murals in some 19th and 20th-century churches are concerned but it is not corroborated by murals in older churches. The extant 16th and 17th-century murals contain the theophany of God the Father rather than the Trinity.

In sum, the 17th-century Gondarene painters created a new form of theophany. The form certainly derives from that of the Trinity. In the same manner as 16th-century painters assembled together three forms of the Ancient of Days into one image of the Trinity, the 17th-century painters divided this image, took one figure and transformed it. The ambiguous pose of Persons in the late 16th-century Trinity who neither clearly stand nor clearly sit, was rectified. God the Father sits in the Moorish manner which is symptomatic of the Gondarene style. He is also clad in a colourful garment ornamented with patterns which recall Oriental textiles. The fluid rectangle was usually but not always replaced by a round glory, similar to that in the triptych No. 4186. The most significant change is the replacing of the book by an orb. Where did the painters take it from? Not from life, because the Ethiopian regalia did not include an orb. The painters could only copy a print or painting. Indeed, the Dimā Giyorgis triptych is very likely the source. In the triptych each Person of the Trinity holds a large orb with an equally conspicuous cross affixed to it. In the Gondarene theophanies this detail is faithfully reproduced. Also the clouds in some 17th-century theophanies might originate from the Dimā Giyorgis painting.

The question is why this change from the clearly trinitarian exposition to a single image of God. Staude, describing the mural of Abbā Antonios, has given it the following interpretation. "Because of the rich garment he [God the Father] looks like a sovereign. The globe expresses that he is creator of the world, which is dominated by the cross. The cross within the nimbus indicates that in the image of the Creator Christ is also revealed." For Staude, however, the absence of the Holy Spirit is surprising. "But the presence of God the Father alone could be explained by the Ethiopian doctrine of the Trinity which is identical to 'one' person, that is God."[75] In other words, Staude wishes to recognize in the Gondarene image of God the Father a compressed Trinity, all rendered by one figure.

This interpretation does not hold if one considers other Ethiopian theophanies.

century, Or. 590, British Library, London; Lives of Saints, 18th century, Tansā'ē Monastery, Tambēn; Book of Litanies, first half of the 18th century, IES Coll. Mss. No. 75; Psalter, 1813–47, Salā Dengāy, Morat, Šawā.

[74] StauReg 255.
[75] StauAnt 212f.

In these, the nimbus with the crosspieces is not an exclusive attribute of Christ. A crossed nimbus adorns the Ancient of Days and all Persons in early images of the Trinity. Therefore, the crossed nimbus added to the figure of God the Father in Abbā Antonios does not necessarily imply that this figure represents both God the Father and Christ. The other reason for rejecting Staude's interpretation is the fact that Ethiopians used to put together the image of the Trinity and that of God the Father. Moreover, to the best of the writer's knowledge, the only Gondarene painting which perhaps can be interpreted as trinitarian in the painter's plan is characterized by a different figuration of Christ and that of God the Father; this positively excludes Staude's hypothesis.

(29) A diptych in private collection, Germany, dated late 17th or early 18th century, was painted in the First Gondarene style (fig. 56). Its subject-matter is outstanding for the richness of its themes; the question is whether these themes represent a free display of subjects popular during the Gondarene period, or a deliberate expression of a particular theological proposition. Three figures in the painting which are perhaps meant to be viewed together as one theme, give a clue.

The upper tiers of each panel are in the form of a pointed arch and in these Christ on the left and God the Father on the right are depicted. Both are shown seated with their legs crossed in the Moorish manner and clad in colourful garments. The clothing is draped in the round bands typical of the First Gondarene school. The rendering of each figure is different. The face of God the Father is in the frontal pose while that of the Son is in a three-quarter pose. The Father is surrounded by a glory and the Living Creatures. The Son is not accompanied by these symbols. Also, the arrangement of the fingers of the right "blessing" hand is different. The Father's palm is facing the front and the arrangement of his fingers is as in the images of the Trinity, while the Son's hand has his palm turned towards him and the arrangement of his fingers is typical of the First Gondarene style. Plainly, the figure of God the Father was borrowed from the 16th-century Trinity, while that of the Son from the First Gondarene pattern of drawing. God the Father, as well as his Son wear a plain yellow nimbus. The cruciform nimbus was rarely used during the Gondarene period.

A new element in the figures is the orbs topped with a cross which both Father and Son hold in their left hand. The orbs are similar to those in the Dimā Giyorgis painting. The First Gondarene representation of the theophany is thus characterized by an orb which has replaced the book.

God the Father is identified by a caption *Egzi'abeḥēr abbā*, God the Father. No caption was added to the figure of Christ but there is a white blank square drawn to his left. In Gondarene paintings, these squares usually serve for inscriptions. We are able to reconstruct the missing text from a similar image of Christ (fig. 57). The image is accompanied by an inscription *Aḥazē 'ālam Egzi'abeḥēr*, God the upholder of the world.[76] Therefore the two figures in the upper tiers of our panels

[76] Mr. Roger Cowley writes "This is a phrase common in the prayers and credal statements and undoubtedly means upholder of the cosmos, the whole world". Personal communi-

represent two manifestations of God, two theophanies, Christ Ascended and God the Father.

This identification helps to understand the meaning of the painting. André Grabar, writing about the theophanies-visions depicted in apses of Coptic chapels, Egypt, explained their significance as follows "... dans ces absides, tandis que la conque évoquait une épiphanie-vision, directe mais momentanée, passée ou à venir, la zone inférieure des fresques rappelait la théophanie essentielle et durable de l'Incarnation du Logos."[77] The mystery was expressed by way of symbols, namely Christ in Glory in the upper register and the enthroned Virgin Mary and Child, the Theotokos, in the lower register.

The Gondar painter expressed the same proposition but in his own way. At the top, he depicted a double theophany that is the theophany of the Old Testament on the right which implies the vision of Eternity and the manifestation of Christ on the left which presupposes the timeless Logos. King Zar'a Yā'qob in his Book of Light made reference to this bond of Eternity "... and before the world", he wrote, "his [Father's] Word existed, and forever will be his word. And the Word [is] of the Father, whereas the Son has a figure of his Father".[78]

The series of images depicted in the main body of the diptych illustrates the theophany which is "essential and lasting". The series starts with the picture of the Virgin Mary, instrument of the Incarnation, and her Son, revealed to mankind. It evolves with the redeeming story of Christ, and ends with the Covenant of Mercy involving the Ascended Christ's promise to show mercy to those who believe in her prayer.

This deep and graphic interpretation of Christian dogma was not repeated by other artists. Instead, the Ethiopian iconography of the Trinity followed an old and well beaten track.

A long pause in the representing of the Trinity in the 17th century was followed by a sudden revival and great popularity in the 18th century. The image of the Trinity which emerged after a period of oblivion was similar in concept and general composition to that of the 16th century, but differed in style, faces and clothing. The faces of the Persons were mostly surrounded with white wavy hair flowing down the neck and covering the garments; the nimbus is mostly in the form of radiating rays, exceptionally plain yellow (fig. 58). The garments, epitome of style, are ornamented with a rosette pattern and composed of a long usually striped tunic with pointed collar and a cape over it. The cape has an opening for the head but not a cut in front. The garment probably reflects the liturgical garments of Ethiopian

cation Sept. 25, 1977. The writer is also indebted to *Dr. Thomas Kane* for his translation of the inscription "God [who] holds the world [in His hands]". The question is whether this means an abstract idea of God's relation to the world or refers to an orb he holds in his hand. The second is very unlikely considering that Ethiopian cosmogony recognized the Ptolomean flat system until the 20th century, and even late in this century some remote centres of traditional learning vehemently rejected the idea that the earth is round.

[77] GraMart 2 (1946) 213.

[78] CSCO 251 (1965) 44.

clergy, but also recalls a chasuble of Catholic priests. The figures are usually shown seated (fig. 59) and rarely standing (fig. 60). The twenty-four Elders are shown usually in paintings on wood (fig. 61) rarely in mural paintings and exceptionally in miniatures. The Second Gondarene Trinities had two particular features. One was an orb and the other a way of framing the Persons of the Trinity.

The orbs which the Persons carry usually in the left hand and exceptionally in the right hand, are never topped with a cross. They are yellow, white, blue or even black. Occasionally, they are of the normal size of regalia and placed on the palm of the hand or, more often, of a very small size, similar to a ping-pong ball, and placed between the thumb and index finger (fig. 62). These globes do not look like regalia.

It should be recalled that in the 17th century, Christ and God the Father hold a large orb topped with a cross. It is possible that these images acted as the channel through which the orbs were transmitted from the 16th-century Dimā Giyorgis painting into the 18th-century images of the Trinity. In the process the cross was dropped.

The other possible channel is the Greek paintings of the Virgin of which a number are known to be imported into Ethiopia. In some of these the Child holds an orb.

The reason why a book was replaced by an orb is not obvious. The fact itself suggests a break between the 16th and 18th-century iconography of the Trinity. In Europe, the late Mediaeval theologians elaborated the attribute of the Trinity. God the Father was identified by an orb which was considered symbolic of omnipotence and of creation; the Son was identified by the cross on which he died, while the Holy Ghost by an open book, the symbol of intelligence.[79]

The painter of the Dimā Giyorgis triptych and Brancaleon did not differentiate between the Persons of the Trinity. The Ethiopians followed this. One wonders whether they have given special significance to either a book or an orb, considering that in some 18th-century Trinities, these did not appear at all; instead the Persons hold a handkerchief in their left hand (fig. 63). However, the orb is mentioned in the list of attributes which were supposed to prove the similarity of Persons within the triune God.

The other feature of the Second Gondarene Trinity was an oval or, more often a rectangular frame in which the Persons were placed. The frame had its four angles cut and each small triangle thus drawn was filled with the representation of one of the four Living Creatures. These were usually composed of a head and two colourful wings spotted white, which were similar to those of the Second Gondarene angels. The lion had its head in full face, the ox usually in profile, the eagle virtually always in profile and the man had the head of an angel in three-quarter pose. The Creatures, except the man virtually never have a nimbus. They turned their back to the Trinity. On the whole, they seemed to be reduced to merely ornamental detail, though in rare instances they gave the impression of supporting the frame.

* * *

[79] DidrIc 435 f.

RELATION OF THE THEOLOGY OF THE TRINITY TO ICONOGRAPHY

In order to put the representation of the Trinity into proper perspective, let us briefly investigate how Ethiopians related the trinitarian mystery to its iconography.

A fervent cult of the Trinity was deeply rooted in Ethiopian Christianity. Numerous proofs of it are found in writings and religious practices.

The religious writings as well as the royal chronicles start usually with an invocation to the Trinity. Thus the earliest chronicle, that of King Amda Ṣeyon (1313–43) starts with the following invocation: "Let us write this book trusting in the Father who helps, in the Son who consoles, and in the Holy Spirit who guides and seek help from the Holy Trinity".[80] A century later or so, the chronicle of King Zarʾa Yāʿqob who according to the narrative put all his trust in the Trinity, starts with an invocation as follows: "In the name of the Trinity in three persons equal in glory and majesty, the Father, the Son and the Holy Spirit".[81] The practice was continued in the 17th and the 18th-century royal chronicles, in which the invocations to the Trinity were often interpolated into the text.

In hagiographical works also, the opening sentence was an invocation to the Trinity. For example the Acts of Baṣalota Mikāʾēl, an Ethiopian saint at the end of the 15th century, start with the usual formula: "In the name of God who is one in three and three in one".[82]

The cult of the Holy Trinity also found its expression in religious practices. King Zarʾa Yāʿqob, who was deeply involved in Church matters advised the Ethiopians to make the sign of the Trinity on their foreheads. "Our patriarchs and all Copts", he wrote, "tatoo the cross on their hands as a sign of Christianity. More important than this is to write the name of the Trinity on the forehead." Referring to the threads which the Ethiopians wore on their necks to indicate their faith, he commented: "These threads ... were not prescribed by the holy Scriptures, but the writing of the name of the Trinity is found in the Revelation of St. John who said ... and His name shall be on their foreheads".[83]

The King himself administered justice in the name of the Trinity.[84]

The strength of the cult is also evidenced by a great many churches dedicated to the Trinity. The King gives a general advice on how to build churches and makes the following remark: "the church should have three doors as an image of the Trinity".[85]

A number of important theological books of the Ethiopian Church deal with the

[80] *C. W. B. Huntingford,* The glorious victories of ʿAmda Seyon, King of Ethiopia (Oxford 1965) 1.
[81] PerrZar 1.
[82] CSCO 29 (1905) 3.
[83] CSCO 262 (1965) 17.
[84] PerrZar 41.
[85] CSCO 262 (1965) 80.

trinitarian mystery. One of these, the *Qerelos*, Book of Cyryl, contains three homilies of the Church Fathers referring to the problems of the Trinity.[86] During the 15th century the religious ferment shook the Ethiopian Church. King Zarʾa Yāʿqob took part in the disputations and wrote two books in which he discussed the trinitarian matters. His *Maṣḥafa Śellāsē*, Book of the Trinity, is a short polemical tract about the orthodoxy of the trinitarian teaching written against the dissenting currents within the Church, particularly against the Stephanites. His teachings and definitions were eventually adopted by the Church, though in the following centuries the problem of the Trinity was frequently discussed.

In his *Maṣḥafa Berhan*, Book of the Light, Zarʾa Yāʿqob disputes against Za-Mikāʾēl and those who "deny the personality of the Trinity." They supported the position that "the Lord does not look like the creatures . . ." and "No one ever sees Him." Therefore "it is not possible to figure the Lord." Zarʾa Yāʿqob opposes these assertions and justifies his stand with quotations from the Holy Scriptures and other texts. "The Lord has the appearance of human", he writes, "which is proved by the passage in the Genesis that man was made in God's image and likeness." The King has found an additional proof in the Didiscalia. "The Apostles," he writes, "demonstrated that the physical form of man was made according to the figure of Lord: We ought not to shave our beards, nor to change the natural form of man; but if thou doest thus, thou art a transgressor of the law and far from God who created thee in his image and his likeness." Plainly, to the King's mind, the beard is an essential component of God's appearance.

Zarʾa Yāʿqob believes that the Incarnation bears evidence of the human form of God the Father as well as of that of the Holy Spirit. "Was Christ, God Incarnate, born with the perfect character of man?", he asks the followers of Za-Mikāʾēl, "If the Son who sits to the right of his Father has the perfect appearance of man . . . should also the Father and the Holy Spirit have the same . . . and are they not similar to him?"[87]

In addition to the above treaties, the Ethiopians composed books for recitations, the so-called *Sayfa Śellāsē* or *Zēnā Śellāsē,* Lauds of the Trinity, of which numerous copies are known.[88] Some of these contain succinct definitions of the trinitarian dogma. The following definition was found in 15th-century Lauds of the Trinity which mirror the invocations of Kind Zarʾa Yāʿqob. ". . . credo in essentiam nominis Spiritus Sancti. Ei gratias ago cum Patre simul a Filio. Dum credo in hanc Trinitatem, te nego, Satana, in seculum seculi. Amen", declared a certain Za-Masqal who wrote this invocation and he continued, "Pater et Filius (et Spiritus Sanctus sunt) consubstantiales; trini (sunt) in divisione personarum; Pater et Filius et Spiritus Sanctus (sunt) in unione trina" . . . "Pater, Filius et Spiritus Sanctus trini (sunt) in divisione personarum (et) unicus Deus in Trinitate; tres

[86] *B. Weischer,* Historical and Philological Problems of the Axumite Literature = JEthSt IX 1 (1971) 86; HeyK 249; K. Wendt in: CSCO 235f. (1965).

[87] CSCO 262 (1965) 71–73.

[88] *S. Strelcyn,* Catalogue des manuscrits éthiopiens de l'Accademia dei Lincei Fonds Conti Rossini et Fonds Gaetani, 209, 375, 376, 377, 378 (Roma 1976) 154–57.

columnae lucis (sed) una (est) dimensio eorum, una pulchritudo eorum; tria fulgura, (sed) unus fulgor divinitatis."[89] This concise formulation of the mystery was handed over from generation to generation until the present.

The introducing of the Trinity in 16th-century Ethiopian painting should be viewed in the context of this fervour in the religious life of Ethiopia as well as of fierce disputations and a search for definition of the dogma. Perhaps as an aftermath to the great strife in the 15th century, there was a need for the figurative representation of the Trinity for didactic purposes. This was met by the fortuitous presence in Ethiopia of the foreign painters who brought with them a ready-made model.

Let us turn to the concept of the trinitarian mystery as understood by the illiterate population and the largely illiterate priests and monks. H.M.Hyatt makes the following terse remark, "... systematic theology is unknown in the Ethiopian Church."[90] F. Heyer came to a similar conclusion, while describing the pictorial representations of the Trinity in Ethiopia. "The Ethiopian theological thinking had a typical Orthodox character and up to the present was not able to part from the primitive Christian discussion on Trinitarian dogma and Christology. Christianity which was never Hellenized and penetrated by a Greek Logos, saw the ideal of humanity in humble servants of God. For them, the Trinitarian mystery was based on a constant reminding that God is triune. The Ethiopian piety emphasizes more the collective triplicity of God than His monotheistic unity."[91] The point is well-illustrated in a definition of the Trinity by Ezrā, a member of the Stephanite community accused of denying the dogma in the 15th century. Ezrā, who learned abroad how to construct the watermill was called by King Nā'od, (1496–1508) to demonstrate it at the court and on this occasion was questioned on religious matters. Ezrā's answer about the Trinity was quoted by the hagiographer: "I worship the Father, the Son and the Holy Spirit ... the Father which has generated, the Son which was begotten, the Spirit of Father and Son which proceeds from the Father and was neither generated nor has begotten. The nature of the Godhead does not admit mingling and variation. There are three "faces" as the Prophet said ... three hypostases, but one nature, three names but one Godhead, one kingship, same power, same authority and thought." This definition was found by Ezrā's examiners to be correct, even plain because they noted scornfully that "This even the nun knows."[92] Ezrā's definition is beautifully worded and refined. It stresses the three "faces" of the Trinity, that is three persons and one nature. These difficult terms had to be translated into a language understandable to the people and clergy untrained in scholastic subtlety. "The common error of many authors studying the Christology of the Ethiopian Church," writes the modern scholar dealing with Ethiopian doctrine, "is their belief that Ethiopians

[89] Vat. 89, 15th century. Latin translation by *G. Grebaut* and *E. Tisserant,* Bibliothecae Apostolicae Vaticanae Codices Aethiopici Vaticani et Borghiani (Vatican 1935) 355f.
[90] *H. M. Hyatt,* Church in Abyssinia (London 1928) 85.
[91] HeyK 249f.
[92] *A. Caquot,* Les actes d'Ezrā de Gunda-Gundē = AÉ 4 (1961) 108.

attribute to the terms 'person' *(akāl)* and 'nature' *(bāḥrey)*, especially the latter, a scholastic-philosophical significance. These terms are given a very concrete meaning based on associations with material qualities."[93] At a level of a simple religious teaching in the Ethiopian countryside, the two terms, nature and person, are defined in an even more visual manner. For example, in a devotional booklet[94] published by monks of the Monastery of Bizan, Eritrea, one of the oldest religious establishments in the country, these terms are explained as follows:

Q. "What does it mean: person *(akāl)* ?"
A. "It means hands, legs, eyes, ears, teeth, mouth, front from the nails of the legs up to the hair of the head."
Q. "What does it mean: nature *(bāḥrey)* ?"
A. "This is a thing which does not feel hunger, thirst, tiredness; a thing which does not feel sick and does not die."[95]

This image of God as a reflection of human charateristics is shared by the illiterate faithful and lower clergy. It is pushed so far that, for example, a rather attractive aroid plant in Tegrē, is called "God's penis". The writer noted that the name was laughed upon but not opposed by the monks because obviously even this part of the body was considered necessary in a complete definition of the divine person.

In 1973 at Dabra Mārqos, capital of Goǧǧām province, well-known for its conservatism and religious learning, the writer assisted at an examination of students studying for the deaconship. After reading the test, the questions referred among others, to the trinitarian mystery. The examiner put the question of the similarity of three Persons as follows:

Q. "Have they the same face?"
A. "Yes, the same."
Q. "Have they the same eyes?"
A. "Yes, the same."
Q. "Have they the same beards?"
A. "Yes, the same."

and so forth with any other part of the divine person.

According to Ayala Takla Hāymānot, the concept of "person" is usually translated by the term *akāl*, as already mentioned; occasionally the *akāl* is replaced by the term *gaṣ* which originally meant "face", and sometimes by *malk'e* which means "effigy".[96]

In several booklets of religious instruction published in the last thirty years in Addis Ababā, the Trinitarian teaching was still explained by anthropomorphic visualization of God, though expressed in more sophisticated wording. Starting with devotional invocation: "worship we the Father, worship we the Son, worship we the Holy Spirit: three in one, one in three", the authors attempted the concretization of the mystery. God in his Godhead is one, but three in Persons, all

[93] ATHCrist 117.
[94] *Mazgaba hāymānot* [= Treasure of Faith] Bizan (Asmarā 1959 Eth. Cal.).
[95] ATHCrist 118.
[96] ATHCrist 120.

consubstantial equal but distinct from each other. Each Person exercises its proper function: God the Father, the creation of the world, God the Son, the redemption of it, while God the Holy Spirit, its sanctification. Since all Persons are equal in every respect, they have the same face, figure and so forth. Considering that the Prophet Daniel saw the person of God the Father as an old man all three by premise should be always represented in that manner because they are identical.[97]

It is clear from the above that a similarity of Persons of the Trinity was and is in Ethiopian thinking of prime importance for explaining its mystery.

To sum up, there seems to be a close relationship between the Ethiopian interpretation of the mystery of the Trinity and its pictorial representation. The expression of similarity of the Persons was achieved to perfection in an image shaped during the last four centuries, but at the cost of oneness. This image was religiously handed over from one generation of painters to another up to the present. Indeed, the representation of three identical elders, placed beside each other, seemed to attain the character of a theological demonstration. On the other hand, during the centuries of copying, there was virtually no attempt to stress the unity of the Godhead. The only instance known to the writer of a correction of this was shown by the painter of diptych No. 8. Apparently not many Ethiopians followed his simple but effective rendering of the trinitarian unity.

<p style="text-align:center">* * *</p>

The iconographic story of the Holy Trinity rendered by three identical elders reached its final phase in 18th-century transmutations and the 19th-century un-creative copying. In the latter part of that century and especially in the 20th century the popularity of the form was beginning to ebb. The subject-matter of murals in great churches built at that time rarely included the triple image of the elders. The foreign representation of the mystery which was introduced into Ethiopia just before it disappeared in Europe was given in that country four additional centuries of life before it in turn started to fade away in its country of adoption.

[97] The writer is indebted to *Abebe Kifleyesus* [= *Abbaba Keflē Iyasus*] for extracting the contents from the following works: Bēta Māryām Ašenē, Ammestu a'emāda mesṭir (Addis Ababā 1952 Eth. Cal.); *Abbā Tēwoflos*, Ammestu a'emāda mesṭir (Addis Ababā 1941 Eth. Cal.).

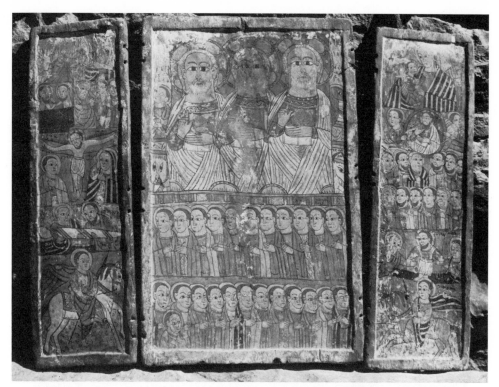

30. Triptych, 16th century. 78,0 : 55,0. Dabra Māʿār (Abuna Abrehām), Garʿāltā (Tl)

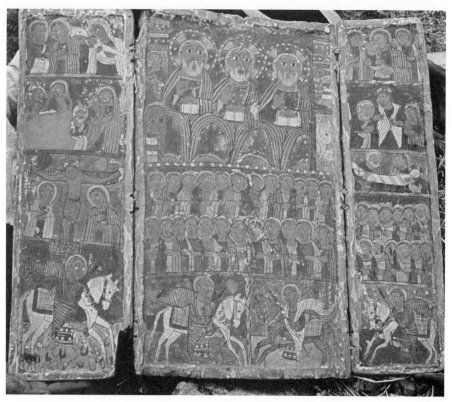

31. Triptych, 16th century. 85,0 : 55,0 cm. Dabra Āsā (Abuna Yoḥanni), Tambēn (T2)

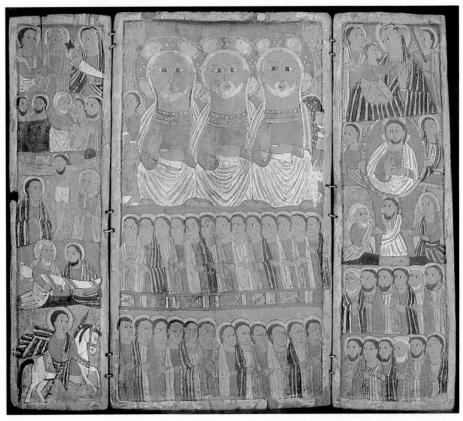

32. Triptych, 16th century. 59,0 : 33,5 cm. Private coll., Germany (T3)

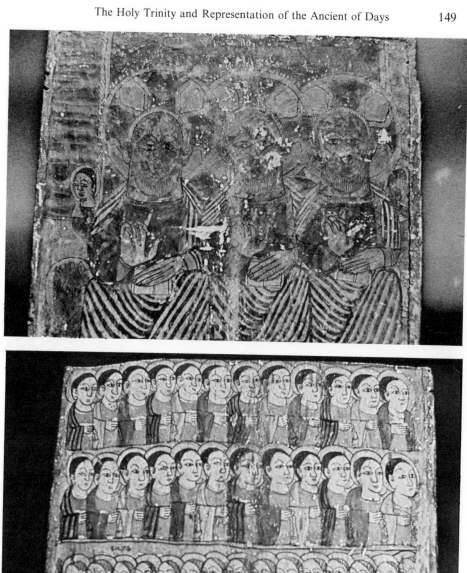

33. Triptych, 16th century. 94,0 : 62,0 cm. IES Coll. No. 4328 (T4)

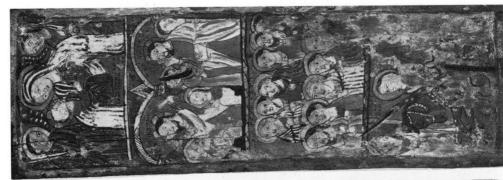

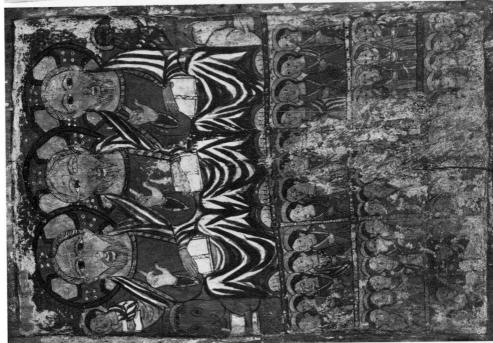

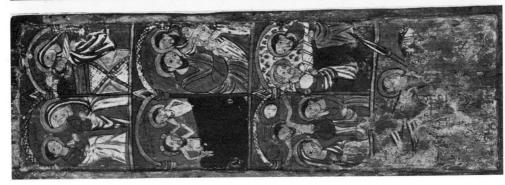

34a (central panel) and 34b (lateral panels). Triptych, 16th century. 88,0 : 60,0 cm. Private coll., Switzerland (T5)

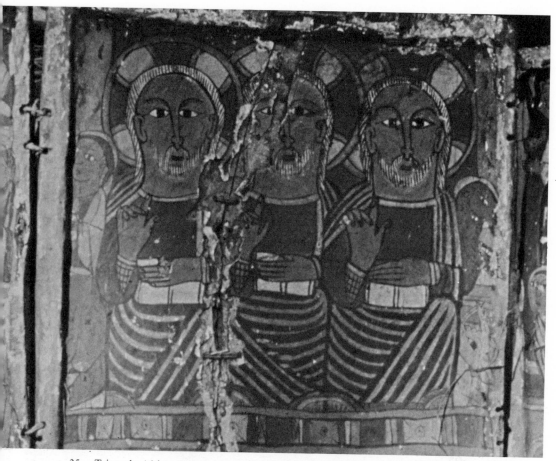

35. Triptych, 16th century. c. 31,0:23,0 cm. Ahiya Afaǧǧ Qwesqwām, Wallo (T7)

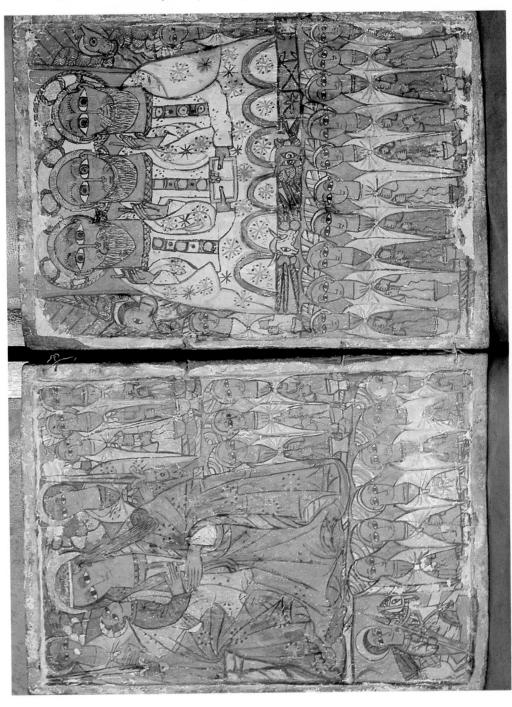

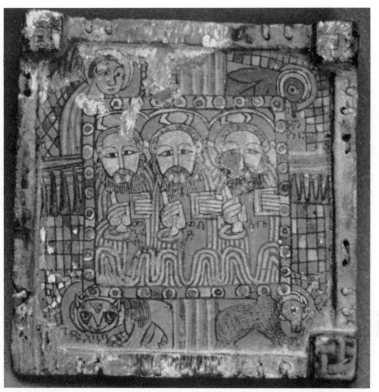

37. Panel, 16th century. 14,0 : 12,0 cm. IES Coll. No. 3898

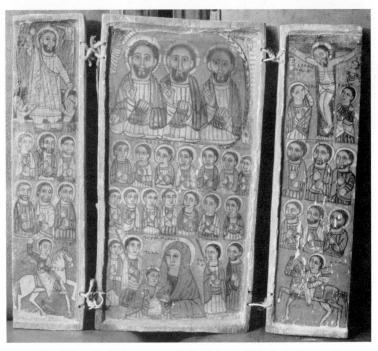

38. Triptych, 16th century. 40,8 : 19,6 cm. IES. Coll. No. 4463

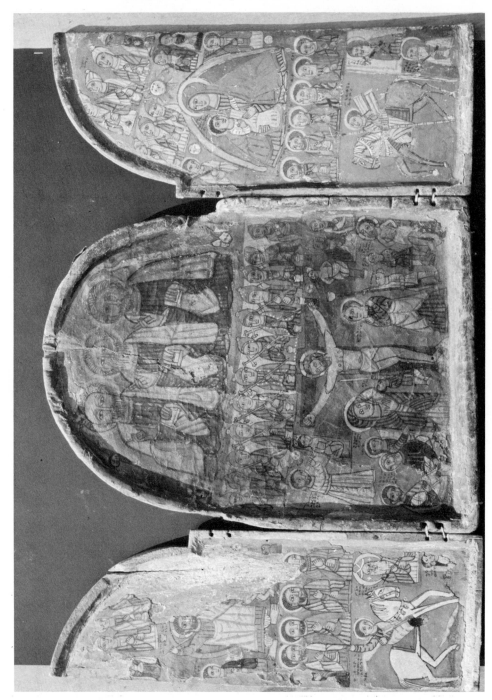

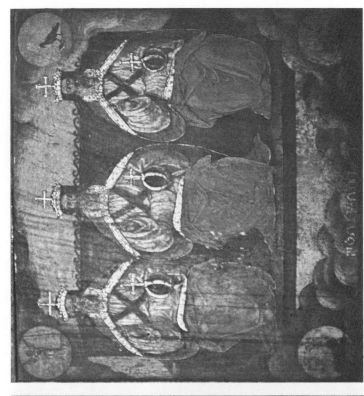
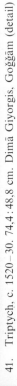

41. Triptych, c. 1520–30. 74,4 : 48,8 cm. Dimā Giyorgis, Goǧǧām (detail)

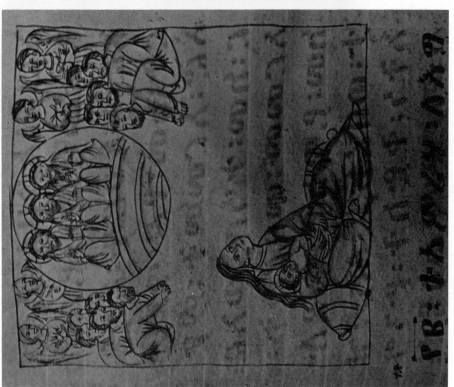

40. Miracles of the Virgin Mary, 1508–20. 25,0 : 20,0 cm. Tadbāba Māryām, Amārā Sāyent

42. Loose folio, late 15th–early 16th century. c. 22,0 : 17,0 cm. IES Coll.

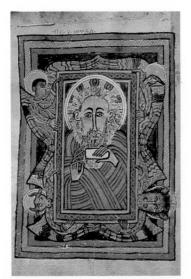

43. Book of Prayers of Sāmuʾēl of Qoyaṣā, first half of the 15th century. 22,0 : 15,2 cm. Dabra Saḥel, Šerē

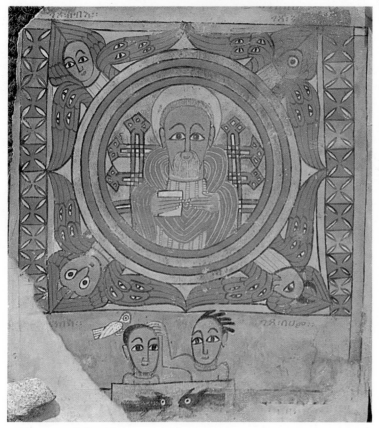

46. Loose folio, 15th century. 29,5 : 24,0 cm. Dr. R. Fechter Coll. PA 3

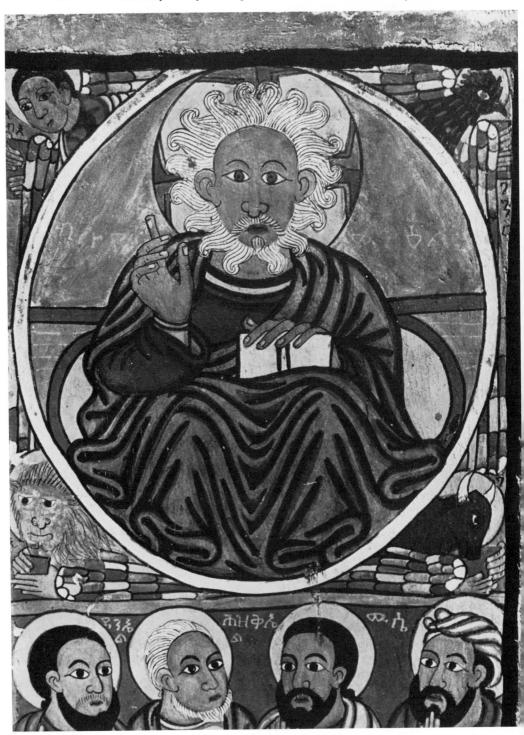

44. Triptych, 15th century, IES Coll. No. 4186 (detail)

45a and 45b. Processional cross, 15th century. 37,5 : 25,7 cm. Dr. R. Fechter Coll. FB/3–2., Germany

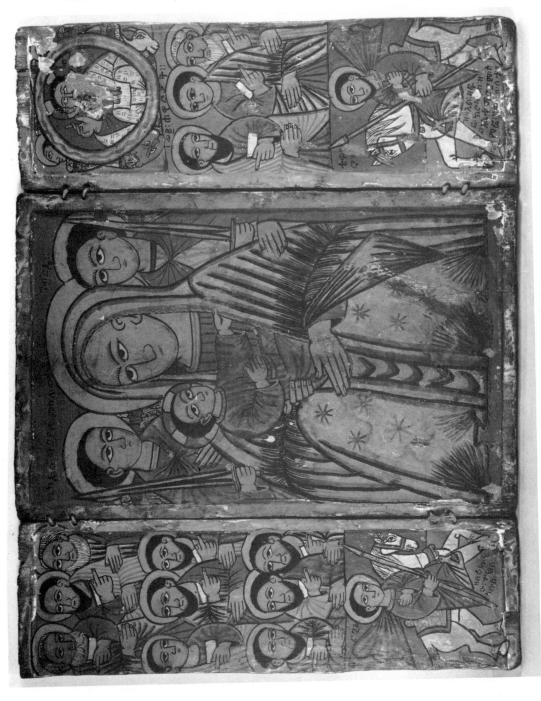

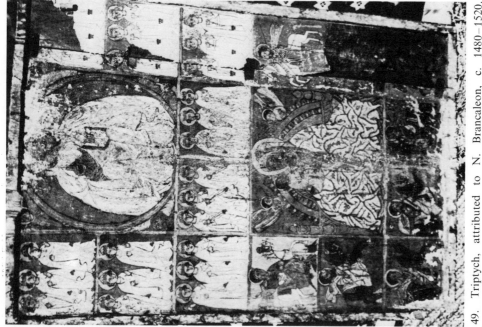

49. Triptych, attributed to N. Brancaleon, c. 1480–1520. c. 43,0 : 30,0 cm. Gētēsēmānē Māryām, Goǧǧām

48. Book of Miniatures by Nicolò Brancaleon, c. 1508–20. 19,0 : 14,0 cm. Wāfā Iyasus, Gončā in Goǧǧām

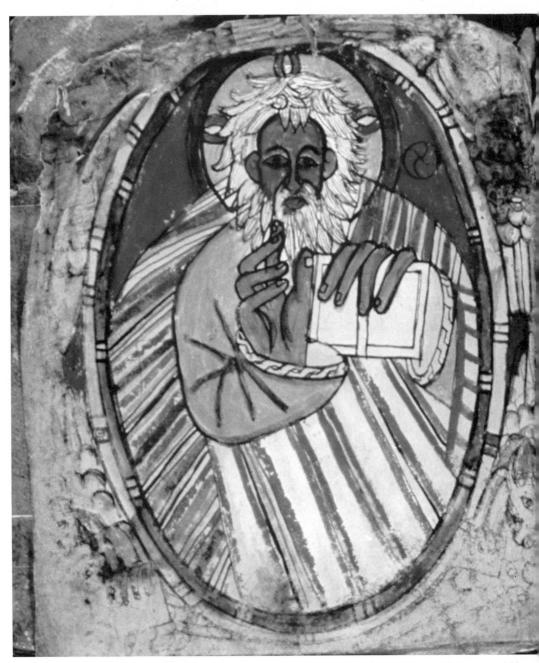

50. Life and Miracles of Gabra Manfas Qeddus, 15th–16th century, 15,0 : 13,0 cm. Ms. or. oct. 555, Staatsbibliothek Preußischer Kulturbesitz (fol. 14v)

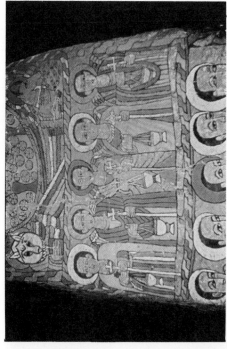

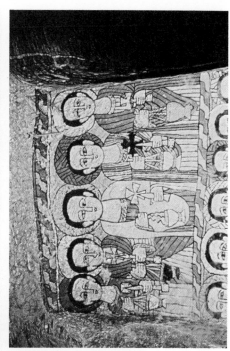

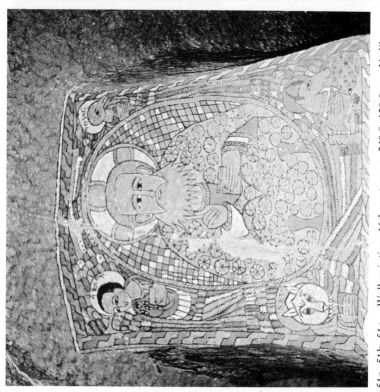

51a, 51b, 51c. Wall painting, 16th century. c. 240,0 : 120,0 cm. Yediba Māryām, Dāwent, Wallo

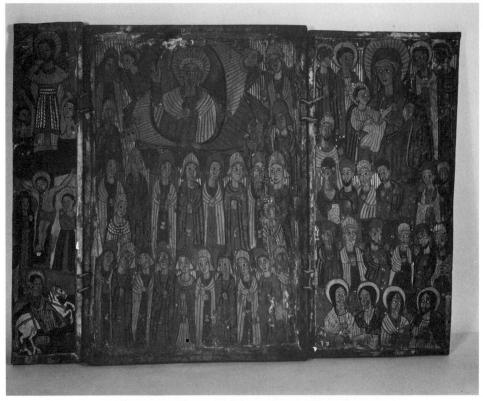

52. Triptych, early 17th century. IES Coll.

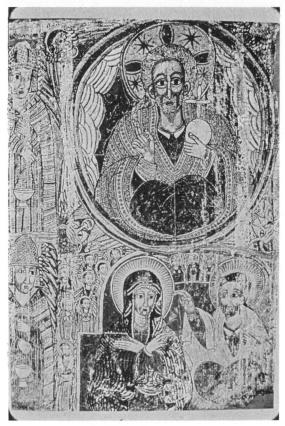

53. Wall painting, late 17th century. Abbā Antonios, Gondar, at present Musée de l'Homme, Paris

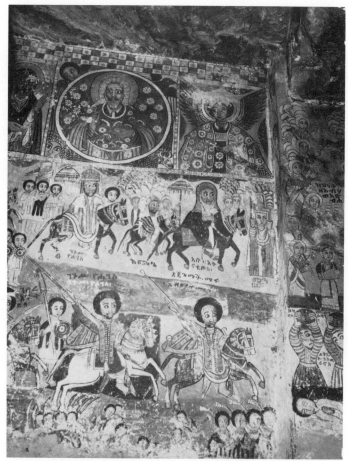

54. Wall painting, c. 1872–89. Abrehā Aṣbehā, Tegrē

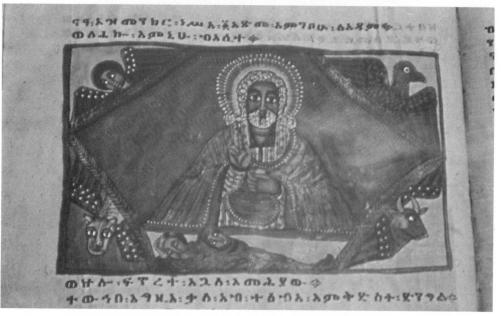

55. Psalter, 1813–47. 22,5:21,0 cm. Salā Dengāy, Šawā

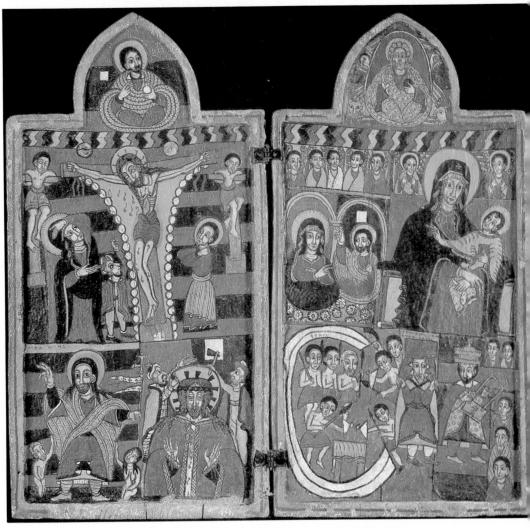

56. Diptych, 17th century. 65,0 : 35,0 cm. Private coll., Germany

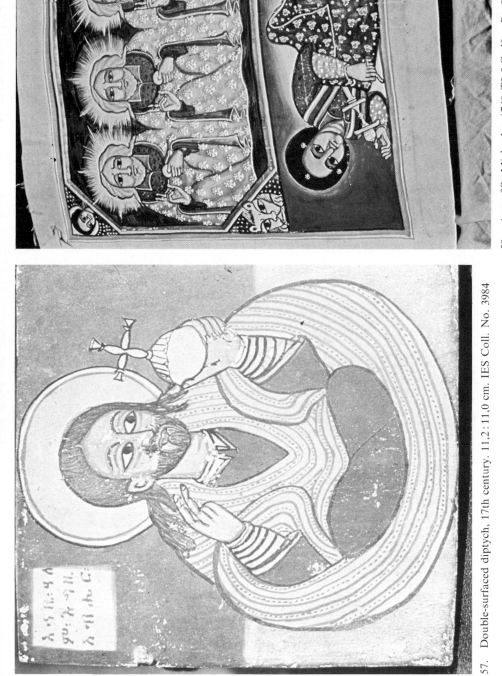

59. Acts of St. Michael. c. 1740. Tārā Gadām, Bagēmder (The figure under the Trinity probably represents Arkaladas d. 1743, uncle of Queen Mentewwāb)

57. Double-surfaced diptych, 17th century. 11,2 : 11,0 cm. IES Coll. No. 3984

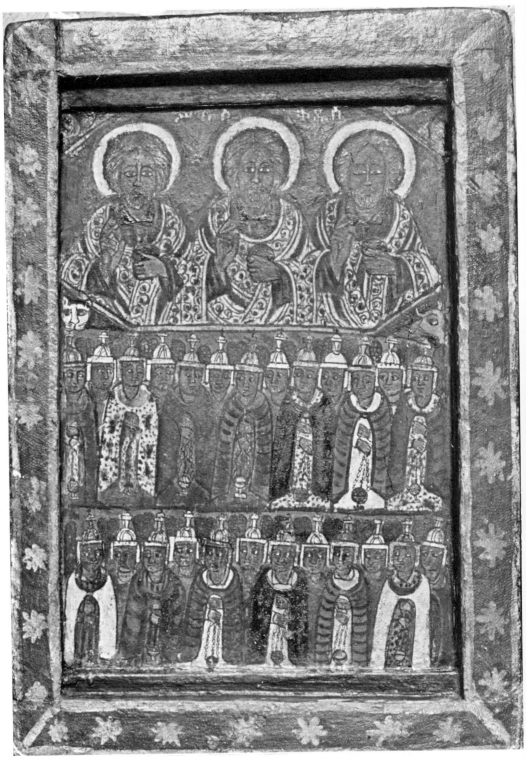

58. Triptych, 18th century. 37,5:27,0 cm. IES Coll. No. 6999.

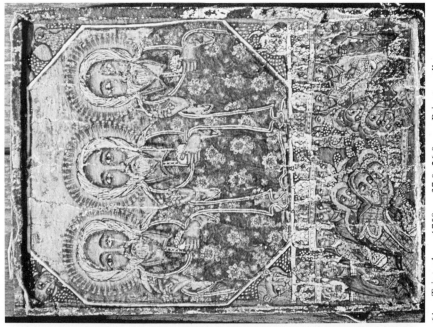

61. Triptych, c. 1750. c. 37,0 : 26,0 cm. Private coll.

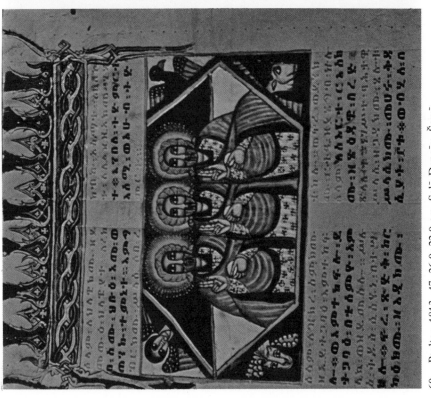

60. Psalter, 1813–47. 26,0 : 22,0 cm. Salā Dengāy, Šawā

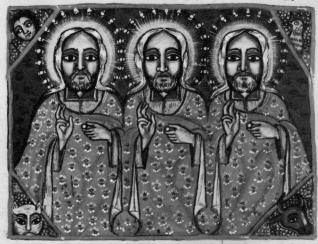

መሳእክት፡መንፈሳውያነ፡ወp፡ ይባርከ፡ወዘይቴዴ፡ከ፡በሰመ፡እግ
ባዴ፡ሊታናት፡እየዝ፡እስ፡ብዘ፡ ዚእብሔር፡ልዕል፡ወስቡሕ፡እግ
ተ፡እዐዩጋቲሆሙ፡ወእየዝ፡ሱ ዚእብሔር፡ወሀ፡ስኮ፡ስታክ፡

ፈፈል፡ኺክነፈሆሙ፡ፀእየሆ መባርዲ፡ረ፡ከመ፡ይሳልዩ፡ወ፡
ሙ፡ዘዩሊብሕ፡ወp፡እም፡ሆሙ፡ዝ ሲእሕም፡ወረስዮ፡ብርጎ፡ና፡ው
ይዚምር፡እም፡ሆሙ፡ዘየእ፡ ያ፡ወል0፡ከ፡ወሀለወ፡ሊ፡ታ፡
ት፡ወp፡እም፡ሆሙ፡ዘዝ፡ብር፡ወዘ መሳክት፡ ወዐ፡ው፡ጴ፡መዝበ፡

62. Miracles of Jesus Christ, 18th–19th century. Abb. 226, Bibliothèque nationale, Paris (fol. 3v)

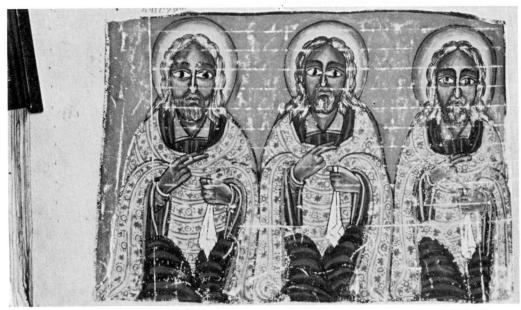

63. Psalter, 17th–early 18th century (text), 18th century (miniatures). 37,0∶35,2 cm. British Library Or. 538 (fol. 51r)

III. THE IMAGERY OF THE VIRGIN MARY

The imagery of the Virgin dominates the subject-matter of Ethiopian art. She is represented in pictures illustrating the life of Christ, in rare compositions illustrating her own life-cycle[1] and especially in innumerable portraits of her, either with or without the divine Child.

This vast iconographic material is of great importance for the study of Ethiopian art and culture; to date, however, few publications have appeared in this field.

The first important step was taken by Ugo Monneret de Villard, who, in his essay published in 1947,[2] has traced the origin of the most popular, even nowadays, Ethiopian image of the Virgin. Its inception in the 17th century marks, in fact, the dividing line between two main periods of Mary's iconography in Ethiopia, the first possibly starting with the earliest representations of her, and lasting until the end of the 16th century, and the second period, from the 17th century until the present. The first period is characterized by the variety of iconographic forms, and the second by their uniformity. Starting with the 17th century, virtually all works of the vast production belong to one iconographic type, and the variations between particular works consist of secondary details and the excellence of their execution. The following four essays refer to developments during these two periods: namely, to the two earliest known to us representations of Mary, the enthroned one and the seated one under the canopy made by outstretched wings of two attending angels; to the dramatic change of her imagery around 1600; and to two unusual iconographic forms developed during the 17th and 18th centuries.

CULT OF ST. MARY IN ETHIOPIA

Mary was given a privileged place in the teaching of the Ethiopian Church and in its liturgy; she also enjoys the fervent devotion of the faithful. The cult of Mary in Ethiopia was ably described by *Khodja* Murād, Armenian resident in Ethiopia, who in 1690 visited the headquarters of the East India Company, Batavia, on behest of Emperor Iyāsu I: "They [Ethiopians] highly venerate the Saints, and especially the Blessed Virgin Mary, Mother of Jesus Christ, to such an extent that

[1] Although Ethiopians used Infancy gospels for illustrating the early life of Christ they virtually never depicted the events preceding the birth of Mary (the Annunciation to Joachim and Anne, their meeting at the gate) and rarely the events of her early life (Anne with Mary, young Mary given to the Temple and others). These themes are well-known in Eastern iconography (Cappadocia) and enjoyed a certain popularity in the West in early Mediaeval times, usually in regions where contact with the East was kept alive.

[2] MonMad 9–90.

they use the word Mary when they want to express something of the highest value..." They reject her statues, "but cherish pictures representing the images of the Virgin Mary..."[3]

Ethiopians adhere to the dogma of Theotokos which means that Mary is not only the mother of Jesus Christ but also mother of God; the dogma was established at the council of Ephesus in 431. The term *Walādita amlāk* by which she is called in Geez, the liturgical language of the Ethiopians, is an exact translation of the Greek term Theotokos, generatrix of God.

The most prominent defender of this creed was Cyril, patriarch of Alexandria. His polemical writings against the Nestorians, who opposed the creed, are included in one of the oldest Ethiopian texts *Qerelos*. Other writings of Cyril also in defence of the Theotokos dogma are part of the basic theological book of Ethiopians entitled, *Hāymānota abaw*, The Faith of the Fathers.

The other reason for a privileged position of Mary was the belief of Ethiopians in her effective power of intercession between Christ and mankind. This belief finds its justification in apocryphal texts, particularly in the so-called Prayer of Golgotha and Prayer at Bartos.

Similar to Copts, the Ethiopians made extensive use of apocryphal writings on Mary. These texts of the Early Church filled the existing gaps in the synoptic gospels and answered popular curiosity about Mary's parents, her miraculous conception and birth, her early life, marriage to Joseph and the infancy of Jesus. Ethiopian Marian liturgy and calendar rest heavily upon these writings. For example each event of Mary's life has a corresponding feast day in the Ethiopian religious calendar. A passage based on the apocryphal test is usually read during the liturgy.

The Virgin was also given a privileged place in the liturgy of the mass. She has a special anaphora, that is the eucharistic prayer modified so as to implore and praise Mary.

The Ethiopian religious literature contains hymns of and litanies to Mary. Especially popular are salutations, *salām*, to Mary and praises, *malkʿe*, of different parts of the Virgin's body. These texts expressed in naive but sincere devotion are recited daily by clergy and faithful.

A great many churches in Ethiopia have been dedicated to the Holy Virgin. According to tradition, Saint Frumentius who was instrumental in introducing Christianity into Ethiopia in 333, named after Mary the first church in Ethiopia built in Aksum, then capital of the Empire. The church still bears her name. In subsequent centuries Ethiopian kings founded many churches and dedicated these to Mary. Among the churches enjoying particular fame there is Bēta Māryām (House of Mary) founded by King Lālibalā, late 12th–13th century, Tadbāba Māryām (Cupola of Mary) founded by Tēwodros I (1411–14), Atronsa Māryām (Throne of Mary) by Baʿeda Māryām, and Marṭula Māryām (Tent of Mary) by Eleni, wife of Nāʾod, early 16th century.

[3] E. van Donzel, *Foreign Relations of Ethiopia 1642–1700; Documents relating to the Journey of Khodja Murād* (Leiden 1979) 74.

The most common manifestation of the cult of Mary is the custom of adopting her name. There is a long list of such names, some widely used. They are Gabra Māryām (Servant of Mary), Hābta Māryām (Gift of Mary), Lāʾekā Māryām (Servant of Mary), Takla Māryām (Plant [shoot] of Mary), or Walda Māryām (Son of Mary).

There is no doubt therefore that virtually from the inception of Christianity, the Ethiopians, like other Eastern Churches, developed a fervent veneration of Mary. It was in the 15th century, however, that her cult was officially established. Taddesse Tamrat believes that this important event in the history of Ethiopia has some connection with the translation of the Book of Miracles of the Virgin Mary into the Ethiopic language.[4] This is a collection of miraculous stories about her which was popular and widespread throughout the mediaeval Christian world. The first set of the stories was translated during the reign of King Dāwit I (1382–1411).[5] The Miracles, subsequently enriched by many stories, local and foreign, attained almost instant popularity, as numerous 15th-century manuscripts, still found in the monasteries of Ethiopia, seem to make evident.

Dāwit's son, King Zarʾa Yāʿqob, institutionalized the cult of Mary by adopting, around 1441–2, the so-called canon of al-Muʾallaqa.[6] According to this, the reading of passages from the Book of Miracles was made obligatory in the Church of Ethiopia,[7] the practice becoming an integral part of its liturgy. Thus, each Sunday morning the selected miracles are read twice, first at the end of the prayer (saʿātāt) before the holy service, and then at the end of it, this time outside the church. Moreover, Mary is commemorated during the liturgical year by thirty-three special feast days of her own. These feasts apparently were known in Ethiopia before the reign of King Zarʾa Yāʿqob, but it was he who enforced their strict observance. Additionally, he was teaching, according to his chronicler, that there should be more than one ṭābot (altar stone) in each church, and one of them should be dedicated to Mary. In the prescriptions for Sunday liturgy by the same king the painted images of Mary are expressly mentioned. They should be venerated in the same manner as the crosses. The image of Mary should be put in place of honour and sheltered with a canopy.[8] Indeed, from the time immemorial such images are kept in Ethiopian churches and monasteries, and carried in procession on Sundays and feast days.

Ethiopians accepted this new trend under the strong pressure of King Zarʾa Yāʿqob, and despite vehement opposition in some quarters of the Ethiopian

[4] TTSteph 112.

[5] An extensive commentary on the origin of the book and its introduction in Ethiopia in CLMM.

[6] The Canon is of Coptic origin. It was decreed at the Council held in the church of al-Muʾallaqa, Cairo. According to CLMM 3, the Arabic original of the Canon is unknown. The redaction of the Canon was effected either at the end of 14th century or in the first years of the 15th century.

[7] CLMM 91 f.

[8] PerrZar 81; CSCO 262 (1965) 2, 26.

Church. In fact, the great religious controversy which convulsed 15th-century Ethiopia was to a large extent generated by the King's insistence on worshipping Mary. The Stepanite movement,[9] so-called after its founder Esṭifānos, strongly objected to this. The movement started around 1430 in the north of Ethiopia and ever since has been influential there. Esṭifānos travelled three times to the court of King Zarʾa Yāʿqob to discuss his stand in several theological issues. "The most important issue discussed", writes Taddesse Tamrat about the final visit of Esṭifānos, "seems to have been the exaggerated cult of Mary". Esṭifānos objected to it so vehemently that he is known to posterity as the enemy of Mary *(ṣara Māryām* or *daqiqa Esṭifā)* and during his life-time was accused of irreverence to Mary.

Faced with the obstinacy of the Stefanites, Zarʾa Yāʿqob reverted to ferocious persecution. Stephanites retreated to the inaccessible places in Agāmē, Tegrē.[10] A few years afterwards, Yeshāq, successor of Esṭifānos, d. c. 1459, founded the Monastery of Gunda Gundē, still existing and famous for its rich library and scriptoria.[11]

Although the so-called Stephanite "heresy" was suppressed, the community nevertheless survived the persecution but mellowed its stand on the issue. Worship of Mary, ever since, dominated the life and religious practices of the Ethiopians. Their contact with the Jesuits in the 16th and early 17th centuries further strengthened their attitudes. The Jesuits, who have been as fervent devotees of Mary as the Ethiopians, played an important role in the development of her iconography.

How were these events mirrored in Mary's early iconography? Before attempting a conclusion, let us review the works which seem to be representative of the period.

THE EARLY IMAGERY OF THE VIRGIN MARY

THE ENTHRONED VIRGIN

(1) Amongst the wall paintings in the rock-hewn church didicated to Mary on Mount Qorqor, Garʿāltā, there is her picture which is one of the earliest known to us (fig. 64). The age of the church and its murals is still under

[9] The Stephanite movement, not yet fully studied, is considered by some scholars as related to Arian doctrines. *M. Rodison*, L'homélie sur la foi en la Trinité de Sévérien de Gabala = Atti del Convegno internazionale di studi etiopici Roma, 2–4 Aprile 1959 (Roma 1960) 388–95; *K. Wendt*, Die theologischen Auseinandersetzungen in der äthiopischen Kirche zur Zeit der Reformen des XV. Jahrhunderts = Atti del Convegno internazionale di studi etiopici, Roma 2–4 Aprile 1959 (Roma 1960) 137–46. King Zarʾa Yāʿqob described the Stephanites as follows: "The followers of Esṭifa . . . say 'we do not worship Mary, twice virgin, and the cross ornate'" in: CSCO 251 (1962) 24.

[10] TTSteph 110–12.

[11] MorGG 29–48.

discussion and not finally established. The few captions under the paintings do not give an indication of their date and therefore the opinions of experts vary a great deal.[12] Nevertheless, it is certain that the murals cannot be later than the 14th century, indeed they might go back as far as the 13th century. According to recent studies, the murals, in part at least, show similarity to the art of Christian Nubia.[13] Whether this is the case with the paintings of Mary will be discussed subsequently.

The unusually large composition represents the Enthroned Virgin and Child flanked by two angels. The Virgin sits on a conspicuous and elaborate throne which has a wide back surmounted by two globes and an equally wide seat supported by four ornamented legs. The throne shows some characteristics of Byzantine art, for example the cushion on which Mary sits, but the other common detail, a foot-rest, is missing.

Mary is rendered in frontal position, with her two hands supporting her Son. He stands within the *clipeus*, a medaillon, and appears to be older than a baby. He holds a book in his left hand and seems to indicate it with his right hand. The nimbus of Christ is plain yellow and not cruciform, the large nimbus of Mary is ornamented with a set of "feathers" around its rim,[14] whereas the nimbi of the angels are drawn with a double line, which is common in 14th and 15th-century art. The angels, Michael and Gabriel, hold a round figure in their hands; this seems to be a paten which is common in Coptic art, whereas an orb is a frequent attribute of Nubian angels. Additionally the angel on the right holds a raised sword.

The face of the Virgin and those of the angels are round which is often found in 13th-century murals.[15] Also the way of drawing eyes corresponds to that which was used during the same period. The irises are attached to the upper line of the eyeballs leaving an open space between these and the lower line of the eyeballs. However, the painter has added his own touch extending the upper line of the eyes and directing it sharply downwards.

The painting is made with a limited range of colours in which brown, in varied shades, and ochre dominate. Light green and red appear here and there. All these pigments are easily available from minerals of the Gar'āltā Valley. Blue is missing altogether. A similar range of colours characterizes Nubian art of the 10th–11th century and the multi-coloured style of the 11th and 12th century.[16] Another significant detail is the checkered ornamentation of the back of the throne. The

[12] *G. Gerster* in GerChRock 80, prudently emphasized that "considerations of architectural history allow the adoption of any date between the seventh and fourteenth centuries..." As for the murals, "The study yet to be done on the ornament of oldest frescoes might considerably reduce this time-span."

[13] GerChRock 80; LepÉth 345.

[14] Identical ornamentation of the nimbus is found in another detail of Qorqor Māryām murals, namely the scene of the Visitation of Anne to Mary.

[15] Bēta Māryām, Lālibalā; Gannata Māryām, Lāstā; Ḥaregwā Mikā'ēl, Gar'āltā.

[16] *K. Michałowski*, Open Problems of Nubian Art and Culture in the Light of Discoveries of Faras = DinNub 14f.

same pattern is used extensively for decorating objects and dresses in 10th and 12th-century Nubian art.[17]

The painting belongs to the category of the Enthroned Virgin and on account of the *clipeus* is called *imago clipeata*. This is the only known to us example in Ethiopian painting. The form is well known in Byzantine art and in areas influenced by this art. The *clipeus* is believed to originate from Roman imperial portraiture,[18] wheras the whole image is a transposition of the *Majestas Domini*, in which the figure of Christ was replaced by a figure of Mary.[19]

The subject of the Enthroned Virgin is found in Coptic art, particularly in murals of Bawît and Saqqārah dated to the 6th through the 8th century. On the other hand, this form of the Virgin is virtually unknown to Nubian painters as far as can be ascertained from their preserved works.[20]

The Enthroned Virgin is depicted in the icon possibly of Syrian origin which was preserved in the collection of St. Catherine's Monastery, Mount Sinai. This is one of the oldest icons known and dates from the 6th or 7th century.[21] The subject was also practised in manuscript illuminations as attested by the miniature in 10th-century Etchmiadzin gospels. However, there is no direct relation between these paintings and that of the Qorqor Māryām.

The painter who made the Qorqor Māryām mural apparently knew and followed the centuries old form of the Enthroned Virgin. The identification of the painter, (whether he was an Ethiopian or a foreigner) is not possible; nevertheless, the following discussion attempts to shed some light on his personality and the artistic stimuli he absorbed.

Some indication is given by the choice of place for the image of Mary. It occupies the space on the southern wall between two pillars close to the entrance door. It is clear that the Coptic or Byzantine schema for depicting Mary in church decorations was not followed in Ethiopia. On the other hand, the position of the image follows its own logic. The glorious image of the Enthroned Virgin faces almost exactly a double composition of the *Majestas Domini* and Christ's Entry into Jerusalem, two equally glorious images of Christ, painted on the northern wall. Both thus juxtaposed compositions recall the theophany-vision found in Coptic paintings at Bawît and Saqqārah.[22]

[17] Comp. a couch of the Virgin and a structure at her back in the Nativity. Reproduced in DinNub (fig. 1).

[18] GraMart 2 (1946) 26f.

[19] Thus Mary "became the principal object of glorification in her rôle as the Mother of God", WaltMonEg 127f.

[20] *T. Gołogowski*, On the iconography of the Holy Virgin represented on Faras murals: standing Virgin holding the Child on her arm = Travaux du Centre d'archéologie méditerranéenne de l'Académie polonaise des sciences 6 (Warszawa 1968) 295–312. In Faras Cathedral the characteristic type of the Virgin is that of standing and protecting the king, prince or ecclesiastics.

[21] *D. Rice*, Byzantine art (Harmonsworth 1968) 362.

[22] GraMart 2 (1946) 207–27 pl. 54; Bawît Ch. 42 reproduced in DinNub fig. 285.

However, one has to consider the possibility that the church was decorated by several hands and at different times; thus the place allotted to both murals could be more a question of chance and available place than of deliberate planning. The picture of Mary occupies the upper register of the wall, the lower register being filled by an extensive composition representing three Hebrew youths in the furnace and King Nebuchadnezzar ordering them to be put into it.[23] The subject is common in the murals of Bawīṭ and Saqqārah. It was also known to the Nubian artists as attested to in the mural of Faras Cathedral. The subject is also found in early Ethiopian painting, namely in the murals of Gannata Māryām and in the gospels of Iyasus Moʾa, both datable to the second half of the 13th century. The Qorqor Māryām painting follows neither Coptic nor Nubian representation of the Three Hebrews in which the angel stands in between, thus dividing them into two groups, but assimilates the Syrian form in which the angel is placed to the left of them.[24] The particular interest of the rendering of the subject in Qorqor Māryām is the addition of the Babylonian king, a detail missing in Faras and rare in Bawīṭ and Saqqārah.

The other addition to this image of the Virgin is a small composition depicted below the left guardian angel and above the angel rescuing the Hebrews. Two men carry a bed on their heads. It seems that there is a man lying on the bed. The poor state of preservation of this section of the mural does not allow identification with certainty but probably the composition represents the man sick with palsy and illustrates the miracle of Christ as narrated by Matthew, 9.2ff. The 13th century mural in Bēta Māryām church, Lālibalā, shows the sick man already cured and returning home with his bed. In Qorqor Māryām possibly the first part of the narration is illustrated, namely, the man being carried on his bed in expectation of the miraculous cure.[25] Neither the three youths standing in the fiery furnace nor the healing of the paralytic are iconographically related to the picture of Mary. They are, nevertheless, indicative of the age of the murals and possibly the areas influencing it. Both themes belong to the oldest in Ethiopian painting. They were extensively used in the 13th century. On the other hand, the Syrian form of the subject of the Hebrews proves that the mural is composed of elements originating from varied areas of Eastern Christendom.

Indeed, the main subject of the mural, the image of the Virgin, is an iconographic amalgam. The figures of the Virgin and Child in the *clipeus* are similar to those found in Bawīṭ and Saqqārah.[26] Particularly striking is the analogy with the mural

[23] *Lepage* believes that the figure in front of the king is a man who stokes fire, LepPÉth 343. This identification needs to be checked, the figure seems to have the head of an animal.

[24] *G. Soteriou* and *M. G. Soteriou*, Icônes du Mount Sinai (Athens 1956–58) list the icon under No. 12 of the collection of the Monastery. They date this encaustic painting to the 5–7th century. Reproduced in: DinNub fig. 325.

[25] The 18th-century mural in Kidāna Meḥrat church, Goǧǧām, shows these two phases of the miracle.

[26] LerMssCopt 23, gives the following list of Coptic images of the Enthroned Virgin with *clipeus*: Bawīṭ, chapel 28, Monastery of St. Anthony (church and cloister).

in Chapel 28 in Bawīṭ. Mary sits on a bejewelled throne decorated with globes; she holds in her two hands a round medallion in which a small standing Christ is depicted.[27] Also in Coptic art, particularly in Saqqārah one has to search for the origin of the curious decoration around Mary's nimbus. In cell A in Saqqārah the Enthroned Virgin nursing the Child has a large halo decorated with a row of pearls inside the rim and a set of sinuous figures around it (WaltMonEg fig. XIII). The "feathers" around Mary's nimbus in Qorqor Māryām seem to be a replica, simplified perhaps, of the same detail in Mary's picture at Saqqārah.

The figures of angels might belong to another centre. Coptic angels are rarely depicted with swords and their headgear is usually different from that of angels in Qorqor Māryām.[28] These angels are clad in an Imperial attire, namely *loros* put on a richly decorated tunic; a tiara holds their hair. In the same church there is an image of the archangel Raphael depicted below a blind arch which is similar to those in our mural. Gerster was "quite struck . . . by the similarity of the picture of the archangel Raphael . . . with a tenth or eleventh-century archangel in the cathedral church of Faras".[29] Indeed, the garments and wings of our angels seem to be painted in the multicolored Nubian style of the 11th century.

The inclusion of varied birds and additional subjects into the picture of Mary is another point of analogy with Coptic art. Two birds facing each other rest on the globes decorating the throne; they are placed symmetrically on both sides of Mary's head so as to made us wonder whether this arrangement has any other purpose than the purely ornamental. Also the area below and to the right of the Virgin is filled with four birds. Two of them are cocks,[30] the third has a crown on its head but otherwise cannot be identified, and the fourth recalls the Byzantine doubleheaded eagle. The murals of Bēta Māryām church, Lālibalā, which are manifestly influenced by Coptic art, also include the double-headed eagle. On the whole, the Qorqor Māryām murals are remarkable for the profusion of birds scattered around the biblical scenes and the images of saints.

Birds as ornaments are common in the illuminations of early Ethiopian gospels. The Qorqor murals should be viewed partly as projection of the bird ornamentation of the gospels into church decoration. The story of Adam and Eve in Paradise, depicted on the northern wall of Qorqor Māryām, is embellished by a number of birds. Their arrangement follows closely the ornamental pattern of the Canons of Eusebius in the manuscripts.

The main reason why the Qorqor Māryām painter scattered birds and other figures around the Enthroned Virgin is different. Ethiopians shared with Copts a

[27] *K. Wessel* in RbK 3 (1973) 366–7, gives the following explanations of the form. The Child in the *clipeus* is a "preexisting Logos" while the *clipeus* represents the universe (Himmelsphere). The form illustrates the Akathistos hymn in the liturgy of Basileos. «The Son of Man took bodily shape the sky cannot contain Him».

[28] WaltMonEg 326–8.

[29] GerChRock 80.

[30] In Bēta Māryām church in Lālibalā, there is a painted frieze showing a cock-fighting while a third bird watches it.

dislike of empty areas in paintings; they had a real *horror vacui*. Copts, according to Walters, composed the paintings in a series of registers and in general liked to crowd the space available indiscriminately with figures. "The artists at Bawit and Saqqara ... frequently had recourse to elements completely divorced from the rest of the composition".[31] Moreover, as J. Leroy pointed out, "The Copts enjoyed depicting animals; the profusion of these in their painting is so great that undoubtedly the Coptic bestiary is one of the richest in the world".[32] The birds in Qorqor Māryām mirror the Coptic *horror vacui* and their love for animal ornamentation. The artist who painted the mural has absorbed to perfection these two characteristics of Coptic art.

There is an evident analogy between the Qorqor Māryām mural and the Coptic images of the Enthroned Virgin and a less tangible but still postulated analogy between the angels in the mural and those in the Christian art of Nubia. The basic form of Mary and Child and their setting are Coptic, and have been used in Ethiopia at least until the 13th century. Possibly, in the process of local reshaping, the forms of Nubian angels have been added. Thus the analysis of the mural in Qorqor Māryām sheds some light on developments in Ethiopian painting prior to the 13th century. Perhaps the mural is the result of combined exposure of the Ethiopians to Coptic as well as Nubian influences. These probably acted at different times. Ethiopians creatively incorporated this double influence into their painting.

THE VIRGIN UNDER THE CANOPY OF WINGS
ANGELS WITH CROSSES

In this form two archangels Michael and Gabriel, flanking the Virgin, outstretch their inner wings above her head. Thus she sits or stands under a canopy of wings. The outer wings of the angels are folded. The rendering of Mary and Child as well as the angels varies a great deal.

There are three types of angels; in one type they carry the cross in one hand and usually extend the other hand towards the Virgin; in the second type they hold a sword in their hand, and in the third they neither hold a cross nor a sword but extend both hands towards the Virgin. These differences are indicative of stages through which the form of the Virgin under the Canopy of Wings evolved.

The following is the description of paintings in which angels holding a cross are found:

[31] WaltMonEg 145.

[32] LerMssCopt 69. An analogy should be mentioned between the animal life in Qorqor Māryām and the illuminations of early Ethiopian gospels as well as the exterior decoration of the Armenian church of Holy Cross, Aght'amar Island, Lake Van. The church was described by *S. Der Nersessian*, Aght'amar Church of Holy Cross (Cambridge Mass 1965).

(2) The miniature in the Book of Prayers[33] which according to tradition belonged
 to Sāmu'ēl of Waldebbā, founder of the Monastery of Dabra Abbāy, Šerē.
 The monk is believed to have lived during the reign of King Dāwit I.[34]

The miniature (fig. 65) represents the Virgin seated on a stylized chair; the pose
of the lower half of her body is similar to that of the Evangelists in frontispieces to
the early Ethiopian gospels. Mary wears a long checked robe and a mantle covering
her head and shoulders. With both hands she supports the Child who is depicted on
her left side. He neither performs a gesture of benediction nor carries a book or a
scroll. The nimbus is ornamented with a cross, the arms of which are flared.

The angels have elongated faces and a large black crown of hair. In the middle of
this there is a red shape which recalls a stylized cross or a star. The significance of
these is not clear. It seems, however, that it may originate from a detail, well-known
in Byzantine and related art, namely a ribbon supporting the hair. Such a ribbon is
occasionally reduced to a small triangle in the middle of the crown of hair. Perhaps
the meaning of the ribbon was not fully understood by the Ethiopian illuminator
who nevertheless retained the detail but altered its shape. The angels wear a tunic
and *pallium* or *chlamys* over it, covering one arm and leaving the other arm
exposed.

The other point of interest is the slippers ornamented with colourful stripes. In
Coptic art the angels usually wear such ornamented footwear *(campagae)* whereas
in Ethiopian art they are virtually always bare-footed.

The way of drawing the face is particular to this miniature. The high eyebrows
defined by a thick black line are not connected with the line of the nose as is usual in
early Ethiopian painting. The irises are placed in the middle of the eyeballs. The
nose is thin, the mouth rectangular. Moreover, the whole figures are reduced to
geometrical forms decorated with a set of slanting parallel lines.

(3) A folio with the miniature (fig. 66) representing "Mary and her beloved Son",
 both sheltered by the wings of two guardian angels is bound together with the
 Book of Miracles of the Virgin Mary, IES Ms. No. 777. The manuscript is
 datable either to the second half of the 15th century or early 16th century,[35]
 while the folio with the miniature is certainly earlier.

The composition of the miniature recalls the one in the Book of Prayers, Dabra
Abbāy, whereas its style is similar to those of the Arsimā (c. 1430), the Kebrān
(ascribed to the period 1380 to 1420) and the Māryām Māgdālāwit Gospels (second
half of the 14th century).[36] In all these gospels, the way of delineating the faces is

[33] A similar Book of Prayers with miniatures is preserved in the Monastery of Dabra Saḥel,
 Šerē. The Book is believed to have belonged to Sāmu'ēl of Qoyaṣā himself, who founded
 this monastery.

[34] KRZHagTrad 89–90.

[35] *Dr. Kinefe-Rigb Zelleke* dated the manuscript on paleographic grounds. At the beginning
 and end of each miracle the name of a certain Gabra Mar'awi is mentioned.

[36] The miniatures in Kebrān and Arsimā gospels have been reproduced in UNESCO,
 Ethiopia: illuminated manuscripts (New York 1961); the miniatures in Māryām
 Māgdālāwit Gospels, Ambā Darā, Tegrē, have been published in the *Oxford University*

characteristic of the style, that is the nose and the mouth are drawn with red colour whereas the eyes and eyebrows are drawn with black. Also in the above gospels are found the elongated fingers of personages expressing emphatically the meaning of the compositions.

Our scribe tends to reduce human shapes into geometrical forms and emphasize the frontality of faces which marks the difference with the gospels. We witness in the miniature the transition from the frontal to the three quarter pose, whereas in the gospels the pose is more settled. As in the Dabra Abbāy Book of Prayers each angel holds a large wooden cross in his hand and the Child is depicted on the left side of his mother. She is seated on a stool which is in fact a square filled with ornamental pattern; this detail is evidently borrowed from the representation of the Evangelists. Another indication for dating the miniature is the nimbi analogous to those in the Arsimā gospels. Moreover, the infant Jesus is adorned with a plain yellow nimbus as in the following miniature. All this suggests that the folio should be dated either to the last decades of the 14th century or the first decades of the 15th century which makes the miniature one of the earliest examples of the iconography of Mary under the canopy of wings. This manner of drawing recalls the Book of Saints, preserved in the Ṣeyon Māryām church, Lake Zewāy. The book was written during the reign of King Dāwit I.

(4) The miniature (fig. 67) painted on the first folio of the Lives of Saints which originally belonged to the Monastery of Hamlo, Tegrē, but at present is kept in the church of Kidāna Meḥrat, Astit, close to Ankobar.[37] According to the colophon, the book was written by Marqorēwos when Salāmā the Translator was metropolitan and King Dāwit I was reigning, i.e. during six years, between 1382, the year of Dāwit's accession to the throne and 1388, the date of Salāmā's death.

The manuscript is ornamented with a number of miniatures executed in a style which accords with our knowledge of 14th-century painting. However, the picture of Mary is different from the rest. One has the impression that the miniature is either the work of another hand or that the same artist has used a different model and followed it closely. It is therefore difficult to decide whether the picture of Mary is contemporary with the rest of the miniatures or added at a later date. In any case, the colophon gives the earliest possible date of the picture which cannot be later than the beginning of the 15th century.

The division of the miniature into two registers is significant; the lower register is filled entirely with a checkered pattern, extended as a background to the upper register in which the Virgin is depicted. The purpose of this display of ornamentation is not clear. It is known only to be practised in the 15th century, perhaps

Exploration Club, Rock-hewn Churches in Eastern Tigray; an account of the Oxford University Expedition to Ethiopia (Oxford 1975) 73–83 and fig. 97–112. As to the date of this important manuscript, the editors extracted two possible dates from the partly erased colophon, the earliest 1363 or the latest 1439. They opted for the former.

[37] The microfilm of the Ms. is kept in the Monastic Library, St. John's University, Minn., under the No. EMML 2425.

exceptionally in the 14th century. The possible analogy to and explanation of this detail is found in Armenian manuscripts produced in the city of Khizan, southwest of Lake Van. A school of manuscript painters flourished in that city in the 14th and 15th century.[38]

The figure of the Virgin seems to be standing but has developed from the seated type; this is manifest because of a square filled with an ornamental pattern drawn on her left. Such squares are in fact the stylized stools of the Evangelists in 15th-century gospels. Mary holds her Child on her right arm, supporting him with two hands. The Child has his hands posed in front of him showing the palms. Mary is flanked by the angels Gabriel and Michael, each holding one hand close to Mary's in a gesture of adoring her, and a small cross in the other hand.

The eyes of all personages are drawn according to the 13th–14th-century method, i.e. the irises touch the upper line of the eyes. The nimbus of Christ is cruciform, that of the angels plain yellow but drawn with a double line which is symptomatic of early Ethiopian paintings. The nimbus of the Virgin is in the form of a crescent depicted over the large mantle covering her head.

(5) The third example of the angels holding a cross is found in the manuscript of the gospels which is in the possession of St. Qirqos church, situated east of Adāgā Hāmus, Tegrē.[39] One of the miniatures (fig. 68) in the manuscript shows Mary and Child accompanied by archangels Gabriel and Michael. Stylistically the miniatures in the manuscript are related to those of the Dabra Māryām (Qoḥāyen) Gospels, which were written around the year 1361.[40] Therefore our manuscript should be ascribed to the same period, i.e. the second half of the 14th century.

The miniature is painted in graphic style. Mary holds the Child on her lap; he seems to lean on her left breast, performs the blessing with his right hand, and presses his left much smaller hand on his chest. He wears a kind of skirt showing striped trousers underneath and bare feet.

The figure of Mary was undoubtedly borrowed from those of the Evangelists in the gospels but the necessary adjustments have continued. The upper half of her body is facing the front whereas those of the Evangelists are drawn in three quarter. The lower half of her body is drawn in profile and she sits on a folding chair similar

[38] Cf. Ms. W 543 in Walters Art Gallery, Baltimore. The manuscript was published by S. Der Nersessian, Armenian manuscripts in Walters Art Gallery (Baltimore 1973) fol. 142 and 147.

[39] The manuscript was studied and described in two articles: Cl. Lepage, Dieu et les quatre animaux célestes dans l'ancienne peinture éthiopienne = DSCÉ 7 (1976) 70–72; He calls the church "Lahen Qirqos pays de Sawné" and does not analyze the picture of Mary. Gigar Tesfaye [= Ǧigār Tesfāy], Reconnaissance de trois églises antérieures à 1314 = JEthSt XII 2 (1974) 60–62, locates the church about 10 km from the Monastery of Sawnē. Jacques Mercier to whom the writer owes the picture of the miniature, gives the location as follows: "Subuha Tsion, Tigrē 10 km à l'est d'Edaga Hamus".

[40] Reproduced and described by D. Buxton, The Abyssinians (London 1970) 138–41, pl. 68–75. He dates the manuscript to the 14th century.

to the Evangelists. Her legs rest on a foot-rest. This detail occasionally appears in 14th and 15th-century Ethiopian images of Mary. Ethiopian painters took it from the Byzantine and related iconography but transformed the piece of furniture into ornamental patterns.

A striking feature of the miniature is the wings of the angels. These are of exceptional length. Moreover, each angel has one hand only, the left angel presses it against his chest while the right angel points his hand at the Child. The lower arms of the cross which the angels are supposed to carry disappear behind their backs. It seems that the painter intended to add crosses to the figures of the angels but had no ready model at his disposal and therefore made this arrangement by himself without bothering about the logic of real life. Clearly we are witness to a formative period of the Virgin's imagery in Ethiopia.

Gigar Tesfaye who published the miniature believed that the missing arms of the angels were possibly incorporated into the radius of their wings and raised over the figure of Mary. A probable source of the "confusion" as he calls it is in distant Armenia; indeed, on the stele from Ta'lin the angels have one hand clearly raised along the wings which form a canopy above the Virgin.[41]

A large ornamental band above the figures of Mary and the angels belongs most probably to the category of decorative inserts similar to that in the Hamlo manuscript.

(6) A variant of the early imagery of Mary combining some details similar to the previous miniature with new elements is found in the room adjacent to the rock-hewn church of Mary on Dabra Ṣeyon, Gar'āltā in Tegrē. The church, according to the life story of Abrehām, organizer of the monastic community on the mountain, was probably hewn by the founder himself and his disciples during the reign of King Dāwit I.[42] G. Gerster suggested that the "domed circular room" is a "'Bethlehem': the place where the eucharistic bread is made".[43] Tradition however, has it that the room was an oratory of the founder, and there is no reason to doubt that.

The dome and walls of the room are ornamented with a variety of geometric patterns. Additionally, on the northern side of the room, a large composition in low bas-relief was crudely cut out of the rock (fig. 69). It shows the Virgin seated on a folding stool and holding the Child on her left arm, similar to the previous miniature. The movement of Mary's hands as well as those of the Child are not clear as this part of the relief has withered. It seems that the Child has no nimbus but Mary and the angels have one. There is a small cross over Mary's nimbus. The same is found in the figure of an unidentified equestrian saint painted on the wall in another room adjacent to the church. This mural which is in a poor state of preservation bears all the characteristics of 15th-century art.

[41] *Gigar Tesfaye* [= Ğigār Tesfāy], Reconnaissance de trois églises antérieures à 1314 = JEthSt XII 2 (1974) 62.

[42] GerChRock 81.

[43] GerChRock 84.

Such cross ornamentation of the nimbus has been already studied by Marylin Heldman who found a similar one in two miniatures of the Gospels of Princess Zir Gānēlā. She writes: "A nimbus with cross appears in the fifth century mosaics of the triumphal arch of Sta. Maria Maggiore in Rome. Although this feature has been considered to be characteristic of early Christian art, it appears later in East Christian art, perhaps as an independent variation ... Several Ethiopian manuscripts contain miniatures in which the cross-marked nimbus appears. The Debra Maryam (Kohain) Gospels and the late fourteenth manuscript of the Life of Gabra Krestos in Marburg ... offer the most obvious example ... The sporadic occurence of this feature suggests that it was not considered to be an important iconographic detail in Ethiopian art."[44] Yet the fact that the Ethiopians used this detail is a patent proof of the persistence of forms in their art.

Mary is flanked by two angels identified as Michael (left) and Gabriel (right). Their heavy inner wings are outstretched over Mary. Michael has one arm (apparently the left) uplifted and the other (probably the right) stretched out towards the Virgin. In addition, a cross is shown behind his shoulder, a detail recalling the previous miniature. Gabriel has both hands uplifted in a clearly praying (orant) position.

Three large crosses added to the composition are an intriguing feature of this bas-relief. One cross with two figures on both sides is hewn on the right of Mary. These figures seem at first sight to be the heads of snakes.[45] Two other crosses, one with a kind of shaft at its base and the other with one arm hidden behind the angel, are shown on Mary's left.

The bas-relief evidences the maker's effort to compose one image of Mary by blending varied iconographic forms known to him. These forms are as follows: the canopy of wings over Mary's figure, the orant pose for the saints which was widely used in 13th and 14th-century paintings, the cross with the elongated lower arm, well-known in Coptic art and carried by angels, a small cross decorating Mary's nimbus as well as three crosses posted on the Virgin's side. The bas-relief evidences the formative period in the Ethiopian iconography of Mary.

(7) The manuscript, Ms. or. oct. 1270, Staatsbibliothek Preußischer Kulturbesitz, was described by E. Hammerschmidt on two occasions. He believes that the manuscript is "most probably from the 14th century and thus one of the oldest known Ethiopian manuscripts".[46] Stephan Wright thought that the manuscript was copied at the latest around the 1430s, and its miniatures stylistically related to those in the Krestos Tasfāna Gospels.[47]

Heldman ascribes the manuscript to "a third quarter of the fourteenth

[44] HelZirGan 148.

[45] Some Ethiopian crosses have their shaft decorated with heads of birds or snakes; cf. the cross in MooreCr fig. 55.

[46] *E. Hammerschmidt*, Illuminierte Handschriften der Staatsbibliothek Preußischer Kulturbesitz = CAe 1 (1977) 23 32–3 and pl. 30–5; E. Hammerschmidt and Otto Jäger, VODH Xv 45–8.

[47] VODH XV 47.

century".[48] Indeed, three miniatures in the manuscript representing Mary and Child under the canopy of wings (fig. 70), and two saints, Gabra Krestos and Abrehām, accord with our perception of the iconography and styles of the 14th through 15th-century manuscript painting. However, the crude execution and the archaic details mixed with those of the 15th century make it difficult to date the paintings with precision.

Square faces and curled crowns of hair recall the Ḥāyq manuscripts; the eyes with the irises attached to the upper eyelids point to the 13th or early 14th-century painting. The wings are similar to those in the bas-relief just described and show much difference with the miniature in the Dabra Abbāy Book of Prayers. The wings seem to recall the 9th-century Coptic miniatures of the Enthroned Virgin, and the scroll which the Child holds in his hand add strength to this impression. As to the dark complexion of Mary and the saints, the earliest examples recorded to date have been in the 15th-century paintings. Similarly the draping of Mary's veil which covers the right side of her head leaving the left side open is known only in works ascribed to that century.

The Gabra Krestos is a well-known Alexios of the Greek tradition, while Abrehām according to Hammerschmidt is "probably one of the monastic fathers of that name". There is no indication whether the latter is an Ethiopian except for his dark complexion. He is represented as a young man with the trace of a short beard on his face, and he wears the striped trousers of the 15th-century Ethiopian personages. On the other hand, the local saints are usually shown as old men, bearded and wearing monacal hoods. Kinefe-Rigb Zelleke lists two local saints bearing the name Abrehām, the one of Qātā and the other of Dabra Ṣeyon, Gar'āltā.[49] If the miniature represents one of them, he must have been depicted after his death.

The reason for putting a cross between the Virgin and the angel is not self-evident. The cross does not belong to the latter. If the scribe intended to put the cross in the angel's hand he would have done it as in the picture of Gabra Krestos. Thus the use of crosses in the miniatures appears to be twofold. Those in the hands of the saints mirror the custom of Ethiopian priests and monks of carrying either small crosses or crosses affixed to long staffs. Those not related to the figures of the saints have probably another significance. A rapprochement with the bas-relief just described would perhaps help to discover the symbolic intent of the miniature and the bas-relief. In both compositions the conspicuous crosses seem to be a focal point of the imagery of Mary and her Child. In the miniature the angel on the left outstretches his short arm and points at the cross filling the space between him and Mary. In the bas-relief, the angel on the left performs the similar movement even more clearly. In both works then, the image of Theotokos is associated with the sign indicating the meaning of the Incarnation, that is the Redemption through the Child's ultimate Passion and Death. The theme is known in Byzantine painting, the

[48] HelZirGan 389.
[49] KRZHagTrad 60f.

earliest examples of its representation dating to the 12th century. There are rare extant examples which date to the 14th and 15th century. However, an elaborate iconography of the Virgin and Child with the Instruments of the Passion has been developed as late as the 16th century.[50] Whether the Ethiopians borrowed the idea and perhaps iconography from the Byzantines or expressed an analogous proposition but in different idiom is a matter of conjecture. The fact is that the miniature as well as the bas-relief reveal an unknown aspect of the early iconography of Mary.

 (8) The miniature described here (fig. 71)[51] is a combination of two types of the Enthroned Virgin, one the origin of which goes back to the earliest iconography of Mary and recalls the Qorqor Māryām painting and one of Mary sheltered by a canopy of wings and flanked by two angels holding the cross. The miniature is found in the Psalter which originally belonged to the monastery of Dabra Warq, Goğğām.

Unfortunately there is no clear indication for dating the manuscript, as the name or names inserted in one of the prayers were subsequently erased according to the customs often practised in Ethiopia. The script seems to be archaic indicating perhaps the 14th century. Moreover, the miniatures follow some features of illumination and punctuation of the early gospels. Especially significant are the signs called "seals of the cross" in between the columns of script and along the margins; these usually appear in early gospels.

Another peculiarity is the Fountain of Life depicted as one of the frontispieces; to the best of the writer's knowledge, the Ethiopian illuminators used to depict the Fountain of Life, which is a part of the Canon of Eusebius and particular to the gospels whereas in this instance it is part of a psalter. Perhaps we are witnessing a formative stage of the production of illuminated psalters in Ethiopia. On the other hand, some miniatures show characteristics of 15th-century art. Jules Leroy already pointed out that some miniatures in the Psalter are of particular interest for the study of their art and has reproduced one of them in his book on Ethiopian painting. The miniature, according to him, shows clearly a "mediterranean" origin.[52] In fact however, all twenty-six full-page miniatures in the manuscript deserve special attention; they are striking for their richness of form demonstrating a particularly eclectric attitude of the painter, or perhaps painters. Indeed, the figures in the miniatures are conceived in three different manners. The old bearded saints and the figures in orant position are characterized by a rigid frontality of their faces and their dress ornamentation closely recalls the figures in the Zewāy Book of Saints. The youthful Elders of the Apocalypse have their faces rendered in three-quarter position, while the particular three figures of the youths as well as that of King David playing a lyre are obviously modelled according to the

[50] ChatzIc 39–41.

[51] Reproduced in *J. Leroy*, Une icône éthiopienne de la Vierge au Musée copte du Vieux-Caire = AÉ 6 (1965) pl. 88.

[52] LerÉthG 52 pl. 16.

"mediterranean" manner. Although there is no indication that these last figures have been added at a later date, there is always the possibility. The features of the youths with blond hair and flowing dresses strike one by their similarity to the paintings found recently in Ethiopia and identified as the works of Nicolò Brancaleon (see p. 395).

The crosses of varied forms which the saints, angels and the Elders hold in their hands are obviously drawn from life and with such precision that the miniatures are an invaluable source of information on 15th-century cross production in Ethiopia. The twenty-four Elders furthermore carry censers which are basically of the same type but nevertheless show slight variations in detail and are doubtless also copies from life. Moreover, inclusion of the Elders into the illustrations of the Psalter perhaps evidences their inception in the subject-matter of Ethiopian painting.

The picture of the Virgin painted on the last folio of the manuscript derives from an early type of the Enthroned Virgin.[53] Mary is facing the front and sits on a rounded cushion and on a throne; however, only the lower part of the latter is visible. She supports the Child who is placed in the middle of her lap with both hands. The Child likewise is facing the front and holds a small scroll in his hand. There is a large nimbus ornamented with a flared cross over the Child's head and an equally large nimbus, plain yellow and traced with a double line over the head of Mary. A point of interest is the bare feet of the Child whereas the Virgin and the angels wear ornamented slippers.

The angels, particularly their wings, crosses, slippers, the movement of their free hand and the red figure on their crown of hair, are similar to those in the Dabra Abbāy Book of Prayers. Nevertheless, there are two important differences; in the Psalter the angel's face is in three-quarter position, and the cushion on which the angels stand has been added.

The combination of rigid frontality of the central figure with the three-quarter position of the side figures is symptomatic of painting of the middle and late 15th century. Therefore the miniature and the manuscript should be tentatively dated to that period.

ANGELS WITH SWORDS

It follows from the above that the earliest form of angels in the image of Mary under the canopy of wings are those holding the cross. Then swords replaced crosses. This new form is characteristic of Mary's imagery in the 15th century and later. The change from crosses to swords is evidenced by engravings on processional crosses, by a number of manuscript miniatures and by a few paintings on wood.

[53] The 6th-century Syrio-Palestinian ivory, Adoration of the Magi; the Enthroned Virgin is accompanied by an angel holding a cross, British Museum, London, reproduced in *D. Rice*, Byzantine art (Harmonsworth 1968) 51.

Let us then start with an art form which flourished in Ethiopia in the middle of the 15th century. According to available evidence, there appeared during the reign of King Zarʾa Yāqob a particular kind of processional cross. These are short armed crosses with knotted ribbon finials which in a way combine the cross with the icon that is carried in processions.[54] Usually one face of the cross bears the image of the Virgin and Child whereas the other face bears the likeness of the Apostles, saints or prophets, and exceptionally of the Crucificion. The following is a brief description of the engravings on three such crosses found in the collection of the Institute of Ethiopian Studies, Addis Ababā, but there is a number of these known to be kept in churches as well as in private collections outside Ethiopia.

(9) Cross No. 4142 (fig. 72) is a rare example of the 15th-century use of silver for manufacturing crosses and bears fine engraving. It shows the Virgin suckling the Child who sits on her right arm. The Child has a crossed nimbus over his head, the angels have a plain nimbus and Mary's is missing. On the reverse side of the cross there is St. George who holds a spear slanting upwards and no dragon is shown which is typical of 15th-century iconography of the Saint.

(10) In cross No. 4197 (fig. 73), the four figures of the image are engraved separately, Mary and Child on one face and two guardian angels on the other. The outstretched wings of the angels form a canopy over their own heads. Moreover, they are shown with both their wings folded and thus each angel has three wings. The Virgin holds the Child on her left arm. He holds a scroll in his left hand. As in the previous cross, Mary has no nimbus whereas all the other figures have one.

The angels are similar to those in the miniature of the book of the gospels discovered by Cl. Lepage in an undisclosed church in Tegrē. He dates this book "to 15th-century Ethiopia" and attributes its miniatures to the Gunda Gundē school. In the image of Mary found in the manuscript she is accompanied by nine cherubim.[55] Two wings of all the cherubim are uplifted thus forming a canopy above their own heads whereas a third wing is folded. This arrangement is similar to that in our cross. This proves that the maker of the cross followed a mode of representing cherubim which was then practised in the scriptoria of Tegrē.

(11) In cross No. 4486 (fig. 74), Mary carries the Child on her right arm and

[54] MooreCr 33.

[55] *Cl. Lepage*, "Révélation d'un manuscrit particulièrement fascinant en Éthiopie au 15e siècle = Connaissance des arts 274 (1974) 83–9. Lepage describes the miniature as follows: "The Virgin in majesty with the Child ... ensures the transition between the figures taken from the Old Testament and the text of the Gospels. She is represented as a sovereign of Heaven surrounded by cherubim who with their wings form a canopy; the gems recall the myth of the immaculate pearl, symbol of Redemption..." Whether the circles around Mary's head are in fact "pearls" or simply a decorative pattern cannot be ascertained. Also the expression "sovereign of Heaven" is ambiguous. The caption accompanying the image explains simply that this is "A picture of the Virgin Mary with her beloved Son" a formula which has been used in Ethiopia from the 14th century until the present.

supports him with both her hands. The Child embraces his mother with the left arm and holds a scroll in his right hand. The angels have one wing only, namely that which is outstretched over Mary. On the reverse side there are three figures, possibly Isaac, Abraham and Jacob, the subject which enjoyed popularity in 15th-century painting.

Summing up, the incised images of Mary and Child contain three common features, though of course they differ in important details. One feature is that all faces are shown in three-quarter position which was generally practised in the 15th century; this is an innovation as compared to the 13th and 14th-century frontality of figures. The other feature of most of the engravings is the way of drawing the Virgin's veil. It runs invariably down only one side of her head and neck leaving the other side uncovered. This fashion of head cover is well-known in Islamic and Persian art, and is also common in Armenian miniature painting.[56] In Ethiopia such draping of the veil is found in a few icons dated to the second half of the 15th century but in general it seems to be peculiar to the engravings on the crosses. In these this manner of arranging the veil appears together with another peculiarity of the crosses, namely Mary is rendered without the nimbus.

In addition to these main traits there is one more which, although less evident, is nevertheless of importance. In two engravings, Nos. 4142 and 4486, the eyes have a space left between the line of the eyeballs at their narrower side.[57] This very distinctive manner of drawing the eyes is found in icons attributed to the middle and the second half of the 15th century. It offers an additional proof for dating to that period both the crosses and the introduction of sword-bearing angels into the image of Mary under the canopy of wings.

(12) A similar image of Mary flanked by sword-bearing angels is also common in 15th-century miniatures. Two of these are given as examples. One is found in the book of the gospels, IES Ms. No. 242, Addis Abābā. The book is incomplete and its last folios which probably bore the colophon are missing but it contains the pictures of the Evangelists and Apostles as well as that of Mary.

The miniature represents the Virgin and Child seated on her right arm and two guardian angels (fig. 75). The tips of the angels' wings cross each other above her head thus giving the impression of a pointed arch. Mary seems to be standing because neither the cushion nor the foot-rest are shown. A dark-blue mantle covers her head and body. On the mantle over her front there appears a shape which is poorly drawn but looks clearly like a crown, ornamented with fleur-de-lis finials and small crosses in between. In addition, the Virgin in the miniature holds a "flower" in her hand. The flower is in the form of three leafless stems ending in a

[56] Lectionary of T'oros Roslin, 1288; Gospels of T'oros Roslin, 1287; Gospels of T'argamanchats, 1232; Gospels, 1316; all reproduced in *L. A. Dournovo, Armenian Miniatures* (London 1961).

[57] This manner of drawing eyes is similar to the other consisting of extending the line of the eyeball at its outer tips. Such eyes are usually found in a face which Lepage defined as "moon-like". He suggests an Islamic influence in the paintings.

bud. The Child seems to grasp one of the stems. Such flowers as well as crowns are typical of late 15th-century icons influenced by Western European art.

There are two other details in the miniature which show its indebtedness to Western art; one detail is the sinuous draping of the Child's robes; the other detail is the wings of the angels which mirror those of a bird. A similar rendering of the wings is found in a Book of Miniatures by Brancaleon (see p. 383) and in icons dated to the second half of the 15th century. All this allows one to conclude that the gospels were copied and illustrated during that period.

We notice an unusual innovation in this miniature. The faces of Mary and the Child as well as those of the angels are dark. This accords with the complexion of the Ethiopian people but is an exception to their practice of painting all faces of personages with pink colour. Ethiopians traditionally believed themselves to be "red" skinned, not black.[58] Although we do not have written evidence why the painter disregarded this rule in his painting, one may guess that perhaps he had a more realistic perception of the environment than was the case with other sections of 15th-century art.

(13) The next miniature (fig. 76), Dr. R. Fechter Coll. PA 1, is one of a few folios preserved of the vanished manuscript; the miniature belongs to a school which developed in and around the Monastery of Gunda Gundē in the last decades of the 15th century.[59] Apparently the school was active throughout the following century. According to the practice pursued by its scribes the picture of Mary was integrated into the pictorial programme of the manuscripts including the Book of Miracles of the Virgin Mary and the gospels.

The Gunda Gundē images of Mary[60] are characterised by a very graphic rendering of figures; flat surfaces are filled with ornamentation composed of zigzag and parallel lines and rows of points between. Mary wears a blue mantle and a red veil on her head. Her head is usually inclined towards the Child whom she supports with both her hands. One hand grasps his neck and the other his legs. The figure of the Child is very small in relation to that of his mother. Mary is flanked by two angels who hold swords; their bluish blades are pointed upwards. Large inner wings striped horizontally form an arch over Mary's head. The bodies of the angels seem to be hidden behind a large second wing folded downwards.

[58] MorGG fig. 20–4, gives reproductions of miniatures representing the leaders of the Stephanite community. These "portraits" accompany their hagiographies which were written around 1500. The scribes rendered the complexion of these monks in various manners. The face of two of them, Gabra Masiḥ and Habta Šellāsē, is dark whereas that of Ezrā and Esṭifānos is pink. This realistic approach is very rare in Ethiopian painting though the Ethiopians are very sensitive to the problem of complexion; indeed they differentiate all possible shades of dark skin.

[59] MorGG 43.

[60] MorGG fig. 23 (Acts of Esṭifānos) and fig. 27 (Book of Miracles of the Virgin Mary). Also *Leroy* reproduced the miniature from the Gunda Gundē manuscript in his: Une icône éthiopienne de la Vierge au Musée copte du Vieux-Caire = AÉ 6 (1965) pl. 86–8; *B. Playne* made a drawing of the miniature and published it in her: In Search of early Christian Paintings in Ethiopia = The Geographical Magazine (Feb. 1950) 410.

Our miniature contains all these characteristics of the Gunda Gundē school except the inclination of Mary's head and a small quare which is occasionally depicted at the bottom of her robe and indicates her seat. Instead there is a long narrow rectangle below the mantle which probably is meant to represent a footrest; this detail is well-known in 15th-century Ethiopian painting. Also true to the Gunda Gundē images of Mary there is no nimbus adorning her head and the Child and angels have plain yellow ones.

(14) A diptych in Dr. R. Fechter Coll. IC 1[61] is a rare example of the Virgin under the canopy of wings found in panel painting (fig. 77). A possible date of the icon is either the second half of the 15th century or the first decades of the 16th century.

Mary and the Child are depicted in the upper register of the multiple-subject icon.[62] She gives her breast to the Child who supports it with one hand. The subject and rendering are typical of 15th-century art and suggest Western European influence. Two guardian angels, Michael and Gabriel, seem to have three wings, one raised over Mary's head and two folded and enveloping their body. The angels hold large swords; a red line is drawn in the middle of the blades in an obvious attempt to represent their three-dimensional character. The same care for realistic detail is evident in rendering the garments. Mary's veil recalls a shawl worn in the Near Eastern fashion.

All faces are of the "tête de lune" type. The nimbi over the angels' heads and that of the Child are decorated with a pattern of intricate red lines. Ornamented nimbi are typical of Islamic painting.

There are two archaic details in the painting: one is a flat nimbus in the form of an inverted crescent similar to that in the Lives of Saints copied in Hamlo Monastery (fig. 67). The second detail is a Greek cross depicted above Mary's nimbus. The origin of such crosses has been already discussed in another place. It is important to note, nevertheless, that in this icon we witness a rare occurrence of such use of the cross in panel paintings.

All the above features suggest that multiple influences interplayed in this icon.

ANGELS WITHOUT CROSSES AND SWORDS

The following are three examples of these types of angels.

(15) The miniature (fig. 78) of the Virgin under the canopy of wings in a Book of Prayers, Dr. R. Fechter Coll. PA 4, should be ascribed to the middle or the second half of the 15th century for three iconographic reasons. The subject of

[61] The diptych is rather odd as far as its technical characteristics are concerned; it has a very thin layer of primer which is unusual in the period to which the painting is ascribed, also its mat gamut of colours does not accord with our knowledge of the pigments of the period.

[62] St. George killing the dragon and rescuing the Maid Birutāwit as well as the Saints Peter and Paul depicted in the lower register. The form of the dragon evidences the transition from the snake into the mythical Oriental beast.

the bird as a pet of the Child appeared around the middle of that century; the draping of Mary's veil is similar to that in the engravings on processional crosses just described; the foot-rest at the bottom of Mary's figure belongs to 15th-century art; in the miniature its significance is still obvious, though it has become rather a detail of ornamentation.

The common model probably used by the engravers on the crosses and the maker of the miniature is responsible for the lack of a nimbus around Mary's head and a plain yellow nimbus instead of a cruciform one, around the Child's head.

The angels outstretch their narrow wings over Mary; the tips of their wings cross each other. The pose of the angels' hands implies an object to carry, most probably a sword. Yet there is none. It seems that in the model which the painter used there was either a cross or more probably a sword in the angels' hands. Around the middle of the 15th century depicting crosses in the hands of angels apparently went out of fashion. For some reason our painter chose not to draw the sword either, but he did not change the position of the hands. In two other examples this was corrected and thus the movement of hands acquired a different meaning.

(16) The Book of Miracles of the Virgin Mary kept in the Monastery of Gešen Māryām, Wallo, was discovered a few years ago by Diana Spencer who photographed its miniatures but not the text. It is hoped that either the colophon or some other part of the text contains indications for dating the manuscript. Until this is available, a preliminary dating of the manuscript is based on an analysis of its miniatures and on paleographical grounds.

The manuscript contains six similar portraits of the Virgin differing in various details. In all of them there appears the figure of a bearded man. In two miniatures he is identified as *Dāwit Negus*, David the King, and it seems to be Dāwit I, during whose reign and apparently with whose encouragement the initial set of the legends of Mary were translated into Ethiopic. Dāwit is known to have had a special devotion to the Virgin Mary. Indeed, in these six miniatures he is rendered in the process of paying homage to her: in the first miniature he is standing straight in front of her, while in each successive one he is gradually bending down until in the last (fig. 79) he performs a deep bow and stretches his hands towards the Virgin, like the angels in the same miniature, i.e. he is clearly performing an act of adoration or supplication.

The other unique feature of the miniatures is that gold is used for painting the figure of Mary and for some parts of the background. This is the rare instance known to the writer when gold was used for painting miniatures.[63] Preparation of gold for making the pigment was apparently considered so difficult that celestial help was needed. One of the 15th-century Ethiopian legends describes Mary's miraculous intervention in producing her own likeness with golden colours. This legend which is important for the history of Ethiopian painting, is included in the

[63] A rare case of using gold for panel painting is found in the diptych IES Coll. No. 6966. The diptych is ascribed to the second half of the 15th century. The imported icons, found in Ethiopia, as well as the icons made by the expatriate artists have some portions painted with gold.

Miracles of the Virgin Mary and refers to the time of King Dāwit I. It runs as follows:

There was a young and intelligent illuminator who used to translate books from Arabic into Ethiopic and make golden colours with which he wrote the name of Mary and decorated her dresses in the pictures. One time when he was producing the book for the King the colour was lacking. The King ordered to produce more of it, but the illuminator told him that the country from which the necessary materials to make gold colour were brought was far away and therefore the production of the manuscript had to be delayed. However, the King insisted on having gold colour at once. The illuminator in fear made an attempt. He did not succeed and the colour produced was dark like earth instead of shining like gold.

In distress the illuminator started to cry and asked the Virgin for help. While he was asleep a stranger appeared to him in a dream. He was a man from "other countries" and an icon maker as well. He asked the illuminator why he was in distress "Because I have spoiled the gold colour. I am very sad and my King as well", answered the illuminator. "Do not be in despair", said the stranger, "because the Virgin likes your King as much as he venerates her". And he revealed to the illuminator the secret of producing the gold colour: he took a white shining stone, crushed it into a white powder, melted gold and added the powder to it. And miraculously the dirty tint was eliminated and the colour became clear and shining.

Next day the illuminator went to see the bishop and inquired whether he had the stone seen in the dream. The bishop did not have it, instead he advised him to search for it the country of Zēmmāt. Indeed the stone was found there in abundance. The illuminator following his dream crushed the stone into powder, and added it into the spoiled colour which became clear and shining like gold.[64]

The man of the dream was a *Romāwi*, vague expression meaning people from the area of the Byzantine Empire. Consequently we can assume that the recipe he proposed was also of foreign origin. The mediaeval guides of painting contain different recipes on how to produce gold colour. The material used in preparation of it was gypsum which is found in Ethiopia in the pure state. The text can be also interpreted in another way: instead of applying a mixture of gypsum powder and gold, the picture is coated with golden leaves. In this case, gypsum mixed with animal glue is used as a background on which gold leaves are glued with white of egg. Examination of the painting on wood in the IES Collection showed that this method was known in Ethiopia. The writer was not able to examine the Gešen Māryām miniatures closely enough to discover which method had been applied.

The story refers to King Dāwit who is most probably depicted in the Gešen Māryām Book of Miracles. Has the use of gold in its miniatures some relation to the legend?

The illuminator went to the bishop to get the white stone. This implies that the bishop was known to be interested in the production of illuminated manuscripts. The bishops of Ethiopia were always of Egyptian origin, and the one who lived

[64] CLMM 89–90.

during the first years of Dāwit's reign was Salāmā, the Translator, particularly known for his activity in the literary history of Ethiopia.

Stylistically the miniatures recall another manuscript, the *Maṣḥafa Ṭēfut*, in the Gešen Māryām Monastery. This important manuscript has not been studied in detail but the scholars in the field ascribed it tentatively to the second half of the 15th century or the first decades of the 16th century. Both works demonstrate such an accomplished art of execution that one wonders whether they were produced by the same hand. The portrait of King Dāwit in the Book of Miracles cannot be considered as proof that the manuscript was produced during his lifetime. Perhaps Dāwit's portrait was added during the reign of Zar'a Yāqob in recognition of his father's part in introducing the Book of Miracles into Ethiopia and his devotion to Mary. According to oral tradition preserved in Gešen Māryām, the manuscript was written during the time of Zar'a Yā'qob.[65] This may well be the case.

In the miniature the Virgin holds the Child on her left arm. She is obviously seated but the chair on which she is supposed to rest is missing; instead, a large foot-rest is shown beneath her striped robe. There is a nimbus over her head.

A crossed nimbus surrounds the head of the Child. His face is directed towards his mother but in fact he gazes at the onlooker. He makes a gesture of benediction with his right hand and holds a scroll in his left hand. The position of his fingers is Greek, namely with the ring finger bent towards the thumb.

The angels stretch their hands towards Mary. One of their colourful wings is raised over Mary's head. Their crowns of hair are strongly flattened like those of the Hamlo miniature.

The garment of Dāwit probably reflects the Ethiopian monarch's way of dressing. He wears a long colourful tunic and a rich toga, an Ethiopian *šammā*, braided with an ornamented border. The toga seems to be wound around his waist according to the customary sign of respect in Ethiopia; the King is bare-footed which corresponds to the manner in which the Ethiopians used to walk in the past.

(17) The incised image of the Virgin (fig. 80a and b) on the processional cross from Waqet Monastery, Ambā Warq in Tambēn, Tegrē offers another important element for the discussion, namely precise dating. The inscription accompanying the image runs as follows: "The sign of this cross is Zar'a Yā'qob, called Qwasṭaṭinos". The "sign" or seal in ancient Ethiopia replaced the signature; thus the meaning of the inscription is that the cross was the property of King Zar'a Yā'qob whose royal name was Constantine. Ethiopian sovereigns used to donate processional crosses to important churches recording this fact on the cross itself, i.e. signing it with their names. Such was no doubt the case with the cross from Waqet which therefore should be dated to the middle of the 15th century. This gives a chronological indication of the type of cross and the iconography of the Virgin as well. Indeed, this exceptionally fine, really royal cross represents a well-known type of the 15th-century short-armed pattée crosses previously described.

[65] Private communication of Mrs. Spencer who obtained the information from the monks in Gešen Māryām Monastery.

The engravings show Mary and the Child on one side of the cross and the Transfiguration on Mount Tabor on the other. Mary holds the Child on her left arm; she has her right hand raised but does not perform a gesture of benediction. No nimbus adorns her head, instead a large mantle covers her head and the upper half of her body and an equally large robe covers her legs.

The angels standing on both sides stretch both hands to her as in the previous miniature.

CONCLUSIONS

The two earliest Ethiopian forms of the Enthroned Virgin are the Qorqor Māryām mural and the Virgin under the canopy of wings. Each form presents a different iconographic problem.

The painting in Qorqor Māryām church is a virtually unique extant example of a majestic image of Mary in 13th and early 14th-century painting. The antecedents of the mural became known through its detailed analysis. The conclusion is that the mural is the result of developments in the iconography of Mary prior to the 13th century but the successive stages of these are not clear. Nevertheless, there is no doubt about the Coptic origin of the basic form and there is a strong possibility of some Nubian influences.

Whether the image of the Virgin in Qorqor Māryām church found its way into miniature painting is not known. We did not find a similar image of the Enthroned Mary in the manuscripts of the 14th century. Also the 15th-century image of the Virgin in the Dabra Warq Psalter did not originate from the Qorqor Māryām murals. Another model was used for composing it. Making allowances for the inevitable losses of pictorial documentation, the general impression is that the period prior to the middle of the 14th century is characterized by a scarcity of images of Mary except in those paintings which depict the life of Christ. Moreover, according to the existing documentation, the practice of adding a frontispiece with Mary's likeness to the gospels and other illuminated books started in the late 14th century and became widespread in the following century.

On the other hand, there is a large number of paintings preserved in which the Virgin is depicted under a canopy of wings. These paintings date from the late 14th, 15th and early 16th century. They provide ample documentation for a study of the developments of the form, each step supported by examples.

Is this image of the Virgin a genuine Ethiopian invention or is it due to artistic borrowing?

The outstretched wings above holy personages are well-known in Christian iconography. For example, a common form was St. Michael sheltering with his outstretched wing the three Hebrew youths put into the fiery furnace; this arrangement of wings vividly expressed the idea of protecting them. Coptic and Christian Nubian artists took pleasure in depicting this subject.

The form of outstretched wings of angels appeared in early Ethiopian painting. Christ and St. John who was baptizing him stand under a canopy of wings in

miniatures illustrating the 13th and early 14th-century gospels.[66] In a 14th-century representation of the Ascension, Mary is sheltered by the wings of the angels flanking her.[67] However, adding the winged canopy to the image of the Enthroned Virgin at the end of the 14th century marks an important step in Ethiopian iconography.

This form is not exclusively Ethiopian; the canopy of wings is found in an Armenian image of the Virgin and there are a few Coptic images of Mary sheltered by such a canopy. "It was Egypt", writes J. Leroy, "which at the Council of Ephesus gave to the Christian world the theological definition of Theotokos thanks to the works of Cyril of Alexandria. In Egypt there are innumerable iconographic documents of this belief..." Varied forms of Mary's iconography have been practiced in Egypt, according to the French scholar, and among these the most popular have been two, namely the Enthroned Virgin with a *clipeus* on her knees and the Virgin flanked by two angels who shelter her with their wings like a canopy.[68] Two Coptic manuscripts among those preserved contain full-folio miniatures of the Enthroned Virgin and angels at her side with outstretched wings.[69] There is no direct iconographic relationship between these representations of Mary and the image developed by Ethiopians. Both Coptic miniatures show Mary nursing her Child, which is not found in earliest Ethiopian images of the Enthroned Virgin. The *Virgo lactans* appeared in Ethiopia in the middle of the 15th century as the result of Western influences, not Coptic.

Assuming that there is an obvious analogy between the Ethiopian image of the Enthroned Virgin under the canopy of wings and that in Coptic art, we cannot single out a model or models which the Ethiopian could have copied. Indeed, analysis of their works leads to the conclusion that most probably they took the idea from outside but composed the image themselves using elements borrowed from varied sources. They also made their own adjustments. That is why there is great instability of main form as well as significant variation in detail, the canopy of wings being the only common feature. It is not possible to correlate, in this large group of paintings, their basic forms and the details. For example, in the Dabra Warq and Dabra Abbāy miniatures, the angels are clearly of the same type whereas Mary and the Child are different.

Considering the Child, he is seated either on Mary's left or on her right arm which proves that Ethiopians did not follow a single rule governing this detail. In early miniatures the Child rarely performs a gesture of benediction and does not hold a book or a scroll. The position of his hands is similar to that of the accompanying angels which hardly mirrors the Coptic or Byzantine iconography of Christ. The hieratic pose of the hand and the book or scroll in the context of the Enthroned Virgin appeared in the middle of the 15th century.

[66] Iyasus Moʾa Gospels and Krestos Tasfāna Gospels.
[67] Dabra Māryām (Qoḥāyen) Gospels.
[68] LerMssCopt 203.
[69] New York, Pierpont Morgan Libr., M. 574 and M. 612, both dated to the 9th century.

Mary either sits or seems to stand. The furniture on which she rests is of varied types, a folding chair in the earliest paintings, a neatly drawn stool or an ornamented square in later paintings. Usually the Virgin supports the Child with both her hands but there are significant differences of the pose in each painting. The symbolic gesture of Mary's hand which enhances the solemnity of her Byzantine images is virtually missing in her early Ethiopian images. The "flower" which she holds in one miniature and the bird in the Child's hand in another are late 15th-century additions to her iconography (see p. 336).

Equally indicative is the rendering of faces. In the miniature from Dabra Abbāy and the bas-relief from Dabra Ṣeyon, all faces are rendered in rigid frontal position, whereas in the miniature from the Qirqos manuscript as well as in the Psalter from Dabra Warq, the frontal position of Mary is combined with a three-quarter position of the angels. The engravings on crosses are characterized by a consistently applied three-quarter pose. It is clear that the rigid frontality in the earliest Ethiopian paintings was replaced in the 15th century by a more subtle expression in the three-quarter position. This change has also affected the image of the Enthroned Virgin.

We observe also multiple transformations of the figures of the angels. They carry crosses, then swords, or neither of these. The configuration with the cross is intriguing. Why the cross and where did the idea come from? The miniature in the St. Qirqos manuscript and the Dabra Ṣeyon bas-relief seem to shed some light on the process. In both, crosses have a long lower arm and appear over the right shoulder of the angels. The Coptic origin of the form is obvious. Such crosses are the common attributes of angels in Bawīṭ and Saqqārah. They are also found in the mural of Faras. In Ethiopia the angels depicted in the Gannata Māryām murals also carry such crosses. It is therefore probable that Ethiopians copied in a rather clumsy manner the Coptic angels including their crosses. It is also possible to make another rapprochement which refers to the customs at the Nubian court. It seems that during ceremonial occasions Nubian sovereigns were accompanied by pages carrying crosses. This is suggested by a description of the voyage of King George (Kirki, Kurki) to Baghdad in 836 by Michael the Syrian. The young prince was riding on a camel sheltered with a ceremonial parasol and "on his right and on his left walked young Nubians carrying crosses in their hands."[70] Whatever the origin of the crosses, the Ethiopians transformed these in their own way. According to the practice in Ethiopia, no doubt a very old one, priests and monks carry small crosses with them which they offer to the faithful for blessing. The crosses which the angels hold in the images of the Enthroned Virgin, except the two examples mentioned are different from those in Nubian and Coptic paintings. They recall benediction crosses used by Ethiopian clergy.

The angels have also three different kinds of wings, namely wings similar to those in the early gospel miniatures (Iyasus Moʾa and Krestos Tasfāna Gospels), wings with elongated radius as in the Dabra Māryām (Qoḥāyen) Gospels, and wings

[70] G. *Vantini*, Le roi Kirki de Nubie à Bagdad: un ou deux voyages = DinNub 42 f.

drawn realistically like those of a bird. There is a clear analogy between the angels in the Dabra Māryām Gospels and those in the St. Qirqos Gospels. It seems therefore that the gospel miniatures also influenced the image of the Enthroned Virgin.

Another significant detail is the slippers or buskins. This footwear with striped ornamentation is found in the art of the Copts, who in turn took it from Byzantine art in which angels are clad in Imperial attire.[71] This detail, in addition to crosses and outstretched wings is an obvious instance of Coptic impact in the early imagery of the Virgin in Ethiopia. Eventually this detail was also adjusted to local conditions and the angels became barefoot.

Summing up, the mural of the Enthroned Virgin in Qorqor Māryām church probably epitomizes the first, little known period of Marian iconography in Ethiopia. The image of the Virgin under the canopy of wings initiates another period which is characterized by a varied and numerous production. The form itself first appeared sometime at the end of the 14th century and probably was prevailing in the first half of the following century. Starting in mid-15th century numerous other forms were introduced. In these the guardian angels also have outstretched inner wings; however, the wings are not raised high above Mary's head but vanish behind her nimbus.

The earliest representations of the Virgin under the canopy of wings are characterized by the crosses in the hands of the angels; probably in the first half of the 15th century but certainly starting in mid-century, the crosses were replaced by swords. The angels who carry neither crosses nor swords but perform the gesture of adoration are ascribed to the middle of the same century.[72] Judging from a few preserved examples, this form has never been much used.

The 15th-century form of the canopy of wings over Mary gradually faded away though examples of the angels' wings outstretched over Mary are known in the paintings of the 16th century and even in the following one. However, in these paintings, the form of the wings differs from that of the 15th century type. The wings are displayed fanwise and on the whole seem to be rendered more realistically than in the early form of the Virgin. Manifestly the painters of the 16th century and after did not copy the 15th century portraits of Mary but occasionally borrowed the idea, that is the outstretched wings over her and included these into the new forms then developed. Two 16th-century paintings (fig. 81 and 82) demonstrate this. One rare example of the 17th-century painting (fig. 83) illustrates the fully evolved canopy over the S. Maria Maggiore image of the Virgin.

How are these developments in the iconography of Mary related to the religious and cultural life of 14th-century Ethiopia? There is no clear-cut answer but two important facts should be mentioned. One of these is the long and brilliant career of Salāmā (1348–88), who was "no doubt the greatest Egyptian bishop Ethiopia ever

[71] LerMssCopt 206.

[72] This gesture of adoration vaguely recalls that of the angels in Coptic manuscript No. 612, New York, Pierpont Morgan Library.

had".[73] Indeed, a great number of translations of religious texts from Arabic into
Ethiopic are attributed to his time and to his own endeavors.[74] This obviously
meant that texts in the form of Coptic-Arabic books were brought into the
country. It was conceivable that some of these were embellished with miniatures
among which there was an image of the Enthroned Virgin. Ethiopians thus could
borrow the idea of including such a full-folio image into their books of translations
and they could also imitate the basic elements of pictorial representation.

The second factor is that the Book of Miracles of the Virgin Mary was then
introduced into Ethiopia and the initial set of legends translated. It is to be expected
that such a book would contain a frontispiece with the likeness of the Enthroned
Virgin. The narrative about the illuminator just quoted provides additional evi-
dence that probably this was the case. The story refers to Mary's picture painted
with gold colours. Assuming that gold was certainly not used in Ethiopia for mural
decoration and that there is no material proof of panel paintings made during the
reign of Dāwit I, the story most probably refers to a miniature in a book. The
period of ordering the miniature by the King corresponds with the chronology of
the images of Mary under the canopy of wings established by study of the paintings.

Concerning the 15th-century controversy about the cult of the Virgin, the
impression is that the events in art apparently evolved in the direction inverse to the
recent findings of Taddesse Tamrat. Indeed, with the century advancing the
production of images of Mary increased in quantity and variety.

There is no immediate answer to what appears to be a contradiction of evidence
taken from written records and those from the developments in art. Probably at
this stage of our knowledge of the period we do not possess enough elements to
elucidate the complex political and religious situation. Two facts, however, should
be noted.

One fact is that during the reign of King Zar'a Yā'qob there was a remarkable
expansion of panel and miniature painting as well as of figurative ornamentation
on crosses. In all these the majestic image of Mary was the main subject. Perhaps
the King used holy images as a religious weapon against the Stephanites and their
refusal to worship these, or maybe he encouraged their production because of his
devotion to the Virgin Mary, or both. The trend continued during the rule of his
successors.

The other fact is that the imagery of Mary is overwhelming in the Gunda Gundē
school of painting that is the very centre of the Stephanite community. On the other
hand, in the pictures of Mary produced by the artists of that school, usually there is
no nimbus adorning her head while the Child and angels have plain yellow ones. It
would be tempting to attribute the first to a change of attitude by the Stephanite
community and mellowing of its stand on the cult of Mary, but more evidence is

[73] TTHayq 102.

[74] A. van Lantschoot, Abba Salama métropolite d'Ethiopie (1348–1388) et son rôle de
traducteur = Atti del Covegno internazionale di studi etiopici, Roma 2–4 Aprile 1959
(Roma 1960) 397–401.

needed to accept this as well established probability. Concerning the second, the consistent omission of the nimbus might be deliberate and mirror the Stephanite objections to Mary. However two considerations rule against this. One is that we do not know what significance was given then by Ethiopians to the nimbus. The second is that as often happens in Ethiopian paintings the scribes used to copy the model integrally; perhaps in the model which was at the root of the Gunda Gundē image of Mary, this attribute of sanctity was missing.

64. Wall painting, 13th–14th century, Qorqor Māryām, Garʿāltā

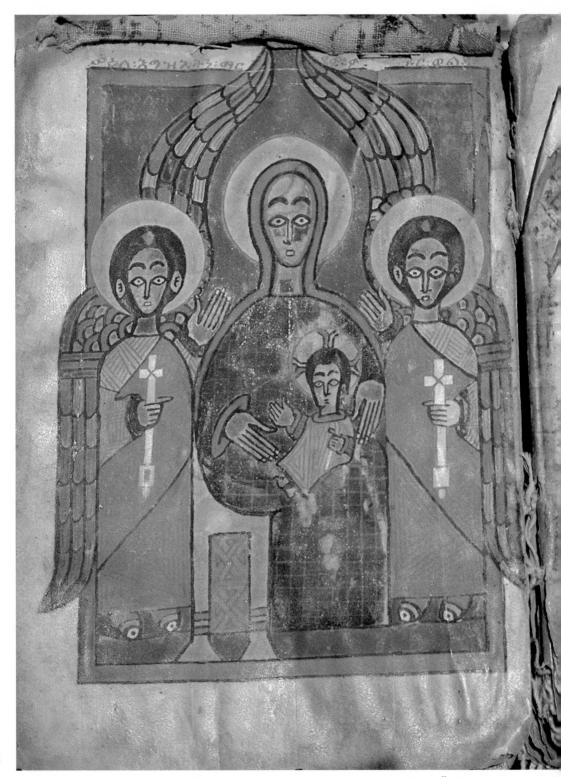

65. Book of Prayers, c. 1400. 23,0:16,0 cm. Dabra Abbāy, Šerē

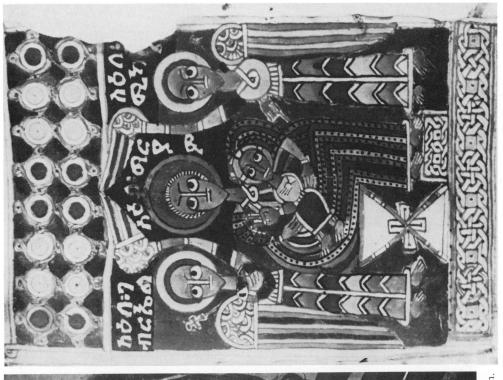

68. Gospels, late 14th century. St. Qirqos, Adāgā Hāmus, Tegrē

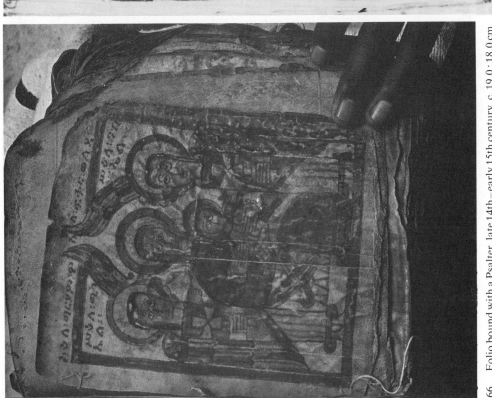

66. Folio bound with a Psalter, late 14th – early 15th century. c. 19,0 : 18,0 cm. IES Ms. No. 777.

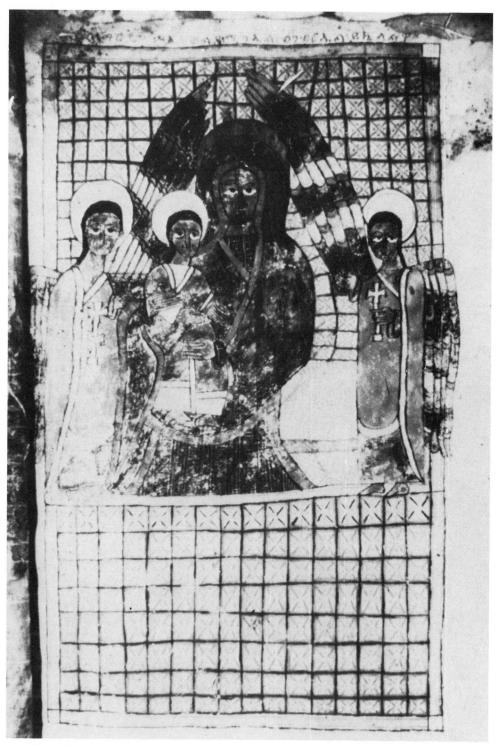

67. Lives of Saints, 1382–88. 28,5 : 21,0 cm. Made for the Monastery of Hamlo, Tegrē, at present at Astit Kidāna Meḥrat, Šawā (EMML 2514)

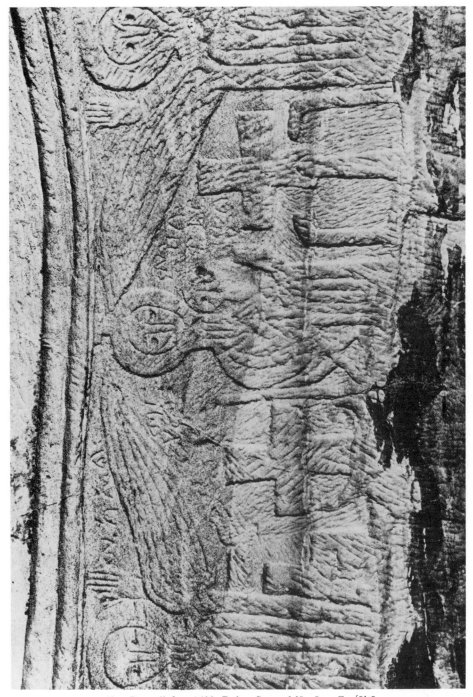

69. Bas-relief. c. 1400. Dabra Ṣeyon Māryām, Garʿāltā

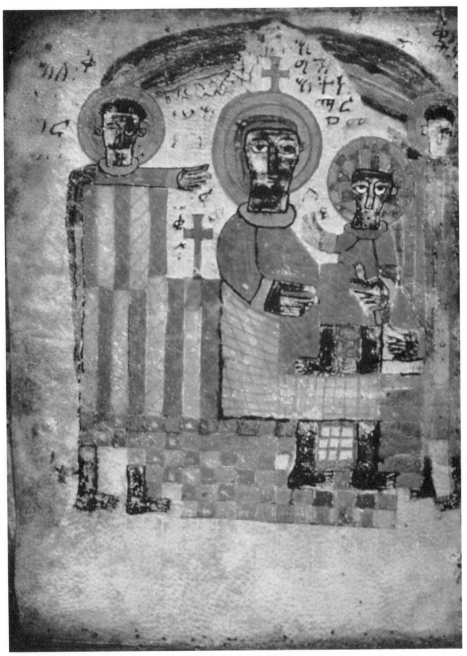

70. Miracles of the Virgin Mary and Life of Gabra Krestos, 14th–15th century. 18,0 : 14,5 cm. Ms. or. oct. 1270, Staatsbibliothek Preußischer Kulturbesitz (fol. 21 v)

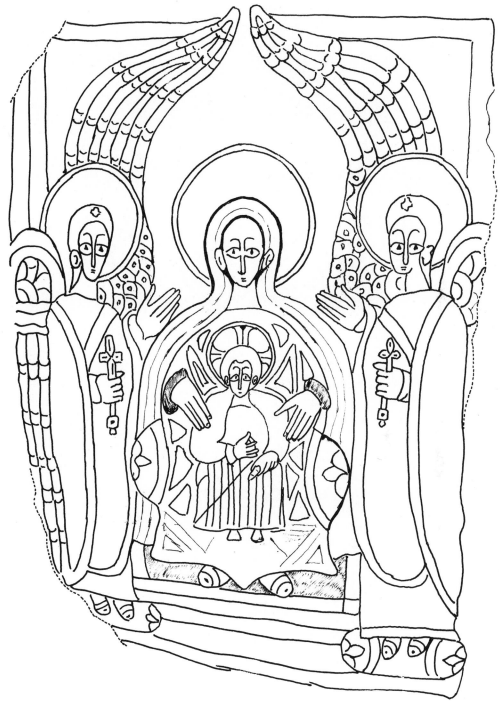

71. Psalter, late 15th century. c. 20,0 : 16,0 cm. Originally kept at Dabra Warq, Goǧǧām, present owner unknown

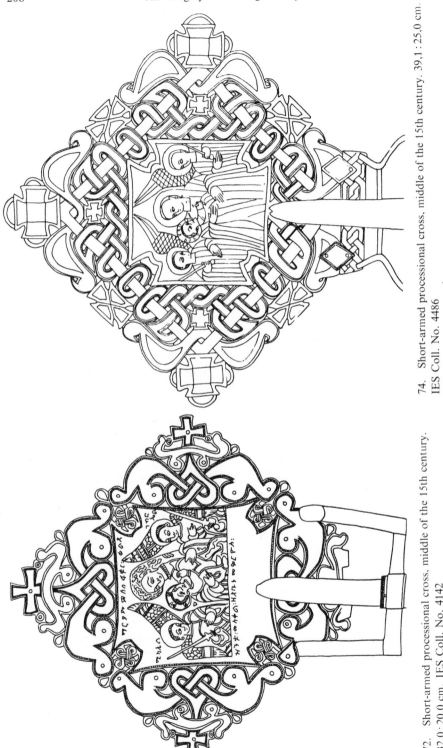

74. Short-armed processional cross, middle of the 15th century. 39,1 : 25,0 cm. IES Coll. No. 4486

72. Short-armed processional cross, middle of the 15th century. 32,0 : 20,0 cm. IES Coll. No. 4142

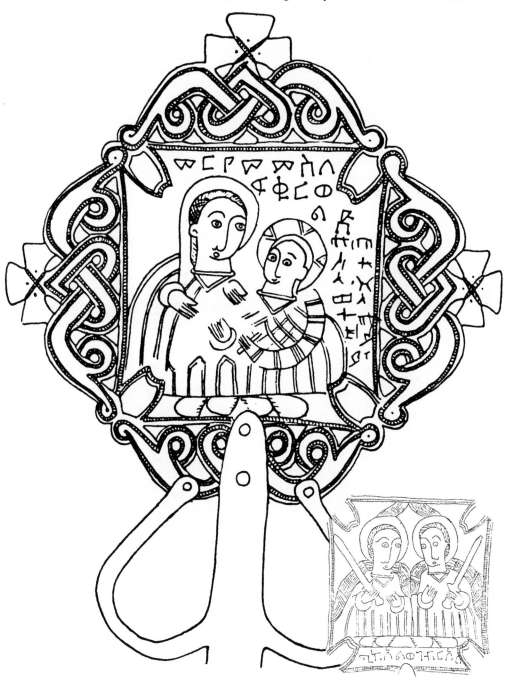

73. Short-armed processional cross, middle of the 15th century. 28,2:17,3 cm. IES Coll. No. 4197

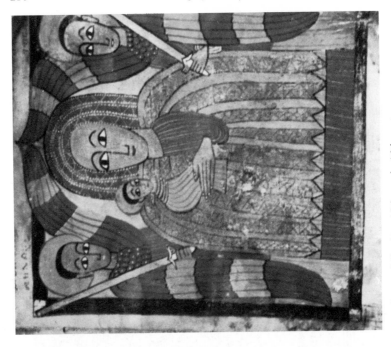

76. Loose folio, late 15th–early 16th century. 29,5 : 24,0 cm. Dr. R. Fechter Coll. PA1.

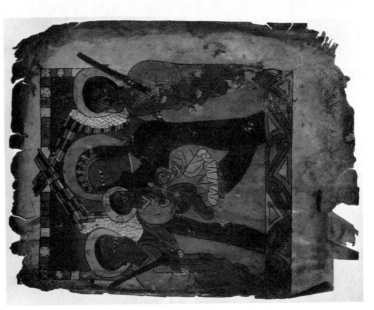

75. Gospels, 15th century. 31,5 : 23,0 cm. IES Ms. No. 242

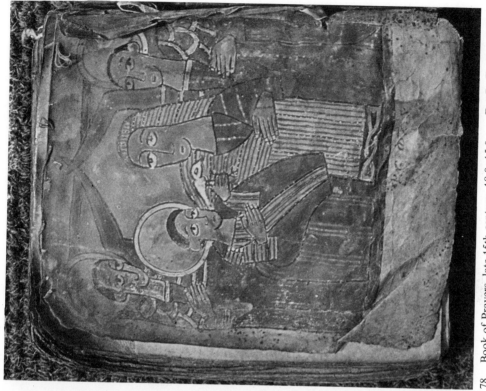

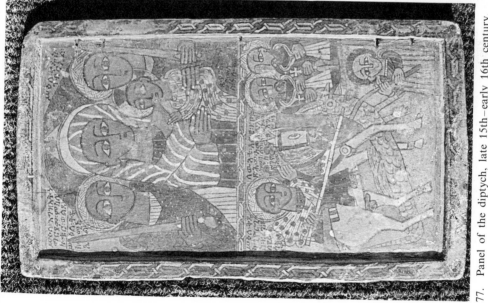

77. Panel of the diptych, late 15th–early 16th century. 35.5 : 20.0 cm. Dr. R. Fechter Coll. IC1., Germany

78. Book of Prayers, late 15th century. 18.0 : 15.0 cm. Dr. R. Fechter Coll. PA4

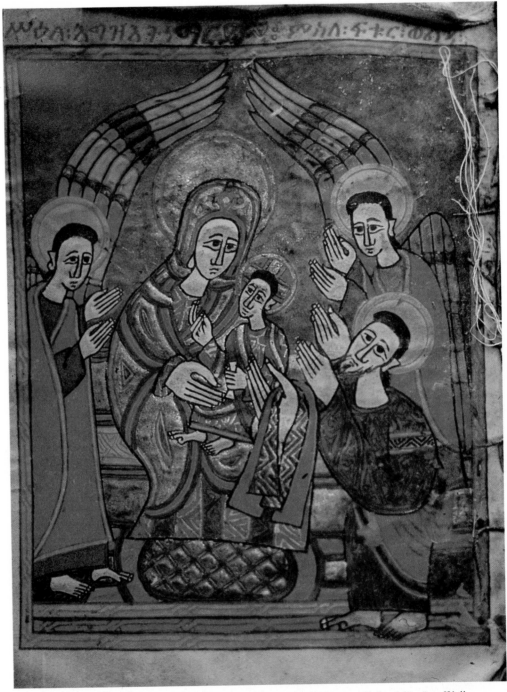

79. Miracles of the Virgin Mary, 15th century. c. 25,0 : 20,0 cm. Gešen Māryām, Wallo

80a and 80b. Short-armed processional cross. 1434–68. 36.0 : 21.0 cm. Waqet Monastery, Ambā Warq, Tambēn

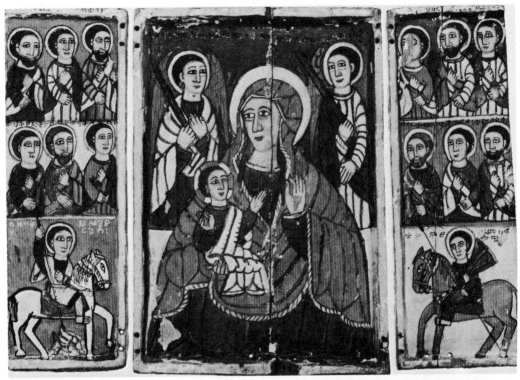

81. Triptych, 16th century. 25,2:18,0 cm. The Langmuir Coll. No. 84. Peabody Museum, Salem, Mass.

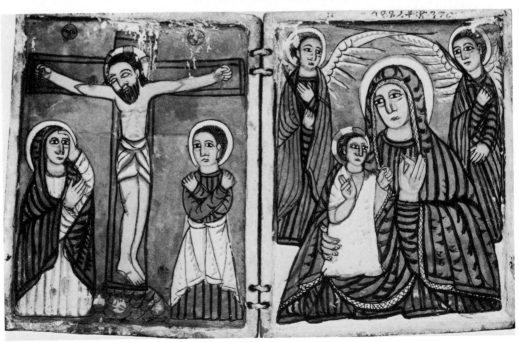

82. Diptych, 16th century. 19,6:16,0 cm. The Langmuir Coll. No. 85, Peabody Museum, Salem, Mass.

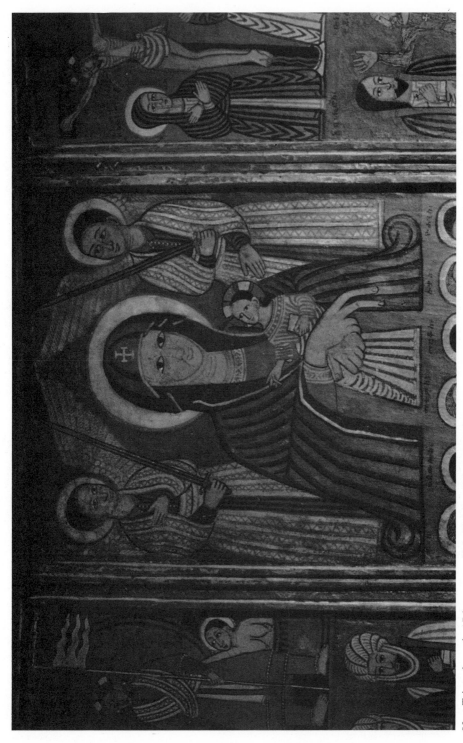

83. Triptych, early 17th century. 58.0 : 32.0 cm. Private coll. Germany

IV. THE VIRGIN OF S. MARIA MAGGIORE

INTRODUCTION

In the first decades of the 17th century, there was a significant change in the iconography of the Virgin Mary in Ethiopia. One form called *Še'ela Māryām*, the picture of Mary, virtually monopolized her imagery for almost four centuries. This image is considered a typical expression of the Ethiopian iconography of Mary. Yet, like others, the form is an artistic borrowing which has a long and interesting story.

Ugo Monneret de Villard was the first to correlate the Ethiopian image of Mary with her greatly venerated picture in the basilica of S. Maria Maggiore, Rome. He also suggested the way in which the copies of the painting reached Ethiopia.[1] Subsequently, Pasquale D'Elia of the Company of Jesus described how, in the 16th century, the Jesuits made copies of the Roman picture and distributed these throughout the world.[2]

Tradition has it that the picture of the Virgin in the Roman basilica (fig. 84a and b) was carried in the 6th century during a solemn procession. However, art historians consider the painting more recent. According to Mario Martini who tried to compromise among conflicting opinions, the icon was either painted anew or completely retouched on an old wooden board which belonged to the original painting.[3] Monneret de Villard believed that this was the 13th-century work of Roman artists who had been strongly influenced by Byzantine art.[4] In popular belief, nevertheless, the painting was made by St. Luke himself and therefore greatly venerated. The official name of the painting is S. Maria Salus Populi Romani because of the miracle it performed in the 6th century at the time of the plague, but more often the painting is referred to as that of St. Luke.

There is no doubt that the Jesuits introduced the Roman picture to Ethiopia, but how it happened is a matter for conjecture. The following are the facts established by D'Elia. St. Francesco Borgia, third general of the Jesuits from 1565 to 1571, had a special devotion to the image of Mary in the basilica of S. Maria Maggiore. He obtained in June 1569 an authorization from Pope Pius V to make a copy of the picture. This was done by an "excellent" painter whose name, however, was not disclosed. His work is still preserved in a room adjacent to the church of S. Andrea di Quirinale in which St. Stanislaus Kostka died. The artist tried to reproduce the

[1] MonMad 9–23.

[2] DElImMar.

[3] *M. Martini*, Faville d'arte e di fede: storia della Madonna di S. Luca in Roma e in Cina alla fine del secolo XVI (Roma 1967) 37.

[4] MonMad 14.

original as faithfully as possible, and on the whole succeeded. He even tried to correct some slight defects of the original. He eliminated the Byzantine stylization of the faces and made them more conform to Italian style. He left, nevertheless, Mary's conspicuous chin and drew it with a strong round line below her mouth; this detail found its way to a number of Ethiopian paintings. He reproduced the cross on the mantle over Mary's front, but left out the star on her left arm. In the copy, Mary does not wear a ring on the middle finger of her right hand as she does in the original. In the latter, the Virgin's eyes are slightly directed to the left and the Child does not look at his mother; in the copy she stares at the beholder, while the Child directs his eyes at her. The other significant change is the book which the Child holds in his right hand. In the original the book shows the spine and its cover is ornamented with four rosettes, while in the copy the book shows the pages and the cover is smooth without ornamentation.

This first attempt was followed by an extensive operation of copying and distributing the Roman image of the Virgin which was carried on by Borgia and his immediate successors. Father Dionisio Vazquez, confessor and historian of Borgia, described how he "ordered the novices at St. Andrea of the Horse Mount (Equilino) to keep the tools needed for printing the holy image and the prints on silk and paper or even engraving on metal; he wanted them to take all these in great quantity to the missions and to distribute them in the whole world. In this manner Father [Borgia] sent from Rome innumerable prints to the Orient and the West Indies, to Japan, Germany, Poland, Spain and other countries."[5] Borgia's preferred image of the Virgin became a weapon against the "heretics" and an effective medium for propagating the Roman faith. D'Elia gives a long list of the reproductions on canvas distributed throughout Europe. These had been sent to queens, kings and princes; other copies were allotted to provincial houses of the Order. The reproductions differ slightly one from the other though the main features of the composition have been strictly followed. Obviously in the process of copying the painters thought of embellishing the original. For example, in some reproductions there is an aureole of flames around Mary's head,[6] a detail which is missing in the original and the first copy. The aureole appears in a number of Ethiopian paintings.

It should be recalled that in the second half of the 16th century and early 17th century there was a combined Jesuit effort to implant Christianity in Japan, China, Mogul India and Ethiopia. The image of the Roman Virgin played an important role in this endeavour. Starting with ca. 1580 it became a standard representation of Mary for the Asian Jesuit missions. Pictures of her have been given as a precious gift to heathen rulers and were subsequently copied by local painters. A Chinese copy was found in 1910.[7] Akbar, Mogul emperor of India was liberal enough to

[5] DelImMar 6.

[6] For example the copy sent by Borgia to Elizabeth of Austria; the painting is kept in the church of Augustinians, Vienna.

[7] At present in the Chinese collection, The Field Museum, Chicago, Ill.

admit Christian pictures to this collection. Indeed, he had two paintings of the Roman Virgin; one painting was made directly from the first copy by special permission of Pope Pius V.[8] The third painting was brought by the Jesuits to Agra in 1600 during their mission to the Mogul Empire. The painting apparently enjoyed great popularity.[9]

To Monneret de Villard the conclusion is obvious: the Jesuits introduced the Virgin of S. Maria Maggiore to Ethiopia in the same way as they did in China and India.[10] This seems to be correct. Considering the large quantity of reproductions of the Roman painting made by the Jesuits at that time, and their systematic policy of propagating these throughout their missions, one or more copies must have penetrated into the Ethiopian highlands. Moreover, the records on the Jesuit activities in the land of Prester John refer to the painting made by St. Luke; thus the missionary Luis de Azavedo wrote in a letter of July 3, 1619 that in the church of Gorgorā, Jesuit station on the shore of the Ṭānā Lake, there was the image of "Our Lady of St. Luke". The painting was sent from Rome by Antonio Mascarenhas who was the Assistant of Lusitania, i. e. responsible for the Indian and Ethiopian missions from 1608 till 1615.[11] This gives the possible dates of the arrival of the painting to Gorgorā. The same painting was mentioned in the annual letter of Michele de Paz written in Goa in 1621 but describing the events which happened in Ethiopia the year before. The Ethiopian Emperor Susneyos (1607–32) who accepted the Roman creed, intended to build a large church in European style. First, however, he wanted to inspect the place and therefore he visited Gorgorā. He entered the small church of the station and "kneeled and piously raised his eyes to the painting. On the altar there was the picture representing the Madonna of St. Luke, of blessed Father Ignace, and of those who first from our Company bore the crown of Martyrdom".[12]

Manoel de Almeida, author of an extensive description of the Jesuit mission to Ethiopia, narrated in a letter written c. 1620 in Fremonā the Jesuit convent in Tegrē province, how he visited the nearby station and met there a humble widow and "good Catholic". She stayed with the Fathers and used to take part in their prayers.

[8] This painting according to the records was exhibited in Goa which was the Jesuit headquarters in India.

[9] DEIlmMar 4f.; *P. Du Jarric*, Akbar and the Jesuits; an account of the Jesuit missions to the court of Akbar by Father Pierre Du Jarric, trans. by *C. H. Payne* (New York 1926) 160–72.

[10] MonMad 20. Additional proof of travelling of church paraphernalia made for Jesuit missions in Asia from one country to another is that in Ethiopia a cross was found bearing Chinese signs on its stem. The cross was exhibited in 1955 at the Gondar Memorial Show.

[11] MonMad 20.

[12] Quoted from DEIlmMar 9, who checked the original letter. Monneret who knew only the text printed in: Lettere annue di Giappone, China, Goa et Ethiopia scritte al M.R.P. Generale della Compagnia di Gesù dai Padri dell'istessa Compagnia ne gli anni 1615, 1616, 1617, 1618, 1619 (Roma 1621) 150, wrongly believed that St. Ignatius had ordered the first copies to be made of the S. Maria Maggiore painting.

She was devoted to a particular image of the Virgin and invoked it in her prayers calling, "O egziatanâ Mariam! O Romawit", which means "O Lady Mary, O Roman". Almeida explained that in Fremonā there was an image of Mary brought from Rome. People had a great devotion to it and called it Our Lady from Rome "as we give names to particular images like Our Lady of Help, Our Lady of Loreto and others".[13]

The records of the Jesuits are consistent about the existence in Ethiopia of the image of the Virgin which they call Our Lady of St. Luke. Moreover, in a few instances they mention that such an image came from Rome. According to Monneret de Villard it cannot be other than that of the S. Maria Maggiore.[14] Although Monneret's conclusion is correct, his interpretation of Jesuit records is not always satisfactory. It would seem that the Jesuits called by the name Our Lady of St. Luke also those images of the Virgin which did not necessarily come from Rome.[15]

The confirmation of Monneret's inference is provided by the iconography; it evidences beyond doubt the impact of the S. Maria Maggiore painting on the Ethiopian imagery of Mary. Indeed, the Virgin of S. Maria Maggiore is represented in a large number of Ethiopian paintings on wood, miniatures and murals. In these the main traits of the Roman image are easy to identify. They are the Child seated on the left arm of his mother; the book in his left hand and his right hand raised in blessing; and Mary with the mantle with fringes, the Syrian *maphorion*, over her head; the crossed hands, right over left; two outstretched fingers of the right hand; the handkerchief, *mappula fimbriata* of noble ladies, held by Mary. This is well evidenced in the particularly fine icon No. 4232 in the collection of the Institute of Ethiopian Studies, Addis Abābā (fig. 85). Although in Ethiopian paintings these traits are virtually always reproduced, their study reveals significant differences of detail. There are two possible reasons for this. The Ethiopians

[13] *M. de Almeida*, Historia Aethiopiae = *C. Beccari*, Rerum aethiopicarum scriptores occidentales inediti 7 (Roma 1908) 462.

[14] MonMad 22. *Ewa Balicka*, Polish art historian, published recently her own view on when and how the image of S. Maria Maggiore has been introduced into Ethiopia. "As the result of present studies", she writes, "it was established that the images [of Mary] starting with the beginning of the 16th century had as model the picture of S. Maria Maggiore, Rome. Probably the copy of it travelled to Ethiopia either with the 'Portuguese embassy' which arrived in 1520, a member of which was the papal envoy Father Alvarez, or thirty years later with the mission of the Jesuits". All these revelations are made on Monneret de Villard's authority: Miniatury piętnastowiecznego psałterza etiopskiego (studium iconograficzne) = Biuletyn historii sztuki 37 (1975) 109.

[15] *Thomas Barneto*, the Jesuit missionary, wrote a letter on March 12, 1627, to Stephen da Cruz, another missionary, describing how he rearranged the sanctuary of the Orthodox church at Aksum. Barneto lists some of the objects there found; among others he mentions two "retabolos" of Our Lady of St. Luke. Both, he points out, are "golden" and in pine boxes. This description suggests the Greek icons rather than the copies of the painting of S. Maria Maggiore. *Barneto* does not mention the Roman origin of the "retabolos" which he probably would do if this were the case. Letter of Barneto in: *C. Beccari*, Rerum aethiopicarum scriptores occidentales inediti 12 (Roma 1908) 189.

used more than one model, and they made adaptations to the local environment. Both reasons are discussed in the following paragraphs.

Once the origin of the image of Mary, which enjoyed great popularity in Ethiopia has been clarified, the next question is whether the Jesuits were also responsible for the 17th-century monotony of her iconography. Indeed, from the 13th until the end of the 16th century, there was a remarkable variety of forms in Mary's rendering. Starting with the 17th century, one form, that of the Roman Virgin is clearly dominant. Monneret de Villard has something to say about it. The Jesuits, he wrote, "used to diffuse systematically sacred images. And as it usually happens with Jesuit propaganda, any religious argument has a basic sacred image corresponding to it and on which they insist".[16] This may be the case but one has to bear in mind that several old types of the iconography of Mary disappeared long before the Jesuits came to Ethiopia. Nevertheless, the impact of the Society of Jesus on Ethiopian imagery of the Virgin was so strong that it continued after the expulsion of the Jesuits in 1633 and the ensuing period of the so-called isolation of Ethiopia in the 17th and 18th centuries. The Roman image of Mary became the major and lasting contribution of the Jesuits to the art of Ethiopia.

PROBLEM OF MODELS

Monneret de Villard put forward a suggestion that the Ethiopians used different versions of the Roman painting. He believed that more than one reproduction of it reached Ethiopia. These reproductions either hand-made or printed were embellished with details which the original did not contain.[17] Unfortunately, the Italian scholar was mainly working on the 18th and 19th-century Ethiopian pictures of the Virgin. These contain changes and additions which have been made during more than one hundred years of continuous copying. Thus, his conclusions are not helpful in a discussion referring to the first decades of the 17th century.

Also the Jesuits did not provide much information about the images of Mary which they consistently described as made by St. Luke.[18] No special copy of the Roman image was given to Emperor Susneyos, as had been the case with the rulers of India and China. If this had happened, the Jesuit records would certainly have registered the event. There is, of course, no reason to believe that the Jesuits paid less attention to the Ethiopian than to other Oriental potentates. The particular situation of the country explains perhaps the reason why the Jesuits did not try to bring a large and bulky painting as a special gift to Susneyos. Starting with the second half of the 16th century, all Ethiopia's outlets to the sea, including the main port of Meṣewwā were blocked by the Turks. The Europeans, especially mis-

[16] MonMad 41.

[17] MonMad 42.

[18] The Ethiopian definition of the St. Luke icon is also rather vague. A number of icons of Greek origin are currently called those of St. Luke. We do not know much about the age and significance of these icons in Ethiopia. *Diana Spencer*, identified seven of these and described them in the JEthSt.

sionaries, had great difficulty in crossing coastal areas; often they had to do so in disguise. In these conditions there was some risk that the holy image would fall into the hands of the Infidel. On the other hand, small images either printed or engraved on copper plates were easy to transport and even to hide in case of necessity. Indeed, according to D'Elia, prints and reproductions engraved on copper were extensively used by Borgia and his successors for propagating the image of the Virgin of S. Maria Maggiore in the missions.

Assuming that varied models account for significant differences in Ethiopian copies of the Roman Virgin, the obvious method would be to compare these with foreign models. However, no such models have been found in Ethiopia. Therefore one has to reconstruct the lost Ethiopian prototypes by analysing those which are preserved abroad. The writer has been more fortunate than Monneret de Villard and could locate and study two copper tablets at the Biblioteca Vaticana with incised images of S. Maria Maggiore.[19] These are the matrix for printing this image and the plaque on which the positive image is engraved.

The matrix which is much impaired by use bears the caption "Vera effigies S. Mariae Maioris", Vat rame 98 S. Maria Magg. (fig. 86); the caption in the plaque, Vat. rame 75 S. Maria Magg., placed in the phylactery runs as follows: "S. Mariae Maioris ex prototypo Hierony. Rossi scul." (fig. 87). The name Rossi is common in Italy but in this case it may refer to Girolamo I Rossi de Rubeis, well-known engraver and painter who was active in Rome between 1632 and 1664, or to his son Girolamo II the Young (1682–1762).[20]

The writer believes that the matrix might have been manufactured during Borgia's life or shortly after, while the plaque might date from the middle or second half of the 17th century. The tablets illustrate two slightly different versions of the image of the Virgin of S. Maria Maggiore. Indeed, in the matrix and the plaque the engravers introduced small but significant modifications though both claim to follow the prototype faithfully. These modifications are as follows:

(a) in the plaque and the matrix there is an aureole of straight pointed flames around Mary's head;

(b) in the matrix the Greek cross decorating the *maphorion* on Mary's head has its arms slightly flared; in the plaque the arms are clearly angular;

(c) in both matrix and plaque, there is a star on Mary's right arm; however in the former the star has eight points and in the latter six points;

(d) in the plaque there is a small cut in Mary's robe below her neck; in the matrix the collar of the robe is round and drawn with a double line;

(e) the handkerchief, *mappula*, in the matrix is long, narrow and inclined to the

[19] The writer is indebted to Mons. Jose Ruysschaert and Sig. Alfredo Diotallevi, Vatican Library, for their help in locating the matrix and the plaque.

[20] Allgemeines Lexikon der Bildenden Künstler begründet von *U. Theme* 29 (Leipzig 1935) 64. According to *Bryant's* Dictionary of Painters and Engravers (New ed.: London 1910) 285, "Rossi Girolamo, called de Rubeis the Elder, born at Rome about the year 1630, brought up at Bologna . . ." The list of his works does not include the plaque of the Virgin of S. Maria Maggiore.

right; it has two small pointed folds at the bottom; in the plaque the handker-
chief is less inclined and has two large folds at the bottom;

(f) in the matrix the Child's curled crown of hair covers the back of his neck and
part of his shoulder; in the plaque the hair in the back of the head is much
shorter; in both, there is a curled tuft of hair on the Child's forehead, in the
matrix the tuft is more marked than in the plaque;

(g) in the matrix, the index and middle finger of the Child's blessing hand are
drawn apart; in the plaque these hold together. Moreover, in the matrix the
thumb of the Child's left hand is strongly bent and its tip is hidden. In the
plaque the thumb of the hand which supports the book touches the forefinger;
in the matrix the spine of the book is distinguishable from the Child's arm and
the thumb of the same hand is separated from the rest of the fingers; also the
clasps holding the book cover and the covers are different;

(h) in both matrix and plaque, the Child wears sandals, his feet in the matrix seem
to be drawn more in profile than in the plaque.

These differences are comparable to those in 17th and 18th-century Ethiopian
copies of the S. Maria Maggiore Virgin. However, the writer does not suggest that
the matrix and plaque have been necessarily the only prototypes of Ethiopian
images of Mary. Most probably there were others as well.

The following is the description of the relevant details:

The nimbus

The nimbus composed either of flames or of radiant lines is typical of Ethiopian
paintings deriving from the S. Maria Maggiore Virgin; but there are two other
forms of the nimbus which are uncommon.

An aureole of flames and rays on the brown background seems to be the earliest
form used by Ethiopians, No. 4130 (fig. 96) and the painting from Dabra
Dāmmo.[21] The flames are rendered fairly realistically. However, in the particular
group of paintings discussed subsequently, the flames take the form of elongated
triangles drawn around Mary's head, Langmuir Coll. No. 91 (fig. 94), triptych
from Markāto (fig. 93). A very fine combination of flames and rays is found in an
18th-century icon No. 3807 (fig. 119) which is almost a direct reproduction of the
imported model. In some paintings the yellow flames on red background become
short and either touch or do not touch the rim of the nimbus Nos. 4232 (fig. 85),
4792 (fig. 102), 4656 (fig. 106) and the painting from Wāšā Endreyās Monastery
(fig. 110).

The second form of the nimbus consists of a yellow disc and a set of fine red

[21] The painting originally belonged to the Dabra Dāmmo Monastery, Tegrē, and was
recorded there by the German scholars; Deutsche Axum Expedition (Berlin 1913) III 50
pl. 149. They recognized the exceptional quality of the painting and tried without success
to acquire it. In 1936 *Antonio Mordini* found the painting much deteriorated; the lower
part of it was already lost. *Mordini* eventually secured the painting and described it in:
RSE 11 (1952) 29–32. *J. Leroy* reproduced the painting in colour in LerEthG pl. 22.

radiating lines within it. The lines are attached to the rim of the disc drawn with a double line; the space between these is usually painted white, No. 4187 (fig. 109).

These two main forms have lost their original clarity in the process of copying and sometimes there is difficulty in deciding whether the nimbus belongs to the first or to the second category.

There is no doubt that the nimbus in the icons No. 4130, 3807 and the Dabra Dāmmo painting originate from the reproduction of the S. Maria Maggiore painting already embellished with the Baroque aureole. On the other hand, the origin of the nimbus drawn with radiant lines is not so evident and therefore the following possibilities are suggested. Either this nimbus developed from the above aureole of flames which in the process of schematization became less and less realistic and eventually changed into a set of narrow lines, or the nimbus was copied from a completely different model; in this model, Mary and the Child had a relatively simple nimbus composed of a disc and radiant lines. The plain yellow halo, well-known in Ethiopian images of Mary from the 13th century onwards, was rarely used by painters for the S. Maria Maggiore Virgin, and only exceptionally did they use the cruciform nimbus for the figure of the Child.

Star and Cross

It seems logical to assume that the cross on Mary's head and the star on her right shoulder have been borrowed by the Ethiopians from the Roman model; but how did this happen? When Monneret de Villard wrote about the Virgin of S. Maria Maggiore in Ethiopia he believed that in the original there was a cross on Mary's head but not a star on her arm.[22] D'Elia assumed that the painter who first copied the original for Borgia left out the star which existed in the original;[23] other scholars are apparently not sure whether, indeed, there was a star at all.[24] Holy pictures are periodically repainted or restored and in the process some details are added and others removed. Therefore the present condition of the painting in the Roman basilica does not necessarily reflect its state in the past. For our discussion it is important to recall that there was no star on Mary's arm in the first copy which was made for Borgia as well as in several other copies made shortly afterwards. On the other hand, in the copy made ca. 1572 for the cathedral in Baia, Brazil, there is a star on Mary's shoulder. Curiously enough in the same painting the cross on Mary's head seems to be missing. The star and cross are found in the plaque as well as in the matrix previously discussed. The conclusion is obvious: there was no uniformity in using the cross and star decoration; same reproductions which followed closely the first copy made for Borgia lack a star but the star is depicted on other early copies as well.

One would expect that reproductions of the much venerated painting distributed

[22] He gives the reproduction of the painting, MonMad 11, on which the star is missing.

[23] DElImMar 6.

[24] *J. Wilpert*, Die römischen Mosaiken und Malereien der Kirchenbauten vom IV. bis XIII. Jahrhundert (Freiburg i. Br. 1919).

for Jesuit missions in Asia, America and Africa would contain all the important details of the original and that these details would be copied by Ethiopian painters. Yet, analysis of their works demonstrates that this fidelity hardly applied to the star and cross ornamentation. They are found in half of the paintings investigated and are missing in the other half. To the latter belong all paintings probably made during the first three decades of the 17th century and a large number of works executed in the First Gondarene manner, i.e. dating from the fourth to the last decade of the same century. In paintings made during the first three decades the cross is shown but not the star. Particularly significant is the correlation between stars and crosses in all First Gondarene paintings. Either the cross and star are depicted together or not at all.

As to the form of the crosses, few of these follow exactly the Greek cross of the prototype. From the onset the Ethiopians tried to give to the cross a local character. Indeed, most of its forms are taken from Ethiopian life.

Like the crosses, the stars vary a great deal. Simple stars usually have eight points, seldom six. Other stars are elaborated with many rays around, some long some short.

Summing up, in early Ethiopian paintings of the Virgin of S. Maria Maggiore there are those:

(a) without stars and crosses;
(b) with the star only;
(c) with both stars and crosses.

There are two possible explanations as to why crosses and stars are missing in a large number of the paintings; either it was the model used by the Ethiopian painters or they deliberately left out the cross and star decoration for some unknown reasons. However, there was obviously no genuine objection to such decorations considering that later on they were consistently used. This also proves that at least in one imported model there were both the star and the cross.

Could Ethiopians have taken the idea of star and cross decoration from sources other than the reproductions of the S. Maria Maggiore Virgin? Virtually all 16th and 17th-century Greek icons found in Ethiopia represent Mary either with the star on her head or on her shoulder or on both. A star on the shoulder often suggests the idea of a brooch though in fact this does not hold the folds of the *maphorion*. Most of these stars are a genuine component of the paintings, but some stars, crudely drawn, might have been added locally at a later date. Did Ethiopians take inspiration for adding crosses and stars to their paintings from Greek icons? It does not seem so. Greek icons have been known to Ethiopians since the 15th century, yet star and cross ornamentation is unknown in pictures of Mary prior to the 17th century. Although the typical Ethiopian 16th-century image of Mary was strongly influenced by Cretan art, both star and cross are missing in that image.

The Mappula

There are certainly two distinct forms of the *mappula*, and perhaps a third form, but this needs further checking.

The first form recalls a roughly folded handkerchief with two or three large folds just below the Virgin's hand and an equal number of narrow, pointed pleats at its lower end. Such a *mappula* is found in the Dabra Dāmmo painting, Nos. 4232 (fig. 85), 4187 (fig. 109) as well as in the icon from Wāsā Endreyās Monastery, Bagēmder (fig. 110). The second form recalls the carefully folded napkin with a narrow space in between its pointed edges. This type neatly drawn is found in Nos. 4792 (fig. 102), 3947 (fig. 115), and 4656 (fig. 106). In other paintings the *mappula* is stylized but the type is still recognizable, No. 4755 (fig. 100).

The third possible form is found in Nos. 4130 (fig. 96), 3807 (fig. 119), and 3976 (fig. 97). It does not seem to be known to the First Gondarene painters. The *mappula* has a tubular shape with no folds in its upper part; instead it has an edge strongly curved at its lower end and two pointed pleats underneath.

In all these forms the *mappula* is twisted around the Virgin's thumb. Curiously enough occasionally this part of the mappula is shown but not the lower part under Mary's hand. It appears that Ethiopian painters never fully became accustomed to the use of the *mappula* and this explains why in a relatively large number of their works the *mappula* is left out altogether; moreover, in the process of continual copying, it lost its original form.

The Book

There are two forms of the book which the Child holds in his right hand. In one form the clasp used for fastening the book is facing the onlooker, Nos. 4056 (fig. 118) and 4130 (fig. 96); in the other form the white pages are clearly depicted, No. 4127 (fig. 108), Dāgā Estifānos, Lake Ṭānā (fig. 113) and Dabra Warq (fig. 111) but not the clasp. The cover of the book is variously ornamented; in a few paintings this ornamentation is effected with lines drawn crosswise which recalls the prototype, No. 3807 (fig. 119). In many late 17th-century paintings the book is rendered as a square with a double line all around according to an old pattern used from the 14th century onwards.

Ethiopian binders used wooden boards and mostly did not cover these with leather as they did the spine. The first printed book probably arrived in Ethiopia in the early 16th century but, although more books were imported during that century and later, the production of hand-written books on vellum and wooden bindings continued well into the 20th century. Therefore the book in the pictures of the S. Maria Maggiore Virgin is of Western origin.

The Hair of the Child

There are two distinct ways of drawing the hair of the Child. In early versions of the Ethiopian Virgin of S. Maria Maggiore, Nos. 4130 (fig. 96) and 3976 (fig. 97), the Child does not have a tuft of hair on his forehead; instead the line of the hair is slightly curved in the middle. On the other hand in many First Gondarene paintings Nos. 4232 (fig. 85), 4127 (fig. 108), 4187 (fig. 109) and the painting from Wāsā Endreyās Monastery (fig. 110), the forehead of the Child is adorned by a curl

in the form of a spiral. Also the hair on his neck and left shoulder is wider and longer in this group than in the early versions. Eventually the painters started to depict the Child as an Ethiopian boy and consequently the tuft of hair disappeared altogether.

The Collar

The collar of Mary's robe is also drawn in two ways. In all early paintings the collar is round and drawn with two lines thus giving the impression of trimming the collar with ornamental lace. Moreover, in a few paintings there is a small brown figure above the collar; this awkward detail is copied from the foreign model and is obviously meant to represent a shade on Mary's neck.

In many Gondar paintings the collar has a triangular opening which is also trimmed with elaborate lace.

These two Ethiopian ways of drawing the collar correspond to the same in reproductions made elsewhere. The slightly pointed collar characterizes the proto-type and its oil-painted copies, while in its engraved reproductions the collar is round.

The Sandals

Ethiopians rarely depicted the Child wearing sandals and this mostly occurred in the group of paintings ascribed to the first decades of the 17th century. This proves that in the model then used the Child had sandals on his feet. When the 18th-century painter of the icon No. 3807 reproduced the same model, he included the sandals though the tradition of rendering the bare-foot Child in the picture of the S. Maria Maggiore Virgin was then over a century old.

The footwear of Ethiopian painting is certainly of foreign origin. Walking bare-foot is well rooted in the Ethiopian way of life and widely practised until this day. A short-lived and very limited attempt by the Jesuits to introduce footwear at the court of Ethiopia in the 1620s did not meet with success. Indeed, in Ethiopian paintings the divine Child is virtually always rendered barefoot.

The above survey can be summarized as follows: Ethiopian painters used more than one model for composing their image of the S. Maria Maggiore Virgin. This is in agreement with the suggestion of Monneret de Villard put forward in 1947.

At present, we can try to reconstruct these models keeping in mind however the adjustments and transmutations which Ethiopian painters were introducing from the inception.

The first model which seems to have influenced the earliest Ethiopian versions of the S. Maria Maggiore Virgin was characterized by

(a) an aureole of flames around the heads of Mary and the Child;
(b) a round collar on Mary's robe;
(c) a *mappula* of the second or third type;
(d) no tuft of hair on the Child's forehead;

(e) a book fastened with a clasp;

(f) ornamented sandals.

Most probably in the same model there was a cross on Mary's head, but the star on her shoulder was missing.

The second model which was used by the Gondarene painters was characterized by:

(a) a cross on Mary's forehead and a star on her shoulder;

(b) a triangular collar on Mary's robe;

(c) a *mappula* of the second type;

(d) a book without a clasp, replaced by clearly drawn pages on the left and upper edge of the book;

(e) sandals.

ARRIVAL OF FIRST MODELS

The question of exactly who brought the copies of the painting in the basilica of S. Maria Maggiore into Ethiopia and when this occurred cannot be answered because the relevant information is not available. Nevertheless, it is possible to define the approximate period in the light of the following facts.

There was a specific Jesuit pattern of distributing images of the Roman Virgin. This pattern was dictated by the rank and importance of the recipient, distances from the centre and difficulties of travel. Starting with 1569, the year when the first copy for Borgia was made, the zealous admirers of the holy image distributed it in a relatively short time in Europe and then in two and a half decades throughout the world. Thus copies were sent to Brazil in 1575, Mexico in 1576 and 1584, Mogul India in 1580 and ca 1600 and to Imperial China in 1601.[25]

It is evident from the above that around 1580 the first copy of the Roman painting arrived in the area of the Indian Ocean and passed through Goa on its way to Mogul India. Goa was the Jesuit headquarters for their Asian mission which also included Ethiopia. Let us now consider the Ethiopian missions of the Jesuits, assuming that they were indeed instrumental in introducing the Roman image of the Virgin into Ethiopia. The first Jesuit mission composed of André de Oviedo and his companions arrived in 1557. The mission proved to be a failure. Distrusted by the Ethiopian clergy and an embarrasment for the royal court, the missionaries lived in isolation and misery in Fremonā, a village in the north of the country. One of the activities of the mission was the spiritual care offered to the descendants of the Portuguese who in 1542 helped the Ethiopians to expel the Moslem invaders. These proud half-castes remained attached to the faith of their fathers. They maintained some contact with Goa.

Oviedo died in 1577 and the last missionary of his group in 1597. In the same year a Catholic priest of Indian descent, Melhior de Silva, was despatched from Goa to Ethiopia to explore the situation. He succeeded in reaching the interior.

[25] DEllmMar 3–5.

The second major missionary endeavour of the Jesuits started in 1603 with the arrival of Pero Paez in Meṣewwā. This second attempt met with ephemeral success and was followed by a period of struggle and decline. In 1622 Paez died. Four years later Alphonso Mendez, consecrated as Patriarch of Ethiopia, arrived. Under his direction the mission headed towards disaster. An official submission of the Emperor to the See of Rome was followed by a civil war, the Emperor's abdication and the expulsion of the Jesuits in 1633. Mendes and most of the missionaries left the country; those who refused were killed one after the other. The last was hanged in 1640.

Records of the arrival of copies of the Roman Virgin in the Indian Ocean area compared with the chronology of the Jesuit activities in Ethiopia give the year 1580 or shortly after as the earliest possible date of introducing the copies of the Roman Virgin into Ethiopia. The year 1603 and the following two decades are the latest possible dates.

These dates roughly correspond with the estimates by Monneret de Villard and D'Elia. The former seems be believe that the "change" in Mary's iconography happened "in the second half of the 16th century" and that there is "an iconographic identity between the images of the Madonna executed by Ethiopian artists after 1600 and the one preserved in the Roman basilica".[26] On the other hand D'Elia seems to favour the later date suggesting that "starting with the first decades of 17th century, Abyssinia received one of the copies which originate from that made for Borgia".[27]

We know little about the developments following the arrival of the copy of the Roman image into Ethiopia. It was apparently accepted without difficulty. Yet, in 16th-century Ethiopia there were several already well-rooted models of representing Mary. How then did it happen that Ethiopians, well-known for their conservatism, ceased to use these models and started, apparently without hesitation to copy a new model? One wonders whether there was a transition period and how the new and old forms interplayed.

We have ample evidence that some details developed in the 15th and 16th-century iconography of Mary were creatively incorporated into Ethiopian copies of the Roman picture and this will be explained subsequently. On the other hand, we have scarce documentation about the influence of the new model on paintings executed according to the old manner. There is no doubt that the production of such paintings continued for some time along with the copying of the Roman painting. Two icons described below illustrate the process of adaptation.

The diptych, IES Coll. No. 4460 (fig. 88), represents the Virgin and Child in the right panel and the Crucifixion in the left panel. Mary holds a flower, which is a detail common in the 15th century, seldom noted in the 16th century and virtually unknown in the 17th century. The other detail, also taken from early iconographic traditions is the stool on which Mary is seated; moreover, the red colour of her mantle is certainly inspired by Cretan icons introduced into Ethiopia in the 15th

[26] MonMad 9 and 22.
[27] DElImMar 5.

and 16th centuries. On the other hand, other features in our diptych are not found in typical 16th-century images of Mary. The Child is seated on Mary's left arm, holds a book in his left hand and makes a gesture of blessing with the other hand; he also wears sandals. The form and position of the Child are obviously borrowed from the S. Maria Maggiore painting. The star on Mary's mantle and particularly the aureole of flames and rays over her head evidence the impact of the Roman painting and prove that the diptych was depicted after the former had been introduced into Ethiopia.

Similar transitional characteristics are found in a triptych, private collection in Italy, (fig. 89) dated to c. 1600. Moreover, the Child is seated on the right arm of the Virgin instead of the left.

The position of the Child apparently created a problem for Ethiopian painters. There is no evidence of rules governing this detail in the 14th and 15th centuries; in fact, Ethiopians used to depict the Child indiscriminately either on the left or on the right arm of his mother. However, with the 16th century advancing, they seem to prefer the right arm. The change of the position of the Child from the right to the left arm of the Virgin introduced by copies brought by Jesuits from Rome apparently encountered some resistance. This triptych No. 95 of the Langmuir Coll. evidences this (fig. 90).

The multiple-subject triptych is painted in the late 16th century manner but with some details announcing the 17th-century. Mary is depicted in the upper register of the main panel, and Christ washes the Disciples' Feet in the lower register. The latter appears in paintings on wood which date from around 1600. Therefore the triptych should be ascribed to the same period.

The figure of Mary is manifestly designed according to the S. Maria Maggiore type except for the star and cross which are missing. Also the figure of the Child was copied from the Roman painting as evidenced by the book and the blessing position. The artist however transferred the Child to the right side, apparently intending to comply with existing custom and in the process changed the position of Mary's hands. There is no difficulty in finding the source of this innovation. The turned up left foot of the Child, showing the sole as in this painting, is symptomatic of the Greek iconography of Mary. In this painting we witness the cross-currents affecting the Ethiopian imagery of Mary around 1600, namely the Cretan current which seems to be fading away and the Western current which was coming up.

The first three, perhaps four decades of the 17th century are the period of transition following the arrival of copies of the Roman painting into Ethiopia. It is not possible to establish a detailed chronology of the developments because virtually in all works investigated an explicit indication for dating is missing. Indeed, in one known image of the Virgin bearing the caption referring to Emperor Susneyos she holds a flower and does not recall her Roman image. Nevertheless, the earliest Ethiopian paintings known to us representing the Virgin of S. Maria Maggiore belong to the art preceding that of the First Gondarene school. These paintings pertain to two stylistically differing groups.

The first group is characterized by an apparent crudeness of execution and

strong stylization of figures. It is easily identified by the extensive use of parallel lines, curved or straight, all drawn close to one another and covering every robe. These lines seem to be intended more for decorative purposes than for modelling the figures. Another peculiarity of the group is that cinnabar red and ultramarine blue are applied extensively while yellow and green, typical of the First Gondar style, are not used at all. Faces and hands are painted in flat pink washes with a few lines to underline feature while in the First Gondar school the modelling was achieved by covering part of the faces with red wash.

The main attraction of the group is its decorative value. The rigid schematization of the drawing is compensated for by the rich, imaginative design decorating the surfaces. For example the Virgin's mantle is composed of a set of lines drawn in rays with small crosses in between, leading up to a large central cross. Mary's *mappula* is reduced to a series of triangles with curved points.

The style probably developed in the province of Tegrē, Northern Ethiopia, and was practised in one or two scriptoria, considering the limited number of paintings preserved. Five reproductions in the text, IES Nos. 4128 (fig. 91), 4261 (fig. 92), a painting which was on sale in 1969 at Addis Ababā market (fig. 93), Langmuir Coll. 91 (fig. 94) and a triptych in a private collection, Austria (fig. 95), illustrate the style but to the writer's knowledge there are few similar paintings in private collections outside Ethiopia.

Obviously the painters had some difficulty in following the Roman model exactly and they made their adjustments probably to comply with the then existing iconography of Mary. Thus in No. 4261 the painter changed the position of Mary's hands and in No. 4128 he left out the book. In three paintings the Child does not perform the blessing with his right hand. Instead in two instances he holds the border of Mary's mantle, the detail which originates from 15th-century Ethiopian art. In one instance the Child holds an ornamental baton. Perhaps the explanation of this unusual detail is found in the description by *Khodja* Murād the Armenian of the Ethiopian court in the middle of the 17th century.[28]

What did the picture of the Virgin of S. Maria Maggiore which served as a model to this group of Ethiopian painters, look like? It derived, of course from the Roman prototype but had specific characteristics. The *maphorion* on Mary's head was ornamented with a cross but there was no star on the right arm; this recalls the copy made initially for Borgia. On the other hand, an aureole of flames adorned the heads of Mary and the Child; this detail is found in both engravings on the copper tablets.

[28] *Murād* reported that Emperor Fāsiladas had at least eighty sons and daughters, who were running around pell-mell in his seraglio. They were known by a round varnished stick, resembling a small bludgeon, which the Emperor had had made for them "and which they carry about with great delight, as a sceptre, to distinguish them from other children". *François Bernier*, Travels in the Mogul Empire A. D. 1656–1688 (Westminster 1891) 143; *E. van Donzel*, Foreign Relations of Ethiopia; Documents Relating to the Journeys of Khodja Murād (Leiden, 1979) 31. The writer is indebted to Dr. R. Pankhurst for drawing his attention to this important passage.

Like the first group, the style of the second group, IES Coll. Nos. 4130 (fig. 96), 3976 (fig. 97), the Langmuir Coll. No. 112[29] and painting from Dabra Dāmmo, also differs from the First Gondarene style. Moreover, the gamut of colours is much softer, bluish-green, pale yellow and red, instead of the yellow-green, bright yellow and cinnabar-red of Gondarene painting.

The figures of the Virgin and Child mirror closely the imported model; indeed, one has the impression that the painters of this group have copied it directly and on the whole succeeded in reproducing its main characteristics. One of these is a peculiar expression of the Virgin's face, as if she were surprised, which is achieved by drawing her eyes with the line of the nose and the line of the eyebrows joining at a narrow angle. The neatly drawn mouth follows the Roman original and is less sensual than in First Gondarene painting. Also the conspicuous chin of the Roman prototype found its way to the paintings of this group though this detail does not exist in the engravings. The chin delineated by a circle with a red dot in the middle features an advancing stylization of this detail in the First Gondarene style.

The other characteristics are one strongly marked fold of the blue *maphorion* over Mary's forehead and the folds of the *maphorion* on her arms and shoulder which are depicted more realistically than in Gondarene painting. Moreover, the Ethiopians reproduced carefully three other details of the model, an aureole of flames, ornate sandals and a handkerchief folded in the first manner, as already explained. In all paintings of this group neither a star nor a cross adorn the *maphorion*. This is not a thoughtless omission, but whether the star and cross were also missing in the model is hard to guess. Perhaps the Ethiopian painters decided not to depict these, considering that they started introducing their own transformations right from the inception of the foreign model. For example, in some paintings of this group they omitted the sandals, in others the aureole of flames, and they even sometimes changed the position of the Child. They could eliminate as well the detail of the cross and that of the star.

Summing up, the first Ethiopian reproductions of the Virgin of S. Maria Maggiore were made in the early 17th century and prior to the advent of the First Gondarene school. They seem to originate from two different versions of the Roman painting. During the first three decades of the 17th century an imaginative and thorough transmutation of the model was initiated in the scriptoria of Tegrē but apparently not continued. In the same period another group of painters attempted to copy the model as faithfully as they could.

[29] In Peabody Museum, Salem, Mass., see Ethiopia: the Christian Art of an African Nation (Salem 1978) 14f.

ETHIOPIAN ADAPTATIONS

The Ethiopian image of the Virgin of S. Maria Maggiore is a blend of the European model and local adaptations carried on during the 17th and 18th centuries. This process of Ethiopianization started immediately upon the arrival of the models into Ethiopia and lasted roughly until the end of the 18th century when the image took its final shape. Monneret de Villard suggested that the local changes were made under the influence of the Jesuits or even by them.[30] However, he did not prove that these changes date from the period prior to their expulsion from Ethiopia. Indeed, the opposite seems to be the case.

PRE-GONDARENE PERIOD

The Sword-bearing Angels

The earliest additions are the archangels Michael and Gabriel who stand at the side of Mary. "Ethiopians...", writes J. Leroy, "always added [to the image of the Virgin] the angels carrying swords without whom it is impossible to conceive royal dignity due to the Mother of God."[31] The earliest known image of sword-bearing archangels dates from the 13th century but angels bearing the cross seem to be more common in the 14th and the first half of the 15th century. In the middle of that century the armed archangels finally replace those with the cross, and since then became symptomatic of the Ethiopian iconography of Mary. Indeed, all 17th-century images of Mary which derive from the Roman painting include the sword-bearing guardian angels. Their swords, however, hardly recall the realistically drawn weapons of the 15th and 16th century. Swords in the Gondarene paintings look like a thin iron rod and usually are inconspicuous. Nevertheless, there are some exceptions, for example icon No. 4792 (fig. 102) in which the swords are depicted realistically and in addition one angel holds a sheath in his hand.

FIRST GONDARENE SCHOOL

The Throne

The addition of the "throne" is a more complex matter. The image of the Enthroned Virgin which in Ethiopia related to Byzantine art is of great antiquity. The mural of the Enthroned Virgin in the Qorqor Māryām church, Garʿāltā, closely reflects Eastern Christian models, but in the process of successive adaptations the form of the throne has been substantially changed. Still the idea of the

[30] MonMad 27.

[31] *J. Leroy*, Une icône éthiopienne de la Vierge au Musée copte du Vieux-Caire = AÉ 6 (1965) 235.

throne persisted as we find a Byzantine cushion in one 15th-century miniature in the Dabra Warq Psalter and ornate chairs in several 15th and 16th-century icons. The 17th-century artists adjusted the image of the S. Maria Maggiore Virgin to the Ethiopian tradition by performing a double transformation: they made the Virgin seated on a piece of furniture and gave to this furniture the form of the traditional Ethiopian bed, an *alga* in Amharic.

The question is why a bed and not a throne as in Byzantine and related iconography? The throne in the form of an ornate chair has never been fully integrated into Ethiopian royal pageantry although special armchairs have been used by Ethiopian sovereigns. One of these pieces of furniture, obviously of Oriental (possibly Indian) origin, is still preserved in the Monastery of Tadbāba Māryām, Wallo. It is said to be the throne of King Dāwit I.[32]

Another ornate piece of furniture with a double-headed eagle carved at its back is kept in the church of Ǧamado Māryām, Wallo.[33] Two other armchairs preserved in the church Dimā Giyorgis in Goǧǧām, are believed also to have belonged to Ethiopian sovereigns. The 17th and 18th-century paintings show Ethiopian kings seated on the throne; nevertheless a bed was also used on ceremonial occasions by kings and nobility and travelled with them whenever they were moving from one residence to another.[34] Therefore the 17th-century painters transmuted the image of the Enthroned Virgin into that of the noble lady resting on her bed.

The bed is always drawn from life and gives a good idea of shape, material and even method of construction. The bed was made by stretching lengths of rawhide on a wooden frame. For example, No. 4069 (fig. 98) shows accurately the form of the legs, Nos. 6793 (fig. 99) and 4755 (fig. 100) show the round ornament on top of the legs, while No. 4187 (fig. 109) shows the method of joining the legs to the frame of the bed. The material used for making beds was, of course, wood, either unpainted (rendered by yellow colour in No. 4069) or decorated with horizontal red, yellow, green or blue stripes, Nos. 4656 (fig. 106), 4792 (fig. 102), 4187 (fig.

[32] Reproduced in SpenLuke 92. This piece of furniture inlaid with mother of pearl originates from India and seems to be more recent than the traditional dating.

[33] Reproduced in *I. Bidder*, Lalibela (Cologne 1958) 106. According to the oral tradition recorded by *D. Spencer*, the throne belonged to Emperor Nā'od.

[34] The oldest representation of such a bed is found in the Lives of the Martyrs, Dabra Māryām Qoḥāyen, Sarāyē; it shows the Lady Amata Le'ul travelling on horseback with her servants. One of them carries her bed. The use of beds by Ethiopian sovereigns in the 17th century is well attested. For example, an Armenian visitor to Ethiopia in 1612 whose name is not recorded provided the British East India Company with the following information: When the king [Susneyos] held court he sat "on a gilt bedstead like those of China". *R. Pankhurst*, The History of Ethiopian-Armenian Relations = Revue des études arméniennes 12 (1977) 294. The same king had a "bed from China, silken and very handsome, which the [Jesuit] fathers gave him..." *R. Pankhurst*, The History of Ethiopia's Relations with India prior to the Nineteenth Century = IV Congresso internazionale di studi etiopici, Roma 10–15 aprile 1972, (Roma 1974) 284.

109) and miniature in the manuscript from Dabra Warq Monastery (fig. 111).[35] The beds were virtually always covered with colourful carpets. The amazing variety of patterns reflects the abundance of carpets, imported or locally made, in 17th-century Ethiopia. No. 3974 (fig. 101) demonstrates further development of the form of the bed. A back was added to it and thus the bed became a kind of sofa or a combination of sofa and bed. In these pictures announcing the 18th-century changes, the lower half of the angel's body is hidden behind the back of such furniture.

The bed depicted in the 17th-century images of Mary is identical to those produced and used nowadays in the Ethiopian countryside. Even the ornamentation of the legs with colourful stripes is still practised in the province of Bagēmder. This remarkable conservatism of rural life in Ethiopia leads to the conclusion that, on the one hand, a study of the implements currently used offers an authentic documentation on the life many centuries back and, on the other hand, detailed analysis of Ethiopian paintings reveals those aspects of the past which otherwise have not been recorded.

The Crown

The second major addition by the First Gondarene painters to the Roman image of the Virgin is a crown on her head. The crown is depicted in icons IES Coll. Nos. 4462 (fig. 103) and 4495 (fig. 104) both painted in the First Gondarene style and in the painting decorating the *manbar* in the holy of holies, Baḥara Māryām church, Tegrē, (fig. 105).[36]

The inception and early developments of the image of the Virgin wearing the crown in 15th-century Ethiopian paintings are discussed in another chapter of this book. The Western European origin of that image is evident.

The question whether the 17th-century reappearance of the crown in the image of the Virgin of S. Maria Maggiore was a continuation of old traditions or was generated by new models brought then into the country is hard to decide. It seems that the former is more plausible. If it were a new model it would be the Baroque representation of the crowned Virgin, while the crown depicted in 17th-century images of Mary is the dome-shaped type then used in Ethiopia.

The crowns in No. 4495 are of the tiara type; in Mary's there are three rings and in the Child's two rings. The "horn" finials at the top of both are typical of Ethiopian crowns depicted in 17th and 18th-century paintings. There is no doubt, therefore that the crowns in No. 4495 mirror the types used then in Ethiopia.

[35] The Book of Miracles of the Virgin Mary, 17th century. Summarily described by AnnTM.

[36] The writer is indebted to Mr. Jacques Mercier for allowing him to study the photograph of the painting taken by him. Considering that the painting is in the holy of holies, the photograph could be taken only from far away and therefore the inscription on both sides of Mary's head is not clear. *Manbar* is a piece of furniture in the church in which the tablet of the Covenant is kept. In the past the *manbar* served as portable altars.

The icon No. 4462 is a work of an artist who put a great deal of imagination into drawing the crown. Also the introvert expression of Mary's face featured by her large almond-shaped eyes is comparable to the other 17th-century masterpiece, the icon No. 4232 (fig. 85). Moreover, the painter was obviously keen on local colour and depicted the Virgin resting on an ornate Ethiopian bed.

The icon No. 4495 is a rare example of the painted bas-relief in Ethiopian art. The 17th century is remarkable for production of small portable icons ornamented on their outer surfaces with carvings combining the cross and geometrical design. Icon No. 4495 is certainly made by one of the artisans who produced these icons, but it is also a rare attempt at modelling human figures in relief. A certain crudeness of execution is probably the reason why stylistically this image of the Virgin seems to be closer to the art of scroll painting than of icon production.

The figures of two flying angels are reduced to their heads and long curved wings folded crosswise. These elongated wings effectively express the movement of the angel's hands, which are hidden behind the wings, and the wide, heavily designed nimbus. The hands support the crown, as in the miniature in the Biblioteca Giovardiana (see p. 339) and thus the significance of this icon is clear: it represents the Coronation of the Virgin.

The crown of the Child is also of particular interest. The Western concept of Christ the King is virtually unknown in 17th and 18th-century Ethiopian art. We know as yet that the concept penetrated into Ethiopia with European devotional prints at the end of the 19th century. The wood carving suggests that perhaps at some stage of Jesuit missionary activities in the 17th century, the image of the crowned Child passed from them to the Ethiopians.

The style of the Baḥara Māryām painting has some relation to the "parallel" style, and on the whole the painting is a blend of old and 17th-century iconography of Mary. The image of the Virgin originated from the S. Maria Maggiore painting but the details around her head have been thoroughly transformed. The borders of her *maphorion* became independent elements and give the impression of either a long tress of hair or irregular flames springing from Mary's head. She is flanked by two celestial beings which recall the 15th-century angels carrying large, realistically drawn swords in one hand and equally well drawn sheaths in the other. Also the crown is a blend of old and new forms. Its upper edge is ornamented with cross and rosette finials, well-known in 15th-century crowns, and two horn-like finials on both ends, which is clearly a 17th-century addition.

The Pleated Cap

The pleated cap under the mantle has been added to portraits of Mary during the First Gondarene period. In its developed form the cap is composed of a set of white pleats arranged above Mary's forehead, on both sides of her face and along the edges of the mantle, IES Coll. Nos. 4656 (fig. 106), 4131 (fig. 107), 4127 (fig. 108), 4187 (fig. 109); icon from Wāšā Endreyās Monastery, Bagēmder (fig. 110); miniature in Book of Miracles, Dabra Warq Monastery (fig. 111). Occasionally the

pleats are found framing only the head of the Virgin, No. 4069 (fig. 98) or only along the *maphorion* on her breast, No. 3492 (fig. 112).

Already Monneret de Villard had noted an analogy between the pleats in Ethiopian paintings and those in the images of the Virgin of the Cretan school. The Ethiopian painters, according to him, did not fully understand the significance of Greek dress and made the pleats much longer, even flowing down all along the border of the mantle. He did not think the Ethiopians would have made this addition and suggested that they had copied an image of the S. Maria Maggiore Virgin in which there was a cap under the mantle.[37] The investigation of Greek icons in Ethiopia does not support this suggestion. For example the icon at the Monastery of Ğamado Māryām, Wallo, shows the pleats just as long as in Ethiopian paintings. In another Greek icon at the Dabra Warq, Goğğam, the pleats are shown only over the Virgin's forehead. This proves that the Greeks used to represent pleated caps in a varied manner and the Ethiopians followed them. The fact is, nevertheless, that in Ethiopian paintings the pleated cap seems rather more an ornamental braiding of the mantle than a separate part of Mary's dress.

The Cretan or Italo-Cretan origin of the pleated cap in the Gondarene portraits of Mary is obvious, and it is hardly possible that there was an Italian copy of the painting of S. Maria Maggiore in which the pleated cap was depicted. Thus a ready-made model was not available and the Ethiopians themselves added this detail. The pleated cap is not shown in any picture of Mary prior to the advent of the Gondar school i. e. this addition was effected after 1630, a few decades after the arrival of the Roman models into the country. The shape of the cap does not truly reflect the Greek dress even in those pictures in which the painters took care to render the pleats carefully. The pleats are an artistic borrowing from Cretan icons then found in Ethiopia, and in the process the pleats were transmuted according to the local art of design.

The Ethiopian painters of the 17th century had no difficulty in finding models. A number of Italo-Cretan icons must have been kept in monasteries and held in great veneration because, contrary to the Roman tradition, the Ethiopians believed these icons to have been painted by St. Luke himself.[38]

The Crescent

The crescent under the feet of Mary in her S. Maria Maggiore image is found in only one painting known to the writer, namely a composition painted on skin, at present preserved in the Dāgā Esṭifānos church, Lake Ṭānā. The painting is outstanding for its size and artistic quality, (fig. 113).

Stylistically the painting belongs to the first Gondarene school but the folds of

[37] MonMad 36–38.

[38] The chronicle of Iyāsu II gives the list of churches in which the icons "brought by our good kings" from Jerusalem and Egypt were kept: Dabra Ṣemunā, Dabra Warq, Gētēsēmānē Māryām, Marṭula Māryām, Tadbāba Māryām. I. Guidi in: CSCO 66 (1912) 106. This list corresponds to the present location of the so-called St. Luke icons.

the mantle recall the linear technique of the pre-Gondarene paintings of Mary.

There are three significant details in this important work. The Child is seated on the Virgin's right arm instead of the usual left, which occurs in paintings ascribed to the early period of the iconography of S. Maria Maggiore in Ethiopia. The way of drawing the Child's feet closely follows the Roman model. The star on Mary's left shoulder is framed in a figure recalling the inverted flame. This unusual innovation was probably inspired by the aureole of flames in the engravings. The painting therefore should be dated to the first half of the 17th century.

The crescent depicted at the bottom of Mary's robe is a rare occurrence in Ethiopian art. The composition combining the S. Maria Maggiore portrait and the crescent is related to other 17th-century images of Mary showing her standing on the crescent. The form is discussed in another chapter. It is nevertheless important to note here that the translation of the crescent from the above image to the image of S. Maria Maggiore was achieved by Ethiopians.

* * *

Apart from these four main additions in the 17th century, there are a few others no less imaginative and culturally significant; they are sporadic and therefore their detailed description would unnecessarily lengthen this exposition.

An example of these additions is found in icon IES Coll. No. 3492 (fig. 112), which most probably dates from the 18th century, though it is painted in the First Gondarene style. Mary is seated on a bed covered with a checkered carpet. The combination of the stylized figure of Mary with the accurate rendering of the bed gives to this icon a special significance. Also the icon demonstrates the dual trend in Gondarene painting: a continuation of old iconographic traditions in some details, and a realistic approach to others which have been taken from everyday life. The expression of the archaic trend is the Child holding a bird in his hand instead of a book. This is a 15th-century subject,[39] introduced into the image of S. Maria Maggiore. One cannot tell why the painter has chosen to depict a bird instead of a book and whether he attached symbolic significance to this change, but certainly it illustrates a conservative aspect of 17th-century art. On the other hand, the innovating trend is expressed by the addition of a necklace to the figure of the Child. This carefully-drawn piece of jewellery is easy to identify as Ethiopian and is still used for children in the north of the country.

SECOND GONDARENE SCHOOL

The 18th-century painters added further enrichments to the 17th-century form. The trend culminated in flamboyant portraits of the Virgin, the supreme expression of Second Gondarene art.

There are three types of the images of S. Maria Maggiore developed during the period:
(a) The figures of archangels Michael and Gabriel are not included in the image.

[39] ChojArtEthE 51–52.

However, if this is in the form of a triptych, the archangels are depicted separately in its wings.

(b) The background of the image is divided horizontally into two registers and the busts of the angels are shown in the upper register.

(c) A screen made of cloth is displayed behind the Virgin and Child; two angels support it with their hands.

Types (b) and (c) are the main ones, the (a) is less frequent.

In the majority of 18th-century pictures of Mary the above types are represented in their pure form, while in others there are combinations of these three types. Also in the process of copying and inevitable stylization of details, these have lost their primary shape and at times their significance as well. Still their origin can be traced to these three expressions.

Monneret de Villard distinguishes four different types of the Virgin of S. Maria Maggiore. He is conscious of the difference between types (b) and (c) as described above but not of type (a). On the other hand the three categories suggested by him are, in fact variants of type (b). His classification refers mainly to Second Gondarene images of Mary but he does not make a distinction between First and Second Gondarene schools; as a result his classification is not too clear.

First type

Three paintings reproduced, IES Coll. Nos. 4606 (fig. 114), 3947 (fig. 115), and 3706 (fig. 116), are representative of the type. The triptych No. 4606 shows in the main panel the seated Virgin; her chair has a rounded high back and sculptured arms; in the wings St. Michael and St. Gabriel are depicted in the upper register, and two equestrian saints, George and Basilides, in the lower register.

The realistic rendering of figures, their faces and wavy blond hair suggest that the painter composed directly from Western models. The angels are depicted full figure, dressed in long flowing robes with a short tunic over these; their large wings are folded downwards and they hold their arms crossed on their chests. This movement expressing submission and respect was noted by Monneret de Villard who traced its origin to Sassanid Iran and suggested that it came to Ethiopia through the Indian channel.[40] Monneret developed his theory on the 18th-century images of Mary known to him. In fact, this position is found in 16th-century Crucifixions, in which Mary often has, and St. John virtually always has hands crossed on the breast.[41] Donors included into the subject-matter, starting in the 17th century frequently have their arms crossed. Such position of arms was well-known and practised by Ethiopians long before the 18th-century painters incorporated it into their figures of archangels. Moreover, the celestial beings give an impression of being copies of Baroque angels rather than the result of very composite Iranian/Indian origin.

[40] MonMad 29–30.
[41] IES Coll. Nos. 4480, 4460, 3672, 4261, 3972, 3563, 3078, most of them dated to the 16th century.

The other feature of the painting is the simplicity of the nimbi, rendered as a plain yellow disc, contrasting with the usual 18th-century rich ornamentation of these, No. 3706. Also the sober use of plain colours, blue for Mary's mantle, yellow with red shading for Christ's robe, and green and mulberry red are significant. The icon No. 4606 and similar works have been painted before the flamboyant pictures of Mary became common, i. e. before ca. 1740. On the other hand, icon No. 3706 in which the figures of archangels are missing altogether is an epitome of the flamboyant style. The icon belongs to a particular group of 18th-century paintings on wood which have frames affixed to the main body of the icon – clearly an innovation brought into the Ethiopian technique of icon making. More-over, the cover is decorated with a set of holes and a copper plaque underneath; this elaborate technique was introduced most probably by Levantine artisans from Smyrna who were active in Ethiopia in the 1730s and the following decade.

Second type

The horizontal line dividing the background into two registers runs behind Mary's shoulders, IES Coll. Nos. 3979, (fig. 117), 4056 (fig. 118), 3807 (fig. 119); Brit. Mus. Or. 655, f. 3a (fig. 120); IES Ms. No. 73 (fig. 121); diptych H. Schweisthal Coll. (fig. 135). The registers are either painted in two plain colours or ornamented with an overall pattern or an ornamented band below the line. The meaning of this arrangement is not clear. In paintings showing Mary seated on a chair with high arms, the flat shape behind her represents the back of the chair.[42] In other paintings it might be a stylized screen made of cloth outstretched behind the Virgin. The busts of the angels vary a great deal but always their body below the chest is hidden behind the screen. As a rule the angels show the head, wings and the upper part of the chest, and exceptionally the head and wings only. The figures of angels in the form of heads to which two wings are attached appeared in Western art during the late Renaissance and became popular during the Baroque period. The form made its way to Ethiopia in the early 17th century. However, one wonders whether the drastic reduction of the figures of angels in the Second Gondarene images of Mary is the result of limited space allotted to the angels or a deliberate imitation of the imported models.

Usually the angels keep a sword in one hand and hold the other hand either on the dividing line or on the top of the chair or on their breast. Occasionally hands are not depicted at all, swords are depicted but not hands, and exceptionally neither hands nor swords are shown. In spite of these variations, the sword-bearing angels are characteristic of the type.

Third type

The third type is the most colourful of all the Gondarene portraits of Mary and contains the major 18th-century addition, a screen or curtain outstretched behind the Virgin and supported by two angels, Brit. Lib. Or. 594, f. 77b (fig. 122).

[42] "sembra un'alta spalliera del trono sul quale Ella è seduta..." MonMad 29.

Monneret de Villard who commented on this detail noted its similarity with the Italian paintings of the 14th or 15th century[43] (see also p. 418). He is correct in believing that the screen is, indeed, an artistic borrowing but he did not explain how such early paintings could have influenced the Ethiopians. We are now in the position to suggest the model they used. It is found in the triptych, IES Coll. No. 3975 (fig. 123) which is a direct copy from European Baroque painting. The Ethiopian painter obviously did not know the Latin script but he reproduced meticulously the captions of the original making understandable mistakes. The triptych represents in its central panel the Virgin and the half-naked Child standing on her lap, both accompanied by an equally half-naked infant, St. John. Such a composition is most unusual in Ethiopian art but common in Renaissance and Baroque paintings. Behind the Madonna two angels hold an outstretched curtain; an identical curtain and similar angels supporting it are found in 18th-century Ethiopian images of the Virgin of S. Maria Maggiore. It is obvious that the painting No. 3975 acted as a channel through which the screen made its way into the Ethiopian images of the Virgin.

Possibly the closest copy of this painting is found in the triptych belonging to Asrat Telahun, USA (fig. 124). The arrangement of the screen and the movement of the angels' hands are identical. The painter replaced the alien figures of Mary, the Child and St. John by the known to him image of the S. Maria Maggiore Virgin, but he kept the aureole of light.

In painting No. 3975, as well as in other paintings in this group, the robes of persons and occasionally the screen are ornamented with an overall pattern of rosettes, stars, and flowers in rich and usually sombre colours, contrasting with the simplicity of design and clear flat colours of 17th-century art. The question is what brought about this substantial change? Significant information is given by the chronicler of King Iyāsu II (1730–55) and Queen Mentewwāb, his mother,[44] who described at length how in 1740 the Dabra Ṣaḥāy church at Qwesqwām, residence of the Queen, was constructed and decorated. There was a picture of Mary in the church, to which the Queen was deeply devoted. The chronicler relates that she advised the painter who made the picture as follows: "Do not make her [the Virgin's] dresses using colours but silk material in gold, silver and blue which is called *zangarli*; put on her breast a red brocade of a kind called *sini*, which is woven with gold". Moreover, the Queen "made the dress of the Child with the brocade mentioned above" and, continued the scribe, "two angels of mercy, St. Michael on her right and St. Gabriel on her left, hold the shining curtain", which obviously

[43] MonMad 36–28.

[44] Empress of Ethiopia (c. 1706–71) and de facto ruler during the reign of her son Iyāsu (1730–55) and grandson Iyo'as (1755–69). Enlightened and liberal in religious matters and the arts, Mentewwāb encouraged the production of illuminated manuscripts and paintings, protected the Syrian craftsmen who found refuge in Ethiopia, and built the Qwesqwām church and palace in Gondar (1740) and the Trinity church on the island Nārgā, Lake Ṭānā (1747). Mentewwāb means "how beutiful she is". Her royal name was Walatta Giyorgis.

means that the curtain too was made of brocade. The effect, according to the scribe, was "most astonishing, the Virgin was surrounded by majesty and seemed to speak to those who looked at her". He praised further the painting by adding that "the Virgin's beauty surpassed all images from Jerusalem and Egypt which were brought by our good kings".[45] The scribe was obviously referring to Greek-Cretan icons.

Whether such clothing of the Virgin with precious textiles and jewellery was invented by Mentewwāb or suggested to her by someone who learned about it from abroad is hard to judge. The practice of clothing holy images with ornamental dresses was of course widespread throughout the Christian world long before Mentewwāb advised the painter in Qwesqwām. The practice is also known in other areas, like India, but there it is mostly applied to sculptured images.

There is no evidence that the practice was known in Ethiopia before the 18th century and therefore the image at Qwesqwām might have been the first of its kind. We have proof that the practice was still in use in the early 19th century. For example in the Śellāsē church at Čalaqot, Tegrē, there is the image of the Virgin donated c. 1800 by Rās Walda Śellāsē, then the ruler of Tegrē. The dresses of the Virgin and Child are made of glittering brocade, (fig. 125).

Summing up, the royal chronicle brings two important points:

(a) the existence in 1740 of a portrait of Mary in which two angels hold the screen behind her; it is suggested that this detail found its way to the image of S. Maria Maggiore prior to that date but after 1730;

(b) that colourful robes were introduced into the same image around 1740, perhaps exactly in 1740.

The above and numerous pictures from the period with donors prostrate depicted below the Virgin evidence that her colourful robes, those of the Child and of the two angels in 18th-century paintings, mirror the garments used by royalty and nobility of the Gondarene court. They were gorgeous indeed. The royal chronicle reports for the year 1748 that Sehul Mikā'ēl, governor of Tegrē, sent to the court among many other gifts "cloth of gold and silver, dazzling by its splendour and colour".[46] The fashion at court run by a Queen who wanted to be beautiful, and her equally attractive daughters enjoying silk and brocade robes, thus passed to the holy images. The relation between the imported textiles, mostly of Indian origin, and the 18th-century flamboyant images of the Virgin Mary is obvious.

Understandably, producing the Qwesqwām painting must have been expensive. Even the Queen did not repeat the experience when in 1747 she founded the church of the Holy Trinity (Śellāsē) on the island Nārgā, Lake Ṭānā. Instead, the beautiful

[45] CSCO 66 (1912) 106. Pankhurst considers *sini* as silk apparently so-called because it has first originated from China [The History of Ethiopia's Relations with India prior to the Nineteenth Century 3 – IV Congresso internazionale di studi etiopici, Roma 10–15 aprile 1972 (Roma 1974) 277]. C. *Conti Rossini* in CSCO 58 (1910) 14, translates *sini* as "soie de Chine". *Zangarli* is a silk most probably from India.

[46] CSCO 66 (1912) 156. In general the continuous flow of Indian luxury goods to Ethiopia is well attested since the 16th century.

image of the Virgin in the church faithfully reproduces in paint the splendour of the Qwesqwām image, (fig. 126). For example, a row of small buttons in Mary's red blouse is found only in those Second Gondarene pictures of S. Maria Maggiore which bear ornamented robes. The golden lace on the sleeves mirrors the bracelet put on Mary's wrist in her Qwesqwām image as well as the lace collar and the golden chain put on her neck. The same applies to the gorgeous mantle in blue with overall scattered colourful rosettes, the seat reflecting precious upholstery, and the screen bearing flower ornamentation.

In painting No. 3975 the angels support the screen or curtain effectively with their uplifted hands and grasp its folded top. The folds into which the soft curtain falls are rendered realistically. This design is followed by most Ethiopian painters and probably mirrors the Baroque model. Some painters, however, reproduced the trapezoid shape of the screen but made it flat and ornamented with stars, flowers and rosettes.

The rôle of angels and the movement of their hands also gradually changed. Although in a large number of paintings the angels have both hands uplifted and seem to support the curtain, in other paintings they bear swords in one hand and hold the curtain in the other. In the Nārgā Śellāsē mural the angels do not support the curtain at all but hold flowers and swords.

A combination of the screen and busts of angels is found in Br. Lib. Or. 721 f. 201a (fig. 127).[47] The screen spread behind Mary reaches her head; the curved folds over it are those of a textile material; the screen is obviously copied from the No. 3975 model. On the other hand, the busts of angels originate from the No. 4056 (fig. 118) model. The angels do not support the screen; instead they rest one hand on its upper edge. Apparently the painter knew both ways of depicting the background and chose to combine these into his own composition.

As a result of continuous copying, the screen became more and more stylized. In No. 3894 (fig. 128) the curtain changed into a fairly regular rectangle and the sword-bearing angels seem to lean against it instead of holding it. In miniature Br. Lib. Or. 634 (fig. 129) an oval replaced the screen. There are several other variants of this detail. On the whole the realistically drawn curtain tends to change into an ornamental background which does not give the impression of a textile material.

An interesting variant of the curtain is found in the Sandābā Iyasus church, Bagēmder (fig. 130).[48] Among its 18th-century murals there is the picture of Mary who is placed under a colourful arch to which a draped curtain is attached, both being rendered realistically. The painter in another 18th-century painting IES Coll. No. 3805 (fig. 131) was probably inspired by the mural in Sandābā Iyasus church; he incorporated an arch into his composition and made the angels support it.

With respect to other details, the general impression is that most of those found

[47] Acts of Takla Hāymānot are "written in a fine hand of the earlier part of the 18th century" and the "Ms seems to be written during the reign of Bakafa 1721–30", WrBm 194. The illustrations, according to the writer, are clearly in Second Gondarene style, i.e. the later date is suggested.

[48] The 14th or 15th-century structure was redecorated in the 18th century.

in 17th-century pictures of Mary have been kept but changed their form; some details were left out altogether and a few new ones were added.

Pleated caps, crescents and crowns are not found in Second Gondarene images of the S. Maria Maggiore. The figures of angels show a great variety, though the form of the winged bust is commonly used. Two other forms are the head of an angel with two wings attached, and the fully shown figure. Angels either support the screen with both hands or keep these crossed on their chests or hold swords and flowers.

The *mappula* continues to be an important element of the Virgin's iconography; usually it has the shape of an irregular rhomboid. In a few portraits there is an entirely new form of the handkerchief; Mary holds it in the middle while its ends hang on both sides of Mary's firmly closed hand (Māryām Pāpāseyti, Garʿāltā (fig. 132); Brit. Lib. Or. 721 (fig. 127). A white *mappula* is rare, instead those in green, dark blue or yellow and ornamented with patterns of dots and lines became popular.

The book in Second Gondarene style is similar to that of 17th-century art but the most common form is a simple square or rectangle usually painted either in green or red. It seems that a cross on the cover is depicted more frequently than in the previous century.

Some 19th-century painters succeeded, in the process of continuous commentaries to the holy images, in changing the book into an orb. The detail was obviously borrowed from the image of the Trinity which was then a common subject. This unusual and rare innovation is found in the drawing, Ms. Eth. 321, Bibliothèque nationale, Paris.

Similar to the first Gondarene painters, those of the Second Gondarene period consistently use the blue colour for depicting Mary's *maphorion*. The only exception to that known to the writer is the diptych, H. Schweisthal Collection (fig. 135), in which Mary wears the reddish-brown *maphorion*. This change of colour is probably due to the influence of Greek icons in which the *maphorion* is either red or red-brown.

Stars and crosses on the mantle are virtually always depicted together. In rare instances only the cross is shown and exceptionally a second star is added to the mantle below the figure of the Child, Dabra Abbāy Monastery, Šerē, (fig. 133). IES Coll. No. 6969 (fig. 136).

The cross continues to be a frequent ornamentation of the mantle on the head of the Virgin except in a few paintings where the cross has been replaced by a star. The cross is mostly moline and similar to that in First Gondarene school paintings though the Greek classical cross seems also to be popular. The moline cross with elongated lower arm is found exceptionally in a few paintings.

An elaborate star on Mary's shoulder is typical of 18th-century art. It is either a large shining disc with multiple radiating rays, or a set of eight or more lines of equal length crossing each other. More elaborate stars have either rosettes or pearls depicted at the tip of each ray; the most studied has been a combination of the star and trinket or brooch pinned to Mary's shoulders.

The 18th-century emphasis on ornamentation is also manifest in the nimbus. It

became an intricate composition of rays ending in varied sets of circles and rosettes. The rays radiate from the luminous yellow effluence skillfully applied around Mary's head. The rays are of different length; short fine rays give the impression of a shining disc; long thick rays seem to be made of filigree work. Another arrangement consists of a combination of zigzag rays and small rosettes in between.

The form in which all rays are of equal length and end with neatly modelled pearls recalls the head decoration of 18th-century noble ladies. Leroy has suggested that this type of decoration is of Indian origin.[49] The background of these nimbi is usually in three colours, green, red and brown.

The 18th-century painters composing a nimbus were probably inspired by two factors: the Baroque representation of spiritual light emanating from the body of saints, and the Ethiopian filigree work of the period. The relation between the form of the nimbus and the head decoration of the noble ladies is evident in portraits of the royal donors depicted with the Virgin. Moreover, her elaborate nimbus contrasts either with the simple nimbus over the heads of the accompanying angels or with the complete lack of it.

The 18th-century painters, following those of the 17th century depicted Mary seated, but they changed the traditional bed into an elaborate armchair or throne or less frequently a kind of sofa. This curious piece of furniture is characterized by two high arms composed of two or three units; the top unit has the form of a stylized lotus flower and the two lower units are ornamented with a kind of spiral, IES Coll. No. 3979 (fig. 117), 3983 (fig. 134), 6969 (fig. 136), IES Ms. No. 73 (fig. 121), Brit. Lib. Or. 655 (fig. 120), Diptych Schweisthal Coll. (fig. 135), IES Coll. No. 4604 (fig. 114). In one exceptional case, a stylized head supports a set of varied shapes, Brit. Lib. Or. 594, (fig. 122). The arms give the impression of a tumble woodwork; they are usually painted in yellow and decorated with dots or various patterns. The legs of the chair are rarely drawn, instead the chair is covered with a precious carpet and has a screen in the back made of plain or colourful textile. In a few instances the arms are not shown at all and consequently the furniture gives the impression of a large sofa. Usually the bottom of Mary's mantle is spread over the seat.

Where has this distinctive type of the Second Gondarene armchair originated from? There is no definite answer because such chairs have not been found to date in Ethiopia. It seems possible that the armchair in the pictures of Mary was drawn from life and that such a piece of furniture was, indeed, used by royalty for ceremonial occasions. Considering that the chair bears a stylized lotus ornamentation, an Indian origin is suggested.

The splendour of the 18th-century pictures of Mary has been greatly enhanced by the addition of two pieces of silverwork: the trinket depicted on Mary's shoulder below the star and the necklace which adorns the Child. The trinket is mostly rectangular, occasionally trapezoid, both ornamented with small bells or balls attached to their lower edge. These are manifestly pieces of filigree work, IES Ms. No. 73 (fig. 121), IES Coll. No. 3979 (fig. 117), Māryām Pāpāseyti, Garʿāltā (fig.

[49] LerEthG pl. 18.

132). The necklace of the Child is usually composed of a number of elongated ovals hanging on a string, occasionally of multiple units of filigree work fixed together and seldom of small crosses attached to a string. In IES Coll. No. 6969 (fig. 136), small balls are fastened on a double silver chain instead of the string.

These additions of local silverwork to 18th-century paintings are most probably the result of Queen Metewwāb's endeavour to make the painting of the Virgin at Qwesqwām as attractive as possible. Indeed, according to the royal chronicler, the picture was loaded with pieces of silverwork whereas the necklace and the bracelet as well as the brooches pinned on the picture were made of pure gold. Moreover, the "Queen put on the neck of the Infant Jesus a small chain made of gold as it is customary with royal children".[50] The 18th-century Virgin of S. Maria Maggiore bears witness to the aesthetic taste of the prestigious Queen.

A minor but significant addition is the buttons on Mary's blouse which are not known to First Gondarene painters. One wonders whether the gold brooches in the Qwesqwām picture mentioned by the chronicler are, in fact, buttons. These occasionally are combined with beautiful needlework around the neck of Mary's blouse, Māryām Pāpāseyti (fig. 132); Ambā Māryām, Enfrāz (fig. 137); Nārgā Šellāsē (fig. 126); IES Coll. No. 3979 (fig. 117); Sandābā Iyasus, Bagēmder (fig. 130). This detail was also drawn from life.

Another addition is the flower which Mary holds in her right hand. The addition of the flower changed the pose of Mary's left hand, which either rests on her knee or supports the Child, IES Ms. No. 315 (fig. 138); Brit. Lib. Or. 634, f. 8 b (fig. 129). Moreover, the *mappula* is left out. The flower bears no relation to the three leafless stems found in 15th-century paintings of Mary.

The bird in the Child's hand instead of the book is depicted very seldom in 18th-century paintings but still demonstrates the attachment of Ethiopian painters to the old iconographic tradition, IES Ms. 315 (fig. 138).

In the picture of Mary at the Sandābā Iyasus church, Bagēmder, (fig. 130). we witness an innovation in Mary's head-gear. She wears a cap or a veil in addition to the mantle. The cap is attractively arranged on both sides of her head and reaches her shoulders. This head-cover is different from the Greek pleated cap found in the 17th-century images of the S. Maria Maggiore Virgin. The 18th-century cap originates from the Portuguese-Goan women's dress as explained in another chapter (p. 308).

Undoubtedly the most significant addition to the 18th-century images of Mary are the portraits of the donors. Kings or knights were sporadically depicted in compositions prior to the 18th-century but the practice of including donors in the subject-matter of holy images became widespread in Ethiopia in that century. Judging from the number of portraits of Queen Mentewwāb, her son Iyāsu and their family, they must have been particularly fond of this kind of portraiture. The Queen ordered her portrait to be painted below the image of Mary in the church of Qwesqwām and her son Iyāsu below the picture of the Crucifixion. The scribe, who recorded it also explained the reason for making these portraits. The Queen, he

[50] CSCO 66 (1912) 106.

wrote, was seeking spiritual refuge in the redeeming power of the holy images.[51] The Queen is also depicted together with the Virgin in the mural of Nārgā Sellāsē church (fig. 126) and her daughter, Walatta Esrā'ēl in the miniature of the Story of Mary at Ambā Māryām Monastery, Enfrāz (fig. 137). A couple of decades later Rās Walda Sellāsē, the ruler of Tegrē and his consort both accompanied by their attendants were depicted in the Čalaqot Sellāsē church which they richly endowed.

Usually the donor is shown laying prostrate below the figure of Mary in the pose of submission well-known in Ethiopian traditional life. In rare instances the donor is standing. This occurs in portraits of King Iyāsu II who in this case is depicted on the side panel of the triptych.

The figures of queens, kings, nobles and churchmen are by no means portraits in any real sense because Ethiopian painters never attempted to render a physical likeness; these figures mirror nevertheless the salient aspects of 18th-century Ethiopia, especially the period's garments, weapons, jewellery, horse trappings and other objects, all drawn from life and with care for details.

The study of the donors, who in general can be identified, is of great importance to the history of the period. For the history of Ethiopian art these colourfully dressed personages are helpful in understanding the dramatic changes of style and content in the 18th-century images of the S. Maria Maggiore Virgin.

SUMMARY AND THE SO-CALLED LEFT-HAND RULE

Around the year 1600 the Jesuit missionaries brought into Ethiopia copies of the famous painting of the Virgin in the basilica of S. Maria Maggiore, Rome. The Ethiopians adopted these copies as models for creating their preferred image of the Virgin. This image virtually eliminated all other expressions of Mary's iconography in Ethiopia, starting with the 17th century. The Ethiopians transformed the Roman model by elements taken from old iconographic traditions as well as from everyday life of the period. Thus they developed a unique image of the Virgin in their remote African country.

The process of adaptation lasted about one century and a half and was completed in the 18th century. Not all transformations then made proved to be permanent. The pleated cap under Mary's mantle, the crown on her head and the crescent at the bottom of the image were exclusive attributes of the First Gondarene school of painting; the buttons on Mary's blouse were a minor and ephemeral addition of the Second Gondarene school; the flower in Mary's hand and the bird in the hand of the Child appeared sporadically in the 17th and following centuries.

[51] CSCO 66 (1912) 106. The figure of the lady donor depicted in Brit. Lib. Or. 634, f. 8 v (fig. 129) obviously represents a queen because a crown is depicted close to her. Possibly the lady is Queen Mentewwāb though not identified by an inscription. She wears a nun's garb and by this perhaps indicates her intention to withdraw from this world and to seek refuge in the "redeeming power" of the holy image of the Virgin.

On the other hand, the archangels Michael and Gabriel flanking the Virgin belong to the permanent additions. Permanent also was the piece of furniture on which Mary is seated which was a First Gondarene invention.

The elaborate dress of Mary and the Child, the trinket on the mantle added to the star, the screen behind the Virgin as well as the necklace of the Child: all these are Second Gondarene embellishments. Moreover, the practice of including the figure of donors, sporadic in the 17th century became common in the 18th century and continued until the present.

The additions and the rendering of the face of the Virgin and Child varied a great deal but the essential elements of the image did not change in the continuous process of copying. These elements are the position and blessing pose of the Child, the book in his hand and the form of Mary's hands, particularly the elongated two fingers of her right hand and the handkerchief in her left hand.

There are three distinct periods of stylistic and iconographic transmutations: the initial period which lasted from the inception of the image of the Virgin of S. Maria Maggiore in Ethiopia until the fourth decade of the 17th century, the First Gondarene period from the fourth decade of that century until the early 18th century and the Second Gondarene period which started around the third decade of that century and has lasted until the present.

During the initial period we witness two tendencies, one to render the model as faithfully as possible and the other to effect a thorough stylistic transformation. The latter epitomized the perennial aesthetic criteria of Ethiopian art and is culturally more significant. It developed most probably in the scriptoria of Tegrē province and is known by a limited number of works. A similar trend in Mary's imagery seemed to emerge in the art of Šawā in the late 18th and early 19th centuries.

The works of the First Gondarene school show on the whole a remarkable stylistical and iconographic stability. The early Second Gondarene works mirror two schools; the court school which developed a flamboyant style enhancing the decorative value of the painting, and the more sober school inspired by the primitive models and early iconographic traditions. With the final stabilization of the image and its unimaginative copying during the 19th and 20th centuries the overwhelming impression is that of monotony of expression.

The adoption of the Virgin of S. Maria Maggiore by Ethiopians as their exclusive model apparently brought about the problem of whether the Child should be depicted on Mary's left or right arm. There is no evidence in Ethiopia of any rule referring to this detail prior to the 18th century. Indeed, the paintings starting with the earliest until the end of 16th century provide ample evidence that Ethiopian painters did not discriminate between Mary's arms and, in fact, there was in their works a remarkable lack of uniformity. However, the 16th-century painters seem to prefer depicting the Child on Mary's right arm; the possible reason for this was the impact of the imported Cretan icons which then influenced the Ethiopian image of Mary; in these icons the Child was seated on her right arm. On the other hand, in the image of the Virgin influenced by the S. Maria Maggiore painting, Mary invariably holds the Child on her left arm, except in a few rare instances already explained.

The conclusion is that the introduction of the S. Maria Maggiore image into Ethiopia effected a change in the position of the Child from the right arm prevailing in the 16th century to the left arm used virtually exclusively in the 17th and following centuries.

The Scottish traveller James Bruce who visited Ethiopia in 1769–72 was the first to note that the Ethiopians accorded a special importance to the position of the Child. He erroneously considered that the Venetian painter "Francesco Branca Leon" was the first in Ethiopia to represent the Child on his mother's left arm (see p. 378). On the other hand, Bruce's information about the "left-hand rule" in 18th-century Ethiopia seems to be correct, in spite of Monneret de Villard's doubts.[52]

Although Bruce was not particularly interested in art, he was nevertheless a man of culture and a keen observer of every aspect of Ethiopian life. During his stay in the country he must have noted that local painters invariably depicted the Child on the left arm of his mother. Obviously a habit repeated for over a century had already acquired in Bruce's time the quality of a strictly defined rule. The following generations of painters rigorously adhered to it because they invariably depicted Mary in one manner only; namely that which derived from the Roman Virgin.

The 20th-century traditional painters whom the writer had the opportunity to meet were unanimous in stating that the Child in the images of Mary must be depicted on her left arm because this is the "proper" manner of making her painting.

This change of a repetitive pattern into a rule is in accordance with the well-rooted conformism of the Ethiopians and with their concept of the past. On the one hand, the painter copied the established archetype because he believed that it was used "since time immemorial". On the other hand, in traditional thinking anything in the present must have its justification in a remote event as a starting point. It is hard to say whether the episode of "Branca Leon" was conceived in the imaginative mind of Bruce, or in historical divulgencies of Ethiopian clerks, even more prone to imagination, or in both. Nevertheless, there is, as usual, a grain of truth in the story. "Branca Leon" as well as the Jesuits were *farang*, the foreigners. In the 17th-century images of Mary the foreign influence was, indeed, a starting point for establishing a kind of left-arm rule for depicting the Child.

The story of the Virgin of S. Maria Maggiore in an African country reveals thus two aspects of traditional Ethiopian culture. A deeply rooted conservatism – the iconographic type introduced some four hundred years ago was continuously copied without losing the essentials of its identification – and the determination, perhaps not fully conscious but nevertheless effective, to transform the alien model into an image bearing a distinctly local character.

[52] MonMad 40, believed that in the 17th century "a proper rule [of the left arm] did not exist". Nevertheless it seems that during the same century the rule started to take root. This is evident considering a large number of the images of Mary then produced in which the Child was depicted on her left arm as compared to a few exceptions.

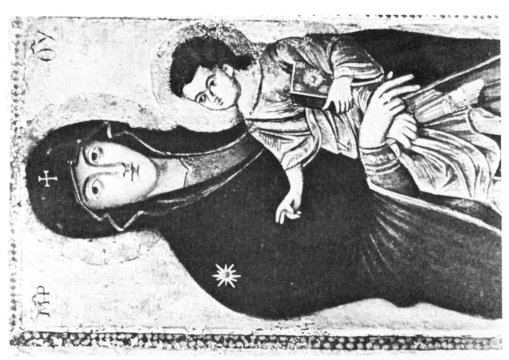

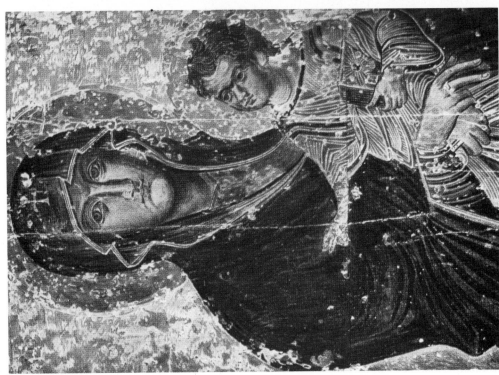

84. Madonna Salus Populi Romani, also called Madonna of St. Luke, 13th century?

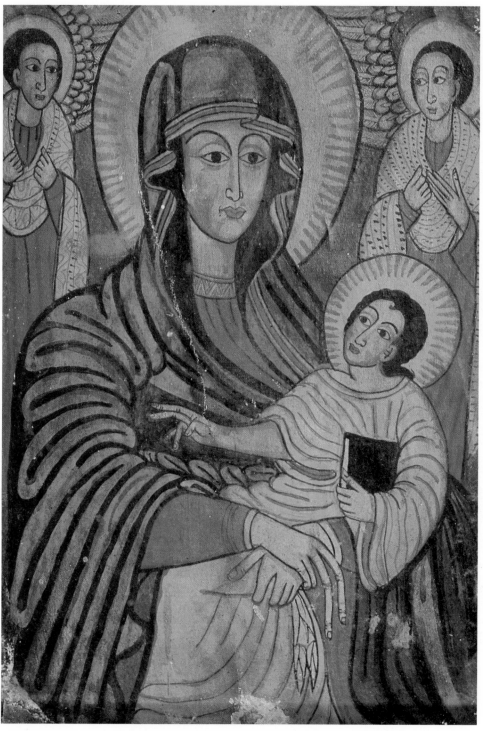

85. Triptych, c. 1630–1700. 44,6 : 34,4 cm. IES Coll. No. 4232

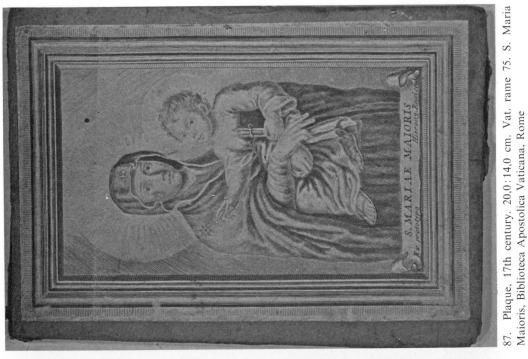

87. Plaque, 17th century. 20,0:14,0 cm. Vat. rame 75. S. Maria Maioris, Biblioteca Apostolica Vaticana, Rome

86. Matrix, c. 1570? 21,0:15,6 cm. Vat. rame 98. S. Maria Maioris, Biblioteca Apostolica Vaticana, Rome.

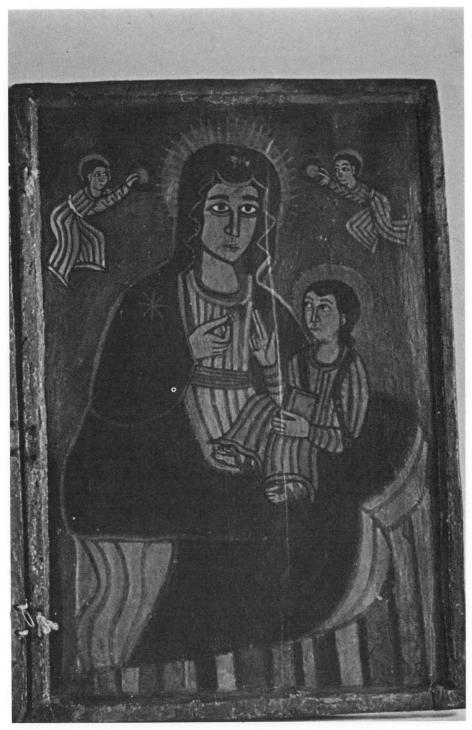

88. Diptych, c. 1600. 33,3 : 23,5 cm. IES Coll. No. 4460

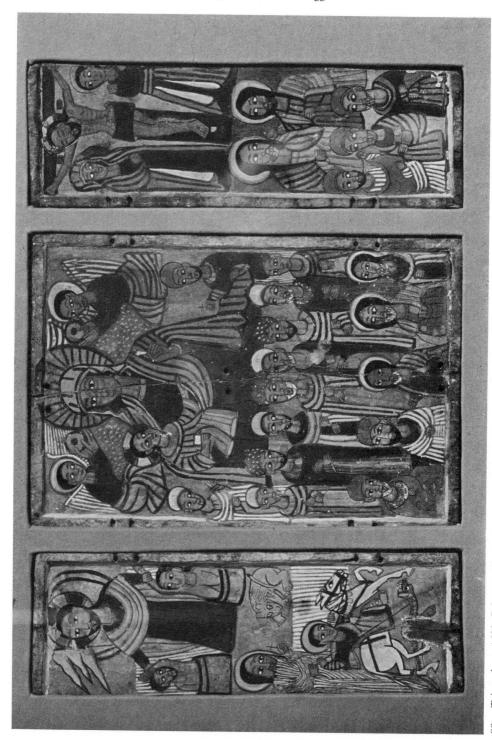

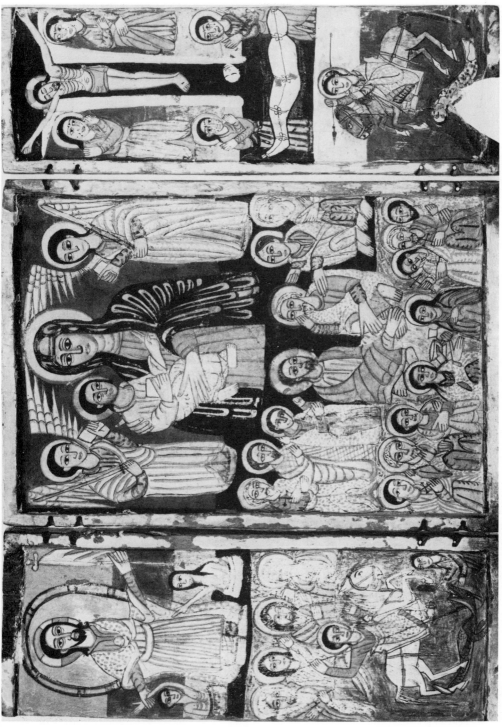

90. Triptych, c. 1600. 39.7 : 26.8 cm. The Langmuir Coll. No. 95, Peabody Museum, Salem, Mass.

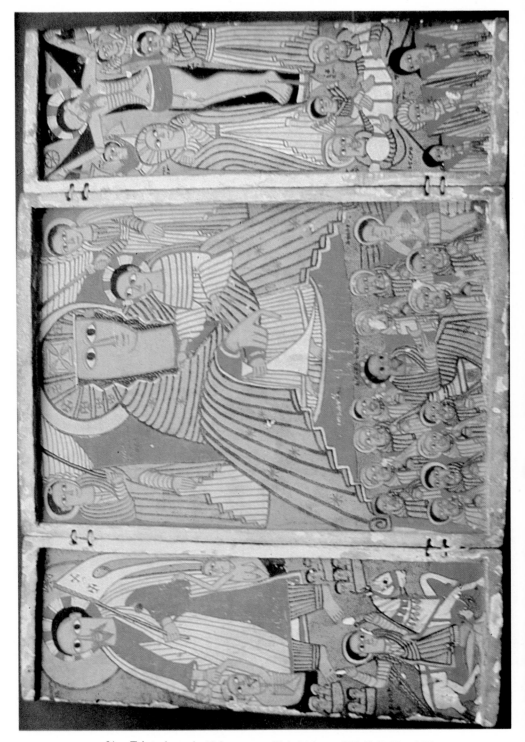

91. Triptych, early 17th century. 35,4:24,0 cm. IES Coll. No. 4128

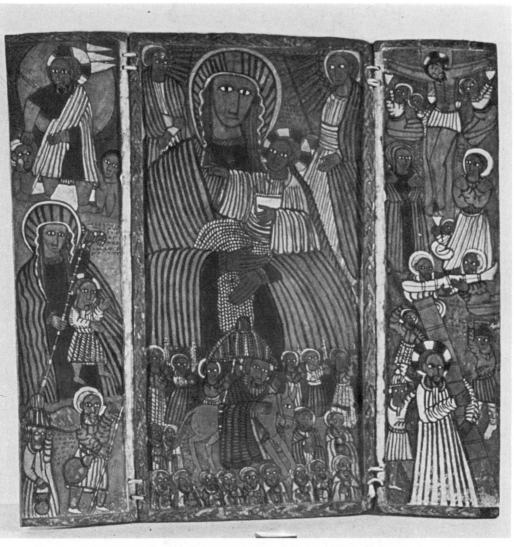

92. Triptych, early 17th century. 51,0 : 25,0 cm. IES Coll. No. 4261

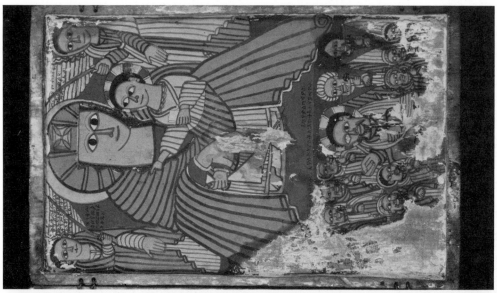

95. Triptych, early 17th century. 41,0 : 27,0 cm.
Private coll., Austria (central panel)

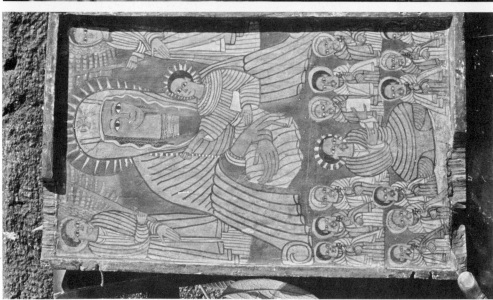

93. Triptych, early 17th century. 38,0 : 22,0 cm.
present owner unknown

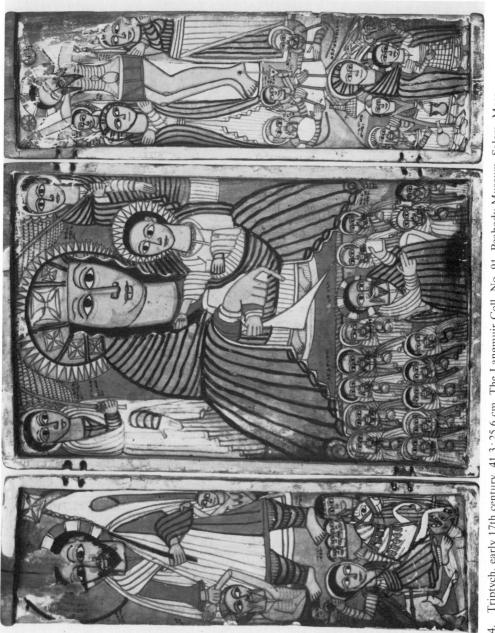

94. Triptych, early 17th century. 41.3 : 25.6 cm. The Langmuir Coll. No. 91. Peabody Museum, Salem, Mass.

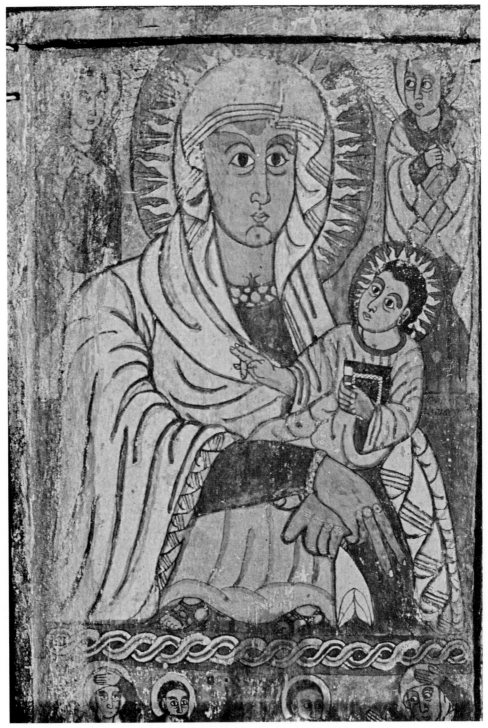

96. Triptych, early 17th century. 37,5 : 23,0 cm. IES Coll. No. 4130

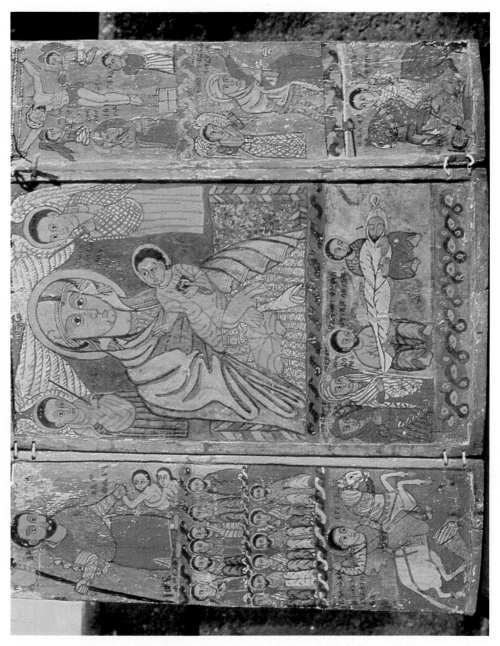

97. Triptych, early 17th century. 37,0 : 24,0 cm. IES Coll. No. 3976

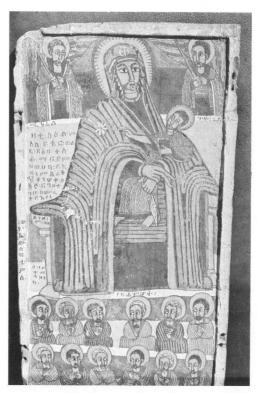

98. Triptych, c. 1630–1700. 40,5 : 24,9 cm. IES Coll. No. 4069 (central panel)

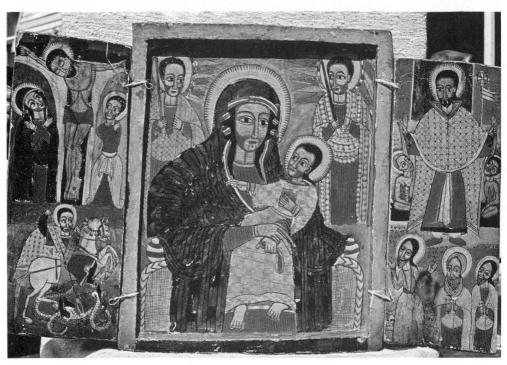

99. Triptych, c. 1630–1700. 21,6 : 18,9 cm. IES Coll. No. 6793

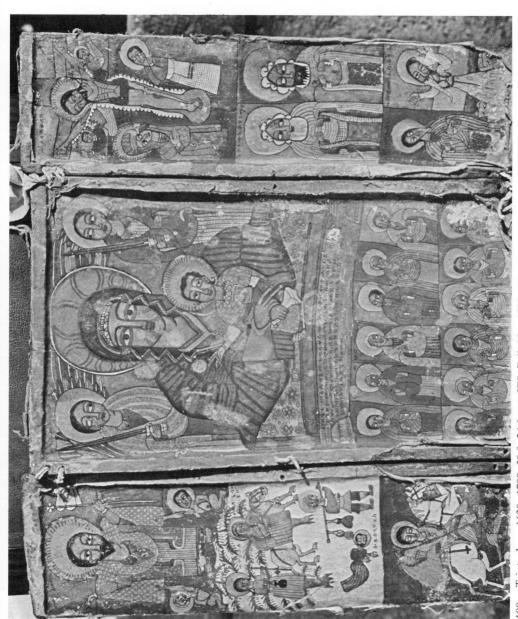

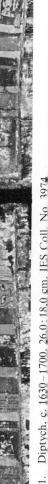

101. Diptych, c. 1630–1700, 26.0 : 18.0 cm, IES Coll. No. 3974

102. Triptych, c. 1630–1700. 38.5 : 26,0 cm. IES Coll. No. 4792

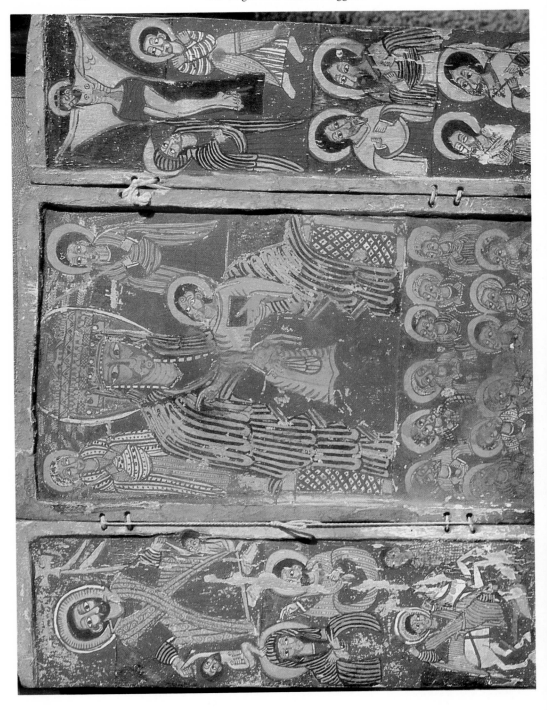

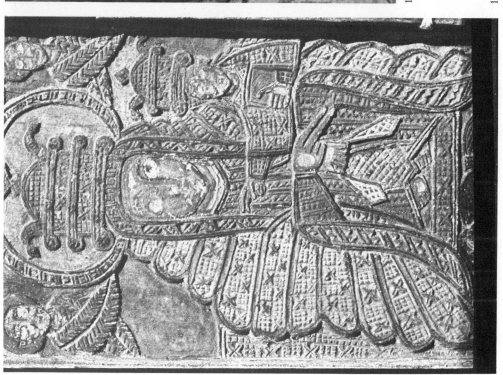

105. Canvas painting on plaster, 17th century. Baḥara Māryām, Tegrē

104. Panel, c. 1630–1700. 18,5 : 12,2 cm. IES Coll. No. 4495

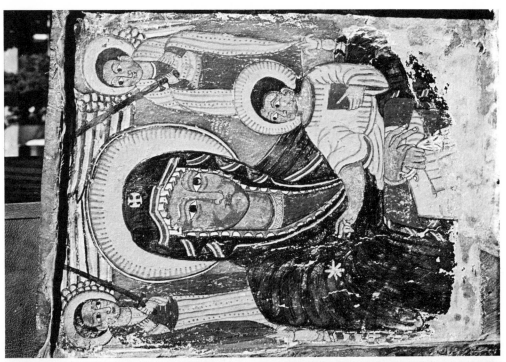

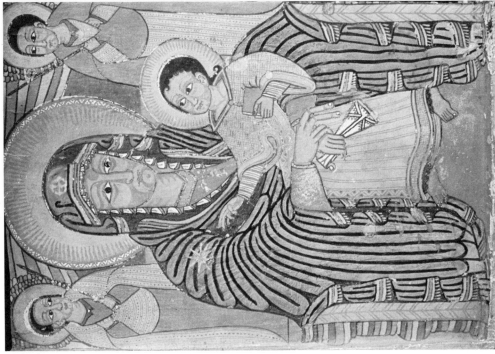

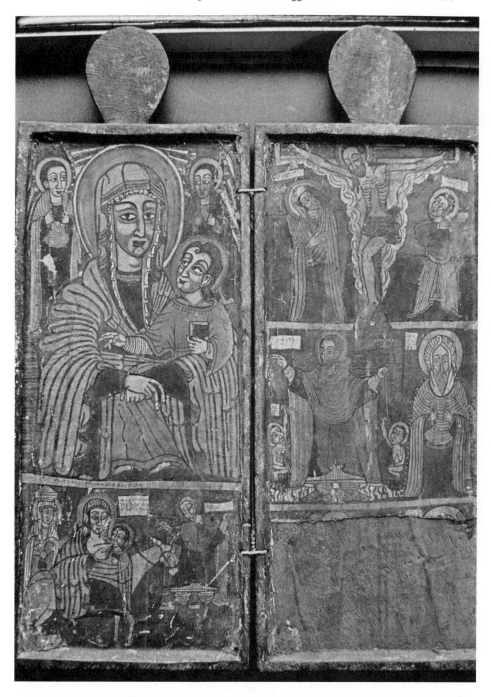

108. Diptych, c. 1630–1700. 25,3 : 18,7 cm. IES Coll. No. 4127

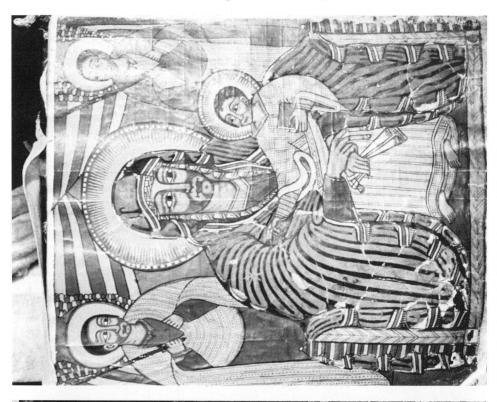

111. Miracles of the Virgin Mary. c. 1630–1700. c. 28.0 : 17.0 cm. Dabra Warq, Goǧǧām

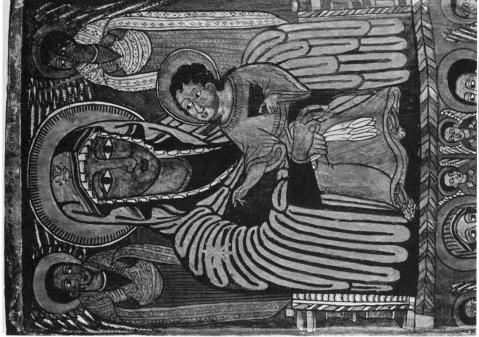

109. Diptych. c. 1630–1700. 94.0 : 37.6 cm. IES Coll. No. 4187 (detail)

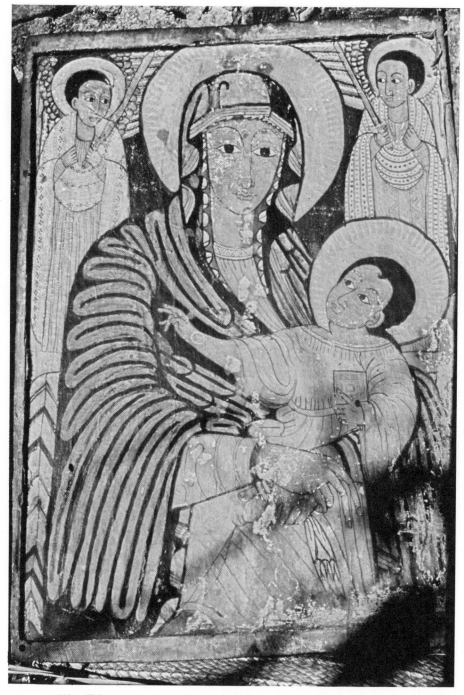

110. Triptych, c. 1630–1700. 59,0 : 40,0 cm. Wāšā Endreyās, Bagēmder

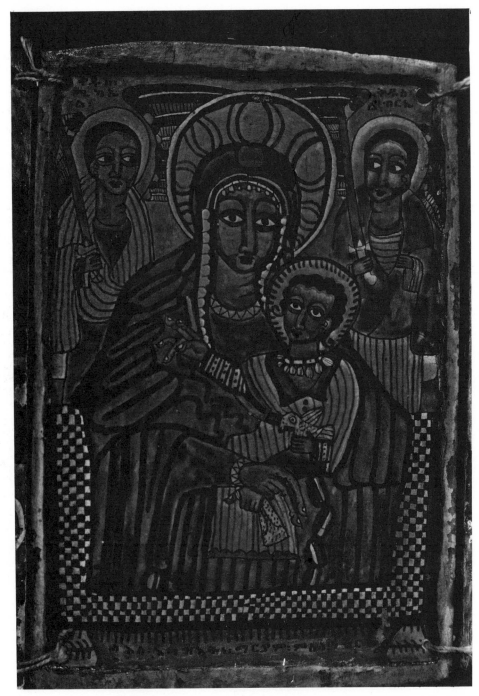

112. Triptych, 18th century. 24,0 : 18,0 cm. IES Coll. No. 3492

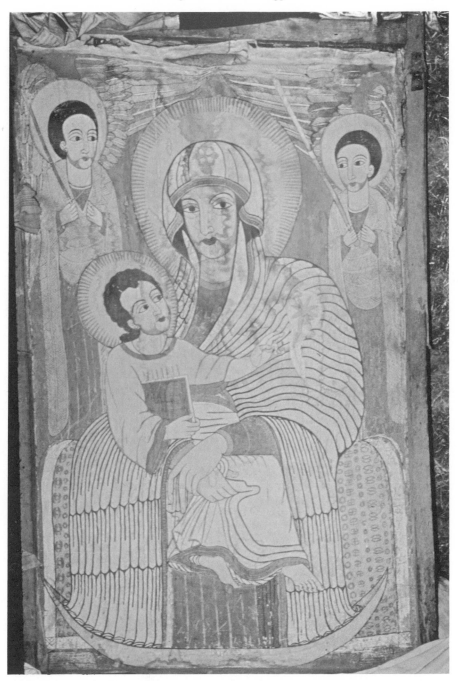

113. Painting on skin, 17th century. 85,0 : 45,0 cm. Dāgā Esṭifānos, Lake Ṭāna

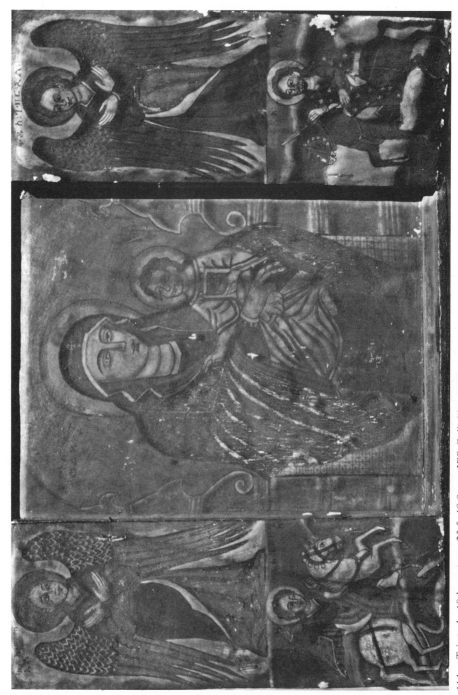

114. Triptych, 18th century. 25.5 : 18,0 cm. IES Coll. No. 4606

116. Triptych, c. 1730–60. 23,0 : 18,0 cm. IES Coll. No. 3706

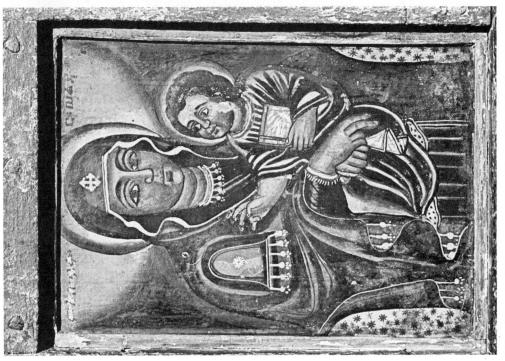

115. Diptych, 18th century. 24,0 : 19,0 cm. IES Coll. No. 3947

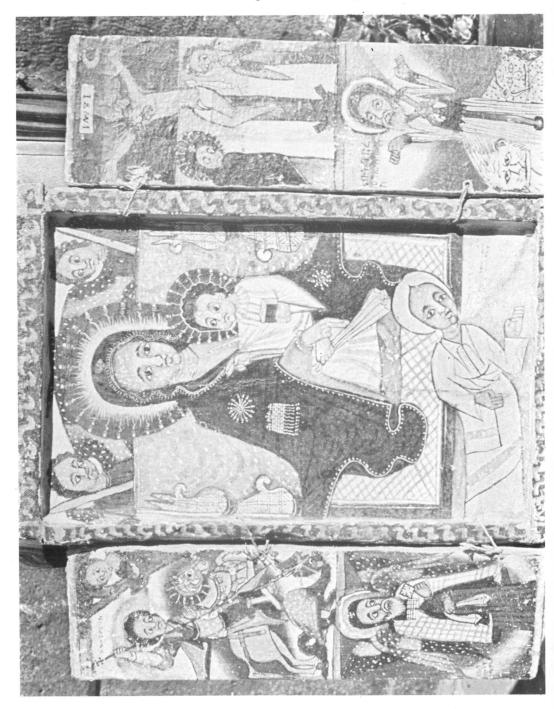

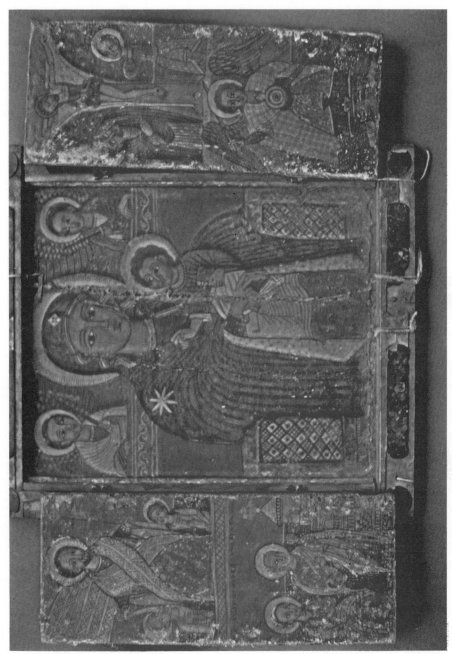

118. Triptych, 18th century. 25,0 : 17,4 cm. IES Coll. No. 4056

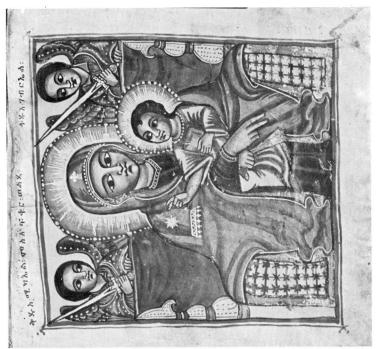

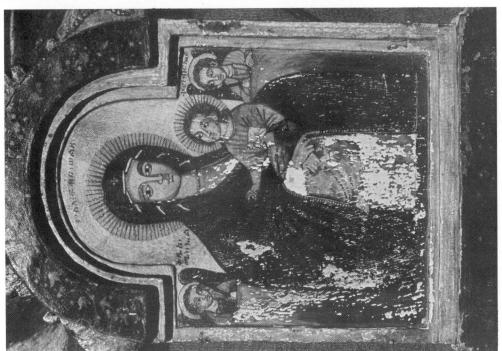

120. Miracles of the Virgin Mary. 18th century. 32.8 : 30.3 cm. British Library Or. 655 (fol. 2r)

119. Double-surfaced triptych, 18th century. 26.0–19.5 cm. IES Coll. No. 3807 (central panel)

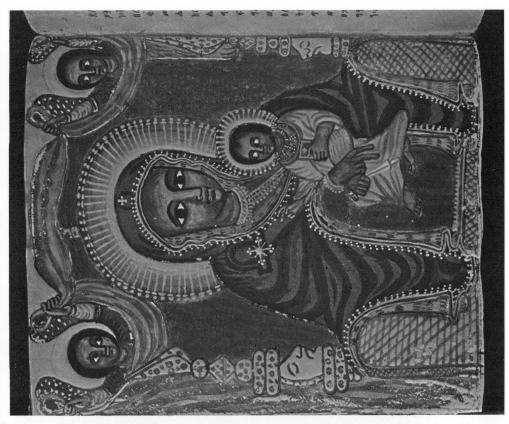

122. Praises of Mary, 18th century. 26.3 : 22.8 cm. British Library Or. 594 (fol. 77v)

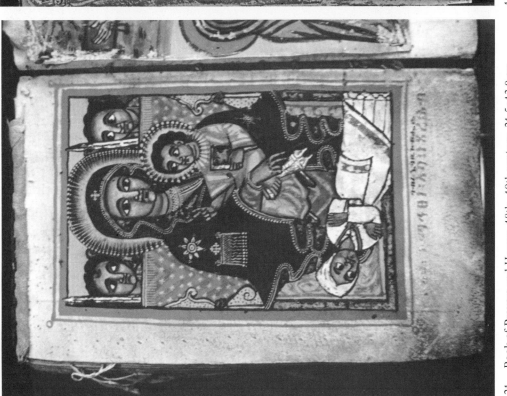

121. Book of Prayers and Hymns, 18th–19th century. 21,5 : 13,0 cm. IES Ms. No. 73

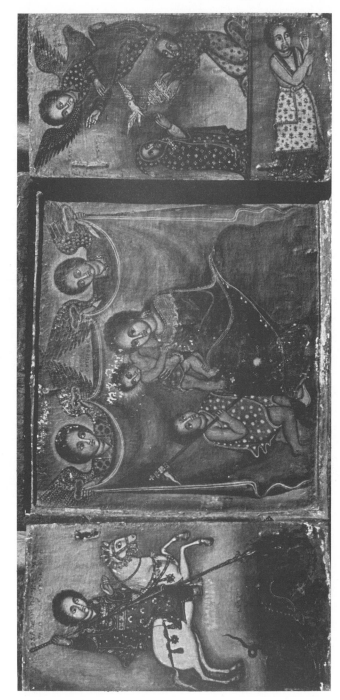

123. Triptych, 17th–18th century. 31.0 : 28.0 cm. IES Coll. No. 3975

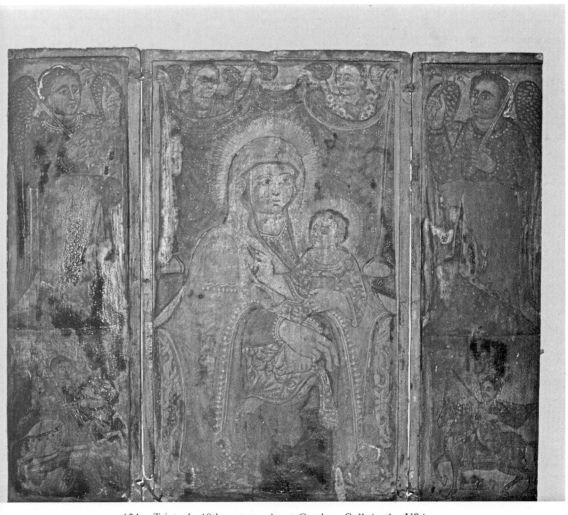

124. Triptych, 18th century. Asrat Getahun Coll. in the USA

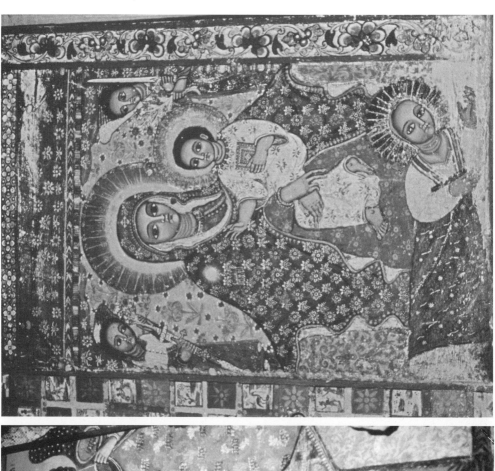

126. Wall painting, c. 1747. Nārgā Śellāsē, Lake Ṭānā. Queen Mentewwāb is depicted below the Virgin

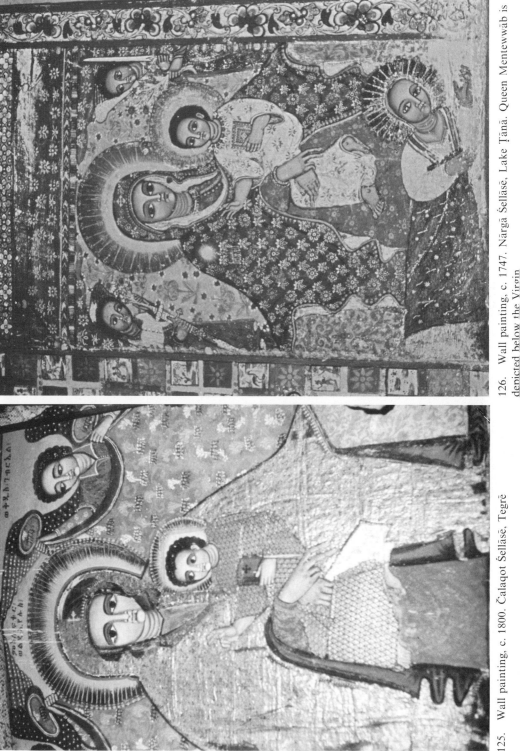

125. Wall painting, c. 1800. Čalaqot Śellāsē, Tegrē

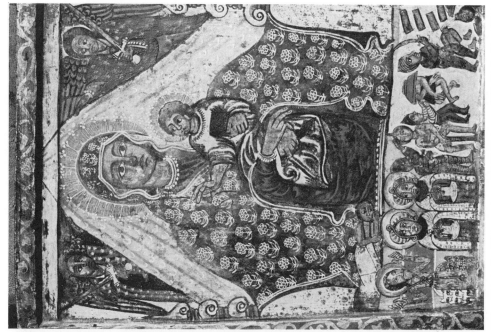

128. Triptych, 18th century. 36.0 : 21.1 cm. IES Coll. No. 3894 (central panel)

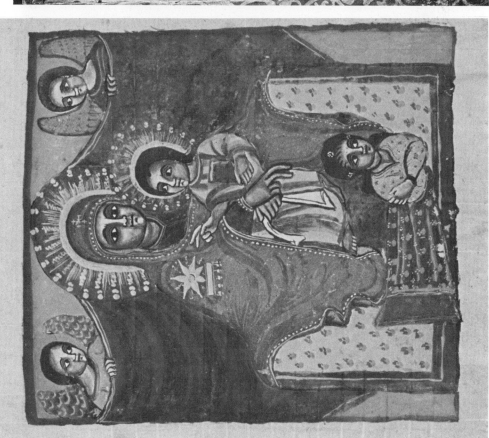

127. Life of Takla Hāymānot, 18th century. 35.9 : 31.3 cm. British Library Or. 721 (fol. 201r)

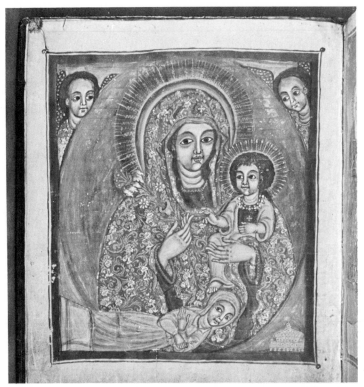

129. Miracles of the Virgin Mary, early 18th century. 45,3 : 38,8 cm. British Library Or. 634 (fol. 8r). The prostrate figure wearing the nun's garb is probably a queen, as the crown depicted close to her seems to indicate

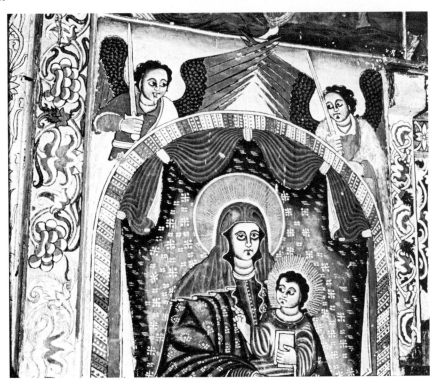

130. Wall painting, c. 1730–50. Sandābā Iyasus, Bagēmder.

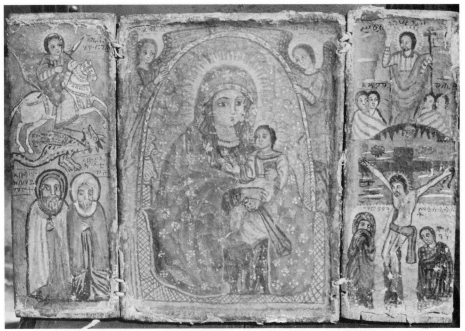

131. Triptych, late 18th–early 19th century. 23,8 : 18,0 cm. IES Coll. No. 3805

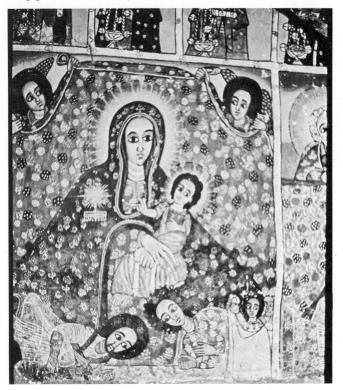

132. Wall painting, c. 1800. Māryām Pāpāseyti, Gar'āltā

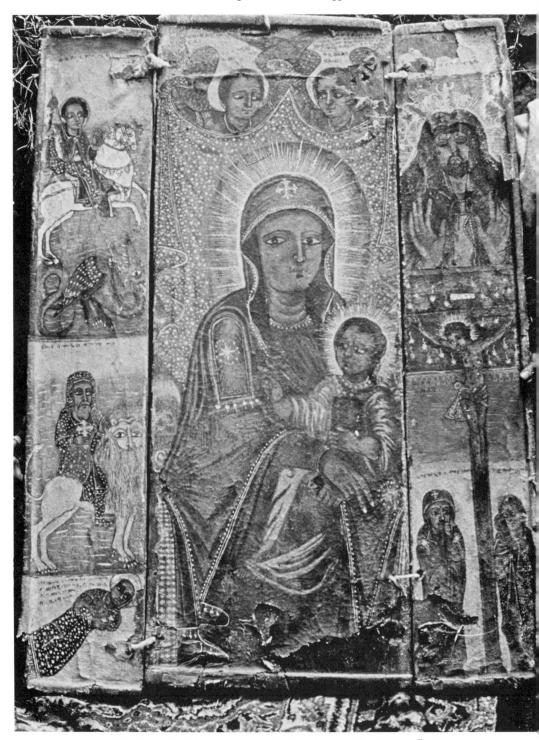

133. Triptych, late 18th century. 77,0:31,9 cm. Dabra Abbāy, Šerē

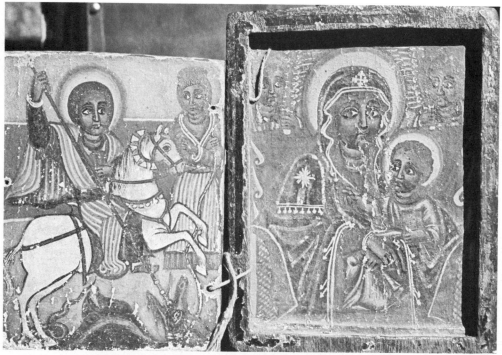

134. Diptych, 18th century. 12,2 : 10,0 cm. IES Coll. No. 3983

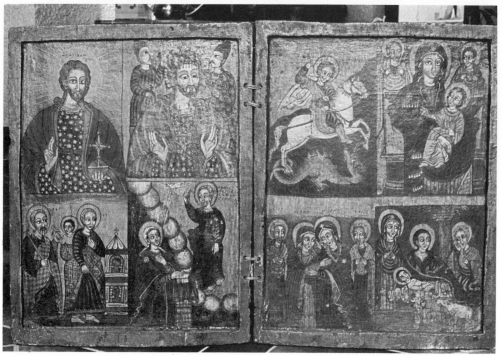

135. Diptych, 18th century. 44,0 : 34,5 cm. Dr. H. Schweisthal Coll. (right panel)

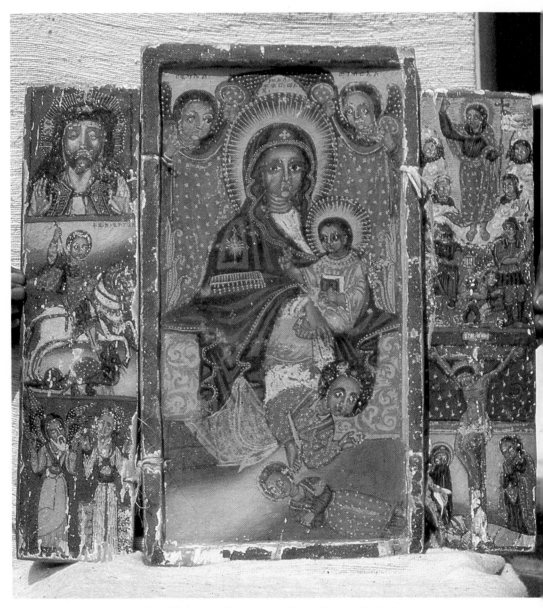

136. Triptych, 18th century. 47,2:34,0 cm. IES Coll. No. 6969

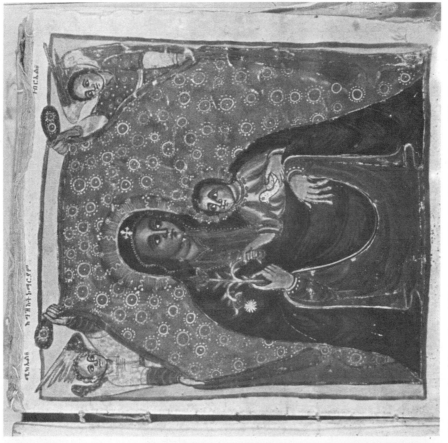

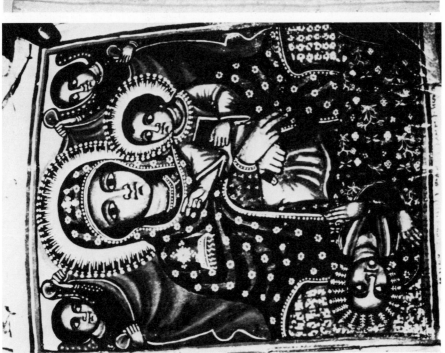

137. Story of Mary, middle of the 18th century. 29,0–21,0 cm.
Ambā Māryām, Enfrāz, Bagēmder. Prostrate figure: Walatta
Esrāʾēl, daughter of Queen Mentewwāb.

138. Book of Devotional Pictures, c. 1730–50. 37,0:31,5 cm. IES. Ms. No. 315

V. DORMITION AND ASSUMPTION OF THE BLESSED VIRGIN

LITERARY SOURCES

Among the feasts of the Ethiopian liturgical calendar commemorating the Virgin Mary, two are celebrated with particular solemnity. These are her Dormition (ʿeraftā) observed on 21 Ṭerr (28. January) and the Assumption of Mary's body to heaven (felsatā) observed on 16 Naḥasē (22. August) of the Ethiopian calendar.[1]

The liturgy of both feasts includes two long readings from the Synaxary which was translated from the Coptic-Arabic text into Ethiopic in the 13th/14th century.[2] The account, describing the circumstances and process of Mary's passing away and the subsequent translation of her body to heaven, goes back to a very ancient tradition that was diffused throughout the entire Christian world.[3]

Other versions of the Dormition and Assumption of the Virgin, published by E. A. Wallis Budge[4] and V. Arras[5] had on the whole limited impact on Ethiopian iconography, except the miniatures in two Mss, Or. 641 and Or. 645 in the British Library.[6] The following is a short resume of the narrative in the Synaxary which had the main bearing on the iconography. Other versions will be quoted during the exposition whenever their impact is evident.

[1] *B. Velat*, Etudes sur le meʿerāf; commun de l'office divin éthiopien = Patrologia orientalis XXXIII (1966) 26.

[2] A large portion of the Synaxarium was translated by Simeon, an Egyption monk who came to Ethiopia in the train of Metropolitan Salāmā 1348–88. *E. Cerulli*, La letteratura etiopica (Milano 1968). It seems, however, that other portions of the Synaxarium were translated before that date.

[3] The peudo-Melito is an apocryphal text about the death of the Virgin and the taking of her body to heaven; it was compiled about the 5th century but the earliest texts preserved date from the 11th–12th century. The gnostic text about the death of Apostle John probably influenced the presentation of the transfer of Mary's body to heaven. The story was at first greatly suspect in the Roman Church but widely accepted in the East. The origin of the legend is either Syrian or Egyptian. To make the story more trustworthy, the compilers ascribed the original versions to Melito, reputedly a student of St. John. *M. Haibach-Reinisch*, Ein neuer «Transitus Mariae»des Pseudo-Melito (Roma 1962) 1–52.

[4] BLM 168–201. Budge translated two texts from Or. 604, British Library, namely: the story of her death by St. John and the "history of the holy and pure Mary, the mother of Christ and of her departure from this fleeting world into life".

[5] CSCO 342f. (1973)–315f. (1974).

[6] The miniatures illustrate Mary's prayer at Golgotha, soldiers guarding the place, the Apostles worshipping Mary, the "righteous souls" of Abraham, Isaac and Jacob welcoming her; these themes, to the writer's knowledge, have not been included into the usual cycle of the Dormition.

Mary was sixty years old when "the Holy Spirit made known to her that she was to depart from this fleeting world." She requested her Son to miraculously bring Saint John the Evangelist from a far away country and all other Apostles as well in order to assist her. She also called the angels to take her "soul and bear it up with [Christ] into the heavens". Accordingly, the Apostles arrived from "all ends of the earth, riding upon the clouds", even those who were already dead. Mary commanded them to bring incense and censer and "summon our Lord Jesus". This they did and there he came surrounded with "tens of thousands of tens of thousands" of angels. "When the time for her to depart from her body drew nigh", continues the Synaxary, "the Apostles and the virgins who were there weeping asked her to bless them, and she laid hands upon them and blessed them. And straightaway our Lord Christ took her pure soul in His divine hands, and He wrapped it up in a cloth of light, and took it up with Him to the habitation above". This happened on Sunday, the 21st day of *Ṭerr*. Christ ordered the Apostles to bury her body in a fitting manner and they carried it to Gethsemane. During the burial a Jew wanted to prevent it and was punished.[7] According to a story of her death told by Saint John, the name of the Jew was Ṭaronyā, obviously a corruption of Jephonias of the Byzantine tradition.

Mary's body remained in the burial place for three days after which Christ sent "angels of light and they carried her body away from the grave and laid it under the Tree of Life which is in the Garden of Delight". There were miraculous happenings during the translation of the body and the one which is especially related in the *Ṭerr* reading of the Synaxary refers to Saint Thomas. He was absent at the time of Mary's death because he was still travelling on clouds. He had, nevertheless, the privilege of seeing her body carried to heaven by the angels. In the reading of the month of *Naḥasē* it was Saint John who witnessed the Christ ordering the "Seven Angels" to go to the earth and bring the body of Mary. Other Apostles lamented because they had not seen her. John announced then that they would see "the body of our holy Lady, the Virgin Mary, sitting on the right hand of her beloved Son". The Apostles waited fasting for two weeks; then according to the promise of John, Christ "caught all of the Apostles up to heaven" and Mary appeared to them, stretched out her hands and blessed them while Christ "gave them the Holy Mysteries". And then Mary went up before them "sitting upon the chariot of the Cherubim". Christ, who attended the scene told his mother; "Tell thy children, the Apostles, to preach throughout the world the commemoration of thy Ascension into heaven ... Whosoever shall celebrate thy commemoration, I will destroy his sins, and he shall never see the fire at all..."[8] In remembrance of the two weeks during which the Apostles waited for Mary's coming, the Ethiopians prepare for the feast of the Assumption by two weeks of fasting.

The death of Mary, *Koimesis* in Greek and *Transitus* in Latin constitutes a major theme in Byzantine iconography figuring in churches among the cycle of great feasts and also depicted in a great many icons. Mary's body lies on a couch; she is

[7] BSyn 523–26.
[8] BSyn 1222–24.

already dead; around stand the Apostles. They express their grief while Peter spreads incense fumes with a censer. Christ stands behind her holding in his arms Mary's soul in the form of a baby swaddled in white. One or more angels descend from heaven to receive Mary's soul. This composition was strictly followed though of course there were secondary additions in particular paintings. These additions refer to the arrival of the Apostles on clouds and the punishment of Jephonias.[9]

Representations of the Dormition abound in Byzantine/Greek and related art whereas they are scarce in that of the Copts. Walters in his list of themes in Coptic art gives three possible representations of the Dormition, namely in the murals of Abyaḍ, Abū Maqār and Suryān monasteries. However, according to him, the identification of these murals is open to doubt because of their poor state of preservation.[10] Neither the Dormition nor the Assumption of Mary are mentioned by Leroy in his analysis of illuminated Coptic manuscripts.[11]

THE BEGINNING

Three examples of the Dormition in Ethiopian paintings prior to the 17th century are known to us:

(1) The triptych by Italian painter Nicolò Brancaleon which is preserved in St. Mary's church Gētēsēmānē, Gonča Valley in Goǧǧām, was described on p. 384f. The painting dates from c. 1380 to c. 1420 and possibly is the earliest image of the Dormition found in Ethiopia. The triptych is in a poor state of conservation and therefore some important details are in doubt.

The composition (fig. 139a) follows the Eastern Christian tradition of the Dormition and contains two phases of the event as expressed by the inscription "how the Apostles gathered together on the clouds of the sky with the angels when Our Lady Mary went to heaven". Indeed, "on each of the side panels", writes Diana Spencer who discovered the triptych, "six angels in swallow-dive position support small green clouds on each of which rests the half figure of an apostle" (139b).[12] The Italian painter thus either read and illustrated the text of the Synaxary or more probably followed the Greek pattern of rendering the Dormition according to which the Apostles fly on clouds to Mary's place.

In the upper half of the central panel there is a figure in an oval mandorla which is supported by the angels. It might be God the Father, or the ascending Mary.

The body of Mary rests on the mortuary couch and her head is directed to the left, conforming to the Greek/Byzantine mode. Behind, the standing Christ seems to hold Mary's soul in his arms, however, this part of the painting is badly damaged and this detail is not clear. Around the couch stand the Apostles including Peter to

[9] K. Künstle, Ikonographie der christlichen Kunst (Freiburg i. Br. 1928) 582ff.; ChatzIc 33–36; Réaulc 605f.

[10] WaltMonEg 133, 310, 315, 319.

[11] LerMssCopt 202–05.

[12] SpencGojj 205.

the left of the couch and Paul to the right of it and at least one woman, probably Salome. They express their sorrow in various ways, but the Byzantine pose of grief is mostly used.

In the background there are two or three two-storey buildings depicted; their form and red-tiled roofing is characteristic of Brancaleon's art and adds an Italian trait to this painting. One building bears an inscription on its front. The structures probably stand for the city of Bethlehem in which, according to tradition Mary passed away.

The discovery of Brancaleon's painting gives support to the hypothesis of the foreign origin of the Ethiopian iconography of the Dormition. Indeed, there is the possibility that the Italian painter initiated the subject in Ethiopia. However, the following paintings differ so significantly in general outlay and details that direct copying from the triptych at Gētēsēmānē seems hardly possible. In particular the subject of the flying Apostles which is well evidenced in our painting, seems to be ignored by the Ethiopians.

(2) The manuscript of *Lāḥa Māryām* preserved in the Bethlehem church, Dabra Tābor district in Bagēmder province dates from the reign of Emperor Lebna Dengel, [13] see p. 58.

In the pictorial plan of the manuscript the main emphasis is put on Mary's life; she is the main personage in six out of twelve miniatures. In the eighth miniature the Dormition is depicted (fig. 140). Jules Leroy who published the miniature suggests that the Ethiopian scribe borrowed the formula from Byzantine art to depict the Dormition but "subjected this formula to modifications to make it conform to their [Ethiopian] own traditions. Thus the funeral couch has disappeared and in its place the artist has portrayed the body of the Virgin entirely wrapped in a shroud..." The manner in which the Virgin's body is shown is similar to that of Christ's in the Entombment. "This first variation on the Byzantine theme brought with it other modifications. The Apostles are ranged above and below the corpse; Christ no longer holds the soul of Mary, but confines Himself to blessing it. Nor are we shown the angels wafting the Virgin's soul to heaven."[14]

Was this composition inspired by the Byzantine iconography as Leroy believes? Had the Greek painting of the Dormition of Mary been brought into Ethiopia and copied by the Ethiopians or had they learned about the subject in another way and reproduced it as they had been told about it? There is no clear-cut answer to these questions.

It is well known that Greek icons had been brought into the country during the 15th and 16th centuries; one of these might well have represented the Dormition. Moreover, in the 15th and early 16th centuries, Ethiopians had extensive contacts abroad.[15] Therefore either a direct influence of Byzantine iconography or through

[13] JäP 362.

[14] LerEthG 52, pl. 13.

[15] For Ethiopian pilgrimages to the Holy Land see *S. Tedeschi*, Profilo storico di Dayr as-Sulṭān = JEthSt II 2 (1964) 114f.; *G. Wiet*, Les relations égypto-abyssines sous les sultans mamlouks = Bulletin de la Société d'archéologie copte 4 (1938) 126–39.

the Coptic channel was possible. Yet, the analysis of the miniature does not fully corroborate Leroy's suggestion. Why does the miniature contain drastic deviations from the Byzantine formula? The French scholar believes that it was "to conform to Ethiopian tradition" but, in fact, the tradition related to the iconography of the Dormition does not seem to exist at this time.

A fully developed Byzantine formula contained three successive stages of the Dormition grouped artificially in one image, namely, the arrival of the Apostles on clouds, Christ and angels receiving the soul of Mary in the form of a swaddled newborn baby and the punishment of Jephonias. Our miniature contains neither the first nor the third stage. Concerning the second, it is iconographically ineffective because the soul of Mary is missing. This is an essential detail in the Byzantine representation of the Dormition. Could the scribe have misinterpreted this detail in the process of copying a foreign model? This seems hardly possible considering that the Synaxary is quite plastic about the form of Mary's soul.

The arrangement of figures of the Apostles and their way of gesticulating recall the late 15th and early 16th-century miniatures representing the Ascension of Christ. There is a remarkable analogy between the Apostles in our Dormition and those in the Ascension of Christ in the *Ṭēfut* manuscript kept in Gešen Māryām Monastery, Wallo. Stylistically, the miniatures in both manuscripts, that of Bethlehem and of Gešen Māryām belong to the same school and also date from the same period. Mary's corpse in our miniature is similar to Christ's body in his Entombment depicted in *Ṭēfut*. In fact, the scribe borrowed the figure from the burial of Christ which is obvious considering the position of Mary's body; her head is directed to the right as in Ethiopian Entombments, whereas, in the Byzantine Dormitions, the head is virtually always directed to the left. Moreover, the mortuary couch on which the Byzantine Virgin is reclining is left out in accordance with the Ethiopian rendering of the Entombment, and Christ is blessing Mary's body before it is given to the earth, his gesture being obviously inspired by the liturgy of the Ethiopian disposing of the dead.

The above leads to a tentative conclusion that the scribe of the *Lāḥa Māryām* took as a model neither the Brancaleon's painting nor necessarily copied the Greek painting of the Dormition. Perhaps we can be excused for interpreting the superficial analogy between our miniature and the Byzantine formula of the Dormition by a common literary source of inspiration. The Bethlehem miniature is probably a blend of forms which recall the Byzantine rendering of the Dormition but mainly derive from the Ethiopian iconographic treasury, a fact observed time and again whenever the Ethiopian painter showed personal initiative in composing the image. Our scribe did not seem to transpose directly the theme of the Dormition from the narrative of the Synaxary into his composition. Perhaps he followed local commentaries of the Synaxary. The subsequent developments in the iconography of the Dormition throw some light on this process of adaptation.

(3) The third early example of the Dormition is a cloth painting made during the reign of Emperor Śarṣa Dengel (1563–97) who, according to the inscription

donated it to the church of Dabra Dagāyē.[16] Of medium size, the canvas probably constituted part of a larger work and served as mural decoration. The varied subjects of what we have of the painting all refer to the Virgin Mary and among these there is her Dormition (fig. 141). Perhaps this is only one section of the large composition representing the final moments of Mary's terrestrial life.

Mary is already dead which conforms to the Byzantine iconography of the Dormition. Her corpse, wrapped in a shroud divides the composition into two registers. Above and below, the "followers of Christ", according to the caption are depicted. Four of them, Peter, John, James and Andrew are placed above the body and five or six other "followers" are placed below. Most of them express their sorrow by a slightly inclined head and the hand pressed against the cheek, which recalls the conventional Byzantine form of grief. The angels fly around and are engaged in the act of lamentation successfully conveyed by their hands drawn exaggeratedly large and held in dramatic position of despair. On the right appears King David playing the lyre, traditionally believed to both express and assuage sorrow. David is mentioned in the Synaxary reading for Naḥasē. When the body of Mary ascended into heaven, "David, the prophet, sang a hymn of praise..."[17] Still further to the right there is a double composition. It shows in the upper register a beared man with a large nimbus over his head who holds in his arms a young woman. She has her long hair loose and descending on her shoulders. She presses her cheek against his cheek in a way found in Eleousa images of the Virgin and Child, both expressing their tenderness towards each other. Below two pairs of flying angels seem to attend the couple and express their sorrow or joy by variously posed arms and hands. The accompanying caption is illegible but most probably this is Christ welcoming Mary in heaven and the angels, ready to receive her soul. The image illustrates the passage of the Synaxary "and our Lord Jesus Christ comforted her, and He said unto her 'Come to Me, O My beloved mother, that thou mayest ascend to the kingdom of heaven, to the joy which is ever-lasting'".[18]

The painting evidences a new pattern of rendering the theme of the Dormition, namely by splitting the composition into more than one image, each section representing a different phase of the narrative in the Synaxary and probably local commentaries on it. Thus dissimilar to the Byzantine image of the Dormition which is iconographically complex but compact, the Ethiopian image is a sequence of separate images. In our painting one section includes the lamentation and another section the arrival of Mary to heaven. The lamentation mirrors the Ethiopian custom of violently expressing grief, which is considered essential in

[16] The canvas, has been kept in Dāgā Esṭifānos church, Lake Ṭānā. In 1966, the canvas which was in a poor state of preservation were brought to Addis Ababa, cleaned and restored. It was subsequently returned to the church; its present condition and fate are not known.

[17] BSyn 1223.

[18] BSyn 1222.

conducting the funerary ritual. The impact of local commentaries is evident in introducing the *bagana*, a lyre, on which King David is playing.

Our painting proves additionally that the theme of the Dormition was known to and practised by the 16th-century painters who starting with the formula similar to the Byzantine, elaborated their own.

17TH-CENTURY DEVELOPMENTS

Around the middle of the 17th century both the theme of the Dormition and that of the Assumption of the Blessed Virgin seem to gain popularity in Ethiopia. It became customary to depict a series of events from Mary's life as a frontispiece to the book of her miracles. These books, richly illustrated, are characteristic of the First Gondarene school and consequently the 17th-century representations of the Dormition are painted in First Gondarene style.

The Gondarene painters developed two or three separate images each illustrating a different phase of Mary's departure. The following is the description of the main works dated to that period and known to the writer.

(4) Two miniatures in the Book of Miracles of the Virgin Mary, Abb. 114 Bibliothèque nationale, Paris. The manuscript does not contain a colophon and therefore its dating is based on iconographic and paleographic grounds. C. Conti Rossini who described the manuscript believes that it belongs to the 18th century.[19] This dating is however disputable. He himself noticed that the manuscript contains two different sets of miniatures; one set is painted in the First Gondarene style and the other in the Second Gondarene style. Among the miniatures of the first set there is one representing an Ethiopian queen praying in front of the image of Mary. Unfortunately her name is erased and replaced by that of Walatta Qirqos. This addition was most probably effected by the same hand which wrote captions to the Second Gondarene miniatures. It is obvious therefore that these were painted later than the miniatures in First Gondarene style. The contention is that the original text was written and the miniatures painted in the 17th century and additionally a set of miniatures was painted in the 18th century. This interpretation accords with the dating of the subsequent manuscript, namely, Rüpp, IV, 2. Iconographically and stylistically manuscripts Abb. 114 and Rüpp. IV, 2. are very similar.

The miniatures in Abb. 114 show the Dormition and the Assumption of the Virgin. In the Dormition, Mary stands on a kind of foot-rest; her youthful face is slightly inclined to the right and her eyes are closed which symbolizes approaching death (fig. 142 a). Her hands are crossed on her chest. She wears a blouse with a low collar and a pleated skirt. A belt is tied around her waist which probably had some significance in the Ethiopian commentary on the apocryphal narrative on the Dormition. A short white veil draped with large folds covers her head and

[19] CRCollAbb II 66–72.

shoulders. A nimbus decorated with multiple rays is typical of the First Gondarene style.

The twelve Apostles "who arrived" attend Mary, eight on her right and four on her left side. All of them are upright; the two at the top hold burning candles, whereas the four others read from the open books which they hold in one hand. These are most probably the Books of the Dead *(sarʿate genᵓzat)* an Ethiopic text dealing with the passing to another world. Except for one Apostle who points with one hand at Mary, none gesticulates; all have hands posed on their chest. As many as five Apostles are depicted as youths which is symptomatic of the First Gondarene style. None has a nimbus over his head.

The second miniature represents the Assumption (fig. 142b). According to Salutations to the members of the body of the Virgin Mary, a popular Ethiopian text for pious recitations, "the body of flesh did not remain on the bier ... for the Spirit of Life ... raised it up quickly." Indeed, the Blessed Virgin emerges from a shape which can be an open grave but might also be a crescent, rather poorly drawn. Mary is youthful and recalls an Ethiopian girl; she has a strikingly expressive face, enormous eyes and a black crown of hair. Her long robe is tied up with a belt at her waist. Her hands are crossed on her chest as in the previous miniature. Additionally a striped scarf winds around her arms and streams along her body.

Mary's figure is encompassed by woolly clouds from which emerge "twelve tribes of angels who came to take her up".

(5) The theme of the *Transitus Mariae* in the Book of Illustrations, Ms.or. Rüpp. IV, 2 at the Stadt- und Universitätsbibliothek, Frankfort on the Main, is developed into three separate images. The book, according to E. Hammerschmidt, is of the 17th century and its miniatures are characteristic of the period of Emperor Fāsiladas.[20]

The image of the death of Mary (fig. 143a) follows the pattern of Abb. 114, with a few significant changes. Mary clearly sits instead of standing; her body below the waist is covered with a large piece of cloth. Her eyes are closed; her hands are folded in a gesture of prayer and inclined to the right, instead of being crossed. She wears a blue cloth on her head which also covers her shoulders and a white veil with a black border underneath. A large plain yellow nimbus adorns her head.

The Apostles grouped around Mary perform different functions; two stand close to her head and hold burning candles, three sit at her feet are ready to recite prayers from the book which they seem to open. The rest either stand or sit on crossed legs. Seven Apostles are clean-shaven and only five are bearded. All have a nimbus around their head.

The next miniature (fig. 143b) shows the burial of Mary or, as explained in the caption, "how the Apostles wrapped [in the grave-cloth] our Lady Mary". Indeed,

[20] VOHD XV (1968) 56–68; *L. Goldschmidt* in his listing of the same manuscripts [Die Abbessinischen Handschriften der Stadtsbibliothek zu Frankfurt am Main (Berlin 1897) 57] wrongly attributed it to the 16th century.

her body is enveloped in a white cloth and tied with a rope or leather strap according to Ethiopian burial customs, particularly of monks and nuns.[21] The body rests on a bed which is carried by two young men; this recalls the traditional manner of transporting the dead to the graveyard. Evidently this composition mirrors a local burial.

Above Mary's body four busts are depicted whose heads are each adorned with a nimbus; they most probably represent the Apostles Peter, John, James and Andrew. Below, a man is depicted who has raised his left hand and touches with it the frame of the bed. His hand is severed from his arm. His other hand also seems to have been cut off but is not shown at all. The man has a nimbus over his head but he is not one of the Apostles.[22] In fact, this is a rare instance representing the story of the "Jew", Jephonias, who attempted to prevent Mary's burial and to throw her body off the mortuary bed. According to the Synaxary, the "angel of God" appeared and smote his hand. Jephonias repented and consequently Mary restored it miraculously.

The process of Mary's ascending to Paradise of "how the angels brought up [to heaven] our Lady Mary" (fig. 143c) is depicted in the third miniature. Mary stands on a crescent. Her head is uncovered and her long black hair flows on her shoulders and along her body. Mary's hands are folded in a manner similar to that of the miniature fig. 143a. She wears a red dress ornamented with green-yellow lace. A scarf or loose belt in red and white stripes is wound around her elbows and waist and billows on her left.

Six heads of cherubim, three on either side of the Virgin emerge from the clouds flurrying around her.

(6) The main portion of the Book of Miracles of the Virgin Mary (British Library, Or. 641) was written and its miniatures painted during the reign of Fāsiladas and the first year of his successor Yohannes I, whereas the initial and the last ten folios belong to the 18th century.[23] This dating explains the two styles of the miniatures of the same manuscript, namely the First and the Second Gondarene styles. The same was noted in Abb. 114 and other manuscripts of the period and accounts for differences in their dating by scholars. The Or. 641 has a colophon stating the time of its production and thus constitutes an important proof for the chronology of the two Gondarene schools of painting as well as the developments of the iconography of the Dormition.

The four miniatures in the 17th-century portion of the manuscript refer to the cycle of the Dormition. They are similar to those in Abb. 114 and Rüpp. IV, 2 and probably have been produced in the same scriptorium. However, the Or. 641 marks a further expansion of the narrative. Among the miniatures, the first represents the death of Mary, the second and third her burial and the fourth her assumption.

[21] Traditional Ethiopia rarely used coffins and then only for distinguished persons like kings and high nobles. The common nobility, clergy and folk wrapped their dead in a cloth and buried these without a coffin.

[22] VOHD XV (1968) 60.

[23] WrBM 48.

In the image of Mary's Dormition (fig. 144a) she is seated; her face is slightly inclined to the right. Her eyes are open but blank and without irises, which probably signifies that she is dying. There is a similar ambiguity in the drawing of her hands; their palms are pressed against each other and crossed, not folded which would indicate the gesture of prayer. A characteristic short white veil covers her head. A large plain yellow nimbus is traced with a double line.

Two small figures of youths depicted on both sides of Mary's head carry burning candles. Below, and at her feet eleven Apostles are present at the event. All except three who hold an open book keep their hands pressed against their chest in a typical Gondarene manner. The books are most probably those of the Dead. All Apostles but one have a nimbus around their head; the youths have none.

The next miniature shows how the body was carried to the graveyard (fig. 144b). The body is wrapped in a white cloth and tied with leather straps, placed on a bed and carried by two young men according to Ethiopian custom. Mary's head is directed to the left as in Byzantine Dormitions. Above, eight Apostles vividly express their grief, beating their head and shoulders in accordance with Ethiopian custom. Below the bed Jephonias is depicted. In this miniature no one has a nimbus; the obvious reason for this is that the painter intended to show the Apostles hitting their heads as a sign of grief and not their nimbi; therefore he eliminated these entirely.

The third miniature (fig. 144c) shows the Entombment of Mary, namely, the lowering of the body into the grave. The composition recalls the burial of Christ depicted in the same manuscript. Indeed, the bodies of Mary and Christ are wrapped in an identical manner in both miniatures except for the position of their heads; Mary's is directed to the left whereas Christ's is to the right which is usual in Christ's Entombment. Moreover, the Saviour's body is carried by Nicodemus and Joseph of Arimathea who always are included in that composition. The painter of Or. 641 in a vein of realism shows how two unnamed Apostles lower Mary's body into the grave by way of rolling the corpse on two ropes. The remaining Apostles are bent over the grave and watch it in poignant contemplation. The image symbolizes a "salutation to thy grave where unto are gathered together all nations and peoples", according to the text of an Ethiopian prayer. All Apostles have nimbi over their heads.

The fourth miniature (fig. 144d) shows how the angels took Mary into heaven, or "the departure . . . unto the House of Life. . . ." according to the salutation which Ethiopians used to recite. Her figure is set in a crown of clouds from which emerge eight heads of cherubim, four on each side. Mary stands on a crescent; her hands are folded in prayer on her right breast. Her head is uncovered and her long hair flows down on her shoulders. The colourful scarves are wound around her forearms and waist and swell on her left. Her large nimbus is identical to that in the Dormition.

The theme of the Dormition is also found in panel paintings and paintings on cloth.

(7) The diptych IES Coll. No. 4656 contains three different images of the Virgin: the S. Maria Maggiore image on the left panel (fig. 106), and the Assumption and the Dormition on the right panel.

In the Assumption (fig. 145), Mary stands on a crescent but otherwise she is rendered identically to her S. Maria Maggiore image in the same icon; her slightly elongated mantle has two folds added at the bottom so as to suggest that she is standing. The draping of the mantle is typical of the First Gondar school, but the painter decided not to decorate it either with the cross or with the star, although he did so in the other image of the Virgin in the same diptych. Mary is flanked by six cherubim, three on each side; with one hand they seem to touch or support the mantle of the Virgin. They apparently help her in her ascending movement. Mary and the cherubim are surrounded by the elliptic glory and, additionally, by stylized clouds.

This painting sheds some light on the process of adaptation of a foreign model to Ethiopian attitudes. The Ethiopians followed the Eastern Christian tradition of representing Mary with her head covered by the Syrian *maphorion*. Apparently an uncovered head did not appeal to our painter and therefore he replaced the alien figuration of Mary by the one familiar to him, the S. Maria Maggiore type.

In the lower register of the same panel the Dormition is depicted. Mary is seated with her hands crossed on her breast; she wears a red robe and a wide blue cloak covering her knees; a short veil draped with large folds clothes her head and shoulders. The chair on which Mary is supposed to rest is not shown, instead a high green rectangular shape behind her is probably meant to represent its back. The Virgin is accompanied by the Apostles, five sitting on her right and seven on her left. All have a nimbus over their head. Two among them hold a book in their hand and two others a candle or a burning torch. The style and composition of this painting is closely related to Abb. 114, Or. 641 and Rüpp. IV, 2 and therefore the diptych should be ascribed to the middle or second half of the 17th century.

(8) Another double composition of the Dormition and the Assumption is found in a small 17th-century pendant diptych, IES Coll. No. 3704, which shows poor craftsmanship (fig. 146). In the right panel, the Virgin stands on a crescent and has her hands folded; her long hair covers her shoulders; she wears a loose robe decorated with scarves and is surrounded by clouds from which the winged heads of cherubim emerge. In the left panel the Virgin is seated, holds her hands clasped and has the lower part of her body covered with a large cloth. Three among eleven Apostles displayed around her hold candles in their hands. Their heads are not adorned with nimbi.

(9) In the painting on canvas preserved at the Dāgā Esṭifānos church, Lake Ṭānā (fig. 147), Mary also stands on a crescent. She is surrounded by clouds and five cherubim on either side of her. The Virgin is dressed in a red robe decorated with long green scarves wound around her chest and waist and streaming along her body. Below, the Dormition is depicted in a way which differs from that previously described by the vertical arrangement of the Apostles in two rows.

18TH AND 19TH-CENTURY DEVELOPMENTS

The painters of the First Gondarene school created a series of images illustrating Mary's death, burial and assumption. The 18th and 19th-century painters either

continued to depict the series or only the Assumption. In the Dormition they completely changed the iconography manifestly adopting the Greek pattern and in the Assumption they kept the iconography but transmuted the details.

The two 17th-century forms of the Assumption continued in the 18th and 19th centuries. In one form the Virgin wears the *maphorion* which is similar to the one found in diptych No. 4656; her head and whole body are wrapped in a blue cloth. The main addition to this form made by the Second Gondarene school is that of the Apostles who in some paintings watch the Virgin's flight to heaven. In the second form she has her head uncovered and instead of the veil her hair is tied up at the crown of her head.

(10) The miniature in the Book of Miracles of the Virgin Mary, Brit. Lib. Or. 637[24] is an example of the first form (fig. 148). The miniature is painted in the Second Gondarene manner. The cherubim and the Apostles are disposed symmetrically around Mary. She stands on the crescent, which in turn is supported by the winged head of the cherub. Other cherubim flutter over the woolly clouds and one hovers above the Virgin's head. Below, ten kneeling Apostles worship her, their faces expressing their grief because of her departure.

Almost two centuries later, during the reign of Emperor Yoḥannes IV (1872–89) a similar composition was painted on the walls of the ancient church of Abrehā Aṣbehā, Tegrē. The arrangement of figures is more symmetrical than in the previous miniature and the crescent is transmuted into a round moon on which the eyes, nose and mouth are depicted.

(11) The second form of the Assumption is found in Ms. No. 73 in the IES Library (fig. 149). The manuscript contains prayers, lauds and hymns to Mary written for a certain *Abbā* Nasara Ab whose portrait appears in two miniatures. The work is ascribed either to the second half of the 18th century or to the early 19th century and according to the linguistic indication was produced in Tegrē.

Mary stands on the crescent; her feet, clad in yellow slippers rest firmly on it. She has her hands folded in prayer on her left breast. She is flanked by two vertical rows of cherubim, three of them on either side. Their round faces with expressive eyes and minute dotted wings are typical of Second Gondar art. They hover on a woolly cloud rendered as white spirals on a brownish background.

The painting bears witness to the artist's care in rendering details. Mary wears a red robe with a low collar; the up-turned sleeves on her forearm show a green lining, while an additional yellow band with red dots on her wrists probably represents bejewelled bracelets; a dark blue cloak ornamented with colourful fringes and tassels covers both her shoulders; one end of the cloak flows down over her left forearm. The cloak is fastened on Mary's breast with a brooch. She does not wear a scarf.

Perhaps this dress reflects the passage of David's psalm quoted in the Synaxary "And the Queen shall stand at Thy right hand, and her apparel shall be of fine

[24] WrBM 52 dates the manuscript to the "later part of the 17th century". However, the style of the miniatures suggests the later date, possibly 18th century.

needlework with gold woven through it" (Psalm 44, 9)[25] but similarly it shows characteristics foreign to life in Ethiopia. The same comment applies to the Virgin's face which is carefully modelled with sombre hues; she does not seem to have either Ethiopian or European features; her large deep eyes directed upwards, her heavy nose and rounded cheeks as well as her dusky complexion indicate a typical woman from the Indian subcontinent. This impression is strengthened by the Virgin's black hair adorned with a high top-knot, fastened at its bottom with a yellow ribbon which also supports the hair on the temples.

The identification of another detail in the miniature, namely an unusually large and intricate nimbus over Mary's head is equally intriguing. The halo is composed of two circles and a space in between divided by radiating lines into thirteen trapezoid figures. In each of them a star is placed. The additional stars decorate the outer circle of a halo. Stars are mentioned in the passage of Revelation referring to the woman who appeared to St. John. She had, we read, "a crown of twelve stars", 12,1. Although the painter put thirteen stars instead of twelve and in spite of the fact that this nimbus does not bear similarity to a crown, one is tempted to recognize in the miniature a pictorial interpretation of the text of Revelation.

(12) The similar but less elaborate representation of "how our Lady Mary was raised [to Heaven]" is found in the Ms. Or. Rüpp. IV, 1, Stadt- und Universitätsbibliothek, Frankfort on the Main, ascribed to the middle of the 18th century. This Assumption (150 b) is combined with the Dormition (150 a) which is depicted on the opposite folio. The Dormition evidences a complete break from the 17th-century representation of the death of Mary and the adoption of the Greek model, in which Mary is already dead. This is explained in the inscription which runs "how the Son took her [Mary's] soul in His hands and how the Apostles wept".

Indeed, Mary's body is stretched horizontally; her head directed to the left; her eyes are closed. One of the Apostles supports her head, the group of others stands above; one, possibly St. Peter, recites prayers from an open book and holds the incense burner in his hand, while the other Apostles hold only the latter. All the Apostles wear the liturgical garments of the Ethiopian Church. They obviously perform the funerary ritual, including the violent crying as it is customary at Ethiopian funerals, and which is expressed by strong black lines on their cheeks. Oh the left, the Christ holds a small girl in his arms. This figure stands for Mary's soul. A large ornamented nimbus adorns the girl's head while another one adorns that of Christ. There is no nimbus over Mary herself and over the Apostles's heads. This omission has obviously been rectified in the following paintings.

(13) The wall paintings of the Šellāsē church, also called Dabra Meḥrat in Čalaqot, Tegrē, were executed around 1800, during the rule of *Rās* Walda Šellāsē. They represent among various subjects the Dormition and Assumption of the Virgin.

The Virgin is already dead; her body lies on a mortuary couch and is wrapped in a dark blue cloth (fig. 151 a). Behind, Christ is bent above his mother; with his right

[25] BSyn 1223.

hand he grasps the Virgin's hand and he carries on his left arm a small baby-girl; a nimbus adorns her head. The figure evidently stands for the soul of Mary. On the left and right of the couch, eleven Apostles express their grief in various ways. Among them, Peter is identified by this woolly white hair and, perhaps Paul by the black hair. Christ and Mary wear the nimbus, but none of the Apostles do.

Above the group, two angels hover. They are rendered in classical Second Gondarene manner as bodyless heads with two small wings decorated with colourful dots.

We witness in the painting a recurrent influence of the form of Dormition which has been painted for centuries in Eastern Christian churches. The painter of the Čalaqot mural followed closely this Eastern form but, as usual, simplified the composition and added some details. He painted the iconographically ineffective heads of the angels (in the Greek Dormition they are supposed to carry the soul of Mary to heaven and therefore must have hands) and a handkerchief in the hand of Christ, a detail that Gondarene painters have been fond of.

Adjacent to the Dormition there is an image of the Assumption of the Virgin who stands on a crescent (fig. 151 b). The painting is similar to that in Ms. No. 73 but striking by the realistic rendering of details. The modelling of the face of the Virgin, of her hands and feet suggests that this picture was copied almost directly from a model.[26] The main difference between the mural and the miniature is that in the former the top-knot of hair is tied with a ribbon only once, the brooch is placed in the middle of the breast and the halo is composed of one wide circle and long rays but no stars in between. Also the cherubim hovering on each side of the Virgin are reduced to two in the mural. In spite of these differences the wall painting and the miniature originate undoubtedly from a common foreign prototype.

(14) The church of the Saviour of the World (Madḫanē ʿĀlam), Adwā in Tegrē, was built in the first half of the 19th century[27] and its murals must have been executed at about that time. The painting of the Assumption was reproduced and commented on by J. Leroy.[28]

The image of the Virgin stems from the above prototype but shows a few substantial changes. The painter reduced the number of angels to only two; one of them holds with both hands a screen displayed on the right of the Virgin. Apparently this is a variant of a screen borrowed from 18th-century portraits of her. Another significant change is that the eyes, a nose and a mouth are added to the crescent, according to a well-rooted in Ethiopia anthropoid rendering of the celestial bodies.

Mary's robe and cloak are draped with curiously pointed ends; these do not seem to be of European or Ethiopian style. The face, and especially the top-knot of hair, as well as the halo, in the form of a large flat disc, were commented upon by Leroy

[26] These details are the folds on the robe of the Virgin below her waist; they give a feeling of legs underneath particularly the left one, slightly bent. In Ethiopian traditional art the anatomy is seldom considered. The way of drawing Mary's figure in the wall painting from Čalaqot is a proof that it was almost directly reproduced from the model.

[27] ACI 242.

[28] LerÉthG 37, 40–41 pl. 12.

who thought that Mary's "tufted chignon, her eloquent eyes, an oval halo [are] more appropriate to a Bodhisattva than to a Christian saint" and represent "Far Eastern elements".[29] R. Pankhurst, who also commented on the picture is of a different opinion and sees in it an Indian influence on Ethiopian art.[30] Leroy's suggestion that the curious "chignon" might originate from the representation of the Buddha is too far fetched.[31] R. Pankhurst is probably closer to the point. The views of Goa by Johannes Linschoten, a Dutchman who described Goa at the end of the 16th century offer a clue. It appears from the pictures that Goan women used to wear their hair in a particular manner consisting of a high top-knot on the crown of the head. The additional indication is that married women covered their head with a veil while the unmarried ones did not and consequently the top-knot was exposed.[32] The top-knot of the Virgin in the miniature (Ms No. 73) and the mural painting (Adwā) recalls those of the Goan women. Apparently the exposed top-knot was considered appropriate for representing the Virgin Mary.

(15) The mural in the church of the Holy Trinity (Šellāsē), built in Adwā during the reign of Emperor Yoḥannes IV follows the Čalaqot pattern of representing the Dormition, Burial and Assumption of the Virgin. The paintings were executed by *Alaqā* Luqās, well-known church painter in the second half of the 19th century.

The form of the Dormition (fig. 152a), which obviously was considered canonical, was characterized by Christ's grasping movement of Mary's outstretched hand and by a girl's bust on his right arm symbolizing Mary's soul.

The Apostles seem to be in full strength of twelve and accompanied by the additional "crowd" of heads. The position of Peter and Paul is reversed as compared to the Čalaqot mural. Mary, Christ and the "soul" have nimbi over their heads whereas the Apostles have none.

The lower section of the mural shows King David playing the lyre and another figure, the *masēnko*, an Ethiopian fiddle. The Dormition with King David has already been recorded in 16th-century painting but not in those of the 17th and 18th centuries. Our mural evidences the strength of Ethiopian iconographic traditions as well as of commentaries on the canonical texts. The figure with the fiddle was manifestly the result of these commentaries.

To the right of the Dormition, the Burial is depicted. It is similar to those of 17th-century miniatures, including the miracle of Jephonias.

Further to the right there is a poorly executed image of the Assumption (fig. 152b). It contains the salient features of 18th-century images of the Virgin, namely the crescent, pose of her hands, her unusual dress, the top-knot of hair as well as

[29] LerÉthG 41.

[30] *R. Pankhurst*, The history of Ethiopia's relations with India prior to the 19th century = IV Congresso internazionale di studi etiopici, Roma 10–15 aprile 1972 (Roma 1974) 297.

[31] The Director of the National Museum in New Delhi, who kindly examined the miniature and the mural, did not seem to recognize in this hairdress the Buddha's skull protuberance.

[32] LinVoy.

two vertical rows of cherubim. Only the clouds are left out and the feet of the Virgin do not touch the crescent, which gives the impression of her hovering over the crescent rather than standing on it. The painting witnesses the fact that the practice of representing ascending Mary with a crescent continued well into the 19th century and that probably the centre of its popularity was the town of Adwā.

The Dormition was also painted in churches of Goǧǧām. The following example differs from the one described in No. 15 and seems to be influenced by the 17th-century series of Dormitions created by Gondarene artists.

(16) The mural in the Waynāma Kidāna Meḥrat church, close to Baččanā, in southern Goǧǧām, was painted around 1800.[33] It represents one section of the Gondarene cycle, namely the lamentation of the Apostles (fig. 153). The painter, however, has combined the historical event, namely the passing of the Virgin, with the liturgy of the Ethiopian funeral which was contemporary to him.

Mary's body is entirely wrapped in a shroud and ready to be taken for burial. The Apostles are lamenting and their tears, or short lines, fall from their eyes. Below, the priests and deacons are already clad in church vestments, wear crowns and hold censers; they are ready to start the ceremony. Above the whole scene, two angels with raised swords are depicted; they guard the body; this is because Ethiopians are very conscious of Mary's elevated rank.

(17) The motif of David's song during the Dormition is found in the wall painting made around 1901 for the Sankorā Amānu'ēl church, in Eastern Šawā. The painting is influenced by the Greek form of the Dormition of the Virgin (fig. 154). She lies on a couch; her soul has departed; Christ stands behind her and holds in his left hand a small female figure, symbolizing her soul.

The painter made significant changes, though; the Apostles are missing altogether, instead Christ is flanked by two wailing women and two angels. King David depicted above the head of Mary, plays on an Ethiopian lyre.

SUMMARY AND INVESTIGATION OF MODELS

The subjects of the Dormition and Assumption do not seem to be known to Ethiopian painters before the late 15th or early 16th century. The earliest images of the Dormition which then appeared are similar to the Byzantine ones, that is they show the Virgin already dead. On the other hand, the Apostles arriving on clouds do not seem to have been painted by Ethiopians. They elaborated their own plan joining the themes of the Dormition, Entombment and Assumption of Mary into a series of narrative images.

The process of creating this series was gradual. As can be judged from the earliest paintings, the Ethiopians focussed their interest on the lamentation of the Apostles

[33] Described by *W. Krafft*, Report on Woyname Kidane Meherat, a little known church in Gojam = EthObs 15 (1972) 80.

which is also known in Byzantine/Greek iconography. The 17th-century painters further extended the subject-matter including in it the transportation of Mary's body to its burial place, lowering the body into the grave and the miracle which Mary worked on Jephonias. The peak of this developement was attained in the middle of that century when two great feasts of the Marian calendar, commemorated separately, namely the Dormition (in January) and the Assumption (in August), were connected iconographically into one extensive set of illustrations. This was possible because the readings for these two feasts in the Synaxary complete each other. Thus the iconography followed and even enriched the readings.

How did this series of compositions illustrating Mary's death and ascension come into being? Are these compositions genuine Ethiopian creations or are they artistic borrowings?

There is no doubt that the paintings depicting Mary's funeral, the lamentation of the Apostles, the wrapping of the body, its transportation and lowering into the grave, mirror Ethiopian life and liturgy. "When life leaves a sick man", prescribes the liturgical book referring to the dead, first wash [the body] with water . . . when this is completed, wrap it up in a new piece of cloth and tie [it] up, and light candles, a few or more, in order to honour the deceased".[34] We suggest that the above paintings have been created entirely by Ethiopians whose only source of inspiration was their burial of the dead, rendered with directness and care for details. On the other hand, the form of the Dormition and that of the Assumption is the result of a complex process of adapting a foreign model to Ethiopian conditions.

Let us consider the Dormition. In the art of the West during the late Middle Ages, Mary is depicted now and then as already dead, but there is also a new form developed. The West Europeans, different from the contemplative Byzantine, preferred to represent Mary at the moment of dying. At first she is reclining on a bed, but starting with Gothic art she occasionally kneels with her hands uplifted or drooping. The Counter-Reformation thought that Mary died without pain, death taking her unawares; she is therefore sometimes depicted not lying on a bed, but sitting on a chair or throne and surrounded by the Apostles. This new form spread widely after the council of Trent.[35]

The Apostles assist Mary and perform various functions. One reads prayers from a book, one swings the incense-burner, and still another holds the candle which he has taken from the dying Mary. All this closely recalls the 17th-century Ethiopian images of the Dormition.

There is thus a possibility that the dramatic change in the 17th century, from the Byzantine-like rendering of Mary as having already passed away, to the Western

[34] *Tecle Mariam Semharay Selam [= Takla Māryām Samhāray Salām]* De SS. Sacramentis secundum ritum aethiopicum (Roma 1931) 101.

[35] *J. Duhr*, La "Dormition" de Marie dans l'art chrétien = Nouvelle revue théologique (Feb. 1950) 48–51; RéauIc II 608, gives the reason of change of the pose as follows: according to the mystics, Mary gave birth to Jesus while she was kneeling and the same position was conceived for her death.

European rendering of her in the process of passing was, indeed, inspired by a foreign model which somehow penetrated into the Ethiopian highlands. Nevertheless, the scene of death is painted, at least in part, from experience and mirrors the Ethiopian liturgy which prescribes the following, "...thereafter, the one who holds the lamp (torch) approaches the (high) altar. Priests stand on the right and on the left and the high priest raises the gospel book and the cross over the head of the sick..."[36] Also, according to Ethiopian custom, candles are carried when the body of a monk is taken to the graveyard.[37] On the other hand, it should be remembered that candles were also carried during religious processions and funerals in Goa according to a Portuguese custom.[38]

The dress of Mary, and particularly the head covering, are of Portuguese origin. Similar dresses are found in the illustrations accompanying the description of Goa by Linschoten already mentioned; one picture shows rua Diretta, the most important street in Goa; at the extreme right of the picture, a group of women out for a stroll are depicted. They wear veils identical to Mary's in Ethiopian pictures. The same veils appear in other views of Goa, in one showing the fashions of women, in another a lady carried in a palanquin and again in the night scene showing a Portuguese lady and her husband going to church.[39] Apparently, a short veil draped loosely on the shoulders was characteristic of the dress of Goan ladies.

We are unable to point to the exact model which 17th-century Ethiopian painters used for the Dormition. The dress of the Virgin and perhaps the detail of candles indicate that there was one. They also indicate the direction to be taken in searching for it. In any case, the model was substantially modified and enriched with elements taken from Ethiopian life.

The demonstration of the model used for representing the Assumption is more positive.

The form adopted by the 17th-century Ethiopian painters includes a number of details which appear in virtually all paintings. These are: the crescent under the feet

[36] *M. Chaîne*, Le rituel éthiopien (Roma 1914) 47. Seven lamps (candles) are lit during the ceremony.

[37] The writer is indebted to *Gr. Georgis Dimtsu [= Gabra Giyorgis Dimṣu]*, a student of the ecclesiastic school in Tegrē, for describing the funeral customs in monasteries of that province. According to him, during the transportation of the monk's body to the graveyard, twelve candles affixed on sticks are carried. One is carried in front of the bier. The candles imply that the monk was "a light to the world". When the grave is already covered with earth, the candles are put on it. According to *J. Doresse*, La vie quotidienne des éthiopiens chrétiens aux XVIIe et XVIIIe siècles (Paris 1972) 244, the candles are lit on the grave: 24 for a priest, 12 for a deacon and a virgin and 7 for a layman.

[38] *Francisco Alvarez*, secretary and confessor of the Protuguese embassy to Ethiopia in 1520 reported that in Cananor he met Antonio, son of Duarte Galvam, the ambassador who was going to Ethiopia but died on the way in that locality. Alvarez brought with him the bones of Galvam. "Antonio" relates Alvarez "begged me not to bring them [bones] ashore, because he wanted to go for them in procession; which he did with all clergy and monks of the city, and confraternities with their candles." AlvPrJ 484.

[39] LinVoy pl. 7, 10, 13, 15, 16.

of the standing Virgin, her head uncovered and long hair covering her shoulders, her hands either crossed or more often folded in prayer and the winged heads of the angels emerging from the clouds which frame the composition. All these bear little or no relation to the text of the Synaxary. The conclusion is that this form was copied from a foreign model.

Another important fact is that there is a significant difference in secondary details between the 17th and 18th century representations of the Virgin standing on the crescent. In the 17th-century representations, her hair is loose and she wears a robe decorated with long scarves. In the 18th century the scarves disappear, instead the hair of the Virgin is characteristically arranged into a kind of a top-knot. This leads to another conclusion that Ethiopians used two different versions of the same foreign image.

The crescent under the Virgin's feet, the position and pose of her hands and the rôle of the angels express a new concept of her iconography introduced into Ethiopia sometime in the 17th century. Where did it originate?

The representation of the Virgin with a crescent under her feet derives from the passage of Revelation of St. John 12,1. "And a great sign appeared in heaven: a woman clothed with the sun and the moon under her feet . . ." This was interpreted in Western as well as Eastern Christianity as referring to the Virgin Mary.[40] Moreover, starting with the 16th century, the image of the Virgin with a crescent has been used in pictorial art for expressing her attribute of the Immaculate Conception.[41] According to the doctrine of the Catholic Church, the "most Blessed Virgin Mary was from the first instant of her conception, through unique favour and privilege of Almighty God, and by reason of the merits of Jesus Christ the saviour of the human race, preserved free from the stain of original sin."[42] The

[40] In popular interpretation, the crescent under the Virgin's feet was related to a historical event, the victory of the combined Spanish and Italian fleet over the Turks at Lapanto in 1572. The outcome of the battle which finally broke the Turkish supremacy of the Mediterranean was attributed to the miraculous intervention of the Blessed Virgin. Pope Pius V instituted a special feast of the rosary of Mary on the 7th of October, the day of the battle, and built the votive chapel of Lepanto in the basilica of S. Maria Maggiore in Rome. Thus, the crescent in the portrait of the Virgin Mary signified in popular imagination the *hilāl* of the Turkish flag (the author is indebted to Prof. Enrico Cerulli for his comment on the discussed image of the Virgin in his letter of October 6, 1967). The Ethiopians had their own difficulties with the Turks. They occupied Meṣewwä in 1575 and blocked for over three centuries Ethiopia's outlet to the sea. In the second half of the 16th century, the Turks attempted to encroach on the Eritrean highlands. Thus, besides enmity based on creed, there was enough reason for the Ethiopians to welcome the popular interpretation of the image of the Virgin standing on a crescent. However, we do not find the reflection of it in Ethiopian paintings.

[41] *A. Romeo*, La donna ravvolta dal sole, madre di Christo e dei cristiani (Apoc. 12) = VirgIm 3 (1955) 216–58; *V. Alice*, L'Immacolata nell'arte della fine dell sec. XV al sec. XX = VirgIm 15 (1957) 115, writes: "Da tempo i teologi e gli scrittori ecclesiastici avevano riconosciuto nella donna dell'Apocalypse il tipo e la figura della Madonna".

[42] *J. C. Fenton*, Our Lady's Queenship and her Immaculate Conception = VirgIm 12 (1956) 72.

doctrine was much discussed by Western European theologians during the Middle Ages, but took root in popular belief and was gradually integrated into devotional practices. In the 16th century the doctrine was rejected by the Protestant theologians but strongly supported by the Council of Trent. The move for acknowledging it as the teaching of the Catholic Church gained momentum in the late 16th and 17th centuries. Spain which was always a centre of the fervent cult of the Blessed Mary became the most outspoken promoter of the doctrine. Eventually in 1661, Pope Alexander VII issued a bulla at the request of Philip IV of Spain in which he defined the doctrine.[43] No wonder, therefore, that Spain became a centre of the artistic activity aiming at the figuration of the Immaculate Conception.

Already in the early 16th century Italian painters unsuccessfully attempted to express the Immaculate Conception by use of various symbols.[44] In the second half of the same century the artistic concept crystallized. It was based on two references from the texts of the scriptures about the woman of great beauty and without stain, ("tota pulchra et sine macula") and the other from the Apocalypse already discussed. The artists, in their attempt to visualize the Virgin's privilege of the Immaculate Conception, concentrated their effort on representing the Madonna as a young, beautiful girl, moved by feelings of purity and spiritual exaltation. In Italy, the painters of the school of Bologna produced several outstanding images of the Immaculate Conception, but undoubtedly the Spanish painters achieved the greatest effectiveness in their glorification of Mary's privilege. Already El Greco and the youthful Velasquez tried their hand at the subject. F. Zurbaran created an impressive *Inmaculada Concepcion* with a dreamy and youthful appearance that was free of additional symbols.[45] Furthermore, Spanish painters have created and popularized in 17th-century art a classic type of the so-called Immaculate Conception. The type represents a youthful Mary with uncovered head and long loose hair, her hands either folded in prayer or crossed at her breast. She wears a loose dress, usually white, with an ample blue cloak over it. She stands on a moon or crescent and is surrounded by clouds while groups of angels or winged heads of angels whirl around her. This representation is called variously *Inmaculada, Concepcion* or *La Purisima*. It is difficult at times to distinguish among these, considering that the theme and general layout show a great similarity. It would be idle to list all these works and therefore the following is a selection of those which are of significance for the discussion.

[43] *J. Alfaro*, La fórmula definitoria de la Inmaculada Concepción = VirgIm 2 (1956) 201–16.

[44] *M. Levi D'Ancona* in her Iconography of the Immaculate Conception in the Middle Ages and Early Renaissance = College of Art Association of America. Monograph on Archeology 8 (1957) made mention of attemps to represent the Imaculate Conception during these periods. In many mediaeval images, Mary is shown treading over the snake, based on biblical passages: Genesis 3:15; Psalms 90; Apocalypse 12. Satan in this context did not appear in Ethiopian art. These mediaeval forms have no bearing on the discussion.

[45] *V. Alice*, L'Immacolata nell'arte della fine dell sec. XV al sec. XX = VirgIm 15 (1956) 106–53.

Francisco Pacheco painted his *Inmaculada Concepción* ca 1620.[46] He early stabilized the iconography of the subject which was later given its greatest popularity by Murillo. Pacheco's work is of special interest because it contains the details which are also found in Ethiopian paintings. These are the aureole of rays spreading from Mary's head, stars placed in between the rays, a double circle around her head, a brooch fastening the cloak on her breast, as well as her hands folded and held on her left breast which is a pose characteristic of many Spanish *Inmaculadas*. Moreover, winged heads of the angels appear in the background filled with clouds.

Pedro Orrente, another Spanish painter, depicted his *Inmaculada* ca 1629.[47] In it, a circle of stars adorns the Madonna's head but the rays are missing. The pose of her hands is characteristic of Orrente and of several other Spanish artists, it shows the tips of the fingers touching each other while the palms remain separated. Mary wears a robe made of colourful material and a cloak trimmed with large shining lace. All these details are found in Ethiopian paintings.

Luis Tristan (ca 1600–1649) called his works *Inmaculada* as well as *Concepción*. In one of them,[48] Mary has her face directed upwards as if she were in a state of great exaltation; her head is surrounded with stars; her robes are in plain colour but one end of her cloak is draped over her left forearm; this is also a way of draping a cloak in Ethiopian paintings.

Three different versions of the *Inmaculada* by Sanchez Cotan[49] contain a new iconographic element. The angels are missing altogether, instead, the mass of heavy clouds tightly surrounds the figure of Mary; an elliptical clear background left between the clouds and her figure gives the impression of her standing in Glory. In Ethiopian icon No. 4656, Mary is also placed in an elliptic mass of clouds. In many *Inmaculadas* of Cotan a white dove hovers over Mary's head.

With B. E. Murillo (1618—82)[50] the Spanish school reached the peak of success and popularity. Murillo was deeply impressed by the doctrine of the Immaculate Conception; he represented Mary as a "divine" being, perhaps in a state of spiritual exaltation and immersed in celestial light pervading her body and ample robe agitated by the wind. Mary gives the impression of being suspended in the air while clouds and garlands of angels around her indicate that heaven is her abode.

In the second part of the 17th century the sense of calm and serenity pervading the early Spanish images of the Immaculate Conception was replaced by the affection of movement and the nervousness of gesture. These new works often

[46] *J. F. Moffitt*, Spanish Painting (London 1973) 91.
[47] IñSPintEsp ill. no. 172.
[48] IñSPinEsp ill. no. 125.
[49] IñSPinEsp ill. no. 48.
[50] His best known are: *La Concepcion*, coll. Soult (Louvre, Paris); *La Concepción* so-called Baring (California, USA); *La Concepción* so-called of Aranjuez (Prado, Madrid); *Inmaculada Concepción* (Ermitage, Leningrad); Immaculate Conception, Coll. Northbrook (now Metropolitan Museum, N. Y.); *La Concepción* Museo de Sevilla (before in Convent of the Capuchins).

painted with poor taste nevertheless contain a few details of interest for discussion. For example, *La Purísima* of José Antolinez (1635–75)[51] has two luminous circles over her head and the stars placed in between. Moreover, Mary's robe is decorated with pearls and precious stones and she wears a bracelet on her wrist. In other versions of the subject by the same painter, rays and luminous circles as well as a shining disc are depicted over the Madonna's head.

A form of the Immaculate Conception thus developed by the Spanish painters widely spread to other European countries including Portugal and travelled throughout the world to the Roman Catholic missions.

The question arises whether there is a relation between the Spanish and other European images of the Immaculate Conception and the Ethiopian images of the Virgin with a crescent. The answer is not easy considering that as yet neither the painting nor the print which served as model to Ethiopian painters have been located. Nevertheless, the analysis of Ethiopian paintings just concluded and the study of their cultural background allows us to proffer the following comments.

Direct translation by the Ethiopians of the text of Revelation into their painting should be excluded. Except one manuscript produced shortly before 1730,[52] Ethiopians did not seem to illustrate the Book of Revelation of Saint John. In their painting the image of the Virgin with the crescent under her feet is virtually always related to the theme of her Assumption. The image appeared in Ethiopia in the 17th century which corresponds to the period of its greatest popularity in Western European art.

It appears therefore that the form of the Ethiopian Virgin standing on a crescent most probably originated from the models inspired by the Spanish image of the Immaculate Conception and that at least two different models reached Ethiopia, the first in the 17th and the second in the 18th century.

In the first model, the rays radiating from the head of the Virgin, the stars and the rich ornamentation of her robe were missing, as far as can be judged from available 17th-century Ethiopian works. The model reflected the version similar to Murillo's Immaculate Conception. It should be emphasized that significant alterations of details occurred in the transmission of the model to Ethiopia and at times an intense local adaptation was carried out in the country, as exemplified by icon No. 4656.

The second model used by 18th-century Ethiopian painters contained the rays, stars and shining circles over Mary's head as well as the ornamented cloak fastened with a brooch on her breast. The model, then, reflected the version similar to Pacheco's rendering of the Immaculate Conception. Again the changes of detail occurred during the transmission. The mural in Čalaqot gives a fairly faithful impression of what the model looked like. Just as in the case for the miniature in Ms. No. 73, the mural demonstrates the process of adaptations effected before the model arrived in Ethiopia.

[51] *A. L. Mayer*, Historia de la pintura española (Madrid 1947) ill. no. 382.

[52] Book of Revelation of Saint John, British Library Or. 533. One of its miniatures contains a graphic translation of the passage 12, 1 into painting.

Of course there is no question of the Ethiopians directly copying from the Spanish paintings and one has to search for intermediaries. The suggestion advanced is that the images of the Immaculate Conception which were used as immediate models by Ethiopians travelled through Portugal to Goa and from that town to Ethiopia. The Goan origin of the images would explain, on the one hand their Iberian characteristics, and on the other hand, the Indian or Eastern touch in Ethiopian images of the Virgin standing on a crescent.

Goa, as the headquarters of the Jesuit missionary effort in the East, played a vital role in transmitting European Christian symbols and devotional objects to Ethiopia. The image of the Virgin with a crescent is probably one of them.

The representation of the Virgin standing on a crescent was apparently well-known and popular in Goa, both Old and New. In Old Goa, a spectacular composition is found in the church of St. Catherine. The church built by Afonso de Albuquerque around 1520 was enlarged in the second half of the 16th and first half of the 17th century and glittering of gold images of the Virgin standing on a crescent as well as of St. Catherine which were placed above the high altar. In New Goa (Panjim) the main church dating from the end of the 17th century was dedicated to the Immaculate Conception; it is decorated with a large painting of St. Mary standing on a crescent. The painting is similar in general composition to the Ethiopian miniature in Ms. No. 73.

It is probable that besides these images of the Immaculate Conception well-known in Goa there were others, but they have been lost. Moreover, small paintings or prints circulated. The Ethiopian paintings of the Virgin with a crescent prove that some of these devotional pictures reached Africa in the 17th and 18th centuries. The Goan pictures must have been adapted to the Indian environment and therefore the European Immaculate Virgin was transmuted into an Indian girl and her hair dressed with an elaborate top-knot.[53] This is suggested by the miniature in Ethiopian Ms. No. 73. Considering that in Northern Ethiopia a top-knot is not used for the traditional hair dressing of women, the Ethiopian painters in the process of continuous copying probably misunderstood its meaning and introduced some distortion of its shape. Such change happens time and again in Ethiopian traditional art. Thus the protruding mass of hair on the Virgin's head vaguely recalls the *usnisa* protuberance of the Buddha's skull, and leads Leroy into believing in an iconographic relation between the Buddha and the Christian Virgin.

The 17th-century image of the Virgin, as exemplified in manuscripts Or. 641, Abb. 114, Rüpp. IV, 2, icon No. 3704 and the painting on canvas from the Dāgā Estifānos church, shows the transformation which probably bears some relation to India and perhaps to the Far East. This is the addition of the scarves wound around Mary's chest, arms and waist and billowing on the left side of her body.

[53] In Spanish images of the Immaculate Conception, Mary's hair is not dressed with a top-knot; her hair is invariably smooth and loose with, at times, a clear parting at the crown of the head. Therefore it does not seem that this detail could be taken from Spanish paintings.

What is the significance of this detail? Does it represent the belt which Mary, according to an old legend, offered to Thomas when he saw her lifted to heaven?[54] This episode which is attested to only by a Latin version of an apocryphal text is not mentioned in the Synaxary. Moreover, neither an explicit iconographic sign nor the caption, allows belief that the Ethiopians knew or intended to depict the episode. The contention is that this interpretation of scarves should be excluded. The scarves represent an unusual addition to the attire of Mary and certainly do not mirror the way Ethiopian women dressed in the past. Also the scarves can hardly originate from the Christian iconography of the Virgin, either Western or Near Eastern. On the other hand, long scarves wound in a variety of ways around the body and flowing loosely are common in the Far East and on the Indian sub-continent. In India, scarves made of light cotton are a common addition to the dresses of Indian, mostly Muslim, women. Scarves in the form of diaphanous draperies adorn Indian Buddhist divinities, but are especially common in Buddhist art of China and Japan. It seems that one has to search for analogy and perhaps for the origin of this particular form in either India or the Far East.[55]

Although the Ethiopian form of the Virgin standing on the crescent most probably originates from the Spanish imagery of Mary, there is no evidence that the Ethiopians have given to the form the same meaning as Westerners. Ethiopian Marian theology originated from the Protoevangelium of James, an early apocryphal text dealing with the birth and early life of Mary.[56] The main themes of the Protoevangelium have been incorporated in the narrative of the Ethiopian Synaxary and additionally the whole text was translated into Geez, the liturgical language of Ethiopia.[57] Though the translation was made long before the 17th century, the profusion of copies produced during that century bear witness to the great popularity of the work.

Ethiopians took no notice of the problem of Mary's immaculate conception so fiercely discussed by Western theologians during the Middle Ages. The Protoevangelium was written for the glorification of Mary but, as E. Hennecke noted it contains all themes that future Marian theology propounded: but the 'Immaculate

[54] The Greeks believe to have this relic which is kept in the monastery of Vatopedi, Mount Athos, whereas the Westerners possess another "authentic" belt in Prato, close to Florence.

[55] How the Chinese Buddhist images could reach Ethiopia is not clear. It should be kept in mind, however, that Chinese trade covered the Indian ocean as well as the Red Sea. A note in Ibn Taghri Bardi's Nujoom written in the 15th century reports the arrival of two Chinese ships in Aden laden with china, silk, musk and other luxury articles. As the Kingdom of the Yemen was in disorder, the captains sailed on to Jedda to discharge their wares. Jedda is situated opposite Meṣewwä on the Eastern shore of the Red Sea. Cf. J. Glubb, Soldiers of Fortune (London 1973) 328. In the 16th and 17th centuries, Goa was the great emporium of the East where Chinese goods were in abundance. LinVoy expressly mentions "curious works of Porsylene from China", 228 and "trafic to Benjala, Pegu, Malacca, Cambaia, China", 184.

[56] HenAp I 370–80.

[57] BLM.

conception' of the mother of Jesus is not thought,[58] though the miraculous birth of Mary is recorded.[59] Ethiopians include in their major feasts two events of Mary's life, namely her conception *(dansatā)* commemorated on 7th *Naḥasē* (14. August) and her birth *(ledatā)* commemorated on 1st *Genbot* (9. May), in addition to the Dormition and the Assumption. Yet the themes of the conception and birth of Mary are virtually unknown in Ethiopian painting.

The captions accompanying the Ethiopian image of Mary standing on the crescent and surrounded by cherubim invariably explain that this is her Assumption to Heaven, whereas in Western art this image often symbolizes two themes, namely Mary's Assumption to Heaven as well as her Immaculate Conception. Whether the 16th and 17th-century Ethiopians related the Assumption to the Western concept of Mary being free from original sin and consequently exempted from the general law of death is a matter of conjecture. It should be recalled that Ethiopian religious thinking tends to operate at a level which combines deep spirituality with great simplicity of dogmatic theology and directness of graphic symbols.

The iconography of the Dormition and the Assumption is in a broad sense parallel to Christ's death and resurrection. In the 16th and 17th century, the primary aim of the painters has been to illustrate the narrative of Mary's departure from this earth. Perhaps the cycle also expressed the basic concepts of Marian theology as the Ethiopians saw it. The overwhelming impression one gets from the compositions then developed is their emphasis on the human aspect of Mary's departure. Her Dormition is rendered as the demise of a pious woman; the presence of Christ and the theologically vital detail of Mary's soul is left out

[58] HenAp I 373.

[59] The apocryphal text relates how Anne and Joachim, the parents of Mary waited a long time for an offspring. Joachim, humiliated by the refusal of the chief priest to let him have priority in offering gifts to the Temple because he had not begot an "offspring in Israel", went to pray and fast in the desert. Anne, in the meantime lamented at home. And while both so prayed and implored God, the angel Gabriel appeared to them and announced a child which "shall be spoken of in the whole world". When Joachim returned home . . . Anne was waiting at the gate and when she saw him she "ran immediately and hung on his neck saying 'Now I know the Lord God has greatly blessed me; for behold, the widow is no longer a widow, and I who was childless have conceived [shall conceive] . . . And Joachim rested the first day in his house." (HenAp I 374–76). The reading in the Synaxary is even more explicit. Gabriel appeared to Joachim and told him that "God would give him seed, through which the salvation of the whole world would come". Joachim returned home and told Anne about his vision "And after this, she conceived . . ." (BSyn 848). In another passage ". . . immediately she had union with her husband Joachim she conceived . . ." (BSyn 37). In his Book of the Light, *Maṣḥafa Berhan*, king Zar'a Yā'qob related symbolically the conception of the Virgin Mary with Moses accepting the Tables of the Ten Commandments. "Those holy hands", he writes, "brought forth the Tables from the hand of the Lord and they did not get burned by the fire of Divinity. Similar in their chaste union, the holy and pure Joachim and Anne brought forth Mary, the two-fold Virgin . . ." [CSCO 251 (1965) 39].

altogether. Instead, the funeral and lowering into the grave are depicted; all these dramatically express the idea that, indeed, Mary has died. On the third day, she is taken to heaven and thus the analogy to the narrative of Christ's resurrection is complete. The same is also suggested by the text of the salutation to Mary: "to thy resurrection which was like unto the resurrection of Christ..."[60]

The 18th and 19th-century painters fully adopted the Greek representation of the Dormition and emphasized the mystic aspect of the narrative. They represented Mary's soul being received by Christ himself which iconographically is difficult. They introduced into the composition the movement of his hand grasping that of Mary probably to make the meaning of the image more explicit. Also they reduced the cycle to one or two images that is either to the ascending Virgin or to the dead and ascending Virgin. The former often stands for the whole cycle. The actual funeral is seldom depicted.

The fact is that even these isolated images of the Virgin standing on a crescent which Ethiopians continued to produce until the present,[61] are invariably related to the Assumption of Mary. In other words, the Ethiopian images are never expressly those of the *Inmaculada,* even though in their country of origin they symbolized Mary's Immaculate Conception. The Ethiopians reproduced this foreign model with remarkable iconographic accuracy but gave to it a different title.

The same happened with the other form of Mary's imagery, the crowned Virgin which is discussed subsequently.

[60] BLM 243.

[61] An example is found in the 20th-century Prayer Book, kept in Dabra Batal Śellāsē church, close to Dasē in central Ethiopia.

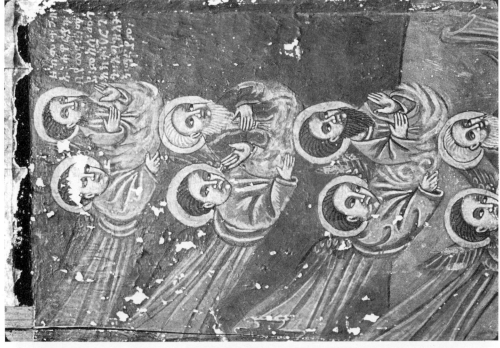

139a and 139b. Triptych by Nicolò Brancaleon, c. 1480–1520. c. 53,0 : 39,0 cm. Gētēsēmānē Māryām, Goǧǧām

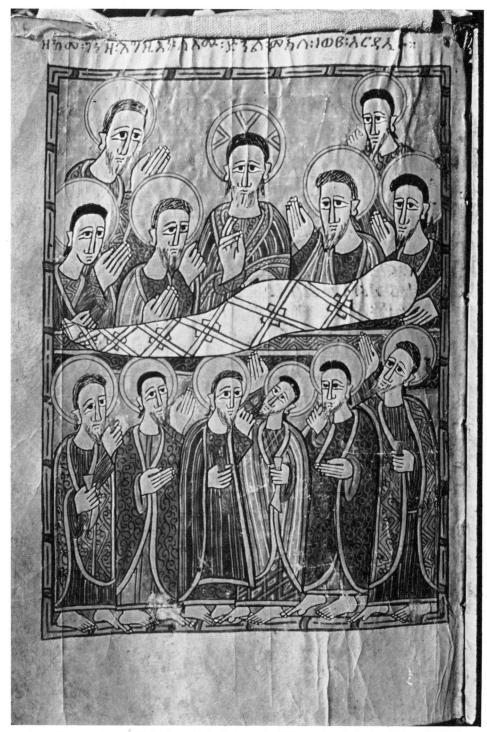

140. *Lāḥa Māryām*, c. 1508–40. c. 30,0 : 22,5 cm. Bethlehem church, Dabra Tābor Bagēmder

141. Painting on canvas, 1563–97. c. 90,0 : 120,0 cm. (Dabra Dagāyē) Dāgā Esṭifānos, Lake Ṭānā

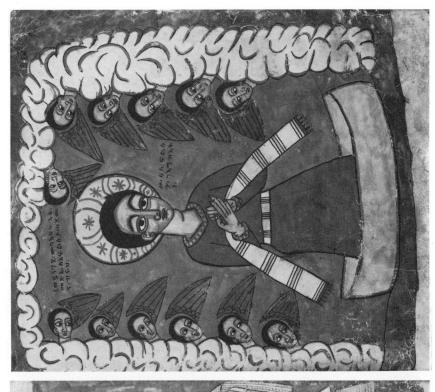

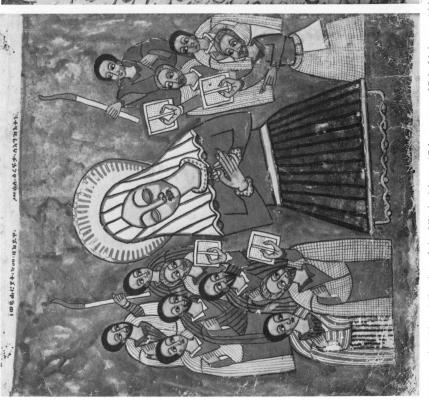

142a and 142b. Miracles of the Virgin Mary, 17th century. 27,0 : 30,0 cm. Abb. 114. Bibliothèque nationale, Paris (fol. 91v, 92r)

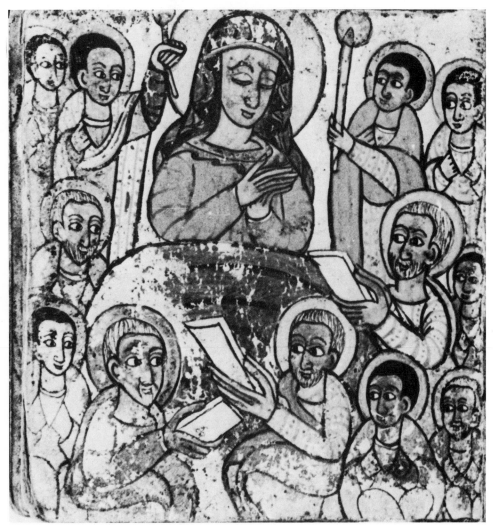

143a, 143b, 143c. Book of Miniatures, 17th century. 9,0:8,5 cm. Ms. or. Rüpp. IV,2, Stadt- und Universitätsbibliothek, Frankfort on the Main (fol. 13v, 14r, 15r)

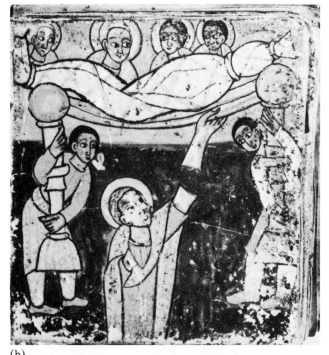

(b)

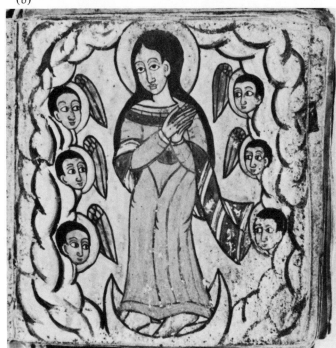

(c)

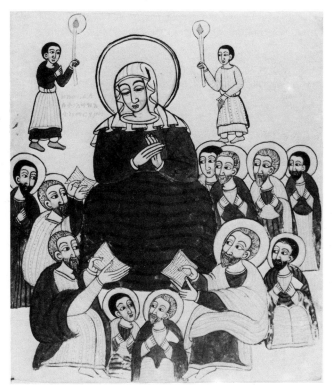

144a, 144b, 144c, 144d. Miracles of the Virgin Mary, c. 1667.
British Library Or. 641 (fol. 19r, 20r, 21r, 22r)

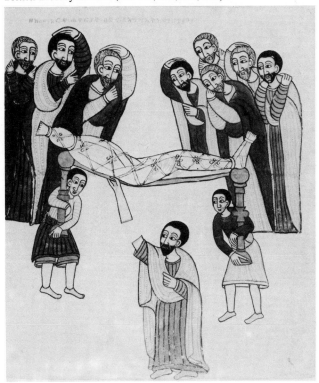

(b)

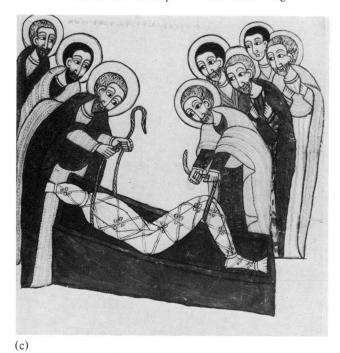

(c)

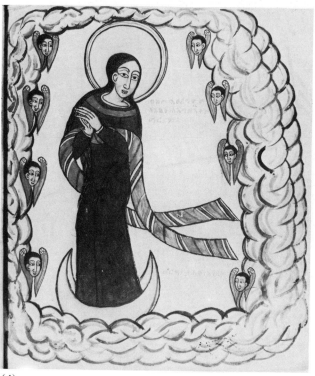

(d)

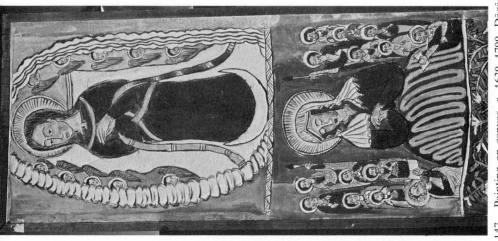

147. Painting on canvas, c. 1630–1700. Dāgā Estifānos, Lake Tānā (this is a copy made for the IES Museum, 107.2 : 46,4 cm)

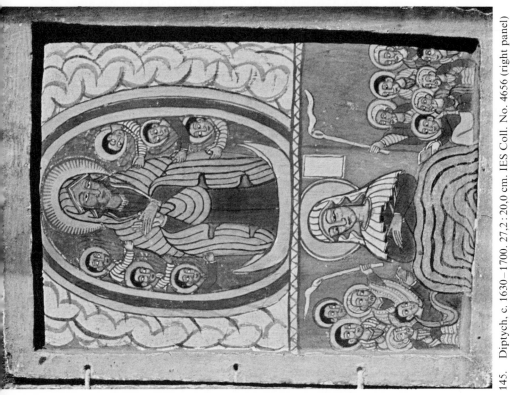

145. Diptych, c. 1630–1700. 27,2 : 20,0 cm. IES Coll. No. 4656 (right panel)

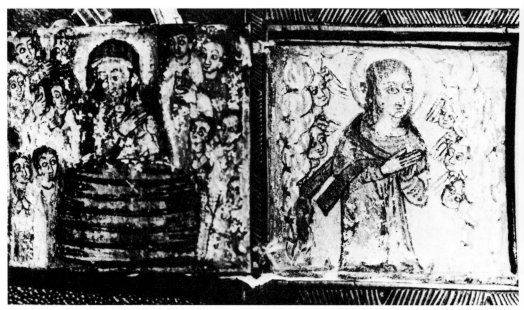

146. Double-surfaced diptych, 17th century. 10,3 : 9,5 cm. IES Coll. No. 3704.

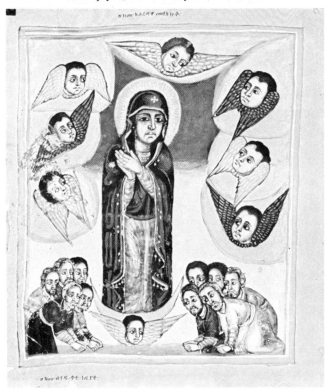

148. Miracles of the Virgin Mary, 18th century. 46,3 : 40,3 cm. British Library Or. 637 (fol. 2r)

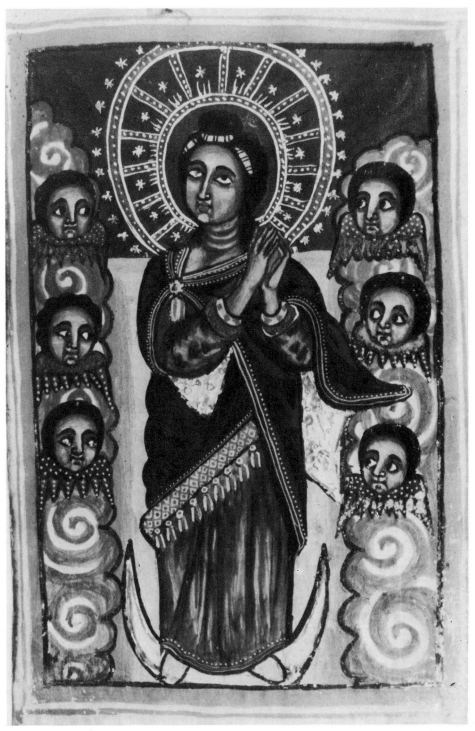

149. Book of Prayers and Hymns, 18th–19th century. 19,0 : 11,0 cm. IES Ms. No. 73

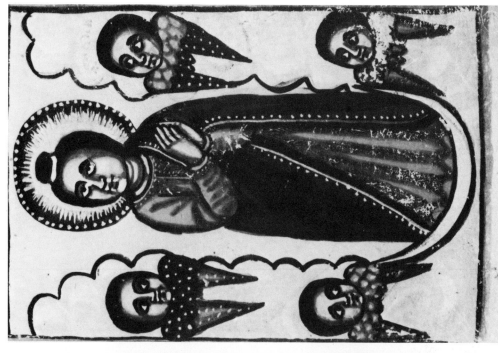

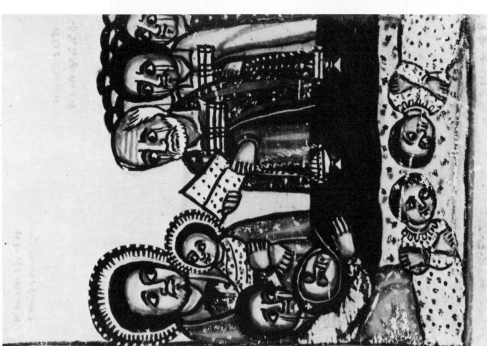

150a and 150b. Prayers of the Virgin Mary, 18th century. 12.5 : 8.5 cm. Ms. or. Rüpp. IV,1, Stadt- und Universitätsbibliothek, Frankfort on the Main

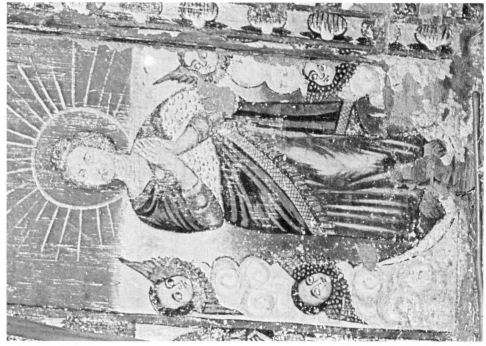

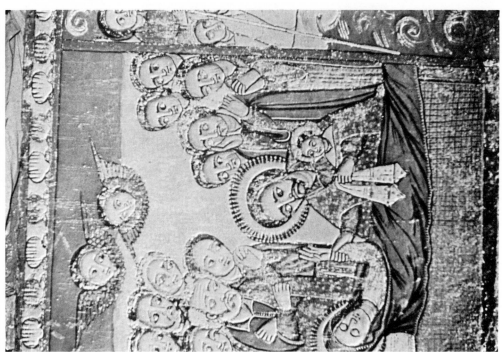

151a and 151b. Wall painting, c. 1800. c. 125,0:98,0 cm. Čalaqot Śellāsē, Endertā in Tegrē

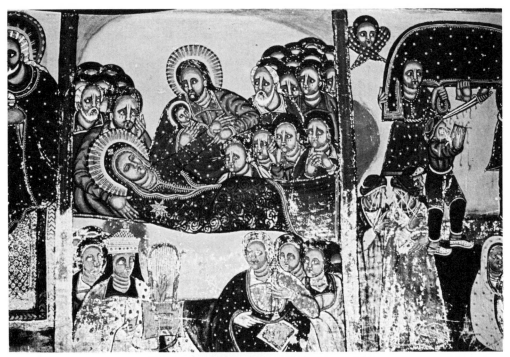

152a and 152b. Wall painting, 1872–89. c. 130,0 : 90,0 cm. Adwā Śellāsē, Tegrē

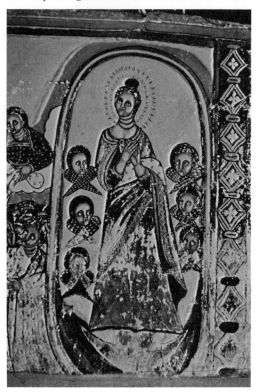

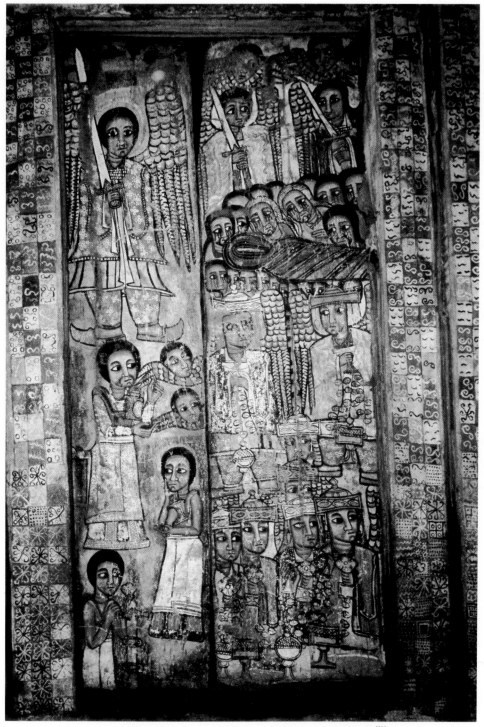

153. Wall painting, c. 1800. Waynāma Kidāna Meḥrat, Goǧǧām

154. Wall painting, c. 1901. c. 117,0 : 160,0 cm. Sankorā Amānuʾēl, Šawā

VI. THE CROWNED VIRGIN AND HER CORONATION

"The contrast between the simple account of the Virgin in the Gospels", writes
Marion Lawrence, "and the exalted position as Mother of God, Queen of the
Heavens, and chief intercessor between God and man given her by the Church is
stupendous, and yet it was reached by gradual steps.

The Early Christians laid no special emphasis upon the Virgin. We find her
depicted as early as the second and third centuries, but often she is left out quite
surprisingly, ... and when she appears, it is in the simplest form definitely
suggested by the Bible story. She is a simple mother with her Child ..."[1]

In the fourth and fifth century following the definition of Mary's dogmatic
position as Mother of God, Eastern and Western Christian art developed majestic
images of her. These images represented her in a form analogous to those of Christ
in majesty and, in addition later on in the West as the Queen and wearing a royal
crown. Placing a crown on the Virgin's head is an artistic expression of the mystic
belief in her coronation by Christ and thus the theme is related to that of her
Assumption.[2] The idea of the *Virgo Regina,* the Virgin Queen, adopted in
Mediaeval Europe does not belong, according to Jules Leroy, to the Byzantine
tradition or even to Oriental tradition.[3] "I have found no example of a crowned
Madonna in the East.", writes Marion Lawrence, "But there is a continuous line in
Italy from the sixth century on."[4]

Although the crowned Virgin is known in Western art since the 6th century,
starting with the 12th century onwards, the examples of it are widespread and
varied. The Virgin wears the crown in images of mystical nature as well as in
historical scenes. Moreover, around the same time appears a new composition in
which the Virgin is represented in the process of being crowned. Mirella Levi
D'Ancona elaborated the significance of the form. "The coronation of the Virgin",
she writes, "is a theme which reflects a shifting of view in the discussions of the
Immaculate Conception. Before the twelfth century, the discussions had revolved
around the problem of the origin of the Virgin Mary – of her purity from her
creation, which tended to be placed at the beginning of time itself. To support this
idea, writers had often quoted ... the verse from Eccl. 24:14 ...'From the
beginning and before the world, was I created, and unto the world to come I shall
not cease to be.' But this verse also contained the idea that the existence of the
Virgin Mary, in addition to having no beginning in time, had no end in time; this
second idea also came to be discussed in the twelfth century. It was buttressed by

[1] LawMar 150.

[2] *S. Rossi,* L'Assunzione di Maria nella storia dell'arte cristiana (Napoli 1940) 69–78.

[3] *J. Leroy,* Une icône éthiopienne de la Vierge au Musée copte du Vieux-Caire = AÉ 6
(1965) 233.

[4] LawMar 150.

the theory that the Virgin alone among all human beings was exempted from the general law of death to which mankind is subject as a consequence of Original Sin. The triumph of the Virgin over death was an accepted theory, developed in the first centuries of the Christian era . . . ; it was celebrated by the feast of the Assumption of the Virgin on August 15. In art, this triumph was represented by one or more of the events which took place between the death of the Virgin and her Coronation in Heaven, and this iconography was well established in the thirteenth century. The Coronation of the Virgin, the culmination of the Glories of Mary, was an especially popular theme."[5]

The way of crowning the Virgin varies. Either Christ or God the Father or jointly all persons of the Trinity perform the ritual. Its pageantry recalls the splendours surrounding coronations of kings and emperors. Other compositions, simpler in setting but equally majestic, show two flying angels holding the crown over Mary's head.

The two manners of representing the Virgin, namely either in the process of being crowned or already wearing the crown on her head are found in the art of Ethiopians. Neither are genuine to this art and their iconographic story is different.

It seems that the form of the Virgin wearing the crown had been introduced some time in the 15th century, whereas that representing her coronation appeared in the early 16th century. Let us follow these two forms.

THE CROWNED VIRGIN: 15TH–16TH CENTURY

The following are the paintings ascribed to the 15 century in which Mary wears the crown. Other particulars in these paintings are significant for the discussion.
(1) Triptych No. 4117 in the IES Collection shows the Virgin nursing the Child in the central panel (fig. 155). In all probability St. Paul is depicted in the left panel. The other panel is missing. The painting is a blend of two possible influences, European and Islamic. The former is manifested by the rendering of the Child and the form of the crown, the latter by the roundness of faces and the way of drawing the eyes. The Child sucks the breast of his mother while holding it with his hand; which recalls Renaissance as well as Cretan Madonnas.[6] The work should be ascribed to the middle of the 15th century.

[5] *M. Levi D'Ancona,* The Iconography of the Immaculate Conception in the Middle Ages and Early Renaissance = College of Art Association of America. Monograph on Archaeology 8 (1957) 28.

[6] In Coptic art the Virgin virtually always supports her breast, a trait which is believed to derive from the Pharaonic representation of Isis nursing Horus. This conception also appears in the early image of the nursing Virgin in the third-century Catacomb of Priscilla.

On the whole the nursing Virgin is a "very unusual treatment" according to Marian Lawrence "and not until the Renaissance is the Virgin again so unconscious of her divinity". LawMar 151.

The Virgin wears a large yellow-green veil which covers her head and shoulders, and a large bluish-green cloak flowing in elaborate folds down to the bottom of the painting. The veil is European; similar head-covers under the crowns had been worn by queens and kings of Mediaeval and Renaissance Europe. The crown on her head is painted in yellow with red dots in an obvious attempt to represent gold and jewels. It is an open crown with the fleur-de-lis and small rosettes or crosslets in between. The fleur-de-lis form of the crown is of German origin and widely used in 14th and 15th-century Europe, including Italy.[7] Such crowns have never been used by Ethiopian monarchs; therefore our crown has been manifestly drawn by someone who either had seen it in other countries or copied directly from a foreign model representing the crowned Virgin.

The subsequent works are painted by less skillful and knowledgeable artists and therefore the crowns are not clearly drawn. Still their Western origin is evident.

(2) The triptych (fig. 156), The Brumit Coll. No. 1, USA, also represents the nursing Virgin and its details are similar to those in the triptych just described, though the general setting is different. The Child is seated on the right side of Mary and stretches his hand towards her breast. She supports it with her hand. The same movement of the Child, expressing his eagerness to be fed, is found in a few 15th-century paintings on wood which manifestly have been influenced by Western art. Whether the theme of Mary giving suck to the Child is purely sentimental as in Western art or had for the Ethiopians a theological significance,[8] is a matter of conjecture.

Some details in the triptych recall the panels in Wāšā Endreyās (fig. 193 and 198), for example the swinging movement of the Child's legs, the realistically drawn wings of the angels, and the imbrication pattern.

The figures of the twelve Apostles, depicted in the wings, are identical to those in diptych No. 3980 (fig. 208) and triptych No. 4186 (fig. 209). Therefore our triptych dates from the middle or second half of the 15th century and originates from the workshop influenced by the art of the European Renaissance.

The Virgin wears a red robe and on her head a pale bluish veil which also covers her shoulders; a dark blue cloth envelops her body. The veil and cloth give the impression of two separate pieces of dress, though this is not as evident as in triptych No. 4117.

[7] In the early Italian images of Maria Regina the crown is always a large tiara covered with jewels which recall Byzantine crowns or the head-dress of the *bazylissa*. After the 12th century, the Italians adopted either the Germanic fleur-de-lis form or a crown of triangular shape (Chartres type) and made these more elaborate. But the essential form remains the same. Cf. LawMar 150 161.

[8] LashGate 145 contains the following passage:
 "And when they [angels] saw their Lord, who had gathered to him all created things, dwelling in your [Virgin's] lap and him who feeds all creation sucking your milk like a nursling, they sought him in the heights, and there they found him with his Father and the Holy Spirit as before".
 Mary's milk was believed to have miraculous curing properties as evidenced in illustrations to the Book of Miracles of the Virgin Mary.

The Virgin also wears a large open crown. The drawing of it is less precise than in the just mentioned triptych, but still an attempt has been made at rendering the stones ornamenting the crown and the fleur-de-lis outline.

(3) The panel, IES Coll. No. 5996 (fig. 157), was made by an exceptionally unskilled hand. The painting combines the details taken from Islamic and Western art. The Child is seated on Mary's right arm; he seems to be a boy a couple of years old. His hair is brown. His long yellow tunic with open collar and red border at the hem recalls the same in the triptych No. 4186. His nimbus with flared, angular cross-pieces, is similar to those found in triptych No. 4186 and diptych No. 3980. Both paintings are believed to be influenced by Western art as well as Islamic. Mary seems to hold a flower in her hand and the Child seems to touch one of its round buds. However, this detail is blurred.

Mary's pale blue cloak covers her head and shoulders, but her body below her breast changes into ornamental pattern. Neither the folds of her cloak, nor the line of the legs and knees are drawn. The whole lower half of the painting is filled with rows of rosettes, which also embellish Mary's cloak.

The panel belongs to the category of 15th-century paintings which are divided horizontally into two sections and one of these is ornamented with a pattern not related to the subject of the painting; the writer already pointed out that this manner was also practiced in the Armenian school of painting of Khizan (see p. 182). Our painting possibly mirrors this far distant school, though the painter had obviously little understanding of what he was copying.

The same lack of apprehension is evident in the way he depicted the crown that the Virgin wears. The crown is of an open type, but the fleur-de-lis form has been transmuted. Moreover, the yellow colour has been replaced by red, in spite of the former having been used for imitating gold.

(4) The Virgin depicted in the diptych IES Coll. No. 3980 (p. 421, fig. 208) wears a crown and holds a flower in her right hand. Her face is directed towards her Child who in his left hand holds one of the buds of the flower.

The head of the Virgin is covered with a mulberry red veil over which is placed a crown or rather an outlined sketch of it. The sketch takes the form of the fleur-de-lis arabesque drawn by someone who did not fully understand the meaning of the European symbol.

Another significant detail of the painting is the "flower" which the Virgin is holding, with three bare stems and yellow buds. Similar flowers are found in other paintings of the period. What could be their meaning?

The flower most probably stands for the Tree of Jesse, known also as the Stem of Jesse. "Isaiah 11,1", writes Gertrud Schiller, "uses the image of the rod (shoot) springing from the stem to express the idea of the Messiah who was to come from the royal house of David". The Church Fathers suggested several allegorical interpretations of the text, "equating the stem *(radix)* with Jesse, father of David, the rod or shoot *(virga)* with Mary *(virgo* = virgin) and the fruit or flower *(flos)* of the rod with Christ." In the visual rendering of the text of Isaiah one has to distinguish between the shoot as an attribute and the complex image of the 'Stem of Jesse'. "From about the year 1000 [in Western Europe], the shoot as an attribute

was often placed in the hand of the Virgin, less frequently of the Son and sometimes of Isaiah and the ancestors of Christ; it was the symbol of Christ's human descent ... The shoot may be portrayed as a long, leaf-like stem, a short, sceptrelike shaft with a flower, later as a rose or flower signifying Christ."[9]

The Ethiopians probably interpreted the "flower" or "stem" in the 15th-century paintings as a symbolic expression of the Tree of Jesse, though there is no mention of it in the captions. The following preliminary conclusions are therefore suggested:

(a) The "flower" or "stem of Jesse" appears first in the middle or second half of the 15th century and only in a limited number of such paintings. It is virtually unknown in the late 16th century as well as in the 17th and 18th centuries.[10] This suggests that on the one hand, there was no iconographic tradition of the Tree of Jesse prior to the 15th century, and on the other hand that this detail did not take root in Ethiopian religious symbolism.

(b) Considering that the shape of the stem, the pose of Mary's hand and the Child's movement of the hand are remarkably uniform in all the paintings, these originate from a single foreign model.

(c) The "flower" symbolizing the Tree of Jesse might have a special significance for Ethiopians because their rulers were believed to originate from the biblical king, Solomon.[11] Thus the flower would indirectly tend to enhance the glory of the dynasty. There is not, however, clear evidence to substantiate this in the paintings.

(5) The wooden cross, IES Coll. No. 3890 (158a and b), has the two faces painted: on the one the Virgin and Child holding a bird is represented and on the other St. George. The cross is of flat-edged type characteristic of the 15th century.

The paintings on the cross are a mixture of the 15th-century innovations with old iconographic forms. Thus, from the presence of a serpent, St. George is obviously meant to fight the "dragon", but one has the impression that the painter has still portrayed the saint according to his "riding" type of iconography. George has his hands crossed on his chest and is not thrusting a spear into the serpent's body. This painting is possibly an example of the transition from the "riding" to the "fighting" version of the iconography of St. George.[12]

The same mixture of old and new forms is evident in the image of the Virgin and Child. The frontal pose of the Child recalls his late 14th-century portraiture and his

[9] Schilllc I 15.

[10] In a few 16th and early 17th-century paintings the Virgin is shown with a flower. However, the form of the flower is different from that in the 15th-century paintings and its meaning is probably not related to the Tree of Jesse.

[11] Among the attributes of Ethiopian sovereigns listed on the Ortelius map of Ethiopia (Antverp 1570) are the following "... born from the tribe of Juda, son of David, son of Solomon ..."

[12] S. Chojnacki, Note on the Early Iconography of St. George and Related Equestrian Saints in Ethiopia = JEthSt XIII 2 (1975) 39–55.

face seems to originate from Coptic art. The Virgin's right hand resting on the Child's shoulder recalls the tender gesture of Christ protecting the monk Menas in the 6th–7th-century Coptic painting in the Louvre. This analogy which might demonstrate the persistence of forms in Ethiopian paintings does not suggest a direct relation with Coptic art. Indeed, the crown on Mary's head and the bird in the hand of the Child clearly define and date our cross to the 15th century.

A large open type crown posed on Mary's head is manifestly European. The arrangement of finials is similar to that in icon No. 4117, but their shape has changed, the fleur-de-lis pattern has become that of looped crosses.

Mary and the Child are flanked by two angels; each holds a drawn sword in one hand and a black or dark blue disk in the other. One would be tempted to recognize in these either orbs or patens which are attributes of angels common in Coptic and Nubian art but extremely rare in Ethiopian art. This identification, however, needs further checking.

(6) The 16th-century mural painting of the Virgin and Child in the Yediba Māryām church, Wallo, evidences a further schematization of the crown. It has become an ornamentation of the nimbus and is composed of two arabesques which hardly recall the real finials of the crown. Still it is obvious that the form derives from the European crown of the fleur-de-lis type.

There is a number of other paintings ascribed to the 15th and early 16th centuries in which Mary is represented wearing the crown. One of these is the miniature in the gospels, IES Coll. 242, described on p. 189.

These paintings do not bring in new elements for the discussion. Thus, the paintings just described allows us to draw the following preliminary conclusions:

(a) The crown adorning Mary's head appears in varied subjects showing her in the process of nursing the Child, holding the flower or stem of Jesse as well as the Child carrying the bird. The flower and bird are of European origin and therefore it would be tempting to conclude that the form of the Crowned Virgin has been brought to Ethiopia through varied channels one of these being Venice. The Italian woodcut called the Madonna of the Fire, Venice, before 1428, offers a remarkable analogy with the 15th-century Ethiopian images of the Crowned Virgin, (fig. 159).[13] This analogy includes the movement of the Child's left hand which appears in several 15th-century Ethiopian paintings influenced by Western European art. Perhaps the crown has been introduced into Mary's imagery by a foreigner who then happened to live in Ethiopia. He was possibly of Italian origin and coming from Venice. Also, the bird and the flower or 'Stem of Jesse' might be the results of his innovating activities.

[13] *A. Hyatt Mayor* in: Prints and People: a social history of printed pictures (New York 1971) writes "The woodcut is adapted from an icon like some now at Mount Sinai, of a type dating from 1180 to 1200, that must have filled Venice after she plundered Byzantium in 1204 . . . The Italian woodcutter . . . certainly crowned the Madonna, who in Byzantium transcended the frippery of jewels". The writer is indebted to *Mr. Peter J. Fetchko,* Peabody Museum, Salem, for drawing attention to the woodcut.

(b) The open crown of European type is found mainly in the portrait of Mary. Whether Ethiopians were aware of the Western concept of Mary's queenship of heaven expressed by the crown is not clear. In 15th-century paintings showing the biblical kings such as David and Solomon or the Roman emperors such as Constantine, these rulers wear ornamented bandlets on their heads. The bandlets seem to be the usual headgear of the 15th-century royalty though, exceptionally, the above kings wear the crowns composed of looped crosses, interlaces and plaitwork. It seems that the European type of crown, an attribute of kings, was then not used by Ethiopian monarchs.

(c) The form of the crowned Virgin as well as of the bird and flower proved to be ephemeral and faded away in the early 16th century. However, if the bird and the flower virtually disappeared, the crown was found now and then in the 17th and 18th-century images of Mary.

THE CORONATION OF THE VIRGIN: 16TH CENTURY

(7) The iconographic story of the coronation of the Virgin Mary in Ethiopia started in 1962 with publication of an article by Ugo Monneret de Villard.[14] He discovered a miniature in the 16th-century Ethiopian Book of Miracles of the Virgin Mary preserved at the Biblioteca Giovardiana, Veroli in Italy. The miniature represents Mary flanked by "St. John and another saint" and two flying angels who support the crown. "The crown", writes Monneret, "open and composed of three fleurons is clearly of the European type which was used in the 14th and 15th century".[15] Moreover, the angels drawn in almost horizontal pose and placed symmetrically on both sides of Mary's head seem to put the crown on it. Monneret concluded that the miniature represents the Coronation of the Virgin and that the theme is not a genuine Ethiopian one but originates from Western European art.

Monneret analyzed all possible European sources of inspiration starting with the 12th century. He excluded the early French and Italian forms in which either an angel descends from heaven in a vertical dive and brings the crown, or Christ himself crowns his mother. "In order to find the origin of the miniature", continues the Italian scholar, "one has to leave France and Italy and turn to Spain".[16] There the form similar to that in the miniature at Giovardiana was conceived in the 12th–13th century. Subsequently the form was introduced into Northern France, Flanders and Germany. The form did not really cross the Alps and therefore the Spanish form of the Coronation of the Virgin is very rare in Tuscany and central Italy. The Italian paintings of the Coronation, according to Monneret, are different from the French and German in that the angels seem to keep the crown

[14] MonCorV 167–175.
[15] MonCorV 167. The miniature was reproduced in: Ethiopia = Collana della Enciclopedia italiana ser. IIa V (1935) 51 and in: Africa Italiana 5 (1938) 81 fig. 8.
[16] MonCorV 169.

raised above the head of Mary. Moreover, the Italian crowns are more elaborate than those in the North and occasionally are of a closed type. In Germany and Flanders, the angels fly horizontally whereas in Italy the "celestial bodies move freely and take varied forms."[17]

Monneret concludes that the model which was used by the painter of the miniature at Giovardiana must be of Northern European origin. This model was not a painting by great masters since Ethiopians could hardly afford the price and in addition, its transportation to Ethiopia would have entailed great difficulties, but it was rather one of the German prints popularizing in the 15th century the main themes of Christian imagery. Monneret also answers the riddle of how the print was brought into Ethiopia. In Jerusalem there was a strong Ethiopian community which acted as a transmitting agent. Written documents also attest that Ethiopians who used to travel to Jerusalem brought with them holy pictures.

Monneret emphatically excludes the possibility of any local development, for example the painting of the Coronation of the Virgin by an European artist then living in Ethiopia. He objects strongly to "... the much abused story of Italian painters in Abyssinia like this Vito da Firenze ... or Nicolò Brancaleone ... together with a group of other adventurers searching for precious stones who were not allowed to leave the country."[18] Monneret was right in emphasizing that Brancaleon and other Italians were unlikely to introduce into Ethiopia the form of the Coronation of the Virgin which was rarely depicted in their own land. Yet, the Monneret hypothesis has two major weaknesses.

The first is that he based his theory on only one example of the Ethiopian Coronation of the Virgin, the miniature in the Book of Miracles, Veroli. The manuscript was taken out of Ethiopia several centuries ago, probably in the 16th century, and therefore the miniature is not fully representative of the developments. Monneret did not seem to consider the possibility of the existence of other paintings in Ethiopia with the same theme and therefore his conclusions should be taken as tentative.

The second weakness is that Monneret is too sceptical of Conti Rossini's theory propounding the presence of the foreigners in the 15th and early 16th century Ethiopia and their impact on her art.[19] He does not give a thought to the painter from another country than Italy who could have lived in Ethiopia and to his possible rôle in introducing the subject of the coronation of Mary. And indeed, most probably, this was the case.

A few years before Monneret de Villard wrote his article, G. Annequin discovered among the treasures of the Dimā Giyorgis church in Goǧǧām, two triptychs painted in oil by a European hand. The Coronation of the Virgin is depicted in one of the triptychs. A year after Monneret published his article,

[17] MonCorV 172.

[18] MonCorV 171.

[19] See chapter on European painters in 15th-century and early 16th-century Ethiopia in the same book.

Annequin published a short note announcing his discovery and briefly discussed the age of the triptychs and their possible maker.[20]

The following is a description of the triptych with the Coronation of the Virgin (fig. 160).

(8) Mary is depicted as a full-scale figure within an oval glory; she stands on a globe from which emerges a crescent. Her head is uncovered, instead her long hair streams onto her shoulders. She looks very young. Her naked Son sits on her right arm and with his outstretched hand "makes a typical Ethiopian gesture of offering and respect" as Annequin writes.[21] Mary wears a blue robe with a low collar and an ample yellow mantle over it. Her right leg is slightly bent while her left is straight, the position shown by the expert drawing of the folds of her robe. A large golden nimbus adorns her head. Above the nimbus, two angels hover in almost horizontal position and support a golden crown composed of three fleurons fixed on a large ring. It is evident that the painter had a good knowledge of European regalia. The angels are clad in liturgical garb, covered with green robes and golden chasubles.[22] Large bird-like wings seem to flutter.

In the left and right panels are depicted St. Gabriel and St. Michael. St. Gabriel holds a phylactery on which is an inscription in Geez, "greetings of Gabriel". St. Michael defends with his raised sword two dead people whose souls are weighted on the scale. A European landscape is shown in the background.

The painter most probably intended to define symbolically the important themes propounding the cult of Mary. He enhanced her glory as Queen of Heaven, hence the image of the coronation, then her participation in the process of Redemption, hence St. Gabriel holding the phylactery with his "salutation", and finally Mary's rôle as intercessor for humanity, personified by St. Michael.

Particularly significant is the figure of St. Gabriel which brings forth the idea of the Incarnation. In Franciscan theology founded by Saint Bonaventura, ". . . the Trinity", writes Gertrud Schiller, "was the active force which brought about the Incarnation and . . . the Incarnation of God conduces to the Redemption of man . . ." This idea is expressed by compositions in which "The Child is included and is shown carrying the Cross on his shoulder travelling down the ray of light . . ."[23] In our composition the same is expressed but in a different manner. The Child does not travel, instead he is placed on Mary's arm and naked to signify his recent birth. His gesture of submission can be interpreted as his acceptance of the redemptive mission which is expressed by the cross pegged close to the figure of Gabriel.

This interpretation is even more evident when one considers the two Dimā Giyorgis triptychs as expressing one proposition. The second triptych (see p. 404 f.)

[20] AnnLebna. The article includes photographs of the triptychs.

[21] AnnLebna 50.

[22] The same is found in German painting. In the Annunciation by the Bavarian master ca. 1450–1460, the angel is shown as an emissary clad in liturgical garments. SchillIc I 51. fig. 119.

[23] SchillIc I 45.

shows the Trinity in the upper register and Mary and the Child in the lower register. The rendering of Mary and the Child is similar in both triptychs except that in one, the Child grasps the bird with his hand. Whether he "plays with the bird" as Annequin thought[24] or his gesture has a symbolic meaning is hard to say because of the figure poorly drawn. Nevertheless, in this painting also, St. Gabriel holds the phylactery with the word of greeting written on it. The intent of symbolically representing the Incarnation is obvious.[25]

The painting is certainly made by a professional painter, though it is not a great work of art. The artist has skillfully applied the European technique and iconography to local conditions, for example, in his way of nailing the frame to the board on which he made the picture. He painted the frame with yellow colour in order to imitate the gold which he used sparingly in the picture; he was obviously short of gold paint.

Annequin believes that both paintings should be ascribed to the first decades of the 16th century because of their style and technique as well as the details of the garments and armour. This seems to be correct and would suggest the reign of Lebna Dengel during which the Portuguese Embassy visited Ethiopia. One of its members was Lázaro de Andrade, a painter from Lisbon.

Did Andrade paint the Dimā Giyorgis triptychs or did the Portuguese Embassy bring these from Lisbon? It is inferred from the Ethiopic inscription on the phylactery that the paintings were made in Ethiopia, provided that beneath the inscription there existed no Latin text. Annequin did not check this detail. The writer had the chance of inspecting the paintings in 1976 and did not find traces of overpainting of the phylactery.

The angels in the triptychs bear manifestly a Spanish (or Portuguese) characteristic according to the enquiries of Monneret de Villard. This is a good reason for assigning the paintings to Andrade aside from chronological considerations.

The discovery of the triptychs render unavoidable a revision of Monneret's hypothesis about the German origin of the Coronation of the Virgin in Ethiopia. Another question is whether the maker of the miniature at the Biblioteca Giovardiana used the Dimā Giyorgis painting as a model? This seems to be rather unlikely. The paintings differ greatly except in two main details, that is, the form of the crown and the horizontal position of the flying angels. The other problem is the dating of the paintings. The manuscript at the Giovardiana was written, according to Monneret, "in the tenth year of the reign of Lebna Dengel", which means in 1517,[26] whereas Andrade arrived in Ethiopia three years later. However, there is always the possibility that the miniature was added at a later date, as happens time and again in Ethiopia.

In conclusion, the problem of how the Coronation of the Virgin was introduced into Ethiopia cannot be solved until other 16th-century paintings are found. One

[24] AnnLebna 50.
[25] A composition which can be also interpreted as representing the Incarnation is found in the Book of Miracles of the Virgin Mary illustrated by Nicolò Brancaleon (see p. 112).
[26] MonCorV 167.

has the impression that the Dimā Giyorgis painting had little impact on Ethiopian art. The 17th-century images of the Assumption seem to have no relation to the Dimā Giyorgis paintings inspite of the common details of the crescent and the uncovered head of Mary. The 18th-century image of the coronation of the Virgin certainly derives from another model.

THE CROWNED VIRGIN: 17TH AND 18TH CENTURY

In the 17th and 18th centuries there appeared two distinct types of the crowned Virgin. In one type, the Virgin is depicted together with the Child. In another type she is without him and is accompanied instead by additional figures as will be explained subsequently.

Usually in the first type the figure of Mary is similar to that in the S. Maria Maggiore image, the only difference being the crown she wears on her head. A typical example of this type is the icon No. 4462 which was described on p. 235f. Among other rare examples are the following:

(9) The miniature (fig. 161) in the early 18th-century Book of Miracles of the Virgin Mary, British Library Or. 653,[27] illustrates her sixth miracle. An old monk, Isaac, prays to the Lord to grant him the favour of seeing his holy mother. The miracle happens. The miniature represents the moment when the Virgin appears to the monk and promises him heaven.

Mary and the Child have an aureole of flames around their heads because according to the story they appeared in a bright light. A church, typical of the Second Gondarene style, is depicted in the background. In front of the roof there is a crown. Mary does not wear the crown which is placed above the aureole, on the other hand there are no angels supporting the crown. The miniature thus combines some elements of the crowned Virgin and some of her coronation.

The figures of Mary and that of the Child certainly derive from the S. Maria Maggiore type, but the artist introduced two important changes. These refer to the pose of her hands, although Mary still carries a handkerchief, and to the Child who holds in his hand a cross on a long staff instead of a book. This pictorial juxtaposition of the cross, an instrument of the Passion, and the image of the Child, symbolizing the Incarnation, probably expresses the idea of the redeeming mission of Christ.

(10) The triptych IES Coll. No. 4326 (fig. 162) represents Mary and the Child in the central panel and two angels in the wings.

Mary watches her Son who is depicted at the bottom of the composition fast asleep. She seems to grasp with her right hand a scarf which is tied up around her breast and with her left hand makes the movement expressing either protection or adoration of the Child. Her head is covered with a white veil on which the crown is posed. The crown is of an open type but does not recall that of the 15th-century

[27] WrBM 57.

Ethiopian paintings. Jesus who seems to be a boy of a few years old has blond hair; his head rests on a round cushion, and his legs are covered with a kind of blanket. Rays spring from his head whereas there is no nimbus around Mary's.

The angels are of the European type with long hair streaming on their shoulders. They do not carry swords, instead they perform with their hands the movement which is similar to that of Mary's.

The painting is certainly inspired by, if not directly copied from, a European work. It is not easy to date it. Some indication is given by the figures of the angels, as well as by their being placed separately from Mary. Similar angels and a similar composition appear in some 18th-century images of the Virgin of S. Maria Maggiore (see p. 238–40). It seems logical therefore to ascribe our triptych to the first decades of that century.

The triptych contains a significant inscription accompanying the image of Mary which reads "Queen of Salvation". The inscription evidences the use in Ethiopia of the term queen as a title for Mary. On the whole, however, the painting is an exception in the Ethiopian iconography of Mary. Indeed, its development in the 18th century took a different turn.

Although the images of the crowned Virgin are rare in the 17th and 18th centuries, the crown has been extensively used in the paintings to express the royal dignity or particular distinction of the figures. Whenever in the paintings appear kings, biblical or other, or martyrs "who received the crown of martyrdom", they usually wear crowns. The kings and queens of Ethiopia depicted prostrate under holy personages have crowns placed close to them in order to emphasize their humility as well as their royal rank. Crowns also adorn the twenty-four Elders of the Apocalypse and 303 Fathers of the Council of Nicaea. A striking example of this new iconography is the image of King David playing on the Ethiopian lyre; he is seated on a royal chair under the royal umbrella carried by the servant and wears the Ethiopian royal crown instead of the bandlet as in the 15th-century paintings.

The 17th and 18th-century crown is different from the 15th and 16th-century open crown with fleurons. The new crown is of a closed dome-shaped type. It is composed of a large ring at the base and of the main body, either cylindrical or square, that is surmounted by a similar square or cylindrical ring at the top. Usually a small cross is affixed to the top. The crowns are always painted yellow in order to imitate gold and are richly ornamented with rows of filigree bells, lozenges, small crosses and rarely, with colourful stones. The most elaborate crown bears the pattern which seems to imitate a repoussé. Another detail of interest is the horns, small or large affixed to the top of some crowns; there are usually two horns but crowns with four horns are also found.[28] All these details are drawn with care and clearly mirror the art of Ethiopian silversmithing.

Such crowns adorn the Virgin in her 17th and 18th-century representations.

[28] High officials (eparchs) in Christian Nubia wore the crowns with either a single or a double set of horns (fragments of the mural, Faras cathedral 11th–12th century, at present in the Muzeum Narodowe, Warsaw, reproduced by *K. Michałowski* in: DinNub fig. 15). Also the dignitary depicted in the Qorqor Māryām church, Garʾāltā, wears a

THE CROWNED VIRGIN IN THE APPARITION AT MEṬMĀQ

The late 17th and early 18th century brought important changes in the iconography of the crowned Virgin. Ethiopians started to depict her without the divine Child; moreover, they included in the composition several new figures and gave to it a unique significance.

The composition is a symbolic illustration of the miraculous apparition of the Virgin which occurred annually in the Egyptian monastery of Meṭmāq during the Middle Ages until its destruction at the beginning of the 15th century by order of the Mamluk Sultan Barsbay (1422–38). The detailed narrative of the apparition is given in the Book of Miracles of Our Lady Mary and in the reading from the Synaxary of the Ethiopian Church for 21 *Genbot* (May 26). According to these, the Holy Family during its Flight into Egypt was passing through a desert; while they were resting in a certain place, the Holy Child made the following promise to his mother: "In this place", he said, "a church shall be built in thy name and in Mine. And I will make manifest therein signs and wonders, until the end of the world ...". Indeed, the monastry of Meṭmāq was built on the spot and the miraculous apparitions took place every year starting with the 21 *Genbot*, for five days. At first appeared the column of light which changed subsequently into a luminous boat in which appeared Mary flanked by two archangels, Gabriel and Michael, and surrounded by a host of angels. Subsequently the apparition evolved as follows: the twenty-four Elders of the Apocalypse, holding incense burners, the Innocents slaughtered by Herod, the holy martyrs, George, Merkurios, Theodoros and Claudius, and the Egyptian saints Anthony, Makarius, Shenute, and others.[29]

The versions referring to the apparition at Meṭmāq in the Book of Miracles and the Synaxary are not identical; for example, the former mentions by name four holy martyrs whereas the latter only three. On the whole the painters seem to prefer the Synaxary for their compositions, but they also borrow some details from the Book of Miracles. This accounts for the difference between particular paintings of the apparition; one has also to always keep in mind the possible local commentaries and the artists' own preference.

At what time did the Ethiopians start to paint the apparition?

(11) A composition in Dabra Sinā church, Gorgorā which Wilhelm Staude identified as the apparition at Meṭmāq[30] dates from ca 1683 to 1708.[31] Staude's

similar crown with horns. The 17th-century representation of the crown with horns is found in British Library, Or. 641, (King David depicted on f. 15). Horned finials decorated the crown which was made for the coronation of Emperor Yoḥannes IV, in 1872.

The article by *R. Brus,* Ethiopian Crowns = African Arts VIII 4 (1975) 8–13, does not offer much information apart from the coloured pictures of the crowns, mostly recent. None of them is ornamented with horns.

[29] CLMM 195–99; BSyn 917f., 223.

[30] StauAnt 217.

[31] According to the inscription on the western wall of the church, the murals were donated

suggestion is most probably correct, though it cannot be ascertained by the caption accompanying the painting which is hardly legible.

In the centre of the composition (fig. 163) Mary sits on crossed legs under a canopy carried by two youthfull servants. She raises her hands in the position of prayer. Her body is wrapped in a blue *maphorion* as in her S. Maria Maggiore portraits and in addition she is dressed in a red robe or trousers. She does not wear a crown.

On the left and right of Mary, the Elders of the Apocalypse are displayed. They are clad in church garments and wear church crowns. Some of them jingle the sistrums, liturgical rattles, and two of them blow the long horns. Below, there is a band of musicians; two beat the military drums *(negarit)*, one a church drum *(qabaro)* whereas others jingle the sistrums. The musicians and the servants carrying the poles of the canopy are clad in the Ethiopian manner, that is, they are stripped to the waist which is a sign of respect, and wear large and long skirts fastened with straps. Mary and the angels have a nimbus over their heads but the nimbi are lacking in the figures of the Elders of the Apocalypse and those of the musicians.

Above the canopy, this heavenly court is enhanced by a row of angels.

The main elements of the apparition at Meṭmāq are included in the composition except for the warrior martyrs who are missing in spite of their popularity in Ethiopia, and the Egyptian saints. The Elders of the Apocalypse are included and are rendered according to the well-known form in the 17th-century painting.

The painter has inevitably simplified the narrative and added a local commentary to it. He has dramatically expressed the glory and solemnity of the apparition which in his mind he equated to a great church ceremony. The climax of the Ethiopian ritual is the dance of priests accompanied by the beating of drums and the jingling of sistrums. The Dabra Sinā painter transposed this ritual into the narrative of the miracle at Meṭmāq. The 18th-century painters followed the idea and elaborated it further.

by a certain *Wayzaro* Malākotāwit. StauAnt 228, identifies her with the concubine of Emperor Iyāsu I. Malākotāwit was associated with Iyāsu around 1683–1684. When other concubines took her place she instigated her son by Iyāsu to kill his father in 1706. After the death of the parricide Takla Hāymānot, Malākotāwit was punished by hanging for her crime in 1708. The identification of Malākotāwit given by the inscription with the concubine of Iyāsu I is quite probable considering the style and iconography of the murals. On the other hand, the identification of Malākotāwit with the daughter of Emperor Susneyos, as local tradition has it was accepted by the editors of the AOI 368; R. E. Cheesman, Lake Tana and the Blue Nile; an Abyssinian quest (London 1936) 383; O. Jäger, Antiquities of Northern Ethiopia (Stuttgart 1965) 63. For the iconographic and stylistic grounds this identification seems to be incorrect. The reason why the daughter of the Emperor was substituted for the concubine is easy to understand. The former was a pious daughter of a ruler and the wife of a nobleman who opposed the submission to the Roman creed, while the latter proved to be a murderess and perished by a shameful death. Therefore even her memory had to vanish; the true story of the building of the church has been concealed and a new one was invented and perpetuated.

The composition seems to be an early, perhaps initial, attempt at rendering the apparition at Meṭmāq. The early 18th century brought substantial alterations to the image as conceived by the Dabra Sinā painter and set up the form which was used until the 20th century.

The following is a description of the major works:

(12) A large triptych IES Coll. No. 4144 (fig. 164) represents according to the caption Our Lady Mary at Meṭmāq (literally "in/at Metmāq for Our Lady Mary").

The painter made, as usual, his own commentary to the narrative; he reduced some categories of the vision and added new ones. He probably did not think it necessary to frame the vision in a boat. The concept of a boat,well-rooted in Egyptian mythology Pharaonic as well as Coptic, is virtually unknown to the highlanders of Ethiopia.[32] The painter has replaced the boat with an arch probably following the text of the Synaxary in which Mary "was seated upon light in a circle, in the church which was built in her name. She was enveloped in divine light, and there were standing round about her all the hosts of the angels and archangels ..."[33] He has also depicted the angels on both sides and above this arch.

The translucent green, red and yellow background surrounded by the yellow band effectively produces the impression of luminosity and thus the feeling of the narration (Mary appears in robes of fire, and green or blue robes alternatively) is well rendered. The twenty-four Elders who in Ethiopian painting usually accompany the Holy Trinity and the Holy Innocents, appearing in the illustrations of the gospels have been left out. On the other hand, the painter kept the martyrs and placed them in the lower register of the right panel. They "bow to her", according to the caption. Indeed, the martyrs have dismounted from their horses and lie prostrate in front of Mary. This rendering of the warrior martyrs follows the text of the Synaxary explaining that "St. George descended from his horse, and two others came and bowed before her."[34] They are easy to identify by the colours of their horses, St. George having the white horse, St. Merkurios the black and St. Theodoros the red one. Opposite the martyrs, on the lower register of the left panel, the angels also "bow to her", according to another caption. The faces of the martyrs as well as of the angels, especially their large eyes, seem to express prayer, worship and perhaps awe.

In the upper registers of both side panels, the crowd of priests and nuns pay homage to Mary; they perform the ritual by song, beating of drums and jingling of sistrums. The priests are clad in sumptuous robes of red and black, with colourful togas, the Ethiopian šammā, tied around the waist and covering the left shoulder according to the old Ethiopian expression of respect. They wear caps and turbans in varied colours obviously identifying different sections of Ethiopian monas-

[32] There are reed boats on the Ṭānā and Zewāy Lakes and these are occasionally depicted in the 18th-century miniatures.

[33] BSyn 917. The arch framing Mary's image is found in the wall painting, Sandābā Iyasus church (fig. 130) and triptych IES Coll. No. 3805 (fig. 131).

[34] BSyn 917.

ticism. Following 18th-century technique, the painter has skillfully arranged the tops of the heads into rows to create the effect of a crowd. He has also placed the irises either on the left or on the right or in the middle of the eyes to express the movement and rapture of the scene. All this is a genuine Ethiopian expression of the Egyptian miracle.

In the central panel, Mary is flanked by two sword-bearing angels, no doubt St. Gabriel and St. Michael. Mary makes a sign of benediction with her right hand and holds an ornate handkerchief in her left, a detail obviously borrowed from her portraits of the S. Maria Maggiore type. This conspicuous handkerchief does not refer to the miracle which happened during the apparition as explained on p. 352 The elaborate garment of the Virgin is composed of a scarlet robe with a low collar, and an ample dark blue mantle, the Ethiopian *kāppā,* trimmed with gold lace. This superbly drawn mantle was obviously made of very precious material. The Virgin wears a crown typical of the Second Gondarene paintings and is rendered with a great attention to details. The green veil placed under the crown reflects the ceremonial attire of Ethiopian sovereigns. A similar crown was carried in front of Emperor Iyāsu I, during the royal procession according to the 18th-century miniature (IES Coll. Ms. No. 315). However, the crown of Iyāsu has a domed top while Mary's crown has a flat one. The crown is ornamented with pieces of jewellery, some red, perhaps rubies, and some green, perhaps agates and a fine set of balls hanging around its lower rim. The cross, equally decorated with precious stones, tops the crown. There is strong reason to believe that this crown was painted from observation and thus reflects the regalia of the 18th-century queens of Ethiopia. Indeed, it is reported in the royal chronicle of Emperor Bakāffā (1720–1730), that during the coronation of Queen Awāldā Nagaśt, the Emperor put on her head the "crown of precious stones".[35]

In the portrait, the Virgin wears, in addition to the crown, two golden necklaces, one in the form of a colourful ring and another composed of sets of large and small balls fixed together and attached to a string. The second necklace is easy to identify as an ornament common even nowadays in Tegrē and the Bagēmder provinces of Ethiopia. This addition of the jewellery does not agree with the texts of lauds of Mary, a popular devotional work in the Ethiopian Church and frequently recited by the faithful. The lauds describe in adulatory manner different parts of Mary's body. Referring to her neck, the poem praises it as follows: "Greetings to your neck, shining with purity, not like one of earthly girls with gold and silver ..."

The realistic rendering of details in the Virgin's portrait is equal to the same in other parts of the composition. The colourful dresses of the martyrs, angels and clergy reflect imported precious textiles, perhaps Indian, of 17th and 18th-century Ethiopia; the bridles, the ornamented double collars, the saddles with high pommels and Turkish stirrups, represent gorgeous horse trappings of Ethiopia, while drums and sistrums recall the musical instruments used during church ceremonies. In this triptych, then, the Egyptian narrative of the miracle at Meṭmāq has been

[35] CSCO 23 (1903) 305.

substantially transformed into the Ethiopian idiom. Moreover, the portrait of Mary reflects the particular situation of Ethiopian history. The Virgin, in Ethiopian art is virtually always dressed in foreign fashion. The most common piece of her garment is the blue mantle, a Syrian *maphorion,* covering her head and almost completely wrapping her body. In the 15th century, exceptionally, we find Mary clad in the Renaissance manner with her head uncovered and a ribbon or a narrow tiara supporting her hair. In a few 17th-century portraits, her head is also uncovered and she wears a large loose robe with a mantle covering her knees and shoulders, but this is an obvious imitation of the Baroque Madonnas. The portrait in the triptych No. 4144 brings a dramatic change in the rendition of the Virgin. One has the feeling that this image of the beautiful lady wearing the Ethiopian crown and jewellery and dressed in gorgeous garments of the Gondarene court, is in fact, a royal portrait, and perhaps the pictorial flattery of the painter, possibly one of the Church clerks, a *dabtarā,* always prone to adulate the mighty of this world. This painting seems to have a double meaning, as in classical Ethiopian "wax and gold" poetry enjoyed at the Gondarene court,[36] and is in fact, the glorification of an Ethiopian queen, perhaps of Mentewwāb herself (see footnote 44, p. 241), disguised as the Virgin. Her fine but mature face with her sensual tiny mouth, narrow nose and enormous eyes represent the Ethiopian concept of feminine beauty. The modelling is delicate and soft, but the image, as a whole, presents the full characteristics of the Second Gondarene school. In spite of her apparent gentleness, the lady's eyes are inquisitive and dominating. Yet, the very refinement of the features modelled on an ideal observed in human faces, re-presents a kind of humanization of the theocratic formulas of the Byzantine tradition in accordance with the fusion of divine and mortal beauty that typifies the Second Gondarene art.

The above analysis allows us to date the painting with some precision. It belongs to the most flamboyant form of the Second Gondarene style. Its technique shows excellent workmanship of the ateliers in the capital, while the translucent colours recall the quality of stained glass, both characteristic of the early period of the Second Gondarene school. Therefore, the triptych should be ascribed to the third through the fifth decade of the 18th century.

(13) The miraculous apparition at Meṭmāq is also represented in the Book of Devotional Pictures IES Ms. No. 315 (fig. 165) which was most probably produced a few decades following the death of Iyāsu I in 1706. In concept and treatment of details, the miniature is similar to the icon No. 4144 except for the general arrangement of the figures.

Mary's portrait still occupies the central position and is almost identical to the one in the icon; the only difference is that Mary rests on a large sofa which is an

[36] *Qenē,* the traditional Ethiopian poetry. *E. Cerulli,* Canti populari amarici = Rendiconti della R. Accademia dei Lincei 25 (1916) and La letteratura etiopica (Milano 1968) 165–69; *D. N. Levine,* Wax and Gold; tradition and innovation in Ethiopian culture (Chicago 1965) 5–9; *J. Doresse,* La vie quotidienne des Éthiopiens chrétiens aux XVIIe et XVIIIe siècles (Paris 1972) 193–96.

obvious borrowing from her 18th-century portraits of the S. Maria Maggiore type. Two groups of angels are placed on both sides of the arch; on the left, a "crowd" of them is expressed by the usual Second Gondarene technique of drawing rows of crowns of heads. On the right three angels are depicted. The angels are clad in short tunics particular to 18th-century paintings and long robes with sinuous folds. The multicoloured wings are folded and decorated with dots according to the Gondarene fashion. In each group, one angel seems to play a small flute, thus enhancing Mary's glory with celestial music. This is a new interpretation of the idea of "blowing horns" which is dramatically expressed in the Dabra Sinā mural.

In the lower register of the miniature, the prostrate martyrs pay homage to Mary as in icon No. 4144, while the clergy perform the ritual of dancing and singing.

The dance of priests is rendered differently. In the middle, one priest or church clerk beats the drum and another, on the left jingles a sistrum and gesticulates with an Ethiopian prayer-staff, a *maqwāmiyā*. A young deacon or nun assists the above priests as is usual in church ceremonies. The local colour of the scene is enhanced by robes, caps and bandlets of the performers, obviously rendered from observation.

(14) Another image of the "Dabra Meṭmāq" (fig. 166) is found in the Psalter, British Library Or. 538, "written in a good hand of the 17th century or beginning of the 18th century". However, its pictures are evidently "of later date than the Ms".[37] Indeed, the painter filled with illustrations the space left by the scribe long after the book was written. This procedure is often followed whenever the manuscript changes owners. In the case of the Psalter, which is a common prayer book in Ethiopia, probably a new owner, a noble lady, had it embellished with holy images and a picture of herself depicted under the figure of Mary. Unfortunately, the illegible caption does not allow to identify her. Nevertheless, her dress suggests the third to fifth decade of the 18th century as a possible date of the miniature.

The painter followed the schema similar to that in the icon No. 4144 and the manuscript No. 315, though in simplified form. He included the main elements of the apparition, namely Mary, angels, dancing priests and martyr saints with their horses and he displayed these harmoniously around the arch. He also depicted the blowing of horns performed by three angels. It should be recalled that in the 18th century, impressive compositions of the Last Judgement and Second Coming of Christ appeared in Ethiopian painting and in some of these, angels blowing trumpets are shown. Perhaps the painter of our miniature has taken the idea from these paintings and has introduced the apocalyptic horns into the image of the Egyptian miracle.

(15) Among the miniatures of the Book of Miracles of the Virgin Mary, Abb. 114, Bibliothèque nationale in Paris (see p. 297), there is one representing her miraculous apparition at Dabra Meṭmāq (fig. 167). The painter followed the previously described compositions but left out the crowd of singing and

[37] WrBM 77.

dancing priests and monks; indeed, merely four angels with raised swords compose Mary's heavenly court. He depicted on the left side of the lower register two martyrs, George and Merkurios instead of the usual three. On the right side, the busts of the Holy Innocents emerge from woolly clouds.

The miniature is rather crude but interesting because of the inclusion of a new subject, the "children whom Herold slew". They are not shown "lamenting before her" and they do not leap up and embrace each other as described in the Synaxary[38] but rather "keep close arm to arm" as explained in the Book of the Miracles of the Virgin Mary.[39]

(16) The two compositions of the miracle at Meṭmāq in the Book of Prayers of the Virgin Mary, Ms. or. Rüpp. IV 1, painted ca 1750 (footnote no. 81 on p. 64) contain the subjects which seem not to appear in works prior to that date. The subjects are the Virgin who drops a handkerchief and a man sitting on a camel (fig. 168a and b).

Mary is depicted in the right folio; she is similar to the one in previous paintings. She also holds a handkerchief in her left hand in accordance with the Gondarene fashion. Additionally, another handkerchief falls from her raised hand. We witness then in this miniature the graphic representation of the miracle which took place at Meṭmāq as narrated in the Book of her Miracles. The faithful watching the Mary's apparition used to throw hats, veils and handkerchiefs towards the cupola of the church. One year a poor maid threw her handkerchief towards the Virgin who took it in her hand. Others through jealousy said that it was not Mary who had the handkerchief but that it simply got attached to one of the nails of the cupola. The Virgin, in order to prove the miracle, three times unfolded the handkerchief and threw it back to the maid.[40] Our miniature illustrates that very moment.

In the left folio, the narrative evolves in two registers. In the upper register, the equestrian saints have dismounted their horses and worship the Virgin. In the lower register, a group of priests performs a ritual dance. On their right, a man sitting on a camel is depicted. He is chained to the beast and his face is drawn in profile. According to the inscription the man is called *Muḥammad*. Who is he? The answer is given by the similar figures which occasionally appear in Ethiopian 19th and 20th-century church paintings, for example in the paintings, Dabra Berhān Sellāsē church. Gondar (footnote no. 65, p. 134).

The painter-priest Kāsā of Gondar who wrote the rules of painting (p. 22) explained the apparition at Meṭmāq as follows. Mount Meṭmāq is situated close to Jerusalem. Every year the Virgin Mary descends from the Mount and appears for five days to the Christians as well as the Moslems. She also orders to bring the Prophet Muḥammad from hell in order to show his fate to his followers. He appears sitting on a camel and tied to the beast with "chains of fire".[41]

The figure of the Prophet in the imagery of the apparition at Meṭmāq is neither

[38] BSyn 917.
[39] CLMM 197.
[40] CLMM 198f.
[41] StauReg 262.

justified by the Synaxary nor by the Book of Miracles. He has been depicted because of the great bitterness towards Islam of the Christians of Ethiopia in general and the people of Gondar in particular. The centuries old struggle with the surrounding Moslem states and especially the wars with Aḥmad Grāñ left lasting scars in the Ethiopian landscape. During the 19th century the Northern Highlands were invaded by the Egyptians, whereas Gondar was burned and looted by the Mahdists of Sudan. Since then it was customary in the churches of Ethiopia to depict the Prophet riding on a camel, naked and rendered in a particularly obscene manner.

The theme of Muḥammad has already been related to the apparition at Meṭmāq in the 18th century. In the manuscript, Fonds éth. No. 144, Bibliothèque nationale, Paris, dated to that century, there is a homily on the miracle in which the Prophet is mentioned.[42] In our miniature his rôle is graphically translated into colour and design.

ORIGIN AND SIGNIFICANCE OF THE ETHIOPIAN IMAGE OF THE MIRACLE AT MEṬMĀQ

Where did the Ethiopian image of the miracle at Meṭmāq originate from?
(17) There is always the possibility of foreign influence. Indeed, among the illustrations ascribed to Brancaleon in the Book of Miracles of the Virgin Mary, Tadbāba Māryām (p. 393) there is a representation of the apparition (fig. 169). The Italian has chosen a moment when the Virgin proved the reality of the miracle by throwing the handkerchief to the poor girl.

Mary is seated on a throne above the roof of the church; hosts of angels hover on both sides, the Elders of the Apocalypse sway the incense-burners and the female and male saints worship her. Below, the crowd gesticulates violently. On the left, the girl is maltreated by the youths who are striking her, in the middle she stands surrounded by the friendly believers who acknowledged the miracle and, on the right, the priests seem to discuss the event among themselves. Four horses, amidst the crowd, certainly belong to the equestrian martyrs cited in the Synaxary. They have dismounted the horses, but it is not evident which figures represent the martyrs.

Brancaleon had painted his version of the miracle at the beginning of the 16th century whereas the earliest known Ethiopian representation of the subject dates from the end of the 17th century. If the drawing by the Italian was the prototype of the latter, many changes would have been carried out during the two centuries which elapsed in between. This would account for the difference in the general plan and in most of the details. Another answer which the writer believes to be more probable is that the 17th and 18th-century representations of the apparitions have been composed by Ethiopians themselves. The apparent similarity between

[42] StauReg 298.

Brancaleon's drawing and the Ethiopian paintings is explained by their common literary source. The fact that in triptych No. 4144 the Virgin holds the handkerchief in her hand does not necessarily imply the intention of its maker to depict the moment of the miracle chosen by Brancaleon. In the 18th-century painting, the handkerchief was a standard attribute of such a great variety of personages that it had lost any particular significance.

The theme for the pictorial representation of the apparition has been taken from the readings in the Synaxary and the Book of Miracles but there is no relation to Coptic art and life in spite of the Egyptian origin of the story. At the time when the Ethiopians were composing their image of the miracle, the monastery of Meṭmāq was in ruins and the miraculous apparition discontinued for over three centuries. Why then have the Ethiopians become interested in the vanished Egyptian tradition? There is no clear answer to this. The Synaxary and the Book of Miracles had been known to Ethiopians for centuries and therefore it must have been an added incentive to depicting the miracle. Perhaps some indication is given by the fact that the Flight into Egypt and events related to it have always been alive in Ethiopian religious thinking. The story of Mary's life, *Nagara Māryām*, which includes an extensive narrative of the Flight into Egypt and the description of miracles then performed by the holy Child, was for the first time illustrated by Ethiopians in the 18th century, though the text had been translated into Ethiopic four centuries before. The miracle at Meṭmāq is related to the Holy Family's stay in Egypt, though not described in the *Nagara Māryām*, and belongs to the extensive 18th-century pictorial cycle illustrating Mary's travel to Egypt.

We are able to follow in the apparition at Meṭmāq the process of translating the literary text into the pictorial image, which is a rare occurrence in Ethiopian painting. Starting from the text, the Ethiopians simplified the narrative and eliminated some details, probably because these did not appeal to or agree with them. Then the painters adapted the narrative to the Ethiopian religious climate and life; hence the substitution of the Elders of the Apocalypse by dancing priests and church clerks. Finally, the painters added a new element not found in the text but which heightens the feeling pervading the image: the crown on Mary's head.

* * *

The apparition at Meṭmāq singles out a final stage in the development of the iconography of the crowned Virgin. To sum up, the crown had been introduced into Ethiopian painting from the Western art of the 15th century and was used as a component part for varied images of the Virgin and Child. Thus Mary wears the crown while she feeds the Child, holds a flower and the Child plays with a bird. Did Ethiopians consider the crown an important element of Marian imagery and give it a theological significance? Did the Western idea of Mary, Queen of Heaven, as conceived by Mediaeval mystics, penetrate into the Ethiopian highlands together with the image of the crowned Virgin?

The 15th-century paintings do not allow such an interpretation. A simple formula which runs, "Our Lady Mary with her beloved Son" was invariably used as

a caption to her images. The expression "Queen" or "Queen of Heaven" has not been noted. Moreover, the crown in Ethiopian iconography of Mary fell into oblivion shortly after the 15th century. The conclusion is that either Ethiopians did not know the mystic meaning of the crown in relation to Mary or did not consider it particularly important.

In the 17th century the portraits of Mary wearing the crown are scarce.

In the 18th century the crowned Virgin reappeared, this time as a main figure in the apparition at Meṭmāq. This composition is not a plain expression of the Western symbolism of the *Virgo regina*. The crown on Mary's head enhances her glory but remains secondary to the main theme of the composition, which is re-enacting through the image, the reality of the miracle at Meṭmāq. The crown adds nevertheless, a new dimension to the glorification of Mary. The Ethiopian painters most probably proclaimed Mary's royal dignity but expressed this with their own idiom adorning her with the crown worn by Ethiopian monarchs.

THE CORONATION OF THE VIRGIN: 17TH AND 18TH CENTURY

The subject of the Coronation of the Virgin is rarely found in the 17th-century paintings. The wood carving described on p. 236 gives the impression that its maker had little understanding of the form and copied the model which had lost much of its iconographic definition.

W. Staude recognized the Coronation of the Virgin in the wall paintings of the Dabra Sinā church.[43] His identification, however, is not certain since he was not able to take a picture of the painting, and did not explain what it looked like. The writer did not find the subject in the photographic record of the Dabra Sinā church in his possession.

In the 18th century a new form of the Coronation of the Virgin appeared, as the following paintings illustrate it:

(18) In the miniature (fig. 170), Ms.or. Rüpp. IV 1 (see no. 16), Mary is seated on a comfortable sofa. She has her hands piously crossed on her chest. A large bejewelled crown placed on her head is supported by two persons of the Holy Trinity, the Father and the Son, represented in the Ethiopian manner as two old men, while the Holy Spirit rendered as a white dove seems to emerge from the back of the crown and hover over it. In the lower register, the prostrate female figure represents Sinā Aser, wife of the owner of the manuscript.

(19) Two large wall paintings were executed around the year 1800 for local rulers and their wives in the province of Tegrē. One of them (fig. 171) is found in the Māryām Pāpāseyti church, Garʿāltā; at the bottom of the painting its donor, *Bašā* Dengyes, governor of that district during the time of *Rās* Walda Sellāsē[44] and his wife *Emabēt* Harit [Hirut] are depicted. The second painting (fig. 172)

[43] StauReg. 215.

[44] Ruled Tegrē from 1788 until 1816. He encouraged commerce and received the first British mission to Ethiopia in 1804 and 1810.

found in Čalaqot Sellāsē church, shows at the bottom either *Rās* Walda Sellāsē
or more probably someone of his family.

The captions accompanying the paintings explain that these represent the
"Blessing of Mary", though, in fact, their iconography is that of the Coronation of
the Virgin.

In both paintings the rendering of the theme is similar to that in the miniature
No. 18, except the crown which in Māryām Pāpāseyti painting is held high above
Mary's head and in both the details of ornamentation are elaborate. In Māryām
Pāpāseyti, Mary is clad in a sumptuous red robe made of brocade in rosette pattern
with a collar braided with gold and gold buttons; a cross on her mantle covering her
forehead and an unusually large star on her right shoulder add still more glamour
to this glittering portrait of the Virgin. Similarly ornate is her mantle in the Čalaqot
portrait which is decorated by two stars and two trinkets on either side of it. There
is no doubt that the miniature and both wall paintings originate from the common
prototype.

(20) The Synaxary in the Vatican Library, Aeth. Cer. 193, is tentatively dated to the
late 18th or early 19th century.[45] It contains three drawings (173a, b, c)
executed by an unskilled hand; these epitomize the evolution in the icono-
graphy of Mary during the 18th century.

In two drawings (fig. 173a and b) Mary is seated on a large and ornate armchair
or bed which evidently is meant to represent her "throne". She has her hands
crossed on her chest; in one drawing she holds in her hands a handkerchief and a
small ball (fig. 173b); the ball is meant to represent an orb symbolizing the rule
over the cosmos. The Ethiopians usually associate an orb with either the figure of
Christ or other persons of the Holy Trinity. In this drawing this "power" of the
Trinity is symbolically transferred to Mary.

In one drawing there is a narrow nimbus over the head of Mary; the nimbus is
ornamented with crosses arranged all around its rim. In the second drawing there is
a large nimbus over her head but no nimbus in the third drawing.

The full meaning of these images is expressed by figures delineated behind and
over Mary's head. In the first drawing (fig. 173a) two angels support a screen and
one of them additionally holds a sword. The screen obviously originates from the S.
Maria Maggiore image.

In the second drawing the angels support a canopy, an Ethiopian *dās,* with two
poles and one angel holds a sword (fig. 173b). Canopy, swords and screen imply the
royal dignity of Mary. In the third painting (fig. 173c) Mary is flanked by two
Persons of the Holy Trinity, probably the Son on her right and the Father on her
left, holding an orb in one hand. Both Father and Son support a large crown over
the head of Mary whereas the Holy Spirit symbolized by a brown bird dives
towards it.

Ethiopians believed in the royal descent of Mary from the house of David as
attested by the Protoevangelium of James and other apocrypha. In paintings of the

[45] The writer is indebted to *Dr. Osvaldo Raineri* for drawing his attention to the manuscript
and help in dating it.

15th through the 18th century, this royal distinction was probably given the visual expression by depicting the crown on Mary's head but the concept of the *Virgo Regina,* Queen of Heaven, penetrated at last into Ethiopian art together with the figuration of the "Blessing of Mary". The compositions showing her seated between God the Father and her Son holding either a crown of flowers or a royal crown over her head while the Holy Ghost in the form of the dove hovers above are common in the Roman Catholic art of the 17th and 18th centuries. The paintings in the Māryām Pāpāseyti and Čalaqot churches as well as the miniature in Ms.or. Rüpp. IV 1 and the drawings in Aeth. Cer. 193, originate from the European model. Where exactly this model came from and how it reached Ethiopia is not known. The turn of the 19th century marks the end of Ethiopia's isolation and her relations with Western Europe became more friendly. In the 18th century the Catholic missionaries persistently though unsuccessfully tried to get a foothold in Ethiopia. Consequently, there were occasions for introducing into the country devotional pictures of Mary; one of these might have represented her in her celestial glory which would have pleased Ethiopians always eager to promote the cult of Mary.

CONCLUSIONS ON THE ICONOGRAPHY OF THE VIRGIN MARY IN ETHIOPIA

The preceding description of varied iconographic forms of the Virgin Mary from the 13th until the 19th century shed some light on her cult in Ethiopia.

There is no doubt that the way the painters depicted Mary and related her portrayal to other subjects mirror her overwhelming rôle in the religious life and thinking of the Ethiopians. Their paintings evidence a dual aspect of this cult of Mary. One aspect is the definition of her position in Ethiopian theology; the other aspect is an expression of Ethiopian religiosity, namely the rôle of her images in everyday Ethiopian life.

The place of Mary in dogma was expressed by her attributes; she was called Theotokos, the God-bearer, and also the twofold Virgin, on account of the Incarnation and the virginal birth of Christ, and finally she was Mary of compassion because of her power of intercession. These expressions were often used in religious texts but virtually never in the captions of the paintings. Nevertheless, the essential bond between the Virgin and the process of salvation of man has been manifested in paintings by a joint representation of the mother and her divine Son. The Ethiopian painting has the Blessed Virgin virtually always represented with the Child and the accompanying caption, "This is the picture of Our Lady Mary and her beloved Son" stresses the theological foundation of her images. The popularity of Mary derived from the deep humanity inherent in the exaltation of her divine motherhood. To the best of the writer's knowledge, there are very few Ethiopian pictures of Mary prior to the 17th century in which the Child is missing. This probably was the reason for the interpretation advanced by Tewelde Beiene, a Catholic monk of Eritrean origin, that "the Ethiopian

traditional painters rejected any representation of Our Lady Mary in which Christ, particularly the Christ-Child did not appear on her side". This is, he explained, because the Ethiopian devotion to the Virgin Mary is basically Christocentric and "the intrinsic value of Ethiopian painting is not only the essence of colours but also of ideas".[46] A similar opinion was expressed by another Catholic monk from Eritrea, A. G. Hailù who added that "the personality of Mary by itself in these [Ethiopian] paintings did not appear; the only reason for her existence was her divine maternity, and therefore nothing is shown [in the painting] which belongs to the life of Mary prior to this maternity."[47]

These suggestions are on the whole confirmed by detailed study of Ethiopian Marian iconography. A. G. Hailù rightly noted that Mary's life prior to the Incarnation has rarely been depicted by Ethiopians, and virtually never before the 18th century. The earliest pictures of the young Mary's arrival to the Temple date from that century, and on the whole are rare.

Whether this limited interest in Mary's early life shown by Ethiopian painters was due to religious considerations or because of the lack of foreign models is hard to judge. The apocryphal story of Mary's miraculous birth and childhood was known in Ethiopia long before the first illustrations of it appeared.

Another example of the growing interest in the life of Mary is the subject of the Dormition and the Assumption. Both events were commemorated in the Ethiopian Marian calendar long before they appeared as a subject of painting in the 16th century. Ethiopians started to depict the Dormition a couple of centuries later than the Byzantines. A full cycle of the Dormition was developed as late as the 17th century. This was probably due to the availability of foreign models.

The images of the apparition at Meṭmāq and the coronation of the Virgin epitomize her glorification in Ethiopian art. At the time when these triumphal images were painted, the iconographic tradition of depicting the Blessed Mary in full glory was many centuries old. The earliest portrait of the Virgin in church murals known to us, the Qorqor Māryām painting, shows her enthroned whereas the earliest miniature shows her under a canopy of wings of the guardian angels, and is dated to the late 14th century. The 15th century brought the dramatic change in the subject-matter of Ethiopian painting, Mary's imagery clearly dominating it. Her portraits are found in a number of frontispieces of illuminated manuscripts including gospels and psalters. In paintings on wood, Mary appears frequently along with St. George. In triptychs, she is virtually always painted on a central panel and usually accompanied by Apostles, Prophets and hosts of angels, as well as equestrian saints. In the 16th century, the iconographic order in the triptychs had finally been set up, with Mary and the Child being placed on the main panel, the Descent into Limbo on the left panel and the Crucifixion on the right, and the equestrian saints below, with an addition of local saints or even scenes from the

[46] *Tewelde Beiene [= Tawalda Bayyana]*, Spiritualità francescana e spiritualità etiopica = Adveniat regnum tuum 28 (1974) 12.

[47] *A. G. Hailù [= Gabra Iyasus Ḥāylu]*, L'idea di Maria corrdentrice nell'arte etiopica = L'Illustrazione Vaticana 5 (1935) 251.

gospels. In all triptychs, the figure of Mary is much larger than any other figure, thus evidencing her privileged position in the spiritual hierarchy. In the 17th century, while the basic arrangement remained the same, new kinds of images of Mary appeared, such as her standing on a crescent and surrounded by hosts of angels. In other images Mary was represented standing or sitting beside Christ who bestowed on her the power of intercession. In the same century a sequence of subjects in church murals was set up and a place of distinction given to Mary. She was painted on the right side of the entrance to the inner sanctuary whereas St. George was on the opposite side.

The 18th century, particularly the first half of it, marks a further glorification of the Virgin in painting, perhaps bordering on mariolatry. In some of the triptychs, the Descent and the Crucifixion were replaced by figures of angels, and thus Mary became the sole focus of worship. Still, she holds the Child in her arms. He does not appear anymore in the images representing the miracle at Meṭmāq. Instead, the imagery of Mary is heightened to the point of producing a dazzling effect. She is neither depicted as a mother of God, because the Child is missing, nor as interceding for mankind. She is surrounded by angel guards taking the place of human witnesses and her glory is epitomized by the might, beauty and bravery of her court, heavenly as well as earthly. Finally, the compositions in the church of Māryām Pāpāseyti and of the Čalaqot Śellāsē evidence the peak of the cult. The divine Triad, God the Father, the Son and the Holy Spirit, bestow on her a royal "blessing" and thus in pictorial expression, she is made the central figure of the Ethiopian spiritual hierarchy. This meant that in the religious practice of the Ethiopians, it was to her and through her that their prayers were to be made. Mary is the most effective intercessor and protector according to the promise given her by the Son. The reality of this solemn covenant was insured by its representation in painting (fig. 174). The image of the Convenant of Mercy developed during the 17th century has been popularized during the subsequent centuries by a great many copies.

Thus, this immensely rich iconography of Mary is a visual expression of her fervent cult pervading the life of traditional Ethiopia.

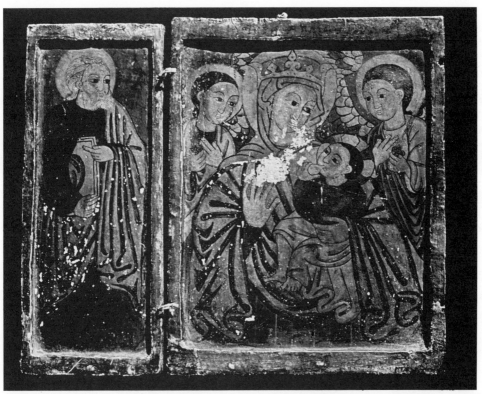

155. Triptych, 15th century. 22,0 : 18,2 cm. IES Coll. No. 4117

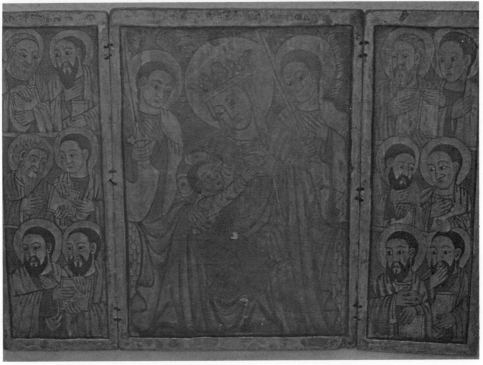

156. Triptych, 15th century, 28,3 : 20,5 cm. The Brumit Coll. No. 1

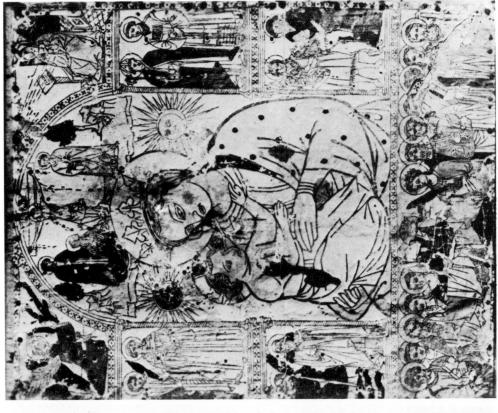

159. The Madonna of the Fire; hand-coloured woodcut, Venice, before 1428

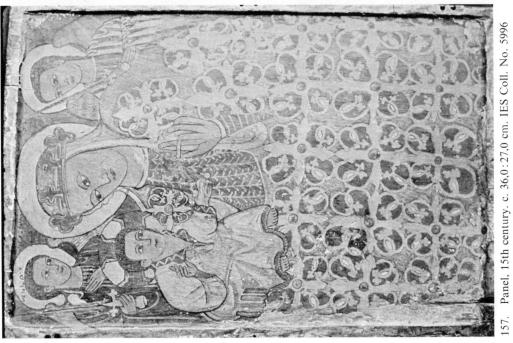

157. Panel, 15th century. c. 36,0 : 27,0 cm. IES Coll. No. 5996

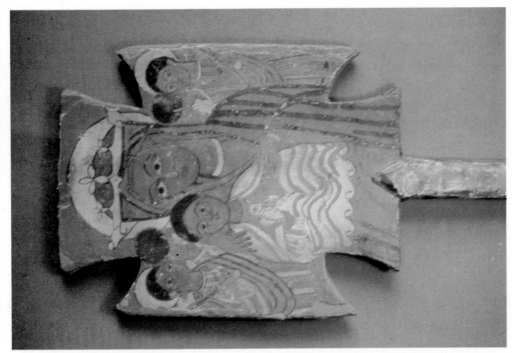

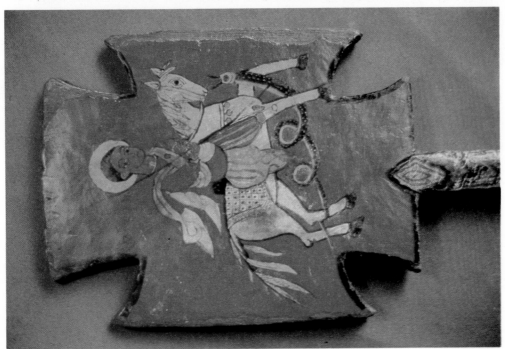

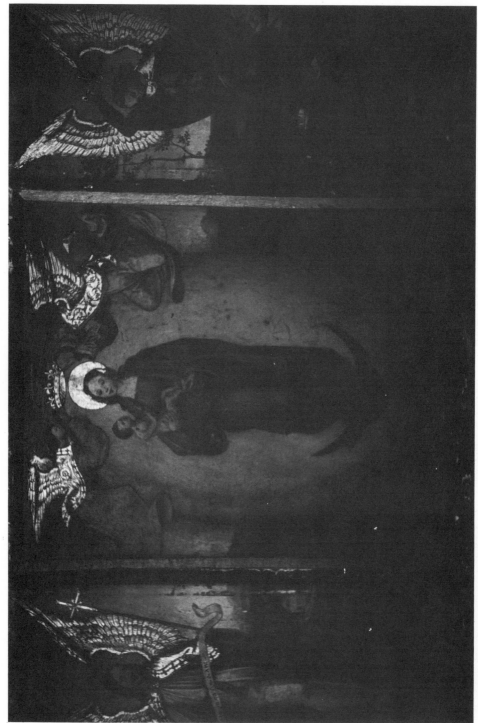

160. Triptych, early 16th century. Dimā Giyorgis, Goǧǧām

163. Wall painting, c. 1683–1708. Dabra Sinā, Gorgorā

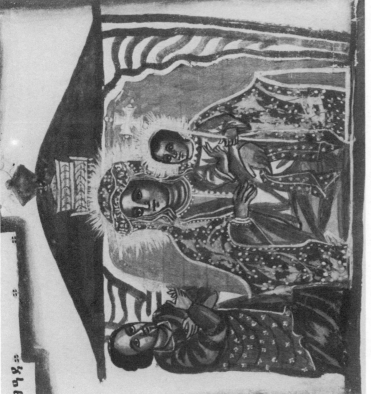

161. Miracles of the Virgin Mary, early 18th century. 33,8 : 31,3 cm. British Library Or. 653 (fol. 17v)

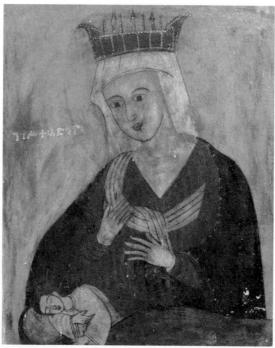

162. Triptych, 18th century, 31,2 : 23,0 cm. IES Coll. No. 4326

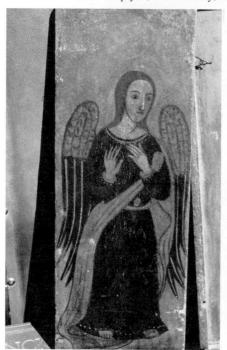

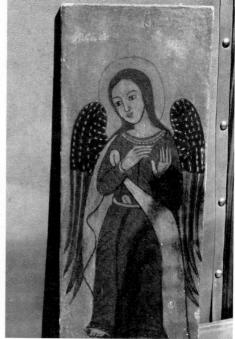

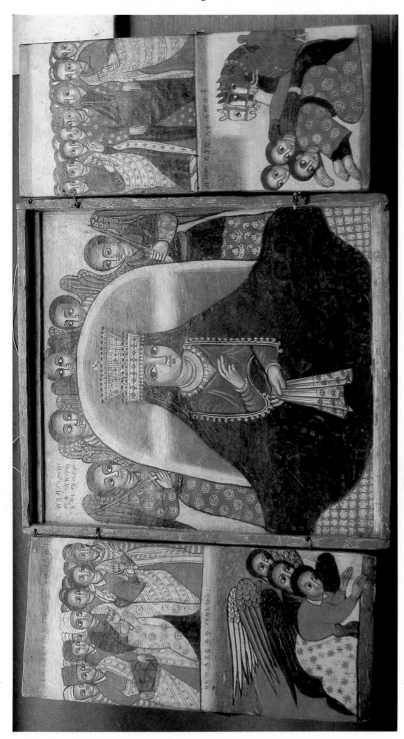

164. Triptych, c. 1730–60, 36,2 : 32,3 cm. IES Coll. No. 4144

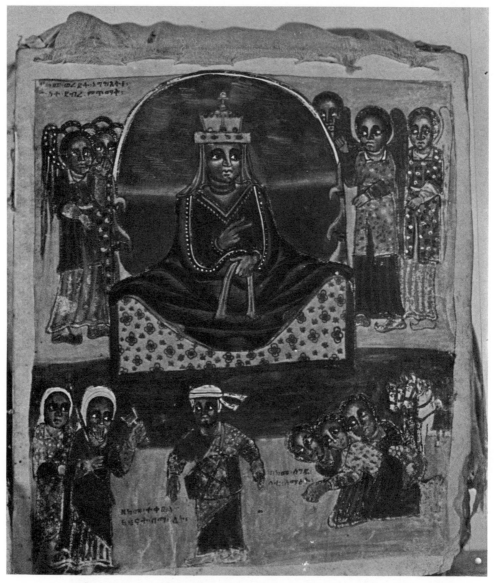

165. Book of Devotional Pictures, 18th century. 37,0 : 31,5 cm. IES Ms. No. 315

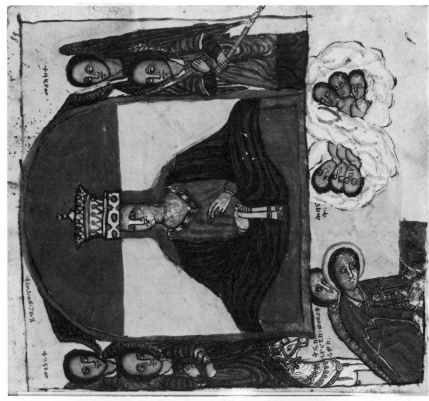

167. Miracles of the Virgin Mary, 17th century. c. 27,0 : 30,0 cm. Abb. 114. Bibliothèque nationale, Paris (fol. 89)

166. Psalter, 18th century. 37,0 : 35,2 cm. British Library Or. 538

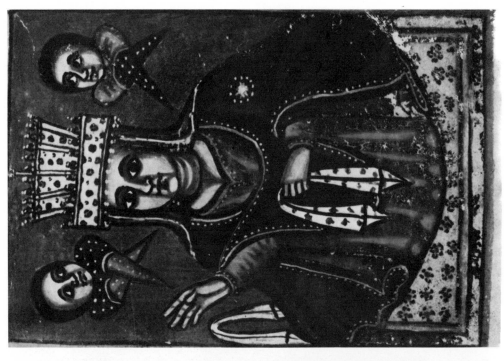

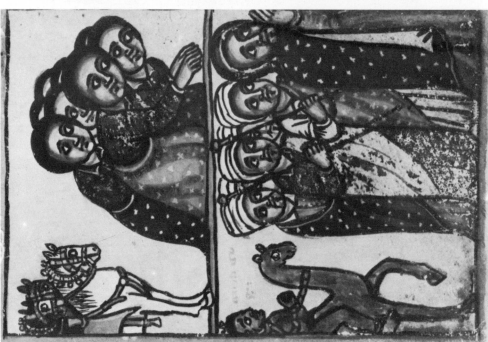

168a and 168b. Prayers of the Virgin Mary. 18th century. 12.5 : 8.5 cm. Ms. or. Rüpp. IV.1, Stadt- und Universitätsbibliothek. Frankfort on the Main (fol. 7r, 8r)

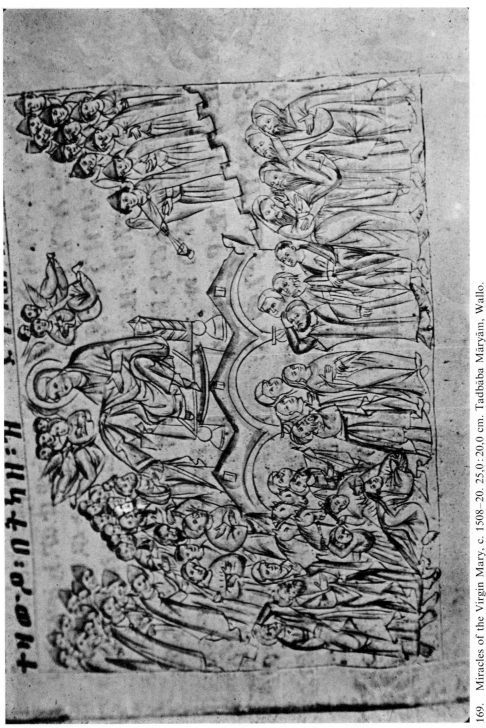

169. Miracles of the Virgin Mary, c. 1508–20. 25,0 : 20,0 cm. Tadbāba Māryām, Wallo.

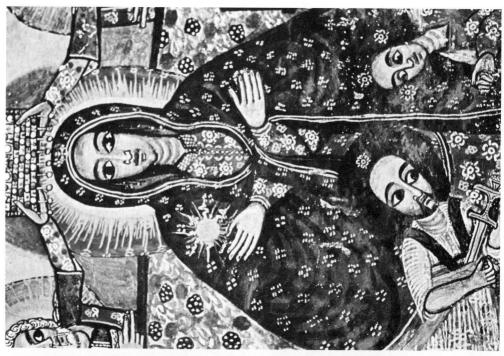

171. Wall painting, c. 1800. c. 120,0 : 90,0 cm. Märyäm Päpäseyti, Gar'ältä

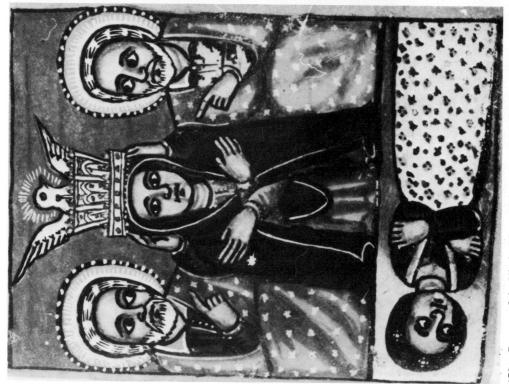

170. Prayers of the Virgin Mary, 18th century. 12,5 : 8,5 cm. Ms. or. Rüpp. IV,1. Stadt- und Universitätsbibliothek, Frankfort on the Main (fol 52r)

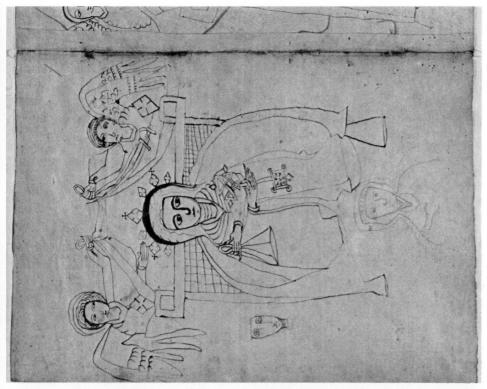

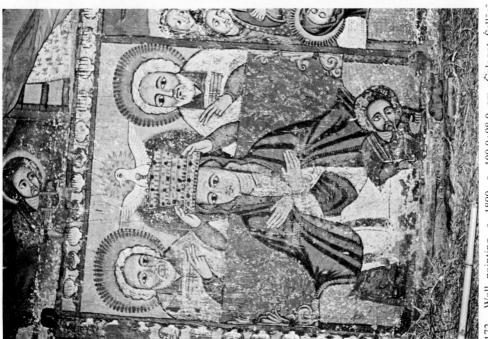

172. Wall painting. c. 1800. c. 100,0 : 98,0 cm. Ćalaqot Śellāsē, Endertā in Tegrē

173a. Synaxary, 18th–early 19th century, c. 46,0 : 41,0 cm. Aeth. Cer. 193, Biblioteca Apostolica Vaticana, Rome (fol. 1v, 2r, 3r)

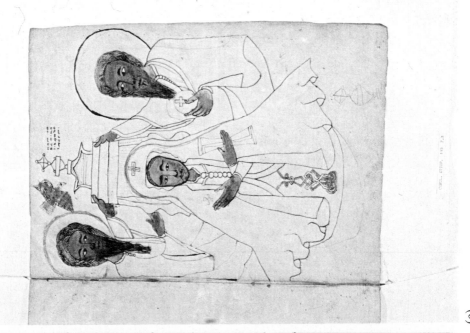

(c)

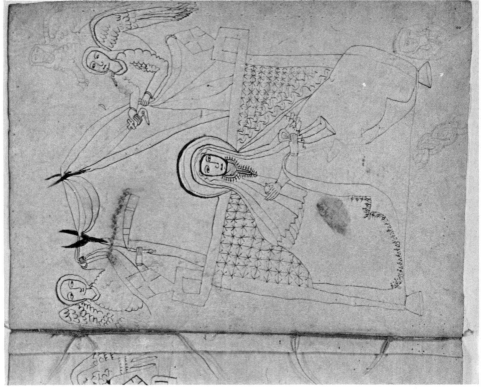

(b)

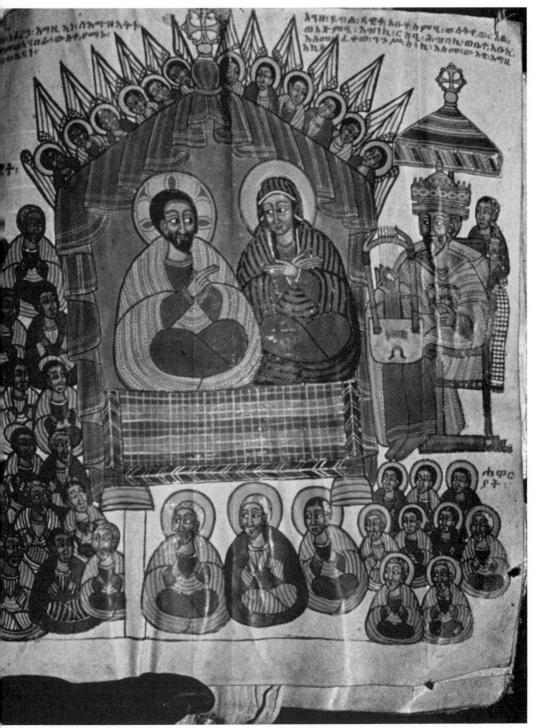

174. Miracles of the Virgin Mary, c. 1630–1700. c. 28,0 : 17,0 cm. Dabra Warq, Goǧǧām

VII. EUROPEAN PAINTERS IN 15TH AND EARLY 16TH-CENTURY ETHIOPIA

Since Carlo Conti Rossini published his article in 1927 in which he hypothesized about the Western European influence on 15th and early 16th-century Ethiopian painting,[1] the discussion on this important problem has continued. Conti Rossini was the first to present a comprehensive view of the problem and he believed that the European impact was considerable. Ugo Monneret de Villard was rather sceptical (see p. 340). Both scholars draw their conclusions from the written records, though they recognized distinct traces of European influence in a few Ethiopian works known to them.

In the 1950s and 1960s Annequin and Leroy dealt with particular paintings which according to them bore an unerring European character, but they did not attempt any specific conclusions. Their findings will be quoted in the course of the discussion.

The late 1960s and early 1970s brought a series of astonishing discoveries thanks mainly to arduous searches in remote monasteries by Diana Spencer.[2] The paintings, obviously made by Europeans were found in Ethiopia. These works bear characteristics of Renaissance art. Moreover, other paintings were also discovered; they are clearly made by Ethiopians but evidence an impact of the above paintings. Thus the scanty written records on artistic activities of Europeans in 15th-century Ethiopia have been substantiated by material evidence and our knowledge of the period has been significantly broadened. The hypothesis of Conti Rossini has been confirmed.

The following is an attempt to correlate the written records with the recently discovered paintings and to find stylistic and iconographic changes introduced into 15th-century Ethiopian art. Although most of the known paintings have been investigated, more paintings are still expected. Recent research in remote churches and monasteries has yielded an impressive crop of paintings. Indeed, in spite of the disastrous Moslem invasion in the early 16th century, the Ethiopians have succeeded in saving from burned churches considerably more illuminated manuscripts and holy icons than pessimistic scholars had expected.

The writer has divided the paintings into a few groups according to their iconographic and stylistic characteristics and attempted to identify these groups with the painters known from written records. The identification of works of art through analysis of their style and iconography is always subject to doubt and discussion and therefore some of the following conclusions should be considered as preliminary. It is hoped that future study and discoveries of paintings will either

[1] CRCodErit; also Africa nos tenet (Roma 1942) 15f.

[2] SpencLuke; SpencGojj.

confirm or correct the following findings. Fortunately, among the paintings recently discovered, three are signed by their foreign maker. This has made it possible to attribute other paintings to the same artist though these do not bear his signature. Most of the paintings bear short inscriptions indicating their subject-matter; the paleography of these is useful for dating the painting.

EUROPEAN ARTISTS IN 15TH-CENTURY ETHIOPIA ACCORDING TO WRITTEN RECORDS

The following investigation deals mainly with three European painters, Nicolò Brancaleon, Gregorio Bicini, and Lázaro de Andrade, who spent part of their lives in Ethiopia and have been identified in written records. However, scarce records in Europe on contacts with Ethiopia at the end of the Middle Ages and one passage in an Ethiopian royal chronicle allude to other foreigners who then lived in Ethiopia and probably produced religious paintings.

The first Ethiopian embassy to Europe known to us began in 1402. It was led by Antonio Bartoli, an Italian native of Florence. Bartoli on his way back to the Land of Priester John passed through Venice. He requested that the Republic send craftsmen to Ethiopia. The Grand Council deliberated on this request during the meeting of August 10 of the same year and it was decided to comply with it. A list was drawn up of craftsmen chosen for the journey to Ethiopia. At the head of the list there was a painter, unfortunately not identified by name. The record states that he was a native of Florence but living in Venice.[3] The above information is of prime importance for the history of Ethiopian painting. Regrettably, no written records have been found on Bartoli's return to Ethiopia and the fate of his group of craftsmen. Recent discoveries in Ethiopia of ruined buildings in the Mediterranean style, in Šawā,[4] one of which according to the tradition was built in the first half of the 15th century,[5] imply the presence of Europeans at that time.

Monneret de Villard made reference to the Florentine painter whom he calls "Vito da Firenze"; he did not give the source of his information.

Another Italian, Pietro Rombulo from Messina, arrived in Ethiopia in 1407 during the reign of King Dāwit I; he lived in the country for 37 years and travelled to India for Ethiopian sovereigns. Eventually he returned to Europe in 1450.[6]

Apparently, in addition to Bartoli and Rombulo, other Europeans visited the remote Christian country in the first half of the 15th century. In 1427, Alfonso V of Aragon received in Palermo a delegation from King Yesḥaq (1414–29). The main purpose of the delegation, according to Taddesse Tamrat, was to ask for craftsmen and specialists in military technique. Alfonso hesitated to comply with

[3] CRCodErit 86–88.
[4] AÉ 6 (1965) 25–26 pl. 22; AÉ 11 (1978) 153–62.
[5] *S. Chojnacki,* Däy Giyorgis = JEthSt VII 2 (1969) 43–52.
[6] *C. Trasselli,* Un italiano in Etiopia nel secolo XV: Pietro Rombulo di Messina = RSE 1 (1941) 173–202.

the request because of the insecurity of the journey. The people he had sent before "died on the way being unable to pass [through Muslim lands]" according to his explanation to King Zarʾa Yāʿqob in 1450. But eventually he agreed.[7]

Other Europeans who attempted to reach Ethiopia met with better success. One of them was Pietro, a Neapolitan, the emissary sent by Duke of Berry to King Yesḥaq. Apparently Pietro spent some time in the country. Bertrandon de la Brocquière, a French traveller, met him at Pera in 1432 recruiting craftsmen for Ethiopia.[8]

Two decades later, King Zarʾa Yāʿqob, entrusted Pietro Rombulo with a mission to Alfonso V, the monarch who entertained good relations with his predecessors. Rombulo took with him to Ethiopia artists who, according to Trasselli, adorned her "with works of art".[9]

The earliest more specific information on foreign craftsmen in Ethiopia is found in the writings of Francesco Suriano, a Franciscan monk who spent many years in the Holy Land. Suriano recorded that in 1482 the superior of the Franciscan monastery of Mount Seyon sent to Ethiopia a delegation composed of Frate Giovanni da Calabria and the layman Giovanni Battista da Imola. In Dec. 27, 1483 Giovanni Battista was back in Jerusalem. He told Suriano that he had met some fifteen Europeans at the court of King Eskender (1478–94). Ten of them had been in the Land of Prester John for 25 years, that is they arrived circa 1457; five Europeans arrived in 1480. Among those was one called "Miser Nicolò Branchalion, Venetiano".[10] Giovanni Battista did not indicate the man's profession.

Royal chronicles and other Ethiopian writings are silent on the foreign artists in 15th-century Ethiopia except for one short passage in the chronicle of King Baʾeda Māryām (1468–78). According to it, the King ordered a foreigner to paint a picture of Mary and Child and this aroused the people's dissatisfaction.[11] The text does not give the reason why. Who was this painter? According to Giovanni Battista da Imola, Brancaleon arrived in Ethiopia in 1480, that is two years after the death of King Baʾeda Māryām. There is no question of Andrade who arrived in 1520. The one remaining is Bicini, or someone else unknown to us.

[7] The statement is from the letter of Alfonso to Zarʾa Yāʿqob written in 1450. *Ch. de la Roncière,* La découverte de l'Afrique au Moyen Age. II (Cairo 1924–27) Cf. 115f. The other delagates were a Spaniard and a Frenchman.

[8] TTCh 259.

[9] *C. Trasselli,* Un italiano un Etiopia nell secolo XV: Pietro Rombulo di Messina = RSE 1 (1941) 266.

[10] *F. Suriano,* Il trattato di Terra Santa e dell'Oriente, edito da P. Girolamo Golubovitch (Milano 1900); quoted after TedArtFig 42f.; CRCodErit 92 lists the expatriates by their names. There is a small difference between the quote from Suriano by Tedeschi and Conti Rossini. Giovanni Battista's family name was De Brocchi: later on he was an officer at the Roman Curia. *Renato Lefevre,* Ricerche sull'Imolese G. B. De Brocchi, viaggiatore in Etiopia e curiale pontificio (sec. XV–XVI) = Archivio della Società romana di Storia patria. A. LXXXI (1958) Terza serie XII 55–118.

[11] *R. Basset,* Études sur l'histoire d'Éthiopie (Paris 1882) 102; *F. Beguinot* La cronaca abbreviata d'Abissinia (Roma 1901) 12f.

The question is whether there was any other European besides Bicini, Branca-leon or Andrade who painted religious images. The passage in the royal chronicle alludes to this but is not sufficiently specific. On the other hand, recently discovered paintings in Ethiopia seem to be the work of more than three persons. The answer could possibly be found through analysis of these paintings, and this is what we shall be attempting in the following.

BRANCALEON AND HIS WORK

Nicolò Brancaleon was well-known to *éthiopisants* starting with the end of the 18th century. This was due to the story by James Bruce, a Scottish traveller, about an European painter in 15th-century Ethiopia. Bruce's book on his Travels to Discover the Source of the Nile was first published in 1792 and since then until the present Bruce's version was uncritically accepted by scholars. Bruce believed that it was "a Venetian whose name was Branca Leon" who painted the picture of Mary which caused the dissatisfaction of the Ethiopians. This was because he placed the Child on Mary's left arm instead of on the right one. "This", writes Bruce who did not lack imagination, "is directly contrary to the usage of the East ... the fanatic and ignorant [Ethiopian] monks ... were fired with rage at the indignity which ... was offered to Our Savior".[12]

Bruce's mistake was eventually clarified by Conti Rossini and Tedeschi.[13] Tedeschi demonstrated Bruce's misinterpretation of texts and established the facts about the Venetian painter. Tedeschi found that the passage about the picture painted by a foreigner varies from one royal chronicle to another. All versions contain the basic information on the Frank, i.e. the foreigner who painted the picture of the Virgin, and concerning the people grumbling about it. The picture was kept in the church of Atronsa Māryām founded by King Ba'eda Māryām. Two of the versions refer to a "portrait" while two other versions to a "picture in a book". In the two versions the painting was destroyed in 1711 by the Oromo or Gallas who, starting in the 16th century, made incursions into Ethiopia.

It has already been mentioned that the information about Brancaleon is found in the Trattato di Terra Santa e dell'Oriente written in 1485 by Francesco Suriano.

The second source of information is the records of the Portuguese embassy of Dom Rodrigo de Lima, who spent six years in Ethiopia from 1520 to 1526. The records were written by Francisco Alvarez, confessor and chronicler of the Em-bassy; they contain an invaluable description of Ethiopia before she collapsed in the 1530s.

Brancaleon is mentioned in four passages of Alvarez's narrative. In the first passage, written on October 29, 1520, Alvarez records that at the court of the Ethiopian ruler he found foreigners who had lived in Ethiopia for many years

[12] *J. Bruce,* Travels to Discover the Source of the Nile in the years 1768, 1769, 1770, 1771, 1772 and 1773. III (Edinburgh 1813) 98.

[13] CRCodErit 90; TedArtFig 38–55.

and were not allowed to leave the country. Among them was "...also a Venetian whom they call Marcoreo in this country, and who says his name is Nicolao Brancaliam; it is thirty-three years since he came to this country."[14]

In the second passage, dated 25. November 1520, Alvarez describes how he celebrated Holy Mass in the presence of the Ethiopian clergy. Brancaleon was there and served as interpreter. On this occasion, Alvarez explains further that "a Venetian painter, who said that his name was Nicolao Brancaliam, who had been for more than forty years in this country (and he knew the language of the country well); he was a much respected person, [very rich,] and a great lord [of a big country with many vassals], although a painter. He was like the interpreter of these canons and priests, and told them what was being done in the mass, such as the Kyrios, the Gloria, the Dominus vobiscum, which meant *calamelos*, which means 'the Lord be with you'; and so with the Epistle and Gospel and all other things. This man was a herald, and they said that he was a monk before he came to this country."[15]

The third passage is as follows: "On 28. December 1520, we came to a place on the road [by which we had come] where we saw a church which we had seen in coming, but not visited, which is named St. George. They pitched the tent of the Prester below the church, and ours in our place, which was already assigned to us; and next day, very early, he [the King Lebna Dengel] sent to call us, and tell us to go to the said church. When we were there, he ordered it to be shown to us, and we saw it very well. It is a big church, with all the walls painted with suitable pictures and very good stories well proportioned, made by a Venetian who has been mentioned before, named Nicolao Brancaliam, and his name is on these pictures, and the people here call him Marcoreos."[16]

The fourth passage, dated 10. January 1521, refers to the conversation Alvarez had with the *Abuna* Mārqos, an Egyptian monk who served as head of the Ethiopian Church. The topic of the conversation was an incident which had happened shortly after the arrival of Mārqos in Ethiopia. The King ordered his court not to observe the customs of the Old Testament like the celebration of Saturdays and the non-eating of pork. And the *Abuna* added: "When this had begun to be done at the Court and in its neighbourhood, not very long ago, there came to this country two Franks who were still living in it, that is to say, one Marcoreo, a Venetian, and after him one Pero de Covilham, a Portuguese; these, when they arrived, before they were at Court, began to keep the usages of the country which were still kept in some parts, that is, to keep Saturdays, and to eat like the people of the country."[17]

The information by Suriano and that of Alvarez prove beyond doubt that a painter called Nicolò Brancaleon lived in Ethiopia from ca. 1480 to the third decade of the 16th century. Although Suriano gives 1480 as the year of Branca-leon's arrival in Ethiopia, a margin of one or two years should be allowed. For

[14] AlvPrJ 279.
[15] AlvPrJ 313.
[16] AlvPrJ 332.
[17] AlvPrJ 357f.

example, in 1481, an important Ethiopian embassy travelled to Cairo and Jerusalem.[18] Perhaps Brancaleon travelled with it and thus he would have arrived in Ethiopia during that year instead of 1480. In a broad sense, however, Suriano's date has been corroborated by the testimony of Alvarez.

The commonly used form of the painter's name is Brancaleone; Tedeschi uses the form Brancaleon which is more authentic. Suriano spells the painter's name as "Branchalion" while Alvarez as "Brancaliam". In his paintings Brancaleon signs his name in two different ways. In three paintings he uses the Latin form. He spells or misspells his name as "Brancalew", in one instance he abbreviates it to NIC BRA and in another instance uses the form Nicolaus Venetus. In his third signed painting, Brancaleon drops his foreign name altogether and uses the name Marqoryos (Merkurios) adding the word Frank *(afringi)*, the foreigner, in order to specify his identity.

Virtually nothing is known about Brancaleon's life prior to his coming to Ethiopia. Tedeschi did not find traces of him in Venetian archives. This was to be expected because Brancaleon was most probably of modest origin and left Venice as a young man. Nevertheless, Tedeschi's searches proved that Brancaleon or Brancalion was a common name in the Republic.[19] The discovery of the paintings brought final confirmation of the painter's Venetian origin.

There is no indication in the texts that Brancaleon passed through Turkish captivity as some other European residents of Ethiopia, but he was probably not allowed to leave the country. This was partly due to Ethiopia's suspicion of foreigners and partly to her need of skilled craftsmen. Brancaleon was well treated in his country of adoption and achieved an extraordinary career considering his modest artistic abilities and his origin. Alvarez did not mention whether Brancaleon was married. Yet, the Portuguese priest, while writing about his countryman, Pero de Covilham, also detained in Ethiopia, made a point of Covilham's two wives, one left in Portugal and the other married in Ethiopia. Was Brancaleon a monk prior to his arrival in Ethiopia as the local story has it? Alvarez repeated the rumor and did not find it strange. Obviously the Venetian had some ecclesiastical education since he was able to explain to Ethiopians the different parts of the Roman mass and knew some Latin.

According to the narrative of Alvarez, Brancaleon's integration into Ethiopian life had been complete. He spoke the language of the country which considering his long stay in Ethiopia was an obvious necessity. He also knew how to write the language; the captions in his paintings are written in Ethiopic, the literary language of the country; in one inscription by his hand that language was used.

Brancaleon also adopted the local name of Marqoryos; the reason for this is obvious. The name Nicolò and Nicholas were not used in Ethiopia and family names are not known there even today. We have the record that another Italian,

[18] *G. Wiet,* Les relations égypto-abyssines sous les sultans Mamlouks = Bulletin de la Société d'archéologie copte 4 (1938) 130 f.

[19] TedArtFig 44 f.

Cola di Rossi who came to Ethiopia together with Brancaleon, also changed his name adopting that of Giyorgis.[20]

In two instances Alvarez stated that Brancaleon was a painter, and that he was invited by King Lebna Dengel to admire the murals painted by the Venetian. There is no doubt that Brancaleon held the position which can be defined as a court painter through there was no such title in Ethiopia.

Brancaleon was over sixty years old when he met Alvarez. The records about him refer only to the first months of the embassy's stay in Ethiopia; the last record bears the date of January 1521. Perhaps after that date, Alvarez did not find anything of importance to report. It is also possible that Brancaleon died before the embassy's departure in 1526. King Lebna Dengel then asked one of its members, a professional painter, to stay behind. Alvarez does not explain the reason for this request, but one may guess that the Italian was either already dead or too old to make paintings.

In 1964, when Tedeschi published his study, he was under the impression that no works survived either in Europe or in Ethiopia which could be attributed to Brancaleon. Therefore, the impact of the Italian on 15th-century Ethiopian art could not be assessed.[21] Ten years later or so, the situation changed dramatically. The works of Brancaleon were found and identified. We have at present a clear view of his art and its impact on Ethiopian painting.

The works of Brancaleon listed below are divided into three groups:
(a) works recorded in travellers' books but either destroyed or not yet discovered;
(b) works recently discovered and bearing an inscription indicating the painter and
(c) works attributed to Brancaleon on iconographic and stylistic grounds, though the written indication on the painting is missing.

The list is tentative for obvious reasons, particularly with respect to group (c).

Works recorded but not discovered

Two items belong to the first group:
(1) The picture of St. Nicholas found in 1625–26 by Jesuit Father Gaspar Paez in the Monastery of Panṭalēwon, Šerē in Tegrē. He described the picture as "old and of good hand". In its lower register there was an inscription written in Latin, "Nicolaus Venetus".[22] According to Tedeschi, the person who fulfills the three characteristics, that of being a painter, of bearing the name of Nicholas and of originating from Venice, cannot be other than Nicolò

[22] G. Paez, Lettera annua di Etiopia del mese di Luglio dell'anno 1625 insino a quello del 1626 = Lettere annue di Etiopia del 1624, 1625, e 1626 scritte al M. R. P. Mutio Vitelleschi, Generale della Compania di Gesù (Roma 1628) 194–95.

Brancaleon.[23] The subject of the painting was unusual because St. Nicholas is unknown in Ethiopian art. It is possible that Brancaleon painted a picture of his patron saint for his own sake and not on command. Nevertheless that image found its way into an Ethiopian monastery and has been kept there with other venerated pictures.

(2) The murals in the church dedicated to St. George were described by Alvarez in the passage already quoted. The Portuguese priest noted that Brancaleon signed the murals.

Scholars tend to identify the church of St. George with that of Atronsa Māryām founded by King Ba'eda Māryām. The church of Atronsa Māryām was partly or entirely destroyed by the Oromos on August 23, 1711.[24] The site of the church has not been established though Beckingham and Huntingford, editors of the text of Alvarez, attempted to identify it from written records.[25] Conti Rossini singles out two churches, that of Atronsa Māryām and that of Saint George, situated "rather close" to each other.[26] In 1969, Diana Spencer visited the present Monastery of Atronsa Māryām on her way to the Monastery of Tadbāba Māryām in Amārā Sāyent. She collected the oral traditions and found the church "in a sad state. On two walls of the *maqdäs* were colourful paintings from the period of Emperor Bäkaffa (1721–30). But much of the mud structure and thatched roof had been severely damaged by the rain. and the *tabot* had been placed for safety in a temporary tin-roofed hut. During the following season's heavy rains, the old church was totally washed away". She was told that this was not the original church, which had been situated in Dabra Kelanto near Warra Ilu (some 100 km west of Dasē, capital of Wallo).

"It was burnt", writes Spencer, "by Ahmad Grañ but the *tabot* is said to have been carried to safety by the monks and brought some two centuries later to this mountain pinnacle [the present-day church now destroyed] over the Blue Nile Gorge, opposite Marṭula Maryam in Gojjam".[27] We can assume that the murals in the old Atronsa Māryām church, probably the major work of Brancaleon, are lost.

The treasured possession of the Atronsa Māryām Monastery is a "very beautiful triptych said to have been brought from the original church. Painted in the Ethiopian style in shades of cinnabar red, the dramatic centre panel shows the Holy Virgin, holding the Child on her right side, with the figures of St. Mika'él and St. Gäbre'él behind."[28] The painting is not by Brancaleon; it belongs to a group of 15th-century images of Mary wearing the crown and holding a flower in her hand.

[23] TedArtFig 43.
[24] *F. Beguinot*, La cronaca abbreviata d'Abissinia (Roma 1901) 12f.
[25] AlvPrJ 29 584.
[26] TedArtFig 41; CRCollAbb III 24.
[27] SpencLuke 73f.
[28] SpencLuke 73f.

Signed paintings

Three items belong to the second group:

(3) The Book of Miniatures (fig. 175a–e) is possession of the Wāfā Iyasus church, Gončā District, Goğğām. The book was discovered and photographed by Diana Spencer in January 1973 during her searches for the St. Luke icons in Ethiopia. She described the moment of the discovery as follows: "With us in the church compound was a large crowd of people, and round about were rugs heaped with manuscripts... Deacons hurried back and forth from the treasure house, bringing fresh supplies. Then a small book, measuring about nine by six inches, was placed in our hands. On the fly leaf was the single inscription in Ge'ez, "Wällätä Dengel", (said to have been the sister of Emperor Lebna Dengel). The rest of the book contained about fifty paintings of angels, prophets, saints and New Testament scenes, with no text except for the Ge'ez inscription at the top of each page... The figures in some of the pictures were attired in strange head-dresses, and the New Testament scenes were painted in perspective, some of them enlivened with a background of red-tiled two-storey buildings, or grey slated kiosks or vegetation. The answer to the dilemma of the little book was found on the twentieth page: there at the foot of the scene of Baptism, we read the Latin inscription "Opus mevs Nicholasv Brancalew Venetis". It was only a short message, but for the history of Ethiopian painting it was a message of historic significance."[29]

The exact reading of the inscription should be as follows: a sign partly erased and reminiscent of the upper arm of the cross; a sign recalling the letter 'h' (Tedeschi

[29] SpencGojj 219. The pictures are reproduced in the text. The writer is indebted to D. Spencer for the following full list of miniatures: (1) Twenty-four Elders of the Apocalypse (2) God enthroned with four Living Creatures (3) Michael, Gabriel, ?Raphael (4) ?Fanuel, Uriel, Raguel (5) Sakuel, Surael, Seraphim (6) Isaac, Abraham, Jacob (7) Moses, ?Aaron, David, Solomon, Enoch, Elijah, Job, Samuel (8) David, Ezekiel, Isaiah, Jeremiah, Ezdras ... Tobias (9) Hosea, Amos, Micah, Joel, Obadiah, Jonah, Nahum, Habakkuk (10) Zephaniah, Haggai ... Zechariah ... Malachi (11) Joachim and Anne praying for a child (12) The Birth of Our Lady Mary (13) The Presentation of Our Lady Mary to the Temple (14) The Annunciation (15) The Birth of Our Lord and The Presentation of gifts by Wise Men (16) The Circumcision of Our Lord (17) St. Simeon receiving Our Lord in the Temple (18) The Slaughter of the children of Galilee (19) The Journey of Our Lady Mary with the beloved Child to Qwesqwām (20) The Baptism (21) Temptations for 40 days and nights (22) The Miracle of Cana of Galilee (23) The Transfiguration (24) The Entry into Jesusalem (25) Our Lord washing the Disciples' feet (26) The Communion of the Apostles (27) The seizure of Our Lord in Gethsemane (28) Our Lord before the High Priest (29) Our Lord before Pilate (30) The Crucifixion (31) Joseph and Nicodemus taking Christ down from the Cross (32) Carrying the body to the tomb (33) Angel standing by empty tomb while holy women look on (34) The Resurrection of Adam and Eve (35) Our Lord appearing before Mary Magdalene (36) Our Lord being touched by Thomas before the Disciples (37) The Ascension (38) *Parāqliṭos* (39) Sixteen men (40) Sixteen women.

suggests that it is an abbreviated form of "hoc est"); OPUS MEUS NICOLASU BRÃCALEÕ VENETUS. The tilde over the 'a' and 'ω' represent a nasal intonation of the 'n'.[30] Tedeschi might be right but it seems that the tilde was also put over the letter 'c'. The full translation of the inscription should be "this [is] my work Nicolò Brancaleon Venetus". The inscription attests beyond doubt that the Italian painted the pictures. The book is the major source for the study of his art. The name Walatta Dengel refers most probably to the owner of the book but it needs to be proved that she was indeed the sister of the king.[31] However, the lady was certainly of noble rank considering that the court painter made for her such an extensive set of devotional images.

(4) The triptych (fig. 176a and b) which in 1968 emerged from a centuries long oblivion and was acquired by the Institute of Ethiopian Studies Museum, Addis Ababā (Mus. No. 4191) shows in its central panel St. George killing the dragon while the Maiden under the horse's belly expresses her distress and her plea for mercy. Below, three local saints, Takla Hāymānot, Ēwosṭatēwos and Kiros are represented. On the side-panels of the triptych, the tortures of St. George are depicted in eight separate scenes.[32] The upper part of the central panel has been badly restored, probably in the 17th century, and thus the Saint's head and hands are not authentic.

The painting contains the inscription "I, Marqoryos, the Frank, painted this picture". Marqoryos is a common name in Ethiopia but used together with the word "Foreigner", it refers to a specific person. Brancaleon took the name of Merkurios as recorded by Alvarez. Taddesse Tamrat who reproduced the painting in his book on 15th-century Ethiopia had no doubt that it was indeed "by the famous Brancaleone, also called Märqoréwos."[33] This writer, describing the painting in 1973, concluded that "the coincidence of the name of the painter who decorated the church of Atronsa Maryam and the painter of the icon may warrant the assumption that the artists are one and the same".[34] The discovery of the Book of Miniatures in Wāfā Iyasus has fully corroborated the above opinions.

(5) A large triptych showing the Dormition of the Virgin on the main panel and Apostles and the equestrian saints on the side panels was discovered by D. Spencer in the Church of Gētēsēmānē Māryām, Goǧǧām (fig. 139, description on p. 293f.). "On the reverse side of the main panel", she writes,"are the Roman letters NIC BRA to which unfortunately I did not pay sufficient attention nor did I record it with the camera."[35]

[30] SpencGojj 219. *S. Tedeschi,* Nuova luce sui rapporti tra Venezia e l'Etiopia (sec. XV) = Quaderni di Istituto Italiano di Cultura, Addis Ababā (1974) 17.

[31] The only recorded sister of Lebna Dengel was Amata Dengel; she was captured by Aḥmad Grāñ. *R. Basset,* Histoire de la conquête de l'Abyssinie (XVIe siècle) par Chihāb ed Din Ahmed ben 'Abd el Qâder (Paris 1897) 439.

[32] The triptych was described and analyzed in ChojIcGeorge = II 56–58 = III 76–78.

[33] TTCh plate 5; he gives the following translation: "I, Märqoréwos, the Frank, drew this painting".

[34] ChojIcGeorge II 58.

[35] SpencGojj 205; a small portion of the icon reproduced on p. [210].

The painting bears the characteristics of Brancaleon's art. Moreover, a similar abbreviation of his name is found in the Book of Miniatures. One of its pictures represents Christ being arraigned; the Jews show him the open books. On one of the pages, the letters NI are inscribed (fig. 175 b); therefore there is no doubt that the triptych was also painted by the Italian.

Paintings attributed to Brancaleon

The following paintings of the third group can be attributed to Brancaleon though they do not bear his signature. The iconography and style of the paintings are the same as those of the second group. Moreover, Brancaleon's paintings are composed of the few basic figures which are always rendered in the same manner though the subjects vary. For example, the soldiers, saints or prophets wear similar garments; this pattern of uniformity is also applied to such details as the folds of cloth, the facial expressions and gestures. This trait of Brancaleon's works makes their identification reasonably certain.

(6) The diptych No. 4325 in the IES Museum represents the Crucifixion on its right panel and the Virgin and Child on its left one (fig. 177 a and b). In its technique and also in the extensive use of particular shades of green and red, the painting bears resemblance to triptych No. 4191. Moreover, the comparison with the Walatta Dengel Book of Miniatures proves beyond doubt that the diptych was painted by Brancaleon himself and is not a copy of his work.

The image of the Virgin is certainly inspired by the Italo-Cretan school. Indeed, two Cretan icons known to us in Ethiopia recall the work of Brancaleon. One of the icons discovered by this writer in June 1974 in the Monastery of Sāmuʾēl za-Qoyaṣā (Dabra Saḥel), Šerē, bears an inscription indicating that it had been given to the Monastery by King Lebna Dengel (fig. 178). The other icon, called Šeʿela Waynut[36], is kept in the Monastery of Dabra Warq, Goǧǧām. The icon is believed to have been painted by St. Luke himself (fig. 179).

There is little doubt that Brancaleon actually copied the Sāmuʾēl za-Qoyaṣā icon; the general setting, the pose of the figures, even the details are identical except that he placed the Child on Mary's left arm instead of on the right as in the Cretan icon. Curiously enough, this detail seems to "ring a bell" with Bruce's story on changing the place of the Child by a foreign painter. A strange shadow around Mary's mouth in Brancaleon's painting can be traced to the much softer modelling of the same in the icon. The figure of the Child has also been exactly copied by Brancaleon and this explains the unusual direction of its face.

Apparently Brancaleon had some difficulty in drawing the Child's feet. Their

[36] SpencLuke 84–85, plate facing 84. Referring to the name of Šeʿela Waynut, picture Waynut, *Spencer* writes: "There was no agreement, as I recall, about its meaning ... but I think it had something to do with the frame", letter of Feb. 24, 1978.

position was probably not sufficiently clear to him and he decided to make this detail in his own manner; it came out particularly clumsy. He also added the lower part of the portrait and made Mary's legs much longer than those in the Cretan icons, a detail which was clearly dictated by the shape of the panel.

The icon from Sāmuʾēl za-Qoyaṣā does not show any angels while in the Dabra Warq icon two of them are kneeling close to Mary's head. Brancaleon also depicted the angels in the two top corners of the panel. They are drawn in swallow-dive flight, their robes are draped in the form of a conch-shell and their nimbi drawn at an angle. This form of the nimbus is unknown in Ethiopia and certainly originates from Western art. The other addition made by the Italian painter is a curious imbricated pattern on Mary's breast. The pattern appears only in a few 15th-century paintings, some of which were painted by Ethiopians and some by an unknown European painter.

According to Manolis Chatzidakis, the *Śeʿela Waynut* icon is an 18th-century copy of the 15th-century Cretan school.[37] Yet, the local tradition has it that the icon was brought to Ethiopia at the time of King Dāwit. If he were Dāwit the First, the icon would date from ca. 1400. Lebna Dengel's royal name was also Dāwit. If the tradition refers to him, the icon would date from ca. 1500. The possibility that Brancaleon had been inspired by the *Śeʿela Waynut* icon adds weight to the local tradition. The other inference, namely that Brancaleon copied the Sāmuʾēl za-Qoyaṣā icon proves its inscription referring to the donation by Lebna Dengel to be truthful and genuine.

The Crucifixion on the right panel demonstrates the departure from Oriental type as shown in early Ethiopian manuscripts and reveals total redirection towards the type obviously inspired by Western European art. This Western influence is partly suggested by the clumsy but still legible inscription INRI over Christ's head and partly by other features which are symptomatic of Western representations of the Crucifixion. These are the crown of thorns on the Saviour's head and the presence of Mary Magdalene, alien to Greek iconography, but common to Western art.

Three angels collecting the Holy Blood from the Saviour's wounds are undoubtedly the most significant addition to the painting. According to U. Monneret de Villard, the theme is unknown to Eastern Christian iconography while we find it in Italy already in the middle of the 14th century. Since then the theme has enjoyed great popularity.[38] Brancaleon probably introduced the theme into Ethiopian art.

The angels are identical to those who accompany Mary in the same diptych, in that their faces are drawn in profile which is exceptional in Ethiopia and their nimbi are at an angle. Moreover, their robes are draped in the form of a conch-shell.

The subject of the swooning Mary, consoled by Salome at the Crucifixion, is unique in Ethiopian painting. Most probably, Brancaleon was the first to paint the subject in Ethiopia. Salome's tender embracing of the Virgin is typical of his way of

[37] SpencLuke 84. Prof. Chatzidakis made his expertise from the photograph.
[38] MonMad 55.

narrating, and the crossed fingers of Mary's hands epitomize his simple but effective method of expressing the feelings of the personages depicted. Moreover, Mary is dressed as an elderly Venetian lady.

The diptych is particularly important for the study of foreign influences on Ethiopian art. It evidences the ways in which these influences penetrated and shows their complexity. The picture of Mary on the left panel bears a Greek character (maniera greca) and proves the Eastern Christian influences on Ethiopian painting. The Crucifixion on the right panel is manifestly of Western European inspiration. How was it possible to have these two impacts combined in one painting? The identification of the diptych as Brancaleon's work clarifies the matter. The contention is that the diptych was painted in Ethiopia, that the painter was an expatriate Italian and that he took as the model for a portion of his work the Italo-Cretan image of the Virgin. Moreover, the fortuitous discovery of the icon in the Monastery of Sāmuʾēl za-Qoyaṣā made possible the identification of the model.

(7) The book of the gospels kept in the Dabra Warq Monastery, Goǧǧām,[39] was copied for King Eskender during the first decade or so of Brancaleon's stay in Ethiopia. The book contains pictures of the four Evangelists as a frontispiece to each gospel (fig. 180) and heading ornamentation in which the fleur-de-lis motif is extensively used. The plan of the illumination is different from that of early Ethiopian gospels, in that the elaborate ornamental pattern framing the Canon of Eusebius, the folio with the Fountain of Life and the miniatures illustrating the life of Christ are missing. Also the rendering of the Evangelists has changed. They are shown standing and hold the cross in one hand and the book on the other instead of sitting and writing with a bamboo stylus. The rendering of the Evangelists is realistic; their faces are modelled with delicate shading especially around the eyes; with the exception of Mark, the Evangelists have grey hair which is drawn with multiple sinuous lines; the beards are round or pointed and neatly trimmed; the lips are well shaped and accentuated with strong red colour. The moustache is shown on both ends of the mouth leaving bare the skin under the nose. The Evangelists wear rich garments composed either of a blue cloak and red robe or of a red cloak and blue robe. The soft design of the folds of the cloak is either in the form of superimposed "V"s or, more often, of three folds showing the lining and traced with a white line at the border. A striking detail of the painting is the hands of the Evangelists, disproportionately small in relation to the rest of the figure. The facial expressions and modelling of the figures, the folds of the cloth, the abnormally small hands as well as the Latin form of the cross are similar to those in triptych No. 4191 and the Walatta Dengel Book of Miniatures. These are good reasons for ascribing the Dabra Warq miniatures to Brancaleon although in these more pink and cerulean blue have been used than in any other of his paintings.

[39] The manuscript was brought in 1965 to Addis Ababā and on this occasion, photographed and its date established from the colophon. Subsequently, its miniatures were photographed by D. Spencer and P. B. Henze.

(8) Two panels and the Greek icon *Śeʿela Waynut* (fig. 179), already mentioned, have been described by D. Spencer as follows: "The two side panels showing St. John on the left and St. Peter on the right have been added to the original. According to Prof. Chatzidakis, they are possibly of 18th-century Syrian origin."[40] The first statement is correct: Ethiopians used to attach locally made panels to imported Greek icons. However, the expertise on the origin of the panels needs to be rectified. The figures of the saints are more elongated than those of the Evangelists in the gospels just described, but this was obviously dictated by the shape of the panels. Also, their attire is slightly different, St. Peter wears a bluish-green robe and red-starred cape over it while St. John wears a red robe covered by a plain bluish-green cape, but the blue and crimson are similar to those used in the miniatures of the Dabra Warq Gospels. The cape is fastened with a round clasp on the chest. Similar clasps ornament the capes of the Elders in the Walatta Dengel Book of Miniatures as well as the capes of the local saints in triptych No. 4191. The headcovers of John and Peter, tied up over the front with a yellow ribbon, seem to be of Venetian origin rather than Syrian. They are identical to the headcovers of the local saints in the above triptych. The other details which are indicative of Brancaleon's art, namely the minute hands, the Latin crosses and the books showing their cover and two sides showing the leaves, as well as the three folds of the cloak, all these are found in the figures of John and Peter. Therefore, the suggestion is that the miniatures in Dabra Warq Gospels and the panels of the *Śeʿela Waynut* icon have been painted by the same hand, that they date from the 15th century and that they are the work of Nicolò Brancaleon.

The dating of the central piece of the triptych, the Greek icon, depends on the identification of the panels. Also additional proof is needed that the panels have been made especially for the icon and not attached to it at a later date. This is not possible at present.

(9) The picture of Mary, the *Śeʿela Sergut* or the Gifted One (fig. 181), and the dilapidated Gētēsēmānē Māryām, Goğğām, in which the picture has been preserved, both had a great past but have nowadays fallen into oblivion and decay. The church was obviously important in the 15th century[41] because it was chosen to house the holy image believed to be painted by St. Luke. According to the local tradition, this icon also was brought by "King Dāwit from Egypt". The icon is encased in a wooden box "covered with red felt whose lids open out to form side panels".[42] The box had been made locally.

[40] SpencLuke 84f.

[41] The Gētēsēmānē church is mentioned in the royal chronicle of Lebna Dengel. In the 21st year of his reign, he was staying in the land of Amhārā, visiting holy places where his ancestors were buried. "These churches are Makana Sellasè, Atronsa Maryam, Dabra Naguadguad and Getsemani", *C. Conti Rossini*, Storia di Lebna Dengel re d'Etiopia sino alle prime lotte contro Ahmed ben Ibrahim (Roma 1894) 22; In 1531, the Moslem invader burned the churches of Amhārā, among others, Makāna Śellāsē and Atronsa Māryām; apparently the church of Gētēsēmānē was spared.

[42] SpencGojj 205.

In Ethiopia, holy pictures were not hung on church walls but shown to the congregations only on very special occasions and either kept in the treasury of the church or in the sanctuary, together with other church paraphernalia. Therefore, protective boxes or panels were added to imported icons. In two instances an expatriate artist and court painter living in 15th/16th-century Ethiopia embellished the pictures with such boxes. The icons are the Še'ela Sergut of Gētēsēmānē Māryām and the Še'ela Waynut of Dabra Warq.

D. Spencer who discovered the Še'ela Sergut describes the panels of the box (fig. 182a–f) as follows: "These are painted each with three scenes from the Gospels; on the left the Crucifixion, Deposition and Flagellation; on the right, the Resurrection, the Carrying of the Cross, and the Flight into Egypt. The Deposition is represented not according to Orthodox tradition, but with the body of Christ clasped in the arms of his Mother in the Western manner; and this, together with certain details of costume such as caps and shoes, and the unusual appearance of looped cord in two of the scenes, seems to strongly suggest a foreign influence."[43]

Although the movement of Mary in the scene, which should be called the Lamentation (fig. 182b) rather than the Deposition, suggests the Western origin of the painting, that way of rendering Mary was also known to the Greeks. Neither the Deposition nor the Lamentation are found in miniatures illustrating early Ethiopian gospels. Whenever the Deposition appears in 16th and 17th-century panel paintings, it seldom includes the figure of Mary.

The Lamentation has been a popular subject during the Italian Renaissance. The theme developed into several forms with a varying number of protagonists, but usually with a very realistic expression of Mary's grief, who at times passionately embraces Christ's body. The Venetian and Italo-Cretan painters produced a number of such Lamentations. Therefore the subject must have been known to Brancaleon.

The Resurrection (fig. 182d) is expressed in the Oriental manner, that is by the Christ's Descent into Limbo, but such details as the white banner decorated with a red cross in the Saviour's left hand is undoubtedly of Western or more precisely of Italian inspiration.

In the Bearing of the Cross (182e), the garments of the soldiers accompanying Christ are identical to those of the Apostles in the Baptism of Christ, depicted in the Walatta Dengel Book of Miniatures. The soldiers, as well as the Apostles, wear on their heads a peculiar kind of large round cap; this detail is indicative of Brancaleon's paintings.

The illustrations to the narrative of the Passion referring to the Mocking of Christ and his Crowning with thorns (Matthew 27, 28–30, and Mark 15, 17–19) appear late in Ethiopian painting. The theme of the Mocking is seldom depicted by Ethiopian painters, while the theme of the Crowning developed into a particular form in the 17th century, though the first attempts to represent the theme date from the late 15th century.

[43] SpencGojj 205.

The Flagellation (182c) is also missing altogether in miniatures to the early gospels, the earliest known image of it being our painting. The soldiers in this Flagellation recall those in other works of Brancaleon. They hold a raised rod in one hand and grasp the body of Christ who is tied to a column. The subject is rare in 16th-century Ethiopian painting. Starting with the second half of the 17th century, the Flagellation appears more frequently, but its form derives from a different source. It is possible that the Italian painter was among the first in Ethiopia to paint the subject of the Flagellation, particularly its form showing Christ tied to a column.

The Flight into Egypt (182f) is rendered in the traditional Ethiopian manner, namely with Mary walking instead of riding a donkey. On the other hand, Mary, Salome and Joseph wear foreign clothes similar to those in the Walatta Dengel Book of Miniatures (see also p. 61).

To sum up, the six panels of the box protecting the Greek icon are the work of Brancaleon, therefore they should be dated to the period ca. 1480–1520. The question is whether the assembling of the box, of the panels and of the icon was effected at the time that the Italian painted the panels, or whether the box and the panels were added to the icon at a later date. The answer depends on the dating of the Greek icon, which is difficult to assess from a photographic reproduction. Nevertheless, the preliminary suggestion is as follows. The icon which D. Spencer considers to be much superior in quality to any so-called St. Luke icons she has seen in Ethiopia, is "surrounded by a gold frame partly covered in blue material with a pattern of gold stars. Surrounding this is a second gold frame consisting of a sculptured frieze at the top and bottom and an inverted column on each side. It is said that the Emperor John I was so moved when he saw the Ikon that he presented his gold crown to be melted down to make the frame".[44] This poetical story belongs to the repertoire of Ethiopian narratives on pious rulers and should therefore not be taken literally. The "golden crowns" proved to be made of copper or brass, at times thinly gilt. It seems that a certain refreshening of colours or a repair of the box was undertaken during the reign of Emperor Yoḥannes (1667–82), but the panels were themselves not touched. If so, the repainting would have been made in the First Gondarene style. Yoḥannes apparently was moved by the beauty of the icon which then was already in the possession of the Gētēsēmānē church. Nothing was said about the assembling of the box.

(10) Two small painted panels (fig. 183a and b), kept in the same Gētēsēmānē
 Māryām, Goǧǧām, are most probably parts of a triptych or diptych. The
 Resurrection is depicted on one panel and the Crucifixion on the other.

The way of representing the Resurrection in this painting is unique in Ethiopian painting. Ethiopians strictly adhered to the Eastern Christian symbolism of the Resurrection and rendered it in the form of the Descent into Limbo. Starting with the 16th century, the subject of the Descent became frequent in Ethiopian painting; the realistic representation of Christ emerging from the grave was very seldom painted. In our panel, on the other hand, Christ

[44] SpencGojj 204f.

stands in front of an open tomb; four soldiers behind him are fast asleep. He has a white cloth thrown over his left arm, his right arm and chest are bare; he holds in one hand a long banner which has a red cross painted over it and raises his other hand in blessing. This then is the Western rendering of victory over death, well-known to Venetian painters of the 15th century,[45] although the figure of Christ is similar to that in the Descent to Limbo painted on the box of the *Sergut* icon.

In addition to our panel, the Crucifixion is depicted in diptych No. 4325, the box forming the *Šeʿela Sergut* icon and in the Walatta Dengel Book of Miniatures. All the Crucifixions are composed in a similar manner and contain details which are virtually identical.

The following is a brief listing of these common characteristics.

(a) Christ is nailed to the cross with three nails instead of four which are found in early Ethiopian miniatures illustrating the gospels. His legs are crossed, right over left, and affixed to the cross with one nail the head of which is in the form of an arrowhead. Christ wears a crown of thorns which recalls an ornamental network rather than a gruesome instrument of torture.

The characteristic trait of Brancaleon's art is an extensive use of cords. Christ in the scenes of his Passion and Saint George, in scenes of torture, often have their wrists tied with a cord. In our Crucifixion, Christ's arms are fastened with cords to the cross.

(b) The cross is always placed on a stylized mound of stones or dirt.

(c) In two paintings, Mary is accompanied by Salome who consoles her. Mary wears a white coiff and a loose cloak or shawl over it. Salome wears a loose cloth and no coiff. In another instance, Mary's and Salome's heads are uncovered and their long hair descends over their arms.

(d) John vividly expresses his grief; the pose of his hands is different in each painting.

(e) In one painting, the angels collect the blood flowing from Christ's wounds, and in another, the figure of a Centurion is added to the composition.

There is good reason to believe that Brancaleon was instrumental in bringing the above innovations to Ethiopia; most of these have eventually been introduced into the Ethiopian representation of the Crucifixion.

(11) A triptych in a bad state of preservation was also discovered and photo-graphed by D. Spencer in the church of Gētēsēmānē Māryām. God the Father and the twenty-four Elders of the Apocalypse are depicted in the upper register. They are almost identical to those in the Walatta Dengel Book of Miniatures (p. 125f, fig. 49). In the lower register the Holy Virgin and Child are represented. "She is seated", writes Spencer, "on a curious wooden chair with knobs. Behind are angels Michael and Gabriel in swallow dive position with their arms crossed over their chests. On three sides are eight small insets

[45] Cf. Carlo Crivelli, 1430–95, Christ emerging from the tomb holding the banner; Giovanni Bellini, Resurrection (Staatliches Museum, Berlin), the staff of the banner has a cross at the top.

each containing an equestrian saint".[46] Undoubtedly the panel was painted by Brancaleon.

(12) A large diptych (fig. 184) in the same church and also discovered by D. Spencer, was described by her as follows: "On one side is the Holy Virgin and Child. She is dressed in a green belted dress and a gold-spangled red veil and cloak, and is seated in the same wooden chair with knobs. The angels Michael and Gabriel are [in swallow-dive position, with their arms crossed over their chest]. The painting is rather clumsily executed, particularly the manner in which the cloak is folded over the drawn-up legs. On the other panel are the twelve Apostles in two rows facing each other in pairs."[47] In this painting the hand of Brancaleon is also obvious: the angels are depicted in swallow dive flight and the Apostles are identical to the ones in the Walatta Dengel Book of Miniatures.

The three portraits of the Virgin, nos. 6, 11 and 12, evidence Brancaleon's varied manner of depicting her.

The first portrait was copied from the Cretan icon as already explained, whereas the two other portraits were the more genuine work of the artist.

In diptych No. 12, Mary wears a glittering and elaborate veil covering the left side of her head and leaving her right side uncovered. A similar draping is found in two miniatures of the Walatta Dengel Book of Miniatures, namely in the Annunciation and the Flight into Egypt. Such draping in Brancaleon's portraits of Mary might as well have been drawn from life as they mirror either the Italian or Near Eastern fashion.

The Child is placed on either the left or the right arm of his mother, which proves that no strict rule referring to the position of the Child was then being followed. However, the right arm was probably preferred. In two paintings, the Holy Child is disproportionately small compared to the figure of his mother. The same peculiarity is found in two Cretan icons which are believed to have been painted by St. Luke and were brought to Ethiopia by "King Dāwit". They are *Śeʿela Adheno*, the Picture of Salvation, kept in the Tadbāba Māryām Monastery, and *Śeʿela Gebṣāwit*, the Egyptian Picture, kept in Ğamado Māryām Monastery, Wallo.[48] If the tradition is correct, the icons would date from the 15th century and would have been in Ethiopia during Brancaleon's time.

The origin of the wooden chair in the portraits is less obvious. Had Brancaleon copied the chair from other paintings or drawn it from life? In a number of 15th-century Ethiopian pictures, Mary is seated on a wide chair with a low back. Similar chairs, as well as chairs with a round high back are known in Greek paintings of the period. For example, such a chair is found in the image of Christ Enthroned which is treasured in Tadbāba Māryām.[49] We know that in the past the Ethiopians

[46] SpencGojj 205.
[47] SpencGojj 205f.
[48] SpencLuke 71f. 80.
[49] SpencLuke 76 95.

imported ornate chairs which were used by their rulers in ceremonial occasions. Brancaleon would have copied one of those chairs.

The additional question is why five works of the Italian painter have been kept in one small and dilapidated church of Gētēsēmānē. There is no immediate answer to this question. Perhaps when the church was famous and favoured by the rulers, the paintings were given to it. Perhaps the paintings were deposited in the church centuries ago in an emergency situation, for example, during the Moslem invasion of Ethiopia in the 1530s, and since then they were forgotten.

(13) In central Ethiopia, near the confluence of the Blue Nile and the Bašilo river, in the Amārā Sāyent district, stands the Monastery of Tadbāba Māryām which nowadays is served by a small religious community. In the past, it was an important religious establishment of the country. In the treasury of the Monastery, an illustrated copy of the Book of Miracles of the Virgin Mary is kept along with a number of objects which have great artistic and historical significance. Diana Spencer who discovered the book in 1969 described it as follows: "A book... [is] dedicated to Emperor Lebnä Dengel (1508–40) whose name is rubricated at the beginning of each chapter. Each page measures 33×28 cm and is illustrated by many drawings in ink with a few brush strokes of colour. The drawings have clearly been done by a foreign hand. The little buildings and the dress of the figures are of the European style."[50]

This fortuitous discovery proved to be of particular significance for the history of Ethiopian painting. One of its puzzling problems was the origin of the illustrations to the Book of Miracles of the Virgin Mary (pp. 192–94). A great number of copies of the Book of the Miracles made in the 15th and 16th century are known. None of these contains miniatures illustrating the text, except frontispieces representing the Virgin and Child. Then, starting with the middle or second half of the 17th century miniatures appeared illustrating the text. These miniatures were painted in the First Gondarene style. Their subject-matter and execution are strikingly uniform. The obvious conclusion is that they derived from one common prototype.

The first to raise the question of foreign origin of the illustrations was C. Conti Rossini. "There is no doubt", he writes, "that the figures which we find in Taʾamra Māryām are very much foreign to Ethiopia or even to Egypt as far as these refer to garments and often architecture, furniture and house implements, though the illustrations contain such Ethiopian details as pottery or the ox belonging to the race of the *bos zebu africanus*".[51]

Enrico Cerulli also discussed the problem of the origin of the illustrations. He found that the miniatures always refer to one particular series of 33 stories in the collection and never to other stories. Therefore the problem is to find a copy of the collection in which these 33 stories have been pieced together. Cerulli did not find

[50] SpencLuke 75.
[51] CRCollAbb I 568 f.

one. Discussing the miniatures in the 17th and 18th-century manuscripts Cerulli writes: "the fact that some miniatures illustrate the miracles of Egyptian origin is symptomatic... The conclusion is that whoever first illustrated the series of 33 stories must have been inspired by foreign models, possibly European, but he did not simply copy them; he made his own illustrations to the Egyptian miracles".[52] Ugo Monneret de Villard excluded the possibility of direct copying from Coptic and European manuscripts though he pointed out the similarities between the Ethiopian miniatures and 14th and 15th-century Italian art.[53]

The suggestion is that the manuscript in the Tadbāba Māryām Monastery, with the illustrations to the text, is the prototype which Cerulli and Monneret de Villard were looking for. Thus the discovery of the manuscript by D. Spencer has given the whole problem an unexpected turn. Its miniatures have an unmistakable touch of Brancaleon's art. The contention is that the gifted Venetian was the one who made the illustrations and, consequently, contributed to the creation of the most delightful set of manuscript illuminations ever made in Ethiopia. On the one hand, the drawings of Brancaleon explain the origin of the curious structures in the 17th-century Ethiopian miniatures. On the other hand, we know the reason why Cerulli and Monneret de Villard could not find a direct relation between the Ethiopian miniatures and those in European and Egyptian manuscripts. The peculiarity of the prototype was that it was conceived and produced in Ethiopia by an expatriate European who illustrated an Ethiopian set of the Miracles that included the stories of Egyptian, Syrian as well as of European origin.

The drawings of the Tadbāba Māryām manuscript (fig. 185a–f) are perhaps more spontaneous than other works of the Venetian known to us. This is probably due to the nature of the idiom used, that is the tinted line. Nevertheless, all characteristics of his style, including the forms of human figures, are embodied in the drawings, and his tendency to narrate with a simple but effective use of gestures is manifest. The artist set figures and scenes under arched structures as in the Walatta Dengel Book of Miniatures but the structures are simpler and some have a slightly different shape. This variety is possibly due to the memory of the buildings which Brancaleon saw during his youth in Venice.[54] Also other details familiar in Brancaleon's paintings are found in the drawings. These are the uniforms and weapons of the soldiers, the angels in swallow-dive flight, the curious hats in the form of upturned baskets and so on. Indeed, one miniature shows Mary with long loose hair and lovingly tending her Baby; this expression of human tenderness seemed to be much preferred by the Italian painter.

The dedication of the book to Lebna Dengel suggests that the drawings were made after 1508, the year of his accession to the throne, and before the 1520s. This

[52] CLMM 536f.

[53] MonMad 57–62.

[54] The setting composed of two arches supported in the middle by one column is found in Jacopo Bellini's Annunciation and scenes of Mary's life. Identical setting is found in Brancaleon's miniatures to the Miracles.

dating corresponds to the chronology of Brancaleon's life in Ethiopia established according to written records.

Diana Spencer photographed the pages with the illustrations but unfortunately not the whole manuscript. It is hoped that this will be done in the future and that the text will offer additional evidence to the above findings. Moreover, the combined analysis of the text and illustrations, not possible at this stage, will firmly establish the already obvious relationship between the 16th-century drawings by the Italian painter and the 17th-century Ethiopian miniatures to the Book of Miracles.

(14) Two miniatures in the 15th-century Psalter which was originally owned by the Monastery of Dabra Warq, Goǧǧām (p. 186f), are most probably the work of Brancaleon. One miniature represents King David playing on a lyre and the other three standing youths in flowing garments. The expression on their faces and their blond wavy hair as well as their long robes tied with a belt at the waist are typical of Brancaleon's art. Moreover, the capes worn over the robes have their borders traced with a yellow line whenever the cape is green and with a black line whenever the cape is brown. All this is found in other works of the Italian. Also, the varied poses of the hands are similar to those in the Walatta Dengel Book of Miniatures. Jules Leroy who published the miniature commented as follows: "even if this manuscript was not actally the work of a Western artist, it was certainly based on a Mediterranean model."[55] At present, we are able not only to corroborate this statement but also to identify the painter of the miniatures.

* * *

The works listed below may be the paintings of Brancaleon, but they do not fully correspond to the criteria of his art as known to us; possibly they are copies of his works or merely paintings made under his influence and therefore painted *alla maniera italiana*.

(15) A small diptych No. 4620 in the IES Collection (fig. 186) has been partly overpainted, particularly the hair and the eyes. It contains several details which are characteristic of Brancaleon's drawing, for example the manner of draping the garments and the smallness of the hand in proportion to the rest of the figure. If the diptych is his work, then it is one of his minor pieces.

(16) Diptych No. 4467, also in the IES Collection (fig. 187) has a carved decoration around the picture imitating its frame. The decoration is in the form of a rope and certainly is of Mediterranean origin. The same ornamentation is found on stone carvings at Day Giyorgis and Enselalē (footnotes 4 and 5), both ascribed to the 15th century and believed to be the works of foreign craftsmen. The figure of the Virgin and Child bears some details similar to those in Brancaleon's paintings but, on the whole, the drawing is softer and the colouring subtle and delicate.

[55] LerÉthG 52, pl. 16.

(17) The Virgin Mary and Child depicted in panel No. 3948, IES Collection,[56] is similar to the one in the previous diptych, except for the way of modelling her face. Mary sits on a round seat in both.

(18) The Virgin and Child depicted in a folio inserted in the manuscript Or. 641, British Library (fig. 188) was discussed on p. 60. The painting seems to be by Brancaleon, except for the shape of the hands and the unusual stiffness of the folds of the cape. If it is a copy, it is certainly very close to the original.

* * *

The previously described twelve paintings and drawings by Brancaleon (Nos. 3 to 18) permit us to define the iconographic, stylistic as well as technical characteristics of his art. Although these are fairly constant, his works are not of uniform quality. Some are more refined, such as the miniatures in the Dabra Warq Gospels or the panels to the St. Luke icon in the same Monastery, while others are rather crude, such as the small panels from the Gētēsēmānē church. Also, the hues of the paintings change. Blue and crimson characterize the paintings which probably date from the first decades of Brancaleon's stay in Ethiopia, while olive-green, Pompeian red and an absence of blue are typical of the paintings of his old age. These mutations are not difficult to explain considering the forty years or so of artistic activity, local adaptation and the difficulty of obtaining pigments. Even if Brancaleon had brought his colours with him, with the years passing, he was bound to use the pigments that were locally available. Consequently his palette changed.

The first overwhelming impression that strikes the viewer is the mediocrity of his technique. When triptych No. 4191, signed by Brancaleon was first discovered, the experts doubted its authenticity because they felt that the painting did not correspond to their high expectations. Further discoveries confirmed the first impression. Judging Brancaleon by European standards, he should be classed as a very average craftsman. The message of his painting is clear; he possessed a limited skill and probably had little or no training before coming to Ethiopia. Yet, he gained fame and played a unique rôle in the development of Ethiopian art.

The background of Brancaleon's paintings is mostly flat. This is partly due to the technical limitations of the artist and partly to the deliberate adaptation to local methods of painting. The Italian did not attempt to depict the landscape, which is a typical feature of Renaissance Venetian painting. In some of his works, there appear either trees or buildings; these are not part of the landscape but emphasize the narration. For example, in the picture of Christ's Agony in the Garden, the two stylized trees and the rocks visualize the idea of the Mount of Olives; a double-storey building drawn in the background of the Marriage in Cana indicates the place where the miracle was performed; in scenes of the Passion, a building or two stand for the city of Jerusalem but there is no attempt to render a view of the town; in other illustrations of Christ's life, an octagonal pavillion supported by slender

[56] Reproduced in ChojArtEth fig. 2.

columns serves as the setting of the action, for example, it stands for the temple in the Presentation. Perhaps the buildings mirror in a simplified form the towns and villages of Brancaleon's native land. These structures are mostly out of proportion with the human figures; they nevertheless signify progress compared to early Ethiopian painting where in similar scenes, except in the Entry into Jerusalem, no structures or trees at all are shown. In a large number of Brancaleon's paintings, however, the background is painted with one plain colour or at times with two colours divided horizontally by a straight line. The colour of the lower register is darker so as to express the ground.

Following a tendency inherited from Western art, Brancaleon narrates the stories by colour and line, using a naturalistic expression. The "Maiden from Beirut" widely outstretches her hands obviously calling for help; St. George's face is shown in pain during the gruesome scene where he is put to the wheel; Nicodemus and Joseph in the Deposition pull off the nail with huge forceps; the soldiers apprehending Christ brandish their swords. All this marks a clear departure from the traditional Ethiopian rendering of the same scenes in which the *dramatis personae* hardly perform an action; their mere presence gives significance to the composition.

The most important technical innovation of the Italian is his effort to render the volume of the figures of the things represented. The personages of Brancaleon wear large flowing robes whose elaborate folds show the line of arms and legs underneath. The artist has, however, obvious difficulty with the drawing of limbs; the hands are at times unnaturally small in proportion to the rest of the body and he is not too successful in drawing the feet when viewed from the front.

In all his works, the Italian painter used a few basic forms for rendering human figures; each form appeared in different scenes. Mary's and Christ's figures naturally vary according to the stages of their lives but in the same situation each form is repeated almost identically. Mary shown as a small girl has her head uncovered; Mary in the Temple has only one side of her head covered with a veil; Mary in the Nativity and in the Adoration of the Magi has a veil covering both sides of her head, while Mary at the Crucifixion has an additional coiff covering her neck and leaving only her face exposed. However, there are exceptions to this pattern due to Brancaleon's obvious preference for rendering Mary with her head uncovered and long hair flowing on her shoulders; this form is even used in the portrait where Mary appears with the Child.

The men wear tunics or long robes invariably tied at the waist by a narrow belt. These robes seem to form pleats below and above the belt. Usually the robes of Christ and the elderly saints reach the calf while the tunics of the soldiers reach the knees. Whenever a cloak is worn over the tunic or robe, it is thrown over both shoulders and falls down to the feet; three wide folds at the bottom show the front and the lining of the cloth, its borders are usually marked with a strong yellow or white line. The soldiers carry small round shields covered with crossed bars and a small circle in the middle. Most of the soldiers also carry a spear drawn as a bamboo cane.

Brancaleon liked to depict old people wearing hats of a great variety of form.

These forms mirror the Italian fashions of his Venetian days. Indeed, the painter borrowed only a few details from Ethiopian life; human figures and their garments are virtually always foreign looking. Even the local saints are clad in gorgeous Venetian attire and wear caps that recall the official headgear of the doge.

The human faces, epitome of Brancaleon's style, are drawn either in full face or in a three-quarter pose. All faces are round; short well-shaped narrow noses have prominent nostrils; lips are small and well shaped. Carefully drawn ears are usually big and protrude strongly whenever the head is drawn in full face. The space between the eyeballs and eyebrows is at times filled with dark colours. The hair is brown or white and drawn in two ways: in one, the hair falls down to the shoulders and this is combined with a long, usually pointed beard drawn with multiple sinuous lines or straight lines; in the other, the neatly trimmed round hair is drawn with multiple parallel straight lines and this is combined with an equally well-trimmed beard, also drawn with straight lines. In some instances, the hair is almost black and then it is not filled with lines.

<p style="text-align:center">* * *</p>

Brancaleon's impact on Ethiopian painting is significant and lasting. Below are listed some of the forms and themes which he most probably contributed, but the final estimate will certainly include more items. The contributions are as follows:

(a) The iconographic type of the Virgin with her head uncovered; in spite of its unusual character, the type was accepted by the Ethiopians and reproduced in their paintings;

(b) Several details in the Ethiopian Crucifixion, namely Pilate's inscription, the mound on which the cross is set up and the crown of thorns as well as the allegorical collecting of the Holy Blood by the angels; the latter has inspired generations of Ethiopian painters;

(c) The banner which Christ holds in his hand while descending into Limbo; the banner thus introduced, became a characteristic trait of the Ethiopian representation of the Resurrection;

(d) The dragon and the Maiden Birutāwit as well as the scenes of the tortures in the imagery of St. George.

A few years ago, no one would have thought about the influence of the Italian on two major themes of Ethiopian painting, namely, the illustrations to the Book of Miracles of the Virgin Mary and the glorious representation of the Trinity. The contribution of Brancaleon to the former is already manifest and the latter is very probable.

GREGORIO BICINI

The existence of Gregorio or Hieronimo Bicini and his life in Ethiopia have been rescued from total oblivion by the fortuitous meeting between an Ethiopian monk and a Venetian erudite. The monk, Brother Thomas, a Franciscan born in the

locality called Ganget in Angot,[57] Ethiopia, talked about Bicini to Alessandro Zorzi, an Italian erudite who recorded it in his Itineraries.[58] Not much is known about Zorzi himself except that he was born before 1470 and was still at work in 1538. He probably travelled extensively to Cyprus, Alexandria, England, Spain and Flanders. He was married to a lady of the family of Ca Vendremin related to Bicini and lived in Venice. Being a man of considerable culture, and keenly interested in new geographical discoveries then being made,[59] Zorzi recorded the itineraries in Ethiopia as told by the travellers who happened to pass through Venice. One of them was Brother Thomas.[60] He described to Zorzi his itinerary from Bararā, the then usual residence of Ethiopian kings, to Jerusalem. He also added general information about the country and told him the story of Bicini. Zorzi went to see the family of Bicini in Venice and found that Brother Thomas had spoken the truth.

Zorzi mentions Bicini in two passages of his Itineraries. The longer passage was written on 7. April 1523, or shortly after and runs as follows: "Brother Thomas aforesaid says that with his Presta Davit at Barara is an Italian of the city of Venice who is called Messer Gregorio or Hieronimo Bicini, whom I [Zorzi] went to seek at Santa Margerita in the Square at his old house. I spoke with a daughter called Maria, who told me that her father aforesaid, departed in 1482 and went with merchandise to Alexandria, leaving his wife Dianora and his 2 brothers Jacopo and Antonio (a priest), and a sister, a nun of Corpus Christi, called Sister Maria and his mother Madonna Lucia; and that now all are dead except the nun his sister and his two children, a man called Messer Alvixi and the other is Madonna Maria; they were relations of my wife of Ca Vendremin. Presta David gave the said Venetian Bicini an estate with castles and a city under him, and he is married and has several children and rides with 70 horses, and is secretary of the said Presta; and he has painted for the said Presta many things and he often resides with him and plays chess and cards with him night and day(?). . . ."[61] Presta David is the name given to Ethiopian kings; Presta reflects the mediaeval belief in Europe that the sovereigns

[57] Angot, a district south of the Lake Ašangi and west of the motor route Waldyā-Qobo. AOI 316, map facing 304.

[58] CrawIt.

[59] The above information was taken by CrawIt 23–25 from the article by *Laura Mannoni*, Notizie sull'Etiopia raccolte da un studioso veneto del secolo XVI = Boll. della Società Geografica Italiana 69 (1932) 603–20 and *Roberto Almagià*, Intorno a quattro codici fiorentini e ad uno ferrareze dell'erudito veneziano Alessandro Zorzi = La Bibliofilia 38 (1936) 313–47.

[60] There were at least three Ethiopian monks whose name was Thomas who were in Europe around the second and third decade of the 16th century. *R. Lefevre* confutes the identification made of Br. Thomas, superior of the Ethiopian hospice of St. Stephen at the Vatican, with that of brother Thomas who in 1513 collaborated with Potken in Rome . . . and with another Brother Thomas who in the year 1524 was questioned in Venice by Alessandro Zorzi. Note su alcuni pellegrini etiopici in Roma al tempo di Leone X = RSE 21 (1965) 16. According to *Lefevre*, our Brother Thomas knew little Latin.

[61] CrawIt 167–69.

of Ethiopia were also priests, and David that they descended from the biblical King David.[62]

The shorter passage also written on 7. April 1523 refers to the land given to Bicini by the King: "... the province of Fesegar, which is 20 days across and has a city one day from Masegne called Sogra, which has the best, freshest, most temperate and perfect air that is in all the provinces of the Presta, and it is to be seen from every point in the boundless plains; and in this place the said Presta, has given [land] to M(esser) Gregorio, i.e. Hieronimo, the Venetian painter... And thus the said Presta settles in such city or land all the skilled persons who come from various parts."[63] The above is all the information we have about the adventurous Italian.[64] The inquiries by Prof. R. Almagià in Venice failed to reveal any trace of him.[65] Bicini's name is missing from the list of the foreigners whom Giovanni Battista da Imola met in Ethiopia.[66] This is not surprising. Giovanni Battista departed from Ethiopia in 1482, the year Bicini left Venice. Bicini probably stayed for some time in Egypt before proceeding to Ethiopia and arrived there after the departure of Giovanni Battista. Once in Ethiopia Bicini was probably not allowed to leave the country as happened then to most foreigners.

Alvarez did not mention Bicini either though he described the foreigners living at the court of King Lebna Dengel.[67] If the story of Brother Thomas about Bicini's career in Ethiopia was correct, Alvarez must have met him if he was still alive. That is why Conti Rossini theorizes about Alvarez' silence about Bicini. Perhaps the Italian was already dead when Dom Rodrigo's embassy arrived in Ethiopia. Conti Rossini believes that Thomas left Bararā in 1521 or 1522, that is, at least one year after the arrival of the Portuguese embassy.[69] Yet, it appears from the narrative of Thomas as recorded by Zorzi that Bicini was still alive when the Friar left his native land. This is evidenced by the use of the present tense "is", "se trova" in the

[62] "Presta Davit, which means Emperor, King and Lord; Davit is not his proper name. They say he is of the line of Davit", CrawIt 167.

[63] CrawIt 161–63.

[64] CRCodErit 94, refers to Frate Nicola da Oliveto who was supposed to have made the visit to Santa Margerita in the Square and to enquire about Bicini. *Conti Rossini* based his information on the authority of *Marcellino da Civezza* who partly reproduced Zorzi's manuscript in Bibliografia Sanfrancescana (Prato 1879) 217 f. It seems that, in fact, there was only one visit, that of Zorzi.

[65] CRCodErit 22.

[66] The list of the Italians is as follows: Gabriele da Napoli, Jacomo di Garzoni of Venice, Pierto da Monte of Venice, Giovanni di Fiesole of Genova; all of these came to Ethiopia circa 1459; Zuan (John) d'Arduino of Venice, Cola di Rossi, Nicolò da Mantova came circa 1480.

[67] Alvarez recorded some 15 Europeans mostly native of Genova, two Catalans, one Greek from Chios Island, one Basque and one German. He recorded by name Pero da Covilham, Portuguese, and Nicolò Brancaleon as well as Tomasso Gradani, Italians. The latter had been living in Ethiopia since 1505.

[68] *C. Conti Rossini,* Geografica = RSE 3 (1943) 177.

[69] CRCodErit 94.

narrative. Moreover, if Thomas departed in 1521, as suggested by Conti Rossini, he would have known about the arrival of the Portuguese and told Zorzi about this important event. The date of Thomas' departure from Ethiopia is not clear from Zorzi's text as edited by Crawford.

The silence of both, Giovanni Battista and Alvarez, broadens the limits of time when Bicini could have lived in Ethiopia. He probably arrived after 1482 and died before 1520. He was apparently in his thirties when he arrived and in his sixties or even seventies when he died. Similar to Brancaleon, he rose to a high position. The statement of Thomas that he was secretary to the king would imply that he spoke and wrote the languages of the country. The reason for his being a "secretary" is not clear since there were many local scribes. On the other hand, the curious information that Bicini played chess and cards with a king "at night" has some credibility. Ethiopians used to play chess in the past.[70] The rumour about the intimate relations between Bicini and Ethiopian sovereigns rightly mirrors the situation at court as reported by Thomas. Ethiopians were not allowed to see "the face" of their kings whereas foreigners could speak to them "face to face".[71]

It is not clear with whom Bicini played games. Conti Rossini says that it was Lebna Dengel,[72] while three Ethiopian monarchs reigned during Bicini's life in Ethiopia. Eskender was six years of age at the time of his accession to the throne and died as a young man of 22. According to a local source he was friendly with the foreigners living in Ethiopia.[73] His brother Nā'od was twenty years old when he mounted the throne and died at 34, leaving his son Lebna Dengel then a boy of twelve. Bicini was in his sixties or over at that time. The rumour of chess and card games could refer to the father and uncle of Lebna Dengel as well as to himself.

What about the paintings which Bicini was supposed to have done for the rulers of Ethiopia? No works signed by Bicini have been found. It would be premature to assign to him some of the paintings recently recorded in Ethiopia and listed in the following section. These paintings are almost certainly not made by Brancaleon and most probably not by another foreign painter living in 16th-century Ethiopia, Lázaro de Andrade. The presumption is that among these paintings there should be works of Bicini, but nothing more can as yet be said because of our limited knowledge of the material. One fact seems to be certain: like Brancaleon, Bicini was not a professional painter. He was a merchant who developed the skill of producing pictures because of his adventure in Ethiopia.

[70] R. Pankhurst, History and principles of Ethiopian chess = JEthSt IX 2 (1971) 149–72.

[71] CrawIt 169.

[72] Conti Rossini thought that Bicini who assumed the name of "Gorgorêwos" was "carissimo al Lebna Dengel". CRCodErit 94.

[73] "And in those days there came Franks from Rome.", relates the royal chronicle. "One of them was a priest called Yohannis. And [the King] received them with honour. When the priests saw this they grumbled and spoke ill of him saying 'The King has joined the religion of the Franks'" (TTCh 291).

LAZARO DE ANDRADE AND HIS WORK

Lázaro de Andrade, the Portuguese, was a professional painter. He is known to us mainly from the records of the Rodrigo de Lima Embassy to Ethiopia, which were written by Francisco Alvarez. Andrade was described by Alvarez as a gifted man in other fields besides painting. He "could sing well", writes Alvarez, and took part in Christmas mass celebrated for Lebna Dengel.[74] During the stay of the Embassy in Ethiopia, Andrade had two unpleasant accidents which were recorded by Alvarez: "There was among us a Portuguese", writes Alvarez, "a native of Lisbon, by the name of Lazaro d'Andrade, who was a painter, and he lost his sight; the Prester [King Lebna Dengel] sent to tell him to go to the tomb of this deceased man [*Ečagē* Yoḥannes who had been an abbot of the Dabra Libānos monastery and considered a saint] and to wash with good faith, and that he would receive health: he went there and returned as he went."[75] Another accident was of a different nature. "On Sunday, 2. December 1520, in the afternoon", writes Alvarez, "our Portuguese painter, named Lazaro d'Andrade, was standing near the King's tent, and was invited to wrestle and . . . he wrestled; and in the beginning of it they broke one of his legs. After it was broken, the Prester gave him a dress of rich brocade and they brought him to our tent on [four] men's shoulders".[76] In spite of these two accidents, Andrade was apparently in good physical conditions when the Embassy was to leave Ethiopia in 1526. King Lebna Dengel, writes Alvarez, requested Dom Rodrigo to allow two Portuguese, "Mestre Joam and the painter", to remain in the country, "as in fact they did". This was, Alvarez noted, on Tuesday, 12. February.[77] The story of João Bermudez, called by Alvarez "Mestre Joam", is well-known; he became a self-styled Patriarch of Ethiopia and has written his own version of his career in the Land of Prester John. The "painter" was obviously Andrade, but all trace of him was lost after the departure of the Embassy. Bermudez and Miguel de Castanhoso, chronicler of the Portuguese expedition to Ethiopia in the 1540s, are silent concerning him. Nothing is known either about Andrade's life and work prior to his departure to Ethiopia. The entry about him in the Grande Enciclopedia Portuguesa merely repeats the information given by Alvarez and another 16th-century writer, Gaspar Correa.[78]

Alvarez is silent about the artistic activities of Andrade but there is little doubt that during his stay in Ethiopia, he was producing paintings. Indeed, Correa thought Andrade was a good painter. Andrade travelled to the land of Prester John probably to record in painting the places visited and the happenings related to the Embassy. However, no such document, with one exception, was found in Europe.

[74] AlvPrJ 61, 325.

[75] AlvPrJ 262.

[76] AlvPrJ 318.

[77] AlvPrJ 380.

[78] Grande Enciclopedia Portuguesa (Lisboa n. d.) 541; *G. Correa*, Lendas da India . . . publicadas . . . de R. José de Lima Felner II (Lisboa 1861) 587. *Correa* mentions Andrade among the Portuguese chosen to accompany Dom Rodrigo in his mission to Ethiopia.

Probably there were none considering that the frontispiece illustration to the first edition of Alvarez is purely imaginary.

Thanks to recent studies on the portrait of Lebna Dengel by R. Lefevre,[79] and the discoveries in Ethiopia, we are able at present to tentatively identify some of Andrade's works.

(19) Let us start with the portrait. Alvarez, after his return to Europe, according to Lefevre, travelled to Italy and delivered to Pope Clemens VII a letter from Lebna Dengel and the gift of the golden cross. There are no records at the Curia that he presented the Pope with a portrait of the King. This, however, must have been the case. An enlightened prelate and friend of Clemens, Paolo Giovio, who collected a gallery of famous men in his villa at Como, noted in his Elogia virorum illustrum, "The hooded Ethiopian priests who live and have their church behind the great Vatican temple, all agree that this is the exact image of their king, brought to Pope Clement together with the golden cross by Peter Alvarez, the ambassador..."[80] Moreover, Giovio either received from the Pope the original painting or permission to make a copy of it. After the death of Giovio, his gallery was dispersed but in 1552 Cosimo, Grand Duke of Tuscany, ordered copies made of the portraits. Among these was that of Lebna Dengel. This copy is still kept in the Gallery degli Uffizi. Subsequently more copies have been made for European collections.

The painting represents a young man (fig. 189) with a fine dusky face; his nose is narrow and straight, he has a short pointed beard and a thin moustache. He wears an Ethiopian garment. A large pearl is affixed to the lobe. The inscription in Latin indicates that the portrait is of "DAVID ATANADI AET: IM". David is a royal name of Lebna Dengel which means Incense of Mary.

The portrait seems to have been made by a professional painter. "The original brought to Bologna", writes Lefevre, "was certainly the work of an expert occidental hand. Was the painting then made by a European after the sitter himself and at the Ethiopian court? One would answer yes, without hesitation, considering that the painter Lázaro de Andrade took part in the Embassy of Dom Rodrigues...", but Lefevre also thought about "Gerolamo Becini, the Venetian" or "Niccolò Brancaleone".[81] At present, the quality of Brancaleon's art is sufficiently well known to exclude him as a possible painter of the portrait. It also seems most unlikely that Bicini, provided that he was still alive in the years 1520–26, would have been asked by the Portuguese to make the portrait of the King when Andrade was at hand. This was also the reasoning of the Portuguese art historian Luis Reis Santos.[82] The conclusion is obvious: Andrade painted the original portrait. He did not sign it, similarly to the two other paintings also attributed to him. By doing so he probably followed the Ethiopian custom of leaving the paintings anonymous.

[79] LefRitF.
[80] LefRitF 30.
[81] LefRitF 31.
[82] ReisSant 29.

(20) Two triptychs kept in the Dimā Giyorgis church, one representing the Trinity (fig. 41) and the other the Coronation of the Virgin (fig. 160) have been described on pages 112f. and 341–43. A summary of the conclusions will be therefore sufficient.

Guy Annequin who discovered the triptychs in 1963 commented on these as follows: (a) the triptychs are painted by the same hand; (b) "the choice of figures, their arrangement and poses recall Italy; the background with vegetation, the shape of houses and perspective point towards the North to Flanders. The taste for details and the type of demons suggest the nordic sensibility rather than the Latin..." According to Annequin, the triptychs are the work of a European painter living in Ethiopia; they date to the beginning of the 16th century.[83]

Annequin's notice of Northern European elements in the iconography and style of the paintings is of particular interest. The Iberian art of the 15th and 16th centuries was indeed influenced by the art of Flanders.

Who painted the triptychs? A tentative identification of the painter is possible thanks to recent discoveries and research. The painter was most probably Lázaro de Andrade. Brancaleon is excluded on stylistic and technical grounds and there is no valid argument for ascribing the paintings to Bicini. On the other hand, there are good reasons to believe that Andrade was the painter of these.

(a) The paintings have manifestly been made by a professional painter though they contain a number of flaws. He painted in a style which obviously belongs to European Renaissance art.

(b) The form of the Coronation of the Virgin is Iberian as explained on pp. 339f.

(c) In both paintings Saint Gabriel holds a phylactery in his hands; in late Mediaeval art, the phylactery is made to appear as if held or coming from the mouth to show what is being said. The use of phylacteries was widespread in Northern Europe and particularly popular in the central and lower Rhine region.[84] On the other hand, phylacteries are virtually unknown in Italian painting. This fact positively excludes an Italian as the painter of the triptychs and provides strong argument for assigning these to an artist who was obviously influenced by Flemish art.

(d) The triptychs which were intended for Ethiopians, probably for their king, bear an inscription in Ethiopic, whereas the portrait of Lebna Dengel which was intended for Europeans bears an inscription in Latin. The Latin letters do not recall the awry calligraphy of Brancaleon, a sample of which is found in the Walatta Dengel Book of Miniatures;

(e) In both triptychs, the painter applied the same method of production. The frame and central panel were cut from two separate pieces of wood and then nailed together. The usual Ethiopian method of making icons was to chisel the middle board leaving a ridge around it. Thus, the "frame" and the main body of the panel always consist of one piece of board. The inner edges of the frames are slanting. No hinges were used for attaching wings to the main panel, but

[83] AnnLebna 50–51; Fouilles et reconnaissances = AÉ 6 (1965) 17.
[84] The Annunciations: SchillIc I fig. 127, 128, 129, 133, 141, 172.

strings were fed through the holes, which is the Ethiopian manner of producing icons. These technical details evidence that the maker of the triptychs was a foreigner but he made these in Ethiopia. Another unusual feature of the painting is the use of gold for depicting the crowns, the globes and the borders of dresses.

Further study of the paintings by experts of Flemish and Portuguese art as well as of the pigments will hopefully add more arguments and finally confirm the above findings.

The following two paintings are classed in the category of works possibly painted by Andrade.

(21) The triptych in the treasury of the Tadbāba Māryām Monastery in Amārā Sāyent, may have been painted by Andrade though some of its details do not fully agree with our perception of the other works attributed to him. The theme of the main panel, the Adoration of the Magi, is uncommon in early Ethiopian painting. St. Gabriel and St. Michael are depicted on the side panels.

D. Spencer who discovered our triptych thought the work to be "in European mediaeval style reminiscent of the art of d'Andrade..."[85] The composition of the main panel is not so monumental as that of the Dimā Giyorgis triptychs. This is probably due to the different proportions of the figures; their heads are larger compared to the rest of the body. On the other hand, such details as the landscape with the castle on the hill, as well as the Archangels, and the use of gold, point to the Portuguese artist.

(22) The panel called *Kwerʿata reʾesu* (fig. 190), the striking of his [= Our Lord's] head, enjoyed in Ethiopia greater fame than any other painting. The Ethiopic name of the panel is a paraphrase of the passage from Matthew 27,30, and Mark 15,19. The panel, however, represents the bust of Christ wearing the crown of thorns, it shows the palms of his uplifted hands and blood streaming over his chest. In Western art this representation of Christ is called the devotional image of the *Ecce Homo*.

This impressive painting is undoubtedly of foreign inspiration and execution. During the 17th, 18th and 19th centuries, the painting was kept in the royal residence at Gondar and was considered particularly holy. Some historical records say that starting with the 17th century the panel used to be taken on campaigns by Ethiopian monarchs. The last who did so was Emperor Tēwodros II (1855–68), who removed the painting from Gondar and brought it to his fortress of Maqdalā. Tēwodros was defeated by the British and died in 1868. The panel fell into their hands and disappeared from view for a long time. In fact, it was in the possession of Richard Holmes, later Sir Richard, member of the staff of the British Museum, who was sent to Ethiopia with the expedition of 1867–68. In 1905 Holmes arranged to publish an article on the painting in Burlington Magazine.[86] After his death, the

[85] SpencLuke 87.

[86] A Flemish picture from Abyssinia = The Burlington Magazine for Connoisseurs 7 (1905) 394.

widow sold the painting to an anonymous purchaser. At present the painting is owned by a private collector in Portugal.[87]

There exist a number of Ethiopian copies of the painting as well as a great many paintings which originate from it but show significant changes. The copies and transformed aspects, invariably called by Ethiopians *Kwer'ata re'esu*, have been studied by Enrico Cerulli who published his findings on two occasions,[88] and by Wilhelm Staude who published one article.[89]

Both Cerulli and Staude worked on the material dating from the 17th, 18th and 19th centuries. The paintings dated to the 15th and 16th centuries, which recently came to light, necessitate a revision of the whole problem.

Our immediate purpose is to discuss the Imperial icon, as it was called by Staude, which was kept at the castle of Gondar. Already Reis Santos dealt with its origin. "Of various plausible theories", he wrote in 1941, "two seem to me the most probable; the panel was either the work of a painter who formed part of the embassy of Dom Rodrigo de Lima in 1520 or it was taken to Abyssinia later."[90] Cerulli's findings are as follows. The icon came from Portugal according to "every likelihood". It was the work of an artist who either lived at the end of the 15th or in the beginning of the 16th century. He belonged to either the Flemish school or one of the schools in the Iberic Peninsula which were under the influence of the great Flemish artists.[91]

Cerulli assumed that the icon was imported from Europe. Evidently he did not think it possible that the icon could have been painted in Ethiopia. This determining factor of Cerulli's argument is herewith challenged. Should we accept as given that the painting must have been imported when we know that, at the beginning of the 16th century, a Portuguese painter lived and worked in Ethiopia and that Cerulli's own conclusions show a striking coincidence with the facts of Andrade's life as known to us?

(a) There is unanimous agreement that the Imperial icon dates from either the end of the 15th or the beginning of the 16th century, which means in the lifetime of Andrade.

(b) Although the painting represents the form originating from Flemish art and the Belgians attribute the painting to the art of Flanders, in the opinion of Reis Santos, it belongs stylistically to the school of painters which was existing in Portugal in the first half of the 16th century. He cited the specific reasons for attributing the painting to Portugal as follows: "...full of a 'serene and powerful feeling' as José de Figueiredo well described the fifteenth-century

[87] *R. Pankhurst*, The Kwer'ata re'esu: the History of an Ethiopian Icon = Abba Salama 10 (1979) 169–87.

[88] *E. Cerulli*, Etiopi in Palestina: storia della communità etiopica di Gerusalemme (Roma 1943) II 264–75; CGesu.

[89] *W. Staude*, Les cinq clous du Christ et l'Icône Impériale éthiopienne = Ethnologische Zeitschrift (1971) 5–26.

[90] ReisSant 29.

[91] CGesù 116.

Ecce Homo of the Museum of the Janelas Verdes... The composition, the gesture of the hands, the attitude of the head, the drawing of the ornament of the robe and the aureole, the treatment of the crown of thorns, the modelling of the face and hands: all these recall details in scenes of the life and passion of Christ in sixteenth-century panels painted in Portugal, especially in the style of the 'Master of the Paradise' and his fellow craftsmen, and handed on to disciples and followers".[92] Indeed, the similarity of our icon with some contemporary Portuguese paintings is striking.

Andrade received his training in 16th-century Portugal. He certainly was able to produce an image of the *Ecce Homo* expressed in the idiom which was particular to his native land.

There remains the problem of dating the Ethiopic inscription above the nimbus, "The striking of his [= Our Lord's] head". Cerulli dated the script of the hand from the beginning of the 17th century. He justified it by a direct analogy of the script to that of the manuscript written for Ḥamalmāla Warq, mother of Emperor Susneyos, (British Library Or. 644).[93] If the icon was imported, it would be difficult to establish the date of the inscription since dating an Ethiopic script is fraught with hazards and pitfalls. On the other hand, if the painting was made in Ethiopia, then painting and writing explanatory inscriptions were usually done at the same time. The Dimā Giyorgis artist did it, and he used a neat but somewhat stiff script which would confuse even an expert. Therefore it is an open question whether the painter of our icon has written the inscription himself, or that it was added at a later date.

Cerulli had already noted that the inscription does not correspond to the subject of the painting and he gave an explanation for this, namely that the Ethiopians thought it convenient to call the imported image by the vocabulary already known and diffused in Ethiopia.[94] But how can we explain the difference when the painting was made in that country? The guess is that the reason could be the same as that given by Cerulli but that there might also be other reasons which as yet we are not aware of.

To sum up, the working proposition for further studies is that Andrade painted the Imperial icon. When Reis Santos and other Portuguese as well as Belgian art historians contested its attribution, the paintings in Dimā Giyorgis and that in Tadbāba Māryām were not known. The final solution of the identification is now possible through a direct comparison of the icon with these paintings; this how-ever, is not possible at the moment.

[92] ReisSant 26–29.
[93] CGesù 120.
[94] CGesù 121.

OTHER EUROPEAN PAINTINGS OF THE PERIOD

The following paintings made by Europeans have recently been found in Ethiopia. The paintings are ascribed to the 15th and early 16th century but they do not seem to be by Brancaleon and are certainly not by Andrade. Perhaps some paintings are by Bicini.

(23) A diptych in private possession, location not specified, of St. George on horseback represented in the left panel and the Virgin Mary with Child in the right panel (fig. 191).[95] In style and execution the diptych differs from triptych No. 4191 in which the Saint is also depicted. Since the triptych is painted by Brancaleon, the diptych must be by another artist.

St. George wears an intricate crown on his head; the detail first appears in the 15th century and has its origin in an old legend about the Saint. After many cruel trials endured for the Christian faith, he was eventually decapitated and in that very moment God gave him the triple crown of martyrdom. The story must have been known to Ethiopians before the 15th century but only then did they start to depict the Saint as a triumphant rider, clad in sumptuous attire and wearing the triple crown of martyrdom.

Our diptych is the earliest known image of the crowned Saint, though the large ornamented crown he wears is not exactly the triple one. Its finely drawn and elongated finials are blue to the side and yellow in the middle and are decorated with intricate flowing patterns of red bands. The crown is fixed to the head with a braided bandlet whose long endings surge behind the Saint's back.

The origin of the form is not known. However, a similar crown is worn by "Constantine of Rome", Belin Sagad, a Tegrean noble and St. George depicted in the Book of Prayers (Abb. 105, Bibliothèque nationale, Paris)[96] and by Prince Yemḥārana Egziʾe, a Tegrean noble, depicted in the Lives of the Martyrs which was most probably made for him.[97] The ms. Abb. 105 was written and its miniatures painted in the years 1476–77, the book of the Prince Yemḥārana also dates from about that time. Therefore our painter adorned St. George's head with the gear which then was probably worn by Ethiopian royalty and nobility but elongated its finials to make it look like a real crown.

The figure of Saint George is drawn realistically and gives the feeling of Italian art. The Saint wears a long blue tunic lined with red, with a red skirt under it and a pink cloak or toga over it. The lower part of the cloak covers the Saint's legs and reaches in harmonious folds below the horse's belly. The main folds of the cloak are in the form of a "V". The hands of the Saint are small in relation to his head and the rest of the body though they are not entirely as out of proportion as in Brancaleon's paintings. St. George is barefoot which is according to the Ethiopian

[95] ChojlcGeorge = I 71–73.

[96] Reproduced in CRCodErit 89–93.

[97] The manuscript was photographed at Dabra Māryām (Qoḥāyen) during the British administration of Eritrea, 1942–52. One set of black and white prints is in the writer's possession thanks to the kindness of David R. Buxton.

custom. This, as well as the Ethiopic inscription, evidences that the painting was made in the land of Prester John.

The gently bouncing horse has a mane which is carefully drawn with fine lines. His eyes have a striking human expression, strengthened by the blue colour of the iris.[98]

The image of St. George is associated with an unusual portrayal of the Virgin. She holds the naked Child in her lap. The Child has his hands crossed on his chest and his loins are covered with a transparent cloth.[99] The theme is exceptional in the Ethiopian iconography of the Virgin but common in Western Renaissance painting. The manner in which the Virgin's hands are folded in prayer also originates from Western art. The suggestion is that the form was introduced into 15th-century Ethiopian painting by the expatriate painters.

Mary's head and body are wrapped in a large yellowish-green mantle fastened with a round brooch; she also wears a red tunic shown at her breast and wrists and a blue-green shirt as in icons of the Italo-Cretan school. Likewise, a white pleated cap under the mantle points to the same school.

Mary's figure is not well-proportioned, her head and shoulders seem too large in relation to the body below her chest. Also, in spite of the elaborate folds of her cloak, one could hardly guess whether the Virgin is sitting or kneeling. It seems that the painter copied the upper half of Mary's figure from Cretan painting and composed the portion below the chest himself. His indebtedness to Greek art is evidenced by his technique of modelling the faces and folds of the garments. He applied strong, clear hues on a basic dark ground colour. Such a method is not used in paintings by Brancaleon or those ascribed to him.

Mary is flanked by St. Michael and St. Gabriel who have their hands folded in prayer. Their long hair is fair and their blue wings are rendered realistically as those of a bird. These details suggest that the painter of the diptych was a foreigner.

(24) D. Spencer discovered in Wāfā Iyasus church, Goǧǧām, a triptych of the Man of Sorrows, or *Imago Pietatis* (fig. 192). The icon is considered holy and revealed from the four doors of *maqdās* three times in the year. Opinion is divided as to the origin of the painting. According to some local priests it was painted by St. Luke and brought by King Dāwit from Egypt. Others say that it was painted by St. John and brought by a certain Aṣēqā Dengel believed to be a brother of Lebna Dengel. Spencer described the triptych as follows:

"Centre panel of foreign origin with Latin, Greek and Ethiopic inscriptions. The sculptured body of Christ is portrayed descending into the bottomless pit of a box-like grave. The hands are crossed in front to reveal the bloodstained marks of the nails. The drooping head with long wavy hair is outlined against a gold

[98] A similar horse is found in a broken panel, IES Coll. No. 3452a, which is ascribed to the 15th century; ChojArtEth 29–31.

[99] A similar naked Child is depicted in the above broken panel, IES Coll. No. 3452b; in both, the Child wears an identical cruciform nimbus. There is no doubt that either the diptych and the broken panel were painted by the same hand or that the painter of the panel was strongly influenced by the diptych.

background which is formed by partially raised, olive-green and gold curtains. The picture is framed in rough wood and of the same proportion as the frame are two side panels, which are evidently the work of a different artist. On the right panel is the full figure of Nicodemus holding the box of spices, and on the left panel is Joseph holding the shroud".[100]

Was the central piece of the triptych painted in Ethiopia or imported? When was the triptych painted and by whom? The answers to these questions are, of course, tentative considering that the following analysis is based on a photographic reproduction and no close investigation of the piece and its pigments was made.

Let us start with the making of the triptych. D. Spencer noted that the central panel was set into a rough frame; this is clearly shown in the photograph. The triptych is an assemblage of the panel with the picture of the Man of Sorrows and its frame which also serves as support for the side panels. This then is the locally made frame or box added to the imported painting. Moreover, the foreign artist painted the panels. The frame might have been constructed shortly after arrival of the panel into the country or in later years or decades.

The triptychs made in Ethiopia are virtually always cut out of a piece of wood and no framing was used. The way our triptych is made provides an argument against the local origin of the central panel.

The image of the Man of Sorrows is virtually unique in the history of Ethiopian painting. "The theme", writes G. Schiller, "is the most precise visual expression of the piety of the Late Middle Ages, which took its character from mystical contemplation rather than theological speculation". The roots of the theme lie in the liturgical art of the Eastern Church. From the East came the prototype of the early Western images of the Man of Sorrows, namely a lost icon in the church of S. Croce in Gerusalemme in Rome. The earliest type of the Man of Sorrows was called Gregorian because of the connection of this icon with the legend referring to Pope Gregory (540–604). The type was common in Central Italy during the 13th and 14th centuries. Starting with the 15th century, additions of figures and other details substantially altered the early, sober form.[101] Our Man of Sorrows in Wāfā Iyasus church embodies almost to perfection the primitive form and recalls some paintings of the 13th and 14th-century Italian schools. The "sculptured" body of Christ, as noted by D. Spencer, the breast drawn with a strong horizontal line and the abdomen with a strong line, are strikingly analogous to the Man of Sorrows with *Mater Dolorosa* in the Museo Horne, Florence. That 13th-century painting is believed to be Italian but strongly influenced by Byzantine art, or perhaps painted by a Byzantine artist living in Italy. In the Wāfā Iyasus panel, the hands of Christ are crossed on his abdomen as in the wall painting by Spinello Aretino, dated 1395. Christ stands in an open grave in the form of a rectangular box without a lid. Such a grave appears in the 14th-century Man of Sorrows of the Rimini school, in the

[100] SpencGojj 207. The local priests call the painting *Kwer'ata re'esu* which is a mistake. In Ethiopia this name usually refers to another iconographic form.

[101] SchillIc II 197–201, fig. 730, 733–36.

painting of Spinello Aretino, and in that of Lorenzo Monaco dated 1404. Although the tombs in 15th-century Venetian paintings of the Man of Sorrows are of the same form,[102] the way of modelling the body of Christ in our panel points rather to Florence. However, it should be recalled that the form of the Man of Sorrows stems from Eastern Christian art, and therefore our icon might be of Greek origin.

The Italian origin of our Man of Sorrows is possible, though it contains some odd details. There are three inscriptions, the original Latin and Greek, and Ethiopic added. Pilate's inscription in Latin is INRH instead of the usual INRI. This peculiar form is also found in the Crucifixion by Brancaleon, who obviously misunderstood the sign and changed the H into an awkward U. The Ethiopic inscription which runs "[Picture of] Jesus Christ" was, of course, added in Ethiopia. This triple inscription is a reason for believing that the painting was imported.

Another odd detail is an olive-green curtain above the head of Christ. The curtain is crudely drawn compared to the rest of the painting. Perhaps this detail was added in Ethiopia to the originally smooth golden background.

To sum up, the Man of Sorrows in our triptych points to either Italy or Greece and the period from the 13th to the early 16th century. Although there are strong arguments for considering the painting as imported, the possibility of its having been made in Ethiopia should not be entirely excluded. If the first suggestion is correct, the panel would probably be the earliest known to us imported painting in Ethiopia.

The side panels of the triptych are painted by another artist, but the figures of Nicodemus and Joseph of Arimathea are directly related to the theme of the central panel. Therefore, the suggestion is that the wings were painted in Ethiopia at the time when the frame to the central panel was manufactured.

The figures recall in some detail those of St. George Crowned (fig. 191). Joseph's blue cloak is draped with the folds which take the form of multiple "V"s, and the cloth of Nicodemus has a fold which is similar to that on St. George's knee. Also, the way of drawing the neck with a strong curved line across, is found in the paintings of St. George. The figures do not show Brancaleon's tendency of drawing the hands minutely, but the feet are unusually small.

The background of the panels is painted in one flat colour which seems to be inspired by the art of the Ethiopians. There is no attempt at depicting the architectural structures or trees as in some of Brancaleon's paintings. The faces and garments are modelled by a careful and effective shading. The painter of the panels seems to possess more skill than Brancaleon.

(25) A small church hewn in rocky slopes east of Lake Ṭānā in Bagēmder province, and dedicated to Saint Andrew (Wāšā Endreyās) treasures two large paint-

[102] Antonio Vivarini painted the Man of Sorrows twice, c. 1450 and in 1464; also Carlo Crivelli, c. 1430–95, and Vittorio Crivelli, 1481–1501. In all these paintings, Christ emerging from the tomb holds his hands crossed on his chest or on the edge of the tomb. In Crivelli's painting, his hands are posed on the lower abdomen.

ings. Both bear characteristics of European art. According to the priests serving the church, the paintings remained in the possession of the church "since time immemorial". They are evidently related to 15th-century art and are some five centuries old, though still in an excellent state of preservation.[103] Both represent the Virgin and Child flanked by the archangels Michael and Gabriel.

The first of the two pictures is a triptych the wings of which are lost (fig. 193). The theme is Our Lady of Tenderness (Eleousa), well-known in Greek and particularly Cretan imagery of the Virgin; however the theme is probably transmuted into the Western expression of love between mother and Child. He is seated on his mother's lap and is supported by the left hand of the Virgin, her forearm passing in between his legs. This slung-leg position of the Child which suggests intimacy mirrors the spirit of Western art though it is also found in the Greek imagery of the Virgin (fig. 194). The Child gazes at his mother and presses his cheek against hers. He grasps her chin with his left hand and holds a fluttering white bird in the other. The bird is positively not meant to be a symbol of the Holy Spirit but is an animal pet of the Divine Infant. This detail manifestly derives from Italian Renaissance painting.

The movement of the Child's hand touching the chin of the Virgin is most unusual in Ethiopian painting. It appears, in addition to our panel, in the diptych No. 36 (p. 421, fig. 208) and one manuscript miniature.[104] It is not known in paintings made after the mid-16th century. The movement was not devised locally and therefore its origin is to be searched for outside Ethiopia. In 16th and 17th-century images of Our Lady of Tenderness painted by the Greeks, the Child touches with one hand the cheek of Mary (fig. 194 and 195) but the movement of the hand in our panel is different. It seems that to find an analogy one has to search in 15th-century European art. An example of an identical movement is found in the central panel of the triptych now in the Wallraf-Richartz Museum in Cologne, showing the Virgin with a Vetch (fig. 196). In the museum catalogue the painting is identified as being by the Master of St. Veronica working in Cologne in the years 1395–1415.[105] This similarity does not suggest a direct copying or even an influence of German art on the Ethiopian picture but the analogy is worth recording.

Mary is seated on a wide chair with rounded back, which is perhaps a simplified version of the chair in fig. 184. An arch over Mary's head suggests European Renaissance art. The background is filled with the curious imbrication pattern in olive-green colour which is also found in Brancaleon's painting (fig. 177), as well

[103] Discovered by the writer accompanied by Dr. Kinefe-Rigb Zelleke and *Ato* Girma Fisseha during a field trip in fall of 1973.

[104] Miniature in the manuscript, Gunda Gundē monastery, Agāmē, published by J. Leroy, in AÉ 6 (1965) pl. 86. The French scholar did not comment on the movement of the hand. He ascribed the manuscript to either the second half of the 15th or the early 16th century. This is, of course, a very approximate dating.

[105] The writer is indebted to Ms. Jennifer Montagu, The Warburg Institute, University of London, for information and comments.

as in the painting No. 27 (fig. 200) described subsequently. Is this pattern an indication of Brancaleon's influence? Mary's dark blue cloak is draped with sinuous folds showing the shapes of knees and legs similar to other 15th and early 16th-century paintings. Mary wears yellow shoes which stand out from her red robe.

The archangels are typical of mid 15th-century paintings and are characterized by the round shape of their heads, and their wings are ornamented with colourful patterns. Both Michael and Gabriel hold an upraised sword in one hand, but the former keeps the other hand on his chest whereas the latter points it upwards. This gesture is particular to a few 15th-century paintings (figs. 197 and 211).

The modelling is delicate and the lineament of the faces is accentuated with light brownish lines. Although the theme of the painting is foreign, the Ethiopian environment comes strongly to the fore. The faces of the angels and particularly that of the Child have clearly Ethiopian features and their hair is black. The panel was painted in Ethiopia, either by an expatriate artist or copied very closely from his work.

(26) Mary and the Infant Jesus, depicted in the second Wāšā Endreyās panel (fig. 198), vividly express their bond of love. He affectionately stretches his left arm towards her, holding with his hand the border of her cloak. Mary responds by grasping his wrist. This intimate movement of the Child also appears in a miniature of the ms. Abb. 105 (fig. 210) and in a small diptych in private possession in the USA (fig. 199),[106] whereas in triptych, The Brumit Coll. No. 1 (fig. 156) the Child seems to grasp the braiding of Mary's robe with his left uplifted hand and her breast with his right outstretched hand. The same movement is found in cloth painting, Dāgā Eṣṭifānos (fig. 207). The Western origin of these uncommon poses is suggested by a singular analogy between the Ethiopian paintings and the Venetian woodcut discussed in another place in this book (p. 338, fig. 159). Ethiopian painters variously depicted the Child's hand; in Abb. 105 the hand is raised and grasping the braiding of Mary's cloak on her head, in the small diptych the hand is outstretched horizontally grasping the border of the *maphorion* on Mary's breast and in triptych, The Brumit Coll., as described above. In all, the painter's intent to show the Child grasping a piece of Mary's dress is as equally explicit as in the Italian woodcut.

The Child holds a dark brown bird, obviously his pet, which sits quietly on his hand. The Child's hair is black but his face does not look Ethiopian as it did in the previous pictures. The mulberry-red colour of his long robe is characteristic of the 15th-century painting. His two small feet at the bottom of the robe are poorly drawn and show a lack of skill similar to that of Brancaleon's in drawing feet

[106] The diptych (Hl USA) is ornamented in the back with patterns composed of pieces of glass. This seems to be of the same type which was used for lunettes of Madḫanē Ālam church, Lālibalà. A. *Monti della Corte,* Lalibelà: le chiese ipogee e monolitiche e gli altri monumenti medievali del Lasta (Roma 1940, 44 f) identified the glass as of *kamarie* type, used in the Near East in the Mediaeval period.

facing the front. Also, Mary's red robe as well as the folds of her blue cloak on her knees and legs recall Brancaleon's pictures. Mary sits on an ornate chair with a low round back and six tumbled legs; the drawing is crude but still expresses the chair in perspective. This is another indication of the painting's foreign origin because Ethiopians knew only two-dimensional design.

The archangels do not recall those in the previous panel, St. Gabriel does not point with his hand upwards, the wings of both are rendered realistically with bird feathers and St. Michael wears a cape clasped in front by an elliptical brooch. The latter is also found in Brancaleon's paintings.

The faces of all the figures have an unpleasant expression which is due to their piercing eyes traced around with a strong black line and dark irises placed in the middle of the eyeballs but not touching the eyelids. The heavy eyebrows are drawn with multiple short vertical lines which are also found in the following diptych and in a number of early 16th-century paintings.

It seems that the painter or painters of both panels had in mind a particular foreign painting or form for depicting the figures of Mary and Child and tried to copy these, whereas they followed the local iconography for representing the figures of the archangels.

The key problem is the relation of the two Wāšā Endreyās panels to the works of Brancaleon. The imbricate ornamentation and possibly the clumsy feet of the Child evidence some kind of relationship. Does this mean that the Wāšā Endreyās panels should be ascribed to the Italian painter? The writer's feeling is that in spite of the similarity of these details, the first panel from Wāšā Endreyās and the diptych No. 4324 described subsequently show such stylistic differences from Brancaleon's work that their attribution to him is not possible. On the other hand, the second panel from Wāšā Endreyās gives a feeling of similarity with Brancaleon's paintings but this impression may be superficial; more evidence is required to ascribe the painting to him.

(27) In the diptych No. 4324, IES Collection, Addis Ababā, St. Peter and St. Paul are depicted in the left panel and three personage of the Old Testament, Isaac, Abraham and Jacob, in the right panel (fig. 200). St. Peter holds a key which is realistically drawn and St. Paul, a book. St. Peter has his hand resting on St. Paul's shoulder.

The men of the Old Testament are displayed symmetrically. Abraham in the middle faces the front and holds his hands on the shoulders of Isaac and Jacob who are shown in three-quarter pose and look at each other. The choice of personages for this symbolic composition was probably dictated by the strong Jewish traditions in Ethiopian culture. The Ethiopic Synaxary refers frequently to Abraham, Isaac and Jacob and contains a special salutation to them (on the 28th day of Ṭerr). The belief that the royal Ethiopian house descended from the Jewish kings is probably the reason for the words in 15th and 16th-century royal nomenclature stating that they derived "from the seed of Abraham, Isaac and Jacob". Thus the painting was possibly commissioned by and certainly agreeable to the royal patron.

The meaning of Abraham's pose of protecting his son and grandson is comparable to that of St. Peter in the same diptych. The spiritual bond is emphazied as

well as the family link in the case of the Biblical patriarch and his progeny. The pictorial expression of the idea might well have been conceived in Ethiopia. However, in art, the pose is seldom depicted and only in 15th and early 16th-century works.[107]

Considering the art outside Ethiopia, the closest analogy is found in Coptic art, namely in a well-known picture of Christ protecting the monk Menas. Writing of the Egyptian picture, Pierre du Bourguet says the pose "... is entirely original ... and exemplifies the marked humane tradition constant in Egypt throughout the ages."[108] The analogy might be based on the same spirit which also pervaded the innovating trends in 15th-century Ethiopian painting.

Some details in the diptych, for example, the hair and beards, are carefully drawn with multiple soft lines, while the drawing of folds of the garments is rather stiff. Three details recall the panels from Wāšā Endreyās. The imbricated pattern used for the background and the modelling of the faces recall the first panel. The clumsy feet viewed from the front and the folds of the garments recall the second panel. The conclusion is that the diptych was either painted by the foreigner who also made the panels of Wāšā Endreyās, or by a local painter strongly influenced by the former's art.

(28) The triptych No. 4117 in the IES Collection (fig. 155, see also p. 334), is outstanding in its delicate drawing of faces and hands, its soft modelling of garments and subdued colouring. It also shows an expert hand at realistically interpreting details. The triptych was either painted by an expatriate European artist or copied directly from his work.

The Child seated on his mother's arm has one foot drawn from the side and the other in three-quarter pose as in the first panel from Wāšā Endreyās. The Child sucks the nipple of the Virgin, supporting her breast with one hand; the same movement is found in 15th-century Ethiopian paintings by Ferē Ṣeyon (fig. 206, p. 419). Nevertheless, the figures of Mary and Child show a strong foreign influence. The angels are similar to those in the first panel from Wāšā Endreyās and the painting of Ferē Ṣeyon, whereas the figure of an old man depicted in the wing recall St. Peter from diptych No. 4324, except that a book has replaced the key.

Also, the folds of the garment evidence the relationship between our triptych, diptych No. 4324 as well as the first panel from Wāšā Endreyās. Particularly

[107] A similar composition of Abraham, Isaac and Jacob is shown in the incised drawing on the processional cross, Monastery of Gunda Gundē. The cross dates from around 1500. On the other face of the cross, there is a similar composition but representing three leaders of the Stephanite current in the 15th-century Ethiopian Church, namely Esṭifānos, Abakarazun died c. 1476 and Gabra Masiḥ (not clear whether first or second). In MorGG fig. 14–15.

[108] BourgCopts 45. The gentle embracing hand on one's shoulder is well-known in Pharaonic art. Mai and his wife Urel, members of the family of the vizir Ramoze (XVIII dyn.). The same pose is found in sculptured figure of Sety I and the god Anubis (Abydos, temple of Sety I), both reproduced in K. Michalowski, Egyptian Art (New York n.d.) pl. 98 and 117.

indicative are the folds of the robes at the bottom. These are composed of one large fold over the feet and of two small folds like a spiral on both its sides.

The imbricated pattern which was manifestly preferred by both the painters of the panel from Wāšā Endreyās and of diptych No. 4324, is missing in our triptych.

The similar form of the nursing Virgin in Ferē Ṣeyon's panel and in our triptych helps to date it. Either the Ethiopian copied this detail from the triptych, or he and the foreign painter shared the same model. In either case, the conclusion is that the triptych was probably painted around the middle of the 15th century.

(29) The diptych, in a private collection in Germany was possibly painted by an unskilled foreigner or more probably copied directly from his work (fig. 201). Some portions of the painting are either unfinished or retouched and this makes its identification difficult.

The iconographic details, the shading of faces and hands, the folds of the garments as well as the slanting inner edges of the frame point to art and technique which appeared in Ethiopia in the 15th century.

The inscription explains that this is the picture of St. George and the Virgin with her beloved Son, and adds the information referring to the donation of the diptych by a certain Yā'qob to "Iyasus".[109] Who was this Yā'qob? He certainly was a man of importance since he possessed a painting made either by a foreigner or copied from his painting.

The figures of both St. George and the Virgin are depicted in a setting which represents a pointed arch over the former and a rounded arch over the latter. In both, the painter endeavoured to depict the constructional and ornamental details which can only be referring to architecture outside Ethiopia. St. George is represented in early 15th-century manner, that is on horseback, carrying a spear slanting upwards and without the snake. The shaft and the spearhead are drawn realistically. The mulberry-red cloak floats out behind him in a series of curves. He wears yellow shoes, instead of having bare feet as is usual in his Ethiopian portraits. Mary wears shoes similar to those of St. George.

Mary is seated on a large and richly ornamented piece of furniture, a kind of throne with a low rounded backrest the volume of which is skillfully expressed. The upper half of Mary's body is facing the front while the lower part is strongly turned to the left. One leg is placed over the other, which is virtually unique in Ethiopian painting. The composition gives the impression that the painter copied the upper half from a model and added the rest of the body himself. This procedure is observed in a number of 15th-century paintings. Mary's body is wrapped in a red cape which is clasped at her breast with a brooch, hidden behind the hand of the

[109] The text is not clear. S. Strelcyn translated is as follows: "Image de [Saint] Georges. Cette image est à Ya'qob qui a été offerte par lui à Iyäsus (Jésus) le jour de sa commémoration (täzkar), et à ses fils, pour les siècles des siècles." Osvaldo Raineri's translation is as follows: "Immagine di Giorgio–questa immagine donó Ya'qob (= donatore) a Iasu (= chiesa che riceve il dono) in memoria sua (= di Ya'qob) e dei suoi figli (= di Ya'qob) nei secoli dei secoli"; considering that the name of Iyasus is exceptionally used in Ethiopia as a personal name the inscription most probably refers to the church of Iyasus.

Child. This arrangement as well as the narrow belt on Mary's waist recalls Brancaleon's paintings. Also, the drawing and the effective shading point to Brancaleon's art.

The Child wears a mulberry-red tunic and a white cloak over it. The folds of the cloak are similar to those in the figure of St. George. The Child holds in each hand a small bouquet of white and blue flowers which do not seem to have symbolic meaning though each bouquet is composed of an equal number of spikes.

Several details of the diptych are also found in other 15th-century paintings:

(a) The arched setting is similar to that in the first Wāśā Endreyās panel;

(b) The white veil which covers only half of Mary's head and runs down on the left side of her neck recalls the diptych ascribed to Brancaleon (fig. 184), a similar arrangement is also noted in incised drawings on the 15th-century processional crosses;

(c) The large rounded but less elaborate chairs are found in two paintings ascribed to Brancaleon and in a few 15th-century paintings by Ethiopians;

(d) The small and poorly drawn hands of St. George and the Child recall the art of Brancaleon, but the modelling of the folds is not his and is rather reminiscent of the painting in the IES Collection No. 5093 which will be discussed in the following section.

ETHIOPIAN PAINTINGS INFLUENCED ,BY EUROPEAN ART

The paintings are of two kinds. The first kind are those related directly to an identified painting made by a foreigner. The second are the paintings which in general contain themes and details borrowed from Western art. In both groups, the alien forms have been simplified according to the Ethiopian mode of expression.

The paintings of the first kind are few but they illustrate the impact of the expatriate European artist. Perhaps these paintings originated from his workshop. The students probably used to copy his works, a method always preferred by Ethiopians in the training of painters. Three examples of the first kind will be given.

(30) One example is the diptych in Dr. H. Schweisthal Coll., Germany, which has the Descent of the Holy Spirit depicted on its right panel (fig. 202). Obviously, the painter owes much to Brancaleon in the choice of theme and in its composition. Also, the left panel representing the scenes from Christ's life evidences some influence of the Italian.

Brancaleon depicted the subject of the Pentecost in the Walatta Dengel Book of Miniatures (fig. 175d). He rendered the meaning of the Acts of the Apostles by introducing a figure of the dove as the symbol of the Holy Ghost. The Ethiopian followed him and also depicted the dove.

According to the known material, the Pentecost was not represented in Ethiopian painting until the late 15th or early 16th century. Even then ,the theme must have been seldom used because of only two examples known to the writer, namely the miniature by Brancaleon and our diptych which is datable to that same

period. The suggestion is that the Italian painter introduced the subject of the Pentecost into Ethiopian painting.

(31) The painter of a diptych, Dr. R. Fechter Coll. IC2, Germany (fig. 203), followed a type of the Crowned St. George which was set up by the diptych described on p. 408 (fig. 191). This is evidenced by the general composition as well as the curious form of the crown, the position of the Saint's hands and the shaft of his spear with the cross affixed to its lower end. The Ethiopian, however, changed the folds on the cloak floating on the Saint's back and added shoes to his feet. He also depicted Seqrāṭes, the servant of St. George. Since the writer published his essay on the Saint's iconography in 1973,[110] two 15th-century paintings were found in which Seqrāṭes appears along with the Saint. This changes the date of the introduction of the figure into Ethiopian painting from the 17th century, as suggested in the essay, to the 15th century. In both 15th-century paintings, Seqrāṭes wears Ethiopian garments and therefore most probably the figure was created locally.

The Virgin and the Child, in the right panel, are flanked by two angels who hold a screen with their outstretched hands. The origin of such a screen in Ethiopian painting was already discussed by Monneret de Villard in 1947 and by the writer on p. 240 of the present book in reference to the image of the Virgin of S. Maria Maggiore. Monneret was struck by an analogy between the screens in some 18th-century Ethiopian paintings and those in Italian paintings of the 13th, 14th and 15th centuries. He theorized about the ways by which the Italian forms came to Ethiopia. The origin of the screen in the 18th-century paintings was solved by the discovery in Ethiopia of the Western model which was datable to the same period (p. 241). However, Monneret's speculations did come true. During the 15th century, perhaps the first half of it, the idea of depicting the angels with a screen penetrated into the Ethiopian highlands as evidenced in our triptych. We do not know exactly how it happened but the screen did not take root and it disappeared for three centuries. Consequently, the 15th-century model could hardly affect the 18th-century iconography of the Virgin of S. Maria Maggiore. Our diptych, nevertheless, is patent proof of the Italian impact on Ethiopian painting and perhaps an indication that the painter who created St. George the Crowned, as well as the image of Mary with the drapery behind, was indeed an Italian.

(32) The third example is a diptych in the Brumit Coll. N. 2 in the USA (fig. 204). The portions of our diptych have been either strongly influenced by or perhaps copied from triptych No. 4191 (fig. 176) by Brancaleon, particularly his gruesome scene of chopping St. George into pieces. According to the Near-Eastern narrative of Theodotus, which most probably was known to the 15th-century Ethiopian, the martyr was crushed into ten parts by an engine especially constructed for the occasion.[111] Brancaleon's soldiers, however,

[110] ChojlcGeorge = II 80–82.

[111] Theodotus, bishop of Ancyra, Encomium of St. George and the description of his martyrdom. Edited by *E. A. Wallis Budge*, George of Lydda Patron Saint of England, a study of cultus of St. George in Ethiopia (London 1930).

use an axe instead of a wheel and the type of axe is European in form rather than the Ethiopian chopping tool. The local painter could not depict the scene as he did, unless he closely followed the painting of Brancaleon. The detail of ropes or cords, which the Italian was particularly fond of, proves a close relationship between the paintings. On the other hand, the figure of the Saint killing the dragon is different except for the dragon. Brancaleon is believed to have been the first to introduce the beast to the iconography of St. George in Ethiopia. The diptych evidences the Ethiopian response.

The left panel represents the iconography of the Virgin and Child which is lacking among the known works of the Italian. Nevertheless, the manner in which the Virgin wears her veil as well as the extensive use of the belt recall his art.

Now the paintings of the second kind:

(33) The left panel of the diptych, the Langmuir Coll. No. 113, Peabody Museum in Salem, Mass., is probably a copy of an unknown work by Brancaleon (fig. 205). Perhaps the same Ethiopian who made the previous diptych also painted this one. The Virgin's uncovered head and her long hair flowing over her shoulders, as well as the sinuate folds of her robe tied up with a belt at the waist, are characteristic of Brancaleon's art. However, the hand, poorly drawn in both triptychs, is a particular trait of the copyist's craft.

The significant features of the painting are two youthful angels holding with one hand the high backrest of the chair on which the Virgin is seated. The backrest gives the impression of a large screen. Similar screen and shape of the angels reappeared in the 18th-century paintings of the Virgin of S. Maria Maggiore. Does the latter originate from the 15th-century model? If this were the case, we would have witnessed a long delayed impact of the Italian painter.

There are a large number of 15th-century paintings by Ethiopians which are to a varied extent influenced by Western art. Therefore, only those are listed in the following which are significant for the analysis of developments because of their date or their contents.

(34) An Ethiopian monk called Ferē Ṣeyon (Seed of Sion) painted the panel during the reign of King Zara Yāʾqob as attested to by the inscription (fig. 206).[112] The painting was donated to the Monastery of Dāgā Esṭifānos in Lake Ṭānā and kept in its treasury until the present.[113]

The panel, framed in a richly decorated border, is divided into two parts: in the upper half, the Virgin nursing the Child is depicted.

[112] "This picture was painted during the reign of our King Zara Yāʾqob and our Abbot Yeshāq of Dāgā. And the painter is one poor man of the Monastery of Guben, Ferē Ṣeyon ..." The anonymous French scholar who wrote the text to the exhibition of Ethiopian art, EthMill item 101, gives the following version of the inscription "Fere Sion pour le roi Zara Yakob (1434–68)". This spurious version implies that the painting was made after the death of the King.

[113] The painting was brought to Addis Ababā in 1967 and the first urgent steps to conserve it were performed at the Institute of Ethiopian Studies. On this occasion the painting was closely studied. Cf. ChojArtEth 26–29 fig. 12; G. Annequin, who first discovered the

The Child, placed on his mother's right arm, sucks her breast. He supports it with his left hand and in his right hand holds a pigeon which is easy to identify as a Spotted Pigeon *(Colomba guinea)*, a common bird in Ethiopia. It has a string attached to one of its legs. Mary holds the string in her left hand. This detail positively excludes any interpretation of the scene as other than that of a child playing with his pet animal. Leroy, commenting on this "exquisite Virgin", pointed at one of its sources of inspiration: "this Virgin with the Bird", he writes, "is without question Italian".[114]

In the lower half of the panel stand St. Peter on the right, St. Stephen in the middle and St. Paul on the left. Peter holds a gospel book (according to the inscription on it) and St. Paul, a sword in his right hand and a book, only, partly visible, in his left hand. St. Stephen is the only personage in the painting represented in full face, his right hand raised in blessing and his left holding the cross. This arrangement of three figures is similar to that in diptych No. 4324 (fig. 200).

The painting is of prime importance for the discussion because of its unusually precise dating and location. Likewise, its complex Western and Eastern elements illustrate these influences on 15th-century Ethiopian art, as already noted by Leroy.

(35) The same Monastery of Dāgā Esṭifānos treasures a large painting on cloth which may also be the work of Ferē Ṣeyon (fig. 207).[115]

The impressive enthroned Christ in Glory is depicted in the upper half of the painting. The image is unique in Ethiopian art insomuch as the mandorla surrounding Christ is supported by two flying angels instead of the Four Living Creatures.[116] Moreover, the bodies of the angels, identified as *Rufā'ēl* and *Fānu'ēl*, float horizontally and their ample robes are curved upwards. Their foreign origin is obvious. Perhaps they came from Armenian art in which the glory is always supported by either two or four angels. The standing angels below the glory carry swords similar to those in Ferē Ṣeyon's masterpiece; they guard, according to the Ethiopian custom, the divine Majesty.

In the lower register, Mary holds the Child on her right arm. The Child has

painting published a short note on it in Chronique archéologique = AÉ 6 (1965) 16–17 pl. 4. Recently F. Anfray in AÉ 11 (1978) 168–69, published a panel, Madḫanē 'Ālam church on Ramā Island, Lake Ṭanā, which according to him can be "ascribed without hesitation" to Ferē Ṣeyon. In the same church there are pieces of the painting on canvas which is in a very poor state of conservation. The painting is stylistically similar to the above panel.

[114] LerÉthG 41.

[115] The cloth is in a poor state of conservation. In 1967, the painting was brought to Addis Ababā, mounted on a frame and cleaned at the Institute of Ethiopian Studies, and subsequently returned to the Monastery.

[116] S. *Chojnacki*, The Four Beasts of the Apocalypse and the Imagery of the Ascension in Ethiopia = Bulletin de la Société d'archéologie copte 23 (1979) 161–83; Cl. Lepage, Dieu et les quatre Animaux Célestes dans l'ancienne peinture éthiopienne = DSCE 7 (1976) 67–112.

thrown one of his arms, probably the right one, around Mary's neck, the fingers of his hand emerging from its left side. He also lovingly outstretches his other arm towards her face as in the Wāšā Endreyās panel, as well as in the miniature in Abb. 105 subsequently described, and touches the fringe of her cloak. Mary leans slightly towards the Child who gazes at her but on the whole the painting differs from the Eleousa or Glykophilousa images of the Virgin in which she presses her cheek against his.[117] Mary is flanked by Abraham and Isaac as well as two personages not identified. None of them carries a book, instead the hands of each of them are drawn in varied poses; the last two in the row keep their hand on the shoulder of nearest figure. This friendly gesture recalls diptych No. 4324.

The modelling of the faces is soft and the draping of the flowing garments, highly sophisticated. The same characteristics apply to the two following paintings on wood.

(36) The diptych IES Coll. No. 3980, Addis Ababā (fig. 208) dates from either the middle or the second half of the 15th century.[118] The framing of the painting seems to be a skillful copying of European and Byzantine case enclosing the picture, with an imitation of inset square blue stones achieved by hollowing the wood and painting the hollows in red and black.

The Virgin, seated on a large object, possibly a throne or a cushion, holds a flower in her right hand. She wears a crown (p. 336). The Child, sitting within the shelter of the Virgin's left arm, holds one of the buds of a flower with one hand and is touching his mother's chin in a gesture of love with his other hand. The gesture, as well as the swinging pose of his legs, recall the first panel of Wāšā Endreyās. On the right panel, the twelve Apostles and St. Paul stand in two rows, which is a usual arrangement in 15th-century paintings. Two equestrian saints, George and Merkurios, appear on the right side at the bottom of the panel. The painter followed the 15th-century manner of depicting the saints, including their spears slanting upwards.[119]

(37) The style of the superb triptych IES Coll. No. 4186 (fig. 209) is identical to that of the previous diptych;[120] indeed, both paintings are probably the work of the same artist. The multiple subject matter of the triptych includes Mary holding a flower, the Child holding a pigeon, the twelve Apostles and St. Paul, the prophets and local saints, the eight sword-bearing archangels, as well as holy riders, and an image of the Ancient of Days (p. 121f., fig. 44).

The four described paintings (Nos 34 to 37) show European influence and are iconographically and stylistically related to the first panel from Wāšā Endreyās

[117] S. Chojnacki, Notes on a Lesser-known Type of St. Mary in Ethiopian Painting = Aba Salama 1 (1970) 162–77.

[118] Anonymous writer of the EthMill item 102, asserts that the style of the diptych "le situe ... au coeur du XVe siècle". Catalogue of the same exhibition, RKÄth 99, gives the date "second half of the 15th century".

[119] ChojArtEth 32–34.

[120] Reproduced in RKÄth 97; In the EthMill item 101, the triptych is ascribed to "middle of the 15th century".

(No. 25) and diptych No. 4324 (No. 27). Indeed, diptych No. 3980 (No. 36) was strongly influenced by the former and even some of its details copied from it.

The first panel from Wāšā Endreyās and diptych No. 4323 were probably made by the same hand, moreover, their impact on the masterwork of Ferē Ṣeyon was strong and direct. This allows us to date the panel and the diptych to the middle of the 15th century or even before that. The first panel from Wāšā Endreyās is earlier than diptych No. 3980 and possibly triptych No. 4186. On the other hand, diptych No. 4324 may be earlier than all four Ethiopian paintings including that of Ferē Ṣeyon. These paintings manifest the school which flourished on and around Lake Ṭānā during the middle of the 15th century. The school is distinct by the roundness and Oriental features of the faces. Cl. Lepage defined the school as that of the "moon-like faces".[121] It would probably be better to name the school by its location, Lake Ṭānā, to differentiate it from other schools which were active in Tegrē during the second half of the 15th century.

Lepage thought that the "moon-face" characteristic of the school should be explained by the influence of "Asiatic painting", mainly, Islamic. He tried to substantiate this hypothesis by citing much used circumstantial evidence taken from Ethiopian history.[122] The Far Eastern impact on the work of Ferē Ṣeyon had already been suggested by Leroy.[123] What we need now, is a systematic stylistic and iconographic analysis of all paintings ascribed to the school in order to explain the process of penetration of Islamic art into Ethiopia.

(38) The Book of Psalms and Prayers of Belin Sagad, Abb. 105 in the Bibliothèque nationale, Paris, was described and commented on by Conti Rossini who dated the manuscript to the years 1476–77.[124]

Among numerous miniatures in the manuscript, there is an image of the Virgin and Child (fig. 210). The unique feature of the image is the missing guardian angels who in the 15th century are virtually always depicted along with the divine Mother and Son. There is no immediate explanation of why the scribe left out the angels but perhaps the omission mirrors the model which he used. The forms are strongly stylized and this suggests a considerable length of time between introducing the model into the country and the writing of the manuscript.[125]

[121] LepPEth 365–71, gives a rather cursory and misleading description of the school. He believes to have discovered that the school was not limited to "paintings on wood" but existed "in the independent way in the Ethiopian painting of the 15th century". As a proof of this "discovery" he cited the page in the manuscript of Gadunā Giyorgis. In fact, nobody ever thought that the school of Lake Ṭānā was only limited to paintings on wood. The IES Collection possesses several folios of the 15th-century lost manuscripts with "moon-like faces" and, of course, the cloth painting from Dāgā Esṭifānos which is a vital document for any serious study of the school, was discovered in 1967. Lepage tends to minimize the European impact on the 15th-century Ethiopian painting.

[122] LepÉthP 370f.

[123] LerEthG 41.

[124] CRCodErit 83–97; also CRCollAbb III 24f. 45–48.

[125] In 1975, the Polish art historian *Ewa Balicka* wrote that the miniature "represents one of the numerous variants of the *Odighitria* type called *Deksiokratusa"* though with some

Mary holds a flower in one hand and supports the Child with the other. The Child extends his arm towards the head of Mary and touches the edge of her mantle. The movement is similar to that in the second panel from Wāšā Endreyās, whereas the manner of drawing the feet of the Child, one seen from the front and one from the side, recalls the first panel from the same church.

The manuscript belongs to the scriptorium which was active in Tegrē during the second half of the 15th century. Two other richly illuminated manuscripts produced by the same scriptorium are known. One which originated from Garʿāltā, was kept for several years in the library at the palace in Maqalē, chief town of the province, and the second was discovered by David Buxton in the Dabra Qoḥāyen church dedicated to the Virgin Mary. In both these manuscripts the image of Mary and Child is missing.

(39) The triptych IES Coll. No. 5093, Addis Ababā, is different from the works of the Lake Ṭānā school but still related to them by its iconographic forms, (fig. 211a–d). Moreover, the triptych has certainly been influenced by two panels from Wāšā Endreyās and diptych No. 4324.

Two technical details are indicative of the Western impact on the triptych. One is its upper rounded tier which is virtually unique in Ethiopia but common in the European Renaissance period and the other is a blue smalt, powdered blue glass used as pigment. According to F. Weihs, the German expert who analysed the painting, the use of smalt is unique even among those Ethiopian paintings which have obviously been influenced by European art. According to him, both the curved top and the smalt point to Italian influence.[126]

Mary and the Child are depicted on the main panel. She is seated on the throne with a low backrest similar to those in Brancaleon's pictures. The Child seems to hold a flower in his outstretched hand; however, this portion of the painting is not clear and the flower could be merely a decoration of Mary's robe. The unusual pose of Michael's hands recalls the first panel from Wāšā Endreyās, whereas his and Gabriel's wings recall the second panel from the same church. The Crucifixion, on the left (211 b), is clearly Western; indeed, the long nails are probably copied from Brancaleon's paintings. St. Peter and St. Paul, on the right (211 c), sit on a large bed and hold in their hands the key and the sword respectively. The key is similar to that in diptych No. 4324 and the sword to that in Ferē Ṣeyon's painting. St. George is

"deviations". She also thinks that the miniature represents the intermediary type between the Hodegetria and Eleousa, which was "widespread in Ethiopian art before the 16th century but the prototype has not been located". Referring to the flower in Mary's hand *Balicka* explains that "it is not found in 15th-century Ethiopian images [of her]". There is some difficulty in reconciling this statement with a large number of published and described 15th-century paintings in which the Virgin is depicted with the flower. Also the other statement that the miniature was painted directly from the image "circulating in the East perhaps of *Odighitria* which was only slightly transformed in the spirit of Ethiopian art" should not be taken for granted [Miniatury piętnastowiecznego psałterza etiopskiego (studium ikonograficzne) = Biuletyn historii sztuki 36 (1975) 108f.]

[126] Einige technische Details zu äthiopischen Ikonen = RKÄth 303. He erroneously gives to the triptych the number 4793.

killing the dragon which lies prostrate under the horse. St. Theodoros (211 d) is represented in the usual 15th-century manner.

The way of drawing the hair of the personage points to diptych No. 4324 while the eyebrows point to the second panel from Wāšā Endreyās.

CHRONOLOGY OF THE ICONOGRAPHY AND CONCLUSIONS

In the preceding survey, the available records on the life and activities of European painters in 15th and early 16th-century Ethiopia were compared with their paintings as well as with the paintings by Ethiopians. Let us recapitulate briefly the developments and set up the chronology of the main themes:

VIRGIN MARY AND CHILD

(a) The earliest record of the bird in the hand of the Infant Jesus is found in the painting by Ferē Ṣeyon; therefore the theme was introduced around or before the middle of the 15th century. The theme is undoubtedly of Italian origin, but for chronological reasons neither Brancaleon nor Bicini brought it into Ethiopia.

(b) The flower first appeared in paintings ascribed to the middle of the 15th century and according to the minature in ms. Abb. 105 was used by Ethiopians around 1476. Consequently, neither Brancaleon nor Bicini introduced it.

The detail of the flower is usually coupled with such themes as the Child caressing his mother, the mother nursing the Child or the Virgin wearing the crown. Rarely is the flower treated as a sole attribute.

There are two forms of the flower. The first is invariably composed of three leafless stems ending with a yellow bud; it is Mary who holds the flower and not the Child. The second form is a bouquet of realistically drawn flowers in the hand of the Child.

Is the flower a genuine Ethiopian invention or was it borrowed from abroad? There are good reasons for rejecting the first possibility. No flowers were used in the iconography of the Virgin prior to the 15th century; one should consider the notorious Ethiopian indifference to the views of nature which were constantly ignored in their works. On the other hand, the Virgin holding a flower was rarely depicted in Byzantine art, but enjoyed popularity during the European Renaissance period. Moreover, there is a written record on the flower motif making its way into Ethiopia. Pêro Gomes Teixeira, a Portuguese traveller, went to the Ethiopian Monastery of Bizan in 1520 and brought from it a parchment book to be sent to the king of Portugal. At the beginning of the book there was a "picture of Our Lady with the infant Jesus who had in his hand a wreath of roses which (voltaua) encircled the Virgin's head";[127] The Western European origin of the flower seems obvious.

[127] AlvPrJ 59.

(c) The crown on the head of the Virgin goes back to the paintings ascribed to the middle of the 15th century. Therefore the crowned Virgin was known before Bicini and Brancaleon arrived in Ethiopia. The crown is invariably of the open type with fleur-de-lis finials, although at times poorly delineated. There is no doubt that the inducement for representing Mary wearing the crown came from Western art and this is corroborated by the Occidental type of the crown.

(d) The problem of the nursing Virgin in Ethiopian painting is more complex. The theme was first recorded in the work of Ferē Ṣeyon and therefore neither Brancaleon nor Bicini brought that form into Ethiopia. Jules Leroy, who commented on Ferē Ṣeyon's masterpiece was quite positive about the Italian origin of the form,[128] but there is reason to believe that Ethiopians copied it from the Greek Galaktrophousa (Nursing) Virgin, as it will be explained in the second section of the chapter

(e) The unusual gesture of the Child caressing the chin of the Virgin appears in paintings around the middle of the 15th century, that is before Brancaleon and Bicini set foot on Ethiopian soil. Yet, the gesture in not genuinely Ethiopian. Does it originate from the Greek Glykophilousa or the distant German art? Until new evidence comes to light, the answer must remain in the realm of conjecture, but there is reason to believe that the panel from Wāšā Endreyās acted as a transmitting agent from foreign art to Ethiopian.

These are the main forms of the Virgin and Child which suddenly appeared around the middle of the 15th century. They do not seem to be favoured by Brancaleon. In two large paintings and a couple of smaller ones of the Virgin by him, Mary neither gives breast to her Child nor holds a flower. Neither does the Infant Jesus play with a bird. Instead, in the painting, he holds an orb, which as far as goes our perception is missing in works of the Lake Ṭānā school.

In the painting not yet assigned to any expatriate artist, the Child is naked and lies on Mary's lap. The Lake Ṭānā school does not seem to know that form of the Virgin and therefore the naked Child and the orb in his hand must have been introduced in the late 15th century.

ANGELS AND APOSTLES

Turning to other figures, those of the angels as well as the Apostles change around the middle of the 15th century.

There are two new forms of the angels, both representing the celestial beings as standing and holding raised swords. These are large and bluish with a darker line running in the middle; their handle is shaped in fleur-de-lis ornament. The wings are either wide, strongly stylized and painted in red, green and yellow, or long and narrow and drawn realistically and recalling birds' wings.

In works by Brancaleon, the angels are different; they are shown in swallow-dive flight and their robes are usually draped in a conch-shell form. Some angels carry swords but mostly their hands are crossed on their chest. In the painting by the

[128] LerEthG 41.

unknown expatriate, the angels kneel and carry a round object, perhaps an orb or paten.

The new form of St. Peter and that of St. Paul includes the symbolic key and sword respectively. All other Apostles, except St. Andrew, are depicted in a similar manner save of course, the key and sword; St. Peter's form is used for depicting the white-haired Apostles and St. Paul's form for the younger ones. St. Andrew is shown with tousled hair. None of the Apostles carries a cross, instead, all hold the book of the gospels. This marks the difference with Brancaleon's way of depicting the Apostles, with both a cross and a book.

The forms of the Apostles are not genuine Ethiopian either; indeed, the drawing in Cod. Aeth. 50 Vat. sheds light on a possible channel through which the models penetrated into the African highlands.

POSSIBLE INFLUENCE OF ARMENIAN ART ON ETHIOPIAN ART

The syncretic character of the Lake Ṭānā school is amply evidenced by its complex iconography. The varied forms of the Virgin and Child clearly point to Byzantine-Greek as well as Western imagery of the mother of Christ. How can this be reconclied with the Far Eastern and Islamic influences postulated by Lepage? Did the Christian and Islamic elements blend in Ethiopia or were they already blended in the art which acted as a channel through which the Islamic elements penetrated Ethiopia?

The scope of the following is to explore the influence of Armenian art which possibly has some bearing on the Islamic features of the school of Lake Ṭānā.

(40) In 1939 Monneret de Villard, discussing early Ethiopian paintings, drew attention to the "Ethiopian-Armenian collaboration" in the Book of Prayers of the Virgin Mary, Cod. Aeth. 50, in the Biblioteca Vaticana.[129] Conti Rossini in 1942 again discussed the problem of Armenian influence on miniatures in the same manuscript. He dated it to the 15th century,[130] whereas the catalogue editors of the Vatican collection ascribed it to the 14th or 15th century. The manuscript contains the miniatures and drawings which the learned editors of the catalogue described as follows: "The ornaments of the frontispieces of the main prayers were not done by an Ethiopian but an Armenian who for checking the ink wrote on fol. 97v the Armenian letter Ω. The same painter, as it seems, made the drawings of Peter and Paul ... and of Jonas whom the whale vomits ... The images have been executed in the Armenian manner with red or purple colours, either strong or diluted. The image of the Annunciation to the Blessed Virgin Mary, freely delineated with

[129] *U. Monneret de Villard*, Note sulle più antiche miniature abissine = Orientalia 8 (1939) 22f.

[130] *C. Conti Rossini*, Miniature armene nel Ms. Et. N. 50 della Biblioteca Vaticana = RSE 2 (1942) 191.

varied colours, also recalls Armenian art."[131] Monneret fully shared this view and substantiated it with his erudite remarks.[132] Conti Rossini demonstrated that the miniatures had been painted together with the text and the manuscript had been produced with great probability in Ethiopia.[133]

Our immediate interest is focussed on two drawings, namely the vignette representing the Apostle Peter and St. Paul on f. 46v (fig. 212a) and the ornamental pattern on f. 3r and 102r (fig. 212b). Monneret de Villard emphasized that the former was "executed by a very able hand". Its iconographic details are shown with precision in spite of the small size of the vignette and demonstrate that the Armenian rendered the Saints in the form well-known in the Christian art of the Near East.

The figures of Peter and Paul correspond exactly to those in the painting of Ferē Ṣeyon. The figure of St. Paul is particularly revealing inasmuch as he holds a sword in his right hand and a book in his left. Apparently a sword was not congenial with the Ethiopian concept of the Saint. In Ethiopian art, the sword in this context did not appear before the 15th century, exceptionally in that century, namely in the masterwork of Ferē Ṣeyon (fig. 206), triptych No. 5093 (fig. 211), diptych attributed to N. Brancaleon (fig. 184) as well as in the Armenian vignette, but virtually never after. The conclusion is that either Ferē Ṣeyon used the vignette as the model for depicting the figure of St. Paul or used the model which was similar to that of the Armenian's. Moreover, in all paintings of the Lake Ṭānā school, the figures of St. Peter and St. Paul are rendered in exactly the same manner as in the vignette, except for the sword, of course. Such a manner is not used in paintings before the 15th century but was continued in the second half of that century and in the early 16th century with a progressive loss of clarity of the prototype.

With respect to the ornament of f. 3r and 102r, we find a similarity in the square border running around the figures in the cloth painting (No. 35). The ornament has been used in other Ethiopian paintings, with more or less ability, but there is a striking precision in the cloth painting and clarity of design characterizing the drawing by the Armenian. The ornamental pattern as well as the figures of Peter and Paul in Cod. Aeth. 50 indicate in general the Armenian influences on 15th-century Ethiopian painting, in particular substantiating the impact of the Armenians on the Lake Ṭānā school.

[131] S. Grebaut and E. Tisserant, Bibliotecae Apostolicae Vaticanae Codices Aethiopici Vaticani et Borghiani (Vatican 1935) 209.

[132] U. Monneret de Villard, Note sulle più antiche miniature abissine = Orientalia 8 (1939) 22.

[133] C. Conti Rossini, Miniature armene nel Ms. Et. N. 50 della Biblioteca Vaticana = RSE 2 (1942) 193.

INFLUENCE OF GREEK ART ON 15TH-CENTURY ETHIOPIAN ART

Let us first clarify the question of whether there were Greek icons in 15th-century Ethiopia. The local tradition has it that a number of the icons painted by St. Luke the Evangelist had been brought by "King Dāwit". Dāwit I (1382–1411), was probably meant. The tradition is not to be rejected off-hand, instead, it should be interpreted according to the Ethiopian cultural context. Diana Spencer, during her extensive searches in monasteries identified four icons which the Ethiopians claimed to have been painted by the Evangelist.[134] All these are Greek icons. Moreover, other Greek icons representing the Virgin have been located.[135] The quality of the icons varies and their dating is uncertain, but most of them belong to either the Cretan or Italo-Cretan school.

Recently, Otto Meinardus argued that the Lucan tradition of the image of Mary had been introduced into Ethiopia as late as the 17th century. In order to substantiate his theory, he ascribed all the icons cited by Diana Spencer to the 17th and 18th centuries.[136] The assertions of Meinardus need a thorough revision in view of new facts. Indeed, as our knowledge of the paintings by Ethiopians advances, their tradition of St. Luke icons seems to gain substance. The existence of Greek icons in 15th-century Ethiopia is now a fact since there is material proof of these having been copied by Ethiopians as well as by the expatriate painters.

The Greek influence on the Ethiopian imagery of the Virgin is well-known. The earliest trace of the Greek Eleousa, the Virgin of Tenderness, appears already in the early 14th century. In the following century, we find a vivid pictorial interpretation of the Glykophilousa, meaning "Sweet Kissing". In the 17th century, Ethiopians used to depict a hybrid type of Virgin between the Eleousa and the Virgin of the Symbols of the Passion, whereas in the 18th and 19th centuries, they produced a number of poor copies of the Eleousa. To sum up, there is an immemorably old practice by Ethiopians of copying the Greek icons which were brought into their country.

The Greek impact on the 15th-century Ethiopian iconography is evidenced by the symptomatic details. One of these is the upturned sole of the Infant Jesus (fig. 204 and 213) which could only be borrowed form a Greek painting (fig. 194 and 195). Another evidently Greek detail is the red zigzag band depicted on Mary's right arm in a small diptych, IES Coll. No. 3986 (fig. 214). The painting recalls partly the panel by Ferē Ṣeyon and partly the first panel from Wāšā Endreyās. The

[134] These are: Šeʿela Adheno, Tadbāba Māryām; Šeʿela Gebṣāwit, Ǧamado Māryām; Šeʿela Waynut, Dabra Warq; Šeʿela Sergut, Gētēsēmānē. The fifth icon erroneously believed to be painted by St. Luke is the Man of Sorrows discussed on p. 409.

[135] The icons are: Ṣegē Radā, in Gētēsēmānē Māryām, which is particularly venerated and Šeʿela Adheno, Wāfā Iyasus church, both in Goǧǧām province. During the last two decades, a number of Greek icons of varied quality passed through the Addis Ababā antiquity market. All these icons had been removed from Ethiopian churches.

[136] O. F. A. Meinardus, Some Ethiopian Traditions of St. Luke as Painter = 7 Abba Salama (1976) 243–52.

band is all that remains of the Greek *maphorion*, or mantle, which frequently is ornamented with a fringe drawn at a sharp angle (fig. 194). Likewise, the pose of the Child's feet, one seen from the front and one from the side, point to the Greek influence. The pose is found in a number of paintings of the Lake Ṭānā school, the first panel from Wāšā Endreyās as well as in several Greek icons discovered by Diana Spencer. The writer does not believe that all Greek icons recorded by Spencer necessarily served as models to the painters of the Lake Ṭānā school, though some might have; nevertheless, he believes that icons of a similar type existed in 15th-century Ethiopia. Therefore, the Greek Galaktrophousa could have been used by Ethiopians as a model for composing their paintings of the nursing Virgin. The first panel from Wāšā Endreyās compared with Theotokos Glyko-philousa, Benaki Museum, Athens, dated 16th century (fig. 195), gives a very convincing demonstration of the possible Greek influence.

How are we to explain the fact that in the painting some details are taken from Greek art and some from that of Western Europe? The answer possibly lies in a very particular process of production. A fascinating aspect of this process is that expatriate painters copied Greek icons for the Ethiopians. An example of this kind of artistic mélange is diptych No. 4325 by Brancaleon as explained on pp. 385–87. The guess is that several decades before Brancaleon, another expatriate painter used to produce similar mixtures. He might have copied for example the Greek image of the nursing Virgin but added to it elements borrowed from his own cultural heritage.

<p style="text-align:center">* * *</p>

The impact of Western art on mid-15th-century Ethiopian painting is also manifest in its style, though the Ethiopian artist never absorbed the idea that colour and design can be used to create three-dimensional image on a two-dimensional surface. He did not attempt to set the narrative or figures in a landscape or architectural background. However, the form of the figures during that period changes dramatically; clearly some movement and life become instilled into the paintings. Soft, sinuous and at times delicate drawings of faces and hands replace the thick outlines of the figures which are characteristic of the 13th and 14th-century works.

Another change is the drawing of the garments. In the 13th and 14th centuries, coloured drawings of the textiles to which the heads and limbs are attached, stand for the human figures. The impression of their flatness is at times softened by filling the coloured areas with imaginative ornamental patterns. In the 15th century, the figures and their garments are drawn differently. Heads and limbs seem to emerge from the mass of sinuous folds which are elaborate and occupy a large portion of the composition. Moreover, the folds are drawn in such a manner as to give the impression of legs and knees underneath. Thus, the classical Greek sculpturing of the draped body found its way into Ethiopian highland, though in a very simplified form.

Also the gamut of colours shows some peculiarities which perhaps are due to the foreign influence. For example, a colour close to mulberry-red is distinctive of the painting produced by the school of Lake Ṭānā.

The display, in the works of the same school, of three figures with one in the middle in frontal pose flanked by two others in a three-quarter pose, is another innovation of the mid-15th-century. The origin of the arrangement is not obvious, but some indication is given by the diptych No. 4324 (fig. 200) in which such an arrangement is used. The diptych is probably by the artist who also painted the first panel from Wāšā Endreyās, and both the diptych and the panel are believed to be made by a foreigner.

The way the wooden paintings are produced is also indicative of foreign impact. The border between the ridge and the panel is at times slanted which gives the impression of a European frame, though the ridge and the panel are, in fact, one piece of board. The ridges are painted with bright yellow, perhaps imitating a golden frame, and are ornamented either with square holes filled with dark blue and framed with red or with small red squares. This is an imitation of the pieces of jewellery inset into corners and frames decorating the holy images in Mediaeval Europe and Byzantium. We find this ornamentation only in works of the school of Lake Ṭānā. Where did its painters get the idea? Either it was thought out by someone or was copied from an imported painting. If the second is the case, the Ethiopians probably copied the frame along with the paintings. These, we believe, represented the Virgin and Child. She was holding a flower and he, a bird.

The sudden surge of the art of painting on wood in the 15th century probably bears some relation to the presence of the European expatriates. Did they introduce this art into Ethiopia or merely contribute to its development? When did the production of panel painting start? The absence of any painting on wood which can be ascribed to the period prior to the 15th century is significant. Moreover, the panels, triptychs and diptychs which date to that century bear little or no traces of 13th and 14th-century art, as known to us from church decorations and manuscript illuminations. Also, a certain duality of style and iconography existed throughout the 15th century. The gospel illuminations, save a few exceptions, still follow the Oriental subject matter; whereas completely new subjects appear in the painting on wood; however, new stylistic and iconographic trends are felt in manuscript illuminations starting with the second half of the 15th century. We suggest, therefore, that the art of producing paintings on wood has been introduced by the expatriates, and those responsible for it brought with them a new form of painting, differing from that of the 13th and 14th centuries by subject matter, execution and feeling. This of course does not invalidate the theory that Greek icons or other paintings penetrated into Ethiopia in the early 15th century, or before. The Ethiopians, however, did not try to reproduce these. No gold is known in paintings prior to the 15th century save perhaps the Kebrān Gospels nor in those of the 16th century, except for the paintings which are believed to be by Lázaro de Andrade. On the other hand, there are a few paintings on wood and one manuscript dated to the 15th century in which gold was used.[137]

[137] Paintings on wood: St. George and Seqrāṭes, IES Collection, Addis Ababā; Man of Sorrows, Wāfā Iyasus church, Goǧǧām; illuminations of the Book of Miracles of the Virgin Mary, Gešen Māryām Monastery (p. 192). According to Coptic sources, the

One of the stories in the Book of Miracles of the Virgin Mary refers to scribe who learned the art of producing golden ink. Conti Rossini rightly considered the story as a genuine indication of the foreign influence on 15th-century Etiopian painting. At present we have the material proof that the story might be founded on real fact. Moreover, gold was used in those works which had been produced before Brancaleon and Bicini arrived in Ethiopia.

How can one explain all the above changes of the iconography and style as well as of the technique? The tentative answer is that this is the result of the presence of an expatriate artist, other than Brancaleon and Bicini. Perhaps, the Florentine painter who joined Bartoli in 1402 had succeeded in entering the mysterious land of Prester John and then disappeared from the annals of Western Europe. If there be someone else, his personality and origin cannot be established with certainty. He may be a European because in his paintings or copies made from these, there are details taken from Renaissance art. Perhaps he was one of those Franks who lived in the Near East and was familiar with the Western as well as with Eastern Christian world. Another possibility is that he belonged to the Armenian community which made their home in many corners of Europe, the Near East and Africa.

It is a well-known fact that Ethiopian rulers of the 15th and 16th century tried to bring to the country foreign craftsmen and among these, painters. For example, King Lebna Dengel explains in his letter to King John III of Portugal that he wants him to send "artificers to make images and printed books".[138] The same king apparently tried to train some Ethiopians abroad. "The Prester John's Ambassador", related Alvarez "left in this city of Goa four slaves, namely two to be taught to be painters, and two others to be trumpeters, and the Capitan Major ordered their food to be given to them and that they should be taught."[139] There is no record whether they completed the training and returned to their country.

The story refers to the happenings in 1526 but is illustrative of the rulers' eagerness to train Ethiopian people as painters. The expatriate European artists who lived in their realm were certainly expected to teach their craft. Likewise, our unknown artist must have trained some Ethiopians. Perhaps Ferē Ṣeyon was initiated in the art of producing paintings on wood in such a workshop. The change of the technique in the works of the 15th century was probably the result of such direct contact with the expatriate artists rather than of mere copying of imported paintings. This factor provides an additional argument for believing that the expatriate artist lived in Ethiopia during the first half of the 15th century. The school of Lake Ṭānā which manifestly absorbed Western, Greek and Islamic influences could as well have been generated by such contact with an expatriate artist.

delegation of the Alexandrian Patriarch Matthew II to King Zara Yā'qob in 1453 brought a "golden image" of the Flight into Egypt, (p. 76).

[138] AlvPrJ 505.

[139] AlvPrJ 483 f.

The above, however, does not belittle the rôle which the imported paintings and prints played in 15th-century developments.

We have records that besides Greek icons, the Ethiopians used to bring in holy images from other different sources.

"This monastery [Bizan, close to the Red Sea] also possesses a great cloth", writes Alvarez, "like a piece of tapestry on which is the crucifix and figure of Our Lady and the apostles, and other figures of patriarchs and prophets, and each one has his Latin name written, so that no man of the country made it".[140]

Another Portuguese, Pêro Gomes Teixeira already mentioned brought from the same Monastery a prayer book written in Ethiopic on vellum "and in front of the book there was a picture of Our Lady with her Son on her arm . . . The picture was made on paper and the friars said that such picture and many others were brought by those who travelled to Jerusalem and Rome".[141]

Alvarez had with him a copy of the popular devotional book in Europe, the Flos sanctorum, Lives of Saints, which contained the pictures of these and additionally scenes of the Lord's Passion. Eventually Alvarez donated the book to King Lebna Dengel.[142] As to the pictures in the book, these might have influenced the scenes of the Passion in 16th-century wood paintings.

* * *

To conclude this exposition, let us sum up our knowledge of the expatriate painters in the 15th and early 16th-century Ethiopia:

The paintings of the Italian Niccolò Brancaleon and the characteristics of his art are fully identified.

Possibly among the paintings which came to light in the last two decades, there are the works of another Italian, Hieronimo Bicini. However, we do not have sufficient evidence to ascribe any particular painting to him.

In view of the developments in iconography and style during the first half of the 15th century, we are led to infer the presence of an expatriate artist in Ethiopia before the arrival of Brancaleon and Bicini.

Since we know at present the untrained hand of Brancaleon's paintings and that the same characterizes other works whose makers have not been identified, the painter of two triptychs in Dimā Giyorgis and the one in Tadbāba Māryām Monastery as well as of the portrait of Lebna Dengel, all executed with professional craftsmanship must have been the Portuguese, Lázaro de Andrade.

[140] AlvPrJ 87.

[141] G. Correa, Lendas da India . . . publicadas . . . de R. José de Lima Felner . . . (Lisboa 1861) II 585.

[142] F. Alvarez, Narrative of the Portuguese embassy to Abyssinia during the years 1520–1527. Tr. Lord Stanley of Alderley (London 1881) 209.

175. Book of Miniatures by Nicolò Brancaleon, c. 1508–20. 19,0:14,0 cm. Wāfā Iyasus, Gončā in Goǧǧām

(a) The Baptism of Christ and the painter's signature

(b) The Seizure of Our Lord in Gethsemane (open book with the monogram NI)

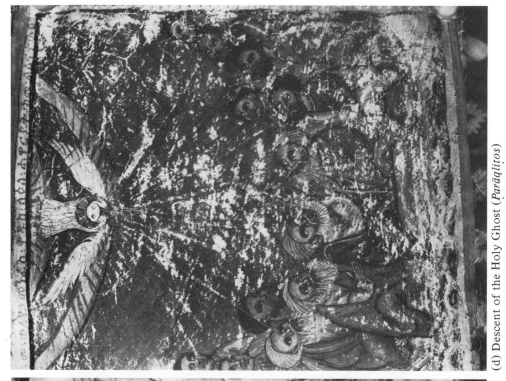

(d) Descent of the Holy Ghost (*Parāqlitos*)

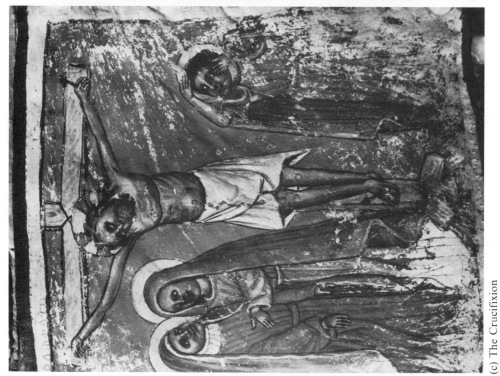

(c) The Crucifixion

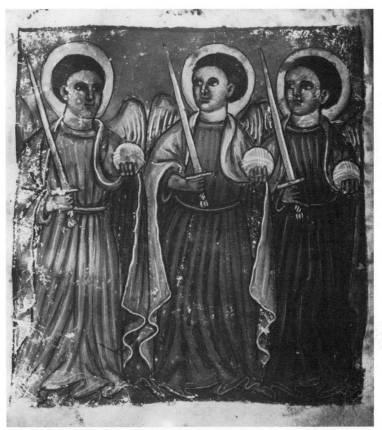

(e) Choirs of Archangels

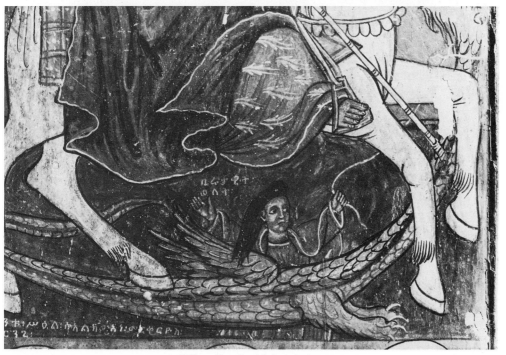

176b. Detail with inscription

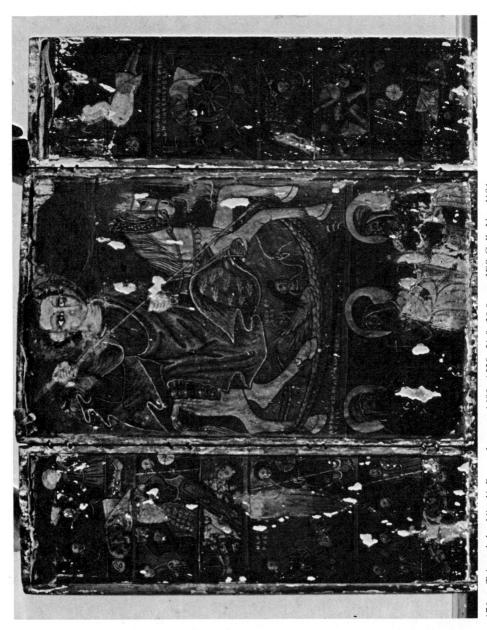

176a Triptych by Nicolò Brancaleon, c. 1480–1520. 51,0 : 30,0 cm. IES Coll. No. 4191

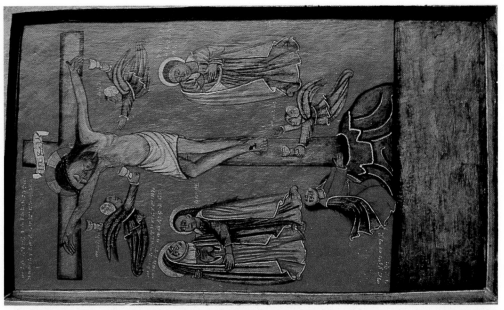

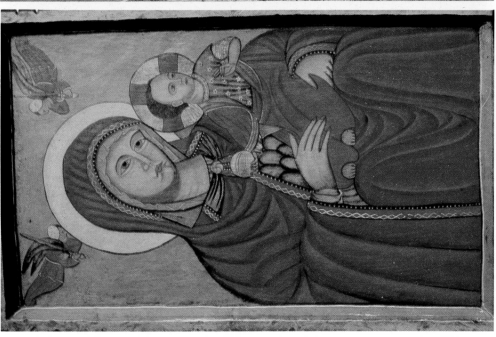

177 Diptych attributed to Nicolò Brancaleon, c. 1480–1520. 51,0 : 30,0 cm. IES Coll. No. 4325

180. Gospels. 1478–94. 24.0 : 21.9 cm. Dabra Warq, Goǧ-ǧām (Frontispiece representing St. Luke)

178. Italo-Cretan icon, 15th–16th century. c. 32.0 : 25.0 cm. Dabra Saḥel, Šerē

182. Lateral panels of the box framing the *Šeʿela Sergut* icon.
c. 30,0 : 13,0 cm
(a) The Crucifixion (b) The Lamentation

181. *Šeʿela Sergut*, c. 29,0 : 24,0 cm. Gētesēmānē Māryām,
Goǧǧām

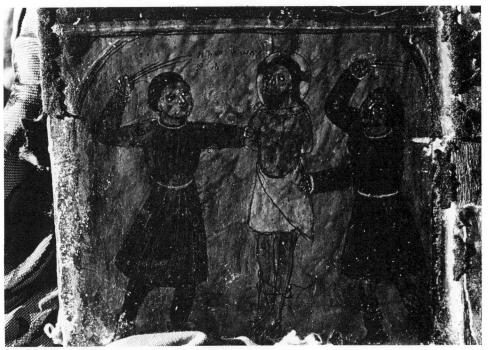

(c) The Flagellation

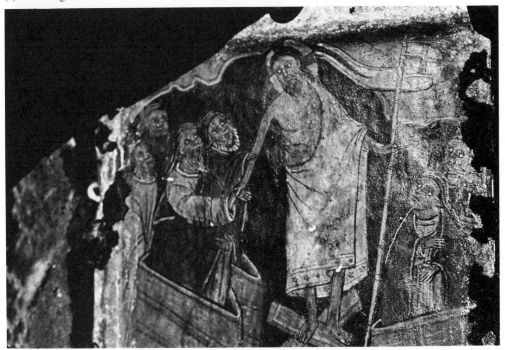

(d) The Descent into Limbo

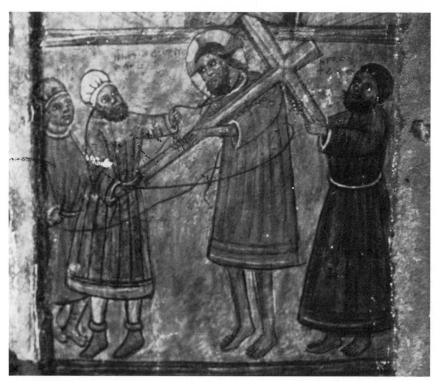

(e) The Bearing of the Cross

(f) The Flight into Egypt

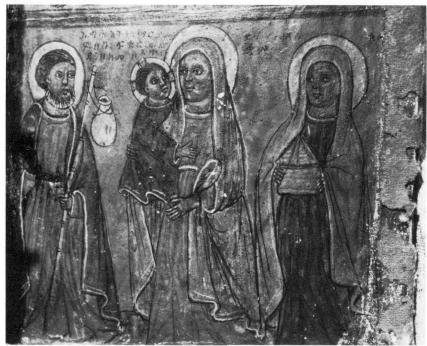

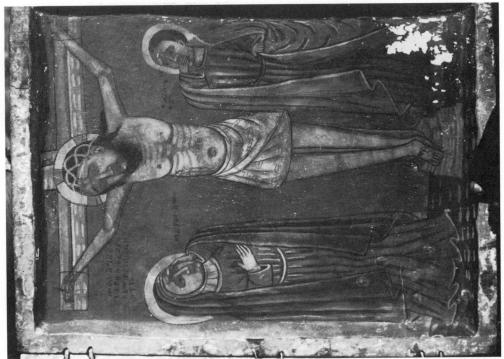

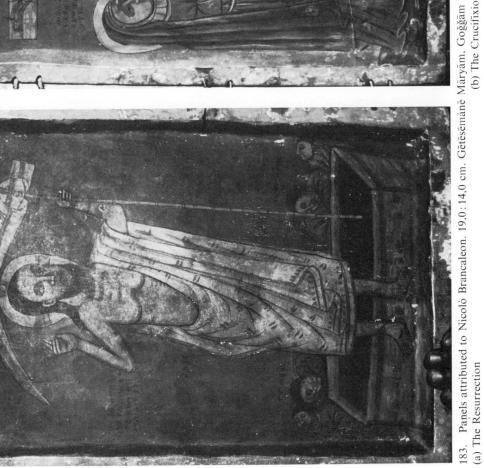

183. Panels attributed to Nicolò Brancaleon. 19.0 : 14.0 cm. Gêtêsêmanê Mâryâm, Goğğâm
(a) The Resurrection (b) The Crucifixion

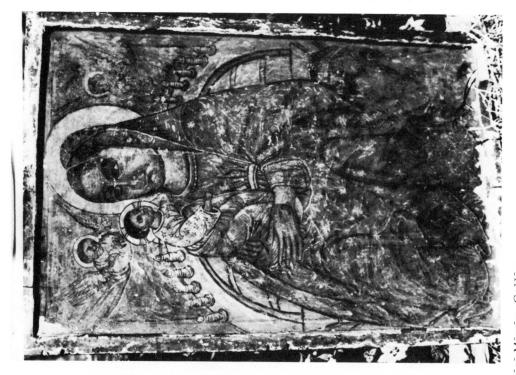

184. Diptych attributed to Nicolò Brancaleon. 42,0 : 32,0 cm. Gētēsēmānē Māryām, Goǧǧām

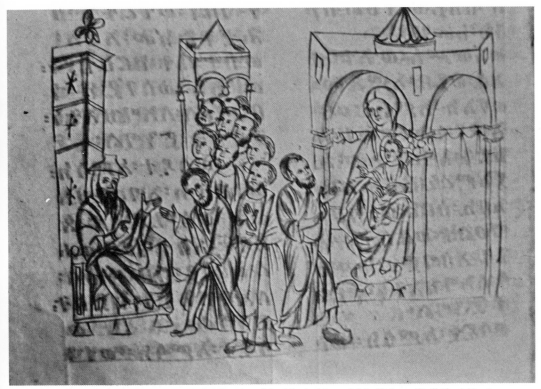

Drawings attributed to Nicolò Brancaleon, Miracles of the Virgin Mary. 25,0 : 20,0 cm. Tadbāba Māryām,
Amārā Sayent
(a) Miracle of the bishop who had "stone foot"
(b) Apparation of the Virgin to Isaac the monk

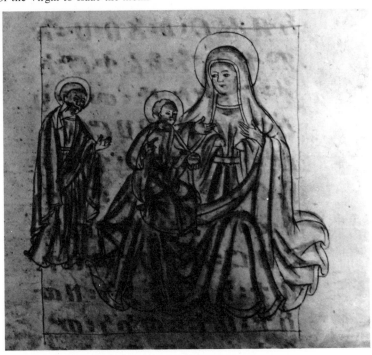

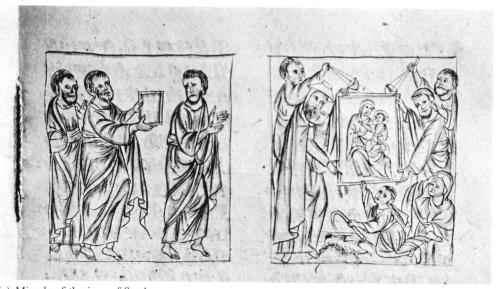

(c) Miracle of the icon of Saydnaya

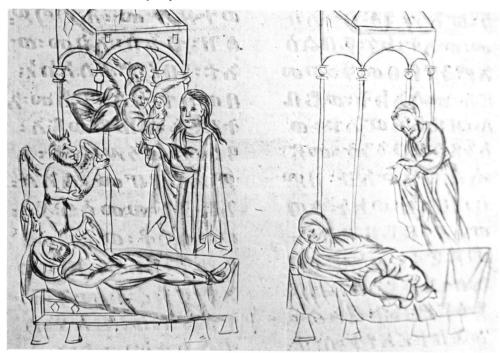

(d), (e), (f) subject-matter not identified

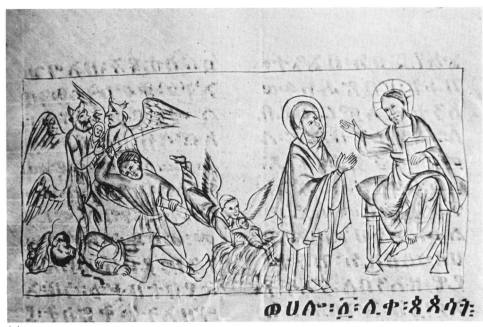

ወህሎ፡ሲ፡ሲ_ቀ፡ጸጸሳን፤

(e)

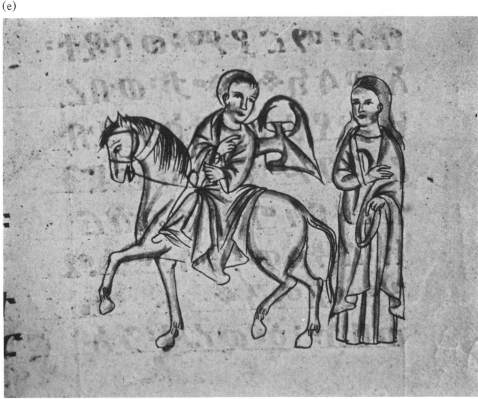

(f)

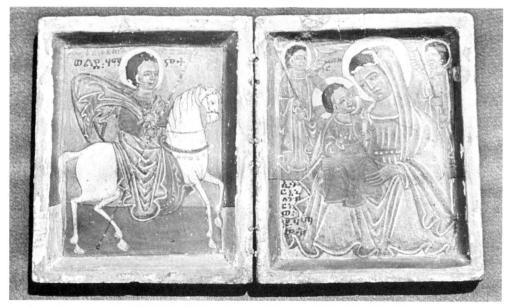

186. Diptych, 15th century. 12,5 : 9,0 cm. IES Coll. No. 4620

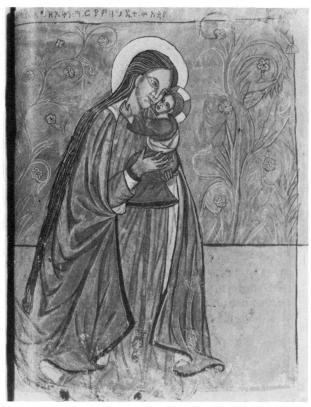

188. 15th–16th century miniature inserted in Ms. Or. 641, British Library. 34,8 : 30,2 cm.

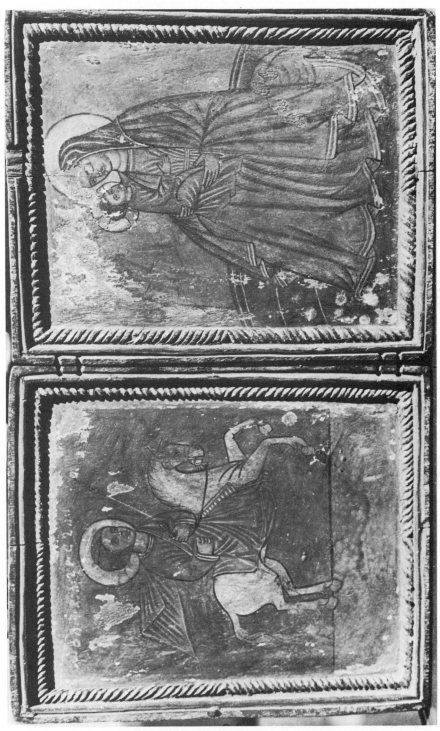

187. Diptych, 15th century. 22,8:19,6 cm. IES Coll. No. 4467

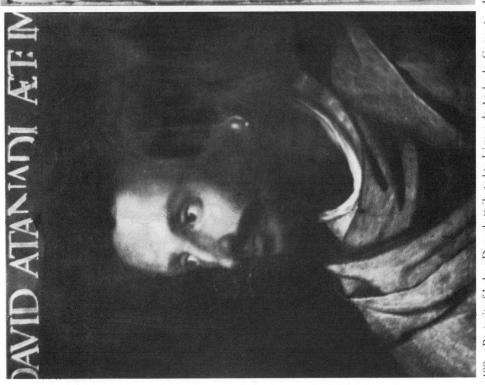

189. Portrait of Lebna Dengel attributed to Lázaro de Andrade. Copy at the Galleria degli Uffizi, Firenze

190. *Kwer'ata re'esu*, 16th century?. c. 33,0 : 27,0 cm. Private coll., Portugal.

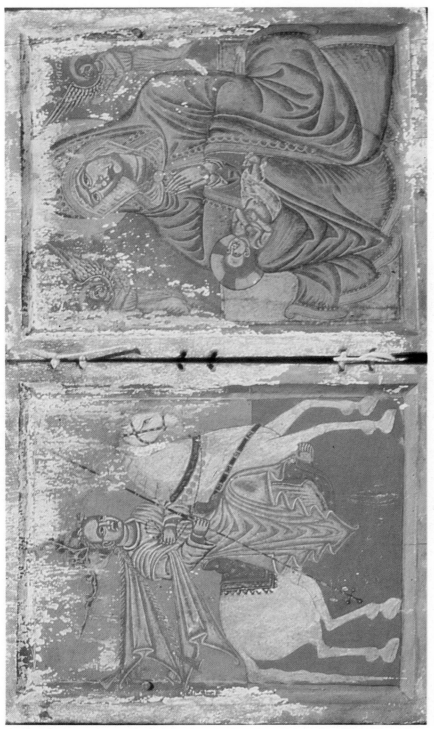

191. Diptych, 15th century. 22,8 : 18,0 cm. Private coll.

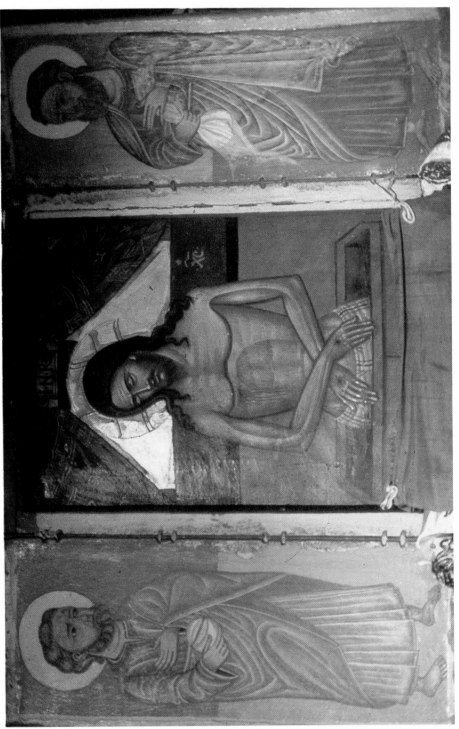

192. Triptych, 15th century. c. 52,0 : 40,0 cm. Wāfā Iyasus, Goǧǧām

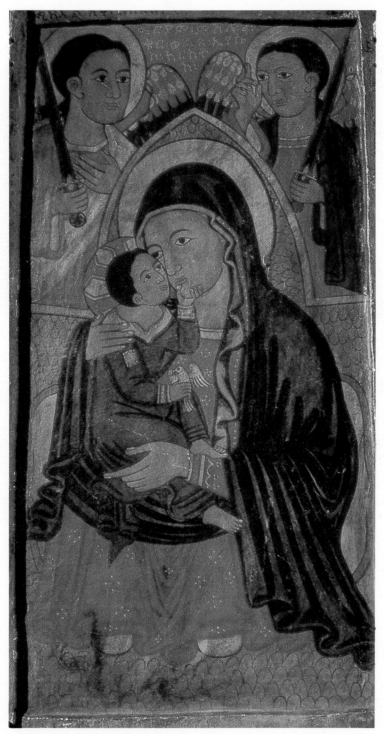

193. Central panel of a triptych, 15th century. 79,2 : 48,8 cm. Wāšā Endreyās, Bagēmder

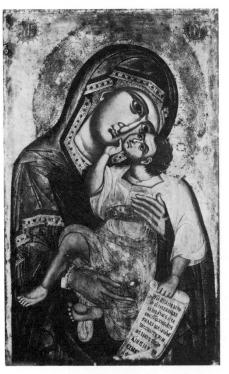

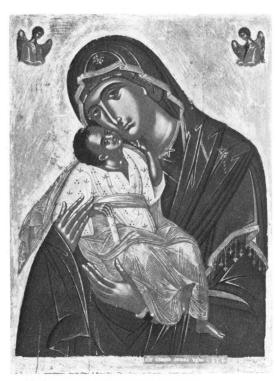

194. Theotokos-Glykophilousa, 16th century, Musée Byzantin, Athens.

195. Theotokos-Glykophilousa by Emmanuel Lampardos, 1609, Benaki Museum, Athens

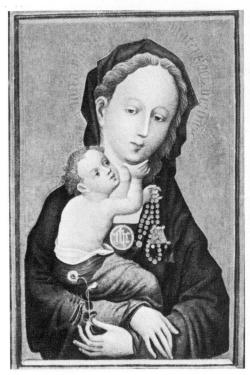

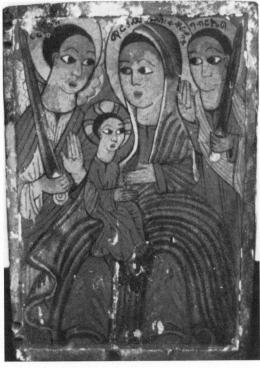

196. Virgin with a vetch, c. 1395–1415, the Master of St. Veronica, Wallraf-Richartz-Museum, Cologne

197. Panel of a diptych, 15th century, Asrat Getahun Coll. in the USA

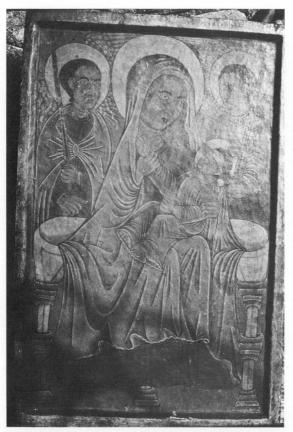

198. Panel, 15th century. c. 80,0 : 50,0 cm. Wāšā Endreyās, Bagēmder

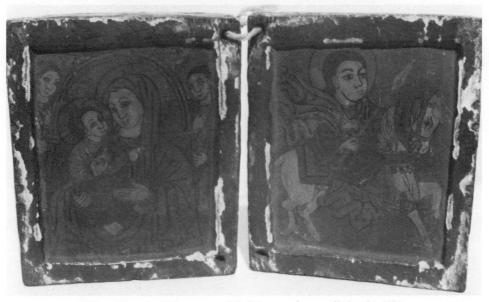

199. Diptych, 15th century. 9,5 : 8,0 cm. private coll. im the USA

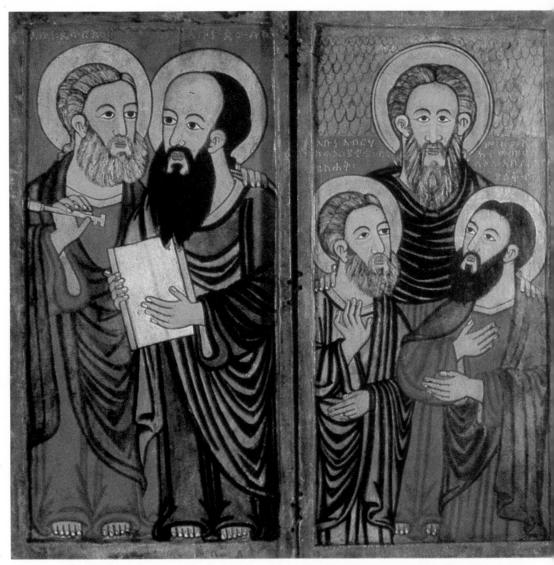

200a and 200b. Diptych, 15th century. 58,1 : 30,0 cm. IES Coll. No. 4324

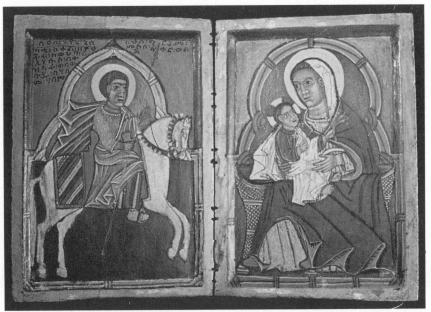

201. Diptych, 15th century. 28,0 : 20,0 cm. Private Coll., Germany

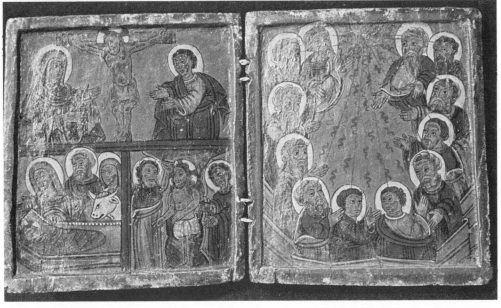

202. Diptych, 15th–16th century. 19,5 : 17,5 cm. Dr. H. Schweisthal Coll., Germany

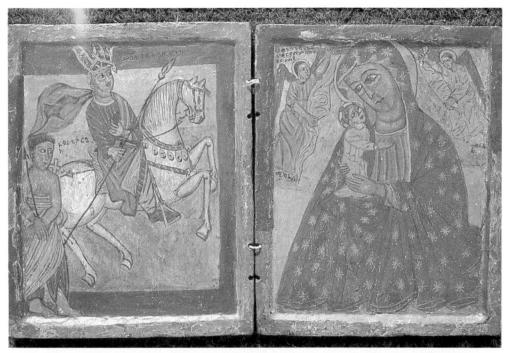

203.　Diptych, 15th–16th century. 20,6:17,0 cm. Dr. R. Fechter Coll. IC2, Germany

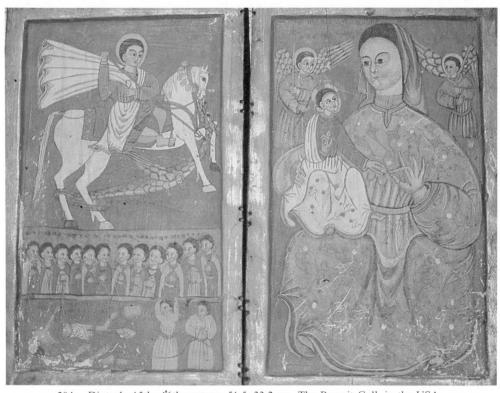

204.　Diptych, 15th–16th century. 51,5:33,2 cm. The Brumit Coll. in the USA

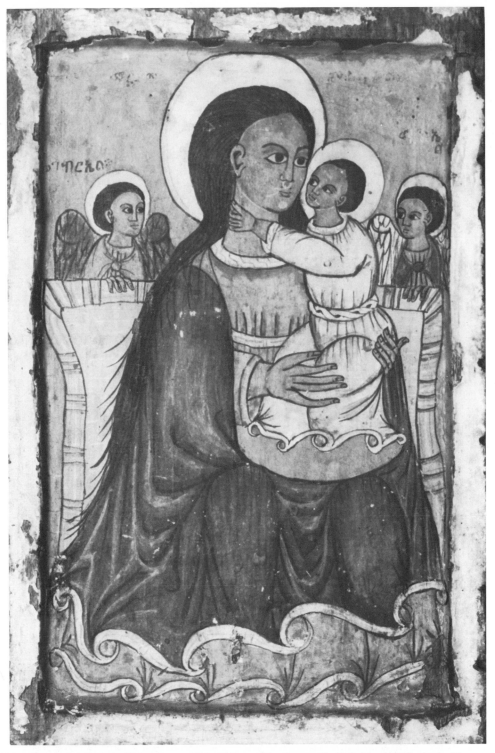

205. Panel of a diptych, 15th century. 33,0 : 21,9 cm. The Langmuir Coll. No. 113, Peabody Museum, Salem. Mass.

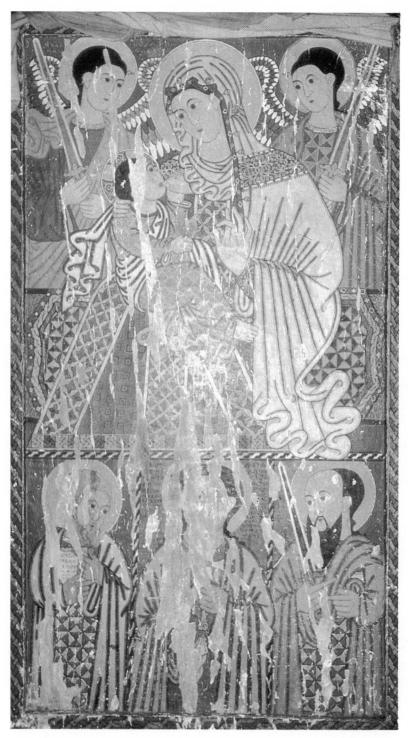

206. Panel by Ferē Ṣeyon, c. 1450. 177,0 : 102,0 cm. Dāgā Esṭifānos, Lake Ṭānā

207. Painting on cloth, c. 1450. 199,0:180,0 cm. Dāgā Esṭifānos, Lake Ṭānā

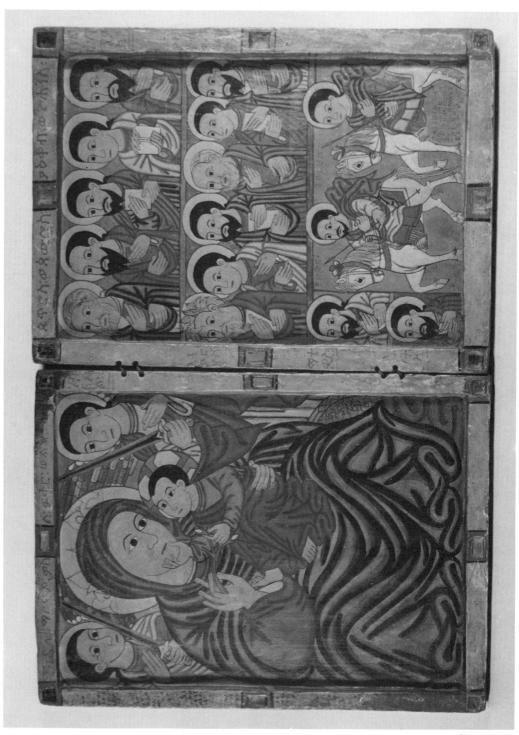

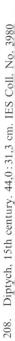

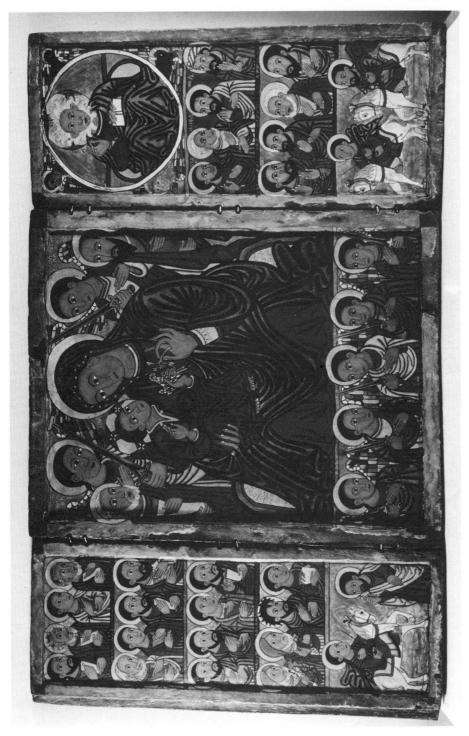

209. Triptych, 15th century. 63,7 : 49,6 cm. IES Coll. No. 4186

210. Book of Psalms and Prayers, 1476–77. 30,2:21,0 cm. Abb. 105, Bibliothèque nationale, Paris

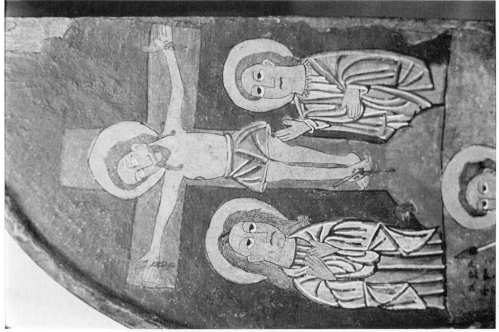

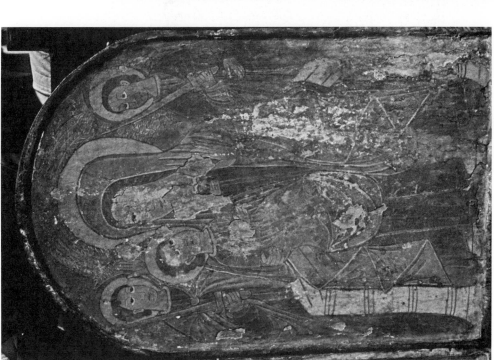

211a, 211b, 211c, 211d. Triptych, 15th–16th century. 38.5 : 28.0 cm. IES Coll. No. 5093

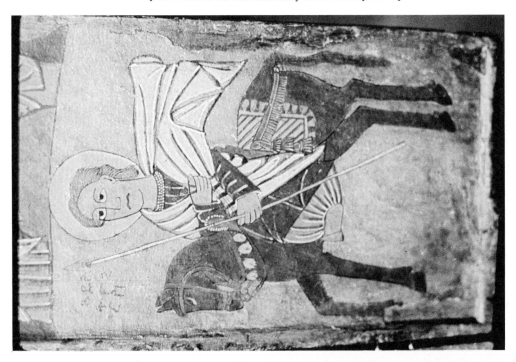

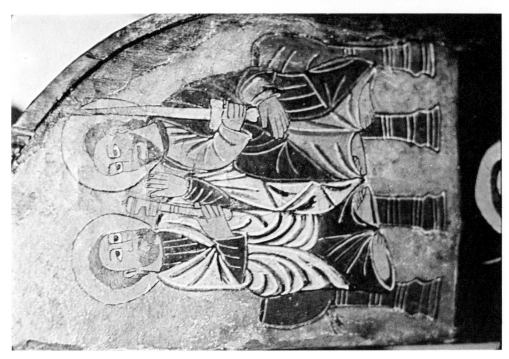

212a. Prayers of Mary, 15th century. 10,0 : 7,8 cm. Cod. Aeth. 50, fol. 3r and 102r. Biblioteca Apostolica Vaticana, Rome (fol. 46v, 47r)

212b. Prayers of Mary, 15th century. 10,0 : 7,8 cm. Cod. Aeth. 50, fol. 46v–47r. Biblioteca Apostolica Vaticana, Rome (fol. 3r, 102r)

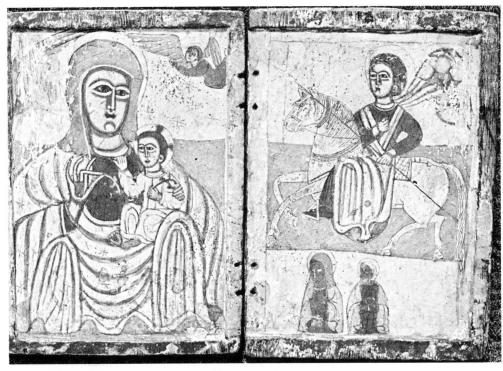

213. Diptych, 15th century. 22,0 : 15,8 cm. Dr. R. Fechter Coll. IC3, Germany

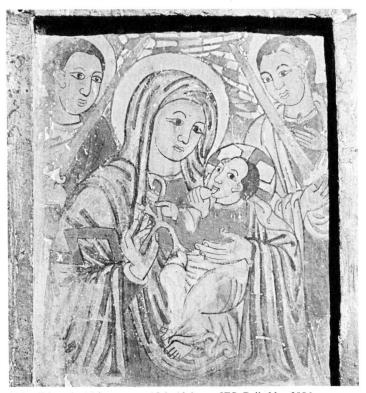

214. Diptych, 15th century. 15,0 : 12,0 cm. IES Coll. No. 3986

VIII. THE ART OF ŠAWĀ IN THE 18TH AND 19TH CENTURY

The following is the description of the pictorial art which developed in Eastern Šawā. This particular expression in the art of the Ethiopians was brought about by the geographical situation and political developments of Šawā during the 17th, 18th and 19th centuries.

The writer's attention was drawn to the Šawān painting on the occasion of microfilming the manuscripts in the districts of Dabra Berhān, Ankobar and Salā Dengāy in Eastern Šawā, by a group of researchers directed by Dr. Sergew Hable Sellassie in the 1970s.[1] These districts constituted in the past a core of the principality and later the kingdom of Šawā which flourished in the last three centuries.

The beginnings of the kingdom of Šawā and its initial expansion in the 16th and 17th centuries are not well known. However, it seems that its existence was due to the Moslem invasion of Ethiopia in the early 16th century and the subsequent incursions of the Oromo people in the latter half of it. The centre of the weakened Empire, which in the 14th and 15th centuries was located in areas corresponding to the present province of Šawā, was moved to the north to the Lake Ṭānā region. This brought about a subsequent loosening of the control over the south of the Empire, including Šawā, by the Gondarene monarchs and resulted in the creation of small, semi-independent political units.

In the mountainous region of Manz in the east of the present province of Šawā and in the south-west of Wallo, the small islands of Christianity survived the 16th-century onslaught by Islam and Oromo and even gained strength. Under energetic local rulers the lost territories were regained and expansion initiated. One of these families of rulers, the so-called Šawān dynasty, particularly gifted in warfare, emerged in the region in the second half of the 17th century. Although the Gondarene emperors claimed rights over the latter's princely state, the area enjoyed, in fact, a very large autonomy. Moreover, its fortunes contrasted with those of the rest of the Empire. Starting with the 18th century, the Gondarene rulers were gradually losing power and eventually in the second half of it their rule collapsed. The princes of Šawā, in the same period, continuously expanded it farther south. One of them, Amhā Iyasus, d. 1774 or 1775, visited Gondar at the time of the travels in Ethiopia by James Bruce, 1769–71; the Scottish traveller has traced an impressive portrait of the Šawān prince who was treated with great consideration by the Imperial court.[2] Amhā Iyasus's son, Asfā Wassan d. 1808, established his capital in Ankobar. His successor, Wassan Sagad d. 1813, moved to not too distant Qundi and was the first of the dynasty to call himself *Ras,* Prince of Šawā. Šāhla

[1] Some 7,500 manuscripts originating mostly from the provinces of Šawā and Wallo were microfilmed by the project. One copy of the microfilm has been deposited at the Hill Monastic Manuscript Library, St. John's University, Collegeville, Minnesota (EMML).

[2] BruceTra VI 37–43.

Šellāsē (1813–47), his son, assumed the title of *Negus,* the King, and during his successful administration substantially expanded his realm. The area between the towns of Angolalā, Dabra Berhān and Ankobar, was the centre of the state which became more powerful than other parts of divided Ethiopia.[3] Eventually, in the late 19th century during the long and prosperous reign of Menilek who was a grandson of Šāhla Šellāsē, Šawā merged with the rest of the Empire. This was effected together with Menilek's accession to the Ethiopian Imperial throne in 1889.

The different political development affected the other fields of Šawān life. The general economic decline of the Empire, due to the constant internal wars, contrasted with the relative prosperity of Šawā. In religious life, its rulers adopted a special interpretation of Christ's nature, the so-called doctrine of his triple birth, which outside Šawā was considered not truly orthodox. Nevertheless, the Šawāns and their rulers were devout Christians. Prince Asfā Wassan, for example, was well-known for his learning in religious matters and generosity in endowing churches. The early Christian establishments in Šawā fell into ruin in the 16th century; a new effort was needed to rebuild the churches. The regeneration of Christian life in eastern Šawā after 1700 is best illustrated by the distribution of the old and the foundation of the new churches in the kingdom. The area of Dabra Berhān shows in the 17th and 18th centuries a large number of new churches added to the few old ones, while in the area of Ankobar almost all churches were founded after the second half of the 18th century.[4] Most of the manuscripts found in Šawān churches also date from the same period.

The state of Šawā was separated from the north of the Empire by the Oromo people who settled in between. The rulers of Šawā being related to the rest of Ethiopia by their religion and culture tried to keep contacts with Gondar, maintaining nevertheless a very large autonomy. The Oromos occasionally blocked the routes leading to the north and in general made the contacts difficult. The resulting isolation of the Šawān kingdom brought about an art which has characteristics of its own.

DESCRIPTION OF THE PAINTINGS

The following description of selected miniatures in the manuscripts and one triptych, all originating from Eastern Šawā, does not follow the chronological order; neither are all the paintings related directly to each other. The arrangement

[3] For a detailed story of Šawā, see *A. Cecchi,* Da Zeila alle frontiere del Caffa (Roma 1886) I 237–43; *N. D. Levine,* Wax and Gold, Tradition and Innovation in Ethiopian Culture (Chicago 1966) 28–38; *Asfa-Wossen Asserate = [Asfā-Wassan Aserāt],* Die Geschichte von Šawā (Äthiopien) 1700–1865. Nach dem Tārika Nagaśt des Belāttēn Gētā Ḥeruy Walda Šellāsē = Studien zur Kulturkunde 53 (Wiesbaden 1980) 22–152.

[4] *V. Stitz,* Distribution and Foundation of Churches in Ethiopia = JEthSt XIII 1 (1975) 11–36.

is meant to demonstrate the stages of the local transformation from the Gondarene models into the Šawān idiom.

It is not possible to suggest that Šawān art gradually reached its stage of self-expression starting form the Gondarene art of the 18th century. We do not have sufficient chronological indications to prove this. Nevertheless, there is no doubt that the main iconographic forms of the Šawā school have been taken from that of Gondar, along with traces of the older forms.

Dr. Sergew Hable Sellasie who investigated the manuscripts has also established their dates;[5] these are given in the description.

(1) Five miniatures are found in the Life of Ḥeṣān Moʾa, Monastery of Dabra Bagʿe in Qābannā River Valley. Text and miniatures date from the 19th century. The manuscript was made for a certain Finḥas by a scribe Takla-Hāymānot, who probably also painted the miniatures (EMML 2349).

The first miniature shows "as Abuna Ḥeṣān Moʾa prayed" (fig. 215a).[6] He is accompanied by two personages, one called Finḥas and another Mārteyānos; both are monks and wear a hood or shawl similar to that of Ḥeṣān Moʾa; Finḥas holds in his hands the praying beads which customarily are carried by monks in Ethiopia. Mārtyānos holds a praying staff, used by Ethiopian clergy during religious ceremonies.

The second miniature, also illustrating the life of Ḥeṣan Moʾa, shows how he "became one of a pair of oxen" while the peasant was ploughing and the ox resting (fig. 215b). The subject of farmers tilling the land with oxen appears in Second Gondarene paintings, usually in relation to the miracles of St. Michael. The theme has apparently been composed from life. Indeed, the peasant whipping his ox has a vivid touch of realism.

The third miniature is an obvious copy from the Second Gondarene painting representing St. George who saves the maid Birutāwit from the dragon (fig. 215c). There are, however, four changes. St. George holds two spears, one with which he stabs the monster, and the second ready to throw. This manner of representing the Saint was apparently popular among the painters of Šawā and Goǧǧām. The second collar ornamented with tassels on the horse's neck, which is indicative of the Gondarene portraits of the Saint, is missing. He has also two toes inserted into the

[5] The author is much indebted to Dr. Sergew for his permission to photograph the miniatures in the manuscripts and his comments on their age.

[6] According to the information extracted from the text by Dr. Sergew, Ḥeṣān Moʾa was born in Šawā during the reign of Dāwit I; as a boy he was a shepherd; he entered the Monastery of Dabra Libānos and there he received his religious education. Eventually he was ordained priest by bishop Gabriel during the reign of Zarʾa Yāʿqob. Ḥeṣān Moʾa taught the children of Baʾeda Māryām and journeyed to the Adel area with an assignment to bury the bodies of Christians killed there during the war between Adel Kingdom and Ethiopia. In his late age he became Abbot of the Dabra Bagʿe Monastery. KRZHadTrad 78 gives another version of Ḥeṣān Moʾa's life. He lived in Northern Ethiopia and came to Šawā at the request of King Zarʾa Yāʿqob to teach his son. Ḥeṣān Moʾa founded the Monastery of Dabra Bagʿe.

stirrup-iron instead of one. The form of Birutāwit's necklace is different than the usual and possibly mirrors the ornaments of Šawān women. The figure prostrated under the belly of the horse is accompanied by the inscription *malk'e Giyorgis*, "effigy of George". This is the donor reciting the lauds of the Saint which are popular in Ethiopia.

The fourth miniature shows the Virgin Mary "with her beloved Son" and flanked by St. Michael and St. Gabriel (fig. 215 d). The iconography is borrowed from the late 17th-century representation of the Virgin of S. Maria Maggiore as evidenced by a handkerchief she is holding, her two elongated fingers, the Gondarene cross appearing on her mantle over her forehead and especially an Ethiopian bed on which she sits. The Šawān painter, however, changed the Child's usual gesture of blessing; His two fingers are not pointed upwards and two bent downwards as usual, instead all fingers are outstretched almost horizontally.

The fifth miniature represents the Crucifixion; the Virgin (caption "tears of Mary") stands on the left and St. John on the right. She is wrapped entirely in a dark blue mantle and covers her mouth with it. Longinus shown in profile transfixes the Christ's right side; all this is characteristic of the Second Gondarene painting, whereas the crown of thorns points to the Western derivation of this image of the Crucifixion. The dramatic movement of mourning by John recalls the 16th-century rendering of the subject. The sun over the cross is in the form of a rosette contrasting with the simple circle of the moon.

The five miniatures evidence the impact of Gondarene art on the 18th and 19th-century Šawān paintings. The main iconographic setting and the flower and rosette ornamentation of the robes are Second Gondarene. However, there are also possible traces of older traditions; the modelling of faces, in particular the shape of the noses and the line of the eyebrows as well as the manner of drawing the mouth, all recall 16th-century art. As compared with the followings works, the miniatures are remarkable for their rich and deep colouring: red in different shades, yellow, greyish and dark blue are used; green is missing altogether.

(2) The 18th-century Book of Miracles of the Virgin Mary, Dans Mikā'ēl church, district of Ankobar (EMML 2634) was produced for a certain Amha Giyorgis by a scribe Walda Giyorgis, who probably also painted the four miniatures in the book. These represent the Virgin "with her beloved Son", the Crucifixion, three saints, and St. George rescuing Birutāwit.

The first miniature derives from Gondarene painting. However, the mantle of Mary is a solid mass of dark blue colour with no feeling of the textile (fig. 216 b). The figure of the Child has become an integral component of the Virgin's robe and neither his blessing hand nor the book are shown. Yet, the feeling of closeness between the mother and her divine Child is successfully expressed. The same lack of realistic effects is manifest in the figures of the angels; for example their hands have become a part of the decorative band on their garments.

The composition of the Crucifixion in the second miniature (fig. 216 a) is also graphic. The figures of John on the left and Mary on the right fill entirely the space below the cross. Their position is reversed as compared with the Gondarene Crucifixions. Their hands do not express sorrow as usual but are included in the

decorative pattern of their dresses. Dominated by the volume of the large cross, they are motionless. The cross is contoured with a dark blue band. The Saviour's demise and the feeling of oneness between the Crucified and the tool of his sacrifice is effectively imparted by a strong inclination of his legs which have lost their power and the curve of his arms visibly supporting the weight of the body. The death of Christ is also epitomized by his eyes: they are blank; the bluish dots over them and two vertical lines recalling the tears of blood suggest the chill of an inert body.

The third miniature represents three well-known local saints, Gabra Manfas Qeddus[7] in the middle, Kiros[8] on the left, and Takla Hāymānot[9] on the right (fig. 216c). Both arms of Gabra Manfas are uplifted in prayer and his eyes directed upwards. The other saints keep one hand pressed against their chest and carry a cross in the other. They seem to wear turbans and to have either a nimbus or a hood above these. All three figures are delineated with a dark blue wash. Their eyes are expressive, their noses prominent, but they lack a mouth.

We witness a similar tendency of simplifying the figures in the representation of St. George (fig. 216d), for example the spear has a circle on its top instead of a cross and the dragon's body has the shape of a sausage. Nor is the drawing realistic: the toes of the Saint are not inserted into the stirrup-irons and they do not even touch them. One portion of the background behind St. George is covered with a dark blue wash, while another portion above him is in red. The painter's intent is not obvious but this addition directs the perception of the viewer along the horse's movement.

The stylistic features of the miniatures are as follows: human figures are changed into geometrical forms; the emphasis is put on the decorative value of the image and the narration or its drama is achieved partly by the distorted shapes and partly by the eyes which are the major medium for communicating the feelings.

The range of colours is limited to red, pale yellow, ochre and dark blue; green is not used.

The modelling of faces which recall scroll painting follow the manner described previously. A thin, inconspicuous line stands for the mouth. The striking feature of the faces is the triangular black beard of Christ and also of John and the angels; the same is found in the following miniatures.

(3) The 19th-century Life of Takla Hāymānot from the Endone Takla Hāymānot church, Dabra Berhān District (EMML 2782), was written for Tesabēta Wald by a scribe Zarʾa Dāwit who probably painted its eleven miniatures. Since Šawān manuscripts are known to be seldom richly illustrated except for the King Šāhla Śellāsē's prayer books, Tesabēta Wald must have been an important personage. The following is a description of the paintings.

[7] A saint believed to be of Egyptian origin who spent his miraculous life in Ethiopia partly in the area of Mount Zeqwālā and of Medra Kābt in Šawā. He is particularly popular in this province but also widely venerated in the rest of the country.

[8] Kiros, an Egyptian anchorite, is commemorated on 8th *Hāmlē* in the Synaxary, BSyn 1095–97. Kiros' popularity in Šawā is attested by the numerous texts about him kept in churches.

[9] The 13th-century monastic leader and founder of the Dabra Libānos Monastery in Šawā.

Three monastic leaders of the 13th–14th-century Ethiopia: Takla Hāymānot and Zēnā Mārqos[10] who both hold the benediction cross and whisk, and Ēwosṭātēwos (see footnote 37 on p. 25) who is holding the beads. The first and the second are represented as elderly people with long white beards while the third is a young man. All three do not wear nimbi over their heads. The crosses and whisks are clearly drawn from life.

Joint pictures of Takla Hāymānot and Ēwosṭātēwos are well-known in Ethiopian art of the 16th century and after. The addition of Zēnā Mārqos, founder of the monastery of Dabra Besrāt in Morat, whose popularity is limited to Šawā indicates that the manuscript was produced in that area.

"As the Jews apprehended Christ" runs the caption explaining the next composition. The faces of the soldiers have lost their human shape, but their profile traced with the sinuous lines and large eyes staring at Christ symbolize to perfection the rôle of the captors in the drama of the Passion. Similarly, the crossed hands of Christ express vividly the idea of his capture. Christ is represented as a young man. No nimbus is added to his figure.

The Temptation of Adam under the tree of Paradise is made visual by the serpent coiled round its trunk and whispering into the ear of Eve (fig. 217a). Adam seems to be listening attentively. The tree recalls an ornamented fan. The bodies of Adam and Eve are anatomically distorted yet express well the meaning of the composition; moreover, their eyes directed to each other reveal dramatically the hidden symbolism of the scene.

St. Michael, with widely outstretched hands, supports the owners of the manuscript, Tesabēta Wald on the right and his wife Walatta Yāʿqob on the left (fig. 217b). The Saint has a pointed beard, while the donor is beardless. In this picture St. Michael has no nimbus whereas in another picture of the same manuscript he has one. This composition illustrates the extensive use by the Šawān painters of interlaces, lozenges, small circles and zigzag lines as ornamentation.

St. Michael holds a sword in one hand and a sheath in another (fig. 217c). He wears a nimbus. His ornamented wings and the striped line under his feet form a square, demonstrating the painter's tendency to reduce the shapes to geometrical figures and to fill free space with ornamentation.

The Anastasis: Christ descended into Limbo holds the hands of Adam and Eve with his widely outstretched hands (fig. 217d). This is a simplified version of the theme which is one of the most popular in Ethiopian religious art. Christ wears a nimbus which is ornamented with radiating lines and gives the impression of the turban often depicted as the saints' head-cover in Gondarene art. A shape appearing close to Adam is probably the snake. The inclusion of the snake in the composition is unusual but seems to be logical, considering that Ethiopians believe him to be the instigator of the transgress of God's order by the First Parents and the

[10] The 13th/14th-century monastic leader and disciple of Takla Hāymānot. He founded the Monastery of Dabra Besrāt, Morat in Šawā. Cf. *E. Cerulli, Gli atti di Zēnā Mārqos* (Citta del Vaticano 1962).

cause of their presence in Limbo. Christ's mouth is traced with two thin lines, which are lacking in the figures of Adam and Eve.

The image of the Crucifixion (fig. 217e) is clearly indebted to the Gondarene school. The Virgin, on the right, is wrapped entirely in her mantle, hides her mouth with it and looks at her dead Son. St. John, on the left, seems to be stripped to the waist and holds his hands crossed on his chest in a pose common in Ethiopian art starting with the 16th century. The strong inclination of his head, combined with the movement of his eyes, expresses his involvement in the drama. The head of Christ is adorned with the dark band which stands for the crown of thorns; the eyes are left blank, emphasizing that death has conquered the body of Christ.

The following is the description of other miniatures in the manuscript which are not reproduced in the book.

An old man, an unidentified scribe, carries an object which could hardly be a cross; he grasps the hand of a young man or a woman who holds a pen in the other.

Three figures with nimbi over their heads, identified by the general term ṣadqān, saints. Here again is applied the 15th-century manner of representing the middle figure in frontal position and those on the side in three-quarter pose. The dark blue background gives the impression of a block print.

The Virgin is depicted "with her beloved Son", but the guardian angels are missing. Such a reduced image still derives from the S. Maria Maggiore type as evidenced by the *mappula,* the elongated fingers and the blessing Child. The pose of his hand, however, is not Gondarene but identical to that in the Life of Ḥeṣan Moʾā described previously (No. 1). The Virgin's mantle is painted with dark blue encompassing the face of Mary and the figure of the Child. The inverted red crescent over the mantle probably stands for the flattened nimbus of the Virgin. The nimbus does not adorn the head of the Child, instead a realistically drawn necklace adds a touch of local colour to this painting.

Gabra Manfas Qeddus is praying and Kiros is holding the beads; the lion is depicted in the back. Neither saint has a mouth; the chin of Gabra Manfas is covered with his white beard. The pose of his hands is harmoniously combined with the parallel lines running along his body. These represent the miraculous hair covering his nakedness. Also, the eyes of the lion have a human shape and are striking by their expressiveness.

The colours used in the miniatures are red, yellow and dark blue, but there is no green, except for the cross in the Crucifixion which is bluish-green.

The miniatures are stylistically related to those in the Book of Miracles of the Virgin Mary described above (No. 2), but the painter's power of expression is more evident. The subjects are partly taken from the Old, partly from the New Testament, and partly from popular devotional themes. The temptation of the First Parents virtually never appears in Ethiopian manuscript illuminations and icon paintings but is well-known in church murals; the miniature has most probably been copied from these. The Descent into Limbo, the Crucifixion as well as the images of the Virgin are common themes of Ethiopian painting; St. Michael gained a tremendous popularity during the Second Gondarene period. The fact that his portrait occupies two miniatures in the same manuscript proves that his fame had

by then reached Šawā. All the above subjects except one have no relation with the text of the life of Takla Hāymānot. However, it was a common practice in Ethiopia to paint such pictures in religious books; the practice is comparable to the present day insertion of printed devotional images in prayer books or missals. The choice of the subjects in the manuscript, especially the one illustrating the passage from Genesis 3, reflects perhaps the personal feelings of either the owner of the book or of the painter himself.

Additionally, the manuscript contains two folios with ornamental bands at the head of the text. In these, the stylized faces are drawn together with the lozenges.

(4) The origin of the triptych IES Coll. No. 6665 is not fully established but according to its last owner it originated from Šawā (fig. 218a and b). It is also an outstanding piece of work by its power of expression and bold stylization. The forms borrowed from the art of Gondar have been thoroughly transformed. Moreover, the impact of iconographic traditions older than those of Gondar is manifest.

In the central panel there are two main subjects of the Christian art in Ethiopia, namely, the Crucifixion in the upper register and below, the Virgin. This disposition is virtually unknown in the Gondarene school, and probably not accidental but expressing the commentaries of the Šawān theologians. This innovation is followed by the displacement of the image of the Descent into Limbo from the left panel to the right one in order to make place for the great martyrs, Theodoros, Merkurios and George. Gabra Manfas Qeddus and Takla Hāymānot are depicted on the right panel below the Descent into Limbo, which is their usual place.

The rendering of the Crucifixion is overwhelming. The irregular shape of the cross is drawn in harmony with the inert body of Christ and blending with it. His head and hands with fingers twisted in pain are disproportionately large as compared to the rest of the body and the legs, and Christ's face with a prominent crown of hair has African features. Moreover, St. John and Mary sway in sorrowful rhythm and their hands and arms seem to perform the funerary dance traditional at Ethiopian funerals.

The figures of Mary and Child obviously originate from those in the S. Maria Maggiore painting but are free from its bondage to realism. The head of Mary emerges from the dark mass of colour on which the stars on her forehead and arm become a combination of circles and serve essentially as ornamentation. White pearls are scattered around the heads of Mary and of the Child and along the edge of her mantle. The whole recalls the portraits of the Virgin by the artists of the 15th-century Gunda Gundē school.

Equally graphic is Christ's Descent into Limbo. He has lifted his hands up and consequently the arms of Adam and Eve which he holds are much longer than normal. This deformation, however, which is well-known in early Ethiopian paintings, is most effective in expressing the ascending of the first parents to heaven. Their private parts are hidden by black squares depicted on their loins which is a clear reference to a passage of Genesis and relate this painting to the miniature in the Endone Takla Hāymānot manuscript (No. 3).

We witness in this work of an unknown master the recurrent extensive use of the frontal pose for depicting the figures as in early Ethiopian painting and a clear departure from the three-quarter pose characterizing the paintings of the late 15th and the following centuries. The use of the nimbus is scarce and erratic. Particularly significant is that Christ in the Crucifixion lacks the nimbus, which is also characteristic of other Crucifixions of the Šawān school.

Reddish-brown, ochre and black predominate in the painting which is in accord with the unsophisticated palette of the Šawān painters. Such reduced colouring recalls scroll paintings.

(5) The illustrations in the 18th-century Book of the Gospels, St. Mary's church Feqru Walda, close to Salā Dengāy,[11] are a blend of the old iconographic traditions and of Šawān innovations.

The canons of Eusebius or tables of the concordances have no longer ornamented frames; the red lines running in between the columns of text divide it conveniently. The big arch has been replaced by small pointed arches topping each set of concordances. The ornamentation on the first folios of each gospel has been simplified and has become a narrow band at the top and bottom of the text. The ornamental pattern of the band seems to mirror the embroidery found on the shirts of the young attendants described subsequently.

The figures of the four Evangelists and their setting stem from the 13th to 15th-century gospels. We find the similar seated pose of the Evangelists, the draping of the garments, the chair with the backrest and the inkpot as well as the knife for sharpening the stylus. The touch of local colour is evident in the drawing of the knives and especially of the inkpots, in that one is painted red and the other black. This is because the Ethiopian scribes used red ink for writing the important names in the text and black ink for the rest of it.

There are, however, significant additions to the old scheme.

One of these is a small cross placed within the nimbus of each Evangelist. Although such decoration appears on rare occasions in early Ethiopian art, particularly in the figures of Mary, Christ and the equestrian saints,[12] the cross marking of the nimbus of the Evangelists seems to be a Šawān invention. How the painter in Šawā conceived the idea of the Evangelist's nimbus ornamented with the cross is not obvious. Perhaps he was inspired by the image of the Virgin of S. Maria Maggiore in which she bears a small cross on the mantle over her forehead, and applied the cross ornamentation to the figure of the Evangelists.

[11] The manuscript was brought to Addis Ababā for microfilming by the EMML project in early 1976. On this occasion the writer photographed and described the miniatures in the manuscript recording its place of origin as given by the priest who procured it. Unfortunately the photographs were lost. In spite of this the description of the miniatures has been included because these dramatically evidence the developments in Šawān art.

[12] On the Virgin's nimbus in the Presentation in the Temple, miniature in Gospels of Princess of Zir Gānēlā, HelZirGan 251; on the equestrian saint's nimbus, the mural, church of St. Mary, Dabra Ṣeyon in Garʿāltā. Such a nimbus decoration is known in Eastern Christian painting. In Saqqārah murals some monastic figures wear crosses over their nimbi.

The main change introduced in the traditional representation of the Evangelists are the young men attending upon them. One attendant carries an umbrella (caption "as they kept your umbrella") to shelter and honour the Evangelist and the other holds the whisk to chase the flies away. Although the attendants wear a nimbus like the angels they lack the essential feature of the wings and in general do not recall the celestial beings. Manifestly their presence and function is explained by Šawān life. The attendants are, in fact, Ethiopian youths clad in the local manner with long shirts reaching either to the calf or the ankle and ornamented with embroidery. Their shirts are tied up with a colourful belt at the waist. Moreover, the attendant of the Evangelist Matthew is stripped to the waist and wears green trousers and golden armbands. We find the same pages in the portrait of King Sāhla Sellāsē depicted in the psalter made for him. The painter of our miniatures must have observed a similar youth either at the court of the Šawān princes or at the household of the provincial lords, and drawn the attendants of the Evangelists from life. He did not attempt either to model the faces, or to express the depth of the setting. However, the double line at the bottom of the robes of the Evangelists as well as those of their attendants are perhaps a timid attempt to express the volume. The faces are drawn in typical Šawān manner, that is with eyes prominent and noses insignificant, while the mouths are entirely left out.

The bird added to the image of the Evangelist John is supposed to represent his symbol, but the bird bears no likeness to an eagle. The reason for this addition is not obvious considering that other Evangelists lack the similar symbols of their identification. In Ethiopian art, the symbolic beasts along with the Evangelists appeared as late as the 17th century and only in the gospels which were strongly influenced by the Evangelium arabicum (p. 66 f.). However, the bird in our miniature is different from the eagle in the Evangelium. We may conclude that the Šawān scribe showed partiality towards Saint John and composed by himself the symbol attached to the former.

The main colours used in the miniatures are red-brown and grey-green; blue is lacking altogether.

(6) The 18th-century Book of the Gospels, Qobo Māryām, Ankobar district (EMML 4476), contains three miniatures representing the Evangelists Luke, Matthew and John. The two former are depicted as usual, at the beginning of their gospels, whereas Matthew is at the end. It seems that the book was rebound, at which point the folio of Mark was lost.

The Evangelists are seated and in the process of writing (fig. 219a and b); however, they dip the stylus in the ink pot instead of holding it close to the tablet. Only one Evangelist wears a nimbus.

The miniatures are particularly attractive and well represent Šawān painting by the variety of chairs on which the Evangelists sit, the imaginative ornamentation of their robes and particularly the writing implements depicted along them. The miniatures illustrate the tools and working pattern of the Ethiopian scribes. In front of each one there is a pair of scissors for cutting the parchment, a knife for sharpening the stylus and two inkpots, one for red ink and one for the black. The scissors, unknown in early miniatures of the gospels, seem to be the 18th–19th-

century addition to the picture of the Evangelists. In our miniatures, there appears another detail taken from Ethiopian life, namely a leather bag for carrying food or a small awl for tracing the lines on the folios. On the other hand, the meaning of the complex shape drawn close to the heads of the Evangelists is not clear; it does not seem to represent an indigenous implement and possibly mirrors a foreign instrument brought to Šawā from Europe which the painter had observed and depicted together with the Evangelists.

Among the three ornamental bands in the first folio of each gospel, two bands contain the human figures and one contains the crosses, which is characteristic of the illumination of Šawān manuscripts of the 18th and 19th centuries.

The miniatures are painted in a dull red and ochre, neither green nor blue are used.

(7) The 19th-century Book of the Gospels, Maṭāq Amānu'ēl church, Dabra Berhān district (EMML 2182), contains a frontispiece with a particularly concise representation of the themes (fig. 220a). In the upper register the Descent into Limbo is depicted and in the lower register the four Evangelists. In the former, Christ is flanked by Adam and Eve according to the Eastern Christian manner. However, Christ's hands are raised instead of lowered and support the first parents, whereas Adam instead of Christ holds the banner of victory. The four Evangelists are depicted together in one row, not separately as is usual in the frontispieces to each gospel. Neither are they shown in the process of writing.

The drawing is supremely graphic and so compressed that the Evangelists can be identified only by the caption while the Descent is defined more effectively. All heads are as large as the rest of the figures; the eyes are wide open; the enlarged irises are drawn in the middle of the eyeballs giving the faces an hallucinating expression. The inner tips of the eyes touch each other as do the pairs of eyes in scroll painting. The noses are drawn by one straight line curved at its lower end. In these image-signs, there was no need of showing the mouth because the magic attraction of the eyes as "windows" to the inner forces was more important than the effects of realistic drawing.

The miniature is painted in three colours, red, ochre and black; green is not used.

In the last folio of the gospels the human figure is composed by way of two triangles, one triangle standing for the head and another for the body (fig. 220b). In this folio, the stylization of the Šawān school attained the excellence of an art.

(8) The five paintings in the 19th-century Acts of Saint Michael, Gubāryā Giyorgis church in Yaǧǧu, Wallo, are outstanding because of their aesthetic quality and the presentation of the subjects (fig. 221 a, b, c, d, e). These are the Virgin Mary and Child, the archangels Michael, Gabriel and Raphael as well as the Crucifixion. Each painting has its own stylistic peculiarity manifested by varied design and combination of colours; all are characterized by the extensive use of blue.

All faces are, in fact, circles covered with bright red wash. The wide open eyes under the heavy curve of the eyebrows suggest hallucination. The flat nose is insignificant and the mouth is altogether lacking, which is symptomatic of Šawān

painting. The faces recall the anthropomorphous representations of the sun and the moon in early Ethiopian art as exemplified by church murals in Lālibalā, Makina Madḫane ʿĀlam and Gannata Māryām, Lāstā. The figure of Mary (fig. 221 b), except for her face and hands, is conceived as a geometrical design, composed of a pattern of lines with blue and bluish-green surface in between. Starting with the horizontal line at the bottom of the composition, a set of parallel lines harmoniously develop around the elongated rectangle which stands for Mary's knees. The lines shape her square breasts and neck and finally wind up in a sinuous curve at the top. The two red hands of Mary are skillfully blended into the design. They seem to emerge from the mass of the textile and support the Child which also is renderd as a geometrical figure. Indeed, the feeling of closeness of mother and Child is most effectively imparted.

Gabriel (fig. 221 a) and Michael (fig. 221 d), armed with swords, are composed differently and rendered in warm hues of red and dark blue. The figures are built up of three sections. In the upper section there is a set of horizontal lines, slightly curved, which stand for the angel's wings and chest. In the middle section there is a decorative pattern of vertically displayed interlaces of alternate blue bands decorated with imbricated pattern and white bands with a rope pattern. These are meant to represent an ornate dress. The robe of the angel at the bottom is a combination of spirals and loops which give the impression of clouds on which he is supposed to stand. As for St. Raphael (fig. 221 c), he is drawn differently. His body is shaped as a rectangle divided horizontally into four sections, each filled with scales and lozenges, each dotted in the middle. The wings are curved at the top, but square at the bottom, thus fitting well into the main body of the figure. Two details in the picture are carefully copied from life, though the angel's human shape has disintegrated into an ornamental pattern of the textile. One is a tattoo on the angel's neck and the other a cross which he holds in his hand.

In the figure of Mary and the archangels, the painter stressed the decorative aspect of the composition, whereas in the Crucifixion (fig. 221 e), he emphasized the gruesome truth of the Passion. The austerity of the presentation and the effectiveness in applying red and blue colours produce a sense of suffering and death. The dramatic curve of Christ's chest and arm, contrasting with the stiffness of his abdomen and legs, powerfully impart the truth of the passage from St. John: "and bowing his head he gave up the ghost" 19,30. The analogous representations of the Crucifixion are possibly found in 15th and 16th-century gospels illuminated in the scriptorium of Gunda Gundē Monastery.

The eyes of Christ are a focal point of the image; they are composed of trapezoid black irises, dividing the white narrow eyeballs and the eyelids in the process of closing; such eyes express the moments of suspense between the fading life and overpowering death; they are not the hollow eyes of a dead body nor do they belong anymore to the living.

A large crown of thorns symbolizes the suffering of the Crucified; the detail was obviously borrowed from the image of the Crowned Christ, Kwerʿata reʾesu, (p. 405), popular in 17th, 18th and 19th-century Ethiopian art.

The painter did not follow the usual Gondarene scheme for composing the

Crucifixion. He replaced the sorrowful Mary and John by the thieves and intro-
duced in the figure of Christ three changes. His feet are not crossed but separate
and fixed to the cross with two nails instead of one. The arms of Christ are tied up
on the cross with cords instead of being nailed (see also fig. 216a). The circle on the
chest possibly represents the fifth nail which pierced the body of Christ according
to popular belief.[13] All these peculiarities most probably are the result of the
commentaries to the Scriptures made by the traditional Ethiopian scholars.

The cross of Christ has an unusual shape, in that its finials are curved at the end
of each arm. Does this cross represent the stylized horns of the ram which
symbolizes Christ's sacrifice?

On the left, Nicodemus and Joseph of Arimathea carry the "fine linen" and phial
with oils for the burial of Christ. The theme appears sporadically in Ethiopian art
starting with the 15th century, but in the art of Šawā is seldom occurring.

(9) In the same church there is the Life of St. George dated to the 19th century.
The book contains three miniatures in which the scene of the Passion and the
story of St. George are represented with exceptional iconographic richness.

The first miniature (fig. 222a) illustrates two passages from the Passion in the
gospels, namely Matthew 27,28–29, "and . . . they put a scarlet cloak about him.
And, plating the crown of thorns, they put it upon his head, and a reed in his right
hand", as well as from Mark 15,17–19, "And they struck his head with a reed . . .
and they did spit on him. And bowing their knees they adored him."

The interpretation of the passages by the Ethiopian painter is unique, though the
origin of the head of Christ and of the soldiers nailing the thorns into it is easy to
identify. These details evidence the impact of the *Kwerʿata reʾesu* to which the
Ethiopians added the motif of the soldiers nailing the thorns into Christ's head; the
form thus enriched was used by our painter. He built up around it a complex
composition which is inspired by another foreign image of the Passion which was
introduced into Ethiopia two centuries later than the first. An example of an almost
direct copy of this image is found in the Book of Miracles of the Virgin Mary,
British Library, Or. 640 (fig. 223). The painting represents a seated Christ holding a
"sceptre" in his hand while the soldiers press the crown on his head with a stick. The
bamboo stick held by Christ is in a slanting position. Our painter put a stick in
Christ's hands but gave to it the horizontal position similar to that which the
soldiers hold in the original. The mocking crowd is symbolized by the heads,
combined with the sketchy silhouettes of the bodies. This manner of representing
"crowds" is also used in the next miniature of the same manuscript as well as in the
image of the Descent into Limbo in the Acts of St. Michael, Rogē Giyorgis,
described subsequently (No. 10).

The second and third miniature (fig. 222b) show two successive happenings in
the miraculous story of St. George. In the second, he fights with the dragon and in
the third Birutāwit takes it on a leash to her native town. Its inhabitants watch
the miracle and, according to the story, become Christians. The tension of the

[13] *W. Staude,* Les cinq clous du Christ et l'Icône Impériale éthiopienne = Ethnologische
Zeitschrift 1 (1971) 5–25.

narrative is expressed by the eyes in which the irises are placed either in the middle or in the corners of the eyeballs.

Stylistically, the miniatures are very similar to those in the Acts of St. Michael just described (No. 8) and the identical range of colours is used. The suggestion is that either the same painter illustrated both manuscripts or that they originate from the same scriptorium.

(10) The 18th-century Acts of St. Michael, Rogē Giyorgis, Yaĝĝu in Wallo, comprise eight miniatures which manifest the advent of the Šawān style, following, nevertheless, the Gondarene iconography. They represent the Virgin and Child, St. George, the Descent into Limbo and the Crucifixion as well as four miracles of St. Michael. The faces are schematically contoured and the noses delineated with large brown lines instead of the subtle modelling with red wash as in Gondarene painting. The mouth is either small or left out altogether, whereas the conspicuous eyes with the irises variously placed express the feelings of the personages and direct the perception of the beholder towards the focus of the narrative.

The Crucifixion (fig. 224b) is striking by its directness of expression, the streaks of dripping blood and the large heads of the nails emphasizing the narrative of the Passion. The same is seen in the miniature illustrating the miracle of Afomeyā (fig. 224c). Her plea for the Saint's protection is expressed by the wing of the garment which Afomeyā has seized and the intense glimpse of her hallucinating eyes.[14]

In two miniatures the scribe has introduced significant changes. In the picture of the Virgin and Child, (fig. 224d), the cross which in Gondarene painting adorns the mantle on her forehead, is depicted above it. Thus the cross has become a part of the decoration of the nimbus as in early Ethiopian paintings.

In the image of the Descent into Limbo (fig. 224a) we witness the simultaneous process of developing the decorative value of the image as well as of enhancing its narrative by multiplying the figures. Christ's banner of victory is in the form of a large band filled with a pattern of spirals, similar to those scattered all over his cloak. The nimbed heads of Adam and Eve emerge from the greenish-black surface which stands for Limbo. Above, the "crowd" of the Just fills the space behind the Redeemer. The "crowd" is composed of rows of heads the eyes of which are directed towards him. The bodyless heads with small wings attached to them have often been depicted by the Gondarene artists, but the heads without wings seldom occur in their works.

The Ethiopians used to display the multiple figures in varied manner. The Apostles in the early paintings are shown in rows with each individual figure either drawn in full or from the waist up. In the 18th century the "crowd" is symbolized by

[14] Acts of Michael, for reading during the month of June, describe Afomeyā as a pious widow who has a special devotion to the Saint. She kept his picture at her home. She also pledged to her late husband not to marry again. The devil came to her, first disguised as an old woman and then as the Saint himself, urging her to break the pledge. She refused and the devil wanted to strangle her. Afomeyā called St. Michael to help her; he appeared and saved her from the devil. The miniature illustrates that moment.

one row of full figures in front and the crowns of heads behind. The Šawān painter introduced an even subtler idiom in which the head stands for the whole body.

(11) Another example of such a procedure is found in the Acts of St. Raphael, IES Ms. No. 103, which originate from Lāstā and date to the 17th century. The miniature of the Saint (fig. 225) in the manuscript throws some light on the developments in art of that province and offers an analogy with Šawān painting. Raphael faces the front, but his nose, mouth and hair are executed in the Gondarene manner. On the other hand, his eyes recall early Ethiopian painting as well as that of Šawā. The widespread wings are filled with rows of small heads all drawn in three-quarter pose and their eyes seem to gaze in varied directions. Although this composition illustrates the story of the Archangel, the multiple eyes and the emphasis put on them impart an occult quality to the miniature. The impression is strengthened by the "eye" motif used in the ornamental frame of the first folio of the manuscript. All this marks a link between the Šawān as well as Lāstā art and that of the Ethiopian scroll paintings.

(12) The miniature in the 19th-century Life of Ḥeṣan Moʾa, Dabra Bagʿe Monastery (EMML 2353), is the consummate achievement of the Šawān painters (fig. 226). The miniature represents two figures accompanied by two captions, one at the top and one at the bottom; these are Ḥeṣan Moʾa and Finḥas for the left figure and Takla Hāymānot and Mārteyānos for the right figure. The long inscription below has unfortunately been erased.

The Šawān artist dropped entirely the idea of copying from life. The human shapes are transmuted into ornamental patterns, the heads conceived as their central element and the legs are a combination of brown and red rectangles whereas the toes are a sophisticated design of black lines and red dots. Each figure, a real masterpiece of decorative art, is a repetition of similar motifs imaginatively developed on the rectangular surface. This combination of lines bears, in actuality, a hidden message since the painter has instilled an inner life into the composition. He has achieved this by the way in which he drew the faces. In Gondarene painting the faces are essentially similar to each other and usually lack expressiveness whereas in our miniature each face is drawn in a completely different manner. In one face the elongated eyes are framed by the white between the upper eyelids and the line of the eyebrows as in scroll paintings;[15] in another face the eyes are characterized by enormous irises whereas the eyebrows are not shown. In the first face our perception is concentrated on the whole eye, while in the second only on one part of it. Such significance given to the eyes is in Ethiopian painting the concern of the occult sciences.

The noses are drawn in two manners; the flattened nose in the left face is traced with two lines curved outwards so as to leave the tip of the nose open; the long nose in the right face is traced with a white line closed at its lower end. These varied ways of rendering the eyes and noses, as well as the white band on the neck and around

[15] MercRoul fig. 35.

the heads, delineate the areas of the magic attraction of the composition. This presumed image of the popular saints follows the esoteric scheme taken from scroll painting. The miniatures as an expression of Christian iconography are hardly effective because the figure of Takla Hāymānot lacks the essentials of his identification, but still the crosses above the heads proclaim the Christian character of the image.

The ornamental band in one of the folios of the manuscript is composed of lozenges and human faces, similar to those in the miniatures.

(13) Two coloured drawings in the 19th-century Horologium for the Night, *saʿātāt*, Ğebden Māryām church, Ankobar district (EMML 2247), represent the Crucifixion and the Virgin and Child flanked by angels (fig. 227).

The inscription above the Crucifixion runs "Jesus Nazarene, King of the Jews". Gondarene paintings of the Crucifixion which are influenced by Western art bear the labels with Pilate's inscription; therefore the idea of making the inscription came probably from Gondar but the foreign label was replaced by the Ethiopic text. The body of Christ and the stem of the cross became one figure whereas his square waist is a replica of the cube which appears at the bottom of Ethiopian crosses. The widely outstretched arms of Christ are depicted below the transverse arms of the cross and his head above it. Mary on the right and John on the left raise their arms in the orant pose and the additional hand is protruding from the Saviour's waist. The scene and personages are expressed by way of complex geometrical forms and recall scroll painting.

The composition of the Virgin and Child bears no relation to the S. Maria Maggiore type, instead it is analogous to the 15th-century portraits of Mary under a canopy of wings. However, Christ stands close to his mother instead of being carried by her, which is unique in Ethiopian art. Mary's and the Child's arms are drawn symmetrically on their chest; they seem hardly to illustrate a part of the body but fit well into the ornamental pattern of their garments. The faces are covered with red wash; neither noses nor mouths are shown. The eyes are the focal points of the faces and of the whole drawings as well.

The scribe has enhanced the decorative value of his work by filling the garments with zigzag lines and lozenges as well as with a net pattern. Also, he tends to interpret the eyes as the instruments of hallucination and perhaps of magic. Although the drawings are composed of Christian symbols, the African background of the scribe comes to the fore and pervades his work.

(14) Another 19th-century Horologium, Muṭar Amānuʾēl church in Dabra Berhān district (EMML 2217), contains two folios with multiple subjects (fig. 228). The first folio represents the Virgin and Child flanked by the angels Michael and Gabriel and, below, Mary Magdalene with two unidentified figures.

The Virgin seems to embrace firmly, perhaps to nurse, the holy Child lying in her arms; her representation then is not that of the S. Maria Maggiore type; it probably stems from 15th and 16th-century prototypes. The angels have their small folded wings and carry a sword in one hand and a sheath in another. Their garments reach the knees leaving their pinkish legs uncovered, a trait which is similar in most of the figures in the drawings. The inclusion of Mary Magdalene into the composition is

significant because she usually appears only in those Ethiopian images of the Crucifixion that are influenced by Western art.

The second folio represents Gabra Manfas Qeddus who is easily recognized by his dress made of his own hair and who is flanked by a leopard. Takla Hāymānot who lacks one foot and his praying staff is drawn close to him. Kiros, a third popular saint of Šawā, holds a cross. The three figures below are identified as saints, *ṣadqān*. Only one of them seems to wear a nimbus. Both drawings are painted in different shades of red, brown, yellow and greenish-blue; no green is used.

This unskilled piece of work is distinguished by the extensive use of geometrical forms and varied patterns of linear ornamentation. The drawings border on the art of Šawān lore, particularly on account of the cross decorations over the head of Mary and the saints, the red wash covering the faces and the upper eyelids painted white, as well as the rectangular shape of the irises all of this characteristic of scroll painting.[16]

Similar to other Ethiopian manuscripts, those in Šawā have the top of the first folio of the text ornamented with bands of interlaced design. These compositions are called the *hārag*. The word *hārag* literally means a slender plant, a vine which climbs and trails. The linear ornaments in manuscripts, especially those of the 14th and 15th century, give the impression of twigs which twist and trail and are called *hārag* by mental association with the climbing plants. In Šawān manuscripts such ornaments lost their original characteristics but were enriched by additional figures, particularly human figures or faces, eyes, crosses and even animals. The ornaments are not only intended to decorate but also to illustrate the text; some seem to have a magic quality.

(15) Such ornamentation is found in the 19th-century Life of Gabra Manfas Qeddus, Yagem Abo church in Dabra Berhān district (EMML 2682) which was written for a certain Walda Mikāʾēl by a scribe named Salomon. Its expanded *hārag* includes human and animal figures as well as crosses (fig. 229). The way of drawing with red, yellow and ochre is very similar to that of scroll painting, though this *hārag* is more elaborate; it also includes the forms and symbols which are characteristic of that kind of painting.

The figure in the middle is easy to identify as that of Gabra Manfas himself because he is usually depicted with leopards and lions. Probably the Saint is exorcising a woman placed on his right. He is praying as evidenced by his uplifted hands; the beads depicted close to his left arm indicate that he is a monk and the *maqwāmiyā*, a praying staff at his side, reflects his old age. An analogous representation of exorcising is found in scroll painting.[17]

The fascinating face of the Saint is covered with a deep red wash on his forehead, bright yellow on his cheeks and chin; the space between the eyes and the eyebrows is painted white. This disposition of colours focuses the beholder's perception on

[16] MercRoul fig. 26 27 35.
[17] MercRoul fig. 23.

the eyes and their triangular black irises. Similarly, each beast accompanying the Saint has one eye, triangular and penetrating. The emphasis put on the eyes is also evident in one of the large crosses drawn on the right side of Gabra Manfas: the cube at the lower end of its stem is decorated with an "eye" pattern. This combination of the square and eyes is an indication of magic intent.[18]

Usually the *hārag* is much simpler in Šawān manuscripts than in the present manuscript and is in the form of a band filled with lozenges, interlaces and other geometrical figures. Moreover, the human heads, eyes and crosses are drawn along the ornamental pattern. For example in the Psalter of King Šāhla Sellāsē there is a *hārag* in which the eyes are component of the interlaces (fig. 230).

(16) An entirely different ornamental scheme is found in the *Weddāsē amlāk*, Praises of God, Kerārgē Gabra Manfas Qeddus church, Sankorā district (EMML 6415). The estimated date of the manuscript is either the late 17th or the early 18th century, though the local tradition has it that the book was found in a cave in which it was supposedly hidden during the 16th-century Moslem invasion.

The margins of most of the folios are filled with drawings in brown colour, all representing birds of various kind and poses (fig. 231 a and b). The drawing is lively and well-proportioned, though the birds do not correspond to the ones known in Šawā. Why the scribe chose birds for embellishing his work is not obvious, but the contention is that he borrowed the idea from the ornamentation in 13th to 16th-century gospels. In these, the canons of Eusebius include a great many birds. True to the Šawān laconic expression, our scribe left out the architectural setting always appearing in the canons and the branches on which the birds are perched, but kept these and arranged them according to his own taste.

DISCUSSION

The following discussion refers mainly to Šawān manuscript painting and partly to painting on wood. The production of the latter was relatively small and with a few exceptions bore the characteristics of the school of Gondar. The churches in Eastern Šawā and Southern Wallo are rarely decorated with murals and those existing have been mostly painted by artists who came from Gondar and date to the late 19th and early 20th century.[19]

[18] MercRoul 142–46.

[19] Usually in Ethiopia such important works as church decorations are entrusted to well-known painters; it is probable, therefore, that church decorators in Šawā although native to it were trained in traditional centres of church art in Goǧǧām and Bagēmder. For example Wassan Sagad, prince of Šawā (p. 469) made his mortuary chape. "The crude fresco paintings in the chapel", writes French traveller Rochet d'Héricourt, "illustrate the battles, hunting parties and royal banquets in which the figure of the King is always prominent." The painter was a Greek whom Wassan Sagad brought from Gondar. *Ch. Rochet d'Héricourt, Second voyage sur les deux rives de la mer Rouge, dans le pays Adels*

Evidently not all clerks in Šawā painted in the same style. At the royal court, the artists were either trained in or originated from Gondar,[20] whereas the countryside scribes used the local expression. They illustrated the gospels, lives of the saints, psalters and other devotional works which had been commissioned by the clergymen and the local notables.

In the 17th to 19th centuries, the art of painting developed differently in Šawā than in Gondar and the north of the country. Whereas the latter painters dropped entirely the iconographic tradition of the early gospels illustrations and largely depended on Western models, the Šawān scribes gradually created their own idiom which was the result of three factors, namely the isolation of Šawā, the continuing influence of the early stylistic tradition and the impact of Ethiopian folklore.

IMPACT OF THE GONDARENE PAINTING AND EFFECTS OF THE PROGRESSIVE ISOLATION

The Šawān works follow the main themes of the Ethiopian Christian iconography, particularly that of the Gondarene school. The image of the Virgin and Child mostly derives from the S. Maria Maggiore painting. The Crucifixion, St. George and Birutāwit as well as two popular saints Gabra Manfas Qeddus and Takla Hāymānot are represented according to the forms adopted by the 17th and 18th-century Gondarene artists. St. Kiros and Zēnā Mārqos are portrayed according to the art of the north of Ethiopia, whereas the crosses are mostly of the Gondarene type. Yet, Šawān scribes, due to their isolation had been little exposed to the changing trends of the Gondarene court. Indeed, they thoroughly transmuted even those iconographic formulae from Gondar which percolated through the Oromo barrier.

The comparison of the miniatures ornamenting two manuscripts of the life of Ḥeṣān Moʾa (No. 1 and 12) demonstrate dramatically the transformation carried by Šawān painters and, in general, the difference between the Gondarene and

et le Royaume de Choa (Paris 1846) 244–45. The murals of the Madḥanē ʿĀlam church, Ankobar, recall these in the church dedicated to the same in Adwā, Tegrē. In general, one has the impression that the 18th and early 19th-century churches in Eastern Šawā were rather modest structures and far from being lavishly decorated as in Northern Ethiopia. The writer has seen in some of the country churches graffiti drawings representing saints and also subjects unrelated to religion. These crude drawings on shutters to inner windows of doors and even on walls do not seem to be representative of Šawān church murals.

[20] This is evidenced by the manuscripts produced for King Šāhla Sellāsē. His Books of Prayers (psalters) are preserved in St. Stephen church, Ḥāyq, and in the church of Takla Hāymānot, Maṭāq. The manuscripts are richly illustrated; the first contains among other miniatures two portraits of the royal owner, while the second, a large number of miniatures depicting his life. The miniatures in both manuscripts are probably of the same hand and of good artistic quality.

Šawān schools of painting. The miniatures in the first manuscript (No. 1) follow the Gondarene manner of painting though they bear some Šawān traits. The miniatures in the second manuscripts represent a complete break from the Gondarene school and the full attainment of the local expression.

The Gondarene painting in its phase lasting from the middle of the 18th century until the beginning of the 20th century has been scornfully marked by the scholars in the field as decadent and has been generally ignored.[21] The main characteristic of the works then produced is their inner dichotomy. The Gondarene painters borrowed heavily from Western models, yet they did not achieve anything close to realistic painting. Their works are still composed of image-signs displayed on the invariably flat surface; perspective and depth have rarely been attempted and the volume of the figures is poorly expressed. The faces symbolize typological masks instead of being individualized. On the other hand, such particulars as garments, ornaments and jewellery as well as weapons are depicted realistically and drawn from life. This clash between the non-realistic general composition and the realistic execution of some of the details is particularly noticeable in the 19th and 20th-century Gondarene works. Owing to the introduction of the pictorial records of everyday life into the subject matter of religious painting, royal or princely processions, hunting parties, wars, banquets or funerals had to be depicted in a way which would allow the beholder to recognize the theme easily. Moreover, the contacts with Europe in the 19th century resulted in further innovations and brought the art of Gondar close to the realistic devotional pictures then prevalent in Europe.

The Šawān school evolved in the opposite direction. The starting point was similar because Šawān and Gondarene art meant to convey an idea or narrative through image-signs. These acquire their visual power mainly by way of representing the human figure which defines the contents of the work. However, the Šawāns dropped the idea of copying from life. Subsequently they elaborated their image-signs in two ways.

First, they increased their expressiveness by distorting the human shape, as it is well-known in folk-art. Whereas the painters of Gondar endeavoured to represent the human and other figures as accurately as their limited skill permitted, the Šawān painters composed theirs in relation to beliefs and narration, even indulging in the grotesque. In early Ethiopian art from the 13th to the 15th century, distortions were extensively used, for example in the elongated fingers of the Apostles in the Ascension of Christ; the difference between the early attempts and those of the Šawāns lies in the degree of distortion and perhaps in the background. The rigid line in the former mirrors the hieratic Eastern Christian model, whereas the

[21] This art deserves closer study not only on account of its wide provincial ramifications but also its cultural significance. The eagerness of some scholars to discover the "old miniatures" by which they mean those prior to the 15th century, made them indifferent to more recent works which they considered probably with some reason, as of inferior artistic quality. Nevertheless, our knowledge of Gondarene art, based mostly on examples in European libraries, is still inadequate, and the first unfavourable impression may change.

rhythmic and at times sinuous drawing of the latter mirrors a freeing from strict bondage.

Second, the Šawāns developed to the extreme the decorative value of their paintings. This direction is manifested in the schematic and linear treatment of the human figure which is conceived as an element of ornamentation. The Šawān effort was centred on the subordination of plastic appearance to overriding tendency of compositional vitality and rhythmic integration.

In addition to the above characteristics, the Šawān paintings are recognized by the following indicative points:

(a) In the image of the Virgin and Child of the S. Maria Maggiore type, the gesture of the Child's "blessing" hand and the arrangement of his fingers differ from those in the prototype;

(b) The figures in Šawān paintings often lack the nimbus, whereas in the Gondarene the nimbi are extensively used;

(c) The human face and eyes appear on the ornamental bands of the frontispieces;

(d) The range of colours in the majority of paintings is limited to red, mostly Indian red,[22] pale yellow, brown and ochre[23] as well as dark blue.[24] The yellow-green and clear Cerulean blue for which the First Gondarene palette is notable and the emerald-green for which the Second one is notable, are lacking altogether.

CONTINUING INFLUENCE OF THE EARLY ICONOGRAPHIC TRADITIONS

In addition to the impact of Gondar, the older iconographic traditions also played an important rôle. For example, the Evangelists depicted in the frontispieces to the gospels recall the early 13th to 15th-century miniatures. As to the human figures, in Šawān painting these frequently face the front, whereas in Gondarene painting, the three-quarter pose is by far the most usual. Another pre-Gondarene trait is an arrangement of three figures with one shown frontally in the middle and two side figures in three-quarter pose. Whether this early heritage was transmitted by oral tradition, or material examples, or both is hard to judge. The recent searches in Šawān churches brought to light the manuscripts, some superbly illustrated, which date from the 14th–15th centuries. These manuscripts were obviously saved from destruction during the Moslem invasion of the early 16th century, and then preserved during the long subsequent period of the Oromo domination. Thus, the Šawān scribes could have at their disposal these early models and possibly have taken advantage of them.

[22] Cinnabar: red mercuric sulphide (English vermillion).

[23] Orpiment: sulphide of arsenic (King's yellow).

[24] Indigo: herbal extract from *Indigo tinctoria*. Blue pigment was always imported, most probably from India.

The most celebrated place where these manuscripts survived is the church of Ṣeyon Māryām on Tulu Gudo Island, Lake Zewāy.[25] The collection reputed for its richness in the past has since dwindled to one richly illustrated manuscript of the Lives of Saints dated to the end of the 14th century and to Gospels with the pictures of the Evangelists dated about the same time. Moreover, two of the loose folios of the Book of the Gospels with miniatures found their way to the collections of the Institute of Ethiopian Studies, Addis Ababā.[26] Another volume of the Lives of Saints, similar to that of Tulu Gudo is at present the property of the Astit Kidāna Meḥrat church (see p. 181). Both manuscripts were produced in the north of Ethiopia and brought to Šawā many centuries ago, probably before the 16th century.

(17–18) The miniatures in the Lives of Saints belong to the style which is charac-
terized by the use of geometrical forms (figs. 232a and b). Indeed, the human figures are conceived as elongated rectangles and as curves at the top of these, the former standing for the body and the latter for the shoulders. The figures are filled with a great many parallel lines drawn either vertically or diagonally on a flat surface painted in pure strong hues. The sense of vibration of the repetitive lines brings forth the inner rhythm of the design. The same feeling of rhythm is found in the miniatures, Book of the Gospels, Qobo Māryām church (fig. 219).

The composition of the figures in the Astit manuscript is remarkably condensed. Two or three saints are rendered by one body to which the heads and feet are attached. Each saint has only one hand in which he holds the staff serving as the dividing line between two human shapes. A similar imaginative reduction of the human form is also found in Šawān paintings.

In the Astit and Zewāy manuscripts, the eyes are the focal points of the composition; the irises are either attached to the upper line of the eyeballs or are all surrounded by the white, similar to the eyes in scroll paintings.

(19) The miniature on loose folios at the Institute of Ethiopian Studies (No. 2475)
(fig. 233) is analogous to those in the well-known Book of the Gospels Ethiopien 32 at the Bibliothèque nationale, Paris, and to the less known but equally interesting Book of the Gospels, Dabra Ṣeyon Māryām, Garʿāltā in Tegrē. The latter does not contain a colophon but should be ascribed to the 14th century on iconographic as well as paleographic grounds.[27]

(20) The ornamentation of the canons of Eusebius in the Dabra Ṣeyon manuscript

[25] Recently described by *P. B. Henze*, Ethiopian jouneys; travels in Ethiopia 1969–72 (London 1977) 109–12. He quotes the witness of the traveller W. C. Harris form the 1840s about the wealth of manuscripts in the church. Apparently some manuscripts were taken by King Menilek during his conquest of the area around Lake Zewāy in 1886 to Addis Ababā, and apparently not returned.

[26] Subsequently it was found that other folios with illustrations which belonged to the same Book of the Gospels were taken out of the country.

[27] The manuscript was discovered and photographed by the writer and Dr. Kinefe-Rigb Zelleke in 1974. Unpublished.

is reduced to a simple linear design though it follows the classical form of the arch supported by two columns. A similar simple design which still derives from the intricate framing of the canons in early gospels is also found in a number of 18th and 19th-century Šawān gospels.

In the miniatures representing the Evangelists, the rigidity of their hieratic figures contrasts with the background filled with a pattern the intricacy of which recalls Oriental rugs. The figures of the Evangelists are an assemblage of geometrical forms; for example the head and beard of Matthew and Mark (fig. 234a and b) are two circles, their arms an oval and a circle, whereas their body is an elongated rectangle comprising squares and triangles in varied colours. Mark and John are placed in a blue mandorla or niche which is ingeniously drawn as a combination of three concentric circles at the top and a rectangle at the bottom. The garments of the Evangelists are, in fact, triangles and trapezoids put together with sets of horizontal or slanting lines.

The Šawān miniatures in the Acts of St. Michael (fig. 221), the Life of St. George (fig. 222), both from Gubāryā Giyorgis church, and the Life of Ḥeṣān Mo'a (fig. 226), offer a striking analogy to the design of the Dabra Ṣeyon miniatures. This, however, does not necessarily mean a direct influence of the latter but rather suggests similar aesthetic attitudes which the Šawān scribes shared with other Ethiopians. The truth is that the artistic expression which was successfully practised by illustrators of the early manuscripts continued in varied forms and by different schools throughout the successive centuries. This was in addition to the new trends in court art prone to follow the foreign influences. Jacques Mercier brought recently to light these early traditions in the 18th, 19th and 20th-century production of the protective scrolls.[28] We are able to identify two schools of religious painting in the 17th century which practised the traditional stylistic expression in the north of Ethiopia.

One of the schools is conveniently called that of the "parallel lines" for its distinctive pattern of ornamentation. The characteristics of the school have been briefly described in another part of the book (pp. 230f., fig. 91–94). The works are painted on wood (no manuscript illustrations in the "parallel style" are known to the writer) and represent a blend of the iconography influenced by Western art and the stylistic canons of the 13th to 15th-century manuscript illustrations. It seems that the school developed and was mainly active in Tegrē.

Another school, also existing in the 17th century, seems to have originated in Lāstā province but was also active in Tegrē. The works of this school are notable for their particular geometrical expression as well as the constant use of red, black and ochre. These characteristics have drawn the attention of those interested in Ethiopian painting. Beatrice Playne in her book of travels published in 1954 refers to two booklets of the miniatures (or folded parchment strips) executed in such a style, one booklet in St. Gabriel's (Bēta Gabre'ēl) church, Lālibalā, and

[28] *J. Mercier*, Étude stylistique des peintures de rouleaux protecteurs éthiopiens = Objets et mondes 14 2 (1974) 90–93.

another in the Ašatan Māryām church, a few kilometres outside that town[29] (fig. 235 a, b, c). The former seems to have been lost since then, the latter was still in the possession of Ašatan Māryām church when the writer visited it in 1976. One booklet was in the Museum of the Institute of Ethiopian Studies, Addis Ababā,[30] one booklet is owned by a private collector in Great Britain who acquired it during his visit to Lālibalā in 1973,[31] and still another in possession of a private collector in Germany (fig. 236). Moreover, the British Library treasures a fine manuscript of the gospels, Or. 516, which is illustrated with five miniatures. The colophon in the manuscript indicates that it was written by Maḥsenta Mikā'ēl; there is no locality given, but according to Bent Juel-Jensen who wrote an essay on the "Ground Hornbill" artist, the manuscript certainly belongs to Lāstā. Juel-Jensen identifies two more works, namely a manuscript at Dibo Māryām church, and the mural paintings at Yoḥannes Meṭmāq Gazēn, both in Aṣbi district in Tegrē.[32] Most probably there exist other works of the same school in addition to those listed above.

Playne and others commented briefly on the above paintings, but Juel-Jensen was the first to link their style with that of 14th and 15th-century manuscripts. He believes that the miniatures were painted by someone whom he conveniently calls the "Ground Hornbill" artist because of the bird which often appears in the paintings and is reminiscent of that species common in Ethiopia. The writer would prefer to credit more than one painter with the known works and to define these as belonging to the Lāstā school.

(21) An outstanding example of the school is the already mentioned booklet in the Ašatan Māryām church, a booklet which is unusually large and executed in exquisite graphic style recalling the Šawān paintings. The miniatures date to the 17th century as evidenced by their particulars deriving from the Gondarene iconography.[33]

The fascinating bird (fig. 235 a) depicted in the frontispiece is expressed by several geometrical figures; its tail is an inverted trapezoid, its body an oval whereas its legs and neck are elongated rectangles. Whether the bird is meant to represent an ostrich the eggs of which decorate the roofs of Ethiopian churches, or the Ground Hornbill as Juel-Jensen has it is a matter of conjecture.

The other paintings can be grouped into two units of three.

The first unit (fig. 235 b) represents the Crucifixion in the middle, St. George and Birutāwit on the left, and the Virgin and Child on the right; the archangels hold crosses in their hands which recalls the early imagery of the Virgin Mary. The

[29] Play 142 pl. D.
[30] The booklet has been missing since 1968.
[31] JuelJGr 63.
[32] JuelJGr 74.
[33] This is the well-founded opinion of *Juel-Jensen*. *B. Playne* who notoriously lacks precision in dating Ethiopian paintings postulates that the miniatures in Bēta Gabreʿēl as well as Ašatan Māryām booklets do "not appear to be old" or at least are not "more than about two hundred years old". Play 49, 142.

design of the Crucifixion is perfectly symmetrical, with the cross dividing the miniature into two squares and two rectangles; the sun and the moon are depicted in the former and the Virgin and St. John in the latter. A similar setup is known to be in the 16th-century icon,[34] but virtually unique in 17th-century art. The large ornamented circles of the celestial bodies balance the heaviness of the cross. The figures of the Virgin and John belong to pre-Gondarene iconography, whereas those of St. George and Birutāwit originate from the art of Gondar. The Saint is drawn in three-quarter pose while all other personages in the miniatures are facing the front. In the booklet of the German collector, the Virgin and Child are similar to those in our booklet, whereas St. George is standing and holding the raised sword and the sheath (fig. 236). This is the earliest form of the Saint's imagery similar to that in Golgotha church (bas-relief) and Gabre'ēl church (painting on manbar) in Lālibalā, c. 13th century.

In the second unit (fig. 235c) there are Gabra Manfas Qeddus, flanked by archangels Michael and Fanuel, as well as two groups of five saints, Merkurios, Theodoros, Claudius, Basilides and Aboli,[35] on the left, and four saints Yemrehānna Krestos, Lālibalā, Na'ākweto La-'āb and Ḥārbāy who are also the kings of the Zāgwē dynasty,[36] on the right. Gabra Manfas is represented in the 17th-century manner, that is, his body is covered with white hair and a scapular is wound around his chest. His hands are uplifted in the orant pose.

The hallucinating power of the miniature lies in the way of drawing the eyes. They are large and have their upper lid curved and the lower straight; the black irises fill most of the eyeballs and either leave shining triangles on both sides or an elongated triangle on one side. This movement of an otherwise static composition entrances the beholder.

The painter used three colours only, red, pale ochre and black on a white background, yet he succeeded in creating an impression of richness. Inner harmony

[34] The diptych is privately owned in the Netherlands; datable to early or middle of the 16th century.

[35] Merkurios, Theodorus, Claudius and Basilides, called the great martyrs, are usually represented as warriors mounted on horses and spearing a dragon or other kind of monster.

Aboli, called also Abib or Abbā Bulā, is an anachoret commemorated in the Ethiopian Synaxary on 25. Ṭeqemt. Native of "Rom" he was a miraculous child who had been tortured during the persecution of Maximianus. Aboli spent forty-two years in the desert sitting on a tree. His particular method of mortification was that whenever he remembered the Passion of Christ, he always cast himself down from the tree: BSyn 189–91. In Ethiopian paintings Aboli is usually represented in the tree and in the process of jumping. In Egyptian Synaxary on the same day (25 Babah) two saints are commemorated Abîb and his companion Apollon (in Arabic Abulû or Abulâ).

[36] Yemrehānna Krestos, 12th century, appears as the 5th ruler of the Zagwē dynasty, Lālibalā, late 12th–13th cent.; Na'ākweto La-'āb, 13th century, successor of Lālibalā; Ḥārbāy, late 12th century. *Belaynesh Michael* [and others] (ed.), The Dictionary of Ethiopian Biography I: From Early Times to the End of the Zagwē Dynasty c. 1270 AD (Addis Ababā 1975).

and softness pervade the design based on a multiple repetition of the same element of ornamentation.

To sum up, the common traits of the Šawān paintings and those of the Lāstā school, both following the stylistic traditions of the early manuscript illustrations are as follows:

(a) Geometrical forms and the linear repetitive ornamentation are extensively used;

(b) A number of figures in the paintings face the front which is an exception to the general habit in Ethiopian painting after the 16th century of drawing the figures in three-quarter view;

(c) The emphasis is put on eyes, the mouth is small and usually does not stand out;

(d) A few basic colours are applied as a flat wash. The intensity or even the richness of colouring is achieved by lines skillfully applied close to each other on a flat background;

(e) The iconographic themes usually derive from the art of Gondar, though the ones dating from older periods and local themes are also used.

IMPACT OF ETHIOPIAN FOLKLORE AND AFRICAN BACKGROUND

Šawān art, left to itself, evolved largely as a folk art and thus is related to another expression of Ethiopia's lore, the painting on scrolls. Indeed, the production of so-called magic paintings on scrolls, *talsam,* was an important component of life in traditional Ethiopia. These paintings served mainly as decoration to the magic texts which abound in the country and they have a place of their own in the history of Ethiopian art.

A study of the stylistic forms and their significance in the paintings on scrolls has started recently; Jacques Mercier investigated them during the 1970s and his findings are relevant to the understanding of the art of Šawā (see p. 528).

The art of decorating the so-called magic texts is named magic art by analogy, and the scrolls with magic texts are called magic scrolls. In fact, a distinction should be drawn between two kinds of scrolls. One kind is produced for religious purposes and usually contains the prayer called *lefāfa ṣedeq,* "bandlet of righteousness", or any other prayer; such scrolls are rare and should be called "protective". The other kind which represents the majority of the scrolls is made according to the manual of arithmomancy and is called the *ʿawda nagaśt,* "cycle of kings". Such scrolls belong to the field of divination, *tenqwalā,* and therefore are called magic scrolls.

Ethiopian painting on scrolls has nothing in common with black magic and little with white, though at times it includes the representation of demons. Ethiopian scrolls differ from the paraphernalia of the European magician, because the "Christians in Ethiopia", according to Mercier, "use painted parchment strips to protect and cure themselves".[37] The function of the scrolls far from inducing

[37] *J. Mercier,* Étude stylistique des peintures de rouleaux protecteurs éthiopiens = Objets et mondes 14 (1974) 89.

aggressiveness is purely passive and beneficial. The scrolls are believed to cure sickness and to shelter agianst the attack by demons, *gānēn,* or spirits of possession, *zār,* as well as against sympathetic magic, *serāy* or *matā.* The use of scrolls is tolerated by the Ethiopian Church provided that the preparation of these does not necessitate the evocation of evil spirits and that the aim is purely protective. The act of unrolling or contemplating the scroll is believed to bring about a miraculous effect similar to revealing a holy image.

The Šawān icon and manuscript paintings show remarkable stylistic similarity with scroll paintings. Indeed, several forms found in the former became clear to us by comparing them with the latter.

There are, according to Mercier, two stylistical tendencies in the paintings on scrolls. The first tendency is figurative and related to the religious art of the Second Gondarene school; the second tendency, which Mercier calls traditional, consist in reducing the shapes into geometrical lines, curves, circles, rectangles and squares, as well as in a flat disposition of design and an extensive use of straight or inclined lines. Moreover, the composition usually develops vertically on both sides of an axis running along the line of the nose, mouth and the middle of the body; this gives the impression of harmonious symmetry which operates as a rhythm commanding the form in continuity from one figure to another; each figure is nothing else but a spontaneous expression of the rhythm which is essential in the process of stylization. Such inner rhythm also pervaded early Ethiopian painting. Also, in the art of Šawā, this manifestation of the inner rhythm is fully achieved. The scroll painting originated from this geometrical art of Ethiopia. However, the scroll painters modified it in order to increase its magical efficiency. Whenever the painting in such style is found in a Christian manuscript or in a painting on wood, this means that their maker was familiar with the art of producing scrolls.

Unless the beholder experiences the feeling of hallucination, the scroll painting is not effective as an object of magic. In order to produce it, one has to apply in the pictorial plan the inversion of the usual visual order of perception from the general to the particular and from dark to light; thus in the hallucinating process, the perception of the human figure would first be the eyes, then the face and last the body. This is achieved by distorting the proportions and the inversion of colouring. Consequently the largest part of the figure is the head, and the largest part of the head are the eyes. Other details like the nose or mouth which are of no consequence for the process of hallucination are either eliminated or significantly reduced in size.

Thus, the body retreats from the visual field, whereas the face and eyes advance and seize the beholder; the eyes in the magical plan stand for the face, and the face stands for the whole body. The face and particularly the eyes captivate the "presence" or "direction" of the magical forces while the hands or the body define a "gesture" or "movement" of the pictorial narration and are less important for the direct magical involvement.

The expressiveness of the faces and figures is achieved by the use of two primordial elements of art, namely flat linear composition corresponding to an old Ethiopian tradition and the application of the magical rules. These refer also to the

distribution of colours or their juxtaposition. Black irises, an element of threat, are abnormally large and are shaped as rectangles, or triangles, or circles and contrast with the white of the eyeballs and eyelids to create the focal point of the mental pressure.

The eyes are the essence of magical drawing and, indeed, they are found everywhere, in the single face or in repetitions of it or as a "magical colony", that is where the eye is extracted from the face and inserted in an geometrical repetitive pattern. The emphasis on the eye in Ethiopian scroll painting is a sign of the hallucinating intent, but it is not correct to attribute to the eye the same "evil" significance as in the Mediterranean world. The eyes in scrolls as well as in Šawān paintings belong to beneficial actions and figures, including those of the angels.

Crosses and varied cross-patterns as an element of ornamentation occur frequently in scroll paintings. However, in some of these, the cross seems to have a rôle of its own. It is drawn either on the sides or in between human figures and is equal in size to these. The cross, according to the accompanying inscriptions, protects against the demons and against sympathetic magic. It overpowers the demons and thus saves the person that is affected, who sometimes draws an outline of the cross with the stylus while touching wood. Whenever the cross is shown along the figures of the saints and is of the same size as these, this probably signifies that both the cross and the saints are equally protective. Such crosses appear in Šawān paintings, for example in the Life of Gabra Manfas Qeddus (fig. 229). Moreover, the crosses ornamented with an eye-design are depicted on the cover of the icon No. 6665 (fig. 218b).

To sum up, the style and fabric of the Šawān paintings are very similar to those of the paintings on scrolls. The inner rhythm of the design which is manifest in drawings illustrating such books as the Life of Ḥesān Moʾa (fig. 226), the Horologium (fig. 227), the Gospels of Qobo Māryām (fig. 219) and the Acts of St. Michael (fig. 221), the inversion of perception applied in the drawings of the Gospels from Maṭāq Amānuʾēl church (fig. 220) as well as an obvious search for the hallucinating effect in the image of Gabra Manfas Qeddus in his life story (fig. 229), all these mirror the same cultural milieu in which the ornamentation of the scrolls and the religious books flourished side by side. With both of these the Šawān scribe was familiar.

* * *

Though the Šawān works lack the polish and refinement of the Gondarene production, they have the vigour and authenticity of folk art. In Šawā, it would seem, that native craftsmen rarely copied directly from imported models but tried in their own way to recreate those which they received through intermediary channels. The resulting works are fascinating though apparently cruder than the distant models. While the cultural court art like the Gondarene responded easily to historical events, to modes and outside contacts, folk art as the one of Šawā was deeply rooted in the life of the remote countryside and changed very slowly. The fabric of Šawān art feeds on the old background of the native forms of expression

rather than on intellectual concepts grafted on African soil. It is well known that the popular touch in art always works in the direction of greater abstractions. The Šawān painting which was a product of the humble social classes would hardly be an exception. Also in this painting the impact of the African roots of the Ethiopians is perceptible.

Frans M. Olbrecht, who published the classical work on African sculpture, enumerated the general characteristics of African art as exemplified in representations of the human form. These are: (1) an absence of realistic bodily proportions; (2) an exaggeration of the size of the head; (3) frontality and vertical symmetry; (4) static poses; and (5) a scarce use of colour, and that only in areas of strong European contact.[38]

Although this concise technical definition does not outline all features of African art, it fits into this writer's line of argumentation. Except item 5, the characteristics as listed by Olbrecht apply to Šawān art as well as to scroll paintings. In both of these, the emphasis on faces and eyes, the abundance of geometrical motifs and the spontaneous rhythm of lines rather than the well-organized reflection of the visual world seem to recall the phantasmagoria of African art. In no case can this resemblance be explained by anything like an actual influence, but rather by the action of a kindred aesthetic inspiration expressed in similar but independently evolved techniques.

There is, however, a difference and a fundamental one, between West African and Ethiopian art. The former traditionally expressed itself in sculpture. Ethiopians, on the other hand, shared with Christian Nubia as well as Coptic Egypt the Judaic prohibition of carving three-dimensional figures, which was also proclaimed by the Christian Churches of the Orient. The idiom which the Ethiopians preferred were colour and line on a flat surface through the medium of wall painting, illustration of books and icons. Initially the miniature and panel painting was not indigenous to Ethiopia; it was grafted on her soil throughout her centuries-long contacts with the outside world and was thoroughly transmuted according to the spirit of the land. The effects of this process which give a unique mark to Ethiopia's art in general, are particularly manifest in the art of the kingdom of Šawā.

[38] *D. J. Crowley*, Stylistic analysis of African art: a reassessment of Olbrecht's "Belgian method" = African Arts IX 2 (1977) 43.

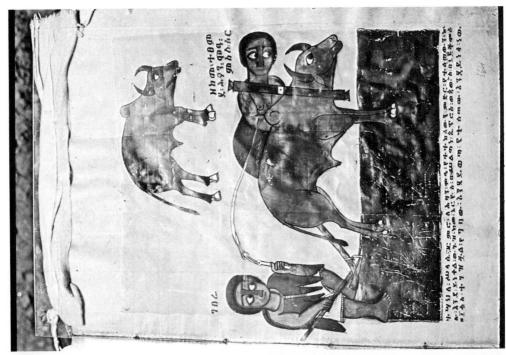

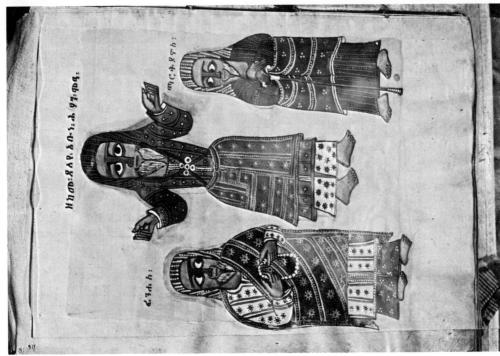

215a, 215b, 215c, 215d. Life of Ḥeṣān Moʾa, 19th century, Dabra Bagʿe, Šawā (EMML 2349)

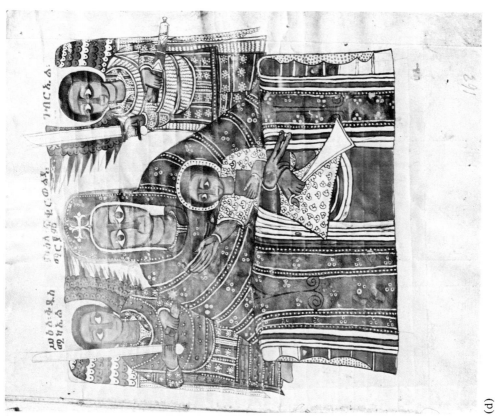

(d)

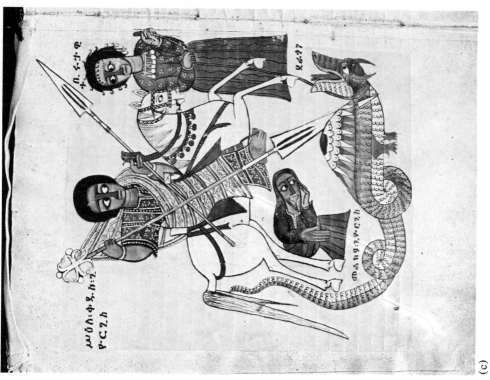

(c)

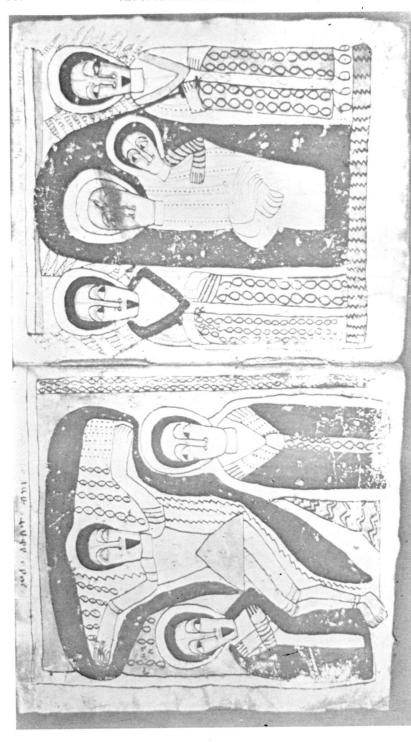

216a, 216b, 216c, 216d. Miracles of the Virgin Mary, 18th century, Dans Mikā'el, Šawā (EMML 2634)

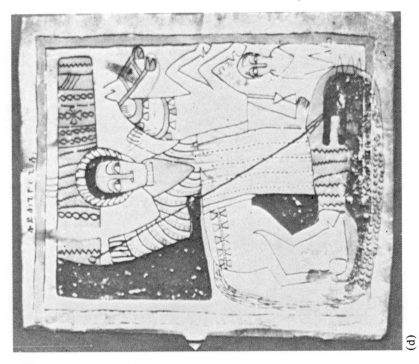

(d)

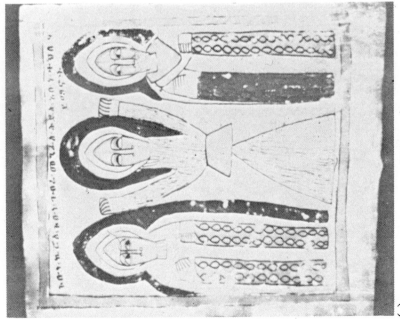

(c)

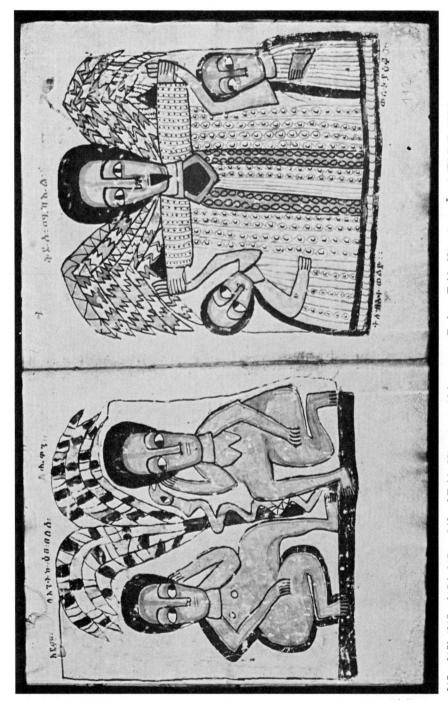

217a, 217b, 217c, 217d, 217e. Life of Takla Hāymānot, 19th century, Endone Takla Hāymānot, Šawā (EMML 2782)

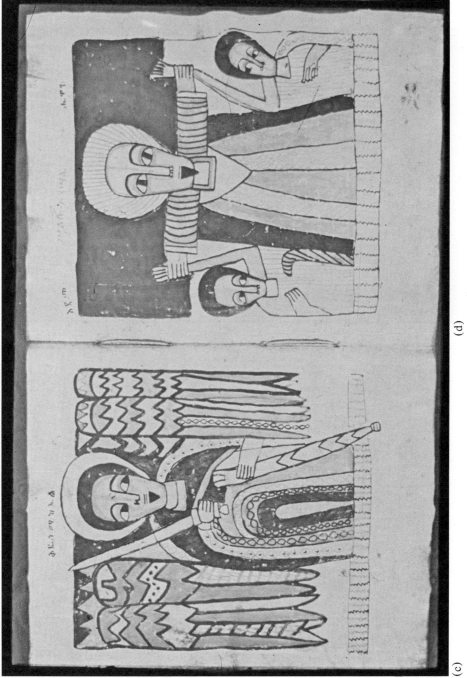

(d)

(c)

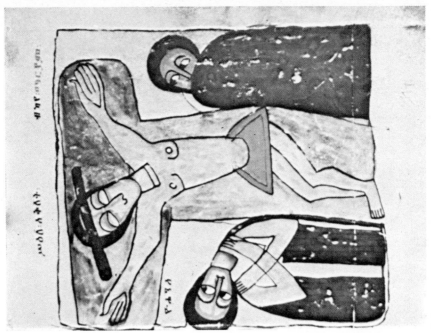

(e)

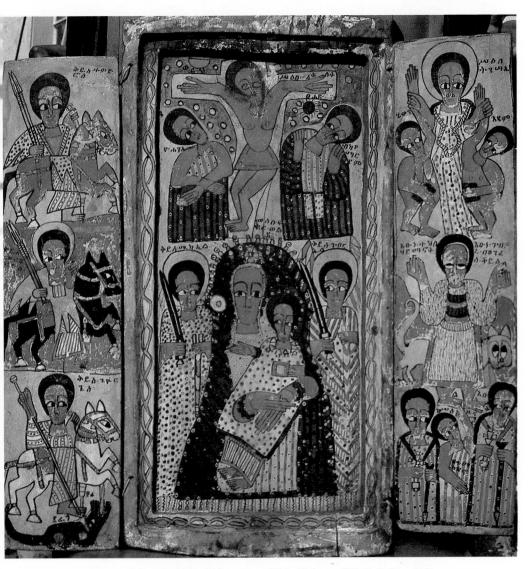

218a. Triptych, 18th–19th century. 35,1 : 18,0 cm. IES Coll. No. 6665

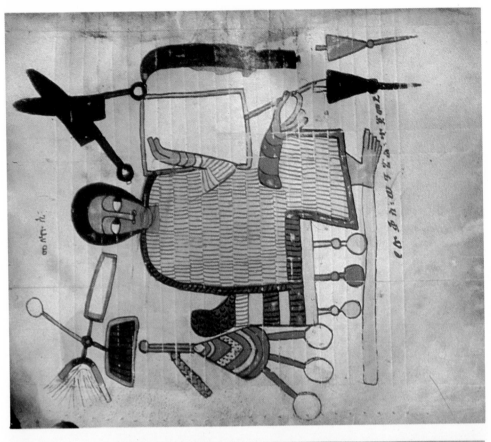

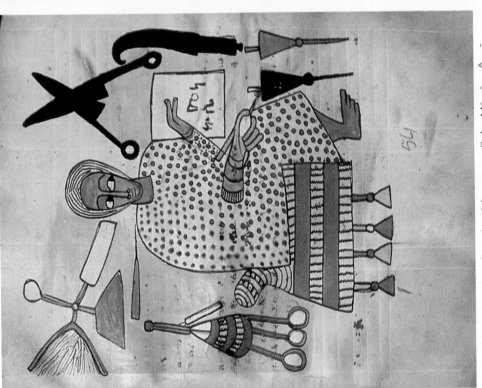

219a and 219b. Gospels, 18th century, Qobo Māryām, Šawā

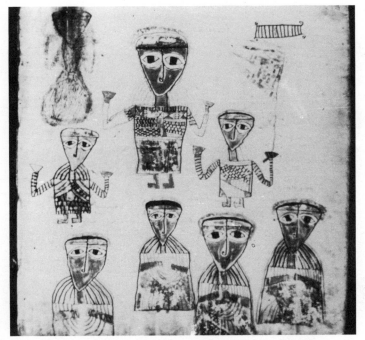

220a and 220b. Gospels, 19th century, Maṭāq Amānuʾēl, Šawā (EMML 2182)

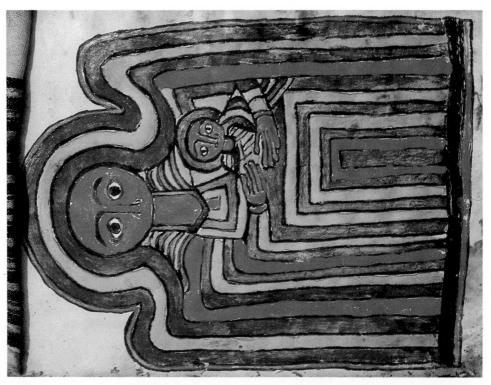

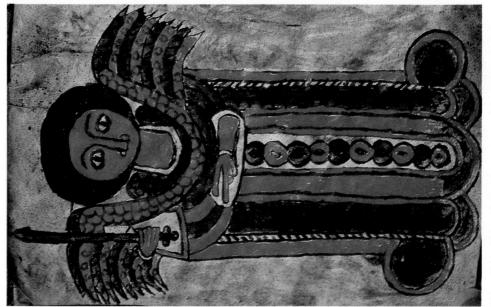

221a, 221b, 221c, 221d, 221e. Acts of St. Michael, 19th century, Gubāryā Giyorgis, Yaġġu in Wallo

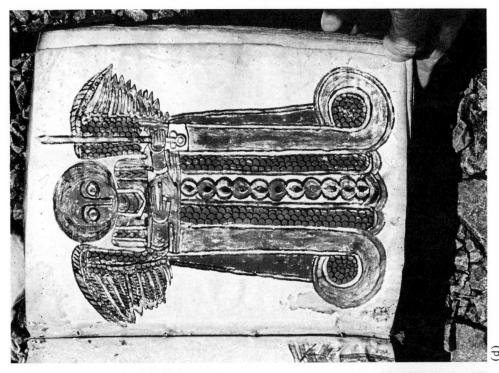

(d)

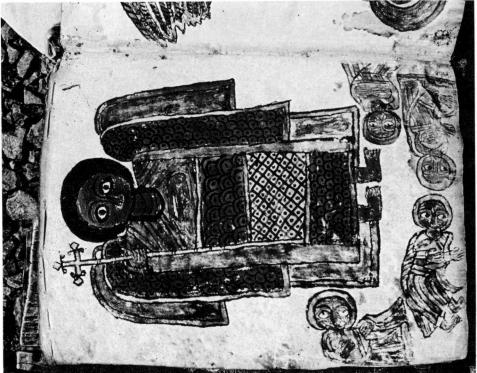

(c)

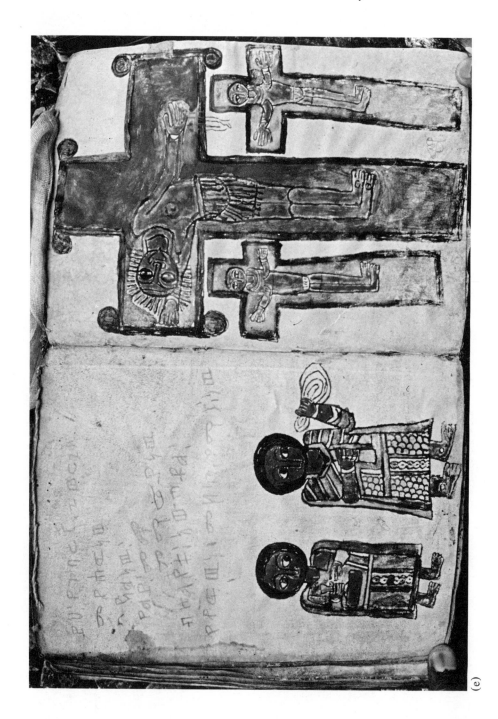

(e)

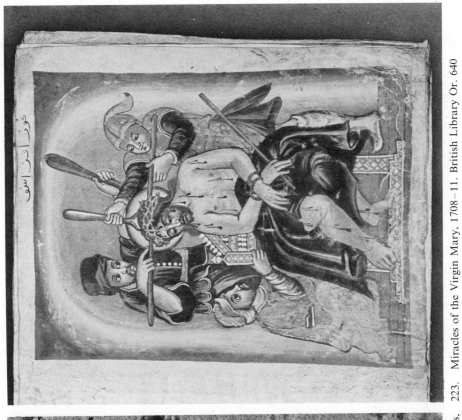

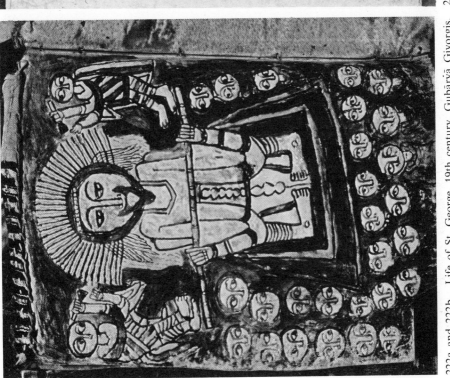

222a and 222b. Life of St. George, 19th century, Gubāryā Giyorgis, 223. Miracles of the Virgin Mary, 1708–11. British Library Or. 640
Yağğu in Wallo

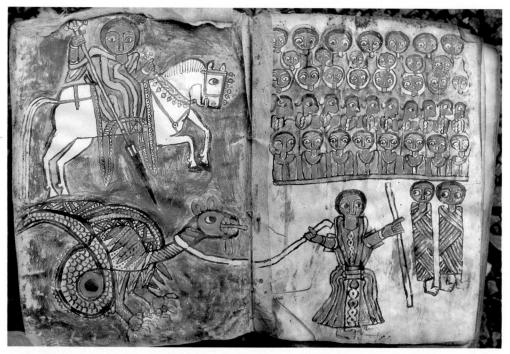

222b.

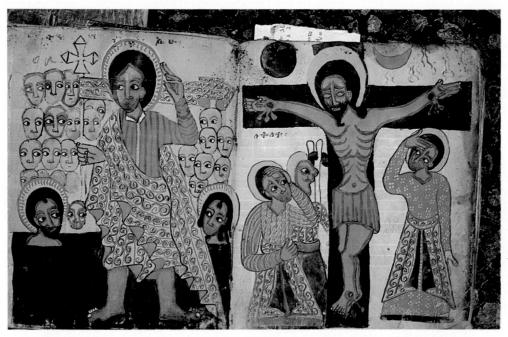

224a, 224b, 224c. V Acts of St. Michael, 18th century, Rogē Giorgis, Yaǧǧu in Wallo, 224d.

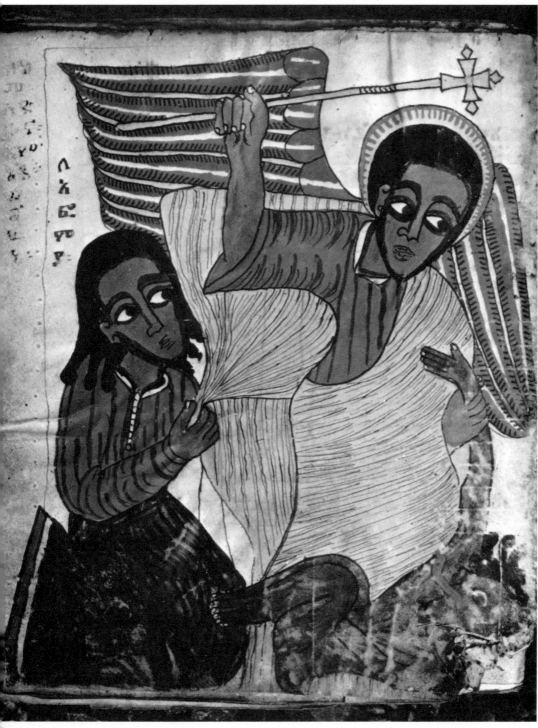

24c.

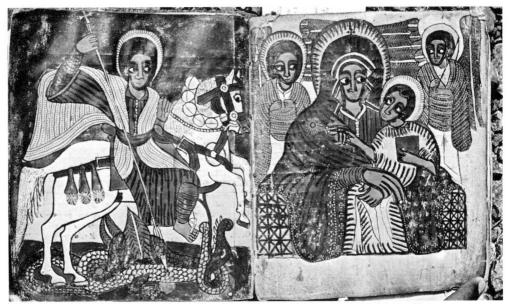

224d.

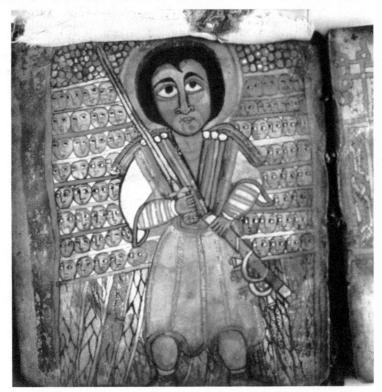

225. Acts of St. Raphael, 17th century. 19,0 : 11,5. IES Ms. No. 103.

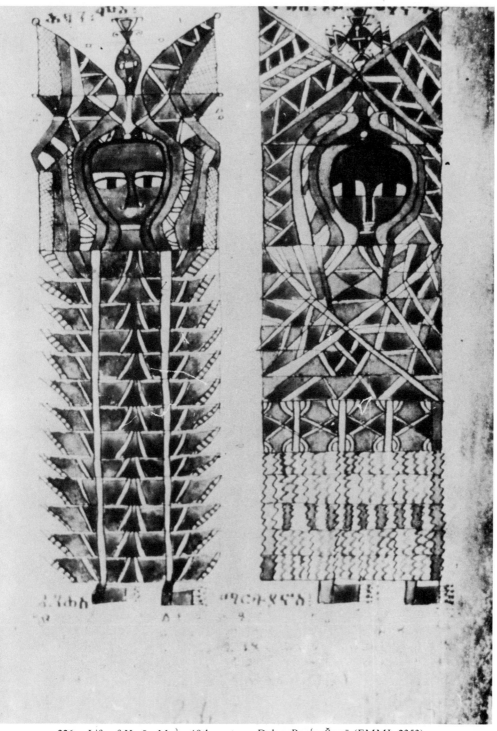

226. Life of Ḥeṣān Moʾa, 19th century, Dabra Bagʿe, Šawā (EMML 2353)

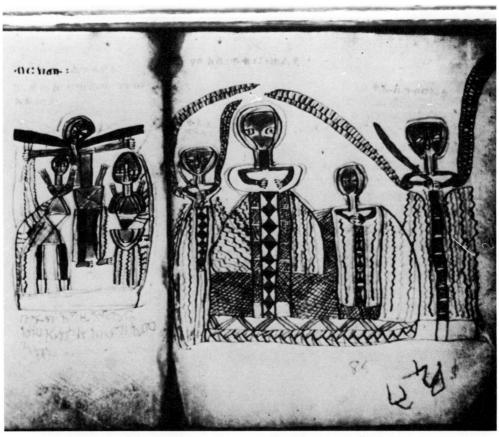

227. Horologium for the Night, 19th century, Ğebden Māryām, Šawā (EMML 2247)

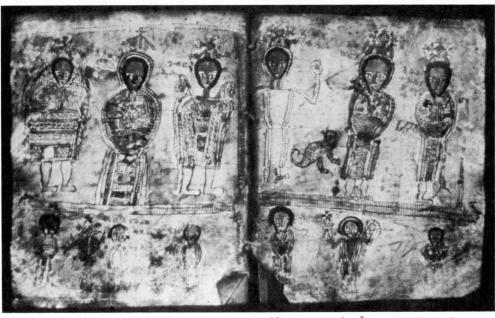

228. Horologium for the Night, 19th century, Muṭar Amānuʾēl, Šawā (EMML 2217)

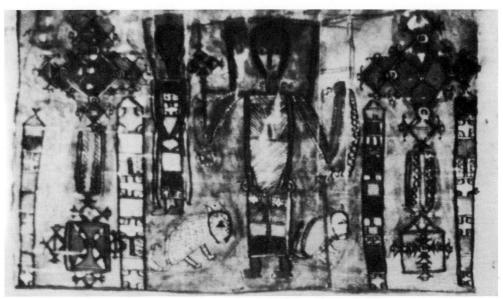

229. Life of Gabra Mansfas Qeddus, 19th century, Yagem Abo, Šawā (EMML 2682)

230. Psalter of King Śāhla Śellāsē, 1814—47, Maṭāq Takla Hāymānot

231a and 231b. *Weddāsē amlāk*, 17th–18th century, Kerārgē Gabra Manfas Qeddus (EMML 6415)

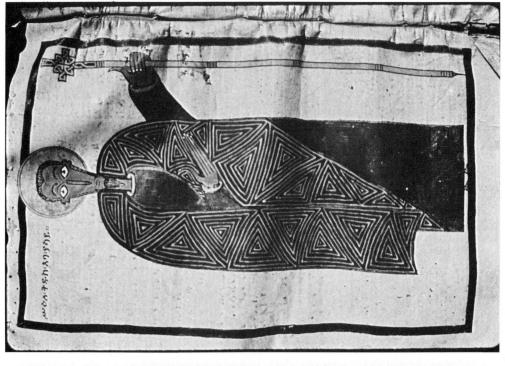

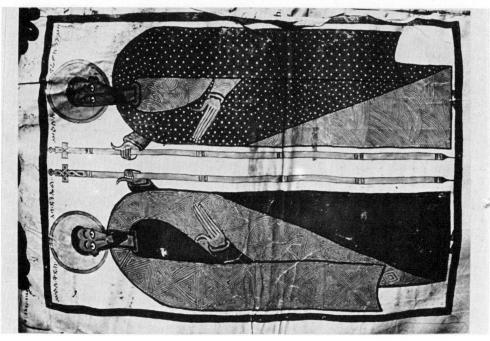

232a and 232b. Lives of Saints, 14th–15th century. 41.0 : 32.5 cm. Ṣeyon Māryām, Tulu Gudo Island, Lake Zewāy

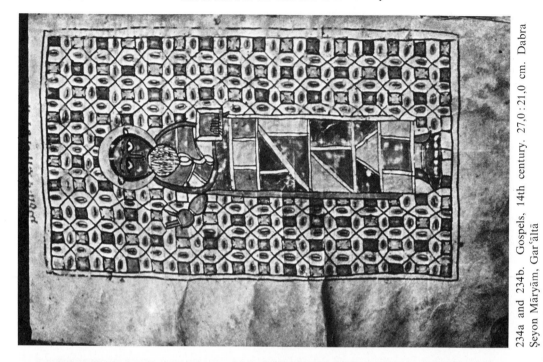

234a and 234b. Gospels, 14th century. 27,0:21,0 cm. Dabra Ṣeyon Māryām, Garʿāltā

233. Folio of the Gospels, 14th century. 30,0:20,5. IES Coll. No. 2475

235a, 235b, 235c. Booklet of Miniatures, 17th century. 14,8 : 13,6 cm. Ašatan Māryām, Lāstā

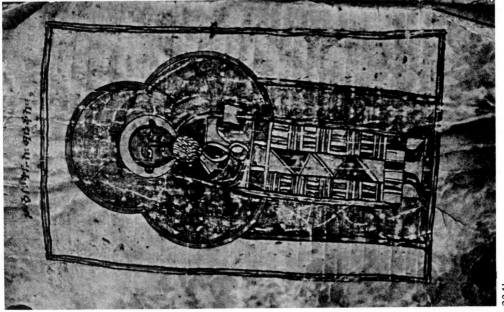

234b.

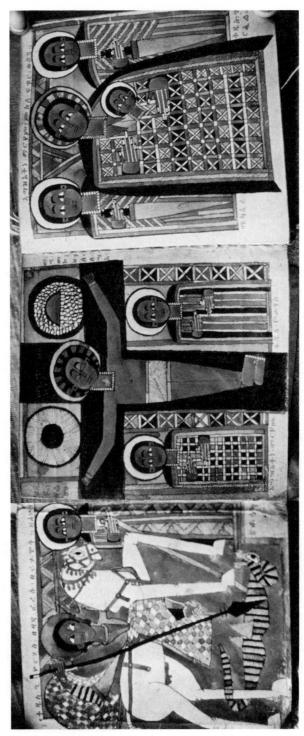

235b.

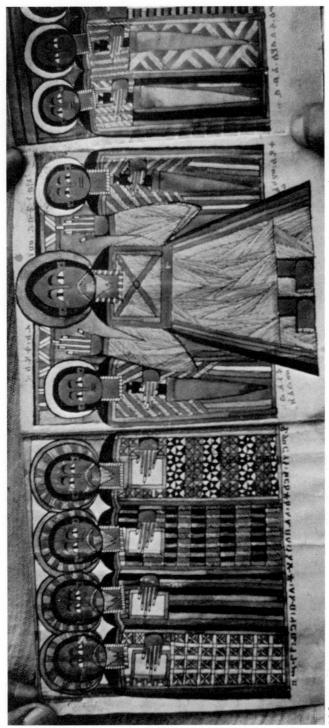

235c.

236. Booklet of Miniatures, 17th century. 10,5 : 9,5 cm. Dr. H. Schweisthal Coll., Germany

SELECTED BIBLIOGRAPHY ON ETHIOPIAN PAINTING

A. *Hailu [= Gabra-Iyasus Ḥāylu]*, L'idea di Maria corredentrice nell'arte etiopica = L'Illustrazione Vaticana 5 (1935) 251–52

G. *Annequin*, Au temps de l'Empereur Lebna-Denguel = Tarik 2 (1963) 47–51

- De Lebna Denguel à Théodoros, quatre siècles d'art et d'histoire (début XVIe–fin XIXe siècle) = ÉthMill 53–57

- De quand datent l'église actuelle de Dabra Berhan Sellase de Gondar et son ensemble de peintures? = AÉ 10 (1976) 215–25

- L'illustration des Ta'amra Maryam de 1630 à 1730; quelques remarques sur le premier style de Gondar = AÉ 9 (1972) 193–226

- Le lac Tana et ses îles = Les dossiers d'archéologie 8 (1975) 80–115

- (Chronique archéologique 1960–1964) = AÉ 6 (1965) 16–17 pl. 14–15

E. *Balicka*, Enluminures d'un rouleau magique éthiopien rapporté par la Ire expédition d'étudiants polonais en Afrique = Africana bulletin 21 (1974) 59–65

- Miniatury piętnastowiecznego psałterza etiopskiego (studium ikonograficzne) = Biuletyn historii sztuki XXXVII 2 (1975) 89–113

G. *Ballance*, Religious and Secular Art of Ethiopia; Museum of African Art, Washington, D. C. December 16, 1976–March 31, 1977 = African Arts X 3 (1977) 66–67

Berhanou Abbebe [= Berhānu Abbaba], The Painted Churches of Lake Tana; Cavalcade of Mural Art on Ethiopia's Monastery Islands = The UNESCO Courier (February 1977) 13–17

O. *de Bouveignes*, Un tableau de l'école Brugeois en Abyssinie = Brousse 3–4 (1949) 13–23

H. *Buchtal*, An Ethiopic Miniature of Christ Being Nailed to the Cross = Atti del Convegno Internazionale di Studi Etiopici, Roma 2–4 Aprile 1959 (Roma 1960) 331–34

E. A. *Wallis Budge*, On the Illuminations of Ethiopian Manuscripts = E. A. Wallis Budge (ed.), The Lives of Mabâ Sĕyôn and Gabra Krĕstos (London 1898) xl–lxxxiii

D. R. *Buxton*, The Abyssinians (London 1970) 136–153

E. *Cerulli*, La Cappella dell'Improperio e l'icone etiopica del «Gesù percosso» – E. Cerulli, Etiopi in Palestina: storia della communità etiopica di Gerusalemme (Roma 1943) 164–74 tav. 13–19

- Il «Gesù percosso» nel arte etiopica e le sue origini nell'Europa del XV secolo = RSE 6 (1947) 109–29

- Il libro etiopico dei Miracoli di Maria e le sue fonti nelle letterature del medio evo latino (Roma 1943) 89–93, 535–37

S. *Chojnacki*, Äthiopische Malerei = RKÄth 34–65

- The Four Living Creatures of the Apocalypse and the Imagery of the Ascension in Ethiopia = Bulletin de la Société d'archéologie copte 23 (1981) 159–81 pl. 1–5

- The Iconography of St. George in Ethiopia = JEthSt XI 1 (1973) 57–73; XI 2 (1973) 51–92; XII 1 (1974) 71—132

- Icons: an Historical Development of Paintings on Wood = Ethiopia: the Christian Art of an African Nation (Salem, Mass. 1978) 1–9

- The Nativity in Ethiopian Art = JEthSt XII 2 (1974) 11–56

- A Note on the Baptism of Christ in Ethiopian Art = Annali dell'Istituto Orientale di Napoli 36 (1976) 103–15 pl. I–IV

– Note on the Early Iconography of St. George and Related Equestrian Saints = JEthSt XIII
 2 (1975) 39–55
– Note on the Early Imagery of the Virgin Mary in Ethiopia = Ethnologische Zeitschrift II
 (1977) 5–41
– Notes on Art in Ethiopia in the 15th and Early 16th Century = JEthSt VIII 2 (1970) 21–65
– Notes on Art in Ethiopia in the 16th Century: an enquiry into the unknown = JEthSt IX 2
 (1971) 21–97
– Notes on a Lesser-known Type of St. Mary in Ethiopian Painting = Abba Salama 1 (1970)
 162–71
– Notes on Old Ethiopian Paintings = African Forum I 3 (1966) 85–90
– Notes on Ethiopian Traditional Art: the last phase = Ethnologische Zeitschrift 3 (1978)
 65–81
– Short Introduction to Ethiopian Painting = JEthSt II 2 (1964) 1–11
– Two Ethiopian Icons = African Arts X 4 (1977) 44–47 56–61 87
G. A. Colonna di Cesaro, L'influenza italiana sul risveglio della pittura religiosa etiopica
 = L'Illustrazione Vaticana 7 (1936) 705–08
R. J. Cornet, La curieuse histoire d'un tableau flamand découvert en Afrique Centrale = La
 revue coloniale belge 85 (1949) 234–37
C. Conti Rossini, Un codice illustrato eritreo del secolo XV (Ms. Abb. N. 105 della Bibl. Nat.
 de Parigi) = Africa italiana 1 (1927) 83–97
– Miniature armene nel Ms. Et. N. 50 della Biblioteca Vaticana = RSE 2 (1942) 191–97
M. Dei Gaslini, Arte del pittore etiopico: piccolo reame del colore = L'Italia d'oltremare 7
 (1942) 198–200
E. Denninger, Naturwissenschaftliche Untersuchungen an einer äthiopischen Malerei =
 Maltechnik 65 (1959) 17–19
J. Doresse, Nouvelles recherches sur les relations entre l'Egypte copte et l'Éthiopie: XIIe–
 XIIIe siècles = Comptes rendus des séances de l'Académie des Inscriptions et Belles
 Lettres de l'année 1970 (Paris 1971) 557–66 3 pl.
– La vie quotidienne des éthiopiens chrétiens aux XVIIe et XVIIIe siècles (Paris 1972) 209–
 217
Ethiopia: the Christian Art of an African nation. The Langmuir Collection, Peabody
 Museum of Salem (Salem Mass. 1978)
Éthiopie millénaire: préhistoire et art religieux (Paris 1974)
R. Fechter, Äthiopische Ikonen und Kreuze = RKÄth 16–19
A Flemish Picture from Abyssinia = The Burlington Magazine for Connoisseurs 6 (1905) 394
G. Gerster (ed.), Churches in Rock; early Christian art in Ethiopia (London 1970)
Gigar Tesfaye [= Gigār Tasfāy], Reconnaissance de trois églises antérieures à 1314 = JEthSt
 XII 2 (1974) 57–75
P. Graziosi, Le pitture etiopiche del Museo Nazionale d'Antropologia ed Etnologia di
 Firenze = Rivista delle colonie VI 10 (1932) 3–17
M. Griaule, L'enlèvement des peintures d'Antonios = La revue de Paris (1 Octobre 1934)
 545–70
– Peintures abyssines = Minotaure I 3 (1933) 83–88
– Silhouettes et graffiti abyssins (Paris 1933)
E. Hammerschmidt, Illuminierte Handschriften der Staatsbibliothek Preussischer Kultur-
 besitz und Handschriften vom Ṭānāsee = *E. Hammerschmidt (ed.)*, Codices Aethiopici 1
 (1977)
E. Hammerschmidt–O. A. Jäger, Illuminierte äthiopische Handschriften = VODH XV
 (1968)

M. E. Heldman, Christ's Entry into Jerusalem in Ethiopia = Proceedings of the First United States Conference on Ethiopian Studies (East Lansing Mich. 1973) 43–60

– The Kibran Gospels: Ethiopia and Byzantium = Proceedings of the Fifth International Conference on Ethiopian Studies, Session B (Chicago Ill. 1978) 359–368

– Miniatures of the Gospels of Princess Zir Gānēlā, an Ethiopic Manuscript dated A. D. 1400/01 (Dissertation, Washington University, Department of Art and Archeology, August 1972)

F. Heyer, Die Kirche Äthiopiens (Berlin 1971) 47–59

O. A. Jäger, Äthiopische Miniaturen (Berlin 1957)

– Ethiopian Manuscript Painting = EthObs 4 (1960) 353–91

– Mönche und Malereien in äthiopischen Klöstern = Der Monat 125 (1959) 29–37

– – *L. Deininger-Engelhart*, Some Notes on Illuminations of Manuscripts in Ethiopia = RSE 17 (1961) 45–60

B. Juel-Jensen, The Ground Hornbill Artist of the 17th-century Ethiopic Manuscript = The Book Collector (Spring 1977) 61–74

Kebbede Mikael [= Kabbada Mikāʾēl], Old Ethiopian Paintings. Anciennes peintures éthiopiennes (Addis Ababā 1961 E. C.)

C. Keller, Über Maler und Malerei in Abessinien = Jahresbericht der Geographisch-Ethnologischen Gesellschaft (Zürich 1904) 21–38

W. Krafft, Report on Wayname Kidana Meherat, a little-known church in Gojam = EthObs 15 (1972) 71–85

R. Lefevre, Francesco Brancaleone: pittore fantasma = Sestante VII 1 (1971) 43–44

– L'Imperatore David II in un ritratto a Firenze = Sestante III 1 (1967) 29–32

Cl. Lepage, L'ancienne peinture éthiopienne (Xe–XVe siècles): analogies et influences = DSCE 5 (1974) 29–37

– L'art du Xe siècle au XVe siècle, des «siècles obscurs» aux «siècles des lumières» – ÉthMill 46–52

– Découverte d'un art étonnant: les églises éthiopiennes du Xe au XVIe siècle = Archéologia 64 (1973) 45–58

– Dieu et les quatre Animaux Célestes dans l'ancienne peinture éthiopienne = DSCE 7 (1976) 67–112 27 fig.

– Esquisse d'une histoire de l'ancienne peinture éthiopienne du Xe au XVe siècle = Abbay [= DSCE 8] (1977) 59–93 16 fig.

– Histoire de l'ancienne peinture éthiopienne (Xe–XVe siècle). Résultats des missions de 1971 à 1977 = Comptes rendus des séances de l'Académie des Inscriptions et Belles Lettres (Mai–Juillet 1977) 325–75

– La peinture religieuse du Xe au XVe siècle = Les dossiers d'archéologie 8 (1975) 60–73

– Peintures murales de Ganata Maryam = DSCE 6 (1975) 59–84

– Recherches sur l'art chrétien d'Éthiopie du Xe au XVes. Résultats et perspectives = DSCE 4 (1973) 39–56 18 pl.

– Révélation d'un manuscrit particulièrement fascinant de l'Éthiopie au 15e siècle = Connaissance des arts 274 (1974) 92–99

J. Leroy, Les étapes de la peinture éthiopienne relevées par les manuscrits illustrés et les églises peintes = Ethiopian studies (Manchester 1964) 245–46

– Ethiopian Painting in the Middle Ages = GerChRock 61–68

– Ethiopian Painting in the Late Middle Ages and under the Gondar Dynasty (London 1967)

– L'Éthiopie: archéologie et culture (Paris 1973) 114–88

– L'Évangéliaire éthiopien du couvent d'Abbā Gārimā et ses attaches avec l'ancien art chrétien de Syrie = Cahiers archéologiques 11 (1960) 131–34

- L'Évangéliaire éthiopien illustré du British Museum (Or. 510) et ses sources iconographiques = AÉ 4 (1961) 155–68 pl. 64–66
- Une icône éthiopienne de la Vierge au Musée copte du Vieux-Caire = AÉ 6 (1965) 229–35 pl. 86–89
- L'icône ex-voto du Negus Lebna Dengel au Monastère du Saint Antoine du Désert (Egypte) = JEthSt IX 1 (1971) 35–45
- Une «Madonne italienne» conservée dans un manuscrit éthiopien du British Museum = RSE 18 (1961) 77–82
- Un nouvel évangéliaire éthiopien illustré du monastère d'Abbā Gārimā = Synthronon II (1968) 75–87
- Objectifs des recherches sur la peinture religieuse éthiopienne = AÉ 1 (1955) 127–36
- La peinture chrétienne d'Éthiopie antérieure à l'influence occidentale = *K. Wessel (ed.)*, Christentum am Nil (Essen 1964) 61–76
- Recherches sur la tradition iconographique des Canons d'Éusèbe en Ethiopie = Cahiers archéologiques 12 (1961) 173–204

O. Løfgren, Äthiopische Wandamulette = Orientalia suecana 11 (1962) 95–120

P. Maarschalkerweerd, Pitture cristiane delle terre di missione nel Pontificio Museo Missionario-Etnologico = Annali Lateranensi 2 (1938) 11–42

O. F. A. Meinardus, Some Ethiopian Traditions of St. Luke as Painter = Abba Salama 7 (1976) 243–52

J. Mercier, Étude stylistique des peintures de rouleaux protecteurs éthiopiens = Objets et mondes XIV 2 (1974) 89–106
- Magie et tradition: les rouleaux protecteurs = Le dossiers d'archéologie 8 (1975) 116–27
- Note sur quelques problèmes de la Talismanique savante éthiopienne = Abbay [= DSCE] 8 (1977) 119–33 7 pl.
- Les peintures des rouleaux protecteurs éthiopiens = JEthSt XII 2 (1974) 107–46
- Les plus anciens rouleaux protecteurs éthiopiens de la Bibliothèque nationale à Paris = AÉ 10 (1976) 227–38 pl. 62–64
- Rouleaux magiques éthiopiens (Paris 1979)
- Sur un type particulier de talisman et les enseignements que l'on peut en tirer à propos de l'art magique = DSCE 6 (1975) 103–18

H. D. Molesworth, Painting in Ethiopia: a reflection of Medival practice = D. J. Gordon (ed.), Fritz Saxl, 1890–1948: A Volume of Memorial Essays from his frends in England (London c. 1950)

U. Monneret de Villard, La coronazione della Vergine in Abissinia = La Bibliofilia 44 (1962) 167–75
- La Madonna di S. Maria Maggiore e l'illustrazione dei Miracoli di Maria in Abissinia = Annali Lateranensi 11 (1947) 9–90
- La Majestas Domini in Abissinia = RSE 3 (1943) 36–45
- Miniatura veneto-cretese in un codice etiopico = La Bibliofilia 47 (1945) 1–13
- Note sulle più antiche miniature abissine = Orientalia 8 nuova ser. (1939) 1–24

A. Mordini, Un'antica pittura etiopica = RSE 11 (1952) 29–33

Oxford University Exploration Club, Rock-hewn Churches of Eastern Tigray; an account of the Oxford University Expedition to Ethiopia, 1974 (Oxford 1975)

R. Pankhurst, Ethiopian Manuscript Illuminations: the Four Evangelists = EthObs 9 (1965) 100–12
- The History of the Kwer'ata Re'esu: an Ethiopian icon = African Affairs 81 (1982) 117–25
- The Kwer'ata Re'esu: the History of an Ethiopian Icon = Abba Salama 10 (1979) 169–87

– Some Notes for a History of Ethiopian Secular Art = EthObs 10 (1966) 5–80

– Traditional Ethiopian Art = EthObs 5 (1962) 291–301

C. F. Perczel, The Queen of Sheba Legend in Ethiopian Art = Art International 22 (1978) 6–11

E. Pittard, Les arts populaires de l'Afrique. Quelques peintures d'Abyssinie = Archives suisses d'anthropologie générale V 1 (1928) 87–103

R. Plant, Painter's Pattern Book, Makelle, Tigre Province, Ethiopia = EthObs 16 (1973) 133–140

B. Playne, St. George for Ethiopia (London 1954) 177–195

– In Search of Early Christian Paintings in Ethiopia = The Geographical Magazine XXII 10 (1950) 400–11

W. Raunig, Zwei Ikonen aus der Äthiopischen-Sammlung des Völkerkundemuseums der Universität Zürich = Ethnologische Zeitschrift 1 (1975) 151–79

L. Reis Santos, On a Picture from Abyssinia = The Burlington Magazine for Connoisseurs 69 (1941) 26–29

– Pintura da Renascença em Portugal. Importante documento evocativo da acção spiritual dos Portugueses na Abissinia = Ocidente V 12 (1939) 72–77

Religiöse Kunst Äthiopiens [Religious Art of Ethiopia] (Stuttgart 1973)

L. Ricci–J. Leroy, La pittura etiopica, durante il medioevo e sotto la dinastia di Gondar . . . (Recensioni) = Rivista di studi orientali 29 (1964) 325–43

– Qualque osservazioni sull'iconografia della «Maiestas Domini» = RSE 15 (1959) 106–11

N. Sanguinetti, L'Espressione e il colore nella pittura popolare dell'Eritrea = Bolletino 2 (1957) 22–26

– Forme e colori attraverso il tempo = Etiopia illustrata 5 (1965)

G. Sanwith, Der Heilige Mercurius und die Hundeköpfe: ein Beispiel visionärer Kunst aus Äthiopien = Antaios 4 (1962–63) 251–60

P. Skehan, An Illuminated Gospel Book in Ethiopic = *D. Miner (ed.).* Studies in Art and Literature for Bella Da Costa Greene (Princeton 1954) 350–57

D. Spencer, In Search of St. Luke Ikons in Ethiopia = JEthSt X 2 (1972) 67–95

– Travels in Gojjam: St. Luke Ikons and Brancaleon rediscovered = JEthSt XII 2 (1974) 201–20

W. Staude, Les cinq clous du Christ et l'Icône Impériale éthiopienne = Ethnologische Zeitschrift 1 (1971) 5–25

– Étude sur la décoration picturale des églises Abbā Antonios de Gondar et Dabra Sinā de Gorgora = AÉ 3 (1959) 185–235

– Iconographie de la légende éthiopienne de la Reine d'Azieb ou de Saba = Journal de la Société des Africanistes XXVII 1 (1957) 139–81

– Die ikonographischen Regeln in der äthiopischen Kirchenmalerei = Archiv für Völkerkunde 13 (1959) 236–308

– Le mauvais oeil dans la peinture chrétienne d'Abyssinie = Journal asiatique 2 (1934) 231–57

– Une peinture éthiopienne datée dans l'église de Bēta-lehem (region de Gaynt, province du Begemder) = Revue de l'histoire des religions 157 (1959) 65–110

– Die Profilregel in der christlichen Malerei Äthiopiens und die Frucht von dem "Bösen Blick" = Archiv für Völkerkunde 9 (1954) 116–61

J. Strzygowski, Der koptische Reiterheilige und der hl. Georg = Zeitschrift für ägyptische Sprache und Altertumskunde (1905) 49–60

S. Tedeschi, Note storiche sull'arte figurativa etiopica medioevale = Bolletino 3 (1964) 18–55

– Nuova luce sui rapporti tra Venezia e l'Etiopia (sec. XV) = Istituto Italiano di Cultura 8 (Addis Ababā, 1974)

E. *Ullendorff*, The Ethiopians. An Introduction to Country and People (London 1960) 165–69

United Nations Educational Scientific and Cultural Organization, Ethiopia; Illuminated Manuscripts. Introd. by Jules Leroy. Texts by Stephen Wright and Otto A. Jäger (Greenwich Conn. 1961)

E. *Wagner*, Die Illustrationen der äthiopischen Zauberrollen der Sammlung Littmann = Der Orient in der Forschung; Festschrift für Otto Spies (Wiesbaden 1967) 706–32

A. J. *Wauters*, Découverte d'un tableau flamand dans l'Afrique Centrale = Congo illustré 4 (1895) 177–79

K. *Wehlte*, Rettung einer äthiopischen Wandmalerei = Maltechnik 65 (1959) 1–18

F. *Weihs*, Einige technische Details zu äthiopischen Ikonen = RKAth 298–305

GENERAL INDEX

A. G. Hailù, 357
Abbā Antonios, 133, 135f., 164
Abbā Garimā, Sallā, 137
ʿAbdallāh Nirqi, 120
Abebe Kifleyesus, 133, 146
Abiy-Addi, 102
Abrehā Aṣbehā, 137, 165, 302
Abrehām, attendant, 64
Abrocoros, 64
Absādi, 25
Abū Maqār, 132, 293
Abū Salih, 51, 57
Abuna Abrhām, Monastery, 102, 147
Abuna Musē, see Yediba Māryām
Abuna Yemʿāta, 37, 127f.
Abuna Yoḥanni, Monastery, 102, 147
Abyssinia, 27, 229, 340, 406
Adāgā Hāmus, 182, 203
Adana, 45, 50
Addis Ababā, 26, 33f., 82, 109, 121f., 125,
 145, 188f., 220, 296, 414, 420f., 423, 428,
 430, 477, 490f.
Adel, 471
Aden, 314
Adwā, 304–6
 Madḥanē ʿĀlam, 304, 487
 Śellāsē, 305, 330
Africa, 16f., 225, 431
Afringi, 380
 see also Farang, Marqoryos
Agāmē, 35, 174, 412
Agara Salām, 56
Agra, 219
Agthᵓamar, 179
Ahiya Afaǧǧ Qwesqwām, 102, 151
Aḥmad Grāñ, 23f., 117, 352, 382, 384
Akāl, 145
Akathistos, 178
Akbar, Mogul, 218
Aksum, 172
Alamanno, Pietro, 391
Albuquerque, Afonso de, 313
Alexander VII, pope, 310
Alexandria, 399

Alfonso V, king of Aragon, 376f.
Almagià, Roberto, 400
Almeida, Manoel de, 219f.
Alvarez, Francisco, 104, 116, 220, 308,
 378–82, 384, 400–3, 431f.
Alvixi, son of Bicini, 399
Amārā Sāyent, 40, 111, 155, 382f., 393, 405,
 445
Amata Dengel, 384
Amata Leʿul, 234
Amata Māryām, 107
Ambā Darā, 180
Ambā Māryām, 246f., 289
Ambā Warq, 194, 213
Ambrose, saint, 114
Amda Ṣeyon (1313–43), 142
America, 15, 225
Amhā Giorgis, 472
Amhā Iyasus, d. 1774, 469
Amhārā, province, 118, 388
Anaphora of Mary, 123
Andrade, Lázaro de, 25, 342, 376–78,
 401–7, 430, 432, 450
Andreas of Caesarea, 121
Anfray, Francis, 420
Angolalā, 470
Angot, 399
Ankobar, 181, 469f., 472, 478, 484, 487
 Madḥanē ʿĀlam, 487
Annequin, Guy, 23, 25, 27, 134, 340–42, 375,
 404, 419
Antolínez, José, 312
Antonio, brother of Bicini, 399
Antonio, son of Duarte Galvam, 308
Anubis, 415
Apocalypse, Book of, 121, 133, 310
 see also Revelation, Book of
Apocrypha, 39, 49
Arabia, 17
Arabs, 16
Aretino, Spinello, 410f.
Arkaladas, 167
Armenia, 183
Armenians in Ethiopia, 171, 234, 426f., 431

INDEX OF THEMES AND FORMS